Select World Wide Web Sites

The following are a few of the most relevant and/or comprehensive World Wide Web sites that readers will find useful in obtaining timely information on topics covered in this book.

International Sites

International Business Network
International Monetary Fund
International Labour Organization
The Textile Institute
United Nations
World Bank
World Trade Organization

http://www.usal.com/~ibnet/
http://www.imf.org
http://www.ilo.org
http://www.texi.org
http://www.un.org
http://www.worldbank.org
http://www.wto.org

U.S. Government Agency Sites

American Textile (AMTEX) Partnership

Bureau of Economic Analysis

Global Export Market Information System

The World Factbook (CIA)

http://www.bthtp://www.bthtp://www.bthtp://www.bthtp://www.bthtp://www.bthtp://www.bthtp://www.bthtp://www.bthtp://www.bthtp://www.bthtp://www.bthtp://www.bthtp://www.bthtp://www.bthttp://www.btht

U.S. Big Emerging Markets (BEMS) U.S. Census Bureau

U.S. Customs Service (USCS)

U.S. Department of Commerce U.S. International Trade Commission U.S. Office of Textiles and Apparel

Softgoods Industry Sites

American Apparel Manufacturers Association American Textile Manufacturers Institute Apparel Net Apparel Exchange, The Demand Activated Manufacturing (DAMA) FiberSource National Retail Federation (NRF) Textile Information Management Systems (TIMS) Textile Institute Textile Web http://apc.pnl.gov: 2080/amtex.www/amtex.html

http://www.bea.doc.gov http://www.itaiep.doc.gov http://www.odci.gov/cia/publications/nsolo/

http://www.stat-usa.gov/itabems.html

http://www.census.gov

http://www.ustreas.gov/treasury/bureaus/customs/

customs.html http://www.doc.gov http://usitc.gov

http://otexa.ita.doc.gov

http://www.americanapparel.org

http://www.atmi.org
http://www.apparel.net/
http://www.apparelex.com
http://dama.tis.llnl.gov
http://www.fibersource.com
http://www.nrf.com
http://www.unicate.com
http://www.texi.org

http://www.textileweb.com/links/

Textiles and Apparel in the Global Economy

Kitty G. Dickerson
University of Missouri–Columbia

Merrill, an imprint of Prentice Hall Upper Saddle River, New Jersey Columbus, Ohio Cover art: Nenad Jakesevic Editor: Bradley J. Potthoff Production Editor: Mary M. Irvin Design Coordinator: Diane C. Lorenzo Text Designer: John Edeen Cover Designer: Susan Unger Production Manager: Pamela D. Bennett Director of Marketing: Kevin Flanagan Marketing Manager: Suzanne Stanton Marketing Coordinator: Krista Groshong

This book was set in Palatino by Carlisle Communications, Ltd., and was printed and bound by R. R. Donnelley & Sons Company. The cover was printed by Phoenix Color Corp.

© 1999, 1995 by Prentice-Hall, Inc. Simon & Schuster/A Viacom Company Upper Saddle River, New Jersey 07458

All rights reserved. No part of this book may be reproduced, in any form or by any means, without permission in writing from the publisher.

Earlier edition, entitled *Textiles and Apparel in the International Economy*, [©] 1991 by Macmillan Publishing Company.

Printed in the United States of America

1098765432

ISBN: 0-13-647280-X

Prentice-Hall International (UK) Limited, London
Prentice-Hall of Australia Pty. Limited, Sydney
Prentice-Hall of Canada, Inc., Toronto
Prentice-Hall Hispanoamericana, S. A., Mexico
Prentice-Hall of India Private Limited, New Delhi
Prentice-Hall of Japan, Inc., Tokyo
Simon & Schuster Asia Pte. Ltd., Singapore
Editora Prentice-Hall do Brasil, Ltda., Rio de Janeiro

Library of Congress Cataloging-in-Publication Data Dickerson, Kitty G.

Textiles and apparel in the global economy / Kitty G. Dickerson. -

- 3rd ed.

p. cm.

Includes bibliographical references and index. ISBN 0-13-647280-X

1. Textile industry. 2. Clothing trade. 3. International economic relations. I. Title. HD9850.5,D53 1999

338.4'7677—dc21

98-13493

CIP

To my mother, Virgie Gardner, one of the true heroines of this world.

About the Author

Dr. Dickerson is Professor and Department Chairman, Department of Textile and Apparel Management, University of Missouri-Columbia (MU). For more than two decades, she has met with industry leaders, policymakers, and other scholars—at both the national and international levels—to gain insight into the complex issues associated with global trade, particularly related to the textile, apparel, and retailing industries. On numerous occasions, she has

met in Geneva, Brussels, and Washington with policymakers representing various national and international organizations and most regions of the world. In addition, she has had short-term experiences in a number of countries and was an invited participant to the World Economic Forum Industry Summit.

Dr. Dickerson is a Fellow in the International Textile and Apparel Association; she has also served as president of that group. She received the *Bobbin* "Educator of the Year" Award and was named to *Textile World's* "Top Ten Leaders" list. Her awards include the American Fiber Manufacturers Association Research Award, the Virginia Textile Award of Merit, and numerous others. Dr. Dickerson serves on the Board of Directors of Kellwood

Kitty G. Dickerson, Ph.D.

Company, a nearly \$2 billion Fortune 500 firm, with both U.S. and international manufacturing and marketing operations in the Apparel and recreational/camping softgoods industries. She has also had previous experience in retailing.

Dr. Dickerson is author, along with Jeannette Jarnow, of *Inside the Fashion Business*, also published by Prentice Hall. Standard & Poor's/DRI/McGraw-Hill invited Dr. Dickerson to write the chapter on

the "Apparel and Fabricated Textile Products" industry for *U.S. Industry and Trade Outlook*, published jointly with the U.S. Department of Commerce. She has also published more than 75 articles in both scholarly and trade journals. Various academic and industry groups in the United States and several other countries have invited Dr. Dickerson to address those audiences. Additionally, she has chaired her university's first Council on International Initiatives (CII), a campus-wide body to provide leadership for MU's international agenda.

Web site:

http://www.missouri.edu/~heskitty/

E-Mail:

dickersonk@missouri.edu

COMMENTS AREA TO SELECT

teratuken (Sikas) banasakit banasan pe Menangkan kenangan banan di Kasa berang Manangkan kenangan banan banan banan banan banan

Preface

Since publication of the second edition of this book, globalization has become a pervasive theme of the tex-

tile, apparel, and retailing industries. A growing number of companies have developed global corporate strategies. Executives in viable firms now realize their companies are an integral part of a worldwide production-marketing network. It is therefore more important than ever before for individuals in these industries to see and understand the big picture and how one's industry and one's company relate to that larger global picture.

In just a few short years, communications technologies have facilitated globalization through faxes, e-mail, and the Internet. Communications can occur more easily than at any time in human history. Individuals in far regions of the world can do business quickly and inexpensively, overcoming barriers of distance and time. Company sales data, patterns and specifications, and electronic transfers of payment move from continent to continent with the ease of doing business in the next state or province only a short time ago. Individuals may access worldwide information sources such as those provided inside the front cover.

Business environments and trade policy changes have spawned new trade relationships. Business partners may be in the next town or on the next continent. As the new World Trade Organization (WTO) policies are implemented, many of the barriers to trade in the past are being removed—particularly for textiles and apparel.

Textiles and Apparel in the Global Economy addresses the rapidly changing global setting.

This edition emphasizes the way in which new communications technologies are fostering globalization, and considers the increasing importance of the field of logistics as a related sector that relies on these technologies to facilitate efficient worldwide movement of goods. Other new related topics include agile manufacturing and virtual companies. This edition examines how the softgoods industry is being restructured on a global basis as well as domestically. Expanded sections provide an upto-date view of the industry in Asia, Western and Eastern Europe, Central and South America, North America, the Caribbean, Africa, and Australia. Updated coverage of regional trading blocs is included. New textile trade policies are discussed, including implications for various segments of the industry. Updated discussion on sweatshops and child labor is included. Among other new features, the book provides information on the North American Industry Classification System (NAICS), which replaces the Standard Industrial Classification (SIC) system for classifying industries.

For many years, the textile and apparel sectors have been on the forefront of globalization. No industries are more broadly dispersed around the world than textiles and apparel. Just as the textile industry led the industrial revolution, textile and apparel production has been among the first sectors to be part of today's global shifts in production and trade.

The general purpose of this book is to provide an overview of the global textile and apparel industries and to consider the U.S. textile complex and the U.S. market within an international context. A primary goal is to encourage

the reader to develop a global perspective as the book considers what is happening in these dynamic industries today. Virtually no aspect of the softgoods industry is unaffected by today's global activity. Additionally, I hope that readers will become increasingly sensitive to the fact that our global interdependence places on us responsibilities as global citizens, as well.

For more than two decades, I have followed the drama surrounding international shifts in the production and trade of textiles and apparel. This book represents a distillation and synthesis of various perspectives based on considerable research and extensive contacts with industry and government leaders as well as other academicians at both national and international levels. Over time, these interactions have been with persons representing virtually all regions of the world. Although my views have been shaped by each of those visits and interviews, in the end, the book represents one person's judgment on what seemed appropriate for a broad, multidisciplinary look at textiles and apparel in the global economy. Reviewers helped in shaping views on relevant content.

Given the sensitive nature of textile and apparel trade, I have accepted the reality that no presentation of the material will be perceived by various interest groups as the final truth. Accepting that fact, this book is an attempt to present objectively the complex economic, political, and social dimensions of the global production and trade of textiles and apparel.

The book is not intended to be prescriptive. Since most aspects of textile and apparel trade have no one "right" answer, I have tried to avoid the pitfalls of prescribing remedies. A top priority in writing the book was to provide as much objectivity as possible. I represent no interest group. Yet, I understand the position of most interest groups and why they take the course of action they do. I have felt a responsibility to readers to attempt to present objectively the various perspectives and let readers arrive at their own conclusions on appropriate

strategies or responses to global activity in these sectors. On occasion, I have identified areas of concern that may not be popular with certain interest groups, but I felt these perspectives were an important part of the total picture.

The book is intended to be used by students, individuals involved in various facets of the softgoods industry, policymakers, and others who have an interest in the multiple dimensions of the textile and apparel industries in the global economy. The book is written for persons who have a basic working knowledge of textile and apparel terminology, either from professional experience or earlier studies.

The previous edition featured the industry in several of the major regions of the world. As a result of suggestions by several individuals, this section has been expanded. This edition also covers many of the changes in both the worldwide and the national business environment that affect the industry. New photos, graphics, and vignettes enrich this edition. Data have been updated.

Emphasis is on concepts and a general understanding of the textile complex within a global perspective. Almost any approach for accomplishing this goal requires fairly extensive use of data. The reader is cautioned, however, that data on production and trade have some inherent difficulties that go far beyond my capacity to resolve. For example, data are available in many different units (dollar value, square meter equivalents, pounds, etc.) and often it is not possible to find consistent measures. Different systems of collecting data create another problem. Data collected under one system are not directly comparable to those collected under another. Further, country groupings are not consistent among the international organizations involved in data collection and analysis. Additionally, political changes in various regions of the world—for example, the economies in transition (the former Soviet bloc)—have caused some international organizations to develop new country groupings for data

analysis. Therefore, continuous data that are directly comparable over decades may not be available. Both the international and national offices that compile and use the data must live with this problem (and some of them have large staffs working on these data). Consequently, I have used data in the form in which they were available to me, but I have pointed out limitations of the measures or data at various points in the book.

And finally, I hope that the book will enhance the reader's appreciation of the vital importance of the global textile complex. The industry has shaped the economic and industrial history of the world. As the world's largest manufacturing employer, the textile complex has had a profound role in global economic development. In many instances, textile and apparel production and trade have redefined international political and social relationships. In short, no commercial sector other than agriculture has had a more significant impact on global economic, political, and social development.

ORGANIZATION OF THE BOOK

Chapters are intended to be complete enough that they may be reasonably meaningful if read alone or if switched in order of study. Some subjects may be discussed more than once to make different points.

Chapter 1 is an introduction, setting the stage for a global focus, at both the micro- and macro-levels, of the textile and apparel industries. Chapter 2 provides a historical perspective on the development of both the global and the U.S. textile and apparel industries. Special attention is given to the role of the industry as a leader in industrial movements. A brief history of broad global trade developments is followed by an overview of the special trade problems that emerged for the textile and apparel sectors.

Chapter 3 provides an overview of the global environment in which textile/apparel production and trade occur. Attention is given to groupings of nations since these divisions are of special significance in the study of textiles and apparel in the global economy. Economic, political, and cultural systems are considered as important environmental factors affecting production and trade. Chapter 4 provides a brief review of theory relevant to global trade in textiles and apparel. Variations of trade theories and development theories are presented.

Chapters 5, 6, and 7 focus on the textile and apparel industries from a global perspective. The titles and order of these chapters have changed slightly from the last edition based on reviewers' suggestions. Chapter 5 provides an overview of the global textile complex and considers the stages of industry development in relation to a country's or region's overall development. Chapters 6 and 7 have been switched in order from that in the last edition. Chapter 6 focuses on global patterns of textile and apparel activities (production, employment, consumption, and trade) with particular attention given to major global shifts for these activities. Chapter 7 reviews the textile complex in select regions of the world, particularly in relation to the restructuring of the industry that is occurring on a global basis.

Chapters 8 and 9 focus on the U.S. textile and apparel sectors. First, Chapter 8 gives an overview of the textile complex and covers common areas affecting both textiles and apparel. Chapter 9 gives a separate overview of the U.S. textile and apparel industries, with special emphasis on issues that influence each sector's ability to compete in the global economy.

Chapter 10 covers textile and apparel trade policies, both at the global and U.S. levels. The U.S. position is given within the broader context of global policy development and implementation. In addition, the chapter provides an overview of the evolution and phase-out of the Multifiber Arrangement, the unique trade

agreement for global textile trade. Chapter 11 presents an overview of the major global and U.S. structures for facilitating or "managing" textile and apparel trade. The goal of this chapter is to help the reader understand how the trade policies are operationalized through key organizations or other structures.

Chapters 12, 13, 14, and 15 focus on textiles and apparel in the international economy from the perspectives of key groups of players. These chapters are intended to provide insight into the conflicting interests of various groups that have a great deal at stake in textile and apparel trade. Chapter 12 presents the interests of industry and labor in textile and apparel trade; Chapter 13 covers the interests of retailers and importers; Chapter 14 considers the interests of consumers; and Chapter 15 focuses on the dilemma of textile trade for policymakers.

Chapter 16 provides a review of the difficulties associated with attempting to resolve international textile and apparel trade problems. The chapter is intended to encourage reflection on the content of the book and to help the reader understand the need to acquire a global perspective in dealing with all aspects of the softgoods industry.

ACKNOWLEDGMENTS

Special thanks go to my husband, Harman, and to our children Derek and Donya for their support. Thanks, too, to Maude and Jessica Dickerson, part of my extended family. To my mother, Virgie Gardner, I dedicate this edition with love and appreciation.

Many industry leaders and policymakers in the United States and abroad have provided valuable insight into the status of both the domestic and international textile complex and an understanding of textile trade policies. Early mentors in Geneva, who have since retired, were Robert Shepherd, U.S. MinisterCounselor of Textiles; Marcelo Raffaelli, Chairman; and Tripti Jenkins, Counselor and Assistant, of the Textiles Surveillance Body (TSB) under the General Agreement on Tariffs and Trade (GATT).

I am especially grateful to Richard Hughes, Counselor in the Textiles Division at the World Trade Organization (WTO), for his assistance with various updated information for this edition. Similarly, I am grateful to Roslyn Jackson, Chief, Merchandise Trade Section in the Statistics and Information Systems Division at WTO, who has played a particularly vital role in all editions in assisting with global data.

Thanks go to my colleagues for their support. Dean Bea Smith has been supportive of the efforts required to complete the book and has exhibited faith and pride in its contributions. I am also indebted to the individuals in this country and abroad for the positive, reinforcing response to the first edition. These have included other educators, individuals in industry, and those in roles associated with developing and/or implementing national and international policies. I have particularly enjoyed stories from executives and policymakers who have taken the book with them to read on vacation—stories my students would likely never believe!

Dennis Murphy, who has provided most of the drawings for the book, has added a delightful and vital dimension to the book making concepts come alive with his talent and wit. He masterfully converts my ideas and primitive sketches into drawings appreciated by readers. I am especially grateful for Dennis' dedication in finishing the drawings for this edition as he recovered from surgery.

Three of my original reviewers still deserve recognition for the help they provided, which continues in this edition. Sara Douglas (University of Illinois), Margaret Rucker (University of California, Davis), and Linda Shelton (now in the Office of Textiles and Apparel at U.S. Department of Commerce) were my "partners" in helping to launch the book.

Many individuals have been helpful with this and other editions.1 These include busy industry leaders, policymakers, and others who gave generously of their valuable time to share various information and perspectives important to the book. These include: Carl Priestland, Chief Economist, American Apparel Manufacturers Association; Sanjoy Bagchi, Executive Director (retired), International Textiles and Clothing Bureau (Geneva); James Jacobsen, Vice-Chairman, and John Turnage, Vice-President of Manufacturing and Sourcing, Kellwood Company; Tom Nugent, Editor of Industry Surveys, Standard & Poor's; Jean-Paul Sajhau, International Labour Organization (Geneva); Mike Ruggiero, David Link, Gail Raiman, and others at American Textile Manufacturers Institute; Robert Wallace, Mary Ellen Sweet, and Jackie Jones in the Textile and Apparel Branch of the U.S. Inter-Trade Administration; William national Dulka, Sergio Botero, and others in the Office of Textiles and Apparel, U.S. Department of Commerce; Bekele Tamenu in the Merchandise Trade Section in the Statistics and Information Systems Division at WTO; Paul O'Day, President, American Fiber Manufacturers Association; staff at the National Retail Federation; Pascal Morand, Executive Director, Institut Français de la Mode (Paris); Geoff Wissman, Management Horizons Division of Price Waterhouse; staff at EURATEX (Brussels); and staff at numerous other organizations. I appreciate the visibility given the book by William Benjamin, Chairman of ITBD Publications (London) in his international trade publications.

Additionally, gracious hosts in many parts of the world have contributed to my education and appreciation for the cultures and perspectives of these regions. Many have shared insights on their industries, their governments, and their lifestyles, sometimes even welcoming me into their homes. I feel privileged and grateful for the gracious hospitality I have received everywhere.

Funding from a variety of sources permitted visits with national and international policymakers and industry leaders. I am appreciative of funding support at various points of time from the University of Missouri Research Council, the University of Missouri Weldon Spring Fund, the Everett Dirksen Congressional Research Center, and the German Marshall Fund.

Thanks to the reviewers chosen by Prentice Hall (and whose identity was unknown to me) to provide critiques and make suggestions for this revision. The insightful, thoughtful suggestions were very helpful in developing this revision. The reviewers were Nancy L. Casill, University of North Carolina at Greensboro; Jai-Ok Kim, Auburn University; and Margaret Rucker, University of California at Davis.

Finally, I am grateful to the Prentice Hall staff for their valuable contributions. My editor, Brad Potthoff, and his assistant, Mary Evangelista, have provided support, encouragement, and assistance in many ways. My production editor, Mary Irvin, has provided the deft orchestration to bring the book into published form—and does so with gracious tolerance for imperfect authors.

Kitty G. Dickerson

¹ The fact that the above individuals assisted in some manner with the book does not imply their support or endorsement of views in the book.

The second second

Brief Contents

PART 1

INTRODUCTION 1

Chapter 1

Textiles and Apparel as a Global Sector 2

PART |

AN OVERVIEW: HISTORY, THE GLOBAL SETTING, THEORY 27

Chapter 2

Historical Perspective 28

Chapter 3

The Setting—An Overview 51

Chapter 4

Theoretical Perspectives 95

PART III

AN OVERVIEW OF THE GLOBAL TEXTILE AND APPAREL INDUSTRIES 137

Chapter 5

Global Patterns of Development 138

Chapter 6

Global Patterns of Textile and Apparel Activities 167

Chapter 7

The Textile Complex in Select Regions of the World 204

PARTIV

THE U.S. TEXTILE COMPLEX IN THE GLOBAL ECONOMY 257

Chapter 8

An Overview of the U.S. Textile Complex 258

Chapter 9

The U.S. Textile and Apparel Industries and Trade 288

PART V

"MANAGING" TEXTILE AND APPAREL TRADE IN THE GLOBAL ECONOMY 335

Chapter 10

Textile and Apparel Trade Policies 336

Chapter 11

Structures for Facilitating and "Managing" Textile and Apparel Trade 388

PART VI

BALANCING CONFLICTING INTERESTS IN TEXTILE AND APPAREL TRADE 419

Chapter 12

The Interests of Industry and Labor in Textile and Apparel Trade 421

Chapter 13

The Interests of Retailers and Importers in Textile and Apparel Trade 457

Chapter 14

The Interests of Consumers in Textile and Apparel Trade 492

Chapter 15

Policymakers and Textile/Apparel Trade 519

PART **VII**

CONCLUSION 547

Chapter 16

Conclusions: A Problem with No Answers 548

Contents

PART	PART
INTRODUCTION 1	AN OVERVIEW: HISTORY, THE GLOBAL SETTING, THEORY 27
1 Textiles and Apparel as a Global Sector 2	2 Historical Perspective 28
A Global Perspective 2 The Global Economy 2 A New Era Emerges 4	The Role of the Textile Sector in Historical Global Industrial Movements 29 The Textile Sector as a Leader 29 Textiles as a Leader in the Industrial Revolution in England 29 Early Developments in the United States 33
A Global Perspective on Textiles and Apparel 5 Reasons for the Shift to a Global Perspective for Textiles and Apparel 9 The Growing Importance of the Logistics Field 14 The U.S. Textile and Apparel Industries within the Global Economy 17 The United States on a Global Stage 17 Key Terms and Concepts 18	
	Early Development of the Apparel Industry 39
	Transitional Years for International Trade 40 The 17th and 18th Centuries 40 The 19th Century 41 The Early 20th Century 42 The Mid-20th Century 43
A Brief Review of Changes in Global Textile	The Late 20th Century 44 Development of Textiles and Apparel as Difficult and Sensitive Sectors in the Global Economy 45 A Leader in Trade Problems 45 Changes in the U.S. Textile and Apparel Industries 45 Changes in the Global Market 46
and Apparel Markets 21 An Interdisciplinary Perspective 23	
Summary 24	
Suggested Readings 24	
	Summary 48
	Glossary 48

Suggested Readings 49

3 The Setting—An Overview 51

Country Groupings 52 World Bank Categories 58 Relevance to Textiles and Apparel 58

Regions of Special Significance in Textile and Apparel Production and Trade 59 Western Europe 59 Central and Eastern Europe, Commonwealth of Independent States, and the Baltic States 63 The Americas 65 The Caribbean Basin Area 68 Asia 72

Formation of Regional Trading Blocs 75
Pros and Cons of Trade Blocs 76

The Division Between North and South 78

Economic Systems 80
Market-Directed Systems 81
Centrally Planned Systems 81
Mixed Economies 82
Contrast of the Systems 82

Political Systems 83
Democratic Political Systems 83
Nondemocratic Political Systems 83
Relationships of Economic and Political
Systems 83

Why Do the Economic and Political Systems Matter for Textiles and Apparel? 84

Cultural Environments 86
Material Culture 88
Social Institutions 88
Humanity and the Universe 88
Aesthetics 89
Language 91

Summary 92

Glossary 92

Suggested Readings 94

Theoretical Perspectives 95

Reasons for Trade 95

Basic Economic Concepts and Trade 96 Scarcity and Choice 96 Opportunity Costs 96 Rationing and Incentives 96 Laws of Supply and Demand 97 Gains from Voluntary Exchange 99

Bases for Trade 100

Trade Theory 100

Mercantilism 101

Absolute Advantage 101

Comparative Advantage 102

Factor Proportions Theory 104

Product Cycle Theory 106

Porter's Competitive Advantage of Nations 107

Why Firms Trade or Internationalize 110 Arm's-Length Trade 110 Intrafirm Trade or Activity 111

Development Theory 113

Trade and Development 114

Emergence of Development Theory 115

Mainstream/Modernization Theories of

Development 115

Structural Theories of Development 119

Development and Textiles and Apparel 125

The New International Division of Labor 128

Agile Competition and Virtual Companies 131

Summary 132

Glossary 134

Suggested Readings 135

PART

AN OVERVIEW OF THE GLOBAL TEXTILE AND APPAREL INDUSTRIES 137

5Global Patterns of Development 138

Brief Historical Perspective 138
Early 20th Century 139
Mid-20th Century 139
Late 20th Century 140

Global Patterns of Development for the Textile Complex 140 Stages of Development in the Textile Complex 141

Textile and Apparel Stages of Development in Relation to Broader Development 144 Developing Stages 145 More Developed Stages 147

The Textile Complex—A Global Barometer of Development 149

A Broad Perspective on Global Supply and Demand 151

Labor Issues 152
Women Workers 152
Child Labor 155
Sweatshops 157
Efforts to Monitor and Correct Labor Abuses
159
Labor Standards and Trade 161

Summary 164
Glossary 165
Suggested Readings 165

6 Global Patterns of Textile and Apparel Activities 167

Global Patterns of Production 167 Textile Production 168 Apparel Production 169

Global Patterns of Employment 171 Wage Differences as a Factor in Employment Shifts 173

Global Patterns of Consumption 174
Fiber Consumption Measure 175
Consumer Expenditure Measure 178
The Impact of Reduced Consumption 180

Global Patterns of Trade 180
An Overview of Textile and Apparel Trade 183
The Importance of Textile and Apparel Trade for
Less-Developed Countries 184
Trade in Textiles 185
Trade in Apparel 191
Influences on Trade 196

Summary of Global Textile/Apparel Activity 199

Summary 200 Glossary 201

Suggested Readings 202

7 The Textile Complex in Select Regions of the World 204

Asia 204
East Asia 205
Association of Southeast Asian Nations 218
South Asia 219

Australia 223

North America 224 Canada 224 United States 226 Mexico 226

The Caribbean Basin Area 229

Central and South America 232

Western Europe 234

Eastern Europe, Baltic States, and Commonwealth of Independent States (CIS) 240 Eastern Europe 243 The Baltic States 244 The Commonwealth of Independent States 244

Africa 247

Summary 250

Glossary 252

Suggested Readings 254

PART **IV**

THE U.S. TEXTILE COMPLEX IN THE GLOBAL ECONOMY 257

8 An Overview of the U.S. Textile Complex 258

Major Segments of the Textile Complex 261
Production of Fiber 261
Manufacture of Textile Mill Products 262
Manufacture of End-Use Products 263

A Related Sector: Textile Machinery Manufacturing 263

Contributions of the Textile Complex to the U.S. Economy 264
Contributions to GNP 264
Contributions to Employment 264
Contributions to Other Sectors 265

The Impact of Consumer Demand 266
Slowed Demand Due to Style Changes 268
Slowed Demand Due to Economic
Changes 268
Lessons Learned 269
Major Trends That Affect Consumer
Demand 269

Challenges to the U.S. Textile Complex 271

Changes in the Textile Complex 273 Closing or Revitalizing Outmoded and Inefficient Plants 275 Restructuring Through Acquisitions. Consolidations, and Mergers 275 Forming New Alliances and a "Scrambled Softgoods Chain" 276 Investing in Advanced Technology 276 Developing Greater Sensitivity to Market Needs 277 Developing Closer Working Relationships within the Softgoods Chain 278 Concentrating on Market Segments in Which the United States Has the Greatest Advantages 278 Shortening the Response Time 279 Downsizing and Total Quality Management 280 Promoting Domestic Products 280 Influencing Public Policy 281 Agility or Agile Manufacturing 281

The U.S. Textile Complex in the Global Market 282

Foreign Investment in the U.S. Textile Complex 284

Summary 284

Glossary 285

Suggested Readings 287

*9*The U.S. Textile and Apparel Industries and Trade 288

Industry/Business Classification Systems 288 North American Industry Classification System 288

The U.S. Textile Industry 289
Brief Historic Review 292
The Fiber Industry 292
The Textile Components and Products
Industries 295
The Textile Machinery Industry 305

The U.S. Apparel Industry 307
Characteristics of the Apparel Industry's
Products That Account for Unique
Challenges in the Industry 309
Types of Operations 310
Factors Affecting Competitiveness 311
Sourcing Strategies 312
Markets 315
Marketing Strategies 318
The Workforce and Wages 319
Trade 321

Summary 329 Glossary 330

Suggested Readings 332

PART **V**

"MANAGING" TEXTILE AND APPAREL TRADE IN THE GLOBAL ECONOMY 335

10Textile and Apparel Trade Policies 336

Historical Perspective 337
Early Development and Regulation of Textile
Trade 337
The Early 1900s 338
The Early Years After World War II 339
Establishment of the General Agreement on
Tariffs and Trade 340

Textile-Specific Restraints of the 1950s 341 Early Development of Textile Trade Policies in the 1960s 343

The Short-Term Arrangement 345

The Long-Term Arrangement 347

The Multifiber Arrangement (MFA) 348

Development of the MFA 348

MFA I (1974-1977) 350

MFA II (1977–1981) 353

MFA III (1981-1986) 355

MFA IV (1986–1991) 357 Extensions of MFA IV (1991, 1992, 1993) 359 Reflections on the MFA 361

The MFA in Operation 363
The End of the MFA 364

Attempts to Control Imports Through the
Legislative Process 364
The Mills Bill 364
The Textile and Apparel Trade Enforcement Act
of 1985 (the Jenkins Bill) 364
The Textile and Apparel Trade Act of 1987 366
The Textile, Apparel, and Footwear Act of
1990 367

Comprehensive Trade Legislation: The Omnibus Trade Bill 367

Multilateral Trade Negotiations 368
The Kennedy Round 368
The Tokyo Round 369
The Uruguay Round 370
Reflections on the Uruguay Round and the
ATC 376

Generalized System of Preferences 380

North American Free Trade Agreement 380

Summary 382

Glossary 383

Suggested Readings 386

11

Structures for Facilitating and "Managing" Textile and Apparel Trade 388

Structures at the International Level 388 Official Governmental Structures 388 Special Interest Groups 393

Structures at the National Level: The United States 395

Official Governmental Structures 395
Special Interest Groups 407
Brief View of Other Structures in North
America 411
Brief View of Structures in the EU 412
ASEAN Federation of Textile Industries 415

Reflections on Structures for Facilitating and "Managing" Textile and Apparel Trade 416

Summary 416 Glossary 417

Suggested Readings 418

PART **VI**

BALANCING CONFLICTING INTERESTS IN TEXTILE AND APPAREL TRADE 419

12

The Interests of Industry and Labor in Textile and Apparel Trade 421

Brief Historical Perspective 422

Adjustment Strategies 422
The Goal of the Adjustment Process 423
Adjustment Progress 423

Policy Strategies 428
Substantial Import Growth 428
A Growing Protectionist Mood 428
Employment Losses 428
Protection of Investments 429

Competitive Disadvantages 429 Concerns for "Burden Sharing" 430 Political Prowess 430

Arguments to Justify Policy Strategies for Special Protection 430

Maintaining Employment 430
Slowing the Pace of Adjustment 431
Preserving the Incomes of Certain
Groups 431

Protecting Domestic Labor Against "Cheap Foreign Labor" 431 Preserving Key Industries 431 Supporting New (High-Technology)

Industries 432
Using Protection as a Lever to Open
Markets 432
Combating Unfair Trade 432

The Desire for a "Level Playing Field" 432
Dumping 435
Subsidies 436
Highly Restrictive Tariff Levels 437
Closed or Partly Closed Markets 438
Foreign Aid 438

Unexpected Outcomes of Protection 440
Development of New Suppliers 440
Shifts in Product Lines 440
Shifts in Fiber Categories 441
Upgrading 441
Guaranteed Market Access 442
Establishment of Foreign-Owned Plants in the Importing Markets 442

Textile/Apparel Industry Marketing Initiatives 443

Marketing Orientation 443
A Service Commitment to Retailers 443
Promotional Campaign for Domestic
Products 443

Global Production and Marketing Arrangements 444

New "Globalization" Theme in the U.S. Textile and Apparel Industries 445 Global Sourcing 446 Multinational Enterprises 446 International Licensing 446 Direct Investment 447 Joint Ventures 448 Exporting 448 International Marketing Considerations 450 International Marketing Philosophies 453

Summary 454

Glossary 455

Suggested Readings 456

13

The Interests of Retailers and Importers in Textile and Apparel Trade 457

Importers 459

Retail Sector Overview 459
Excess Selling Space 460
Retail Business Failures 460
Restructuring 460
Emergence of Power Retailers 460
Repositioning Strategies 461
Nonstore Retailing 461
Private Label Programs 461
Matrix Buying 462

Background on Channel Relationships 462

Retailers and Imports 463
Types of Global Sourcing 464
Retailers' Reasons for Buying Imports 466
Problems for Retailers in Buying Imported
Apparel 470
A Survey of Retailers' Problems in Buying
Imported Apparel 477

Rethinking Distance 477

A More Integrated Softgoods Chain 478

Retailers Who Have Actively Sought Domestic Merchandise 478

Retailers and Textile Trade Policies 479
Retailers Become Politically Active on Trade
Matters 481

A Move Toward Improved Channel Relationships 483

Global Retailing 484 A Profile of Global Retailers 486 Summary 488

Glossary 489

Selected Readings 491

14

The Interests of Consumers in Textile and Apparel Trade 492

Consumer Textile and Apparel
Expenditures 492
Apparel Prices 493
Apparel Expenditures 493
Textile Prices and Expenditures 496

Consumer Gains from Textile/Apparel Trade 496

An Increased Range of Products Available 496 Potentially Lower Prices 498 Increased Global Production and Consumption 499

The Consumer Perspective Related to Textile and Apparel Trade Restraints 500

Restraints That Involve Costs to Consumers 501
Costs Associated with Trade Restrictions 503
Estimates of the Costs of Protection 507
Estimates of the Costs to Consumers 507
Estimates of Welfare ("Deadweight")

Costs 507

Estimates of the Costs of the Congressional Textile Bills 509 Weighing the Costs of Protection Against the Alternatives 511

Consumers' Lack of an Organized
Voice 513
The International Organization of Consumers
Unions 513

Global Consumers 514

Summary 516

Glossary 516

Suggested Readings 517

15Policymakers and Textile/Apparel Trade 519

A Review of Textile/Apparel Trade as a Special Problem 520 Political Problems Related to Employment 521

Textile Trade and the U.S. Political Process 522

How Policymakers Become Involved in Originating Special Protection 522 The Executive Branch and Textile/Apparel Protection 523 Congress and Textile/Apparel Production 524

Various Textile/Apparel Political Tugs of War 526

Taking the Legislative Approach 527
Tactics for Influencing Policymakers 528
Multiple Pressures on Policymakers—
Examples 531

Textile Trade and the Global Political Process 533

Conflicting Demands of Exporting and Importing Countries 534 Demands from within a Participating Nation 536

How National Pressure is Applied to Global Policymakers 538

Reflections on Policymaking and Textile Trade 543

Summary 544

Glossary 545

Suggested Readings 545

PART VII

CONCLUSION 547

16

Conclusions: A Problem with No Answer 548

The Dilemma: A Broad View 548
Shifts in Global Production 548
Use of Policy Measures 549
Problems Have Changed Over Time 550
The MFA Quota System—The Gradual Demise of an Imperfect Compromise 550

Future Outlook for the More-Developed Countries in Textile/Apparel Trade 551

Future Outlook for the Less-Developed
Countries in Textile/Apparel Trade 556
Population Changes and Demand 557
General Observations about the Outlook for the
Less-Developed Countries 557

Future Outlook for Textile/Apparel Trade Policies 559

Globalization of Retailing 561

How Time Can Change the Game 561

The Social Dimensions of Globalization 562

Developing a Global Perspective 565 Increased Interdependence 566

Implications for Industry Professionals 567

APPENDIX: Participants in the Multifiber Arrangement 568

Bibliography 570

Index 591

A primary goal of this book is to consider the textile and apparel industries in a global context. In

Chapter 1, we consider globalization and global interdependence as realities of the world in which we function today. As we examine linkages between economies and the interconnectedness of nations, we become increasingly sensitive to the fact that a country's textile and apparel sectors are part of a global complex. Activities on one continent may have a profound impact on industries and workers in another part of the world. Moreover, all segments of the softgoods industry are affected by the global changes in textile and apparel production and trade.

In Chapter 1, we explore some of the developments that have fostered an increased interaction of the world's inhabitants. Furthermore, we consider the impact of these changes on the global textile complex.

In addition to providing key terms and concepts for the book, Chapter 1 describes how various disciplines help to provide insight into the complex study of textiles and apparel in the global economy. Finally, the chapter includes a brief review of changes that have occurred in the global textile and apparel markets. This review helps to prepare the reader for the complexity of issues considered later in the book.

1

Textiles and Apparel as a Global Sector

A GLOBAL PERSPECTIVE

Once a futuristic concept, globalization is a reality today. The interconnectedness of people and nations characterizes the modern world. Advances in communication and transportation systems provide linkages with people throughout the world to a degree unprecedented in history. Moreover, increased interaction has developed into a **global interdependence** of humans and nations. Our economic production and consumption, our national security, the quality of our environment, our health, and our general welfare have become surprisingly dependent on the world beyond our borders.

The Global Economy

Our global interdependence is clearly evident today in economics—the means by which the human family produces and distributes its wealth. We have moved to a globalization of the economy, shifting from self-sufficient national economies to an integrated system of worldwide production and distribution. The unit of economic analysis and policy is expanding from the national to the world economy. As we learn to think globally, we will find

that there is no room in our vocabulary for words such as *foreign*.

We can easily trace how we depend upon other parts of the world to provide many of the goods we consume daily, and we can think of how producers in other parts of the world are affected by our demand for their goods. Our global economic interdependence is far more complex, however, than this simple cause-andeffect relationship between consumer and producer. The global economy includes a web of linkages through which the actions of the actors in one system can have consequences often unexpected, unintended, and unknownfor actors in another system. For example, a dramatic change in the stock market in one country has a profound ripple effect on stock markets around the world; a change in currency exchange rates can cause important shifts in where production takes place and how much products will cost; plant closings in one country may create jobs in other countries; and changes in consumer tastes can cause production to shift from one region of the world to another. See Box 1–1.

As players in the global economy, we have unprecedented opportunities to interact with others in the human family, with whom we share a common destiny. The global economy

THREE FACES OF GLOBALIZATION

Maria. Maria and her young family migrated from Mexico's heartland to Ciudad Juárez, the city bordering the United States to the north. She and her husband, Miguel, came to seek jobs in this dusty Mexican city of factories and shanty settlements. Although the new location is crowded and frightening, Maria knows they have better prospects of earning a living than if they had stayed in their impoverished home region. Back home, farm jobs paid very poorly. Now they have two children to think about. Although it was hard to leave their relatives, Maria felt it was a sacrifice they had to make. Maria found a job in a garment factory, and Miguel works in an electronics plant. She makes \$6 a day, and Miguel makes \$8. Together they can afford a tarpaper shack near the two factories; this is important because they have no car. The choking pollution, the crowding, and the dust from unpaved roads cause Maria to miss the fresh air back home, but the present job enables her to dream of some day having a cinder-block home and a few extras for her children.

Evelyn. Evelyn is a garment worker in a jeans factory in South Carolina. Because she is a resident of a rural area, the factory where she works is the only source of nonfarm jobs in her region. Most of the women in her county who need to work are employed in this same factory. The work is hard, but her 20 years at the factory enabled her to support her family after her divorce. Her factory income provided the things her three children needed as they were growing up. Now the children are married and gone, and Evelyn hopes to have a few years before her retirement to make modest improvements to her home. An uneasiness eats away at Evelyn as she continues to hear rumors that her factory is closing. She hears that her company is having a hard time competing against imports and is thinking of moving production to a low-wage country. Then Evelyn's fears become reality. When she goes to work, see sees a notice of the plant's closing posted on the front door.

Huang. Huang is in his mid-30s and works in the Hong Kong office of a major U.S. retail chain. He enjoys his job as a quality control inspector for the company, spending a lot of time visiting garment factories in China's Guangdong Province near Hong Kong. Huang has worked with many of the same factories because as long as these factories meet his company's expectations, the retailer continues to contract production there. Huang's job is to make sure that garments are produced according to the retailer's standards and specifications. As he visits the factories, Huang often reflects on how fortunate he is to have a job that pays relatively well and provides variety in his work. He observes the young women who have migrated from China's rural provinces to work as sewing operators in the factories, where the days are long and the pay is low. It reminds Huang of his mother's years as a garment factory worker in Hong Kong. Now Huang and his friends hold responsible professional jobs in Hong Kong's fashion industry. Like Huang, they switch easily between languages, speaking English with the U.S. company representatives and Chinese with the factory personnel. Huang and his generation also understand a great deal about how the global fashion industry works today.

- Are the lives of Maria, Evelyn, and Huang in some way interconnected?
- What are the broader issues at stake?
- These and other issues are what this book is about. Think about Maria, Evelyn, and Huang as you read this book. We shall consider them again in the last chapter.

offers challenges, too, as nations, firms, and individuals learn how to function on a larger scale and how to interact with persons of different races who may speak different languages. We see the emergence of a growing number of global companies whose executives conduct business with little regard for national boundaries. The global economy brings with it the advantages of varied products and lower relative prices due to differing costs of production in certain regions of the world. On the other hand, in countries such as the United States, firms have also discovered the increasing challenge of sharing their domestic market with producers in other countries.

Renato Ruggiero (1997), Director General of the World Trade Organization (WTO) in Geneva, notes that globalization represents a huge opportunity for countries at all levels of development. The 15-fold increase in global trade volume over the past four decades (compared with only a 6-fold increase in production) has been one of the most important factors in the rise of living standards around the world. Global trade continues to account for a growing share of global income and now represents 24 percent of worldwide gross domestic product. This trade has not only spawned economic improvements but has also fostered greater stability and peace in many regions.

A New Era Emerges

New technologies are transforming the globe—the way business is conducted domestically and globally, who and where business partners are, and the speed with which all commerce occurs. These technologies of the postindustrial era do not just facilitate global business, they now *drive* it. Additionally, political and economic changes have transformed the landscape on which business occurs. Borders and barriers have been eliminated to bring the people of the world together as never before. Globally, we are redrawing the lines of who buys

what from whom and where. In concert, these changes have transformed the globe at a pace that would have been unimaginable even a decade ago. As a result of these converging influences, today we see:

- Business partnerships transcend geographical boundaries, time zones, and cultural differences;
- Teams around the world work together without ever meeting face to face;
- Designs or valuable company data are transmitted around the world on the information superhighway;
- Agile competitors and virtual companies shake off tradition and provide customized products and services in new, unheard-of ways;
- Production and distribution cycles are compressed;
- Many major companies earn more than half of their profits abroad;
- Capital is transferred electronically across national boundaries and is valued at far more on a daily basis than merchandise trade;
- Trade blocs bring countries and companies into new partnerships;
- Companies in strategic alliances, domestically and abroad, share data electronically as if they were part of the same company; and
- Reformed trade policies turn competitors of the past into today's partners.

Transforming technologies also bring a paradox. The transformations taking place allow us to be players on the global stage, to participate in the larger global picture. At the same time, however, new technologies also permit a microscopic analysis of the key individual unit in the production-distribution chain: the consumer. That is, new micromarketing techniques, made possible by computers, enable us to know more about a consumer's lifestyle and preferences than ever before.

Now, more than ever, companies, governments, and individuals must think globally. Technology has vastly expanded our horizons. These expanded horizons represent unprecedented opportunities—but only for those willing to become informed, to think in global terms, and to take the risk to participate.

A GLOBAL PERSPECTIVE ON TEXTILES AND APPAREL

Not long ago, textile and apparel industries around the world constituted many independent sectors and independent markets. Today these industries no longer operate in isolation; rather, textile and apparel production and marketing activities form one global sector, with one global market. In fact, no sector of commerce is more global than textiles and apparel—a fact we shall discuss throughout the book. Although individual countries have their own textile and apparel industries, the complex production and marketing chain that produces and sells textile and apparel products is unquestionably a global business. See Figure 1–1.

The textile complex not only serves the basic needs of humans around the globe by providing clothing and other basic textile needs, but also plays a powerful role in sustaining life worldwide by employing masses of the world's peoples. Together, textile and apparel production is the *largest source of industrial employment in the world*, providing jobs for millions. These industries play a particularly vital role in employing masses of persons who have few other job alternatives—both in the **less-developed countries**¹ (also called **developing countries**) and generally in the **more-developed countries** (also called **developed countries**) as well.

As a vital sector, textile and apparel production is dispersed around the globe. This industry has both manufacturing operations and marketing centers throughout the world. National boundaries no longer confine production, and globalization has given birth to creative production options.

Advances in global communication technologies have also led to the transfer of fashion trends around the world with lightning speed, giving us what might be termed 24-hour fashion. In the past, new fashion concepts from European shows might have taken 2 years to trickle down for mass production and consumption. Today, however, satellite television transmits new trends around the world instantaneously, stimulating demand for new garments within 24 hours. Consumers from Jakarta to Juneau want the new look promptly—not 2 years later. As it turns out, consumers are not the only viewers following the new trends. Within hours of a Paris runway show, a garment firm halfway around the globe can copy and produce the new look. See Figure 1-2. Consequently, we are seeing a significant globalization of fashion. Young generations in particular, who pick up quickly on trendy new fashions, are similarly attired in many parts of the world. Young people many time zones apart may be dressed much more similarly to each other than they are to their respective parents in the same country.

Production and distribution processes are interlinked on a worldwide scale. The resulting global production systems have made it increasingly difficult to identify products as either foreign or domestic. Now many of our products are global products—the result of components and manufacturing operations in several different countries. As an example, a Korean company may ship fabric made of Japanese fiber to the United States, where it is cut. Bundles of cut garments then may be sent to a sewing plant in Honduras, which might be a joint venture between a Hong Kong corporation and a Honduran corporation. After the garments are assembled, they are reexported back to the United States.

¹ Several countries that are still classified as *developing* nations by international organizations have advanced far beyond early stages of development; therefore, the terms *more-developed* and *less-developed* are often used to reflect a continuum rather than suggesting that only the extremes exist.

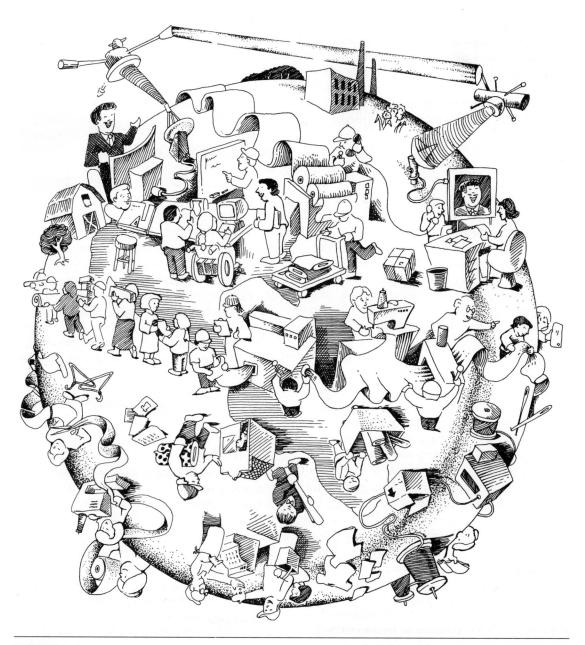

FIGURE 1-1

Today's textile and apparel industries form an interconnected global production and distribution network.

Source: Illustration by Dennis Murphy, based in part on a Leviworld graphic, adapted with permission by Levi Strauss & Co.

FIGURE 1-2

Today's "24-hour fashion." Satellite communications transmit new runway fashions around the world. Within hours, consumers want the new looks, and local apparel producers set about to copy the new lines. *Source:* Illustration by Dennis Murphy.

Virtually every nation in the world has at least a rudimentary textile and/or apparel industry to serve its domestic market, to provide employment, and to earn foreign exchange through exporting. Today approximately 200 nations produce for the international textile/apparel market. Production occurs under an almost unbelievable range of conditions. Examples of the range of contrasts are:

- From sophisticated cities in the developed world to mud huts in poor developing countries
- From factories in quiet rural communities to refugee camps on the edges of some of the most troubled spots on earth
- From highly trained textile scientists to child laborers who toil for long, grueling hours

- From state-of-the-art equipment to looms hand-fashioned from scrap, weathered wood
- From complex chemical fibers to cotton picked by hand and hauled by oxen
- From production of high-fashion garments in designer salons to assembly of clothing in makeshift alley shops in the slums of the poorest, most underdeveloped countries
- By polymer chemists to workers in their first industrial jobs
- By workers in lab coats, saris, veils, jeans, and tribal dress

Figures 1–3 to 1–5 depict the contrasting circumstances under which textile and apparel products are made.

FIGURE 1-3

A young mother in Laos tries to earn a modest living by spinning yarn that will be used in local hand-weaving projects. Source: Photo courtesy of International Labour Office, Geneva.

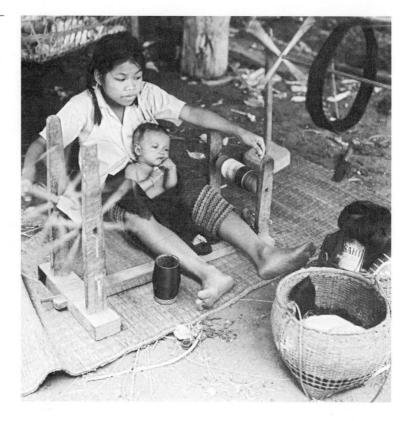

FIGURE 1-4

In countries where the industry has access to computer technologies, a growing number of functions are performed with the use of computers.

Source: Photo courtesy of Burlington Industries, Inc.

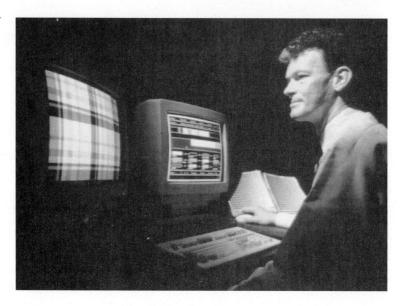

FIGURE 1-5

An Indian boy earns a modest income by sewing for customers on the street.

Source: Photo by J. Maillard, courtesy of International Labour Office, Geneva.

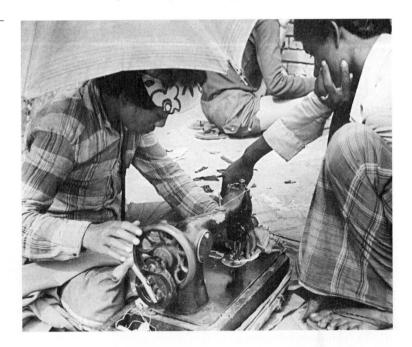

Reasons for the Shift to a Global Perspective for Textiles and Apparel

Developments in the second half of the 20th century have thrust all of us who are involved in various aspects of the textile and apparel industries—from the largest, most powerful firms to the most unassuming consumer—into a global arena. Among the most influential developments causing this change are the following:

1. Economic growth. During periods of sustained global economic growth, such as that since World War II, trade between countries has tended to increase. Although fluctuations have occurred during this period, it has been a time of relative prosperity for many parts of the world. Ruggiero (1997) notes that many forecasters predict that world production of goods and services will double by the year 2020. Trade is affected by changes in economic growth because (a) in periods of economic growth, consumers in many countries have the means to purchase products from various

parts of the world; (b) companies have been willing to add capacity to serve foreign markets when they believed sustained demand would occur; and (c) in general, fewer restrictions have been applied to imports when the economy has been booming (for political reasons, textile products are often an exception to this rule).

Varying stages of economic development in many newly developing countries. In recent decades, many of the less-developed countries have made concerted efforts to improve their economic status. Recently, this has involved the export of manufactured products (apparel, for example) rather than commodities such as agricultural products and minerals. Textile and apparel production often have been the first industries for these countries as they have moved toward economic and industrial development. Apparel production, in particular, has been an attractive first industry. The amount of labor involved in manufacturing garments, the availability of low-cost labor, and the limited technology

BOX 1-2

APPAREL "MARCO POLO"

Michel R. Zelnik, a pioneer in globalization of the apparel industry, experienced the "wild, wild West" of early global sourcing. The following are a few examples of Mr. Zelnik's adventures as he charted new waters for an industry that later followed his lead.

Mr. Zelnik, a Frenchman by birth, has worked from a New York base for most of his career. Holding both a U.S. and a French passport, this apparel "Marco Polo" functions as a global citizen—at home anywhere in the world.

Currently, Mr. Zelnik is chairman of the board of Monet Jewelry. He is also owner of a chain of Canadian stores, Moore's The Suit People, and Kleinfeld bridal stores. Previously Mr. Zelnik was president and CEO of Bidermann Industries, a \$500 million company that made licensed Ralph Lauren women's wear, Yves Saint Laurent menswear, Calvin Klein menswear, Daniel Hechter menswear, Karl Lagerfeld women's wear, and Bill Robinson menswear.

• Mr. Zelnik was one of the very first Westerners to go to Shanghai in late 1978. When his plane arrived at about 9:00 p.m. on a cold winter night, there were virtually no lights on the runway or at the airport. A representative of the Shanghai corporation he was visiting met him at the airport. Mr. Zelnik, the driver, and five other people (plus their luggage) rode in one car to the hotel. The car drove from the airport to the hotel without the lights turned on, as he later saw to be the norm in Shanghai—a measure to save the batteries. At the only

Shanghai hotel for Westerners, a dimly lighted lobby greeted him. The next day, when he visited the corporation, there was no heat at all. Heat was not permitted south of the Yangtze River. Because of the need to feel fabrics, Mr. Zelnik remembers that it was extraordinarily difficult to buy fabrics while wearing gloves.

- In later years when Mr. Zelnik visited Shanghai, he was always met by company representatives in a Chinese-made "Red flag car"—the Chinese version of a stretch limo. He sensed that the car was never used except when the company representatives met him; on these occasions, the car was dusted off and sent to the airport.
- When he went to Colombia, South America, in the early 1970s, every factory he visited to buy fabrics or to look for garment production was surrounded by high fences and armed guards. The only way to enter a factory was to follow the guards as they went in.
- In a visit to a leather supplier in a village in southern Brazil, Mr. Zelnik discovered that the owner of the leather business owned *everything* (yes, *everything*) in the town—the hotels, the stores, the taxi, the country club, and so on. As they flew to tanneries in small planes, he experienced a new way to hail a taxi. Airports were always on top of a hill, with the towns below. As the plane approached a town, it made one circle over the town before landing. That circle signaled the taxi to come to the airport to meet them.

and capital requirements for apparel production make this industry a natural first choice for these emerging countries. At the same time, emergence of the industry in many less-developed countries has represented opportunities for industry executives with a taste for adventure and challenge. See Box 1–2.

3. New communication technologies. Although the apparel industry has had a significant global dimension for decades, it has been the advances in communication technologies that propelled it rapidly into a global era. The following story illustrates the important role of communication technologies in connecting segments of the industry.

- In Burma (now Myanmar), he was taken 1 1/2 hours by boat and another 1 1/2 hours by car to visit a factory. Upon arrival, he found a fantastic new factory with 400-500 brand new sewing machines—and no people. The reason: The factory had no electricity—had never had any electricity—and had no prospects of getting electricity! It had been built with Japanese foreign aid funds, and the equipment supplier had benefited handsomely from the sale of hundreds of new machines. Never mind that there was no electricity. Mr. Zelnik adds, "It wouldn't have mattered anyway. Burma had a quota in that category for only 100,000 dozen items, and the factory could easily have produced three times that amount."
- In 1985, Mr. Zelnik went to both North and South Vietnam to buy shirts that could be used in the French market (but not in the U.S. market because of the severed diplomatic relationship). He waited in the hotel for 2 weeks for the government official to tell him which factories he might visit. Those 2 weeks were spent in his hotel room, from 9:00 to 5:00 every day, waiting for calls to tell him what to do. No one in the hotel took messages for the guests staying there. Instead, guests waited alone all day in their respective hotel rooms for messages. At the end of the day, they met for dinner together.
- In the early 1980s, Mr. Zelnik negotiated with Romanian officials to purchase all the country's wool suit production, equal to the amount U.S. quotas would permit imported. He secured the right to be the exclusive distributor for Romanian wool suits in the United States. Later, after returning to New York, Mr. Zelnik had a call from a man who wanted to see him. The caller identified himself as the ex-

- clusive U.S. distributor for men's wool suits from Romania and wanted to do business with Mr. Zelnik!
- Other experiences included a fire in a factory in Thailand where his garments were being produced. On another occasion, a boat sank with some of his merchandise aboard.

Mr. Zelnik commented that his strategy had been to take risks by going to undeveloped areas, where he was often the first outsider to seek business relationships, and to develop factories there. This gave him an edge over competition and also helped his company to be firmly established before quotas began to restrict shipments. His goal was to bring factories to a high quality level in 6 to 12 months. As part of that effort, he negotiated to keep the same prices that were in effect when he entered the picture. This permitted the high gross margins he wanted for his company.

When asked what were the most important lessons he had learned in his pioneer experiences, Mr. Zelnik provided sage advice. He said without hesitation, "Develop good relationships with people. If you are honest and friendly, people will do whatever you need. They will be your lifelong friends." He mentioned that over time he became "like a member of the family" of the Brazilian who owned the whole town. And, although oranges were difficult to get, when the Brazilian owner learned he liked them for breakfast, he always made a point to have them available when Mr. Zelnik visited.

Source: Based on author's interview with Mr. Zelnik, 1997

If you buy a pair of tennis shorts from New Jersey-based Sportif USA Inc., chances are the label will say "Made in Sri Lanka." That's because in 1992, the late Sri Lankan President Renasinghe Premadasa issued an edict outlining the steps his nation's garment factories would take to compete with other Asian producers. A top priority: In a

country with only one phone line for every 200 people—among the lowest ratios in the world—Premadasa required that every factory have two: one for a phone, a second for a fax machine.

Fax machines in Sri Lanka, cellular phones in the Brazilian rain forest, satellite dishes in Russia, videophones in Manhattan—they're all part of a telecommunications revolution that, with blinding speed, is changing the way the world works. With high-capacity cables, digital switches, and satellites, a multinational corporation—or a tiny garment factory—can conduct business anywhere, anytime, searching out customers and suppliers around the world. (*Arnst & Edmondson*, 1994, p. 118)

Developments such as satellite transmissions and fiber optics have reduced the time, cost, and distance demands of international trade. These technologies have not only thrust us into the global era, but also represent perhaps the most significant single dimension for exponential leaps ahead in this postindustrial era. Kobia, an executive with AT&T, noted: "Today, information is equivalent to the raw materials of the industrial age. The trade routes of the New World are made of hair-thin glass fibers. The cargo (information) moves across those routes as tiny pulses of light. The machines that process, switch, and transport cargo, like trading ships in the past, are today's critical assets" (Kabala, 1992, p. 42).

The World Wide Web and the Internet have roared on the scene as the ultimate medium for fast, inexpensive communications anywhere in the world where computers are available and systems are compatible. Technical standards are being developed to permit increasingly compatible systems, and nearly all regions of the world are improving their communications infrastructures. By mid-1996, the Internet was accessible in 174 countries and on all seven continents, linking together nearly 13 million host computer systems (World Bank, 1997). The number of Internet subscribers is expected to exceed one billion by the year 2000. This means that even if only one person uses each computer with access to the Internet, nearly one-fifth of the world will be connected. And, this is just the beginning.

The Internet has valuable use for e-mail communications and research. However, it is quickly becoming the key global communications tool for manufacturers, retailers, and component suppliers in managing and expediting global production and distribution activities. Another form known as intranets closed networks within an enterprise—permit on-line collaboration and information sharing within a company and its partners. In the forseeable future, factories in Asia may have access to a retailer's daily sales data so that garment production is adjusted to demand. Although not at this stage yet, Liz Claiborne does have a regional intranet infrastructure and email among 250 mills, factories, and offices in the Pacific Rim. Levi Strauss & Co.'s "Leviworld" Network is a communication system that sends and receives information from LS&CO offices and locations around the globe. The system permits worldwide videoconferencing and electronic transmission of new patterns and fabric designs to LS&CO facilities around the world. The company's Levi-link electronic services system, which is connected with retail customers to replenish inventories quickly, is now connected to global retailers.

Cycle times are becoming shorter and shorter. A new breed of consumer wants products faster than ever before, placing demands on all segments of the industry to compress the time required for manufacturing and distribution. Equally important, companies want to move quickly to reduce inventory costs. Although this is true in many industries, it can be said that the clock runs much faster in the fashion industry—a reference to the fast-moving nature of the business because of the volatility of fashion. New communications technologies are becoming the instruments to make these fast changes happen. All segments of the industry are being tied into the new technology loop. Distribution centers are becoming highly computerized and can respond quickly with orders. No segment of the industry wants to hold inventory. Consequently, we see an evolving inventory-in-motion phenomenon in which shipping companies play an increasingly important role in reducing business costs and assuring "time-definite" deliveries. The growing field of logistics management expedites product deliveries between suppliers and buyers. **Global tracking** systems now make it possible for a company to track a shipment of its products virtually anywhere in the world. Inventory tracking systems permit a company to track the status of an order at its offshore production sites continents away. A new dense code the size of two postage stamps can now replace bar codes and contains far more information to expedite distribution and tracking.

Several softgoods companies are using new communications technologies in various ways in manufacturing, merchandising, marketing, and sales. Among these, J.C. Penney uses a form of videoconferencing to send sample information to buying offices, headquarters, and offshore contractors rather than having to send sample garments. Penney can also link designers in corporate offices to overseas mills that supply textiles to its private label apparel manufacturers. Conferring on each design and production feasibility allows the company to reduce costly mistakes. Wal-Mart uses a variety of stateof-the-art communication technologies to facilitate their vast buying and distribution programs. In their ambitious global expansion plans, both of these major retailers make extensive use of new technologies to stay in touch with new stores being opened in other countries.

Additionally, the worldwide spread of electronic media has played a powerful role in stimulating demand in other parts of the world. As consumers around the world observe the lifestyles and the new fashion trends in other countries, markets become increasingly globalized. As a vast array of products and services becomes available via the Internet, we are increasingly moving toward a market without boundaries that might be called the *global cyberspace market*.

4. Easy access to most parts of the world through improved transportation systems. Transportation improvements have also led to the sense

of a shrinking world, permitting us to travel farther and faster than a decade or two ago. These advances, along with those in communications, have created a global community not even dreamed of when the United Nations was born. The unprecedented ability to transport people and goods throughout the world has altered dramatically the world economy.

As a result of improvements in global transportation systems, retail buyers can travel to any country in the world with relative ease to find products for their stores. Similarly, manufacturers may travel to various countries to promote the sale of their products or to establish production facilities in those areas. Although many developing countries lack modern transportation systems, significant progress is underway in most regions. Improved transportation systems also make it possible for merchandise to be moved thousands of miles for sale in other countries. Because most textile and apparel products are relatively lightweight, they are transported more easily and more economically than many other products. This, too, accounts for the farflung global nature of the industry today.

5. Institutional arrangements on the part of business and government. Various institutional innovations have made it possible for individuals and businesses in various countries to participate with moderate ease in international trade. These institutional arrangements facilitate both the exchange of goods and services and the transfer of payment for those goods and services. An important example is the development of basic rules and guidelines to establish order in international trade. These rules erase most of the uncertainty that accompanies transactions across national boundaries. Other examples of these arrangements include transfer of payments from one country to another rather than reliance on barter, conversion of payments from one country's currency to that of another, and procedures for clearing shipments from one country to another (port authorities, shipping visas, and so on).

To illustrate these institutional arrangements, consider that a U.S. retailer has purchased garments made in India. Among the arrangements that make this trade possible are the following: the existing rules for orderly trade between the two countries; the mechanisms for transferring payment from the U.S. retailer's bank to an Indian bank, with an accompanying conversion from U.S. dollars to Indian rupees; and finally, U.S. Customs Service operations that process the shipments of Indian garments so that they may enter the country and be received by the retailer who ordered the merchandise.

Another example is the "plasticization" of business—through credit cards—which has also helped to facilitate global business. The traveler in another country can purchase souvenirs with a credit card and have the bill arrive later at home showing the conversion made to the local currency.

In recent years, a combination of these five developments has enhanced global trade. That is, the international economic climate has fostered increased global production and distribution, while improved communication and transportation systems, along with improved institutional arrangements, have helped to facilitate this expansion.

The Growing Importance of the Logistics Field

When the term *logistics* is mentioned, most individuals think of military logistics, which is the process of moving soldiers, material, and supplies to support an operational mission. In the business world, however, logistics has a broader meaning. According to the Council of Logistics Management, an international organization of supply-chain professionals, business *logistics* is the process of planning, implementing, and controlling the efficient, effective flow and storage of goods, services, and related information from the point of origin to the point of consumption to meet cus-

tomer requirements. In simple terms, it is the process of getting the right product to the right customer at the right time and at the right price. Logistics connects a firm to its suppliers and also to its customers.

The logistics field is discussed here because of its mounting importance in the textile and apparel industries today. It is also relevant to discuss at this point because this fast-growing field brings together factors 3, 4, and 5 to facilitate the compressed production-distribution cycles now present in the softgoods industry. Logistics professionals bring together the advances in communications and transportation, and many have become experts on the institutional arrangements involved in trade. Logistics firms offer a growing range of services to textile and apparel suppliers and retailers. Some even have divisions dedicated specifically to these industries.

In the past, a textile or apparel firm or retailer generally contracted out the shipping and other services needed for delivering supplies or shipping finished products. In the last decade, however, more and more companies have turned to the specialists who can provide multiple integrated services. These are called integrated logistics companies, contract logistics specialists, or third-party providers. These specialists offer services covering a broad spectrum of activities associated with getting products to market. These include fleet management, carrier selection and negotiation, warehousing and inventory management, order fulfillment, product packaging, shipment preparation, customs processing, and more.

Why are more textile/apparel/retailing firms turning to logistics specialists? Many know they do not have the expertise, software, and systems needed to manage their "inventory in motion." For fast-moving product areas such as apparel, timing has always been an issue. Today, however, companies in all segments of the fashion-related industry strive to keep low inventories (to reduce the investment idle inventory represents) and therefore must be able to count on

prompt replenishment as needed. Retailers try to forecast consumer needs as accurately as possible, and this is achieved more easily when ordering close to the selling period rather than several months in advance. Today, no segment of the industry wants to hold the inventory, hence the inventory-in-motion phenomenon. Thus, many textile/apparel/retailing firms are turning increasingly from ordinary freight carriers to third-party logistics specialists who can provide a range of activities to support their companies. For many companies, logistics has evolved from a functional activity to a strategic operation and a key to the company's business success. Collectively in all industries, this trend has created a powerful logistics sector estimated to be in the \$900 billion range by the year 2000.

As noted, some logistics firms have programs especially for the textile and apparel industries. One company, for example, advertises, "Emery Worldwide has a unique logistics program specially designed for the fashion and textile industries," further noting, "Your business is global in scope, including both sources of material and markets for finished goods. Emery Worldwide offers daily air freight service to and from every major fashion center in the world. Europe, North and South America, the Orient and the Caribbean are all included in our fashion program, offering both Garment-on-Hanger (GOH) and carton service from every major domestic apparel center to the world market" (Company brochure, no date). See Figure 1-6. Emery's fashion services are backed by a large worldwide network that includes nearly 100 jet airliners, ocean carriers, and a fleet of over 2,000 trucks. The company has nearly 600 service and agent locations in North America and nearly 100 countries worldwide, providing service to 206 countries. Emery Global Logistics, a subsidiary of Emery Worldwide, provides customers scheduled or chartered air, ocean, and truck transport; shipment monitoring and expediting; warehousing, inventory management, and order fulfillment; customs clearance; management reports; and single-source invoicing. A wide range of new information technologies permit Emery to work with customers to track shipments, as well as to tie directly to customers' computer systems to process shipping orders and many other forms of documentation.

Logistics firms like Emery can provide these sophisticated services because they have been able to capitalize on the advances discussed in the previous section and integrate them into coordinated services to serve industry. For global industries such as textiles and apparel, these services are vital. As apparel firms and retailers contract production across several continents, logistics specialists enable companies to manage a farflung network of production and distribution activities, with assurance that components and finished products arrive when, where, and how they are needed.

Individual softgoods companies have implemented logistics concepts within their own distribution systems. For example, Sears's head of logistics is a retired three-star general who moved guns, fuel, and troops in the Gulf War; he sees his job at Sears as being similar except that he is moving dresses and bathrobes. He oversees a unit that ships 600,000 truckloads annually from more than 160 distribution centers and warehouses to 821 full-line Sears stores. Using logistics efficiencies, he has trimmed 40 percent off the costs of moving apparel from Sears's five fashion centers to its stores and boosted annual inventory turns at the centers to 42 times in 1996, compared to 12 times in 1991 (Seckler, 1997).

In reflecting on the evolution of the textile and apparel industries, we might well conclude that *production* was the driving force up to the early 1980s; then the industries took on a *marketing* orientation. Today, however, *logistics* has become the driving force in the successful management of this globalized production-distribution sector.

FIGURE 1-6

Integrated logistics companies are playing an increasingly important role in the global textile and apparel industries. Emery Worldwide has a division devoted specifically to these industries, and this ad depicts the role a logistics firm can play. *Source:* Reprinted courtesy of Emery Worldwide.

The U.S. Textile and Apparel Industries within the Global Economy

International trade (the exchange of goods and services among nations) has long influenced the U.S. textile and apparel industries. However, in the past, the U.S. industry focused on its domestic market. Moreover, a limited number of other countries directed their textile and apparel products to U.S. markets. More recently, however, the proliferation and increased proficiency of textile and apparel producer nations around the world have changed dramatically the environment in which U.S. textile and apparel manufacturers—and all those individuals affiliated with these industries—must function. In short, the globalization of production and marketing in textiles and apparel is the single most important phenomenon to reshape the softgoods industry in this century.

Changes in global production of textiles and apparel, and the resultant changes in the international market, require that we now focus on the **world view**. We can no longer think of a purely domestic industry—or a domestic market. Virtually all aspects of the production and distribution of textile and apparel products in the United States have been affected profoundly by increased global activity in this sector. The same may be said for those firms and industry employees within nearly all nations who are now manufacturing and distributing textile and apparel products.

The U.S. textile and apparel industries now function as part of a **global economy**. U.S. manufacturers are part of this global economy, and even if they choose not to participate actively in international trade, they are affected nevertheless by activities in the world market. Manufacturers are competing for many of the same markets sought by producers in nearly 200 other countries. Many of those competitors have become partners as U.S. manufacturers contract to have garments produced in lowerwage countries. Industry workers are part of

the worldwide sector and compete for jobs, often without knowing it, with workers from other countries around the world.

Similarly, retailers of textile and apparel products are affected by the proliferation of goods in a shrinking world—a world that seems smaller because of advanced communication and transportation linkages. Many retailers must assume a global view as they scout the far corners of the globe to select merchandise for their stores. Choices have expanded for retailers as an increasing number of textile- and apparel-producing countries compete for their orders. Retailers have also formed partnerships with producers in low-wage countries and contract production of their private label lines directly with those factories. Consumers, too, are part of this global economy and choose from merchandise produced throughout the world.

To participate meaningfully in almost any aspect of the textile and apparel industries, individuals and companies must come to view themselves as part of a global community and as players in a worldwide market. Participants in the textile and apparel sectors no longer have a choice. To engage meaningfully, even at the domestic level, we must understand the broad scope and some of the complexities of the international market. Increasingly, textile and apparel industry leaders must have a global perspective—along with global skills—to function effectively in this competitive sector.

The United States on a Global Stage

The United States is only one part of a much larger world—and a much larger world economy. Americans often forget that the United States represents only about 260 million persons in a world inhabited by more than 5.9 billion. Although the United States has a long history of participating in the international economy, we have become increasingly dependent on that system. Our economy is dominated by what is happening globally. In 1996,

BOX 1-3

MAJOR WORLD LANGUAGES AND NUMBERS OF NATIVE SPEAKERS

Chinese	1,100,000,000	Portuguese	160,000,000	Voyage	70,000,000
	, , , , , , , , , , , , , , , , , , , ,	Tortuguese	160,000,000	Korean	70,000,000
English	330,000,000	Russian	160,000,000	French	65,000,000
Spanish	300,000,000	Japanese	125,000,000	Tamil	65,000,000
Hindi	250,000,000	German	100,000,000	Telegu	65,000,000
Arabic	200,000,000	Panjabi	90,000,000		
Bengali	185,000,000	Javanese	80,000,000		

Source: Compiled from Gunnemark, E. (1992). Countries, peoples and their languages: The geolinguistic handbook (p. 167). Gothenburg, Sweden: Länstyckeriet.

the United States shipped \$624 billion worth of goods abroad while selling \$189 billion worth of services to consumers in other countries. These exports contribute more than 10 million jobs and created 23 percent of the new private-sector jobs between 1990 and 1994 (Ruggiero, 1997).

If we are to participate effectively in an increasingly interdependent world, we must possess certain basic competencies. By and large, Americans are lacking in these competencies. They have been criticized for a lack of understanding of international events and for limited sensitivity to activities in the rest of the world. In survey after survey, U.S. adults and youth rank poorly compared to citizens in many other countries on geography skills and in understanding major current events outside the United States. Proficiency in languages other than English has been sadly lacking. As Box 1–3 indicates, the native English-speaking population of the world is relatively small when the total is considered. However, many residents in other parts of the world know English as a second language.

In the late 1980s, the National Governors' Association (NGA) began to address the lack of global competencies. The NGA Task Force on International Education noted: "In educating

students, the languages, cultures, values, traditions, and even the location of other nations are often ignored" (NGA, 1989, p. 4). Unfortunately, in the past, many economics courses and textbooks have focused on the U.S. economy as if it were a closed system, functioning in isolation from the world around it.

Key Terms and Concepts

An understanding of several key terms and concepts is necessary to establish a common vocabulary to approach the study of textiles and apparel in the global economy. In the following chapters, important terms are printed in boldface when they are first introduced and explained and are then combined with their definitions in the Glossary at the end of each chapter. An index to Glossary terms is presented inside the back cover of the book.

Although new terms and concepts will be introduced throughout the book in the manner described, clarification of a few basic terms will be helpful here.

 The textile complex, as shown in Figure 1–7, refers to the industry chain from fiber, to fabric, through end uses of apparel,

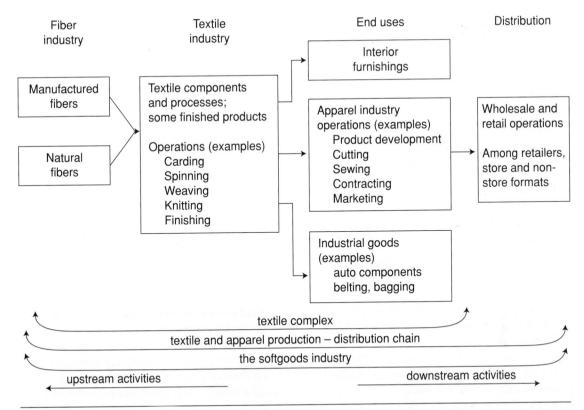

FIGURE 1–7
The textile and apparel production-distribution chain.

interior furnishings, and industrial products.

The term textile sector has two common interpretations—which at times can be confusing. (1) Often the term is used in a comprehensive sense (synonymous with textile complex) to include all aspects of textile and apparel production from the fiber stage to completed end-use products. Typically, trade officials use the term in this manner and even shorten it to textiles in references to the comprehensive sector. In this usage, trade sources might say, "Textiles poses special problems in world trade." (Often this form suggests difficulty with grammar if one is unfamiliar with this usage!) (2) The term is also used for the portion of the industry that produces

"textiles" in a more limited sense, that is, the segment that manufactures fibers, yarns, fabrics, and select finished products. Except for certain knitwear, use of the term in this manner usually does not include apparel.

Generally, in this book, the term *textile* sector will be used in the latter manner. An exception will be in discussions related to trade policies, in which the working language—for example, *textile* policies—includes policies for the entire complex.

- References to the textile industry may also have the same double meaning mentioned earlier. However, this term more commonly refers to the fiber-to-fabric segment of the industry in the more narrow sense.
- References to the apparel industry are less confusing. This term applies only to the

- industry segment involved in the manufacture of garments and certain accessories.
- The sewn products industry includes all stages of apparel production and, in addition, a number of other sewn product categories such as interior furnishings items (such as draperies and linens), luggage, awnings, and sewn toys.
- The terms softgoods chain and softgoods industry are the most comprehensive given here. Each of these terms includes the manufacture of textile or apparel products from the fiber stage through completion of end-use products, as well as the retailing or other distribution phases associated with making the products available to the consumer.
- Upstream activities refer to those processes in the early stages of the manufacturing/ distribution chain. These include specialized suppliers of the inputs for production—for example, fibers, textile machinery, and dyestuffs.
- Downstream activities refer to those processes further along in the manufacturing/distribution chain (closer to the end-use customer). These include the wholesale and retail trades as examples.
- Intermediate inputs, for our purposes, are the textile components used in producing finished or nearly finished goods. These include the fibers, yarns, and fabrics sold to producers at the next stage of the production chain.
- International activities (production, trade, marketing, etc.) are those that occur in interaction with others outside the home base country. Although the terms international and global are used interchangeably, many sources consider international to be more limited (intermeans "between"). Although international activities involve interaction related to other countries, these may be fewer in number and may be limited, for example,

- to a firm's own regional trading bloc. Some interpretations consider international firms to be those that operate entirely from a home base.
- Global activities are generally considered to be much more encompassing than international ones in terms of geographic spread (if we think of *inter-* as "between," *global* might be considered "among"). Global activities are likely to include countries beyond the firm's own regional trading bloc and may be worldwide. *Global* may also reflect a different way of thinking in which there is not a "headquarters mentality" that may exist in an international firm.
- Global interdependence means that all
 nations are dependent on other nations for
 their economic well-being. Furthermore,
 countries are interconnected in such a way
 that one nation's actions affect other
 countries; similarly, that nation is affected
 by the actions of other countries.
- Global products are those that are the result of manufacturing, and sometimes marketing, operations in several different countries.
- Globalization refers to an acceptance and/or integration of concepts or practices on a global scale.
- Globalization of fashion means that fashions are widely accepted on a global basis.
- Microeconomics is the study of individual behavior in the economy and of the components of the larger economy. Thus, a microperspective refers to a focus on the individual units—for example, the consumer, an individual nation, or a specific sector treated as a single unit participating in the economy.
- Macroeconomics is the study of aggregate economic behavior, that is, of a nation's economy, such as monetary policy, employment, inflation, and fiscal policy. Schiller (1983) compares macroeconomics

to looking at a completed puzzle; microeconomics focuses on each of the pieces.

- The terms more-developed (or developed) and less-developed (or developing) countries are common means of describing and classifying nations according to their levels of economic and industrial development. More-developed (or developed) countries are the more industrially advanced and prosperous countries in which a higher level of living is common. Less-developed (or developing) countries are limited in their economic progress and may have little or no industrial development; these are typically the poorer countries. A third group of countries, the newly industrialized countries (NICs), are former developing countries that have progressed to more advanced levels of economic and industrial development; the NICs have become proficient exporters of manufactured goods. Country groupings will be discussed in greater detail in a later chapter.
- Imports are intermediate and final goods and services purchased from other countries.
- Exports are intermediate and final goods and services produced within the home country and sold to other nations.

A BRIEF REVIEW OF CHANGES IN GLOBAL TEXTILE AND APPAREL MARKETS

Since the early development of a domestic industry, U.S. textile producers have considered foreign competition a threat. The degree of concern has vacillated from time to time. In the 20th century, however, U.S. textile and apparel manufacturers experienced remarkably little serious competition from producers in other nations until the 1950s. Manufacturers had the

luxury of directing their products toward a receptive, and nearly captive, domestic market. Because of the vast size of the U.S. market, the country's textile and apparel manufacturers found ready markets for the products they made. The industry enjoyed relative prosperity, and most companies saw little reason to become involved in international activities or to be concerned about a global perspective.

In the 1950s and 1960s, however, significant changes affected the global environment for the textile and apparel sector. In contrast to earlier years, when a relatively limited number of countries manufactured textile and apparel products for world markets, several nations particularly those in East Asia—became proficient producers. Many of these countries developed their textile and apparel industries as primary export sectors for economic development. That is, these countries directed their resources and efforts to building textile and/or apparel industries that could produce goods to sell to other parts of the world. Payments received for those products contributed importantly to the economic advancement of those countries. By the 1950s, U.S. textile and apparel manufacturers began to feel the impact of increased international activity in the sector.

In the last two decades, the number of producers for world markets has incompleted decades, with nearly every nation competing for market share. Although the number of new producers for world markets has escalated, the industry remains a top employer in the developed countries. In both the United States and the European Union, for example, the textile complex employs nearly one of every 10 to 12 manufacturing workers. Consequently, as the less-developed countries gain an increasing share of the world market, the industrialized countries face major adjustment problems as they attempt to maintain employment of large workforces dependent upon this sector.

In recent years, the growth in the number of textile- and apparel-producing nations around the globe has changed dramatically the climate for producers everywhere. Excessive production capacity has fostered intense competition. Because of the greatly increased competition among nations for market share, world trade in textiles has become sensitive and volatile. Many political and social issues accompany the economic concerns as developing countries and industrialized nations compete in the face of the excessive production capacity. Determining who can export textile and apparel products to whom and who will import these products from whom, and to what extent, engenders the following concerns, as depicted in Figure 1–8.

• Economic concerns. Which nation's economy should gain at another's expense? To what extent can U.S. policymakers justify trade policies or other legislation to shield the large domestic textile and apparel industries from the impact of increasing imports? To what extent do the developed countries have an obligation to assist less-

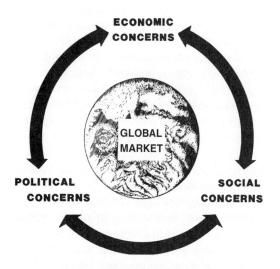

FIGURE 1-8

Many economic, political, and social concerns are involved in resolving issues related to producing textile and apparel products for global markets.

- developed nations in their economic growth? These questions are further complicated by the need to balance sectoral interests; for example, if textile and apparel imports are restricted, will the governments of other countries retaliate in ways that affect other sectors, such as agriculture?
- Political concerns. How will opening or restricting the markets of the developed countries to textile and apparel imports affect broad political relationships with the exporting countries? How can the political pressure of a particular sector be coordinated with concerns for political goodwill with other nations? Does some other political agenda determine the volume of imports to be accepted from a country or region? As an example, the U.S. government has supported programs to develop apparel production in Latin America in an effort to reduce civil unrest and to increase political stability.
- Social concerns. In a global industry that employs in production jobs persons with few gainful employment alternatives, which nation's workers in which sector should benefit at the expense of others? Should workers in France or the United States give up their jobs so that individuals in the Philippines or Nepal can be employed? If so, to which jobs should the displaced workers turn? Alternative jobs for both of these groups of workers may be limited. Consequently, global textile and apparel production and trade involve complex global social concerns, as well as those within specific countries.

From any perspective, textile trade has become a difficult segment of global commerce. National economies, international political relationships, and workers' lives depend upon market forces and policymakers' ability to resolve the problems caused by excessive production capacity within a limited global textile market.

The U.S. textile and apparel industries have experienced increasing competition in the international marketplace for more than three decades—longer than most other U.S. industries that are now facing similar competition. In this sense, the trade problems of the textile and apparel industries have been forerunners of similar difficulties that followed for other sectors. Just as they fostered economic development historically, textile and apparel producers are in the front line of today's changes in the global economy.

AN INTERDISCIPLINARY PERSPECTIVE

A study of textiles and apparel in the international economy draws upon the contributions of a number of academic disciplines to understand the issues involved. That is, the insight provided by various disciplines provides an interdisciplinary perspective. Relevant disciplines include economics, geography, history, sociology, political science, anthropology, and certain functional business fields such as marketing, management, and finance. A fundamental grasp of some of the theories and concepts from these disciplines can help in understanding the complexities of global textile trade. Several relevant theories will be presented later, but at this point, a brief review of the contributions of these fields may be helpful.

 Economics provides theory that explains why nations exchange goods and services with one another, and some of the analytic techniques provide ways of determining the impact of trade and trade policies.

 Geography provides helpful perspectives on the location and type of the world's resources and their availability for use by individuals or industries. For example, the study of the distribution of the world's population is particularly relevant to the global textile sector as an employer.

• History permits us to review the past in systematic ways to better understand the present. As an example, an awareness of the historical development of the textile industry as a leader in a number of global industrial movements may give us a greater appreciation of this sector. Or, in a more specific example, an understanding of early textile trade policies helps us to understand current policy.

Sociology provides theories of development and social change that may help us understand issues of social stratification, the distribution of power, and international relations. An awareness of these changing international forces is relevant to the study of the production and trade shifts for the textile complex within a global economy.

 Political science provides an objective study of governmental institutions and processes, and of how these may determine the business environment in various countries and at the global level. As an example, a political science perspective is helpful in analyzing the influence of special interest groups on the development and implementation of textile trade policies.

 Anthropology aids in understanding and appreciating the differences in cultural environments in various parts of the world. Sensitivity to cultural differences is vital to functioning effectively in the global economy.

 Business areas help us to understand the specific applications needed to operationalize global production and distribution of textile and apparel products. For example, a study of international marketing provides expertise to promote products differently from one country to another. As logistics assumes an increasingly critical role in business today, study of this specialized field is particularly relevant.

SUMMARY

Advanced communication and transportation systems have led to increased interaction of the world's inhabitants. The resulting interdependence has led to a global economy characterized by a web of linkages through which actions of the players in one system can have consequences for those in another system.

As an important part of an increasingly globalized economy, textile and apparel production is dispersed around the world. Together, textile and apparel production represents the largest source of industrial employment in the world. Production processes are linked on a global scale, often resulting in global products. The globalization of textile and apparel production has not been without its problems, however. As growing numbers of nations entered these sectors as a means of fostering economic development, an overcapacity of production occurred in an international market where demand was increasing slowly. As a result, competition in the global textile and apparel market is intense. Consequently, many economic, political, and social concerns are inherent in efforts to resolve the problems associated with excess global production capacity.

Expanded worldwide textile and apparel production, along with accompanying trade shifts, represents the most important changes affecting the global complex today. Similarly, the textile complex within many countries is affected by these global changes. Without question, all aspects of the U.S. softgoods industry are affected by the globalization that has occurred. Given the growing international dimensions of the textile complex, in order to participate meaningfully in any aspect of the U.S. industry, individuals and firms must have an understanding of the broader global context in which we now operate.

SUGGESTED READINGS

Bonacici, E., Chang, L., Chinchilla, N., Hamilton, N., & Ong, P. (Eds.). (1994). *Global production: The apparel industry in the Pacific Rim.* Philadelphia: Temple University Press.

A collection of scholarly articles about the apparel industry in the Pacific Rim; social issues are emphasized.

Boulding, K. (1985). *The world as a total system*. Beverly Hills: Sage.

An examination of several systems of which the total world system is composed.

Dicken, P. (1992). Global shift. New York: Guilford Press.

This book focuses on the internationalization of economic activity.

Goldman, S., Nagel, R., & Preiss, K. (1995). *Agile competitors and virtual organizations*. New York: Van Nostrand Reinhold.

The authors consider how companies must reinvent themselves to compete in a new era.

Hamish, McR. (1996). *The world in 2020: Power, culture, and prosperity.* Cambridge, MA: Harvard Business School Press.

This book examines world economic trends and changes in the next 25 years and the forces that will affect future progress.

Naisbitt, J. (1994). Global paradox. New York: Avon. Naisbitt writes that as globalization occurs, individuals want to identify with smaller and smaller entities.

Naisbitt, J. (1996). *Megatrends Asia*. Old Tappan, NJ: Simon & Schuster.

A focus on eight Asian megatrends that are shaping the world.

National Governors' Association. (1989). *America in transition—The international frontier*. Washington, DC: Author.

A review of America's growing need for international competencies to participate fully in an increasingly interdependent global economy.

Ohmae, K. (1990). *The borderless world*. New York: Harper Business.

A management consultant's view of a borderless world that has already emerged in the financial and industrial spheres.

Textile Institute. (1994). *Globalization: Technological, economic, and environmental imperatives.* Manchester, UK: Author.

A focus on issues related to globalization of the industry.

Toyne, B., Arpan, J., Barnett, A., Ricks, D., & Shimp, T. (1984). *The global textile industry*. London: George Allen & Unwin.

A study of the global textile industry and factors affecting its competitiveness.

United Nations. (1990). *Global outlook* 2000. New York: Author.

United Nations writers look back at the past 30 years and forward to 2000 and predict changes related to economic, social, and environmental issues.

U.S. Department of Commerce, International Trade Administration. (1995). U.S. global trade outlook 1995–2000: Toward the 21st century. Washington, DC: Author.

An assessment of the place of the United States in the global economy.

Women's Wear Daily (WWD). (Periodic). Global edition.

WWD began its global edition in July 1997 and publishes this periodically; distributed to global readership.

The chapters in Part 2 are intended to set the broader stage for the study of textiles and apparel in the global economy. These chapters are designed to prepare us to view our study within the broader context of history, within the various dimensions of an international setting, and within a theoretical context.

Chapter 2 provides a historical perspective on the development of both the global and U.S. textile and apparel industries. Special attention is given to the role of the industries as leaders in industrial movements. A brief history of broad global trade developments provides the backdrop for our study of textile and apparel trade. Subsequently, we shall consider an overview of the special trade problems that emerged for the textile and apparel sectors.

Chapter 3 provides an overview of the global environment in which textile/apparel production and trade occur. Attention is given to groupings of nations, since these divisions are of special significance in the study of textiles and apparel in the global economy. Economic, political, and cultural systems are considered important environmental factors affecting production and trade.

Chapter 4 builds, to some extent, on concepts presented in the prior chapter and provides a brief review of theory relevant to global trade in textiles and apparel. Select economic (trade) theories and development theories are presented to provide a framework for considering the shifts in production and trade for textiles and apparel in the global economy.

Historical Perspective

Textile production, from the production of fiber through subsequent steps, represents one industry common to all countries in the global economy. Textile manufacturing, one of the oldest industrial sectors in the world, has contributed in important ways to the development of economies and the resulting living standards of inhabitants in regions scattered around the globe. A study of the development and the geographic shifts of the textile sector as it has moved through time and around the globe provides insight into the economic and social conditions of the occupants of continents and countries at a given time.

Textile production became one of the earliest large-scale economic activities that led the industrialization process centuries ago. Similarly, certain segments of the industry continue to play a key role in the initial industrialization process of most countries. This role has resulted because (1) the industry serves a basic need of nearly all humans and usually provides for some or all domestic demand, and (2) different aspects of the industry's production have been adaptable to a wide range of available resources. For example, when capital and technology are available, more technolog-

ically advanced textile production occurs. On the other hand, when a country has neither of these, certain segments of production (e.g., small-scale textile production or apparel assembly) often thrive because of other abundant resources such as labor.

Both as a leader and as a sustainer of economic and industrial activity, the textile sector has contributed in important ways to serving the needs of the world's peoples. In many respects, the emergence of the textile industry and its role in economic development are themes often replayed in country after country. The early development and the socioeconomic impact of the textile industry in England and the United States are repeated today, in somewhat different forms, in many developing countries. This almost universal reliance on the textile/apparel sectors for economic and industrial advancement accounts for many of the complexities found in today's global textile market.

In this chapter, we will consider (1) a historical perspective on the development of the textile and apparel industries; (2) the development of global trade; and (3) a brief review on how textiles and apparel became difficult areas of trade.

THE ROLE OF THE TEXTILE SECTOR IN HISTORICAL GLOBAL INDUSTRIAL MOVEMENTS

The Textile Sector as a Leader

The textile sector played a leading role in the development and evolution of worldwide economic and industrial history. In this role as an industrial leader, the textile industry shaped economic and social thought. Many of the developments in this industry occurred first in England and later spread in similar form to the United States and to other countries. Some of the ways in which the textile industry was a leader are the following:

- Textile production led the Industrial Revolution when it became the first sector to shift from the use of skilled hand labor to production based on hand-powered machines and, later, steam power.
- The textile sector's early use of technical inventions made it the first to build factories to apply the new developments on a large scale. This means that the industry was among the first to transform England and later the United States from an economy based on farming and household industries to one using factories and mills.
- The establishment of factories to produce textiles led to the development of mill towns in rural areas of England and later the United States.
- Development of textile production into a factory system created the jobs that led to participation of the first generations of both English and American women in widespread employment for wages outside the home.
- Poor working conditions in the textile mills, and later in the garment factories, led to the first industrial reforms. Workers' protests against excessive work demands and poor working conditions led to policies to

protect workers from abuse by their employers. See Figure 2–1.

Some of these developments in textiles not only had an impact on other sectors of industry that came later, but also profoundly shaped the socioeconomic environment of many nations. Although other contributions could be given, these represent significant examples of the ways in which the textile industry left its imprint on economic and industrial history. A brief overview of these developments provides a useful historical backdrop against which we will consider the present status of the global industry. An awareness of the leadership of the textile industry in these areas helps to provide a special appreciation of the importance of this sector in global social and economic evolution. This historical perspective, as portrayed in Figure 2-1, is particularly useful because a number of more recent industry developments in various locations of the world parallel certain aspects of the industry at earlier stages in the United States, Great Britain, and other developed countries.

Textiles as a Leader in the Industrial Revolution in England

Until 1750, most English families lived on farms or in small villages, and family members produced virtually everything they needed. Ordinary people lived simple lives and required little from outside the family or the village. Poverty was common. Up to this time, methods of production had changed slowly.

Although scientific investigations and inventions had occurred in the 1600s, these were not focused on machines or other processes related to production. Although wealth was present, money was not invested generally in inventions related to science or production. The movement we now call the Industrial Revolution began to occur in the mid-1700s when, for the first time, both science and capital were

Use of machines for production (Industrial Revolution)

Development of factories

Migration from farms, development of mill towns

Widescale employment of women outside the home

Worker protests leading to industrial reform

FIGURE 2-1

The textile sector as a leader in historic industrial movements.

used to solve the problems of production. Although both science and **capital** had been available before, they had not been applied *together* to solve practical problems (Crawford, 1959; Ellsworth & Leith, 1984).

As the English became interested in new products and new conveniences, capitalists saw an opportunity to make profits by bringing science and capital together to produce new goods. Around 1690, for example, textile production was stimulated by cotton cloth from India, which appealed to fashionable persons because of its lightness, cleanliness, and brightness. Demand grew as others saw these fabrics. Although production of cotton fabrics (fustians, a blend of cotton and linen) had begun in England as a cottage industry about 1600, it was viewed as a household activity, as the earlier woolen industry had been. Until the colorful hand-loomed Indian cottons grew in popularity and were banned by Parliament, growth of domestic textile production was slow. Consequently, this political action, which cut off Indian textiles, was instigated so that the British could develop their own industry, produce their own fabrics, and keep the profits at home (Ellsworth & Leith, 1984). Figure 2-2 depicts workers celebrating the passage of a bill to protect the British woolen industry.

Elimination of competition quickly expanded England's cotton cloth production. At first, the cloth was made by domestic workers who were supplied raw materials by "manufacturers" or entrepreneurs. Once the Indian textiles were no longer an option, the purchase of English cloth grew rapidly because, in addition to domestic use, the cloth was valued in the slave trade. Producers could not keep up with the demand. Seeing an opportunity, early capitalists encouraged inventors to develop machines to produce the goods. Manufacturers began to offer prizes for a machine that would increase production and improve the profitability for British producers.

Gradually textile production became more sophisticated and played a prominent role in broader industrialization efforts. The textile industry led the Industrial Revolution with the development of a series of interrelated mechanical inventions. As each development solved a pressing industrial need, it created an imbalance within the industry that necessitated other inventions. In 1733, John Kay developed the mechanical flying shuttle, which permitted a single worker to weave fabric wider than the length of a person's arm. Prior to Kay's invention, if wide fabrics were woven, two workers were required to move the shuttle back and forth to insert the weft thread. Kay's flying shuttle expanded weaving output greatly, making it more difficult than ever for spinners to support the demand for yarn. Up to that time, a weaver required five or six spinners to supply yarn for the weaving, but Kay's improved loom had made it impossible for spinners to meet the demand.

Three important inventions revolutionized spinning between 1764 and 1779. These were Hargreaves's spinning jenny, Arkwright's water frame, and Crompton's mule. The jenny produced yarns of fine quality that were too weak to be used for the warp, whereas the water frame produced stronger yarns of lesser quality. Crompton's invention combined the principles of the jenny and the water frame to produce strong, fine-quality yarns. The mule was soon fit with 300 to 400 spindles, permitting it to replace that many spinners. At that point, spinning potential would have surpassed availability of raw material had it not been for the 1793 invention of the cotton gin by the American Eli Whitney (Crawford, 1959).

The Industrial Revolution altered profoundly the notion about how goods could be produced, and the textile industry led the way in this revolution. As the new industrial developments began to spread abroad, these production changes provided the groundwork for the transformation of the Western world into a true international economy.

Marszal (1985), a Polish industrial geographer with a special interest in the textile industry, reinforced the view that the British textile

fleece t'employ your poore [sic]." The center one reads "Now lett [sic] us all joyn [sic] hand in hand t'advance what most promotes our land." And the bottom one reads "ENGLAND'S GREAT JOY AND GRATITUDE express'd to the King and messages focus on passage of a bill to protect the British industry from imports. The top left one reads "Preserve your Parliament for passing the BILL for the more effectual imployment [sic] of the poor, and Incouragement [sic] of the FIGURE 2-2 This 17th-century handbill illustrates the processes of the woolen and worsted industries. Center manufactures of this Kingdom." (Source unknown).

industry was a forerunner of similar industrial developments in other countries and other sectors. Textile production also led the Industrial Revolution on the European continent years later, with France having the distinction of being the next European country to develop its textile industry (Strida, 1985).

Development of the Factory System

New spinning machines led to the development of the factory system because the machines were so large that cottages could not hold them. Further, the machines were so heavy that mechanical power was needed to run them. Because the inventions were operated most economically by water, factories clustered where water power (and later steam) was available. Arkwright became the first industrial capitalist, establishing a large number of textile factories during the 1800s employing 150 to 600 workers (many of whom were children), rendering England's cottage industry obsolete (Addy, 1976; Crawford, 1959). These early mills are generally regarded as the first modern factories. Other industries, such as iron and steel, soon copied the factory model developed in the textile industry.

As noted in the earlier example, one invention for textile production often created an imbalance in other areas. Whereas yarn was scarce earlier, weavers later found that they could not keep up with the overabundance of varn being produced in the spinning mills. To fill this need, Cartwright developed a power loom in 1795; however, handloom weavers, concerned about job security, blocked its use in the industry and prevented its widespread adoption until about 1810. Although the use of power looms in factory settings had the potential for operating on a more widespread basis, Mantoux (1927) noted that large numbers of handlooms continued to be operated until late in the nineteenth century.

Early Developments in the United States

Although early industrialization began in England, a review of the earliest developments of the textile industry in the United States will be helpful at this point—particularly since the remainder of our historical industry perspective in this chapter will focus primarily on the U.S. industry. The industry in many other countries followed at least some aspects of this pattern of development. Although the U.S. industry developed after the English system had been in operation for a long time, once the first machines for textile production came into use in the United States, the new nation followed quickly in the British path of establishing factories.

Although the influence of the Industrial Revolution spread much later to the textile industry in the United States, compared to Europe, colonists had long valued textile production. As early as 1645, the Massachusetts Bay Colony encouraged newcomers to bring as many sheep from England as they could. Families from the textile-producing areas of England and other parts of Europe settled in the colonies and applied their knowledge and skills to fledgling textile production efforts. Colonists were eager to become proficient at producing their own fabrics so that they might clothe themselves and reduce their dependence on England. British authorities believed, however, that a major role of the colonies was to absorb products from the mother country; as a result, they tried to block the development of a textile industry in the colonies and prohibited trading with any other nations. The British wanted the colonies to remain dependent; in addition, they wanted the profits that accompanied the sale of goods.

In 1705, Lord Cornbury expressed the concern that English officials could foresee in the dangers of letting the colonies achieve self-sufficiency in textile production: "If once they see they can clothe themselves, not only comfortably, but handsomely too, without the help

BOX 2-1

THE ENGLISH TEXTILE FACTORIES

Although English textile mills led the way in establishing the factory system, working conditions were shameful. According to Addy (1976), men hated not only the new textile machines but also the factories. They disliked the long hours and the rigid rules. "The domestic worker saw little difference between the mill and going to prison or to an army barracks. Hence the early manufacturers found it difficult to obtain labour" (Addy, 1976, p. 30).

Gradually the factories attracted workers from the poorest areas seeking more opportunities and better earnings. Women and children were considered excellent prospects for the industry because their nimble fingers and natural dexterity made them suitable for joining broken threads on the mule or water frame. In addition, child labor was cheap—about one-third the cost of adult labor, plus food and lodging (Taylor, 1912).

An easy way to obtain child laborers was through the town poorhouses. Overseers of the poor were authorized to board out pauper children and pay a bonus for each one that survived. Addy (1976) cites accounts of 50 to 100 pauper children being shipped to the textile mills, where conditions were disgraceful:

 "Their working day was often from sixteen to eighteen hours and some worked twenty-four hours per day, and accidents were frequent when the exhausted children had to continue working" (p. 31).

- "The conditions of the factory buildings were a hazard to health. Rooms were low, with narrow windows that were nearly always closed, to economise on space. The carding rooms had an atmosphere heavily laden with fluff, making it probable that eventually lung diseases would develop in the operative" (p. 32).
- "Those who survived the stresses and strains of the factory system were stunted, deformed and mutilated as well as ignorant and corrupt. They had received little education and little technical training, only sufficient to enable them to perform a routine process, and therefore unable to take up any other employment, which made them virtually factory slaves. Adult workers were not treated so badly as the apprentices and free children but in turn adults suffered from long hours, overcrowded mills, objectionable foremen and employers. The basic cause of the trouble was the uncontrolled power of the capitalist, whose responsibility was confined to the payment of wages for work done and nothing else" (p. 33).

of England, they, who are already not very fond of submitting to government, would soon think of putting in execution designs they had long harbourd [sic] in their breasts" (de Llosa, 1984, p. 8; original source unknown).

George Washington envisioned the potential of the domestic textile industry:

Many articles, in wool, flax, cotton, and hemp may be fabricated at home with great advantage. If the quantity should be encreased [sic] to tenfold its present amount (as it easily could be), I apprehend the whole might in a short time be manufactured especially by the introduction of machines for multiplying the effects of labour in diminishing the number of hands employed upon it. (*de Llosa, 1984, p. 8; original source unknown*)

In the early years after independence from England, the United States was buffeted by changes in the international economy, and the new nation groped to establish a secure economic independence. Textiles continued to be an important product area to the new country, and Thomas Jefferson noted in 1786 that homespun cotton produced by the four southernmost states was "as well manufactured as the calicoes of Europe" (de Llosa, 1984, p. 8; original source unknown).

During these same transition years, a Philadelphian, Tench Coxe, who was a delegate to the Continental Congress and later became Assistant Secretary of the U.S. Treasury, "emptied his pockets" to secure some of the English textile inventions such as the spinning jenny. In addition to securing new technology to develop the domestic industry, the new nation imposed measures to keep out products from other countries. In an ironic twist on earlier regulations imposed by England on the colonists, the first Congress in 1789 imposed its own tariff of 3 cents a pound to protect American cotton production, estimated at a million pounds annually.

In 1793, the United States had two milestone textile developments: (1) Whitney's cotton gin, which was tremendously important because now a machine could perform the tedious task of separating the cotton fibers from the seeds, which had been done by hand up to that point, and (2) Samuel Slater's cotton mill, the first successful cotton mill in America, which Slater had constructed from memory. Despite these advances, however, the new nation lagged behind England in the industrialization process in the early 1800s. British industry, and textiles in particular, had been developing new technology for decades. In the early 19th century, the United States adapted (or stole) technology developed in Britain and also began to develop its own inventions.

The War of 1812 exerted new demands on the fledgling U.S. textile industry to provide cloth and blankets for soldiers. In addition, **embargoes** on products from other countries added to the scarcity of textile goods. Leading what was perhaps the first formal textile **lobby**, Eleuthère Irénée DuPont led a committee to Congress to plead the case of 27 cotton manufacturers and

14 wool producers. DuPont's committee sought "the interference and protection of our own Government to nurse and foster their infant manufactories for a few years" because they found they were "incapable of entering upon the competition with even a hope of success" against "superior advantages, public and private capital, ill-founded prejudices of a part of their own fellow citizens, and a powerful foreign Government." The committee's appeal indicated the manufacturers' wishes that their efforts "would highly conduce to our national safety and independence, our Army and Navy clothes by our own industry" (de Llosa, 1984, p. 10; original source unknown). As we will see in later chapters, this argument for protecting the domestic industry for national security purposes has surfaced in more recent years.

The U.S. textile industry experienced impressive growth between 1812 and 1816, with 170 mills reported by the end of the war. Poulson (1981) notes that a major issue in studies of early American industrialization is the extent to which the growth of these industries can be attributed to protective tariffs. Poulson speculates that embargoes were more influential than tariffs in fostering industry growth. Although restrictions on foreign products aided the development of the industry, technology was also important. Adoption of the power loom contributed greatly to the success of the industry during this period. Although 170 textile mills existed by 1816, only 5 percent of all textile manufactures came from factories. Nevertheless, the early textile mills led the young country into the Industrial Revolution and indelibly altered the structure of manufacturing from that time on.

The Shift from Farms to Mill Towns

As it had in England earlier, textile production became an industrial enterprise that affected the development of the new country as a whole. Workers migrated from the farms, and small villages developed where the factories

BOX 2-2

EXPANSION OF A MILL TOWN

In the 1830s, Lowell, Massachusetts, home of the Merrimack Manufacturing Company (a large textile firm), experienced growth unmatched in America. As Dunwell (1978) noted:

The city bloomed more quickly than its most optimistic promoters could have imagined. Mills and boarding houses multiplied along the canals. Farmers' daughters poured into the city and took their places at the machines. This seemingly magical growth astonished all ob-

servers. John Greenleaf Whittier, who resided briefly in Lowell, called it "a city springing up, like the enchanted palaces of the Arabian tales, as it were in a single night—stretching far and wide its chaos of brick masonry and painted shingles" and he felt himself "thrust forward into a new century." Lowell seemed the prelude to a "millennium of steam engines and cotton mills" [Whittier, 1845, p. 9], and Whittier, though impressed, was troubled by the prospect [p. 40].

emerged. Young men and women attracted to the textile mills, shoe factories, and a few other budding industries were part of a mass social movement that in the early to middle decades of the 19th century transformed New England from a rural, agrarian society into an urban, industrial society. The textile industry's influence in restructuring the socioeconomic character of New England is but one example of the social implications of the industry and its evolution, both in the United States and in many areas of the world.

Employment of Women Outside the Home

In addition to leading the industrialization of production and the development of factories and mill towns, the textile industry contributed to another historic global industrial movement—the wide-scale employment of women outside the home.

After Samuel Slater built a spinning machine in the late 1700s, his factory was the first to be established in the United States. The first spinning mills were modeled after the English factory system, which employed whole families. Child labor was common, and many crit-

ics opposed this form of industrialism. Figure 2–3 shows a child employed in the mills.

Most early U.S. industry leaders wanted to avoid duplicating the horrors of the English factory system as they moved toward industrialization. A group led by Francis Cabot Lowell argued that it was possible to develop manufacturing without the accompanying human degradation typical of the factory system in England. The resulting Waltham system introduced the first modern factory in America, as well as a new labor system different from the English factory system. The textile factory established in Waltham, Massachusetts, on the Charles River, was a fully integrated mill (with spinning and weaving under one roof) in which, for the first time, all machinery was power driven.

Designers of the Waltham system deemed that *adult females* would be the production workers in factories built on this model, rather than whole families. This decision may have been partly due to the fact that the equipment at Waltham was too complicated to be operated by children. Moreover, if mills were to reduce the use of child labor, another source of low-cost labor was required (child laborers continued to be used in other jobs in the facto-

FIGURE 2-3

Although many critics opposed the use of child labor—adopted in the early days of the industry—the practice continued even into the early 1900s. Here children are seen working in a Georgia cotton mill in 1909. Source: Photo by Lewis W. Hine, courtesy of George Eastman House.

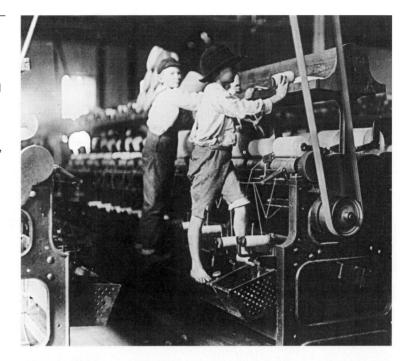

ries, however). Male leaders conceived the mills and the factory towns and directed the activities of workers. These same industry men "created a paternalistic system that employed and controlled the young women drawn into the mills from the surrounding countryside" (Dublin, 1981, p. 2). These young women came to be known as *factory girls* (a label still used in many areas in the late twentieth century).

Industrialists convinced rural families that their daughters would be provided a safe life of "culture" in the mill villages. This assurance was critical because of the need to overcome the vice-ridden reputation of the English factories. Mill owners built boarding houses and dormitories, and staffed them with matrons who supervised the young women's behavior and church attendance. In efforts to attract workers, mill towns were promoted as centers of moral and cultural development for young women.

The Waltham factory system flourished even more in Lowell, Massachusetts, than it

had in Waltham. Factories accompanied by dormitories spread throughout New England, and young women continued to leave the farms for the new alternative employment. Often the workers sent all or part of their meager earnings (in the late 1830s, about \$1.75 per week after they paid their board) home to their families. Typically the factory women arose at 4:30 in the morning and worked until 7:00 at night, with two half-hour meal breaks. Some factory visitors observed that the factory women seemed more victims than beneficiaries of their industrious labor (Lerner, 1969).

Early Stages of Industrial Reform

Eventually the production demands of mill owners exceeded the willingness of workers to respond. As a result, the textile industry experienced another new form of industrial change—worker revolt. The textile industry was once again the forerunner in the earliest

BOX 2-3

THE REALITY OF FACTORY LIFE

The factory girls found the conditions in the mills oppressive and quite unlike what they had expected from the promotional efforts that had lured them to the mill towns. This firsthand report denotes the hardship:

The time we are required to labor is altogether too long. It is more than our constitutions can bear. If any one doubts it, let them come into our mills of a summer's day, at four or five o'clock, in the afternoon, and see the drooping, weary persons moving about, as though their legs were hardly able to support their bodies. . . . I have been an overseer myself, and many times have I had girls faint in the morn-

ing, in consequence of the air being so impure in the mill. This is quite a common thing. Especially when girls have worked in the factory for considerable length of time. We commence as soon—and work as long as we can see almost the year round, and for nearly half the year we work by lamp light, at both ends of the day lighting up both morning and evening. And, besides this, from November till March our time is from twenty minutes to half an hour too slow. So you see instead of getting out of the factory at half past seven o'clock in the evening, it is really eight.

Source: "R" from Voice of Industry, March 26, 1847.

stages of a broad industrial reform that eventually spread to most other industrial sectors.

Female workers tolerated the long workdays because they were accustomed to dawnto-dusk schedules on the family farms before they entered the factories. However, owners of the newer factories refined their power systems in ways that permitted a steady increase in the pace of work required of women in the mills. As stockholders demanded greater profits, employers increased the workload of each mill hand. For example, the average number of spindles per worker increased by about 64 percent in the eight major textile firms in Lowell. In addition to increased production demands and, in some cases, longer workdays, wages were reduced twice during the early 1830s (Dunwell, 1978; Foner, 1977).

In acts of great courage, contrary to social conventions of the day, female factory workers rallied in protest against the excessive work demands, the pay cuts, and other grievances. In 1834 and 1836, the workers took to the streets and paraded in protest against their treatment. During this time, they formed the

Factory Girls' Association, which had 2,500 members by 1836. By 1845, the factory women became more militant and organized another early union of female factory workers, the Female Labor Reform Associations. A petition bearing over 2,000 signatures was presented to the Massachusetts legislature to shorten the length of the working day (Dunwell, 1978). By 1853, the workday was shortened to 11 hours. Thus, the courage of the female textile workers thrust the industry into another historic industrial movement—labor reform.

In addition to the significance of the Lowell protests in labor reform movements, the mill women's courageous efforts were of broader historical importance. The Lowell factory workers organized one of the first large-scale protest efforts of women to assert their rights. At the same time that other early feminist leaders were pressing for full citizenship for women, the mil-

¹According to Wertheimer (1977), the first women's union was not in the New England mills but rather in New York City. In 1824, the United Tailoresses formed their own union and demanded higher wages.

itant factory workers pressed for the justice due them. The mill women were outspoken about the excessive demands made on them in the factories—demands that permitted the mill owners to live in luxury. The factory women were aware of the need to organize to assert their right to justice, and in this role they also became pioneers in the movement for women's rights.

Shaping the Economic and Industrial Future

Although the textile industry assumed many roles of leadership in economic and industrial development both for the world and for the United States, not all of these developments generate a feeling of pride. However, few persons dispute the *significance* of this industry in shaping the economic and industrial future of the world and the nation. Technological changes in textile production led to a complete revolution of industry, and the transfer of the new industrial techniques from one country to another provided the groundwork for an international economy.

EARLY DEVELOPMENT OF THE APPAREL INDUSTRY

The U.S. apparel industry did not begin to develop, at least to a significant degree, for nearly a century after textile production was industrialized. The textile industry was instrumental, however, in fostering apparel production outside the home. First, the widespread availability of good-quality cloth encouraged improved garment making compared to the earlier crude, homemade clothing methods. Many persons aspired to better-quality, more attractive clothing. Second, the industrial movement led by textiles caused shifts to employment outside the home, from farms to mill towns—creating a more hectic lifestyle than

had been experienced before. Many persons became preoccupied with business and were ready for easily obtained clothing.

Tailors filled an important role in the transition from home-produced to mass-produced clothing. Adapting their custom tailoring approaches, tailors began to produce a selection of completed garments available for customers to consider. Later, the earliest known clothing "manufactory" was established in Philadelphia to produce uniforms for the War of 1812 (Kidwell & Christman, 1974). The sewing for this early "mass production" operation and those that followed was done by women in their homes, for which they were paid a piecework rate. All of the sewing was done by hand for most of this period.

The development of the sewing machine advanced garment production because manufacturers discovered the extent to which output could be increased. As demand for readymade clothing increased in the second half of the 1800s, the massive immigration of Europeans to the United States provided the necessary labor to run the growing industry. As in the textile industry, garment workers were treated poorly, often working in sweatshop conditions. Courageous workers eventually resisted the abuse and exploitation. Protests led to one of the earliest known collective bargaining efforts and, eventually, to the establishment of the International Ladies' Garment Workers' Union (ILGWU) in 1910. In addition to providing the groundwork for the type of collective bargaining common today, the ILGWU achieved a number of welfare and educational advancements on behalf of workers.

The apparel industry continued to grow, eventually passing the textile industry as a major U.S. industrial employer. Many of the characteristics of the early industry still describe the present-day sector: The industry requires a great deal of **labor**—that is, it is a **labor-intensive industry**; labor is a major cost in producing the end product, particularly compared to other industries; the industry is easy to enter, requiring

BOX 2-4

REGULATION OF TEXTILE TRADE UNDER MERCANTILISM—AN EXAMPLE

The British government went to great lengths to promote exports of *finished products* rather than *raw materials*. It was believed that keeping raw materials at home made them abundant and cheap for use in the production of finished goods, which were more profitable to export. The government enacted a number of measures to prohibit the export of raw materials and semifabricated goods. One of the most severe measures was in textiles, as Ellsworth and Leith (1984) related:

The English woolen textile industry, accounting in 1700 for half the country's exports, was thus favored; we find sheep, wool, woolen yarn, and

worsted, as well as fuller's earth (used in cleaning wool) all on the list of prohibited exports. Enforcement of the law was Draconian in its severity; for the first offense the transgressor was to have his left hand cut off; the second offense carried the death penalty. (p. 21)

In addition, strict measures applied to importing finished goods into England. Most products carried prohibitively high tariffs. Because of the importance of the textile industry, importing finished woolen and silk fabricated goods was prohibited, whereas incentives existed for imports of textile raw materials.

only limited capital and technical knowledge; the sewing machine is still the basic piece of equipment; this basic production equipment is fairly easily mastered; and the industry is quite fragmented—that is, it is composed of a large number of small manufacturing establishments. These characteristics also explain why the apparel industry is often the first entered today by many developing countries.

TRANSITIONAL YEARS FOR INTERNATIONAL TRADE

A brief review of the major changes in international trade will provide a helpful setting for understanding the global development of the textile industry and the changing environments in which textile/apparel **trade** took place. We shall consider briefly the period between the early development of the textile industry and the second half of the 20th century—in which the pace of global textile/apparel trade quickened.

The 17th and 18th Centuries

The Era of Mercantilism

Early developments in the textile industry took place during the 17th and 18th centuries in an era of mercantilism. This economic philosophy relied on the belief that a country's wealth was dependent upon its holdings of treasure, usually gold (by means of stockpiling). Exports were expected to exceed imports as a means of increasing wealth. This was an era of close regulation and control of foreign and domestic business as the colonial powers (particularly England, France, and Spain) attempted to monopolize trade by restricting manufacturing in the colonies. In fact, one grievance that led to the American Revolution was the British restriction on colonial manufacturing.

In this period, enterprising British business leaders successfully transferred industrial production techniques from textiles and iron to a broader range of industry. British capital, labor, and expertise were applied to provide these same production advances on the European continent.

The Emergence of Capitalism

As the middle class—which included merchants and manufacturers—became more numerous and more prosperous, mercantilism began to restrict business leaders' opportunities for economic expansion and growth. As the merchant/industrialist class became more powerful politically and economically, it successfully pressed for reducing the restrictions of mercantilism. Many of the capitalists wanted to broaden their markets, and the best way of doing that was through freer trade. The decline of mercantilism and the movement toward more economic freedom—and thus the emergence of capitalism—were reinforced by the thinking of Adam Smith.

Smith (1930, originally published in 1776) advocated a policy of laissez-faire, or a let-alone approach for the functioning of business. Smith believed that all benefited by the greatest possible freedom of enterprise and as few regulations as possible. The liberal political and economic thinking of Smith and some of his contemporaries was important in reducing the influence of mercantilism and in promoting individual thought and action. Smith's thinking provided the intellectual groundwork for specialization of production within nations. Smith, who has been called the "father of free trade," believed that the specialization and increased interdependence among nations would lead to greater benefits for all countries involved.

The 19th Century

Foreign Expansion

With the elimination of mercantilism during the 1800s, British and other European business leaders began investing in foreign countries. This international investment expanded the markets for lending countries' export industries and provided to the borrowing countries the capital for economic growth. Free of mercantilist restrictions, international trade grew rapidly. Rough estimates indicate that the value of i ternational trade doubled between 1830 and 1850. Then, in the next 30 years, the value of world trade increased by three or four times what it had been (Ellsworth & Leith, 1984). Foreign trade became a primary economic activity rather than an unimportant adjunct to domestic activity.

A Time of Important Changes in the United States

The 19th century brought tremendous economic change to the United States, and by the end of the century the young nation was the major industrial power in the world, dominating international markets. This was a boom period for the textile industry, as the New England textile mills developed and prospered. The U.S. cotton industry was a relatively minor industry at the beginning of the 19th century, but it emerged as the country's leading manufacturing industry prior to the Civil War. Poulson (1981) provides a number of possible explanations for the growth: (1) population growth, (2) westward expansion, (3) increased per capita income, (4) introduction of the power loom, (5) reduced transportation costs, and (6) of particular significance, import substitution. Poulson notes that between 1820 and 1830, domestic producers' contribution to the U.S. market went from 30 to 80 percent. Import substitution appeared to have been encouraged by the high tariffs levied on imported textiles in 1816, 1824, and 1828, thus providing protection to U.S. producers.

Migration of Labor

In focusing again on the international perspective for this era, migration of labor was another major development that accompanied the foreign investment mentioned earlier. Between 1820 and 1930, 62 million people (mostly from Europe) migrated; about three-fifths of these relocated in the United States (Ellsworth & Leith, 1984). Ellsworth and Leith noted that for the most part, both labor and capital moved from areas where they were abundant to areas where they were scarce and dear. In the second half of this period, immigrants became an important labor source in both the New England textile mills and later the garment factories in New York and other areas of the northeastern United States.

The Early 20th Century

Development of an International Economy

The period between the Napoleonic Wars and World War I (1814–1914) was particularly significant to the development of an international economy in a number of ways. Government regulation of trade was replaced by regulation by market forces. Specialization among nations developed, and as Ellsworth and Leith (1984) put it: "A large and constantly growing volume of international trade linked the various regions of the world into a smoothly functioning, integrated economy of global scope" (p. 281). A sense of international economic interdependence developed during this time. The volume of world trade grew more rapidly than world output, and this boom era provided an opportunity for a greater number of nations to participate in the gains from trade and, as a result, helped the newer entrants move toward economic growth. Also significant during this period was the development of an international monetary system based on the gold standard; this facilitated world trade and provided greater stability to this trade.

Economic Nationalism Builds

By the late 1800s and early 1900s, the positive spirit of global integration and economic inter-

dependence that had fostered international trade was suffering from the growing threat of **economic nationalism** from the major world powers. This was a period of "colony grabbing" in which most of the major powers, excluding the United States, extended their empires into foreign territories. Economic growth fostered the claiming of new lands as sources of raw materials. Economic growth required new sources of raw materials because traditional sources were inadequate.

Emergence of Protectionism

The emerging nationalism in the latter part of the 19th century provided at least a predisposition toward protecting markets from imports by imposing tariffs, quotas, or other restrictions (i.e., **protectionism**). Ellsworth and Leith (1984) noted that the United States was one of the first countries to disrupt the positive flow in international trade by imposing increased tariffs on foreign products. Other countries responded by imposing similar trade restrictions. Consequently, international trade was already greatly hampered, even before World War I, and the war itself further divided nations.

The economic environment of the early 20th century was quite different from that of the 19th century and, as a result, international trade declined. The two world wars and the Great Depression altered seriously the international cooperation and interdependence that had blossomed earlier. Nations imposed trade restrictions and **devalued** their **currencies** to bolster their trade positions. Nationalistic economic policies slowed both trade and migration of people. Devalued currencies buy less abroad and encourage consumption of domestically produced goods.

U.S. trade declined sharply during the Great Depression but grew rapidly after each world war. Industrial exports reflected the increasing importance of industry in the American economy. Overseas markets exerted a major influence on U.S. industrial growth in the

20th century in contrast to the importance of the domestic market in the 19th century.

The United States as a Leader in World Trade

The United States began to occupy an increasingly important position in world trade in the early 1900s. The young country had already passed Great Britain as the world's leading manufacturing power, and in this era became the major exporter and the principal international investor. Commenting on the United states's assumption of this dominant global position, Ellsworth and Leith (1984) emphasized the importance of this role: "As the world's outstanding manufacturing power, its largest creditor, and one of its two largest traders, the economic health and the economic policies of the United States were of the greatest significance to the suppliers, customers, and debtors of that world" (p. 461). This meant that economic changes in the United States "could easily disrupt economic life in most of the rest of the world" (p. 461). Similarly, the economic importance of the United States permitted the country to have a positive influence on other countries. In this role, the country's leadership also imposed serious responsibilities in its relationships with the rest of the world.

Poulson (1981) noted that in absolute terms international trade in the United States grew rapidly in the 20th century. In the years after World War II, the expansion of trade fueled a tremendous surge of economic growth and was the basis for the United States' global economic leadership between 1945 and 1960. As U.S. trade expanded, it closed the distance that separated the U.S. from other cultures—and competition.

The Mid-20th Century

Trade Became More Volatile

Although trade grew more rapidly as the U.S. economy matured, it also became more volatile.

Increased trade brought growing concerns about "protecting" domestic markets. Remembering the devastating effects of the Smoot-Hawley Tariff Act² of 1930, which had hampered world trade tremendously (and many believed it had triggered the Great Depression), government leaders looked for other solutions. Leaders in major trading countries initiated two efforts in the early years after the war, which had important stabilizing effects on the global trading climate:

• Establishment of the International Monetary Fund (IMF). In 1944, representatives of the Allied governments met in Bretton Woods, New Hampshire, and established the rules by which exchange rates between currencies would be determined. Up to that time, home governments had been able to manipulate to some extent the value of their currencies. A country could lower the value of its currency in relation to other currencies and slash the price of its exports. In doing so, its exports became more attractive to other countries; however, this created a bias in trade. The Bretton Woods conference established the gold-exchange standard (as opposed to the gold standard), which initiated a system of fixed exchange rates and ended the practice of manipulating currencies. Under this system, the dollar (which had replaced the British pound as the world's major currency) was convertible—for official monetary purposes—into gold at a fixed price.

² The Smoot-Hawley Tariff Act of 1930 enacted severe measures to restrict imports and stimulate domestic employment. Although more than 1,000 American economists signed a petition urging President Herbert Hoover to veto the bill and 36 countries threatened to retaliate, the president signed it into law. Under the Smoot-Hawley provisions, the average import duty in the United States was 59 percent by 1932, a record high. By 1932, 60 countries relaliated by imposing their own high tariffs. The Smoot-Hawley Act had a devastating effect on global trade, causing the worldwide economic depression to worsen. By 1932, U.S. imports were only 31 percent of the 1929 level; exports dropped even more dramatically (Salvatore, 1987).

• Establishment of the General Agreement on Tariffs and Trade (GATT). GATT was established in 1947 and became the second pillar of the postwar economy. Its goal was to promote unrestricted trade, particularly the reduction of tariffs. Although efforts to reduce tariffs had occurred earlier, GATT represented a comprehensive approach. A founding principle of GATT was its most favored nation provision, which meant that if a country gives a trade advantage to one country, it should give the same advantage to every other country with which it trades. This concept means that every country has an equal opportunity in trade with a particular country. (Textile trade has had provisions that permit countries to violate this principle. This controversial point will be discussed later in the book.)

44

GATT was a positive influence on international trade during an era in which trade expanded rapidly. As world trade grew, so did GATT membership. Originally established by 23 member countries, which were the major industrial powers, GATT was at times considered a "rich man's club" (because membership consisted of the more prosperous nations). However, about two-thirds of the members are developing countries—an important point to remember for later discussions on textile trade policies. In 1995, the World Trade Organization (WTO) replaced GATT; this will be discussed in Chapter 10.

The United States prospered in world trade during the first 25 years of GATT's existence. As one of the few major industrial economies not damaged by World War II, the United States was in an advantageous position to export. U.S. technological innovations during this era added to the strong exporting activity. As a result, the U.S. economy prospered.

The Late 20th Century

Development of Floating Exchange Rates

By the late 1950s, the dollars flowing out of the United States through loans, grants, military expenses, and private investment exceeded foreign demand for U.S. goods. By 1958, the U.S. dollars abroad exceeded the value of the nation's gold reserves. During the 1960s, government spending expanded even moreespecially to finance the Vietnam War and the social welfare programs promoting the Great Society. Unwilling to raise taxes to cover its high level of spending, the U.S. government began to print more dollars—a step that fostered inflation and encouraged foreign governments to obtain the gold available to them as part of the Bretton Woods plan. Half of the U.S. gold reserves were gone by 1969.

The large U.S. balance of payments deficits and the sharply reduced U.S. gold reserves caused widespread concern that the dollar would be devalued. This led to a speculative flow of funds to other currencies—especially the German mark, the Japanese yen, and the Swiss franc—which had a further destabilizing effect on the Bretton Woods fixed exchange rate system. This led to the demise of the Bretton Woods system of converting dollars into gold.

In 1971, President Richard Nixon ended the Bretton Woods system—a step that did, in fact, cause a devaluation of the dollar. By 1973, the prices of most currencies were *floating*—like the prices of commodities such as sugar or coffee, with their value going up or down according to supply and demand. Although the devaluation of the dollar fostered trade (goods were less expensive) and the trade balance improved for a time, global markets became far less stable than they had been under the Bretton Woods system. The resulting *floating exchange rate* system introduced an element of unpredictability into foreign trade. Trading na-

tions had to accept the fact that favorable or unfavorable shifts in exchange rates would affect conditions of trade.

Growing Difficulties in Textile Trade

In the 1970s, as total U.S. imports increased significantly, the textile/apparel sectors felt keenly the impact of imports. Although a great deal of the growth in total imports (particularly in discussions that consider the value of imports) was accounted for by increased prices for petroleum products, the 1970s was the decade of highest growth up to that time for textile imports. Poulson (1981) noted that at the time of his writing, most of the acceleration in trade involved prices rather than quantities of traded goods, particularly for imports. Although the prices of petroleum products greatly influenced these calculations, the same observation holds for textile products. (In fact, this is a controversial point in calculating the extent to which textile imports have penetrated U.S. markets. At issue is whether to report import growth in prices or quantities; the extent of apparent import growth varies according to the measure used.)

DEVELOPMENT OF TEXTILES AND APPAREL AS DIFFICULT AND SENSITIVE SECTORS IN THE GLOBAL ECONOMY

By the 1960s, both the textile and apparel industries in most industrialized countries felt the impact of increased imports from the low-wage developing countries. Although the relative economic well-being of apparel and textiles as separate industry segments in the developed countries varies from one time to another, the two segments have experienced many similar problems in maintaining inter-

national competitiveness in the last two decades.

Problems experienced by the U.S. textile and apparel sectors in this era began to receive special attention because of certain characteristics of the industries, particularly the large numbers of persons employed. We should keep in mind, however, that the textile and apparel industries in most of the other developed countries were encountering similar difficulties, as were several other mature industries (e.g., iron and steel, shipbuilding, shoes).

A Leader in Trade Problems

Although other sectors had similar difficulties, in some ways the problems of the textile and apparel industries may have been more acute. Many economists have debated the claim, however, that the problems associated with textile and apparel trade are unique. Nevertheless, problems related to international competitiveness of the developed countries' textile and apparel industries have been forerunners of similar problems in other sectors. In this sense, these sectors were once again in a leading position in a major international and national industrial (and trade) dilemma—a role they would not have chosen to occupy. (Similarly, as we shall learn later in the book, these sectors have been leaders in securing policy measures in an attempt to protect domestic markets.)

Changes in the U.S. Textile and Apparel Industries

Job losses in the *textile* industry have been common in all developed countries, particularly since 1973, when a recession severely affected this and many other industries. Employment in this segment of U.S. industry has declined since World War II, when it boasted a peak employment of 1.3 million workers in 1945. In 1996, the U.S. textile segment employed around 698,000

persons³ (U.S. Department of Commerce, *U.S. Industrial Outlook*, various years). Despite employment declines, textile *production* increased during this period.

Although the size of the U.S. apparel workforce increased in the 1950s to a peak of 1.4 million persons, it declined to approximately 823,000 persons in 1996. The number of apparel establishments declined substantially—losing, for example, nearly one per day between 1970 and 1976.

The Impact of Imports

The surge of textile and apparel imports into U.S. and other developed-country markets was surely disruptive. No market can absorb massive quantities of imports in a particular sector without affecting severely the domestic producers in that sector. The textile/apparel sectors in the industrialized countries were unable to offset the influx of imports with a comparable increase in exports, although some segments of the sectors were at times quite competitive in exporting. Thus, the trade imbalances were often seen as responsible for the unemployment, decline in establishments, and drop in earnings experienced by both sectors at times in recent decades. The growth of imports cannot be blamed as the sole reason for the problems that occurred in these industries, however; many of these problems would have happened without imports. Significant increases in imports no doubt aggravated and accelerated many problems. At the same time, imports may have encouraged improvements in the domestic industries as manufacturers attempted to remain competitive.

Changes in the Global Market

The increasing competition in world textile and apparel markets cannot be minimized. In any sector of global trade, a dramatic increase in the number of producers for the market will intensify competition. In the case of the textile and apparel sectors, many newly developing countries began producing for the same world markets that had many fewer producers only a short time earlier. The combination of rebuilding textile sectors in the developed countries after World War II and the entry of many producing nations accounted for a sevenfold increase in international textile trade between 1945 and 1975 (Ford, 1986). And, to complicate the problem further, the world market grew modestly during these latter years when many new producer nations entered the picture. Figures 2-4 and 2-5 illustrate the change; the number of producer nations is, of course, symbolic to make the point rather than representing actual numbers. Of the approximately 200 nations in the world, virtually all produce textile and apparel products—and most of them produce at least some products for world markets.

As a result, global competition in textiles and apparel has made these difficult and sensitive sectors. Because of the significant role the sectors play as major employers in both the developed and developing countries, many issues related to international production and trade of textile and apparel products have become political in nature, often taking on seemingly disproportionate importance in broader relationships among nations. Because of these sensitive aspects of textile and apparel trade, the institutional arrangements (agencies, trade policies, and other special treatment) that exist to handle problems in the sectors are unique and elaborate compared to most other sectors. Later sections of the book will cover the special international and U.S. provisions that exist to resolve the complexities of global textile and apparel trade.

³ This employment figure includes both the textile mill products segment and the manufactured fiber segment of the industry.

FIGURE 2-4

Even as recently as the 1960s, the number of countries producing textile and apparel goods for the world market was relatively limited.

TEXTILE- AND APPAREL-PRODUCING COUNTRIES (a limited number)

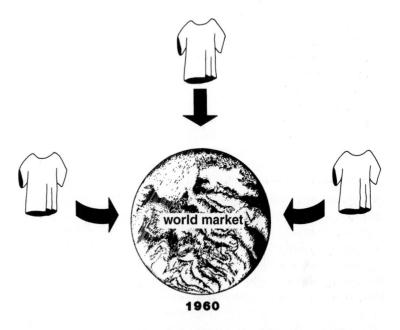

FIGURE 2-5

In recent years, the number of nations exporting to world markets has expanded greatly, leading to a global overcapacity for production.

TEXTILE- AND APPAREL-PRODUCING COUNTRIES

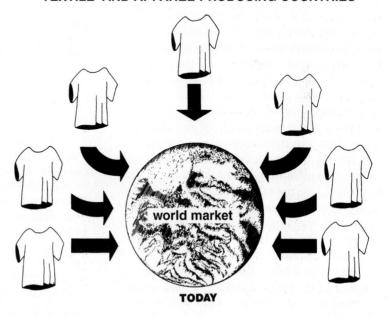

SUMMARY

As a leader in the Industrial Revolution, first in England and later in the United States and other parts of Europe, the textile industry played a key role in major industrial movements. In both Europe and the United States, the economic and social changes effected by the textile industry shaped the nations in a broad sense. Examples of ways in which the industry was a leader included the launching of the Industrial Revolution through the use of machine rather than hand labor, the development of the first factories, the impetus for the establishment of the earliest mill towns, widespread employment of women outside the home, and industrial reform resulting from worker abuse. Other industries followed many of these early developments in the textile sector. Similarly, many additional countries imitated England, other parts of Europe, and the United States in using the textile sector as the first industry through which to pursue economic development.

Shifts in the economy and the trade climate from one period to another influenced significantly the development of a global textile complex. Capitalism and more liberal political and economic thinking replaced the mercantilism of the 17th and 18th centuries, leading to expanded trade. The period between the Napoleonic Wars and World War I (1814–1914) was particularly significant for the development of an international economy. Specialization among nations developed; market forces rather than governments regulated trade; and a sense of international economic interdependence developed during this era. By the late 1800s and early 1900s, economic nationalism emerged, however, bringing with it measures to protect markets from imports. The United States became a major force in world trade but was one of the first nations to increase tariffs. International trade became more volatile than it had been earlier, and shortly after World War

II, measures were taken to provide greater cooperation and stability. These included the establishment of the International Monetary Fund (IMF) and the General Agreement on Tariffs and Trade (GATT). By 1971, however, the Bretton Woods gold exchange standard was replaced by the floating exchange rate system.

Expansion of international trade in much of the 20th century bridged the gaps between continents and countries, creating the global textile and apparel markets that exist today. As growing numbers of developing countries started textile and apparel production and looked to exports for their growth, the industries in the United States and most other developed countries felt the impact of the growing competition. As a result of intense international competition, the textile and apparel industries became forerunners of similar trade problems in other sectors.

GLOSSARY

Capital is a factor of production that includes all aids produced to further production; in addition to monetary resources, capital includes physical inputs, such as buildings and machinery, used in the production process.

Capitalism is an economic system in which investment in and ownership of the means of production, distribution, and exchange of wealth are made and maintained chiefly by private individuals or corporations rather than by government.

Capitalists are individuals who have capital, often extensive capital, to invest in businesses.

Devaluation of currency refers to the deliberate reduction of the value of a country's currency in relation to those of other countries. The lower value of the currency means that products from other countries are more expensive in home markets, thus encouraging the use of domestic products over imports. Moreover, this practice makes the home country's exports more attractive in other countries.

Economic nationalism refers to the tendency of countries to focus only on their own economic interests.

Embargo is a prohibition on exports or imports.

Exports are goods and services sold to other countries. Floating exchange rates are prices of one currency in terms of another currency in a system that permits the value of currencies to fluctuate with supply and demand.

Free trade is international trade that is not restricted by government measures aimed at protecting domestic industries.

Gold-exchange standard established a system of fixed exchange rates; under this system, the dollar could be converted (for official purposes) to gold at a fixed price. This system was used from 1944 to 1971.

Gold standard was the international monetary system used from about 1880 to 1914; gold was the international reserve.

Imports are goods and services purchased from other countries.

Import substitution refers to the substitution of domestic products for previously imported goods.

Industrial Revolution is the name for the complex social and economic changes resulting from the mechanization of production processes, which began in England in the mid-1700s.

Industrialized countries are those countries whose economies are heavily dependent on mechanized industry. This term is often used synonymously with the term developed countries. In general, the industrialized countries are the more prosperous countries of the world.

International monetary system consists of the rules, customs, instruments, facilities, and organizations for effecting international payments (Salvatore, 1987).

Labor is the term for the services provided by all types and skills of workers.

Labor-intensive industry is one in which a high labor-to-capital ratio exists; that is, a great deal of labor (relative to capital) is required for production. In addition, a high ratio of production workers to all workers is typical. Grunwald and Flamm (1985) note that a labor-intensive industry is defined as one in which the proportion of unskilled labor is 160 percent or more of the fraction of unskilled employed in all industries. Labor-intensive goods are those made under the conditions of a high ratio of labor to capital.

Lobby is a group of persons who conduct a campaign to influence the voting of legislators.

Mercantilism is the belief that a country's wealth depends upon its holdings of treasure, usually gold. Under this economic philosophy, exports should exceed imports as a means of increasing wealth.

Protection (or protectionism) is a term for measures taken to "protect" domestic markets from imports. Protection may include tariffs, quotas, trade policies, and numerous other measures.

Protective tariffs are those tariffs imposed on imported goods primarily to discourage shipment of the products to a country trying to protect its domestic market.

Tariff (also known as a duty) is a tax on imported goods.

Trade refers to the voluntary exchange of goods and services between two or more countries.

SUGGESTED READINGS

Addy, J. (1976). The textile revolution. London: Longman.

This study of the English textile industry traces the evolution of the industry and its impact on economic development and trade.

Crawford, M. (1959). The textile industry. In J. G. Glover & R. L. Lagai (Eds.), *The development of American industries*. New York: Simmons Boardman.

A review of the early development of the U.S. textile sector.

Ellsworth, P. T., & Leith, J. C. (1984). *The international economy*. New York: Macmillan.

A historical review of international economic developments and theories.

Foner, P. (Ed.). (1977). *The factory girls*. Urbana: University of Illinois Press.

A collection of writings on life and struggle in the New England textile mills.

Harte, N. B., & Ponting, K. G. (1973). Textile history and economic history. Manchester, UK: Manchester University Press.

This book discusses the important role of textiles in economic history.

- Jeremy, D. (1981). Transatlantic industrial revolution: The diffusion of textile technologies between Britain and America, 1790–1830s. Cambridge, MA: MIT Press. A study of the westward diffusion of early industrial textile technology and its role in economic development.
- Kidwell, C., & Christman, M. (1974). Suiting everyone: The democratization of clothing in America. Washington, DC: Smithsonian Institution Press. A review of the development of mass-produced apparel in the United States and the role of that clothing in the "democratization of America."
- Mantoux, P. (1927). The Industrial Revolution in the eighteenth century. New York: Harcourt Brace Jovanovich.
 - This book provides a useful account of the role inventions played in the Industrial Revolution. Important early textile developments are discussed.

- Poulson, B. W. (1981). Economic history of the United States. New York: Macmillan.
 - This book traces changes in economic, social, and political institutions and how these changes influenced American economic development.
- Stein, L. (Ed.). (1977). Out of the sweatshop. New York: Quadrangle.
 - This book of readings on the early days of the U.S. garment industry focuses particularly on labor concerns.
- Tucker, B. (1984). Samuel Slater and the origins of the American textile industry, 1790–1860. Ithaca, NY: Cornell University Press.
 - A study of Slater's introduction of the British textile manufacturing system in America and the impact of this system on industrial development.

3 The Setting—An Overview

Although new communication technologies and a global economy have brought the peoples of the world together in new ways, we still exist in a world of vast differences in the way we live our lives and conduct business affairs. Participating in a global economy requires an appreciation for the differences we find in the international setting. Moreover, our global citizenship requires that we keep in mind that we are part of a much larger picture and that there are many right ways of functioning. In short, we must be sensitive to the differences in our worldwide environment, in the broadest sense of the word, to function effectively in it. The main goal of this chapter is to focus on various aspects of the international setting that influence textile and apparel production, trade, and consumption.

A crucial aspect of studying textiles and apparel in the international economy will be to review the geographic shifts in production around the world and the resulting trade shifts fostered by this trend. As we study these shifts, we will be making repeated references to various country groupings. Thus, an overview of the major regions and countries provides a common language for further discussions.

A review of country groupings will be followed by a brief overview of economic systems, political systems, and cultural environments that affect the climate for global textile and apparel production and trade. Special attention will be given to the division between the more-developed countries and the less-developed countries.

Staying informed about the international setting has become increasingly difficult in recent years. Geographic and political boundaries have been dramatically altered as old alliances have dissolved and new ones have emerged. For example, the former Soviet Union became 15 different countries; East and West Germany became one; and Yugoslavia splintered into many war-torn states. Names of states and major cities changed, and sometimes factions have been unable to agree on the names or the spelling of the names for the areas. World map publishers have not struggled this hard to stay current since 1960, when 17 African nations asserted their independence and adopted new names. Nevertheless, all of us who wish to influence our fate in today's interdependent world must strive to comprehend the social, economic, and political dimensions of our global community.

52

FIGURE 3-1

Although we have increasingly close ties with our global neighbors, countries and regions have many unique distinctions that set them apart.

Source: Illustration by Dennis Murphy.

COUNTRY GROUPINGS

Country groupings used in industry or trade discussions are often based on levels of **development** or **economic development**. Most of the distinctions made among countries in the various groupings relate to differences in average incomes. A term often used to express relative wealth (or, for many countries, the lack of wealth) is **gross national product** (GNP)¹ or **per capita gross national product**. Additionally, however, the groupings have different economic and political frameworks, varying levels of economic development, and many other divergent socioeconomic conditions.

International agencies, scholars, and others concerned with international activities use a variety of groupings and terms to classify and describe countries. Since these various categorization systems and terms appear in the literature and often are used interchangeably, two sets of terminology are identified here.

The first set of country groupings are those that are used most often in this book and that correspond closely to those of the United Nations. These groupings are as follows:

• *Developed countries*² (also known as the *more-developed* or *industrialized countries*) are those that have achieved a high level of

¹ Some sources use gross national product (GNP) as a measure of national productivity or output; others use **gross domestic product (GDP).** See the glossary for distinctions between these two terms.

² The World Bank classifies countries on the basis of per capita GNP into the following categories: high-income, middle-income, and low-income economies. The low-income and some of the middle-income countries are combined by some organizations that use the term *developing countries*.

- physical and material well-being. This category includes Western Europe, some countries in Eastern Europe, the United States, Canada, Japan, Australia, New Zealand, and South Africa. The largest flow of trade occurs among these countries, although these nations account for less than one-fifth of the world's population.
- Centrally planned economy countries are those that are governed by single-party communist regimes. As a result of the move away from communism to market economies in the former Soviet Union and Eastern Europe (now known as the transition economies), the number of these countries has decreased dramatically in recent years. Remaining countries include China, North Korea, Vietnam, and Cuba.
- Developing countries³ are those in which the population as a whole has a lower level of physical and material well-being than exists in the developed countries. This category includes other countries not in the above groupings—particularly in Latin America, Asia, and Africa (with the exception of oilrich exporting nations). Most of the Eastern European countries are in a transitional or developing stage rather than at the level of developed countries. Although rapidly progressing in development, Hong Kong,⁴ Taiwan, South Korea, and Singapore⁴ are often included in this grouping. Overall, the developing countries account for a large pro-

portion of the world's population but a small amount of its wealth.

• Newly industrialized countries (NICs) (also known as the newly industrialized economies [NIEs]) are frequently included with developing countries rather than identified as a separate category; however, the rapid development and rising levels of material well-being in these countries distinguish this group from other developing countries. In fact, when this small group of NICs is included in the developing country grouping, this upper tier represents a concentration of the greatest industrial and social progress in the group. These nations may still resemble developing countries in some ways (e.g., the advances may not be dispersed broadly among the population), but most have a significant degree of industrialization as well as fast-growing economies. Many of the NICs export a substantial volume of manufactured goods. Major NICs include Hong Kong, South Korea, Taiwan, Singapore, Malaysia, and Brazil; the first three are among the most important NICs in the global textile and apparel sectors. (Some classifications place South Africa in the NIC category rather than in the developed country grouping.)

The other common system for classifying countries to distinguish between levels of development is as follows:

- First-world countries are the free, well-off industrial market economies, which may also be known as the developed or industrialized countries.
- Second-world countries are those moderately well-off nations making the transition from centrally controlled economies to market economies. The United Nations refers to these as transition economies. They include the Baltic states and the Commonwealth of Independent States (CIS) from the former Soviet Union, plus the Eastern European countries.

³ At times, the World Bank and other international organizations group together the low-income and middle-income economies into this one group.

⁴ Singapore (and previously Hong Kong) is a city-state rather than a country; however, rather than drawing this distinction each time, I will include it in references to countries. Hong Kong was a British colony but was returned to China in 1997. It will be discussed as a separate economy because the Chinese government has promised separate systems for 50 years. Further, Hong Kong has been such a significant participant in the global textile and apparel industries that the distinction is still very important. In this book we shall use the term *country* as the United Nations does to refer also, as appropriate, to territories or areas (United Nations, 1990).

TABLE 3-1 GNP per Capital and Life Expectancy Among Countries with a Population of Over 1 Million

	GNP per Capita Dollars 1995	Life Expectancy at Birth (years) 1995		GNP per Capita Dollars 1995	Life Expectancy at Birth (years) 1995	
Low-Income			41 Senegal	600	50	
Economies	430 w ^a	63 w	42 China	620	69	
Excluding China		43 Cameroon		650	57	
and India	290 w	56 w	44 Côte d'Ivoire	660	55	
1 Mozambique	80	47	45 Albania	670	73	
2 Ethiopia	100	49	46 Congo	680	51	
3 Tanzania ^b	120	51	47 Kyrgyz Republic ^c	700	68	
4 Burundi	160	49	48 Sri Lanka	700	72	
5 Malawi	170	43	49 Armenia ^c	730	71	
6 Chad	180	48				
7 Rwanda	180	46	Middle-Income			
-8 Sierra Leone 180		40	Economies	2,390 w	68 w	
9 Nepal	200	55	Lower-Middle			
10 Niger	220	47	Income	1,670 w	67 w	
11 Burkina Faso	230	49				
12 Madagascar	230	52	50 Lesotho	770	61	
13 Bangladesh	240	58	51 Egypt, Arab Rep.	790	63	
14 Uganda	240	42	52 Bolivia	800	60	
15 Vietnam	240	68	53 Macedonia, FYR	860	73	
16 Guinea-Bissau	250	38	54 Moldova ^c	920	69	
17 Haiti	250	57	55 Uzbekistan ^c	970	70	
18 Mali	250	50	56 Indonesia	980	64	
19 Nigeria	260	53	57 Philippines	1,050	66	
20 Yemen, Rep.	260	53	58 Morocco	1,110	65	
21 Cambodia	270	53	59 Syrian Arab	4.400		
22 Kenya	280	58	Republic	1,120	68	
23 Mongolia	310	65	60 Papua New			
24 Togo	310	56	Guinea	1,160	57	
25 Gambia, The	320	46	61 Bulgaria	1,330	71	
26 Central African	020	40	62 Kazakstan ^c	1,330	69	
Republic	340	48	63 Guatemala	1,340	66	
27 India	340	62	64 Ecuador	1,390	69	
28 Lao PDR	350	52	65 Dominican			
29 Benin	370	50	Republic	1,460	71	
30 Nicaragua	380	68	66 Romania	1,480	70	
31 Ghana	390	59	67 Jamaica	1,510	74	
32 Zambia	400	46	68 Jordan	1,510	70	
33 Angola	410	12	69 Algeria	1,600	70	
34 Georgia ^c	440	47 73	70 El Salvador	1,610	67	
35 Pakistan	460	60	71 Ukraine ^c	1,630	69	
36 Mauritania	460	51	72 Paraguay	1,690	68	
37 Azerbaijan	480	70	73 Tunisia	1,820	69	
38 Zimbabwe	540	70 57	74 Lithuania ^c	1,900	69	
39 Guinea	550	44	75 Colombia	1,910	70	
40 Honduras	600	67	76 Namibia	2,000	59	

w = weighted averages.
 In all tables GDP and GNP data cover mainland Tanzania only.
 Estimates for economies of the former Soviet Union are preliminary and kept under review.

TABLE 3-1 (CONTINUED) GNP per Capita and Life Expectancy Among Countries with a Population of Over 1 Million

		Life			Life	
	GNP per	Expectancy		GNP per	Expectancy	
	Capita -	at Birth		Capita	at Birth	
	Dollars	(years)		Dollars	(years)	
	1995	1995		1995	1995	
77 Belarus ^c	2,070	70	East Asia and Pacific	800 w	68 w	
78 Russian	0.040	65	South Asia	350 w	61 w	
Federation	2,240	69	Europe and			
79 Latvia ^c	2,270		Central Asia	2,220 w	68 w	
80 Peru	2,310	66		2,220 W	00 11	
81 Costa Rica	2,610	77	Middle East and			
82 Lebanon	2,660	68	North Africa	1,780 w	66 w	
83 Thailand	2,740	69	Latin America and			
84 Panama	2,750	73	Caribbean	3,320 w	69 w	
85 Turkey	2,780	67		0,020 11	00 11	
86 Poland	2,790	70	High-Income			
87 Estonia ^c	2,860	70	Economies	24,930 w	77 w	
88 Slovak			108 Korea, Rep.	9,700	72	
Republic	2,950	72	109 Portugal	9,740	75	
89 Botswana	3,020	68	110 Spain	13,580	77	
90 Venezuela	3,020	- 71	111 New Zealand	14,340	76	
			112 Ireland	14,710	77	
Upper-Middle-			113 †Israel	15,920	77	
Income	4,260 w	69 w	•		77 76	
91 South Africa	3,160	64	114 †Kuwait	17,390	70	
92 Croatia	3.250	74	115 †United Arab	17 400	75	
93 Mexico	3,320	72	Emirates	17,400		
94 Mauritius	3,380	71	116 United Kingdom	18,700	77	
95 Gabon	3,490	55	117 Australia	18,720	77	
		67	118 Italy	19,020	78	
96 Brazil	3,640	07	119 Canada	19,380	78	
97 Trinidad and	0.770	70	120 Finland	20,580	76	
Tobago	3,770	72	121 †Hong Kong	22,990	79	
98 Czech Republic	3,870	73	122 Sweden	23,750	79	
99 Malaysia	3,890	71	123 Netherlands	24,000	78	
100 Hungary	4,120	70	124 Belgium	24,710	77	
101 Chile	4,160	72	125 France	24,990	78	
102 Oman	4,820	70	126 †Singapore	26,730	76	
103 Uruguay	5,170	73	127 Austria	26,890	77	
104 Saudi Arabia	7,040	70	128 United States	26,980	77	
105 Argentina	8,030	73	129 Germany	27,510	76	
106 Slovenia	8,200	74	130 Denmark	29,890	75	
107 Greece	8,210	78	131 Norway	31,250	78	
			132 Japan	39,640	80	
Low- and Middle-			133 Switzerland	40,630	78	
Income	1,090 w	65 w	. CO OTTLECTION	. 0,000		
Sub-Saharan Africa	490 w	52 w	World	4,880 w	67 w	

[†] Economies classified by the United Nations or otherwise regarded by their authorities as developing.

a w = weighted averages.

b In all tables GDP and GNP data cover mainland Tanzania only.

^c Estimates for economies of the former Soviet Union are preliminary and kept under review.

^{*} For years or periods other than those specified.

Source: World Bank. (1977). World Development Report 1997. Washington, D.C.: Author.

FIGURE 3-2

The world: GNP per capita, 1995.

Source: World Bank. (1997). 1997 World Bank Atlas 1997, (p. 30); reprinted courtesy of the World Bank.

FIGURE 3–2 Continued

- Third-World countries are the poorer countries of the world. These are also commonly known as the less-developed countries (LDCs) or the developing countries in the categories previously listed (Thompson, 1978). These are generally disadvantaged, have-not nations.
- Fourth-world countries is a label sometimes applied to the poorest countries in the world. These are the most underdeveloped of all nations. This designation is not very common; usually, all the developing countries are considered in the Third-World classification.

World Bank Categories

The World Bank (the International Bank for Reconstruction and Development), an organization originally established to make loans for post-World War II reconstruction, exists primarily to make long-term loans to the less-developed countries. The World Bank collects extensive data on the economic status and other demographic characteristics of nations. Table 3-1 (pp. 54-55) displays the broad range of GNP per capita among countries with a population of over 1 million. In many cases, the middle-income economies differ from the low-income economies because they are oil exporters or because they export a substantial volume of manufactured products. Life expectancy is shown as a measure of the general level of living and well-being within countries. Figure 3-2 (pp. 56-57) gives a global view of GNP per capita among countries. (This map will also serve as a reference as the reader uses the book.)

This table and map show that much of the world is made up of developing or less-developed countries. More than half of the world's population lives in countries where the annual per capita GNP is only about \$600.

Despite the well-being many individuals in more-developed nations have experienced as a result of technological revolutions of the 20th century, more than 1 billion people (onefifth of the world's population) live on less than 1 dollar a day—a standard of living that Western Europe and the United States attained 200 years ago (World Bank, 1995, p. 1). The number of people living below the poverty line increased 40 percent over a 20year time span. Although urban poverty is growing in the developing countries, the rural poor still account for over 80 percent of the poor people, according to the United Nations, (United Nations NGLS, 1992). Furthermore, the per capita GNP for the more-developed and less-developed countries of the world reflects a growing gap between the two groups.

Although the United Nations (World Economic and Social Survey, 1996) reports economic growth in many developing countries, for many countries per capita GDP growth has been slight and in most regions remains below what it was in real terms in 1980. Sadly, gains by the more-developed nations and the upper tier of developing countries are not shared by their poorer brethren.

Almost all the low-income countries are located in Asia and Africa. The middle-income countries are more dispersed. The Latin American countries are for the most part in the middle-income grouping.

Whatever grouping or term is used, the developing countries as a rule face many serious problems related to health and other basic human needs (as shown in Table 3–1 by the lower life expectancy in those countries), such as lack of education, internal political strife, growing debt, difficulty in participating competitively in global trade, and a population growth that exceeds available resources.

As developing countries attempt to strengthen their economies, many shift from the export of primary products (such as food, agricultural products, and minerals) to the export of manufactures. A large proportion of these countries tie their hopes for economic development and improved quality of life to textile and apparel production as one of their first industries.

Relevance to Textiles and Apparel

An understanding of the types of countries that constitute each of these categories is important to a global study of textile and apparel production and trade. Characteristics of different countries account for shifts in production and trade for these sectors. In recent years, the difficulties in textile trade have often reflected the dichotomy between the developed and the developing nations. Moreover, the political dimensions of textile trade problems have *inten-*

sified the division between the richer and poorer nations. The textile and apparel sectors represent a particularly critical area of trade because they account for about one-third of the manufactured exports of the developing countries. In some cases, textile products constitute more than one-half of the exports; for many, the industry is the primary export sector.

As we will discuss in more detail later, because of the unique role that the textile and apparel sectors play in the economies of both developed and developing countries, many of the issues surrounding textile trade have significant social and political repercussions.

REGIONS OF SPECIAL SIGNIFICANCE IN TEXTILE AND APPAREL PRODUCTION AND TRADE

Although a good case could be made for giving special attention to many specific countries or regions, space does not permit. Selected regions are shown in the following maps to aid in following frequent references to these areas. These are areas of particular significance at present in textile and apparel production and trade. Additional information on the textile and apparel industries in these regions is provided in Chapter 7.

TABLE 3-2 Levels of Regional Cooperation or Integration

In recent years, we have seen increased examples of cooperation and integration among countries that are largely market-generated and market-determined. Economic integration, the removal of economic barriers between or among nations, characterizes a number of these regions. In general, economic integration facilitates trade and resource flows: resources flow to efficient producers, and economies of scale often occur as markets grow. The major forms of economic integration are: free trade area (FTA), customs union, common market, economic (and monetary) union, and complete integration, which would encompass a political union. Table 3-2 provides a summary of these arrangements and what each level entails. Note that these range from the free trade area, which is least integrated, to the economic/monetary and political unions, which are extensively integrated.

Western Europe

Western Europe is home to some of the world's most productive and prosperous people, who inhabit only 3 percent of the earth's total land surface. Western Europe is composed of diverse countries with distinctive histories, languages, and traditions—and pride in these national heritages. Compared to some regions of

Characteristic of Cooperation	Free Trade Area	Customs Union	Common Market	Economic and Monetary Union	Political Union
Elimination of internal duties Establishment of common barriers	Yes No	Yes Yes	Yes Yes	Yes Yes	Probably Probably
Removal of restrictions on factors of production	No	No	Yes	Yes	Probably
Harmonization of national economic policies Harmonization of national political policies	No	No	No	Yes	Probably
	No	No	No	No	Yes

Source: Onkvisit, S., & Shaw, J. (1997). International marketing: Analysis and strategy (3rd ed., p. 65). Upper Saddle River, NJ: Prentice Hall. Reprinted courtesy of Prentice Hall.

the world, the Western European nations share many characteristics: healthy, well-fed populations, birth and death rates far below world averages, incomes far above the world average, predominantly urban populations, industrially oriented economies, and market-oriented agriculture sectors. Although three countries (Spain, Portugal, and Greece) are not as advanced in economic development as some other parts of Western Europe, they are members of the European Union. The Western European culture, although not as old as some others, has profoundly shaped the world as we now know it. Today, many other parts of the world accept and aspire to the European way of life (De Vorsey, 1995).

The following country groupings, with relevance for trade, exist in Western Europe.

The European Union

60

The European Union (EU) consists of 15 Western European countries, but this entity has changed in size from its original group and has become increasingly integrated on a number of common matters. The original six member states formed a customs union when the group was established in 1952, later becoming the European Common Market. The intent was to eliminate barriers and discrimination in trade among the members and to harmonize the trade policies of the member states with those of the rest of the world. Later, membership grew and member countries began to cooperate on a broad range of issues. As member states expanded their common agenda beyond trade matters, they became known as the European Economic Community (EEC), the European Community (EC), and more recently the European Union (EU). The most recent stages resulted in a single internal market with freedom of movement for goods, services, people, and capital.

These European member nations moved toward increasingly integrated plans for cooperation. The EU began as a customs union, later became a common market, now embodies economic integration, and will become an economic and monetary union in 1999. Increasingly, the EU might be thought of as "the United States of Europe."

The EU is a group of 15 West European nations that have joined together for cooperation on a variety of economic, social, environmental, and other issues. The unified market permits these nations to function more as one coordinated unit in world trade and gives the EU a more favorable competitive position in its dealings with the United States and Asian trading blocs in particular.

Readers should be familiar with the composition of the EU. Many parallels in the history and status of the textile and apparel sectors bind the EU and the United States into common positions on many textile and apparel trade matters. The EU includes the following member states, as shown in Figure 3–3: Austria, Belgium, Denmark, Finland, France, Germany, Great Britain, Greece, Ireland, Italy, Luxembourg, the Netherlands, Portugal, Spain, and Sweden. A number of other European countries aspire to join the EU. In the year 2000, membership is anticipated for the Czech Republic, Slovakia, Slovenia, Hungary, and Poland. Other nations may be permitted to join later. See Figure 3–3.

In most matters, member countries still govern themselves independently of each other and retain national identities. Increasingly, matters are decided at the EU level in Brussels, and the EU makes policies and laws that apply in all of its member countries.

The unified EU is one of the world's largest markets, with 350 million consumers. In addition, the elimination of trade barriers among member countries is having a significant impact on traditional methods of producing, marketing, and distributing. Changes permit manufacturing in different European countries, centralized shipping, elimination of delays in crossing borders, and smoother accounting and billing procedures. Moreover,

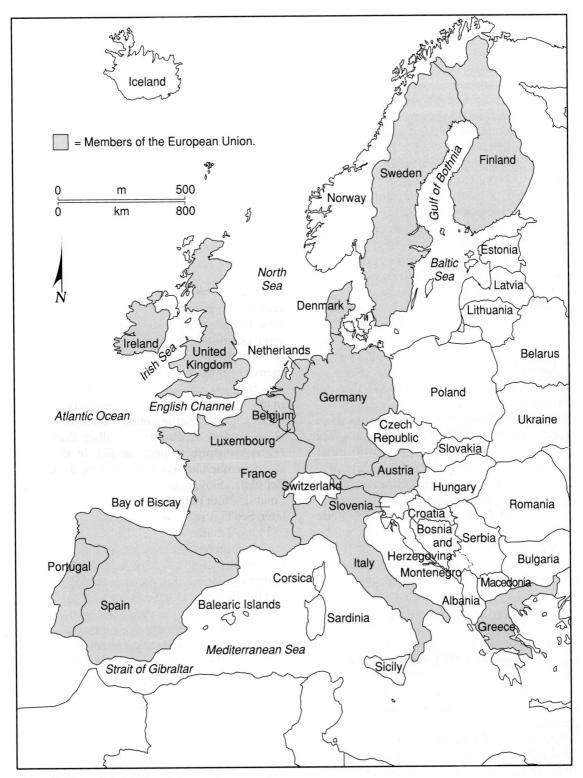

FIGURE 3-3 Western Europe: the EU and members of EFTA.

the changes affect other nations that conduct business with Europe, as well as altering commercial relationships within the EU. The strength of the unified market permits the EU to wield increased power in global trade relationships. Activities in the global textile and apparel sectors are affected by this change.

EU integration into a unified Europe has not been easy. Centuries of tradition for each member country have led to a reluctance to adopt new EU ways of viewing life and going about business. A great deal of bickering has characterized the progress to date, and the average citizen has shown little sign of enthusiasm for a new, pan-European identity. Historic resentments have remained the greatest obstacle to closer integration, but cross-border contact appears to be easing old tensions (Horwitz, 1993). Textbook writers are developing books to encourage the younger generation to have a European rather than a national perspective.

EU members agreed on another step toward deepening integration by signing the Treaty of Maastricht in February 1992. The Maastricht Treaty represents efforts to move toward a full-fledged EU through the establishment of closer economic and political integration. The final goal focuses on an Economic and Monetary Union (EMU) with the establishment of a single currency, the **euro**, on January 1, 1999.

Not only has the EU strengthened its own 15-country integration, it has also widened its associations to include two other groups of countries, as noted in sections that follow.

European Free Trade Association

Another example of economic integration, the European Free Trade Association (EFTA), was formed in 1960. EFTA comprises Austria, Iceland, Liechtenstein, Norway, Sweden, Switzerland, and Finland. In this *free trade area*, member countries eliminated tariffs on manufactured goods and agricultural products that originate in and are traded *among member countries*. This group of European nations sought the benefits

of free trade among its members but preferred that each country retain its own external tariff structure for trade with other countries.

As following sections indicate, EFTA nations have joined the EU to form the European Economic Area (EEA), which means that nearly all barriers between the two groups related to the flow of people, products, capital, and services were eliminated except for the sensitive agricultural sector, for which special arrangements exist. The future of EFTA may be somewhat in question because Austria, Finland, and Sweden are now members of the EU.

European Economic Area

In January 1993, the EFTA nations joined the EU to form the world's largest integrated market—the European Economic Area (EEA). This accord creates a free trade area with 380 million people and 40 percent of the world's GDP (European Economic Area, 1994), including some of the world's most affluent consumers in the EFTA nations. This agreement results in a GDP of about \$7 trillion and accounts for about 40 percent of world trade. Formation of the EEA was the first step for some EFTA members to seek full membership in the EU.

"Greater Europe"

Another agreement may expand trade ties so far that the region will be known as Greater Europe—a huge trading area of 450 million people in at least 25 countries (Hammes, 1991). For this expansion, the EU has signed agreements with some of the countries of Eastern Europe that have sought preferential access to the EU market. A 1991 agreement provides improved access for Hungary, Poland, Slovakia, and the Czech Republic, paving the way for complete free trade with the EU within 10 years. This agreement may have been even more significant than that with EFTA countries because the EU and EFTA already had close trade ties and conducted a great deal of

business in each other's markets. That is, the ties with Eastern Europe represented new markets for countries in each region. This agreement was of limited value to the Eastern European nations, however, because the EU retained stiff barriers on agricultural and other "sensitive sector" products such as textiles, apparel, steel, and iron—the most important products to the economies of those formerly communist countries.

In 1996, Turkey and the EU began a customs union agreement. This is significant for the textile and apparel industries. Already important suppliers of apparel to the EU market, Turkish manufacturers could sell products under the new agreement without quota and tariff restrictions.

Central and Eastern Europe, Commonwealth of Independent States, and the Baltic States

Prior to the fall of communism in Central and Eastern Europe and the former Soviet Union, most of these countries were characterized as having centrally planned economies and nondemocratic political systems. This region includes a number of countries whose identities have changed significantly—some are new, in most cases a portion of a larger nation that existed earlier. The former Soviet Union emerged as 15 newly independent states; Czechoslovakia became the Czech Republic and Slovakia; Yugoslavia splintered into many new states; and East Germany reunited with West Germany. (Figure 3–4 provides an overview of the region.)

In recent years, revolutionary changes have been underway in Central and Eastern Europe,⁵ the Commonwealth of Independent states (CIS),⁶ and the Baltic states,⁷ with

economies in transition from the old order of central planning to new market economies. In many respects, the transition has been painful and costly in economic terms. Citizens, excited over the new freedom from communism, were not prepared for the difficulties in store or for the time required to make the transition. No formula existed to guide a country through this process; no precedent existed.

Previously, many of these countries participated in the Council for Mutual Economic Assistance (CMEA or COMECON) and were major trading partners with one another. In the transition to market economies, a new trading system based on convertible currency transactions and world market prices was implemented. A lack of convertible currencies and workable payment mechanisms caused all the countries in Eastern Europe and the former Soviet Union to reduce their trade with one another. Many of the intermediate materials for production had been obtained from other trading partners in the region; therefore, when trade among these countries slowed dramatically or stopped, manufacturing suffered. For example, a few countries grew most of the cotton; others had most of the petroleum required to make manufactured fibers. Whereas these countries once relied on one another for inputs, now a country might prefer to sell to outsiders with currency valued more highly on the world market. Different states were at varying stages in developing political and institutional changes in their economies; this, too, affected intragroup trade and payment relations. A domino effect from all these factors led to severe economic disruption. United Nations (1996) writers noted that the depth of the plunge in economic activity has been hard to grasp and even harder to measure.

Total output for these countries as a whole measured one-third less in 1995 than in 1990. As a signal of the severity of the shock, population growth abruptly declined in the 1990s (United Nations, 1996). Unemployment rose to high levels in some of these economies—in a

 $^{^{\}rm 5}$ The Central and Eastern European transition economies are referred to as the CEETEs.

⁶ The CIS comprises the Russian Federation, Kazakhstan, Kyrgyzstan, Tajikistan, Turkmenistan, Uzbekistan, Azerbaijan, Armenia, Ukraine, Moldova, Belarus, and Georgia.

⁷ The Baltic states include Estonia, Latvia, and Lithuania.

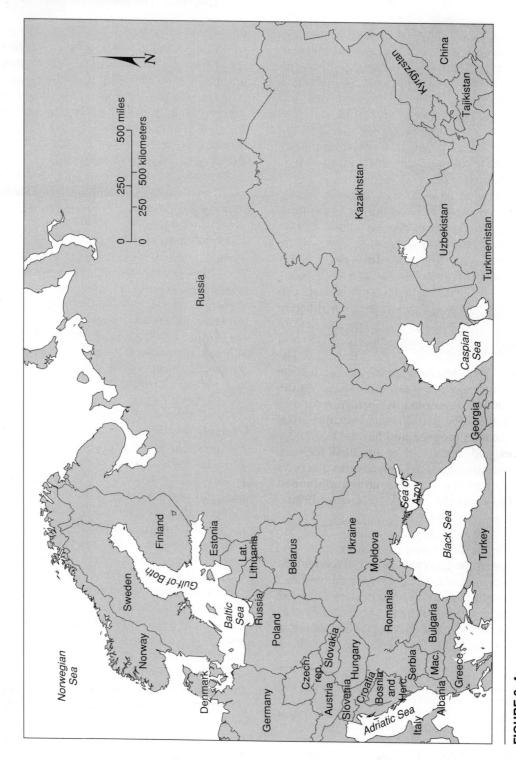

FIGURE 3-4
Central and Eastern Europe, CIS, and Baltic states.

few cases, four to six times the normal rate. Real wages and salaries declined; therefore, household incomes plummeted. Public expenditures for health and education services declined. Poverty grew. Impatience and disenchantment led to worries that if more authoritarian forms of government appeared to represent stability, democratic reforms might be at risk. United Nations (1992) authors summarized the situation as follows: "Although individual freedom has been strengthened by the weakening of various forms of authority and previously accepted values of collectivism, in a sense society has become more fragile" (p. 26).

Economic improvements have begun to occur in the transition economies as a whole; however, a great disparity in gains can be seen. Differences in growth rates reflect the different policies implemented. The Central and Eastern European Transition Economies (CEETEs) and the Baltic states had begun growing by 1994. The economic situation has been more difficult in the CIS countries, where output continued to decline (but at a slower rate than in the past). Within the CIS, the Russian Federation has made notable progress and has the human resources and infrastructure essential for economic growth. In contrast, short-term prospects for a resumption of economic growth are limited for other CIS countries (United Nations, 1996).

The Americas

Following Europe's trend toward broader economic integration, Canada, Mexico, and the United States began to develop integrated markets as well. So far, agreements to strengthen these trade associations have occurred in two stages. Like Europe, the countries of North America have considered more extensive economic integration.

The Canada-U.S. Free Trade Area

In 1989, Canada and the United States entered into an agreement to establish a free trade area

between the two countries (CFTA). Although nearly 80 percent of the trade between the two countries already occurred with no tariffs or restrictive regulations, the agreement removed barriers to trade for the remaining 20 percent—which included textile and apparel products. The agreement included a gradual phasing out of all tariffs and quotas within a 10-year period. U.S. textile and apparel industry leaders were opposed to the agreement; they feared that Canada would become a conduit for lowwage imported products directed to U.S. markets (Wall & Dickerson, 1989).

In the first years under the Canada-U.S. agreement, the United States appeared to benefit more than Canada. Many Canadians blamed the pact for the economic slump that increased Canada's unemployment in the 3 years following the agreement. However, as we shall discuss further in Chapter 7, the textile and apparel industries in both countries gained as a result of the agreement.

North American Free Trade Agreement

On January 1, 1994, Canada, Mexico, and the United States entered into a new era of trade for North America. Under the North American Free Trade Agreement (NAFTA), all tariffs on trade among the three countries are to be eliminated over a 15-year period. The combined market, stretching from the Yukon to the Yucatan, is one of the largest and richest in the world, with an \$8 trillion annual output and 370 million consumers. Formation of this trade area will have a significant impact on textile and apparel producers and consumers, not only in North America but also for producers in other parts of the world.

The three NAFTA nations already had strong trade relationships. The United States and Canada were already each other's leading trade partner, and Mexico was the third largest partner of the United States, following Canada and Japan. Similarly, Mexico's most important trade partner and greatest source of foreign

direct investment (FDI) has been the United States, which accounts for 70 percent of Mexico's trade.

66

NAFTA plans met with considerable concern, particularly among certain industries and segments of the population in Canada and the United States. Until the late 1980s, Mexico's closed economy had not made the nation an attractive free trade partner. However, by the time NAFTA discussions began, protectionist policies that made it difficult for other countries to conduct business with Mexico had been reduced or eliminated. Although Mexico had made tremendous advances in its economic and political structures, many Canadians and Americans feared that free trade with a lower-wage nation might take jobs from their countries. Critics predicted the famous "giant sucking sound" of jobs going south. Although many U.S. and Canadian industry groups saw the advantage of selling to one of the fastestgrowing markets in the world, with a population of more than 90 million, other industries and labor groups were less enthusiastic. The fact remained, however, that these countries were already important trade partners with one another; NAFTA merely facilitated trade by removing some of the existing impediments.

Shortly after NAFTA went into effect, Mexico experienced serious economic upheaval when the peso was devalued. The peso was devalued by one-third to one-half relative to the U.S. dollar, which meant that American goods became much more expensive for Mexicans. In 1995, the United States had more than a \$15 billion deficit with Mexico, giving some critics a chance to question being part of NAFTA. However, the Mexican economy has stabilized and trade has continued to be strong.

NAFTA has changed the balance of top U.S. trade partners. U.S. trade within North America is growing at a far greater rate than U.S. trade with other regions of the world. Moreover, job losses to Mexico have not been nearly as dramatic as critics had predicted, and some

of the companies that moved operations to Mexico would have done so without NAFTA. The Labor Department has certified that 128,303 U.S. workers in all sectors have lost their jobs so far because of increased competition from Mexico and Canada. In contrast, an estimated 2.2 million jobs have been created each year since NAFTA began (Magnusson, Malkin, & Vlasic, 1997).

Other Latin American Countries8

Many other economies in Latin America are developing rapidly and merit greater attention than space permits here. Many of these countries are already important U.S. trading partners, and the potential exists for even further economic ties (see Figure 3.5). However, the most advanced countries in Latin America are making rapid strides to develop other mutually beneficial trade relationships. Because the United States has been slow in following through on its plans to form a large Western Hemisphere free trade region, many of the countries are proceeding without their neighbor to the north. See Box 3–1. The EU has seen the tremendous economic potential in the region and has signed a free trade pact with a major regional trade group. Among the important regional trade groupings are MER-COSUR, the Andean Group, and the Group of Three. See Box 3-2.

Latin America is a region of dramatic physical contrasts and deep social and economic divisions. Contrasts range from sophisticated urban populations, particularly in prosperous countries of southern South America, to villagers throughout the region who barely feed their families. Many of the countries have rich resource endowments, but the greatest resource of all—human beings—has often been tragically wasted. Economic change through

⁸ Latin America extends southward from Mexico's border with the United States to a small island below the tip of South America and includes numerous Caribbean island nations.

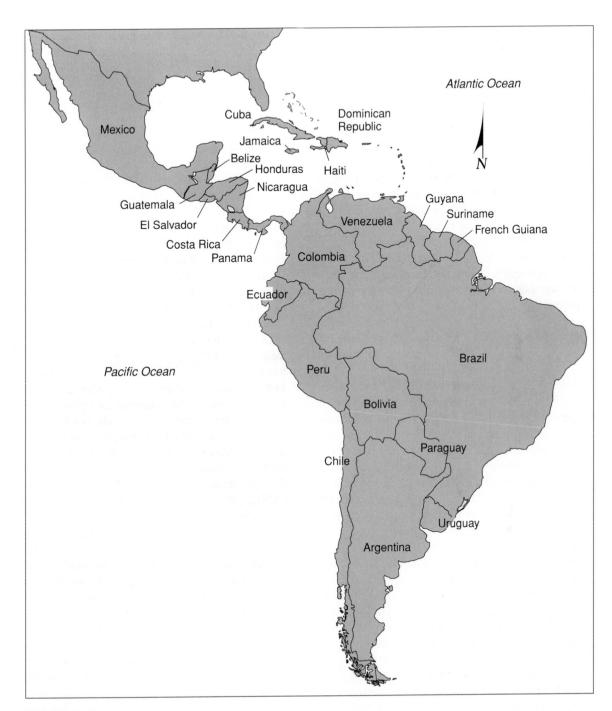

FIGURE 3–5 Latin America.

industrial development has been limited in much of Latin America because of inadequate transportation and communication networks, an untrained work force, small local markets with limited purchasing power, and little accumulation of money or capital. However, many of these nations are making dramatic strides in overcoming these obstacles. Modern infrastructures are developing, literacy is improving, an emerging middle class is developing in the cities, and many of these individuals are employed in the growing industrial sector of the economy (Clawson, 1995). Textile and apparel industries are well developed in some of these nations and are seen as offering great potential by many others. Much of Latin America is dependent on investment from external sources.

Broader Trade Agreements in the Americas

68

ENTERPRISE FOR THE AMERICAS INITIATIVE. NAFTA was seen by farsighted leaders as an important step toward free trade in the Western Hemisphere. In 1990, President George Bush announced his vision for a free trade area that would extend from Alaska to Argentina, to be known as the Enterprise for the Americas Initiative (EAI). The EAI would incorporate trade, investment, and debt reduction to bolster the economies in the Americas.

FREE ENTERPRISE OF THE AMERICAS. Late in 1994, President Clinton hosted Latin American leaders at a Miami summit meeting designed to foster closer working relationships. By the end of the summit, President Clinton announced that more than 30 leaders had signed an agreement called Free Enterprise of the Americas to pursue free trade among their countries by 2005. As Box 3–1 indicates, many of these nations have moved forward with agreements among themselves, while the United States is being left out. U.S. protectionist forces have made it politically difficult to

move forward on this goal. It is anticipated that opposition to these agreements will be even more intense than was true for NAFTA.

U.S.-Israel Free Trade Area Agreement

In 1985, the United States signed its first free trade area agreement (FTAA); the partner was Israel. The result was that by 1995, all customs duties and most nontariff barriers (e.g., quotas) between the two countries were eliminated. As a result, U.S. exports to Israel have tripled and Israel's exports to the United States have doubled (Thanos, 1995). Figure 3–6 shows an example of Israeli apparel being sold in the United States. The FTAA gives suppliers from Israel an advantage over most other nations that sell in the U.S. market because the duty-free status keeps Israel's prices competitive.

The Caribbean Basin Area

The Caribbean basin area (Figure 3–7) has grown rapidly as a major apparel production area for U.S. markets, particularly as a result of trade policies intended to aid the region. Textile and apparel products have been very important to these economies, and the impact of this production has been significant, particularly for the U.S. industry and for some Asian producers.

The Caribbean region is "an ethnic blend of almost all the peoples and cultures of the world" (Knight, 1990, p. 308), resulting from early colonization by Great Britain, France, Spain, the Netherlands, and North American colonies—a colonization that left its stamp on the language, religion, music, dress, and even the work orientation of the separate peoples. Colonization also left an economic legacy. Colonial powers sought raw materials and sold finished products there; agriculture products and extracted natural resources became important exports from the region. The Caribbean economies depended heavily on exports and foreign capital; industrialization was

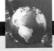

U.S. BUSINESSES ON THE OUTSIDE LOOKING IN

Larry Liebenow, president of Quaker Fabric Corp., a Massachusetts textile maker, had established a good customer base across Latin America, Asia, and Europe for his company's upholstery fabrics. Speaking fluent Spanish, he had been to visit furniture manufacturers in Chile and Argentina; however, by the end of the trip, Mr. Liebenow was discouraged over long-term business prospects for American firms in Latin America.

On Mr. Liebenow's trip, his customers were far less interested in Quaker's fabrics than in the past. The reason: companies are now able to buy upholstery fabrics from neighboring Latin American countries, with which their respective governments have free trade agreements, at reduced prices because tariffs have been reduced or eliminated. For example, a former customer in Argentina told Mr. Liebenow that his company is now buying fabrics from Brazil because the two countries have a free trade agreement that removed tariffs. In contrast, buying from Mr. Liebenow now adds a 25 percent tariff to the price of goods because the United States does not have a similar agreement with Argentina. Mr. Liebenow understands why his former customers can no longer afford to buy from him.

Mr. Liebenow is discouraged because he sees no U.S. effort to follow up on the promises made by President Clinton at the Miami summit to form an enlarged NAFTA that encompasses 30 or more Latin American nations. Because of the political risk in an election year, Clinton had obviously put the matter on the back burner.

In the meantime, a mosaic of trading arrangements is forming among the Latin American countries. Business is booming among Brazil, Argentina, Uruguay, and Paraguay—whose combined economies account for 70 percent of South America's total. In 1995, this group formed a customs union called MERCOSUR, through which

nearly all tariffs have been eliminated. Chile, expecting to be the first country admitted to an expanded NAFTA, felt jilted by Washington and joined MERCOSUR as an associate member. Bolivia is in negotiations to join. Chile also has free trade agreements with Canada and Mexico. Even the EU has negotiated a landmark agreement with MERCOSUR that commits the two groups to the gradual establishment of what may become the world's largest free trade zone.

While Washington is embroiled in political hassles that prevent U.S. leadership and participation in the envisioned "Free Trade of the Americas," cooperative agreements and business deals throughout Latin America are flourishing. As trade expands among Latin American countries, it will become increasingly difficult for the United States to form a hemispherewide free trade area. Small to medium-sized companies such as Mr. Liebenow's will be hurt most by U.S. lack of participation in free trade agreements with Central and South America. Large multinational firms will be able to establish facilities within the countries that are part of MERCOSUR and other pacts and therefore take advantage of the free trade agreements as they conduct business in the region. However, Mr. Liebenow and many other U.S. business representatives will be on the outside looking in, unable to compete because domestic politics have kept the United States from being an active leader and participant in these Latin American agreements. As the world's largest exporter, the United States cannot afford to sit on the sidelines in the free-trade game.

Source: Based on Greenberger, R., & Friedland, J. (1996, January 9). Latin nations, unsure of U.S. motives, make their own pacts. Wall Street Journal, pp. A1, A4; Magnusson, P. (1997, April 21); Beyond NAFTA: Why Washington mustn't stop now." Business Week, p. 46.; and United Nations (1996). World economic and social survey 1996. New York: Author.

FIGURE 3-6

This advertisement for swimwear from Israel emphasizes the duty-free status of products from Israel under the U.S.-Israel FTAA.

Source: Reprinted courtesy of Israel Economic Mission.

limited (Axline, 1979; Balkwell & Dickerson, 1994; Knight, 1990).

After World War II, most of the Caribbean colonies gained independence, sought national identities, and tried to expand industrialization. Manufacturing generally consisted of assembly operations that used components made in the developed countries. The apparel industry was a leading industry in this development. Although the Caribbean economies made significant strides, the difficult world economy of the mid-1970s led to large govern-

ment debts, diminished optimism, and, in some cases, widespread discontent.

Beginning in the early 1980s, the United States enacted trade policies to bolster the Caribbean region. Particularly since the 1986 enactment of these policies, which provided special access to the U.S. market for apparel assembled in Caribbean basin countries, many U.S. apparel firms have shifted production to the region. In fact, virtually all Caribbean-produced apparel is destined for U.S. markets (Steele, 1988; U.S. Department of Commerce,

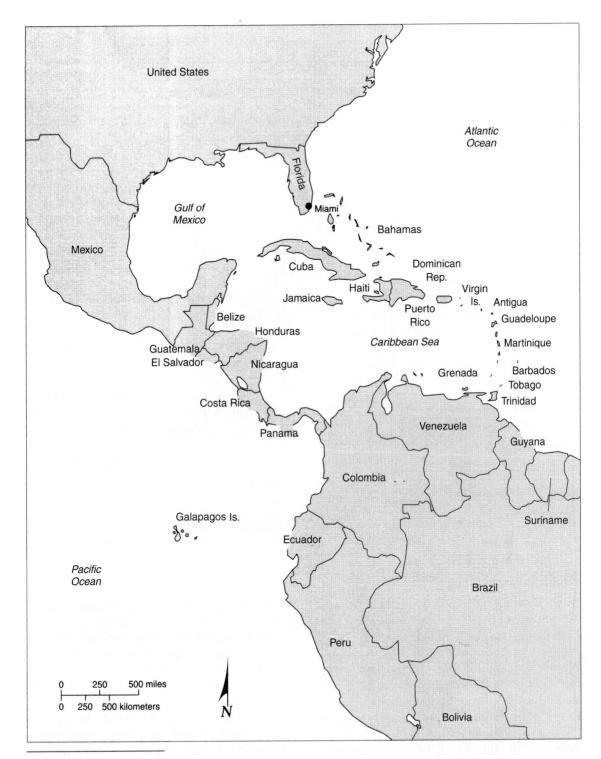

FIGURE 3–7
The Caribbean basin area.

72

1993). Manufacturers who have production facilities in the Caribbean are taking advantage of labor that is far less costly than that in the United States, yet the location is much closer to the domestic market than is Asia. In response to the potentially large loss of business, a number of Asian producers have established production sites in the Caribbean region themselves, specifically to ship to U.S. markets. Moreover, Asian producers who face tightened quota restraints on products made in their home countries have established Caribbean production as a way to have access to U.S. markets.

NAFTA, which gives Mexico greater trade privileges with the United States than exists for the Caribbean countries, has been a concern for those manufacturers who are producing garments in the Caribbean. Therefore, Caribbean producers and U.S. firms with production in the Caribbean have sought equal treatment (parity, in trade terms) with Mexico.

THE CARIBBEAN ECONOMIC COMMUNITY. The Caribbean Economic Community (CARICOM), a grouping of Caribbean economies, was formed to reduce trade barriers among member nations and is moving toward a customs union with a common external tariff for goods entering the community. CARICOM's long-term goals are to enhance economic development and reduce the region's external dependence.

Asia

This area, often called Monsoon Asia by geographers, is the southeastern quadrant of the Eurasian land mass. It includes regions sometimes designated as East Asia, South Asia, and Southeast Asia. This area accounts for about 7.2 percent of the earth's total land surface (excluding Antarctica and Greenland) but has about 56 percent of the world's population (an estimated 3.4 billion in 1994). Its population density is the highest in the world (Pannell, 1995). Figure 3–8 shows the countries of Monsoon Asia.

Of all regions of the world, Asia has changed most in the last two decades. As John Naisbitt, author of Megatrends Asia (1996), noted: "What is happening in Asia is by far the most important development in the world today. Nothing else comes close-not only for Asians but for the entire planet. The modernization of Asia will forever reshape the world as we move toward the next millennium.... In the 1990s, Asia came of age. And as we move toward the year 2000, Asia will become the dominant region of the world: economically, politically, and culturally" (p. 10). Although many Asian economies experienced severe difficulties beginning in 1997, this region will continue to play an increasingly important role on the world stage.

Asian countries have relied heavily on textile and apparel production in their economic development process. Therefore, many of these countries have had enormous influence on the global picture for textile and apparel production and have accounted for the greatest shifts in production and trade in recent decades.

East Asia

This region, often referred to in the past as the Orient or the Far East, has been transformed remarkably in little more than a decade. Its economic growth and development are among the fastest growing in the world. East Asia boasts countries that are some of the major suppliers in today's international textile and apparel markets. Many of these countries (e.g., Japan, Hong Kong, South Korea, and Taiwan) have well-developed production and marketing structures and exert a powerful influence on global markets for the sector. Companies in these countries control a good deal of production in neighboring countries. Japan was clearly the early leader in developing its industry and exporting products to other parts of the world. Not long ago, China was in the early stages of developing its textile and apparel in-

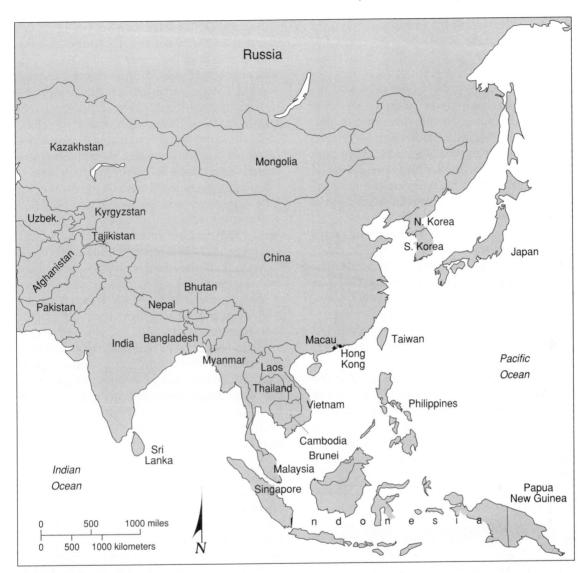

FIGURE 3–8 Asia.

dustries, but it rapidly became a major force in global markets. By the early 1990s, China had become the world's leading apparel exporter.

Hong Kong, Taiwan, and South Korea have been called the Big Three because of the major role they have played in global production and trade for these industries. China is often added to the Big Three, constituting a group known as the Big Four in textile and apparel trade. Although other countries in Asia are at varied stages of economic development, and although textiles and apparel may be among those nations' primary exports, the industries in those nations have not

74

yet exerted the impact on global markets equal to that of the Big Four.

Southeast Asia

Mainland Southeast Asia (sometimes called Indochina because of its interface between India and China) includes Thailand, Laos, Myanmar (formerly Burma), Vietnam, Cambodia (known for a time as Kampuchea), and western Malaysia. Island countries include the eastern portion of Malaysia, Indonesia, Singapore, the Philippines, and Brunei.

The level of economic development varies greatly among the nations in this region, ranging from Singapore, which ranks next to Japan in prosperity (based on per capita GNP) in Monsoon Asia (Pannell, 1995) to other countries with large populations living in poverty. The region is a mosaic of people with disparate national histories, cultural heritages, political allegiances, and religious followings. Agriculture remains important in most of the countries; however, economic development has been dramatic in some, such as Malaysia, Indonesia, and Thailand. In many of the Southeast Asian countries, the textile and apparel sectors have led the way in economic growth.

Some of the Southeast Asian countries have entered into economic integration efforts.

ASSOCIATION OF SOUTHEAST ASIAN NATIONS. The Association of Southeast Asian Nations (ASEAN) was the first major Asian effort toward integration; cooperation has occurred on development and trade matters despite the cultural disparity among the countries. Organized in 1977, the ASEAN network includes Malaysia, Singapore, the Philippines, Thailand, Indonesia, Brunei, and Vietnam (admitted in 1995); Laos and Myanmar were admitted in July 1997. In one of the fastest-growing regions of the world, ASEAN was formed to foster economic, political, social, and cultural cooperation.

Rapid growth in textile and apparel production in the ASEAN nations was spurred first by investments from Japan and the Big Three. This shift of production to ASEAN nations occurred in many cases as Japan and the Big Three experienced tightened quotas for shipping to U.S. and EU markets. That is, Japanese and Big Three suppliers established production in ASEAN countries where more abundant quotas permitted the products to be shipped to major developed markets. Additionally, Japan, the Big Three, and other countries looked to the ASEAN nations for low-wage labor as workers for the textile and apparel industries became scarcer and more costly in their home countries.

In late 1992, the ASEAN group agreed on the main elements for a free trade area among its members (the ASEAN Free Trade Area, or AFTA), with the goal of fully eliminating tariffs on trade with one another by 2003. AFTA is intended to foster trade within the region, which encompasses over 400 million consumers, to attract foreign investment, and to counteract the economic integration occurring in Europe and North America. (The emergence of powerful trading blocs will be discussed later in this chapter.)

South Asia

South Asia, known also as the Indian subcontinent, consists of three countries with very large populations (India, Pakistan, and Bangladesh), plus Sri Lanka, Nepal, and Bhutan. Also included is Afghanistan, which is an interface state with historic ties to both South Asia and the Middle East. Exceeded only by China, India is the second most populous country in the world. Although the countries of South Asia have different levels of economic development, all are considered poor by Western standards. Political disputes and military conflict have kept these nations from reaching their potential (Pannell, 1995).

For most of the South Asian developing economies, textile and apparel production has

been extremely important. For example, in 1995 textile and apparel exports accounted for 73.5 percent of Pakistan's merchandise exports. Similar exports represented 3 percent of India's merchandise exports (WTO, 1996a) and perhaps would have been even greater had not India's previously closed economy made it very difficult for more developed nations to invest and produce there (in contrast, most ASEAN members were open to outside investment and production). In the early 1990s, India made progress in opening its economy and encouraged foreign investment more than in the past. South Asia is expected to continue to be an important textile and apparel region.

Asia Pacific Economic Cooperation Forum

In 1989, 15 nations, including the ASEAN countries, Japan, South Korea, China, Hong Kong, Taiwan, Australia, and New Zealand, plus the United States and Canada, formed the Asia Pacific Economic Cooperation (APEC) forum. More recently, Chile, Mexico, and Papau New Guinea have joined. As ASEAN has grown, it has also added more members. The group's purpose is to encourage freer trade and to encourage major economies in particular to settle their differences without retaliating against countries perceived to be engaged in unfair trade. This group is not technically a trade bloc since it includes trading partners outside Asia. The group's goals are to make the region a major exporting force in the world economy, to attract investment, and to be an Asian counterpoint to the European and North American trade blocs (United Nations, 1992, 1996).

FORMATION OF REGIONAL TRADING BLOCS

New communication and transportation technologies have permitted neighboring countries to interact and trade with one another as never be-

fore. Even "neighboring" countries in some cases are hundreds or thousands of miles away. Therefore, new technologies have permitted closer interaction, collaboration, and trade. Enhanced exchanges in both dialogue and goods have led to the formation of regional trading blocs.

Fear of competition or isolation has also fostered trade blocs. Following the EU unification efforts, other countries grew concerned that they might have more limited access to the large EU market—that is, that the EU might become "fortress Europe." As a result, EU unification spurred a continuing trend toward the formation of regional trade blocs. In fact, the proliferation of these agreements, as shown in Box 3-2, reflects the growing interest in trading with neighbor nations—as well as the fear of being excluded from existing blocs. Some of these trading blocs have been mentioned earlier in sections on country groupings; as a review, those are included briefly along with others. The three major blocs are:

- The European bloc. As the EU moves through successive stages of integration (unification of its 15 members, adding EFTA countries, and developing cooperative agreements with Eastern Europe), this large, powerful bloc is known as the European Economic Area (EEA) and perhaps later as Greater Europe.
- The Americas bloc. With the conclusion of the NAFTA agreement, this region represents another important trading bloc. Further, if the Free Enterprise of the Americas becomes a reality, this will unite the Western Hemisphere into a formidable trading bloc.
- The Asian bloc. Seeing the formation of the European bloc and the NAFTA bloc, Asian countries became increasingly motivated to unite into a bloc to offset the effects of the other two. Although Japan represents the major industrial trading power in the region, that nation has not taken the lead in the formation of the Asia Pacific Economic Cooperation (APEC) forum. Rather, Singapore has been the leader. As the ASEAN nations form

BOX 3-2

REGIONAL TRADE GROUPINGS

Other regional or subregional trading arrangements (some of which are or may be included in the larger blocs listed on p.75) are:

- Andean Group ("Andean Common Market").
 In January 1992, a free trade pact among Bolivia, Colombia, and Venezuela became effective; Ecuador and Peru later joined. Peru later withdrew. Panama is expected to join.
- ASEAN Free Trade Area (AFTA) has moved from an association that was less integrated on economic issues toward becoming a regional common market.
- Asia Pacific Economic Cooperation (APEC) forum. Discussed earlier.
- Black Sea Economic Cooperation Region. This
 grouping consists of Turkey, Bulgaria, Romania, and the republics of Armenia, Azerbaijan,
 Georgia, Moldova, Russia, and Ukraine. The
 group was formed to help members integrate
 with the world economy and resolve regional
 problems (United Nations, 1992).
- Caribbean Economic Community (CARICOM).
 Although this group was established in the 1970s, finally in the early 1990s it became a common market with a common external tariff among members.
- Central American Common Market (CACM). Although a regional economic group existed in the 1960s, it dissolved after a few years. In the early 1990s, Costa Rica, El Salvador, Guatemala, Honduras, Nicaragua, and Panama agreed to reestablish a common market among members. Colombia and Venezuela are expected to join.
- Group of Three. Colombia, Mexico, and Venezuela.

- Gulf Cooperation Council (GCC). Countries in the Middle East in GCC now permit movement of capital and labor among themselves and are expected to develop a common external tariff. GCC has discussed a cooperative agreement with the EU.
- North American Free Trade Area (NAFTA).
 Canada, Mexico, and the United States.
- South African Development Community (SADC) plans to convert its trade and regional integration strategies into a southern African economic community by the year 2000. Overlapping somewhat is the Common Market for Eastern and Southern Africa (COMESA), which is a formal common market, and the Southern African Customs Union (SACU).
- South American Free Trade Area (SAFTA). Talks are underway for potential integration of MERCOSUR and the Andean Group, including eventual elimination of tariffs for internal trade.
- Southern Cone Common Market (MERCOSUR or MERCOSUL). In March 1991, Argentina, Brazil, Paraguay, and Uruguay completed a common market agreement that not only removed barriers to trade but also included plans for coordination of policies on broader industrial and financial matters. Trade has expanded among members, and firms in the region have changed investment strategies as a result of the agreement. Chile is an associate member. In 1995, the EU signed a free trade agreement with MERCOSUR.

AFTA and as APEC unites economies in the region, this bloc will also be a powerful force in the global economy, representing a majority of the world's consumers and many fast-growing economies. Prior to the economic crisis, Naisbitt (1996) predicted that Asia's combined GNP might have doubled that of

Europe and become one-third of the entire world economy by the year 2000.

Pros and Cons of Trade Blocs

Trading blocs and regional groupings are a fact of life in today's global economy. See Box 3–2.

FIGURE 3-9

The formation of regional trading blocs has the potential for being divisive rather than forming a broader global trading community.

Source: Illustration by Dennis Murphy.

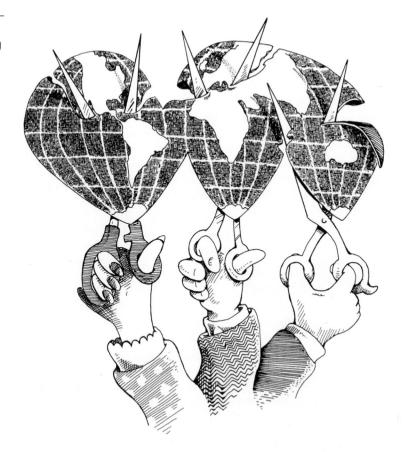

As the number of regional trade groupings continues to grow and as the three major blocs expand, concern exists that these regional groupings will be a divisive influence in the world economy—that is, that they may fragment efforts to form a global trading community. As the World Trade Organization (WTO) attempts to foster world trade by removing various kinds of barriers, some sources feel that the proliferation of regional trading blocs may undermine the broader effort (Magnusson, 1992).

On the positive side, trading blocs encourage member nations to participate in trade, at least to an extent. That is, a country that has had an isolated, closed economy may partici-

pate in a regional arrangement more readily than in a broader one, thus learning the benefits and skills involved in trade. In this case, the regional bloc may be a stepping stone to broader participation. Second, since consumers generally benefit from free trade, it follows that consumers in a region should find advantages in having more choices and better prices from a greater number of producers in the region compared to only the home country.

On the negative side, trade blocs may simply divert trade rather than create it. There is a tendency to substitute products in the region for those from the rest of the world, causing a reduced demand for products from outside the bloc. Additionally, powerful trade blocs may

be inclined to push for trade policies that benefit them, whereas individual countries not in blocs will be at a disadvantage.

In reflecting on trade blocs, United Nations (1992) writers concluded: "The costs of consolidation of the world into a few large trading blocs would probably be borne not by the countries in the blocs, but by those left out. Those would most likely be small, open, export-oriented countries—especially developing ones—that thus far have gained the most from a strong and liberal multilateral trading system" (p. 61).

THE DIVISION BETWEEN NORTH AND SOUTH

Of all the country groupings relevant to the study of global textile and apparel production and trade, the division between more-developed countries and less-developed nations merits special attention. Terms for the division between the "North" and the "South" come from an imprecise reference to the fact that the industrial market economies are in the Northern Hemisphere (Australia and New Zealand are important exceptions), and the greatest proportion of the less-developed countries are in the Southern Hemisphere. Although the distinctions between these two groups of countries is less obvious in some ways as a number of the previously less-developed nations make significant strides, in many ways the divisions remain.

Economic concerns, including trade in particular, have led to these divisions. This North-South split has become especially sensitive on nearly all global economic and trade matters in recent decades and is a key point in the difficulties associated with global textile and apparel production and trade.

In this section, we will review the division between North and South. In the next chapter, this division will be considered within a framework of *development* theory. In various portions of the book, the reader will see the division between more-developed and less-developed countries as a repeated theme in discussions of textile and apparel production and trade.

First, a brief historical review will be helpful in understanding the origins of the relatively recent division between the developed and developing countries. In the 19th and early 20th centuries, international trade provided opportunities for growth and prosperity for the dominant nations of the times. During this era, the economies in newer countries such as the United States blossomed. Since World War I, however, global trade has grown more slowly than it had earlier. The volume of international trade grew 270 percent between 1850 and 1880, 170 percent between 1880 and 1913, and only 57 percent between 1928 and 1958 (Nurkse, 1961).

After World War II, a wave of decolonization swept the world, liberating the peoples of Africa and Asia. The newly independent states were said to be "sovereign and equal to other nations, old and new, large and small" (Agarwala, 1983, p. viii). The developing countries' admittance to the United Nations reinforced their status of sovereignty. In the years that followed, however, a large proportion of the developing countries began to feel they had ended an era of political colonization only to enter one of economic colonization. Many of these Third-World countries embarked on plans for national economic development. They attempted to adopt the earlier industrialization strategies of the developed countries; this approach had been relatively successful in some of the Latin American countries. Goals for economic growth in developing countries were formally included in the official development strategies of the First and Second United Nations Development Decades (the 1960s and 1970s).

The developing countries expected trade to play a major role in their economic advancement, as it had for the developed countries. However, Third-World countries' success in trade fell short of expectations.

Until 1953, world trade in general expanded more rapidly than global production output, but after that, trade grew more slowly than output. Trade no longer fueled growth and prosperity, as it had earlier. Developing countries that aspired to the same kind of economic development they had observed in the industrialized countries felt that their opportunities had been stymied by the wealthier nations. The developed countries increasingly stricted the developing countries' exports of agricultural commodities and manufactured goods such as textile products and leather goods. A sense of frustration mounted as the developing countries expressed resentment that the international economy was not functioning in their interests.

Other factors affected relationships between the developed and developing countries in the early 1970s. First, the Middle East oil embargo of 1973-1974 led to quadrupled oil prices that affected both groups of countries. During this time, some Third-World nations became aware of their important roles as sources of major natural resources on which the developed countries depended. Thus, some developing nations discovered their ability to wield a certain amount of economic and political power. This power was minimized, however, because the economic conditions of both the developed and developing countries deteriorated seriously in the mid-1970s. Problems in the developed countries, including inflation, unemployment, and unused industrial capacity, focused concerns on domestic economieswith less interest in assisting the Third World (Agarwala, 1983).

All these factors caused leaders in many countries to realize that problems associated with the North-South split must be addressed as part of a changing international economy. Consequently, this concern stimulated a host of declarations and studies by the United Nations and the international community at

large. Several efforts relevant to discussions on the division between North and South are described below.

 The United Nations Conference on Trade and Development (UNCTAD) has played an active role in attempting to coordinate the relationships between the developing countries and the industrialized nations. UNCTAD focuses on such areas as commodities, manufacturing, shipping, and other trade concerns. It was at the first UNCTAD session in Geneva in 1964 that developing countries began to speak in a strong, collective voice regarding their frustrations with the world economy. The developing countries began to pressure the industrialized countries to give preference to manufactured exports from the developing countries. This was the beginning of what is now known as the North-South dialogue.

· The North-South dialogue is a term for the discussions that resulted from protests of the developing countries regarding their status in the world economy. This dialogue has continued since 1974, with the primary concern of the developing countries being how to transfer wealth from the developed countries to the developing nations. Key issues addressed in these dialogues have been reduction of trade barriers in the developed countries, increased aid and investment, stabilization of export earnings and commodity prices, and repayment of debts. In general, the developing countries made greater demands than the industrialized countries were willing to meet.

 The Group of 77 is a coalition of developing countries (originally 77 countries, now well over 100) within UNCTAD that coordinated the efforts of the LDCs in requesting fuller participation in the world economy. In recent years, the Group of 77 has focused strongly on concerns related to the effect of trade barriers on their exports to industrialized countries.

80

A New International Economic Order (NIEO)
 emerged as an agenda issue at the 1974
 meeting of the UN General Assembly. The
 developing countries, aware of their
 economic leverage because of their control
 of the supply of a number of important
 fuels and raw materials—as well as being
 purchasers of about 25 percent of the
 developed world's exports—felt that the
 existing global economic system was
 inadequate for their future growth.

Increasingly dissatisfied with the way in which the world economic system affected them, the developing countries pressed for a "new international economic order" to address their needs. They proposed that this include (1) greater control by the LDCs over their own economic fate, (2) a reduction in the gap of per capita income between developing countries and the industrialized nations, and (3) an increased share of the world's industrial production occurring in the LDCs. To achieve these goals, the LDCs requested tariff preferences for their exported products (i.e., that their products have reduced tariffs when shipped to the developed countries), increased transfer of funds to the LDCs from the industrialized countries, and maintenance of prices on LDC commodities (Ellsworth & Leith, 1984; Mansfield, 1983).

 Organized in 1961, the Organization for Economic Cooperation and Development (OECD) is composed of 25 primarily industrial, market economy countries—that is, mostly the North. Many persons outside the organization call it the "rich man's club" because member nations are the most prosperous in the world. OECD was formed to assist member governments in formulating policies to promote economic and social welfare, as well as to stimulate and coordinate members' assistance to developing countries. Although the goals of OECD include far more than trade and economic issues, these concerns have taken on special significance in recent years. One should also note that OECD was organized before the North-South division erupted.

Issues related to the North-South dialogue are particularly relevant to the position of textiles and apparel in the international economy. A later discussion concerns the intense divisions between the North and the South on textile trade matters. In fact, the sensitive and difficult aspects of global textile trade are tied to the divisions between these two groups of countries and the role of the textile and apparel industries in each group.

ECONOMIC SYSTEMS

According to Schiller (1983), the **economy** is an abstraction that refers to the sum of all of our individual production and consumption activities. Schiller also compares the economy to a family. What we collectively produce is what the economy produces, and what we collectively consume is what the economy consumes.

An economic system is a way of organizing the production of goods and services that people want and then distributing those products to the end-use consumer. The economic system determines the allocation of resources within a nation—that is, the control of economic activity and the ownership of factors of production (e.g., land and capital). In capitalist economic systems, the factors of production are owned by individuals, and allocation decisions are made by market forces (see the following discussion on market-directed systems). In contrast, in socialist economic systems, all nonlabor means of production have been owned by the state, which controls resource allocation (see the following discussion on centrally planned economic systems). We must keep in mind, however, that these systems have changed in a number of countries. The type of economic system present in a country significantly affects the environment for domestic textile and apparel production and distribution, as well as the conditions for international trade for these products.

Market-Directed Systems

Mansfield (1983) defines a market as a group of firms and individuals that are in touch with each other in order to buy or sell some good (this definition may also be expanded to include services). Consumers and producers come together in a market, although this may be through systems that do not require that all the players interact in person. In market-directed systems, consumers have the opportunity to choose from among the array of goods and services available at any given time, and firms are given the freedom to respond to consumer demand in ways perceived to be most beneficial to each company. In addition, firms are given the freedom to stimulate consumer demand. Individuals who exchange their goods and services in the marketplace for those produced by others are submitting to the market mechanism. Consumers respond in a domestic market or, as has been more typical in recent years, participate increasingly in the global market system.

Price becomes the regulator of supply and demand and determines shifts in resources from one area of production to another. Prices regulate local, domestic, and worldwide markets, and the free market inhibits those who provide unwanted goods or attempt to price goods above the market price. This system rewards the workers and companies who respond most sensitively and competitively to consumers' desires. When this idea is applied on a global scale, economists contend that protecting an industry from foreign competition reduces that industry's need to function at its best to remain competitive. Debate over this point as it relates to the textile and apparel sec-

tors will be covered in a later section. Cateora (1987) summarizes well the market system in its ideal state as follows: "Theoretically, the market is an automatic, competitive, self-regulating mechanism providing maximum consumer welfare and regulating the use of factors of production" (p. 47).

In reality, however, market-directed economies and centrally planned economies are ends of a continuum, and perfect examples do not occur. Economies more strongly resembling the market-directed type have been successful in many of the major developed countries. Most of the rest of the world considers the U.S. market as a good example of a prosperous market economy; however, several limiting factors in the United States prohibit the operation of a perfect market economy. Limiting factors include government policy and labor unions, which provide mechanisms that restrict the influence of market forces.

Centrally Planned Systems

Governments play a primary role in determining the allocation of a nation's resources in a centrally planned system. Rather than permitting consumers and producers to compete and be rewarded on the basis of price, as the market-directed system does, countries with central planning allocate resources according to government goals. The government may establish what will be produced, by whom, and for whom. Often the goal in central planning focuses on political objectives rather than the efficiencies that bring greater reward in the form of profits. Because of the emphasis on goals other than meeting consumers' needs, the centrally planned systems experience a variety of problems. Often supply and demand are mismatched, and frequently the production of component parts is not synchronized in timing or volume to the production of end products.

China and Vietnam are examples of centrally planned economies. Both of these na-

tions, however, have incorporated into their economic systems an increasing number of features that permit free market operations to function.

Under the former Soviet Union's centrally planned system, widespread shortages of many basic goods⁹ were a fact of life. However, the political changes and resulting freedom in the former Soviet Union and in Central and Eastern Europe have permitted citizens of those countries in many cases to witness the greater availability of consumer goods in market-directed systems. In short, the dramatic alterations of the political climate in the former Soviet bloc countries have fostered equally significant changes in the economic systems.

Mixed Economies

82

Most markets are a combination of market systems and centrally planned systems. For example, the U.S. market is characterized by a certain amount of intervention in the form of government regulations. Trade restraints are one example. Similarly, China and Vietnam have embraced an increasing number of market economy concepts. Other countries are much more clearly mixed economies; for example, France has private ownership of businesses but maintains strong central control.

Contrast of the Systems

Try for a moment to envision the contrast in the two systems in relation to apparel production, particularly for fashion products, for which timing is a concern. (Admittedly, in the past, the timing of fashion goods was less of an issue in many of the centrally planned countries. In recent years, however, an increasing desire to export has enhanced the sensitivity to this issue. In addition, the new freedom in these countries has permitted greater interest in fashion products.)

Consider the difficulties of coordinating the component parts involved in apparel production when influences other than market forces determine availability. Think of the phases of production involved in manufacturing a shirt, from the production or harvesting of fibers to the assembly of the garment. Fiber producers may have little incentive to match the type and amount of fiber to the shirt producer's end product. Perhaps the shirt producer wished to manufacture 1,000 dozen Pima cotton men's shirts. However, because of the limited incentive to satisfy customers (in this case, "customers" also included producers at various stages of the production chain), the intermediate producer at each stage modified the amount and type of fabric according to that mill's convenience. By the time the fabric reached the shirt producer, the factory had received homespun (i.e., rough, nubby weave) cotton yardgoods of the incorrect colors, the incorrect width, and in yardage to produce only 600 dozen men's shirts. Consider the added dilemma if the original shirt orders had been placed by a market-oriented country in which the particular shirt ordered had current, immediate fashion appeal. Contrast this to production in a market economy where the producer at each stage prospers or suffers according to the profit-oriented company's ability to respond efficiently.

Few centrally planned economies remain. However, many countries in Eastern Europe and the former Soviet Union have struggled to eliminate the long-term effects of central planning as they make the transition to market economies. Workers have had to accept the idea that a job and an income are no longer guaranteed, as they were previously by the state, regardless of one's productivity. They have learned that incentives come from meeting

⁹ A 1989 study by the USSR State Committee for Statistics (Bogert, 1989) reported that 1,000 out of 1,200 basic consumer goods were hard to find in at least some regions of the Soviet Union. Half of all communities surveyed indicated shortages of cotton underwear. Also in short supply were towels, men's cotton socks, children's shoes, men's and women's boots, and children's tights.

customers' needs and doing a good job. Factories and other business enterprises have had to make painful adjustments while learning how to function with profit as an end goal. For example, one German consultant who advised textile companies in Eastern Europe reflected on the difficulty of assisting industry personnel who had no concept of what interest rates on capital meant.

Market-directed economies also have their share of problems. Examples are extremely unequal distributions of wealth and income, large and unpredictable shifts in economic activity and indicators, the tendency toward monopolies with attendant dysfunctions, and high social costs such as wasteful abuse of the environment.

POLITICAL SYSTEMS

Just as different economic systems determine how the textile and apparel industries will function both domestically and internationally, the political system of a country also has a great influence on how textile and apparel production and trade occur. A political system is built around ideologies (a body of constructs, theories, or what we might commonly call the philosophy of a society) and provides a means of integrating a society into a functioning unit. Political systems are closely tied to economic systems in the operation of a country. Moreover, a large proportion of today's societies are pluralistic, which means that many ideologies are held by different population groups rather than only one ideology supported by everyone. Although there are many different divisions among political systems, a more simplified approach is considered here.

Democratic Political Systems

Under this type of system, individuals have the right and responsibility to be involved in decision making that involves their well-being. At least theoretically, all persons have equal rights under democratic systems. Because of the difficulty of having the masses participate in decision making, various forms of *representative* participation occur. As an example, individual consumers may not have a firsthand opportunity to vote on congressional trade legislation; however, all citizens do have an opportunity to vote for the representative who will speak for them.

Nondemocratic Political Systems

In nondemocratic systems (totalitarianism or authoritarianism), individuals have little right to participate in decision making. A select few individuals, who generally do not permit opposition, hold the power and make the decisions. Totalitarianism exists in numerous forms; one of the most common is communism. Truly totalitarian communism exists today in only a few countries—North Korea, Cuba, and China, to name three. It also exists in military dictatorships such as Libya or religious states such as Iran.

Relationships of Economic and Political Systems

Although some types of economic systems are more commonly found within certain political systems, there are too many exceptions to generalize. A look at the common patterns may be helpful, however, in trying to remember or to apply the categories presented previously. Often, countries with centrally planned economies have nondemocratic political systems in which the factors of production are state owned. Similarly, market economies are more commonly found in countries with democratic political systems that permit public ownership of the factors of production. Keep in mind that exceptions to these observations are plentiful. For example, France's democratic socialism assumes that the democratically controlled economy requires regulation by an elected government. Several communist countries are

BOX 3-3

CHINA: BOOMING STATE CAPITALISM

Southeastern China, from Hong Kong to Shanghai, is leading the country to become an economic powerhouse. Gone are the days of Mao's baggy blue suits and isolation from the rest of the world. Foreign investment is pouring into China, exports are exploding, and the gross domestic product is expected to double by early next century. Although per capita income is low compared to that of some of its Asian neighbors, China's budding middle class is emerging and spending on luxuries such as makeup, clothing, and color televisions.

Although capitalism appears to be flourishing, the Chinese economy is a form the world has not seen before. China is not expected to embrace Western-style capitalism; rather, it is a mixed economy in which the leadership intends to keep the means of production in the public sector. Beijing is giving provinces and towns the opportunity to operate quasi-public companies. A new class of managers, who may drive a Mercedes but are card-carrying members of the Communist Party, is emerging. Along with decentralization of economic control is an effort to extend reform and growth to the pennies-per-hour workers

in the interior provinces so that these regions may share some of the boom experienced by the coastal areas. Much of the vast country is desperately poor, and peasants are migrating to the wealthier cities in staggering numbers, creating massive social problems.

Corruption is a serious problem and, for many, a way of life. China's growth mush-roomed before the rules, regulations, and transparent laws were in place to run a capitalist economy over the long haul. Nor is there a competent and corruption-free bureaucracy. Consequently, problems are common in conducting business in China.

Whatever form China's emerging economy continues to take, there is little question that this nation will become one of the world's top economic powers in the next century. If China's economy were to grow as fast over the next 13 years as it has over the past decade, by 2010 its GNP will be larger than that of the United States. Home to one-fourth of the world's inhabitants, China has an influence that will be felt around the world (Barnathan, Curry, Einhorn, & Engardio, 1993; Laris, Clemetson, Liu, & Hirsh, 1997).

experimenting with combined systems that do not fit the typical patterns. Some totalitarian governments may have economic systems that are in effect state capitalism. China represents a notable example of state capitalism.

WHY DO THE ECONOMIC AND POLITICAL SYSTEMS MATTER FOR TEXTILES AND APPAREL?

The following example illustrates the impact of the broader economic-political system on the textile and apparel sectors. This example, using blue jeans, illustrates how the mechanism of the capitalistic market economy responds to serve the needs of consumers. We shall use China's transition from its totally centrally controlled status to a quasi-market economy as an example. For our product examples, let's think about the shift from Mao's traditional baggy blue suits to jeans.

When consumers want to wear blue jeans rather than baggy blue pants, mechanisms of the capitalist system encourage producers to recognize their wishes. Profits accompany the production of what the consumer wants (the jeans), and production is increased to meet the demand. Baggy blue pant production decreases

because declining demand reduces the possibility for making a profit. A limited market for baggy blue pants may continue, but production shrinks to match the shrinking demand.

In countries with centrally planned economies where profits may not exist, mechanisms in the economic system do not encourage production to respond to what the consumer wants. Instead, the government must anticipate consumers' needs. To make matters more complicated, the government's decisions may be based on some objective considered more important than satisfying consumers' needs—for example, providing employment. This has been true in China in the past. In centrally controlled economies, shortages occur in goods that are in demand, and a strong black market demand for jeans results. On the other hand, overproduction of goods that consumers no longer want is common. The mismatch of supply and demand occurs when market mechanisms are not present to reward the prompt response to changes in consumer demand. Without the market mechanism, the manufacturer of baggy blue pants does not receive the message to switch to jeans. Or, even if the signal was received, no reward system in the form of profit makes it worthwhile for the manufacturer to go through the inconvenience of shifting production lines. Only when a government official notices that one product is selling and another is not can production shifts be made.

Try to imagine the monumental task of balancing production and demand from a centralized agency, as was true earlier in Beijing, China's capital. As a way of attempting to visualize the difficulty of this coordination (or control) function, envision being the individual in your town who has been appointed to oversee this task. (Although this hypothetical exercise is oversimplified, it may be helpful in considering how the broader economic-political system influences production for the sector.) As the coordinator, you must attempt to balance all the clothing produced for your area with the needs of all the individuals who live

there. Consider the changing desires for various fashion goods (although this was not an issue previously in China). Think of the mobility of residents and how your supply would be affected as people come and go. (Mobility was restricted by Beijing, in China's case.) Are the sizes what the residents need? Now try to envision being asked to expand your role to that of being the clothing supply and demand coordinator for your country. The task seems overwhelming. This assignment would involve added headaches if you also knew that the government's main goal for the textile and apparel industries was to provide jobs for a large number of unemployed persons rather than to satisfy consumers' needs.

Although we have said that China is a mixed economic and political system, perhaps this mental exercise will be helpful in contrasting the merits of the capitalistic market system to those of a socialist, centrally controlled systemparticularly for sectors such as textiles and apparel. The market system appears to offer many advantages for sectors in which the products often play an important role in personal identity (i.e., being able to find the products the consumer believes to be right for him or her) and for which the timing of products is important. We must keep in mind, however, that individuals in other parts of the world may not view clothing as playing this role in personal identity in the way many persons do in the more-developed countries. The market system provides an environment in which fashion-related industries often respond to new trends with remarkable speed (at least this is the ideal situation, and it occurs with amazing regularity). Moreover, those businesses that do not respond to what the consumer wants have a limited life.

Trade between countries with centrally planned economies and those with market economies can pose difficulties, however. As the People's Republic of China has applied repeatedly for membership in the General 86

Agreement on Tariffs and Trade (GATT), now the World Trade Organization (WTO, the primary international forum for trade matters). many market economy countries have been concerned about China's participation. Concerns stem from the unequal conditions for trade in the centrally controlled Chinese economy. For example, because the Chinese government chose textiles as a primary industry to develop and expand within their economy, the government funneled vast resources toward building the industry. Market economy countries felt that it would be difficult to accept as an equal trading partner (within GATT/WTO) a country whose government made production decisions and subsidized the industry. In other words, if one nation is dependent upon market forces to compete and the other is not, they are not on an equal footing. If profits are required to survive, competing against producers who need not concern themselves with profits can be a serious disadvantage. We must also clarify here, however, that government subsidies and production decisions that result from government policy occur in market-directed economies as well as centrally planned economies.

An understanding of the different economic and political environments in various countries is helpful as we examine textiles and apparel in the global economy. The varied environments have implications both for the production of textile and apparel goods within countries and for exploring the potential for marketing products to nations with diverse systems.

CULTURAL ENVIRONMENTS

As the textile and apparel industries have become global, individuals associated with these sectors must be increasingly sensitive to cultural differences in various parts of the world. ¹⁰ To function effectively and responsibly in the global arena—whether in production, marketing, or other activities—industry representatives must be aware of the important role the cultural environment plays.

Because all the activities of a business are performed by people, human differences give rise to different business practices in various parts of the world. Although there may be variations within a country, generally certain physical, demographic, and behavioral norms are present, which may influence the way business is conducted from one nation to another. Business activities are unlikely to succeed if differences in cultural environments are ignored. In fact, U.S. business representatives often have been criticized for their lack of sensitivity to cultural differences in other countries and their tendency to assume that the American way is better-an attitude known as ethnocentrism. Of course, individuals from any country can be guilty of thinking and acting in this manner.

One of the difficult aspects of ethnocentrism is that we become blind to the fact that we live within a culture and that our views of what is appropriate have been shaped by that culture. We make the mistake of assuming that our way is the natural or only way.

Culture includes all parts of life. In the study of humanity's way of life, anthropologists focus on several dimensions of social heritage that constitute culture. If we look at

¹⁰ **Culture** is defined as the *learned* behaviors, beliefs, attitudes, values, and ideals generally shared by members of a group. Stokes (1984) suggests that one way to understand the concept of culture and how it affects social behavior is to think of culture as the script of a play. Although the actors may vary their performances somewhat, the script provides the basic plot, defines the roles, and provides the dialogue. The script gives the play its basic shape, just as culture shapes human behavior. Culture shapes our views on appropriate behavior for various occasions, beliefs about what is right and wrong, concepts of beauty or ugliness, the appropriate clothing to be worn for various occasions, the meaning of symbols such as a flag or a cross, the meaning of gestures, and other details of life.

MORE THAN THE MANNERS YOUR MOTHER TAUGHT YOU

Remembering the good manners your mother taught you is not enough to succeed in conducting business in other countries in which cultural differences dictate a different set of social behaviors. Although your mother was probably right for the setting in which you lived, she didn't anticipate the fast approach of a global economy in which many of us would interact with individuals whose mothers (and others, of course) had taught them a different set of social customs and expectations. Therefore, today's global business climate requires that we learn about and be sensitive to these cultural differences if we are going to succeed in international commercial endeavors. The following are a few examples of how international behaviors vary.

- Talking business. In some parts of Europe, talking business after the work day ends may turn off hosts. On the other hand, the Japanese spend many of their evenings with business associates in restaurants or bars, and whether they talk business or not, the purpose is business. Declining an invitation for after-work socializing may jeopardize a business deal. However, talking business after just meeting a Japanese person is not considered appropriate.
- Space relationships. In conversations, Latin Americans and Middle Easterners stand very close to others—sometimes toe to toe or side by side, brushing elbows, whereas North Americans feel comfortable standing 2 to 3 feet apart. When Middle Easterners and Americans talk, the Middle Easterner will move closer as the American backs away.
- Who walks where. Although younger Japanese women may not comply with this tradition, Japanese women may walk behind the men or even behind another woman walking beside a man. On one occasion when a Japanese professor and his wife visited the author, the wife seemed unable to keep up as the three of them walked from place to place. When the author slowed down to allow the wife to catch up, she walked even more slowly. Finally, the author realized that the wife was intentionally walk-

- ing behind herself and the professor, her husband, as a matter of tradition and courtesy.
- Greetings when meeting. Although the Japanese and Koreans prefer to greet one another by bowing, they cater to Westerners by shaking hands. If one tries to bow, a Korean friend advised the author to make a "really deep" bow to persons who deserve a great deal of respect. When Middle Easterners and East Asians shake hands, they prefer a gentle grip. Although North Americans are taught that a firm grip shows genuine warmth, East Asians may feel that this suggests aggressiveness.
- Eye contact. North Americans are taught to look individuals directly in the eyes when conversing and when greeting others. Japanese and Koreans are taught to do the opposite; to them, eye contact may suggest disrespect, intimidation, or even sexual overtones.
- Exchanging business cards. When a North Americans receives another person's business card, he or she quickly stores the card in a pocket or another safe place. In contrast, East Asians attach special meaning to one's association with a company and therefore accept a card with great respect. Consequently, when receiving a business card from an East Asian person, one should treat it with a great deal of respect and study it carefully before putting it away.
- Conversation. Europeans follow international affairs and read publications that provide worldwide coverage; therefore, it is important to follow world events to engage in conversations with Europeans. In most parts of the world, politics, religion, and personal matters represent sensitive conversation areas. In some Asian countries, however, individuals are quite curious about visitors, so one should not be too startled if asked one's weight, height, or even income.

Source: Axell, R. (Ed.). (1990). Do's and taboos around the world. New York: Wiley; McGarvey, R. (1992, June). Foreign exchange. Air Magazine, pp. 58–65; and the author's experiences.

culture from the anthropologist's perspective, this gives us a framework for considering the elements of a cultural environment in which international commerce occurs. Each of these elements influences the ways in which business is transacted from one country to another. Various authors define and categorize the elements of culture differently. Herskovits (1952) defined them as follows.

Material Culture

88

Material culture consists of (1) technology and (2) economics. *Technology* refers to the techniques and know-how of a society that are used in the creation of material goods. *Economics* (from the anthropologist's perspective) refers to the way in which people employ their capabilities and the resulting benefits. Both the type of economic organization and the technology employed in a country have a profound impact on the production, distribution, and use of textile and apparel products within that country.

Material culture determines the quality, type, and quantity of products required to maintain the cultural system, as well as the means of producing and distributing them. As an example, clothing demands and the means employed to produce that clothing vary considerably from a developing country like Nepal to a developed nation like the United States. As a contrast in level of demand, a family in Nepal would have difficulty finding storage space in its modest home for the volume of clothing owned by the average U.S. consumer.

Social Institutions

Social institutions include (1) social organization, (2) education, and (3) political structures. These include ways in which people relate to one another, live in relation to one another, govern themselves, and pass on to other generations the expectations for appropriate behavior. Differing social institutions affect such

areas as work relationships, political environments for business, and appropriate appeals for marketing products. For example, in some countries, women's roles are defined in such a way that women would not be permitted to work in textile and apparel production jobs outside the home. In other regions, women constitute nearly all the production workforce for sewing operations, but men would never consider those jobs as being consistent with the definition of the male role. By contrast, in some regions, men have become quite willing to perform sewing operations.

Humanity and the Universe

Humanity¹¹ and the universe include religion, belief systems, superstitions, and their related power structures. Religion and other belief systems can have an all-powerful impact on how people live, the products they use or do not use, when and how they will work, and many other activities related to international business.

In many countries, religion and other belief systems play an important role in determining appropriate dress. For example, in predominantly Islamic countries, many of the workers in textile and apparel factories wear head scarves. See Figure 3-10. A suburban Washington, DC, J.C. Penney store found itself in a legal and public relations nightmare when a Muslim employee was fired because she insisted on wearing a head scarf. Following a press conference by the Council on American-Islamic Relations, Penney sources reported that although the initial local store policy was not to allow any type of head apparel while working on the selling floor, "The response to our associate did not accurately reflect the company's policy regarding reasonable accommodation for an associate's sincerely held religious practices, beliefs, or traditions covering dress and appearance" (Ostroff, August 8, 1996, p. 12). The worker was reinstated.

 $^{^{11}\,\}mathrm{This}$ is an adaptation of Herskovits's category, which referred to mankind.

FIGURE 3-10

In textile and apparel factories in Moslem countries, Islamic women are seen wearing traditional headwear (or scarves), such as this woman in Indonesia.

Source: Photo by Kitty Dickerson.

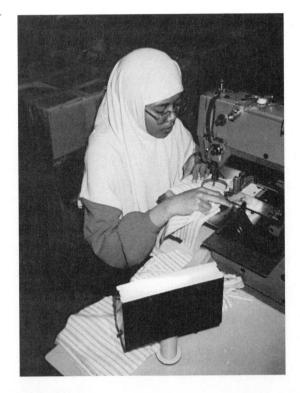

In certain countries, religion plays an important role in the work ethic. For example, Max Weber, a German sociologist, at the turn of the century observed that the predominantly Protestant countries were the most economically developed. The Protestant ethic attached great importance to work. That Protestant ethic appears to have shifted away from the developed countries to other regions of the world ("What Is Culture's," 1986).

Superstition may also play an important role in some parts of the world. For example, Malaysian factory workers have been known to experience attacks of hysteria from seeing a particular variety of ghost. Workers may fall to the floor in convulsions, screaming, and soon the hysteria spreads up and down the assembly line. Sometimes the plant must be closed for a week or more to exorcise the "spirits" (Ehrenreich & Fuentes, 1981).

The importance of religion and belief systems may be seen in textile and apparel facto-

ries in various parts of the world. For example, in Taiwan small shrines may be found in garment factories; these are to ward off bad luck. In Mexico, a predominantly Catholic country, many garment workers have small shrine-like arrangements near their work areas reflecting their faith. In Islamic countries, small mosques may be found in some garment factories so that workers may worship during the day. Although certain textile production requires continuous operation for either technical or economic reasons, religious restrictions in some countries (e.g., Israel) may prohibit continuous production.

Aesthetics

Aesthetics include arts, folklore, music, drama, and dance. Aesthetics play an important role in the definition of what is attractive and desirable within a culture. A person or a product considered attractive in one culture may not be

BOX 3-5

NIKE PROJECTS "UGLY AMERICAN" IMAGE ABROAD

Nike has built a successful global brand, with consumers in virtually every country able to recognize its Swoosh logo. Nike ads are recognizable throughout the world and are tailored to the favorite sports of the countries where the ads appear. However, despite the company's successful efforts to emphasize the sports passions of other countries, Nike is finding that some of its brash, in-your-face ways are not received well elsewhere.

Nike's irreverent approach has included sniping at authority, worshipping athletes, and glorifying the lowly sneaker to parlay Nike into a modern U.S. colossus. Nike and its Swoosh logo have had a tremendous impact on U.S. sports and on popular culture as well. However, a number of critics in other countries are not amused, finding the Nike approach rude and abrasive. The company's lack of sensitivity may be detrimental to its global ambitions.

A Nike ad in Soccer America magazine read: "Europe, Asia and Latin America: Barricade your stadiums. Hide your trophies. Invest in some deodorant. . . . As Asia and Latin America have been crushed, so shall Europe. . . . The world has been warned." A Nike TV commercial of Satan and his demons playing soccer against a team of Nike endorsers was a hit in the United States; however, it was considered too scary and offensive to be shown in prime time when children were watching. Following the deodorant comment, another ad on British TV featured a French soccer bad boy proudly detailing how his spitting at a fan and insulting his coach had garnered him a Nike contract. Later the world's soccer leaders were offended by Nike's marketing buyout of the Brazilian national soccer federation for \$200 million—infecting the sport with the American money-will-get-you-everything disease. Similar incidents have conveyed to other countries that Nike needs to grow up.

Without naming Nike, the general secretary of the International Federation of Football Associations in Zurich condemned an "advertising trend that glorifies violence or bad taste." He commented on Nike's Satan soccer ad: "Technically clever and futuristic as it may be, such a style does nothing to promote values, especially among impressionable youngsters."

The International Olympic Committee has been angry over a Nike advertising campaign during the Atlanta Games that used the slogan "You don't win the silver, you lose the gold." The Committee felt that the ad denigrated the Olympic spirit of competition and belittled all those athletes who came to the Games with little prospect of winning gold medals. The Committee's director of marketing commented, "A company that ignores its social responsibility is playing with fire. No matter how creative you are, if you are inviting youths to question authority and rule and applaud hooliganism, it gets borderline."

As the problems of global diplomacy accumulate for Nike, it appears that the rude bully approach that has attracted America's youth may not win friends and followers abroad. Nike may need a new chapter in its global strategy: sensitivity training.

Source: Based on Delaney, J. (1996, May). Vive la difference. International Business, pp. 42, 43; Thurow, R. (1997, May 5). In global drive, Nike finds its brash ways don't always pay off. The Wall Street Journal, pp. A1, A10.

in another. Therefore, for a textile or apparel firm to market its products successfully in other parts of the world, its marketers must be sensitive to the aesthetic values of that country or region. This may involve modifying products for another market, and promotion of the product will vary greatly. For example, Nike's brash ads, which work in the U.S. market, are offensive to customers in other parts of the world. See Box 3–5. France's uninhibited tele-

vision commercials for undergarments would be considered quite offensive in many parts of the world. Chanel's commercial for Egoiste women's fragrance, featuring beautiful women flinging open windows of a French hotel and crying "Egoiste" as they raged at men's selfishness, did not make a positive impression in the United States, where the fragrance has had limited success.

Aesthetic values may also affect perceptions of quality in different parts of the world. Workers in countries like Japan, where perceptions of quality are largely similar to those of the industrialized West (or perhaps even more discriminating in quality expectations), may be better prepared to produce items suited for export to the West than are workers in some developing countries who have limited technological capacity for producing and limited understanding of Western concepts of quality or aesthetics. Conversely, traditional aesthetic standards in some new exporting countries may require enormous labor-intensive and costly attention to detail in the manufacture of certain products. Such products may be unable to garner enough market share to make their introduction to the international marketplace profitable.

Although firms in many countries have been sensitive to these cultural differences and have adapted products and marketing approaches to local export markets, many have not. Unfortunately, in the past, some American firms viewed foreign markets as a place to dispose of products that were not selling well in the domestic market rather than considering these markets as new opportunities to build long-term sales relationships. This difference in attitude affects the extent to which the firm will adapt to the local culture's aesthetics.

Language

Understanding the language of a country or region is critical to conducting business in

other parts of the world. If textile and apparel firms have production facilities in other countries, plant managers from the firm's home country must be able to communicate with local workers. If companies intend to market their products in other nations, they must have staff who know the language. Often, firms find it advisable to work with the assistance of a national (a local person) in the country to relate effectively in another production or marketing environment.

In addition to the dictionary translation of the language, companies must have representatives who are sensitive to the idiomatic interpretation as well. Many humorous stories of advertisers' blunders in language usage remind us of the importance of language in relating to local markets in selling American products. One U.S. firm was taken by surprise when it discovered that the name of the product it introduced in Latin America meant "jackass oil" in Spanish. Another firm sold a shampoo in Brazil called Evitol. Little did it know that it was selling a "dandruff contraceptive" (Delaney, 1996).

Educational systems in many countries have fostered the study of foreign languages to a far greater extent than has the U.S. system. Because of the geographic size of the United States, and to some extent because of the global power it wielded in the past, Americans have not been motivated to learn foreign languages to the same degree as have people in many other countries. As a result, Americans typically expect representatives from other countries to communicate with them in English.

Recently, however, the world economy has fostered an increase in second language learning by Americans. Many U.S. companies recognize that to compete overseas they must have multilingual employees, as many of their global competitors do. As a result, enrollment in foreign language courses has grown dramatically. Moreover, a noticeable shift from European languages to Asian languages is apparent.

SUMMARY

This chapter provided an overview of several areas important to the understanding of how the textile and apparel industries fit into the global context. An understanding of differing economic, political, and cultural environments is critical to functioning effectively in the global textile and apparel markets.

A review of country groupings included the common categories used in discussions on trade, with per capita GNP as a common measure used in making these distinctions. These country groupings reflect dramatic differences in relative wealth and prosperity—differences often resulting from varying levels of trade activity.

Several regions of special significance to textile and apparel production and trade were presented. Because of references throughout the book to these regions, this chapter helps the reader become familiar with the regions and understanding the major economic and political changes that have occurred and are now taking place there. In today's global economy, these changes have an impact not only on textile and apparel production and trade for the country or region, but also for these industries in many other countries. The formation of regional trading blocs was also considered, along with brief discussion on the implications of these blocs for the broader global trading community.

The differences in the relative wealth of nations have led to a division between the more-developed and less-developed nations. Many less-developed countries planned their economic development around industrialization and trade, attempting to imitate the successful strategies of the more-developed countries. Unfortunately for many less-developed countries, these aspirations have never materialized. Through what is known as the *North-South dialogue*, the developing nations have become increasingly vocal in asking that their needs be considered more fully. The North-South division is particularly relevant to textile and apparel production and trade.

Different types of economic and political systems make a dramatic difference in the environment in which a country's textile and apparel industrial and trade activities occur. These environments affect the ways in which all segments of a textile complex might respond to meeting consumers' needs, with quite varied results.

The cultural environment of each country influences the way in which textile and apparel firms conduct business there. Whether a company is establishing production operations in another country or attempting to sell its products in another market, sensitivity to differing cultural environments is critical to success and to understanding the impact of business practices on the participants.

GLOSSARY

Capitalist economic systems are those in which the factors of production are owned by individuals and allocation decisions are made by market forces.

Centrally planned system is an economic system in which the government plays a primary role in the allocation of the nation's resources.

Common market has the characteristics of a custom unit but also eliminates restrictions on factor mobility (i.e., resources used to produce goods and services—e.g., labor and capital—may be transferred, at least to a certain degree, across national boundaries).

Culture is defined as the learned behaviors, beliefs, attitudes, and values generally shared by members of a group. Culture refers to the social heritage of the human race—"the totality of the knowledge and practices, both intellectual and material of society. . . . [It] embraces everything from food to dress, from household techniques to industrial techniques, from forms of politeness to mass media, from work rhythms to the learning of familiar rules" (Guillaumin, 1979, p. 1).

Customs union is a form of economic integration that eliminates internal tariffs and establishes a common external tariff.

Development, as defined by Fisher (1992), is "the process by which the political, social, and especially economic structures of a country are im-

proved for the purpose of assuring the well-be-

ing of its populace" (p. 15).

Economic development is "a process of improvement in the material conditions of people through diffusion of knowledge and technology" (Rubenstein, 1992, p. 302).

Economic integration is the removal of economic barriers between or among national economies.

Economic system is the way of organizing the production of goods and services that people want and then distributing those products to the enduse consumer.

Economic union is similar to a common market but has a degree of harmonization of national economic policies.

Economy is an abstraction that refers to the sum of all our individual production and consumption activities.

Ethnocentrism is the belief that one's own group or culture is superior, the tendency to view other cultures in terms of one's own. An ethnocentric attitude in international business usually means that a firm believes that what worked at home should work abroad, ignoring differences in the culture and the environment.

Euro is the name of the common currency the EU will adopt on January 1, 1999.

Factors of production are the resources used to produce goods and services to satisfy wants. Land, labor, and capital are three basic factors of production.

Foreign direct investment (FDI) is foreign investment in plant(s) and equipment. This generally refers to ownership or part ownership of foreign production facilities.

Free trade area (FTA) is a form of economic integration in which tariffs are removed among members but each member maintains its own tariff against non-FTA countries.

Gross domestic product (GDP) is a yardstick of economic activity in a country. It is the market value of the final output of goods and services produced domestically in a country in a year. Unlike GNP, it excludes profits made by the overseas operations of a country's firms. By the same token, if temporary migrant workers are employed in a country, the output of these workers is included in GDP. In short, GDP is a measure of all the goods and services produced by workers and capital located in a country, regardless of its ownership or the origin of the workers.

Gross national product (GNP) is a measure similar to GDP, except that it is the value of output produced by domestic residents. Although data from many sources are available only in GNP terms (e.g., some international agencies), in today's international economy the GDP measure may be more appropriate as workers go to other countries to work and as corporations move their capital to other countries to produce.

Level of living refers to the material well-being of individuals or families. This includes the basics of food, clothing, and shelter. For more affluent societies, distinctions in level of living may include many other things beyond these basics.

Market refers to a group of firms and individuals that are in touch with each other in order to buy or sell some good or service (Mansfield, 1983).

Monetary union is a group of countries that share a common currency, as the EU is expected to do in 1999.

Multilateral refers to many ("multi-") countries.

Parity refers to equality in status or treatment. This term is used in seeking trade conditions (i.e., tariff-free trade) for the Caribbean countries equal to those Mexico has under NAFTA.

Per capita GNP is the country's GNP divided by midyear population.

Political system is built around ideologies (a body of constructs, theories, or what we might commonly call the *philosophy* of a society) and provides a means of integrating a society into a functioning unit.

Quota is a limit on the quantity of a good that may be imported in a given time period.

Socialist economic systems are those in which all nonlabor means of production are owned by the state, which controls resource allocation.

Subsidies (government subsidies) are a form of government payment or support to exporters so that they may compete more effectively in world markets. *Indirect subsidies* are applied to components (e.g., the fabric for shirts) that become part of exported products. Indirect subsidies may also include lowcost loans, state health insurance, and so on.

Trading blocs are groups of countries participating in a special trade relationship that encourages and facilitates trade within the region, often in preference to that with outside nations.

Transition economies are those countries formerly under the Soviet Union's central control that are now struggling to become market economies.

94

SUGGESTED READINGS

- Axtell, R. (Ed.). (1990). Do's and taboos around the world. New York: Wiley.
 - A guide to international behavior and protocol.
- Axtell, R. (Ed.). (1991). Gestures: The do's and taboos of body language around the world. New York: Wiley. A guide to multicultural interpretation of gestures.
- Cooper, H. (1988). Foreign language and today's interdependent world. *National Forum*, 68(4), 14–16. This article addresses the importance of foreign language education.
- Delamaide, D. (1994). *The new superregions of Europe*. New York: Dutton.
 - An examination of the transformation of Europe into a region of greater unity, yet with many divisions.
- Ehrenreich, B., & Fuentes, A. (1981, January). Life on the global assembly line. *Ms.*, 54–71.
 - This article reviews important economic, political, and cultural issues associated with work "on the global assembly line."
- Ellsworth, P. T., & Leith, J. C. (1984). *The international economy*. New York: Macmillan.
 - This book provides a helpful overview of the international economy; its approach blends theory, history, institutions, and policy.
- Enderlyn, A., & Dziggel, O. (1992). Cracking Eastern Europe. Chicago: Probus.
 - A look at the political, economic, and social environment in Eastern Europe.
- Harris, M. (1985). *Culture, people, nature* (4th ed.). New York: Harper & Row.
 - An introduction to general anthropology.
- Hayward, D. (1995). International trade and regional economies. Boulder, CO: Westview Press. *The influence of regional blocs on international trade.*
- Humphreys, J. (1996, September). Mercosur magnetism. International Business, pp. 41–45, 50. *An examination of the impact of economic integration and regional blocs.*
- Mansfield, E. (1983). *Economics*. New York: W. W. Norton.
 - A general economics textbook with a useful section on international trade.
- Michelmann, H., & Soldatos, P. (Eds.). (1994). European integration: Theories and approaches. Lanham, MD: University Press of America.
 - Historic, legal, and economic perspectives on European integration.

- Naisbitt, J. (1994). Global paradox. New York: Avon. The author focuses on how, as the world becomes "smaller" and more integrated, individuals and groups seek to identify with smaller units.
- Naisbitt, J. (1996). *Megatrends Asia*. Old Tappan, NJ: Simon & Schuster.
 - The author reports on the rapid development and other changes occurring in Asia and how the eight Asian megatrends he identifies are shaping the world.
- Price Waterhouse. (various dates, usually current).

 Doing business in ______. Various countries:
 Author.
 - A series of publications on business conditions in the countries in which Price Waterhouse has offices or does work.
- Rubenstein, J. (1992). *The cultural landscape: An introduction to human geography* (3rd ed.). New York: Macmillan.
 - An overview of the cultural characteristics (such as language, social customs, and industry) of the world presented with a topical approach.
- Thompson, W. (Ed.). (1978). *The Third World: Premises of U.S. policy*. New Brunswick, NJ: Institute for Contemporary Studies. *Papers on U.S. policy for a changing Third World*.
- United States Chamber of Commerce (International Division). (1989). Europe 1992: A practical guide for American business. Washington, DC: Author. This book provides a good overview of EU integration and the implications for firms in other countries that wish to conduct business in the unified EU.
- United States International Trade Commission (1985, July). *Emerging textile-exporting countries*, 1984. (USITC Pub. No. 1716). Washington, DC: Author.
 - A study of emerging textile-exporting countries expected to become increasingly important in global trade.
- World Bank (annual). World Bank atlas. Washington, DC: Author.
 - An annual source of economic and social indicators that describes trends and characterizes differences among countries.
- World Bank (annual). World development report. Washington, DC: Author.
 - An annual review of social and economic conditions of the world, with a special emphasis on the developing countries. Each annual volume focuses on a timely area of concern.

The subject of textiles and apparel in the international economy is so extensive that focusing in a meaningful way on what is happening may be difficult. Because so many things happen simultaneously, it is difficult to sort the meaningful occurrences from those that are not without using some kinds of organizing concepts. These organizing concepts are needed to focus attention on the important aspects of a situation and may be thought of as the building blocks for theories (McNeill, 1986).

Theories from a number of fields provide a helpful framework in which to consider the economic, political, and social concerns associated with textiles and apparel in the international economy. Although many aspects of production, and even trade, of these goods occurred before the theories developed, these theories help to provide systematic approaches for considering this important area of study. Theories help to explain existing situations or allow us to speculate on the ideal that perhaps should prevail. The goal of this chapter is to present several relevant theories and models that apply to the focus of this book. This chapter is selective; it does not include all existing theories that might be considered.

REASONS FOR TRADE

Trade between nations occurs for the same reasons that trade takes place within a nation people seek to enjoy higher standards of living and therefore greater satisfaction. As individuals or families, most of us choose to participate in the exchange of goods and services rather than to be self-sufficient. Others can produce various products and services more efficiently than we can, so we choose to exchange the money we receive from producing our goods or services (i.e., what we do for a living) for those produced by others. As an example, most of us would not choose to produce our own shoes. We lack the skills to produce shoes that would be comfortable and durable. Instead, we exchange some of the money we earn in selling our own goods and services (our income) for shoes produced by firms employing machines and people who have the skill to make shoes of the quality we want to wear.

Trade among nations can provide the same advantages we identified in choosing to have others make our shoes. According to traditional theories, trade fosters specialization, and specialization increases output. When

96

countries trade, one nation can specialize in goods and services it produces particularly well and can trade these for goods and services other countries are good at producing. A particular country as well as its trading partners benefit by the exchange. As consumers come to depend on products that originate in many other countries, they discover that trade has contributed importantly to the global interdependence that characterizes the latter part of the 20th century.

In this chapter we consider some of the classical economic theories on trade. We also consider some of the newer theories—coming from a variety of disciplines—that give differing perspectives on why trade occurs and who benefits from this trade.

BASIC ECONOMIC CONCEPTS AND TRADE

Ankrim (1988) distilled basic economic concepts into what he considered five *concept clusters* that underlie all economic theory. In other words, human behavior related to economic activities might be explained to a great extent by these five clusters. These concepts are basic to economic activity on the local, national, and international levels. The trade theories we consider next in this chapter are based on these underlying concepts.

Scarcity and Choice

No society can provide everything its people want. Resources of time, labor, machinery, and land are scarce. Therefore, our wants generally exceed our resources—especially since hu-

mans tend to have insatiable wants. Consequently, scarcity requires that we choose between competing demands on resources. Economics, as a discipline, is based on the concept of choices that are necessitated by scarcity.

Opportunity Costs

The **opportunity cost** of using resources a certain way is the value of what these resources could have produced if they had been used in the best alternative way. That is, the sacrifice a person or country incurs to produce a product might be considered in view of what the next best application might have been. For example, growing cotton in New York City would make no sense because of the sacrifice of valuable land resources to produce something of limited value compared to other, more profitable uses for the land. This far-fetched example suggests that the opportunity costs of growing cotton in New York City are too great. A key point is that the sacrifices affect the values of products. If cotton were grown in New York City, its price would be prohibitively high because of the potential for other, more profitable use of the land. In other words, cotton will not be planted in New York City because the opportunity costs are too high.

Rationing and Incentives

Because our collective wants exceed the available supply of goods and services, we must devise ways of rationing (distributing) the scarce supply. Rationing systems are devised to distribute the scarce goods and services, and people respond to rationing schemes to get some of the supply. For example, in the United States, goods and services are usually given to persons willing to sacrifice the most money. In short, in market economies, prices determine who will receive scarce commodities. In centrally planned or mixed economies, people respond to the rationing systems that operate there. People respond to incentives in pre-

¹ This perspective reflects the neoclassical international trade theory of Adam Smith and David Ricardo, whose theories are discussed briefly early in this chapter. We must keep in mind that this is orthodoxy, and not everyone believes it (McGowan, 1989).

dictable ways. This provides an opportunity to predict behavior and forecast the consequences of that behavior.

Laws of Supply and Demand

These relationships are described by two separate theories that have proven true so consistently that they have been labeled *laws*. Both show how people respond to incentives, particularly in market-directed economies.

Law of Supply

The **law of supply** is a general statement about how producers adjust the quantity of goods or services available in relation to incentives (prices in market-directed economies). When the reward offered for a specific product rises, this reward provides an incentive to produce more of the product. For example, the popularity of cotton textiles among consumers has motivated a number of U.S. farmers to produce cotton as an income crop. The failure of cotton crops in other countries began driving up cotton prices, reaching a record high of around \$1 per pound in 1995.2 Once the king of all crops grown in the South and later a symbol of rural decline, cotton began making a strong comeback as the crop of choice in response to the high prices. Farmers who had no cotton-growing equipment and equipment suppliers were sold out; however, farmers devised makeshift machines to do the job. Many of the farmers had never seen this demanding crop grown. The following describes the cotton fever that prevailed:

Little wonder many farmers can think of little else. "They're going to have new trucks and their wives will have new diamond rings," says J. W. Kellar, manager of Farmers Gin Cooperative in Cotton Plant, Ark.

As planting now begins in earnest, some farmers from California to the Carolinas are giving up soybeans, sweet potatoes, rice, peanuts, corn and even tobacco in favor of cotton. Cotton acreage here in Newport is expected to rise tenfold from last year to 2,500 acres. . . .

The boom is also raising prices that farmers must pay. Seed and fertilizer dealers report sales up as much as 30%, and there is some talk of shortages. . . . Prices of cotton fertilizer are up 50% since last year. . . .

Economists are beginning to fear another classic boom-to-bust cycle, with farmers taking on heavy debt during the good times, then defaulting on 15-year and 20-year loans when prices fall and ending up losing their farms.... And feeding fears... are county agricultural agents' reports of more and more U.S. farmers jumping on the cotton bandwagon.

"If we have a good crop year, we will flood the market," says Carl Anderson, an economist and marketing specialist with the Texas Agricultural Extension Service. "High prices usually cure high prices." (Gerlin & McCartney, 1995, pp. A1, A8)

Within 2 years, as other cotton-producing nations gathered successful crops, the demand for U.S. cotton lessened. Cotton prices dropped to slightly over 70 cents per pound. See Box 4–1 for another example of how the law of supply works.

Other textile examples help to illustrate this concept. Vicuna fiber from the endangered vicuna found in the Andes—a prized and precious wool once reserved for clothing for Incan nobility—has sold in recent years for \$3,000 to \$4,000 per yard in Europe. The vicuna population, reported at 250,000 in the late 1950s, was devastated by uncontrolled hunting, causing a drop to 7,500 vicunas in the late 1960s. Unlike most other specialty hair animals, vicunas must be killed to harvest their wool. Until recently, marketing of vicuna wool was banned; however, the ban meant big profits for poachers and the underground vicuna trade. By the late 1980s, Peru's vicuna population had reached nearly 120,000. By 1989, Peru was per-

² For illustrative purposes here, we are not considering the added complexity of federal price support programs for cotton farmers.

BOX 4-1

EXAMPLE OF SUPPLY CURVE

The supply curve shown in Figure 4–1 relates the quantity of cotton supplied to prices; the upward slope indicates that the quantity supplied increased as prices increased. Just as farmers increased the supply of cotton as it became more profitable, the same thing happened in this hypothetical example. At \$200 per bale 10,000 bales were supplied, but at \$300 per bale 39,000 were supplied. The shift of the supply curve from S to S₁ represents an increase in supply that may occur for various reasons. In addition to increased cotton prices, the relative prices for other crops influence farmers to choose one crop over another. Improved technology (e.g., advanced mechanical pickers and chemicals that defoliate the plants, control plant height, fatten the bolls, and speed ripening) has been an important factor. A decrease in supply would be represented by a shift of the curve to the left.

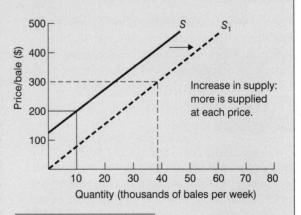

FIGURE 4–1
Example of a supply curve.

mitted once again to har vest vicuna wool and transform it into cloth. If we apply the law of supply, we might speculate that most Peruvians made an effort to protect vicunas not only to preserve the species but also to reach a point once again where they would be able to harvest this treasured wool fiber bringing exorbitant prices (Scott, 1989).

Law of Demand

The **law of demand** is a general statement about how individuals respond to changes in price. This law applies to both individual consumers and **aggregate** (combined) **demand**; aggregate behavior is considered market demand. *Rising prices for a product usually cause a drop in demand*—that is, there is a tendency to "economize." For example, when cotton

prices are unduly high, consumers are willing to accept products made from other fibers. Both producers and consumers respond to changes in product prices in predictable ways. Rising prices are a market signal telling producers to supply more and an incentive to consumers to demand less of a good. As Figure 4–2 illustrates, when prices fall, producers have an incentive to supply less—but consumers have an incentive to demand more of a product.

Other textile examples illustrate how the law of demand works. For example, if we refer back to the earlier vicuna example, we can guess with reasonable accuracy that the demand for vicuna wool fabric selling at \$3,000 to \$4,000 per yard was quite limited. Only elite customers of European fashion houses might have searched for fabrics in that price range.

BOX 4-2

EXAMPLE OF DEMAND CURVE

In the hypothetical example illustrated in Figure 4–2, the demand curve shows how individuals respond to changes in price for cotton products. At \$200 per bale the demand is 57,000 bales per week; at \$300 per bale the demand is 19,000 bales per week. Demand may increase because of a rise in income, a rise in the price of a substitute, a change in taste favoring the commodity, or an increase in the population. In our cotton example, demand may also increase because of consumers' preference for natural fibers or perhaps because rayon prices increase (i.e., creating a smaller price advantage for rayon over cotton).

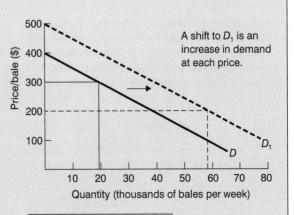

FIGURE 4–2
Example of a demand curve.

That is, demand diminished as prices increased.

In another instance, 1989 cashmere prices began rising in China, where about 60 percent of the world's cashmere—and generally the best-quality cashmere—is produced. Shortages caused the price of cashmere—already an expensive luxury fiber—to increase by as much as 50 percent. These shortages boosted the prices of apparel using cashmere fiber; that is, the garment factories were forced to charge more to cover the rising cost of the cashmere yarn. As a result, the increased price of cashmere garments reduced the demand by consumers unwilling to pay the higher prices.

Equilibrium Price

And finally, Figure 4–3 illustrates another important related concept, **equilibrium price**, the price at which the quantity demanded equals the quantity supplied. Our cotton example also illustrates this concept.

Gains from Voluntary Exchange

In a voluntary exchange—that is, buying and selling of goods and services—both parties must feel they are benefiting. Both parties are pursuing their own best interests and believe they will be better off as a result of the trade.

Ankrim (1988) concluded that the economic perspectives in the five concept clusters are applicable in studying both world trade and the U.S. economy. These clusters are helpful in understanding how resources are allocated—at the global, national, or other level—for the use of humans.

Although the motive of improving one's standard of living may be basic to all people, the circumstances under which it is applied vary greatly from one part of the world to another. Diverse cultural and political backgrounds, as well as different economic systems in various countries, mean that these concepts tend to be applied quite differently from one place to another.

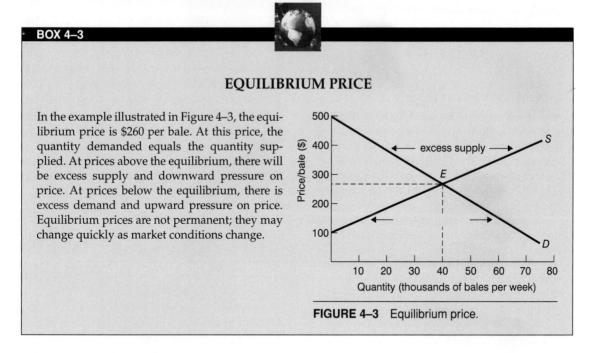

BASES FOR TRADE

International trade occurs when both the buyer and seller expect to gain from the exchange. Otherwise, there would be no reason for the trade. Therefore, participants in world trade are responding to the positive incentive to gain. Both importers and exporters believe they are trading something that is relatively less valuable for something that is relatively more valuable in their country. As participants in trade, most countries *specialize* in the production of various goods and services—at least to some extent. It is important to consider what constitutes the basis for this specialization and trade.

The type and the quantity of resources a country has—human and nonhuman resources—provide important bases of specialization for trade among nations. Specialization occurs to some extent because of unequal distribution of resources. If countries have natural resources such as farmland and minerals or human resources for a workforce, specialization for trade usually takes advantage of those plentiful resources

within each country. Although almost all theories acknowledge the importance of resources, some newer approaches emphasize the special importance of *how a nation uses its resources*.

Additionally, we must remember that the bases for specialization change over time as the resources and priorities in countries change. As a result, shifts in international specialization—and, therefore, trade—will occur. For example, changes in international specialization dramatically affected trade in textiles and apparel, accounting for many of the difficulties in these sectors. That is, as many developing countries shifted labor and other resources from agricultural production to textile/apparel manufacturing, this change altered earlier global patterns of specialization dominated by the more-developed countries.

TRADE THEORY

Most traditional trade theories are based on the economic concepts discussed previously. These classic theories have been a useful means of examining what products or services might be produced most competitively in certain nations, as well as where one might produce and sell products most advantageously. An understanding of the classic as well as the newer trade theories also is helpful in considering the potential impact of trade policies. The following sections provide a brief review of some of the more relevant trade theories for the purposes of this book, beginning with theories that were important historically and including later theories as well.

Mercantilism

Between 1500 and 1750, when nation-states began to emerge, the dominant powers of the time such as England, France, and Spain competed and often fought to acquire colonies and gold. Mercantilism was an economic philosophy based on the idea that a country's wealth depended upon its holdings of treasure—in particular, gold. Mercantilism today might be called *economic nationalism* because of the emphasis on building domestic industries and domestic economies. One nation's prosperity was usually achieved at a loss to other nations.

Leaders believed that their nations gained from participation in trade only if they had a favorable balance of trade (a balance in which the value of exports exceeded that of imports). Therefore, governments established policies that emphasized exporting more than importing and sought the continuous inflow of gold from their trade surpluses. Under this philosophy, the main goal was to make one's nation rich and powerful through the regulation of trade and the domination of its colonies. Strict trade rules promoted exports and limited imports. Merchandise trade balances were carefully monitored. Since textile products were among the earliest manufactured goods traded, a mercantilist climate meant that England tried to force its colonies to buy British textile goods and refused to accept those of the colonies. The British went so far as to ban the sale of textile

equipment to the colonies to keep the colonists dependent on imported fabrics.

Although mercantilism declined in popularity by 1800, this philosophy left an imprint on the terminology used to discuss trade. We still refer to a "favorable" balance of trade when exports exceed imports or to an "unfavorable" balance when the reverse is true. Because of the typical interpretation of these words, we tend to think of favorable as beneficial, whereas economists now often disagree on this point. In the mercantilist era, the difference in trade (the "imbalance") was compensated for by the transfer of gold, but today credit is granted to the deficit country. (As a result of today's U.S. trade imbalance, other nations are using accumulated U.S. currency to buy U.S. assetsland, companies, and buildings.)

Absolute Advantage

Adam Smith (1930/1776) developed the theory of absolute advantage, which suggests that different countries can produce certain goods more efficiently than others. In contrast to mercantilism, which had promoted national self-sufficiency and local production, Smith questioned why consumers in a country should be required to buy domestic goods when they might purchase foreign-made items more cheaply. His views fostered the idea of an international division of labor. In his book The Wealth of Nations (1930/1776), Smith challenged the mercantilist view that a nation's wealth depends on its stockpile of treasure. Instead, he believed that the real wealth of a country consisted of the goods and services available to its citizens. In contrast to the mercantilist emphasis on the well-being of the nation-state, Smith's emphasis was on the welfare of the individual. He believed that individuals and businesses, given freedom of choice, would look after their own interests, providing the most effective regulation of commerce and trade. This became known as his laissez-faire (let-alone) philosophy.

As part of Smith's theory, he advocated that nations should be free to trade with one another without restrictions. The opportunity to trade freely would encourage nations to specialize in the product areas in which each had an absolute advantage. Thus, this theory encouraged a nation to concentrate on industries in which its costs are lowest. It suggested that a country trade part of its output for goods that other nations can produce more cheaply. That is, a nation exports a product if it is the world's low-cost producer. Trade on this basis, according to Smith, would provide all nations with a greater quantity of goods at low costs.

102

According to Smith's theory, nations would shift resources to those industries in which they could be most competitive and labor (the workforce) would shift accordingly. The "advantage" in this theory included either

- a natural advantage available to produce a product because of climate or natural resources, or
- **2.** an acquired advantage achieved through technology or skill that enables the country to produce a differentiated product.

In the textile sector, a country may have a natural advantage in producing certain vegetable fibers such as cotton or ramie because of the availability of agricultural land and a suitable climate, but the country may have limited technical capabilities to produce manufactured fibers. Certain regions of China and India would fit this description. Another country may have the technical sophistication to produce synthetic fibers but lack the land to produce cotton or ramie. Japan would be an example here. Under Smith's theory, each of these countries would shift resources to the production in which it had an advantage and would specialize in these areas in world trade.

Let's consider a hypothetical example³ to illustrate how absolute advantage might work. In the following example, Panama produces shirts but not computers efficiently. Using the labor and equipment available, it takes a worker in Panama 1 hour to produce a shirt and 10 hours to produce a computer.

	Time to Make 1 Shirt	Time to Make 1 Computer	
Panama	1 hour	10 hours	
Canada	1.5 hours	4 hours	

On the other hand, Canada has the resources (the skilled labor and equipment) to produce computers more efficiently than Panama, but in our hypothetical case, Canada does not produce shirts as efficiently. In this example, if Panama and Canada decide to specialize in what they produce best, Panama will produce shirts and Canada will make computers, as depicted in Figure 4-4. If we considered the difference in output for a workweek, the results would make an even stronger case for specialization. Admittedly, this is an oversimplified example because international trade involves many different products and countries. The general principle holds, however, that if each country specializes in producing those items in which it has competitive advantages and trades with other countries, more goods and services are available for everyone.

Comparative Advantage

Adam Smith's theory of absolute advantage came under criticism because it assumed that an exporting nation must have an *absolute* advantage—that is, it must be able to outpro-

³ The time given to make the products in each country is strictly hypothetical and is not intended to reflect on the country or its workforce. Additionally, the discussion is intended to be illustrative and not prescriptive.

FIGURE 4-4

Each nation gains by producing and trading those products and services in which it has some natural or acquired advantage.

Source: Illustration by Dennis Murphy.

duce its competitor nations. Critics believed this theory overlooked the nations that had no superior production areas. Many poor countries were not superior producers in any area, while a few countries were able to produce nearly all products at an absolute advantage; thus, Smith's theory did not encompass these extremes. In the early days of textile trade, a few countries had the absolute advantage in the elementary production available at that stage, whereas most of the smaller or poorer countries had an advantage in few or no textile production areas. Smith's theory might have suggested that the poorer

countries had no justification for entering textile trade.

David Ricardo, one of the most significant writers of the 19th century in influencing trade theory, extended Smith's work by showing that even countries without absolute advantages could benefit from specializing in goods that had comparatively low production costs, particularly in comparison to nations with which trade is intended. Ricardo's theory relied heavily on the *labor theory of value*, which asserted that the value of any commodity is determined by its labor cost: "The value of any commodity... depends on the relative quantity of labour which is necessary for its production" (Ricardo, 1960/1817).

The principle of relative labor cost determines the value of exchange for goods. For example, if it takes 10 worker-hours to produce a computer and 2 worker-hours to produce a shirt, then the value of the computer will be five times as high as that of the shirt.

Ricardo used this labor theory of value to develop his theory of **comparative advantage** (or relative advantage), which advocates that a country will produce and export products that use the lowest amount of labor time relative to foreign countries and import those products that have the highest amount of labor time in production relative to domestic products. Further, only *relative* amounts of labor matter.

In the last example, Panama had an absolute advantage in producing shirts and Canada had an absolute advantage in making computers. We will now present an example in which one country has an absolute advantage in the production of both computers and shirts and will consider whether countries should still trade.

	Time to	Time to	Time to
	Make 1	Make 5	Make 1
	Shirt	Shirts	Computer
Panama	2 hours	10 hours	15 hours
Canada	1 hour	5 hours	5 hours

In this example, Canada has an absolute advantage in producing both shirts and computers. This does not mean that Panama should refrain from producing both items because it has a disadvantage in both. In this case, according to Ricardo, if the two countries decide to specialize and trade, Canada should specialize in manufacturing the product in which its advantage is comparatively greater (computers) because Canada is 10 hours more efficient in making each computer, whereas it is only 1 hour more efficient in making each shirt (or for five shirts—the same time required for making a computer—Canada is only 5 hours more efficient). According to this theory, Panama should specialize in shirts—in which its disadvantage is comparatively less (a difference of 5 hours for making five shirts compared to 10 hours for making a computer). This is what is known as comparative advantage. As a result, both nations gain if they specialize in the production of those things they can produce at the lowest relative cost.

Ricardo's theory, which focused on comparative cost, was an advance over Smith's philosophy. A country can be at an absolute disadvantage in all lines of production yet be an active participant in global trade. Perhaps a country needs to have only a comparatively *smaller disadvantage* and not necessarily an absolute advantage. Countries with comparative advantage in most production areas may gain more from trade by focusing on the areas in which they have the greatest comparative advantage. In short, Ricardo's theory was based on differences in labor productivity from one country to another.

Both Ricardo's and Smith's theories were based on assumptions that should be clarified. (1) Both assume that resources are fully employed—that is, that no shirt makers or computer makers are experiencing unemployment. (2) The theories also assume that countries are primarily interested in profit maximization or maximum efficiency when, in fact, they may be more concerned about objectives

other than output efficiency. An example of this would be the textile and apparel industries in China, where providing employment has been more important than output efficiency. (3) Ricardo's example, like the one above, uses two countries and two commodities, which may not be very realistic. (4) Neither theory considers the cost of transporting products. (5) Both theories assume that resources can move from one good to another domestically but are not free to move internationally. Although Ricardo's theory and the modifications of it that followed had shortcomings, this philosophy was important in articulating the gains from trade. Ricardo's theory of comparative advantage shaped trade philosophy until well into the 20th century and is still a fundamental concept of trade and in shaping many nations' trade policies.

International trade in today's world is far more complex than the simple examples used to illustrate absolute and comparative advantage. Nations generally specialize, however, in producing those things for which they have an absolute or comparative advantage. Increases in international trade have encouraged specialization; in turn, this specialization has helped to increase the total amount of goods and services produced in the world.

Factor Proportions Theory

Ricardo's comparative advantage theory is based on the relative differences in the productivity of labor among nations; however, the theory fails to explain *why* this comparative advantage (relative efficiency of labor) exists. Secondly, although Smith's and Ricardo's theories show how specialization increases the output of different countries, these theories give no clues in identifying the product areas in which countries might have their greatest advantage. Instead their theories depend on the influence of the free market to determine in what areas countries might compete most effectively.

BOX 4-4

COMPARATIVE ADVANTAGE IS NOT FOREVER

Countries may have a comparative advantage in some type of production at one point and later discover that new developments have left them with almost no market at all. As an example, Tanzania was once one of the major world producers of sisal, and production of this fiber was a mainstay of the country's economy.

However, the introduction of manufactured fibers virtually eliminated the demand for sisal because the new fibers were cheaper and functioned as well as or better than sisal. As a result, sisal can be sold on world markets at prices dramatically less than those it formerly brought.

Two Swedish economists, Eli Heckscher and Bertil Ohlin, expanded on Ricardo's comparative advantage theory when they developed the factor proportions theory. This theory is based on two requisite factors of production capital and labor. According to the Heckscher-Ohlin theory, differences in countries' endowments of labor relative to their endowments of land or capital explain differences in factor costs. For example, if labor were abundant in relation to land and capital, labor costs would be low and land and capital costs high. On the other hand, if labor were scarce, the cost of labor would be high in relation to that of land and capital. In other words, that which is scarce is dear.

According to the Heckscher-Ohlin theory, a country should specialize in and export those commodities that use resources in good supply (and which are, therefore, cheaper). Capital-abundant countries will export products that use a great deal of capital in their production (capital-intensive products). For example, Switzerland might be expected to export hitech textile production machinery because of the capital required for its production.

Countries with a good supply of labor, compared to capital, should have a comparative cost advantage in the production of commodities that use more labor than capital. Therefore, this theory suggests that the countries with

abundant labor should export labor-intensive products (e.g., labor-intensive apparel products) and import capital-intensive ones (e.g., hi-tech industrial textile equipment) from countries with relatively abundant supplies of capital.

When examining relationships of land and labor, we note that observations of global production and trade support the notion that where there are many people (labor) in relation to the amount of land, land prices are quite high. Manufacturing follows this pattern as well. As an example, land in Beijing, China, is scarce in relation to the number of persons and is quite expensive. Apparel production is an ideal industry because it requires little space per worker and factories can be several stories high. On the other hand, the open, abundant land in rural mainland China (where there are fewer people in relation to the amount of land) is ideal for growing cotton.

In contrast to what might be expected under this theory, studies of land-to-capital relationships have produced surprising findings. These studies have found that U.S. exports were less capital-intensive and more laborintensive than U.S. imports. This may be explained because the Heckscher-Ohlin theory did not take into account the differences in labor (skills, training, and education) in various countries. Thus, this theory is valid only when

human capital in the form of training and education (requiring capital expenditures that do not show up as traditional capital outlay) is included in the calculation of a nation's capital stock.

Although the Heckscher-Ohlin theory has been helpful in explaining trade on the basis of the relative use of factors of production, this theory has shortcomings today. For example, much of the current trade in manufactured products takes place between countries with similar factor endowments.

Product Cycle Theory

The theories discussed up to now apply for the most part to standardized or homogeneous products. In addition, there is a need for theories that have some predictive ability; this is particularly true for new products. In the 1960s, Vernon (1966) and others developed a body of theory based on the stages of a product's life and postulated that certain kinds of products go through a cycle consisting of four stages: introduction, growth, maturity, and decline. Although Vernon's original product life cycle theory was not related to location, later he argued that each phase had important implications for location in terms of both production and demand. Adding the location dimension, Vernon speculated that production moves from one country to another as the product's life cycle changes; the stages are on a continuum rather than being distinct. This theory attempts to explain why a country may have a technological advantage in producing a particular product at a particular time. As a way of making the stages more relevant, let us consider the development and production of popular running shoes as an example.

1. Introduction. According to the product cycle theory, producers in a country (most often a developed country) observe a need and a potential market for a product to fill the need. New products are more likely to be developed

in response to domestic rather than foreign needs because the producer is able to observe the potential market close at hand compared to that in another country. At the early stage, technology to assist in production is undefined, and product development expenditures may be relatively high. Advocates of the product cycle theory believe that new products are more apt to be produced in the industrial countries. Most production at this stage is focused on the domestic market, with a limited amount of the product exported to other countries. Usually these exports go to other industrialized countries where consumers have heard about the new product and have the money to purchase it.

Running shoes were developed as an adaptation from what were once known as "tennis shoes" to fit the needs of the American population as large numbers of persons became increasingly active physically. Early production was based on research of users' needs, and product development was quite costly in the early stages as the leading producers "reinvented" a shoe for active wear.

2. Growth. In this stage, according to the theory, sales may increase in both domestic and foreign markets where consumers have the money to purchase the product. The originating country's exports may increase noticeably. Competition increases as other producers enter the market by adapting the product slightly to avoid patent infringements. At this stage, machinery and other technologies are likely to be developed for large-scale production.

Some foreign production begins at this stage, most likely in other industrial countries; many developing countries may lack the resources for startup operations. At this point, foreign countries may impose a tariff on the product to encourage their own production. Alternatively, the costs of transportation and tariffs may encourage the original producer to establish a manufacturing base abroad.

Running shoes quickly became popular despite the relatively high prices for high-quality lines. Additional manufacturers adapted the leading firm's product. Mass production soon developed, and production soon occurred in other countries.

3. Maturity. In the mature stage, products become quite standardized and price becomes a more competitive factor. The original producing country probably no longer has a production advantage as more countries begin production. Changes in comparative advantage encourage the movement of production to the developing countries, where unskilled, low-wage labor can be employed to produce the standardized product more cost efficiently. The extent to which industries relocate in developing countries will depend for the most part on the extent to which unskilled labor can contribute to reducing the costs of production.

Production of running shoes shifted to developing countries, first to the NICs and later to less-developed countries, where unskilled labor was an advantage in production costs. Additionally, shoes could be marketed in those countries.

4. *Decline.* Finally, as products reach this stage, most production occurs in the developing nations and the innovating country becomes a net importer. By this stage, production of running shoes for U.S. firms shifted almost entirely to developing countries.

Although many products fit into the product life cycle theory, several do not. Among the exceptions are products with short life cycles (e.g., fashion items) that may not permit global shifting, luxury goods for which price is not an issue, and products for which transportation costs are too high to encourage export sales (Giddy, 1978). Other arrangements that affect the validity of this theory are (1) multinational firms' introduction of products in several countries at the same time and (2) international subcontracting (sending products to low-wage countries for assembly operations).

In short, Vernon's product cycle theory introduced important concepts of location into trade theory. For example, Porter (1990) notes that the product cycle notion was the beginning of a truly dynamic theory in suggesting the importance of home markets on influencing innovation. In general, however, even Vernon himself (1971) believes that this approach has too many shortcomings to explain current trade patterns for the reasons noted in the previous paragraph.

Porter's Competitive Advantage of Nations

Michael Porter, a faculty member in Harvard University's Business School, has been a leading innovator in developing new approaches to studying the competitiveness of industries and why firms based in particular nations succeed internationally in certain industries and certain segments (Porter, 1980, 1985, 1986, 1990). In The Competitive Advantage of Nations (1990), Porter looked specifically at the "decisive characteristics of a nation that allow its firms to create and sustain competitive advantage in particular fields" (p. 18). Rather than considering the usual economic question of why some nations succeed and others fail in international competition, he focused on this question: "Why does a nation become the home base for successful international competitors in an industry? Or to put it somewhat differently, why are firms based in a particular nation able to create and sustain competitive advantage against the world's best competitors in a particular field? And why is one nation often the home for so many of an industry's world leaders?" (1990, p. 1).

Porter believes that classical trade theory has been inadequate to explain trade patterns in today's global market in terms of how certain industries in certain nations succeed while others do not. His approach draws extensively on the theory of competitive strategy plus insights gained from a broad range of disciplines.

In his efforts to develop a comprehensive theory of the competitive advantage of nations, he studied a wide range of nations and many industries within those countries. He noted that although the basic unit of analysis for understanding national advantage is the industry, nations succeed not in isolated industries but rather in *clusters* of industries and their relationships. Although it is difficult to summarize Porter's extensive work, a few highlights will give the reader a sense of his ground-breaking theories.

In examining why a nation achieves international success in a particular industry, Porter concluded that "four broad attributes of a nation shape the environment in which local firms compete that promote or impede the creation of competitive advantage." (1990, p. 71). He termed these the *determinants of national advantage* and portrayed them as a system in the diamond model shown in Figure 4–5. The determinants that form the diamond in Porter's model are:

- 1. Factor conditions. Although factors of production such as labor supply and infrastructure are important, Porter believes it is where and how effectively factors of production are deployed that prove more decisive than the factors themselves in determining international success. Contrary to earlier theories, Porter asserts that the factors most important to competitive advantage in most industries, particularly the industries critical for productivity growth in advanced economies, "are not inherited but are created within a nation" (1990, p. 74).
- **2.** Demand conditions. Porter found that the nature of the demand in home markets played a significant role in shaping the rate and character of improvement and innovation by a nation's firms. Nations develop a competitive advantage in industries and industry segments when the home buyers (either industrial buyers or consumers) pressure local firms to improve continually and innovate quickly. So-

FIGURE 4-5

108

Porter's determinants of national advantage.

Source: Porter, M. (1990). The Competitive Advantage of Nations (p. 72). New York: The Free Press. Reprinted by permission of The Free Press.

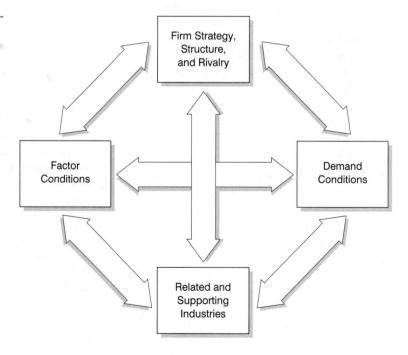

phisticated, demanding buyers force local firms to meet high standards in product quality, features, and service. This forces firms to be sensitive to trends in buyers' needs and to respond quickly to those needs. Demanding home buyers help to position a company, and even an industry, advantageously in competing internationally. The pressure to upgrade continually makes the firm or industry more competitive with international rivals and, in addition, embodies potential mechanisms through which the nation's products or services are "pulled" abroad (e.g., multinational buyers, foreign demand for products).

- 3. Related and supporting industries. Here Porter refers to the presence or absence in the nation of supplier industries and related industries that are internationally competitive. His premise is that "competitive advantage in some supplier industries confers potential advantages on a nation's firms in many other industries, because they produce inputs that are widely used and important to innovation or to internationalization" (1990, p. 100). Among the potential advantages are rapid access to the most cost-effective inputs, partnerships with world-class suppliers that are in the process of innovating and upgrading, related industries that share technology development (e.g., Japan's water jet weaving machines that weave long-filament synthetic fibers), and success in one industry that boosts international sales for complementary products or services.
- **4.** Firm strategy, structure, and rivalry. This refers to "the conditions in the nation governing how companies are created, organized, and the nature of domestic rivalry" (1990, p. 71). Characteristics of a nation are often reflected in how firms are managed and run, such as the training and "orientation of the leaders, group versus hierarchical style, the strength of individual initiative, the tools for decision making, the nature of relationships with customers, . . . the attitude toward inter-

national activities, and the relationship between labor and management" (1990, p. 109). These features create advantages or disadvantages in competing in certain kinds of industries. Porter asserts that nations will succeed in industries where the goals and motivations of employees and managers are aligned with the sources of competitive advantage. In some cases, national pride or a long tradition in an industry represents a competitive advantage; generally, where employees and shareholders have a sustained commitment to the firm and the industry, firms have a competitive advantage if other determinants are favorable. Moreover, domestic rivalry that forces firms to compete vigorously in the home market often leads to competitive advantage internationally because those firms have been forced to improve and innovate.

Porter's determinants provide the setting in which a nation's firms compete. As he notes:

Firms gain competitive advantage where their home base allows and supports the most rapid accumulation of specialized assets and skills, sometimes due solely to greater commitment. Firms gain competitive advantage in industries when their home base affords better ongoing information and insight into product and process needs. Firms gain competitive advantage when the goals of owners, managers, and employees support intense commitment and sustained investment. Ultimately, nations succeed in particular industries because their home environment is the most dynamic and the most challenging, and stimulates and prods firms to upgrade and widen their advantages over time. (1990, p. 71)

Porter noted that two additional variables are important aspects to consider in completing his theory: (1) government and (2) chance. Government policies can have a significant effect on an industry if those policies influence one or more of the four determinants. Government policies can have an impact on industry in a wide range of areas, such as educational policy, tax policy, antitrust policy, regulatory

policy, fiscal and monetary policy, and many others. He sees government's proper role as unleashing and amplifying the forces within the diamond and he believes that government should play a direct role only in those areas where firms cannot act—such as trade policy. Chance events are developments beyond the control of industry such as pure inventions, technological changes, changes in world financial markets, political decisions by foreign governments, or wars. Chance events have an impact by altering conditions of the diamond.

Porter concludes that nations are most likely to succeed in industries or industry segments where the national diamond is most favorable. This does not mean that all firms will survive in this environment, but rather that those that do emerge will succeed in international competition.

Moreover, Porter views the diamond as a mutually reinforcing system in which the effect of one determinant is dependent on the state of others. Additionally, advantages in one determinant can create or upgrade advantages in others.

WHY FIRMS TRADE OR INTERNATIONALIZE

Most classic trade theories focus on *countries* and their participation in trade. Countries are the focus because of common economic characteristics typically found within a nation's borders. Except in centrally controlled economies, decisions to participate in trade are not made at the country level, however. Instead, *decisions are made at the firm level*. Firms may choose to trade or internationalize their business activities by importing and exporting or through a variety of other structural arrangements. In all cases, the reason is the capitalistic *drive for profit*. That is, companies trade or participate in other international activities when they believe they will gain from

importing, exporting, or other arrangements (i.e., that these activities will increase or sustain profitability). Like individuals, companies have limited resources and invest them where rewards are greatest. Decisions on whether to participate in domestic or international business activities will be influenced by this basic economic concept. Now we shall consider two major categories of firms' participation in trade or internationalization activities.

Arm's-Length Trade

In the first of these categories, firms may participate in conventional **arm's-length trade**. In this form of trade, producers in one country trade goods with buyers in other countries (Figure 4–6). Business relationships may be defined simply as buyers and sellers. Examples might include the sale of Swiss watches to customers in other countries, the sale of Italian shoes in other nations' markets, or the exporting of U.S.-made jeans to Turkey.

Companies may choose to *export* for the following reasons:

- Increased profitability. Cultivating markets abroad may vastly increase the potential to sell products compared to focusing on just the domestic market. Levi jeans can be sold in nearly all parts of the world; this dwarfs the market for selling in the United States alone.
- Survival. Some countries do not represent an adequate market for a company; the firm needs far broader markets to survive. For example, Swiss textile machinery producers could not survive if they were limited to the relatively small textile industry in Switzerland.
- Cost reduction. Serving international markets permits the firm to take advantage of economies of scale; the increased output may reduce unit costs of production.
- Balancing variable demand. If a recession or other cyclical factors affect sales in certain

countries, demand in other parts of the world may offset these slumps. For example, if the textile market is sluggish in the United States, major textile firms such as Milliken and Company may benefit from having established markets in other countries not experiencing the downturn.

Companies may choose to *import* for the following reasons:

- Cheaper inputs or products. The importing firm may import components or completed products to reduce costs. Apparel manufacturers may import fabrics that are less expensive than those obtained in the domestic market; fabric producers may import their yarns for the same reason; or textile producers may even purchase imported greige goods, which are then printed and finished before being sold to their customers. In a study of U.S. textile CEOs, nearly 52 percent indicated that their firms use some imported materials in their production (Hooper, Dickerson, & Boyle, 1994).
- Unique products. Companies may supplement domestic production with imported products that provide distinction. For example, a company selling coordinated sweater and skirt sets may produce the skirts domestically but import the sweaters to add design interest to the line.
- Expanding the supplier network. Developing alternative suppliers, including those in other countries, makes a firm less dependent on a single supplier.

Intrafirm Trade or Activity

Our second category of firms' participation in trade or internationalization is **intrafirm trade** or activity. In recent years, these forms of international participation in business have become increasingly important.

In intrafirm trade, a company has operations in other countries in addition to the home country (Figure 4–7). Firms of this type are known as **multinational corporations (MNCs)** or **transnational corporations (TNCs)**. Many international organizations and some writers prefer the term *transnational corporation* because it can be applied more broadly. Dicken (1992) believes that the term *multinational corporation* suggests operations in a substantial number of countries; *transnational corporation* suggests operations in at least two countries. According to Dicken, all multinational corporations are transnational but not all transnational corporations are multinational.

TNCs have had a profound influence on the global economic system according to where and how they have invested in operations in other countries, how they have secured component parts, how they have marketed the products, and the extent to which they have transferred technology and other expertise. Although the typical image of the TNC is that of firms from more-developed nations setting up operations in less-developed nations, this is only one scenario. Actually, much TNC activity is among more-developed nations; more recently, some of the NICs have established TNCs. Because most TNCs are based in the more industrialized nations, their influence, particularly on less-developed economies, has often been dramatic. Although the TNCs have often provided much-needed jobs, some sources consider their influence in Third-World countries questionable in the long run. This notion will be explored further later in this chapter.

We should note here that TNCs render traditional trade theories of comparative advantage inadequate in explaining why and where a nation exports. Whereas classic trade theory assumes that trade is subject to external market prices, the intrafirm trade of the TNCs is subject to the *internal decisions of the firm*. Rather than simply importing and exporting, the TNC also may compete in other countries

FIGURE 4-6

In arm's-length trade, products are sold by one country to another.

Source: Illustration by Dennis

Murphy.

FIGURE 4-7

In intrafirm trade, operations in other countries may be owned or contracted by TNCs; thus items shipped in trade are for the same company.

Source: Illustration by Dennis

Murphy.

with its own subsidiaries located in those countries or regions.

Intrafirm trade as executed by TNCs—that is, trade between parts of the same firm across national boundaries—accounts for a substantial amount of world trade. Dicken (1992) suggests that an increasing proportion of world

trade in manufactured products is *intrafirm* trade rather than *international trade*. Because most countries do not collect trade data in a manner that can separate out intrafirm trade, the exact extent of this trade is difficult to determine. This information does exist for the United States and Japan, and Dicken (1992)

BOX 4-5

THE ROLE OF TNCs

The textile and apparel industries have "played a significant role in the industrialization process of a number of developing countries and in the growth of their manufactured exports" (United Nations, Centre on Transnational Corporations, 1987, p. x). Authors note that the two sectors are major examples of international industrial relocation and of the international restructuring of the world economy. They consider that TNCs have been determining factors in that process.

Because of the intensive use of low-skilled labor in most segments of the textile and apparel industries, TNCs have limited potential for deriving firm-specific advantages from **direct foreign investment** in the textile and apparel sectors. That is, firms desire the advantages of the low-cost labor but may prefer minimal capital commitments. For that reason, other forms of transnational activity have figured significantly in the internationalization of the textile and apparel industries. These activities include international subcontracting of assembly operations,

brand name and trademark licensing, and importing of finished garments.

On the other hand, the complex technology of the *manufactured-fiber industry* offers greater opportunities for TNCs to exploit their firm-specific advantages through direct foreign investment. The Japanese textile sector has participated extensively in TNC activity as a means of ensuring markets abroad for Japanese manufactured fibers. That is, the Japanese have established textile production in other countries to be sure that they can sell their products in those markets.

Transnational activity in apparel production most often includes foreign assembly of apparel or licensing programs. Further, some countries—for example, Germany and the United States—have national legislation that provides tariff concessions for the foreign processing of apparel; this has provided an added impetus to the internationalization of the industry. Most often, however, the sewing plants in the less-developed countries are dependent on TNCs to provide market outlets for their products.

notes that more than 50 percent of total trade (imports and exports) for both of these countries is TNC trade. Dicken, who is British, believes that possibly 80 percent of the United Kingdom's manufactured exports result from U.K. firms with foreign operations or from foreign-owned operations in the United Kingdom. The type and extent of intrafirm activity vary from one industry to another.

In summary, theories are helpful in examining textile and apparel trade. The theories provide various scholars' views on how we might consider the larger picture and examine trade in a systematic manner. Various theories help us to look more objectively at what is happening in trade and to explain shifts that have re-

organized textiles and apparel in the global economy. At the same time, however, trade theories have their limitations and cannot account for all the complexities involved in trade, particularly textile and apparel trade.

DEVELOPMENT THEORY

Development, or international development, focuses on the imbalances in the distribution of resources between the rich and the poor nations of the world. (See Box 4-6). For the most part, this imbalance is between the North and the South, and development efforts are aimed at reducing the gap.

BOX 4-6

EMERGENCE OF THE DEVELOPMENT GAP

McNeill's (1965) *The Rise of the West* helps us to understand that the development gap is a fairly recent occurrence when viewed in the context of world history. During the 15th century there were slight developmental differences among the major civilizations, and the differences that did exist favored the Islamic civilizations of the Middle East and India over the civilizations of

Western Europe and China. Contrary to what might have been expected in the 15th century, China and the Islamic civilizations became the world's poorer regions. In general, European countries and nations of European origin became the wealthy regions of the world, while non-Western regions became the poor regions.

Reasons for the gap between the rich and poor countries are easily observed. Rich countries have economic systems that are very productive because they are able to produce a surplus over and above what is required for the population to survive. The surplus permits the rich countries to continually improve the population's standard of living, as well as to make investments that further enhance productivity. In contrast, the economic systems in poor countries are relatively unproductive because production is barely adequate for a subsistence level of existence. These countries have little surplus to use for investments that would increase productivity and reduce poverty. That is, the rich countries get richer because their investments continue to improve productivity, whereas the poor countries cannot take food from the mouths of the population to make similar investments.

Munck (1984) considers development as "the historical process of capital accumulation and the extension to the far reaches of the globe" (p. 1). Although economic conditions are basic to the disparity between the rich and poor nations, development issues are seen generally as extending more broadly to social and political concerns as well.

In a landmark perspective on development, Pope Paul VI's 1967 Encyclical entitled "Populorum Progressio" ("The Development of Peoples") introduced the phrase "development is the new name for peace" to emphasize the importance of integral human development (Carr, 1987). Even today, in New York's United Nations headquarters, this phrase is displayed frequently in connection with UN development projects. In the Encyclical, development was defined as a process aimed at creating conditions to provide the material necessities of life and bring about changes in oppressive social structures. Development, according to this view, includes economic growth, self-reliance, and social justice (Carr, 1987).

As scholars have studied international development, various schools of thought have evolved. As we have seen, the same was true for the emergence of theories related to international trade. We will review some of these theories briefly after considering why development issues are relevant to our study.

Trade and Development

In the past, trade was an "engine of growth" that often stimulated a country's development (Robertson, 1938, p. 48). Trade in general exerts an important influence on economic development. Textile and apparel production and trade, in particular, play a vital role in economic development. This was true in the early industrialized

nations more than 200 years ago. It remains true today for much of the less-developed world (Figure 4–8).

As we study the impact of international trade on global interdependence, we become aware of evolving patterns of development among nations of the world. Levels of development typically change to a degree over time in a particular country. We hope that these developmental changes represent improvements. It is important to keep in mind, however, that as each country changes, the relationships of nations to one another shift as well.

Development patterns are particularly significant as we study textiles and apparel in the international economy. As we look at textile and apparel production and trade for a particular country, we must be aware of where these sectors fit into the overall development scheme for that country. That is not enough, however. We must look also at what is happening more broadly in the world. Acquiring an understanding of *global development patterns* is equally important in comprehending how the domestic industry will be affected by worldwide shifts in production capabilities and other aspects of development.

Particularly in view of the fast spread of textile and apparel production to the developing countries, development theory provides another systematic means of studying production and trade shifts for these sectors. Development theory is quite complex because of its interdisciplinary nature; therefore, here we present only a brief overview to provide another perspective for analyzing shifts in this global sector.

Emergence of Development Theory

Development theory represents a body of scholarly approaches for attempting to understand and explain the imbalances between the rich and poor nations of the world. Development scholars have tried to explain the nature of the imbalances and how these differences evolved;

many have attempted to identify strategies for improving the conditions of the disadvantaged nations. Development theories vary drastically in orientation; disagreement among various schools of thought has been common. No unifying theory for development emerged in the past, nor is one likely in the future because of the complexity of the problems and the ideological and political differences (Bernstein, 1973; Schiavo-Campo & Singer, 1970).

Modern development theory emerged just after World War II. Interest in development increased after the war as European colonies in Asia and Africa began their struggle toward political independence and were thought of as potential Western allies in a world that was divided by the Cold War.

When scholars made their first attempts to construct development theories, the concepts of development and economic growth were often considered the same thing. Therefore, most early development theories came from the economics field. For example, the work of two well-known leaders from the classical period of economic thought—Smith and Ricardo—provided important links in early development theory. Smith's and Ricardo's economic theories promoted division of labor and distribution of production among various classes of society—along with international trade. Sociology also contributed importantly to early development theory.

Development theory might be considered in two broad umbrella groupings, according to Mc-Gowen (1987): (1) the mainstream/modernization theories of development and (2) the structural theories of development. Each of these will be discussed briefly in the next two sections.

Mainstream/Modernization Theories of Development

In the late 1940s and early 1950s—the early days of development theory—underdevelopment was seen as the difference between rich and poor countries. The problem of underdevelopment was considered one of a *shortage* of

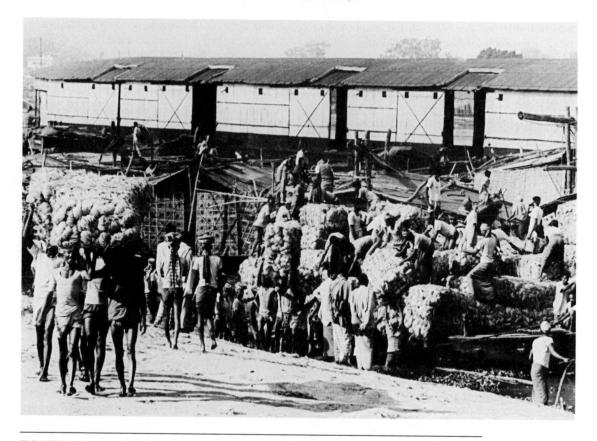

FIGURE 4-8

Textiles have played a vital role in development in many parts of the world. In this jute facility in Bangladesh, "pucca" bales (a better-quality jute) are being unloaded to be brought to the compressor. Teams of three carry the bales, which weigh about 400 pounds each. About 90 percent of the annual production has been destined for export; however, in recent years, manufactured fibers have replaced jute in bagging, carpet backing, and other low-grade textile applications.

Source: International Labour Organization.

capital. Development was seen as the process for bridging the gaps by having the poor countries imitate the industrialized nations.

In the late 1950s, the theory of development began to expand beyond its roots in economics and sociology. Scholars in several fields began to study the ways in which developing countries attempted to imitate the industrialized countries in the development process. Economists continued to examine the economic structure; other scholars analyzed social institutions; and some studied human behavior involved in development. Soon the theory of development became interdisciplinary in nature as anthropologists, political scientists, and psychologists joined the economists and sociologists in focusing on these changes.

According to one group of scholars, development was considered an evolutionary process through which the less-developed countries would eventually assume the qualities of the industrialized nations. McGowan (1987) com-

TABLE 4–1The Mainstream/Modernization Model of Development

	Per Capita GNP, 1995 ^a	Life Expectancy at Birth ^a	Year Drive to Modernize Began ^b
Developed Countries			
Switzerland	\$40,630	78	1798
Japan	39,640	80	1868
Sweden	23,750	79	1809
USA	26,980	77	1776
Newly Industrialized Countries			
South Korea	\$9,700	72	1910
Mexico	3,320	72	1867
Brazil	3,640	67	1850
Less-Developed Countries			
Ghana	\$390	59	1957
Bangladesh	240	58	1973
Ethiopia	100	49	1924
Tradition > Preconditions > Take-o FIVE STAGES OF DEVELOPMEN	ff > Maturation > Mass	Consumption	

^a Source: World Bank, 1997.

in Education. Modified and used courtesy of The American Forum for Global Education.

bines the development theory of this school in his mainstream/modernization model (see Table 4-1). In essence, McGowan's model provides an umbrella under which several theories with similar characteristics are grouped. Theories represented by this model may be called mainstream theory, modernization theory, and conventional or traditional development theory. To a great extent, theories of this school were based on the notion that development and growth were synonymous; that is, development was closely tied to the idea of capital formation. Modernization, a key aspect of this approach, followed George's (1984) growth/ trickle-down model, in which the results of economic growth and modernization of the industrialized countries would trickle down gradually to the poor nations.

Rostow's (1960) theory or model⁴ of economic development—considered important during the late 1950s and 1960s—reflected the perspective common to mainstream theories. His approach, used to classify countries by stages of economic development and to show growth from one stage to the next, identified five stages (countries in the first three were considered *underdeveloped*):

1. The traditional society. Countries are limited in their production capabilities by their levels of knowledge and technology.

^b Walt Rostow, *The Stages of Economic Growth: A Non-Communist Manifesto,* 1962. *Source:* McGowan, P. (1987). Key concepts for developmental studies: In C. Joy & W. Kniep (Eds.), *The international development crisis and American education* (p. 45). New York: Global Perspectives

⁴ Some sources (e.g., Cateora, 1987) refer to Rostow's effort as a model, but others (e.g., Blomström & Hettne, 1984) refer to it as a theory.

2. The pre-take-off stage. Characteristics of the traditional society begin to disappear as the beginnings of modern technology are applied to agriculture and production. Transportation, communications, education, and other components of the infrastructure are initiated.

118

- 3. The take-off. A growth pattern emerges. Human resources are cultivated to sustain development. Industrial modernization becomes significant, with certain sectors taking the lead.
- **4.** *The drive to maturity.* Progress is maintained; technology is extended to all forms of economic activity. The country becomes involved in international economic activities. Specialization develops.
- 5. The age of high mass consumption. Citizens can satisfy most of their basic needs, and consumption shifts to durable consumer goods and services. Income rises, with greater amounts of discretionary income available.

McGowan's (1987) mainstream/modernization model of development incorporates Rostow's stages of development. This model attempts to show the perspectives of modernization theorists who believe that all countries must go through the stages of development experienced by the already developed countries. These theorists believe that the less-developed countries can and will develop as others have "if they are patient and politically stable, open their economies to foreign investment and technology, reform their cultural and social institutions . . . , and adopt correct economic development policies emphasizing comparative advantage in their exports and less state intervention in their domestic economies" (Mc-Gowan, 1987, p. 46).

Although Rostow's approach helped to explain the economic evolution within a country, his efforts were characterized by the shortcomings later associated with the mainstream/

modernization theories. A common limitation of development theories from this school was the notion that poor, developing countries must follow in the tracks of the United States and Western Europe to be on the proper road to development.

The mainstream/modernization approaches of Rostow's era told the poor of the world that if they wished to develop, they must pursue individual self-interests-like Americans and Europeans. For many of the world's peoples, following this pattern is not possible, and many would not wish to imitate this strategy even if it were possible because they value community, religion, or family more than individual achievement. The modernization perspective dominated several social sciences in the 1950s and 1960s. Blomström and Hettne (1984) contend that the modernization approach had widespread appeal in the North because of the paternalistic attitude toward non-European cultures. Further, they believe the modernization theory established the rationale for foreign aid and the form it took. These authors concluded that the general outlook of mainstream/modernization theory constitutes what still prevails as the popular image of developing nations in the developed countries.

A later group of scholars decried the mainstream/modernization development models asserting that to apply the Western experience of development over the past 200 years to the rest of the world is ethnocentric and biased.

Despite the criticism of the mainstream/ modernization theories, this school of thought tends to reflect the massive changes taking place in the developing countries as they move toward adoption of Western culture. Adoption of lifestyles, consumer products, and bureaucratic administration is seen in the proliferation of three-piece suits, fast-food restaurants, supermarkets, and rock music in urban areas around the world.

We are reminded that modernization is not the same as development. Although the two may be related, there is also some evidence that diffusion of Western practices and beliefs may hinder development. The author is reminded of hearing a teacher from a developing country relate the story of residents in the countryside who had purchased a refrigerator because they desired the status this appliance represented. However, the family had no electricity to run the refrigerator; it simply sat there with no cooling capabilities. In this case, the desire to imitate the West (i.e., modernization) did little for development.

According to the later group of scholars, it makes no sense to expect the development experience of Ecuador or Nepal to follow the earlier patterns of the United States or France. Consequently, the modernization approach was contested by another group of scholars by the early 1970s.

Structural Theories of Development

A later group of scholars formulated theories that were quite different from the mainstream/modernization approaches for explaining the imbalances between the rich and poor of the world. McGowan (1987) combines several of these later approaches into what he calls *structural theories*. A few scholars had proposed a structural approach in the 1950s, but these views were not generally accepted until the 1970s. In fact, it is important to keep in mind that the structural theories still represent a minority view.

Van Benthem van den Bergh (1972) used a sports analogy to explain development from the structuralist perspective. He suggested that rather than viewing the process of development as a race, we might think of it as a league of commercially run football teams. We might assume that some of the teams are more successful than others. The more successful teams have the ability to attract and purchase the poorer teams' best players. As a result, the poorer teams tend to deteriorate even further,

and prospects for improving their league standing virtually disappear.

Keeping this example in mind, then, development, according to the structuralists' views, is no longer thought of as a race in which some of the participants have fallen behind. Underdevelopment is considered a problem of *structural relations* rather than a problem of scarcity. Development for one of the parties generally suggests underdevelopment for the other.

A major limitation of the modernization approach to explaining development is that it treats underdeveloped nations as isolated units. That is, a nation is considered to succeed or fail in its development efforts because of internal factors—societal beliefs and values, government systems, organization of the economic system, and so on. This isolated perspective fails to recognize the profound influence the more-developed nations have had on the poorer nations. For example, many of the underdeveloped nations emerged as independent states after a long history as colonies of the Western powers. Critics of the modernization approach often assert that the poorer countries are still "economic colonies" because of their relationships with the developed world.

Theorists in this school believe that certain structural factors require alternative models for development in the underdeveloped countries. These structural factors include those that exist between the North and South, as well as those within the underdeveloped countries, such as a permanently high level of unemployment. For example, the North has the ability to produce high value-added manufacturers, whereas the South relies heavily on agriculture, natural resources, and simple manufactures—resulting in decreasing terms of trade. Thus, we see a vicious cycle in which the disparity between the North and South increases rather than decreases. Consequently, the structural theories are based on the notion that the relationships between North and South restrict development for the less-developed nations.

Theorists of this school are hostile to the idea that diffusion of modern attitudes and behavior from the developed to the underdeveloped countries is the answer to economic development. From the structuralists' point of view, the long and continuing history of contact between the rich and poor countries is the cause of underdevelopment. These scholars believe that all nations of the world are locked together in a single system, which includes a network of economic, social, and political exchanges, all of which work to the disadvantage of the poorer nations. The structuralists generally view the relationships as exploitive of the developing countries.

120

Advocates of structural development theories consider that TNCs have played a key role in the exploitation of the periphery. Structuralists are troubled because although the TNCs provide low-paying jobs for workers in the host country, the corporate headquarters in core nations benefit most.

According to the structuralists, the notion that underdeveloped countries could imitate the industrialized countries seemed unlikely. The optimism regarding underdeveloped countries' development prospects was toned down, and economic models of the day were no longer seen as useful in analyzing the problems of development. Underdevelopment could no longer be explained by a lack of capital. In short, despite economic growth in a number of the underdeveloped countries, significant progress appeared unlikely. A number of studies began to refer to "growth without development" (Blomström & Hettne, 1984).

Structural theories provided another way of viewing the problems of underdevelopment. We have noted that these theorists believe underdevelopment is the result of structural problems, but how did those problems occur? McGowan (1987) suggests that structural theories are based on global processes of development as they unfolded in history. Two striking facts about world history over the

last 500 years count heavily in the structural approaches:

- 1. The world became "an integrated and interactive system characterized by sharp inequalities between a minority of well-off people and a majority of poor people" (p. 49). Except for Japan, the rich part of the world is European or of European origin, while the poor part represents the non-Western peoples of the world.
- **2.** "Structural models recognize that this world-division did not always exist: the development gap is a product of modern history" (p. 49).

If these world divisions did not always exist, how did Western Europe and its overseas extensions, such as the United States, come to dominate the world—economically, politically, and culturally? How did China and the Islamic civilizations end up as part of the world's poorer regions?

McGowan's (1987) structural model of development is also an umbrella approach for grouping together a number of theories with similar characteristics. His structural model integrates views of a number of development scholars (including Raúl Prebisch and Immanuel Wallerstein, two influential writers) and attempts to describe how these major divisions in levels of development occurred. According to McGowan, dependency theory and world-systems theory, other important development theories instrumental in the break from mainstream theory, are represented in this model. For example, Wallerstein's worldsystems approach considers "zones" of development similar to those shown in McGowan's model in Figure 4-9.

As McGowan traces the divisions that emerged, he notes that major changes began to occur about 1000 A.D. as "the trade network of Eurasia became ecumenical, embracing all substantial blocs of population in its tentacles for the first time" (McNeill, 1986, p. 223). From

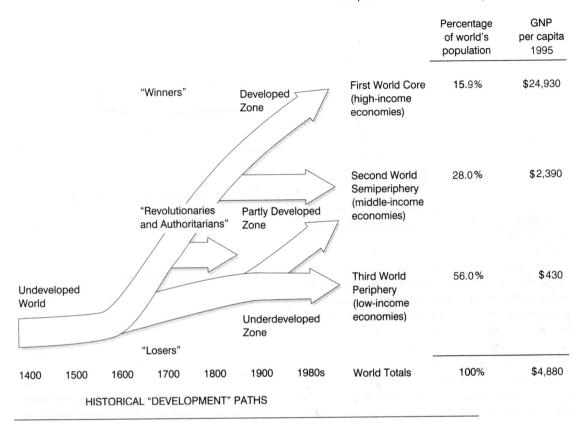

FIGURE 4-9

A structural model of development.

Source: Updated data from World Bank. (1997). World Development Report 1997. Washington, DC: Author. Chart originally from McGowan, P. (1987). Key concepts for development studies. In C. Joy & W. Kniep (Eds.), The international development crisis and American education (p. 50). New York: Global Perspectives in Education. Modified and used courtesy of The American Forum for Global Education.

that time on, major Old World civilizations were linked through the trade of items such as silk and spices. Until about 1450, trade had not influenced development differences among trading regions; however, it produced two changes in Europe that were of monumental importance in altering global development relationships in the future:

1. The Italian trading states developed *merchant capitalism* and *banking*. The capitalist-oriented market behavior that spread around the world during the next 500 years changed the world dramatically.

2. By 1450, wealthy European aristocrats had developed a *taste for the luxury goods* that resulted from trade. European leaders also felt the need to increase their incomes to support their armies and to pay for their luxury goods. Thus, the European civilizations were expanded to other parts of the world, and by 1900 "Europe and its overseas extensions such as the United States ruled the world" (McGowan, 1987, p. 51).

According to McGowan's (1987) structural model, the time between 1450 and 1600 A.D.

122

marked a turning point—the beginning of the divergent paths in worldwide development. Up to that time, most of the world was undeveloped—that is, civilizations were roughly similar in their wealth, power, and other achievements. After 1500, however, the spread of capitalism and the "rise of the West" caused the development paths of the world's peoples to diverge markedly. Thus, these historical differences in development paths are basic to development theories that advocate that the underdeveloped countries must pursue strategies other than trying to imitate the industrialized countries. These divergent paths set the stage for the problems in structural relations mentioned earlier.

As capitalism and the Western influence spread around the globe in the next 500 years, various regions of the world developed differently. The controlling influence of the more powerful nations caused regions to develop in widely divergent paths. Consequently, according to a number of development theories and models, three different zones emerged (at least one theory suggests four zones). Note that these zones roughly parallel the country groupings discussed in the prior chapter. Descriptions of the zones follow.

First-World Core

This group consists of 25 democratic, industrialized countries of North America, Europe, Japan, and South Korea⁵ (the OECD countries). Chirot (1977) noted that as this group emerged, its member nations acted like the "international upper class" (p. 8). Members are the rich, economically diversified, and industrialized powers that have dominated the world scene. Wallerstein (1974) uses the term core societies for the rich societies whose success changed the rest of the world. This

group has the smallest proportion of the world's population—somewhat over 900 million persons.

Second-World Semiperiphery

This is an intermediate zone of partial development consisting of societies that acted as an "international middle class." Many in this group have tried to catch up to the rich and have taken advantage of poorer societies to use them in their catch-up efforts (Wallerstein, 1974). This zone consists of three distinct types of societies and regions:

- 1. Formerly communist ruled. This is the oldest grouping, consisting of countries in Eastern Europe and the former Soviet Union. The economies of many of these countries have been in a fragile state during the transition to market economies.
- 2. The NICs. These are formerly underdeveloped, peripheral societies such as Taiwan and Brazil that have moved up to the next level of development. Some development models are based on the belief that all countries can move to the NIC status and beyond. The structural approach, however, accepts the likelihood that only a limited number of countries can move to this stage. This outlook is based on the fact that there is not enough world income and that it is too unequally distributed to buy the products of 50 South Koreas (McGowan, 1989).
- 3. The OPEC countries. Most of these countries were in the periphery prior to 1973, when their oil wealth provided greater opportunity for development and began to influence world financial markets.

Third-World Periphery

As a result of colonialism, imperialism, and unequal trading relationships imposed by the core countries, McGowan (1987) asserts that this

Love societies = rich societies

⁵ South Korea became a member of the OECD in October 1996, making it a member of the "rich man's club," as the OECD is sometimes called.

zone—which represents almost 60 percent of the world's population—did not experience development within the world system. Chirot (1977) described this group of societies as filling the role of an "international lower class" that provides cheap labor, certain raw materials, and certain agricultural products; they have remained poor, weak, and overspecialized in a limited number of export products. Limited manufactures have been produced through low-wage, low-technology processes. This zone includes more than 3.2 billion persons in countries and territories in the Caribbean, Latin America, Africa, the Middle East, and Asia.

Underdeveloped countries constitute the periphery. Within structural approaches, underdevelopment is the term for the condition in which a country becomes (i.e., this is not a God-given condition [McGowan, 1989]) specialized in the production of low-wage, low-technology products. Long-term prospects are quite different for countries characterized as underdeveloped in contrast to being on a path of development. The latter brings with it prospects for higher wages and advanced technology. Nearly all of the periphery countries are poor and agrarian. The limited industry present in these countries is generally controlled by the core countries (Mc-Gowan, 1987). Often an additional factor is the presence in the periphery countries of a com**prador** (local agent) who stands to benefit from this structure. The World Bank data presented in Table 4–2 provide a summary of the world's population and wealth. The World Bank categories correspond roughly to the structural model's zones.

A quick analysis of these data provides a jolting awareness of the contrasts from one zone to another. The core's 25 countries account for only about 16 percent of the world's population but 80.5 percent of its wealth. In contrast, the more than 100 countries in the periphery represent 56.1 percent of the world's population but account for less than 5 percent of its income. Although a large number of countries constitute the periphery, China and India dominate this group in both size and population. The semiperiphery represents slightly over one-fourth of the world's population and about 14 percent of its income.

United Nations population experts project that the population growth in the regions representing the periphery will continue to increase at a far greater rate than will be true in the developed or core countries. Figure 4–10 illustrates this dramatic growth expected in the periphery. The reader is also reminded of earlier discussions regarding the relative decline of incomes in the developing nations compared to those of the developed countries.

TABLE 4–2The World's GDP and Population, by Major Country Groupings

				THE RESERVE THE PROPERTY OF THE PARTY OF THE
Country grouping	1995 GDP (billions of dollars)	% of world GDP	1995 population (millions)	% of world population
Low income Middle income High income World	1,352 4,033 22,486 27,946	4.8 14.4 80.5 100.0	3,180 1,591 902 5,673	56.1 28.0 15.9 100.0

Note: Totals may not equal 100 percent due to rounding.

Source: Data from World Bank. (1997). World development report 1997 (pp. 214, 215). Washington, D.C.: Author; World Bank. (1997). World development indicators 1997 (p. 136).

Washington, D.C.: Author.

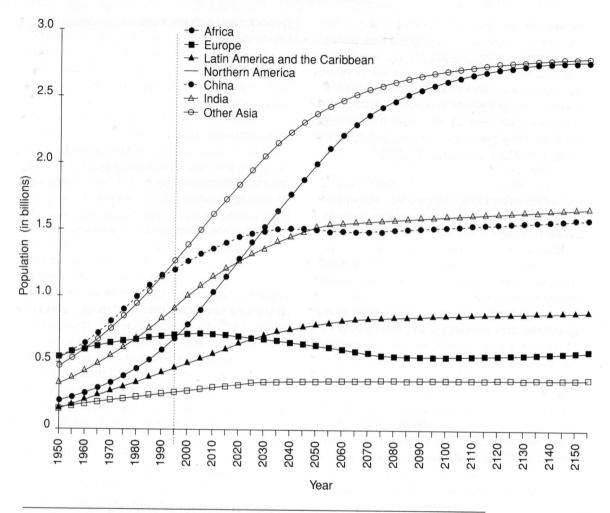

FIGURE 4–10

Population size of the major areas of the world (medium fertility scenario, 1950–2150).

Source: Population Division of the Department of Economic and Social Affairs at the United Nations Secretariat. (1998). World population projections to 2150 (p. 4). New York: United Nations. Reprinted

Secretariat. (1998). *World population projections to 2150* (p. 4). New York: United Nations. Reprinted by permission.

Structural Theories: Relationships among the Zones

Various structural theories of development (including dependency theory and the world-systems approach) examine the relationships among the zones. Consequently, these theories

do not present a very flattering picture of the core countries. In fact, some of the structuralist views are considered radical in the core countries and, as a result, have not been accepted widely. The resulting structural models suggest that the world's development inequalities

are not just the result of different resource endowments and economic performances; rather, the differences are politically created and maintained. Chirot (1977) asserted that the periphery countries are poor not merely because of internal conditions but also because of their relationship with the rich societies—that is, as a result of structural relations, a concept we noted earlier as basic to structural theories and/or models.

In a world of profit makers (the workers) and profit takers (the capitalists), McGowan (1987) noted that this relationship usually takes advantage of workers in periphery countries. Of all the capitalists and workers in the world, workers in the periphery nations have the least power of all. Most have no advocates to represent their interests. Moreover, policies in underdeveloped countries have often been developed and supported by individuals or groups that prosper under current conditions: import-export firms or others serving as local agents for participating in various forms of trade.

Therefore, we find a remarkable phenomenon within our world: "The exact same job earns very different wages depending upon where it is located" (McGowan, 1987, p. 55). As a result, we find apparel workers earning a fraction of the wages in poor, developing periphery countries that their counterparts earn in North Carolina. Scholars who support the structural views of development reject the economists' views of comparative advantage. Structuralists believe the notion of comparative advantage gives license to exploit the developing countries.

Chirot (1977) asserted that the capitalist leaders in core societies have not been interested in making poorer regions independent and prosperous. Instead, he stated, it is to the advantage of the core countries to keep the poorer areas dependent and overspecialized in the production of certain cheap goods. This is not intended as a plot by the rich against the poor but rather is the result of "interconnected"

forces within rich societies and within the entire world system" (p. 9). As a consequence, according to McGowan (1987), profits are transferred from the periphery to the core, and high-wage core societies grow richer faster while low-wage peripheral societies lag behind—with the development gap growing rather than diminishing. Thus, we are reminded of the football league analogy and the premise of the structural approach, which asserts that underdevelopment is primarily a problem of relations rather than simply a problem of scarcity (Blomström & Hettne, 1984).

Some of the newer development perspectives that emerged-such as dependency theoryencouraged representatives of Third-World countries to demand changes in the world economy. Otherwise, many believed the lessdeveloped countries may be "stuck" permanently in their underdeveloped conditions; they believed the industrialized nations would continue to take advantage of the low-wage labor and other resources needed to make profits. Hence, concerns of this type stimulated several efforts discussed in an earlier chapter: the North-South dialogue, the emergence of the Group of 77, and the pressure from the lessdeveloped countries for a "new international economic order."

Development and Textiles and Apparel

Development theories and models are relevant and useful in studying global textile and apparel production and trade in the following ways:

- Development approaches provide another means for viewing the larger picture of global textile and apparel production and trade and for explaining the global dispersion of these industries.
- Development perspectives help us to consider certain social and political dimensions of textile/apparel production

and trade that traditional economic theories, for example, may not offer.

- We have a better understanding of why in recent years so many countries have participated in simple textile and apparel production. Further, we may comprehend more clearly that many developing countries have few other prospects for participating in world trade.
- By viewing the world in this perspective, we can see that developing countries are likely to continue to be important textile and apparel producers.

A Promising Future or Stuck at the Bottom?

If we reflect on the two major types of development theories considered, we can see that the future role of the developing countries will be quite different in the two.

If one subscribes to the mainstream/modernization approach, developing countries involved in the simplest textile/apparel production that is, agricultural production and simple manufacturing—might consider simple production a transition stage in their development. Operating under this model, nations might look forward to advancing eventually to the levels of the NICs or the more-developed countries. A number of less-developed countries, particularly several in Asia, made tremendous progress in following this approach. Currently, workers in Vietnam are some of the poorest in the world, but if their country follows the strategy that led to other East Asian successes, their incomes might double in a decade. Manufacturing wages in a group of export-oriented East Asian economies rose 170 percent in real terms between 1970 and 1990, while manufacturing employment increased 400 percent (World Bank, 1995). The mainstream/modernization strategy remains the one that almost all Northern conventional economists, core governments, and several key international organizations (World Bank,

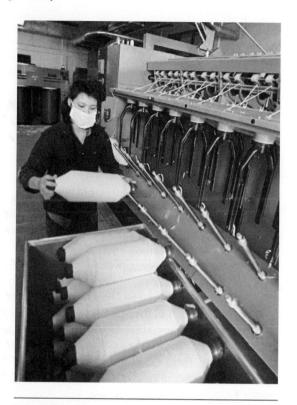

FIGURE 4-11

According to the mainstream/modernization theories, underdeveloped countries may progress toward more advanced levels of development. This Laotian pilot spinning plant reflects the efforts to bring about industrial development.

Source: Photo by J. Maillard, photo courtesy of International Labour Office, Geneva.

International Monetary Fund, and United Nations organizations) say the less-developed countries should follow (McGowan, 1989).

If one subscribes to the *structural approaches*, developing countries involved in these simple production stages may be stuck at that level of development. Companies in the industrialized countries find the low-priced labor and other resources in the periphery countries attractive in furthering profits for the core countries.

Structuralists would consider many textile and apparel jobs in the periphery to represent exploitation. Other persons might consider,

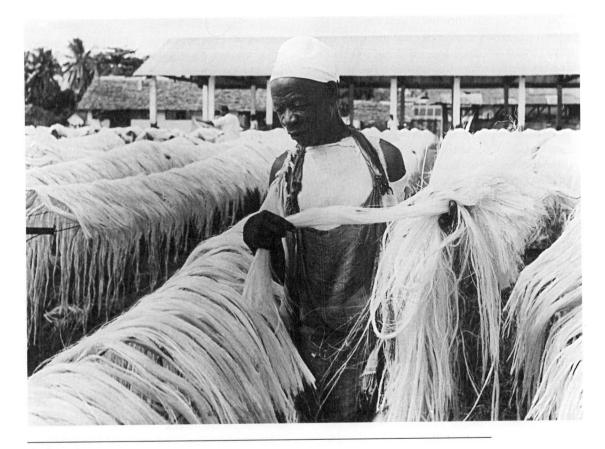

FIGURE 4-12

According to the structural theories, underdeveloped countries may be unable to achieve development that expands beyond agricultural production and simple manufacturing. These views suggest that the sisal plantation worker in Tanzania who is checking the degree of dryness of the fibers typifies the long-term prospects for the periphery. *Source:* Photo courtesy of International Labour Office, Geneva.

however, that these jobs represent an opportunity because the sector provides valuable employment to workers in a world where there are 120 million unemployed workers and millions more have given up on finding work (World Bank, 1995). For many individuals in developing countries, agrarian fiber production or apparel assembly may provide the only means of earning an income.

Various development theories suggest implications for future relationships between the North and the South in textile and apparel pro-

duction and trade. Development perspectives may provide clues as to which countries or regions of the world are apt to be involved in various production and trade activities for the sector. For example, analyzing the global picture through a development approach may suggest which regions will be competitors in the textile and apparel sectors. That is, if a substantial number of countries move to more advanced stages of development, global competition will become more intense in those segments. For example, if significant numbers

of Third-World periphery nations advance to the NIC level of development, competition among those countries for certain segments of the global market will be even more intense than at present. On the other hand, to companies in the core, these models may provide clues to the long-term prospects for a lowwage workforce to perform apparel assembly operations.

128

As we consider the development process (or lack thereof) of nations, it is also useful to consider the typical stages through which the textile and apparel industries evolve. Because of the important role of the textile and apparel sectors in the development process of many nations, changes in these sectors often parallel national development. We shall discuss these concepts in greater detail in Chapter 5.

THE NEW INTERNATIONAL DIVISION OF LABOR

The concept of an international division of labor is not new; however, as a global economy becomes an increasing reality, this production strategy has gained special attention. Moreover, in recent decades, this concept has taken on a new dimension. The notion of the **new international division of labor** borrows from economics, in some ways resembling Adam Smith's division of labor and Ricardo's comparative advantage; it also relates to development models, embracing some of the perspectives of the structural theories.

As advances in communication and transportation systems have transformed the world from comparatively independent national economies to an integrated system of world-wide production, a changing division of labor between the developed and developing countries has emerged. As production is segmented into tasks that can be dispersed to various regions of the world, internationalization results from the complementarity between factors of

production in the developed and developing nations.

In essence, the new international division of labor refers to the restructuring of the global economy in which we see a shift of industrial production from the core economies to the periphery. The publication of The New International Division of Labour by Fröbel, Heinrichs, and Kreye (1980) provided groundbreaking perspectives on this phenomenon; interestingly, these authors focused on the textile and apparel industries. In this type of international activity, we must keep in mind that we are not referring to trade but rather to having different aspects of individual firms' production take place in different parts of the world. (This corresponds to intrafirm activity discussed earlier in this chapter.) Dicken (1992) asserts that the TNC is the most important factor to have influenced the global shifts in production to which we are referring. The new international division of labor differs from the old one espoused by Smith and Ricardo in that these earlier writers proposed that countries specialize in components or completed products—not the separation of stages of production.

The new international division of labor breaks down complex manufacturing into small, simple production processes that are contracted out to various parts of the world. Production is reduced to simple tasks that can be performed by unskilled laborers who can be quickly trained. By contracting production to lowwage countries, manufacturers in the more industrialized countries are able to replace skilled labor receiving high wages with unskilled or semiskilled labor receiving much lower wages. At the same time, the more technical aspects of production, requiring more highly skilled workers, generally occur in countries with greater technological and financial resources.

Translated into modern business terminology, a form of the new international division of labor is called **outsourcing**. <u>Outsourcing refers</u> to securing parts or whole products or to con-

tracting production from other manufacturers while the buyer maintains its own company or brand name. Outsourcing may occur within a country as one company outsources certain operations to another that specializes in those activities. For example, many companies outsource payroll functions to firms that specialize in performing payroll activities for other businesses. More and more, however, the term outsourcing has been applied to having laborintensive goods produced under contract in low-wage countries. (The reader may wish to refer back to Figure 4-7.) Although some of the outsourcing is domestic, 30 percent of Fortune 1,000 industrial corporations outsource more than 50 percent of this manufacturingamounting to between \$100 and \$250 billion per year. These 1,000 companies account for 60 percent of the manufacturing contribution to the U.S. GDP (23 percent of GDP in 1993). Cross-border trade flows within companies (intrafirm trade) now account for roughly onethird of world trade and perhaps as much as 15 percent of the world GNP (Goldman, Nagel, & Preiss, 1995; World Bank, 1995).

A worldwide reservoir of labor has become available for industrial employment as Third-World workers have shifted increasingly away from primitive agricultural production to seek industrial jobs. Between 1960 and 1990, manufactured products as a share of all exports from developing countries grew from 20 to 60 percent (World Bank, 1995). This population shift from agriculture to industrial employment is similar to that which occurred in Europe and the United States more than 200 years ago.

Another concept, the internationalization of capital—the movement of capital from one country to another—is often related to the new international division of labor. For example, companies in more-developed nations may invest in production arrangements in less-developed countries—which is often the case for apparel production. Or, stated another way, as industrialization begins to occur in developing countries, it is often a result of investments by the core soci-

eties. Many developing countries have pursued economic development through strategies that Sklair (1989) has given the acronym ELIFFIT: export-led industrialization fueled by foreign investment and technology. In fact, many Third-World nations receive the foreign capital to start industrialization because of policies that promote "investment by invitation"—that is, many developing countries actively seek foreign investments and production through a variety of incentives and concessions, often competing against other Third-World countries.

Typically, the industries employing the new international division of labor use very basic technology to make relatively simple products. Apparel has been an especially important example of such production, and this industry has led the growth of manufactured exports from the developing nations. Firms in the more industrialized countries have found the low wages in Third-World countries particularly attractive as labor costs have risen in their home countries. Therefore, the developing countries' desire to increase industrialization and exports complements the need of corporations in the more-developed nations to find sources of less costly labor. Hence, since the 1950s, TNCs have frequently split their production processes, locating the more labor-intensive assembly operations in the Third World.

Various writers have applied a number of terms to the resulting co-production relationships dispersed around the globe. Drucker (1977) coined the term *production sharing* for this arrangement. Grunwald and Flamm (1985) refer to the *global factory* as they concluded that the 1960s and 1970s ushered in a new stage in the evolution of the world capitalist system as U.S. (and the same could be said for European) TNCs switched, on a fairly large scale for the first time, to overseas production of manufactured exports for the domestic market.

As firms in the industrialized countries view developing countries for the possible location of simple production processes, they consider a country with a good supply of nonunionized labor, political stability, developed **infrastructures**, and other incentives as an appropriate investment climate.

The relocation of industrial investment and the new international division of labor require a number of technological developments, most of which are readily available. Today's transportation and communication systems permit certain industries, such as textiles and apparel, to be located almost anywhere in the world. Garments and most other textile items are lowbulk, low-weight commodities ideally suited to the new international division of labor. Fax machines and electronic mail facilitate communication among a company's operations around the globe.

Although the shared production arrangements have advantages to both the investor firms and the host nations, conflicts are inherent. Moreover, many scholars are critical of these arrangements, using arguments that closely resemble those of the structuralists' development theories. That is, they state that the conflicts reflect a struggle between the North and the South, the have and have-not nations. Although the shared production arrangements provide export earnings and jobs for large unemployed labor pools in the developing countries, critics see many limitations. For example, Fröbel et al. (1980) charged that "this process also perpetuates those structures which generate dependency and uneven development and the marginalisation of a large part of the population without creating even the most rudimentary preconditions for alternative development" (p. 404). Similarly, Sklair (1989) concluded that the goal of these relationships is to ensure the continued accumulation of capital at home and abroad—as has always been true for global capitalism. Additionally, Pantojas-Garcia (1990) asserted that the arrangements benefit class interests rather than all of society. He believes these arrangements often falsely portray economic development for the masses; however, in many cases,

special interest groups have designed strategies to benefit themselves.

Thus, critics believe that assembly operations condemn host countries and workers to continued underdevelopment. Because TNCs generally make decisions in their headquarters located in the developed nations, the host country's potential supplies of intermediate inputs may be ignored, development of local management and other skills are often overlooked, and the use of technology along with research and development from the investor nation neglects the nurturing of these activities in the host country. As a result, the international division of labor may do little to help the developing economy advance to stages in which local management, investment, technology, and research and development would play a dominant role in the production process. Moreover, wage increases may be difficult to pursue for local workers because host countries often worry that increasing labor costs may cause the investor firm to move to more favorable settings in other countries.

Critics use other arguments to illustrate that shared production arrangements are detrimental to host economies and that underdevelopment will be perpetuated under these schemes. For example, critics assert that TNC investor firms may have a negative impact on the local industry structure in the developing country, often building too many plants or plants of inappropriate size in their efforts to capitalize on market position at a given time. Furthermore, the powerful TNCs may have the potential to exploit economies of scale, product differentiation, technological advantages, marketing advantages, and vertical integration, which may be significant entry barriers to local firms in the host country.

In general, globalization and trade create jobs and improve local economies. However, in any major structural change, there are winners and losers. Globalization and the new international division of labor are blamed for job

losses in the more-developed countries caused by the transfer of production elsewhere. Although many Third-World nations have welcomed foreign companies and investors, and although those economies are booming, the older industrialized economies have flourished far less in recent years. Some workers will suffer job losses if they are stuck in declining activities and lack the mobility and flexibility to change. As Dicken (1992) noted, unemployment in the Western industrialized countries reached levels in the 1970s and early 1980s unknown since the Great Depression of the 1930s. In 1970 there were 8 million unemployed workers in the OECD countries; in 1995 there were 35 million, or about 8 percent of the workforce-most of them unskilled workers (World Bank, 1995).

Factory closings, job losses, and shifts from manufacturing to service jobs have created the term deindustrialization to describe the developed economies—often with older industrialized regions in each nation facing the greatest unemployment. Ironically, it is often the dilemma of competing with lower-cost imported goods from developing countries that leads to a firm's decision to relocate its own production abroad. As might be expected, labor unions in the developed nations believe jobs have been lost as a result of foreign assembly and are opposed to this "export" of jobs. Workers in France have staged public demonstrations to decry the effects of globalization on the French workforce. These issues will be debated further in later chapters.

In conclusion, many textile and apparel production processes are scattered around the globe. This globalization is the single most significant change affecting the textile and apparel sectors in recent decades. Familiarity with the new international division of labor concept provides another useful way of considering in a broad perspective what is happening in global textile and apparel production and trade.

AGILE COMPETITION AND VIRTUAL COMPANIES

Goldman, Nagel, and Preiss, authors of *Agile Competitors and Virtual Organizations* (1995), note that although no theory has yet developed for these concepts, many businesses in all industries today are using these concepts to stay competitive in an unprecedented age of dislocation and change. These concepts are covered briefly here because of their timeliness and their relevance to the topics just covered in this chapter. Because space permits only a superficial discussion of this topic, readers are encouraged to consider further sources to understand these dynamic changes, which are expected to provide a new paradigm for business in the 21st century.

Goldman et al. assert that in developed societies new approaches are replacing the massproduction system in factories and corporations that evolved from the industrialization that mushroomed in the early 20th century. An agile competitive environment is supplanting the mass-production environment, and the authors believe the new approach will become the norm for global commerce. They define agility as "a comprehensive response to the business challenges of profiting from rapidly changing, continually fragmenting global markets for high-quality, high-performance, customer-configured goods and services. . . . Agility is, in the end, about making money in and from a turbulent, intensely competitive business environment" (p. 4). Although mass-production companies may have been customer-centered, agile competition goes beyond that. Agile competition demands that the processes that support the creation, production, and distribution of goods and services be centered on the customer-perceived value of products. In contrast to the mass-production purveyors of standardized, uniform goods and services, successful agile companies know a great deal about their customers and interact

with them regularly and intensively. Rather than gearing products to an average or typical customer, agile competition "offers individualized products—not a bewildering list of options and models but a choice of ordering a product configured by the vendor to the particular requirements of individual customers" (p. 6). Success comes from developing customer-value-based business strategies for competing in the most competitive, most profitable markets. McHugh, Merli, and Wheeler (1995) consider an agile company one able to assemble dispersed resources rapidly in a deliberate response to changing, unpredictable customer demands.

Goldman et al. (1995) note that broader product ranges, shorter model lifetimes, and the ability to process orders in arbitrary lot sizes are becoming the norm in the most advanced markets. "The information-processing capability to treat masses of customers as individuals is permitting more and more companies to offer individualized products while maintaining high volumes of production. The convergence of computer networking and telecommunications technologies is making it possible for groups of companies to coordinate geographically and institutionally distributed capabilities into a single virtual company and to achieve powerful competitive advantages in the process" (p. xv). Business Week (1993) defined a virtual company as a new organizational model that uses technology to dynamically link people, assets, and ideas.

Goldman et al. (1995) note that "These market characteristics have triggered structural changes in how companies are organized to create, produce, and distribute goods and services. At the same time, the economics of doing business have shifted. The robustness of the mass-production system—its ability to function in less-developed societies—makes it increasingly difficult to realize profits large enough to justify locating such a facility in the most developed countries. Operations that produce market-segmenting, knowledge-based, service-

oriented products customized to the requirements of individual customers, however, can still be profitable in these societies" (p. xv).

In today's global economy, with improved global transportation and communications systems including high-capacity information systems, profitable companies view markets and production as no longer domestic only. These advances now permit the integration of design, production, marketing, and distribution activities being performed at sites around the world into a coherent "virtual" production facility. A company can have its own functions located wherever it works best, or it can link some of its capabilities with those of other firms with complementary strengths. This might mean that an apparel firm buys the services of a design firm to create its line, may contract the sewing operations to a factory in a low-wage country, and may ship products back to the United States via a commercial logistics firm.

Hence, we begin to see the connection of these new concepts to discussions on the new international division of labor and outsourcing. The virtual company concept embraces similar practices of locating production or other activities wherever competitive conditions deem most advantageous. Goldman et al. (1995) believe that companies will have no choice but to make these changes if they are to survive in an agility-dominated economy.

SUMMARY

Theories are helpful in focusing on global shifts in textile and apparel production and trade. Theories and concepts help us to see the broad picture and examine these global trends in an organized manner. Further, theories may help to explain what is and what could be produced competitively in a given area.

Several trade theories provide various perspectives on why production and trade occur as they do. Mercantilism provided the ground-work for the idea that a favorable balance of trade is desirable. Adam Smith's theory of absolute advantage suggested that a nation should concentrate on industries in which its costs are lowest and that the country should trade part of its output for goods other nations can produce more cheaply. Ricardo's theory of comparative advantage shows that a country can specialize and develop a comparative advantage, although it has no absolute advantage. Smith's and Ricardo's theories focused on the question: Is trade beneficial? Both of these writers emphasized the benefits for all countries through trade.

Later theories focused on the question: What should be produced where? The factor proportions theory suggests that relative factor endowments of land, labor, and capital will affect the relative costs of these factors, therefore determining the goods a country can produce most efficiently. The product cycle theory suggests that products will shift locations for production according to stages in the product's life cycle.

More recently, Michael Porter's *The Competitive Advantage of Nations* (1990) provided new perspectives on why some nations succeed in certain industries and certain segments. His determinants of national advantage shape the environments in which a country's firms compete to promote or impede international competitiveness.

Although trade theories examine global exchange on a country-to-country basis, decisions to trade or not to trade are generally made by firms within those countries. Firms may trade to use excess production capacity, to lower production costs, or to spread risks.

Development theories and models are relevant and useful in studying international textile and apparel production and trade. Although development theory has its roots in economics, development approaches extend to historical, social, and political issues as well. As we observe the emergence of textile and ap-

parel production in nearly all Third-World countries, development theory helps us to understand these global trends. Moreover, various development approaches provide insight into the long-term outlook for the role of the textile and apparel sectors in various regions.

Early mainstream/modernization theories of development relied on the premise that poorer countries would imitate the development patterns of the industrialized nations. Newer theories, grouped into what McGowan (1987) calls structural theories, reject the notion that the poorer countries are likely to develop in patterns similar to the richer nations. The structural theories, which McGowan considers to include dependency theory and world-systems theory, are based on the idea that problems in structural relations existed because of vastly different historical paths of development for three major groups of countries or societies: the core, the semiperiphery, and the periphery.

The concept of the new international division of labor, which borrows from both economic and development theories, refers to the breaking down of complex manufacturing into small, simple production processes that are contracted out to low-wage countries. Internationalization of capital refers to the investment by core nations in the periphery regions to use the less-developed countries for low-wage production processes. These global shifts in production and investment offer advantages to both TNCs and host economies in the Third World. At the same time, these strategies have been subject to criticism from various quarters.

Agile competitors and virtual companies are expected to become increasingly important as the old mass-production model gives way to approaches centered on the customer-perceived value of products. To achieve this kind of response, companies will exploit complementary resources in other companies, forming alliances that become virtual companies. Many of these alliances will be part of global networks.

GLOSSARY

Absolute advantage exists when one nation can produce more of a commodity with a given amount of resources than another country can.

Aggregate demand is the sum of a group of individuals' demands; this represents the market demand.

Agility or agile manufacturing is characterized by the ability to assemble dispersed resources rapidly in response to changing, unpredictable customer demands. Agile firms emphasize the innovation and teamwork necessary for rapid changes.

Arm's-length trade occurs when producers in one country trade goods with buyers in other countries. Business relationships may be defined sim-

ply as buyers and sellers.

Balance of trade measures the difference between the value of a nation's exports and the value of its imports. The balance of trade includes services in addition to merchandise.

Capital-intensive products are those that result from production with a high capital-to-labor ratio; that is, a great deal of capital is required for

production.

Comparative advantage is a concept in trade theory that suggests that a country "should specialize in producing and exporting those products in which it has a comparative, or relative, cost advantage compared with other countries and should import those goods in which it has a comparative disadvantage. Out of such specialization, it is argued, will accrue greater benefit for all" (Dicken, 1992, p. 92).

Competitive advantage refers to whatever it is that enables a firm to beat its competition in the mar-

ketplace.

Compradors are local agents who facilitate business with investor companies from other countries.

Deindustrialization refers to the phasing out of industrial activities in the more-developed countries.

Dependency theory (in Spanish, dependencia) originated in Latin America as the less-developed countries concluded that they were too dependent on the sale of a few primary commodities and/or too dependent on a limited number of developed countries as customers and suppliers. According to dependency theory, industrialized countries have dominated and exploited the Third World.

Development, in addition to the definition given in Chapter 3, focuses on the imbalances in the distribution of resources between the rich and poor nations of the world. Development efforts are aimed at reducing the gap.

Direct foreign investment refers to ownership or part ownership of foreign production facilities.

Division of labor refers to the division of production jobs or tasks because certain groups of workers are presumed to provide efficiencies in the use of resources (e.g., labor costs, skills, technology).

Equilibrium price is the price at which the quantity demanded equals the quantity supplied.

Greige goods are unbleached, unfinished fabrics that will receive further processing, which may include dyeing, printing, or other finishing.

Factors of production are the basic inputs required for production; these include natural resources (land and raw materials), capital, labor supply, knowledge resources, technology, and infrastructure.

Infrastructures are the underlying systems or frameworks within a country that support the activities of industry or other operations; these include communication networks, energy, roads, railroads, and seaports (and some sources include education). Infrastructures reflect a nation's level of development and affect the country's ability to participate in global commerce. For example, if a less-developed country produces a large volume of cotton but does not have the infrastructure to transport it to ports, the country has little opportunity to export the cotton.

Internationalization of capital refers to investments by core countries in the early industrialization efforts (also mines and plantations) of periphery nations. Often, this is associated with contracting simple production processes to the less-

developed countries.

Intrafirm trade occurs when trade takes place between two or more units of the same company, or its contractors, across national boundaries.

Law of demand suggests that there is an inverse relationship between the market price and the quantity demanded when other factors remain constant. That is, as the price increases, the demand decreases; as the demand increases, the price decreases.

Law of supply suggests that there is a relationship between the quantity supplied and the price; as the price rises, producers are encouraged to increase

output.

Licensing (or licensing arrangements) involves an agreement between a firm in one country and a foreign manufacturer to use the former's trademark and expertise to produce and market the product (e.g., garments) in the foreign manufacturer's country.

Mercantilism is an economic philosophy built around the idea that a country's wealth depended on its holdings of treasure—particularly gold.

Merchandise trade balance is the difference between the money a country receives from selling its goods (merchandise) abroad and what it pays to buy goods from other countries.

Multinational corporations (MNCs) are those that own, control, or manage production and distribution facilities in more than two countries.

Nation-state is what we now call a country.

New international division of labor refers to dividing complex manufacturing into small, simple production processes that are contracted out to other parts of the world to be performed by low-cost labor.

Opportunity cost is the cost of using resources for a given purpose, measured by the benefit or revenues given up by not using them for their best alternative use.

Outsourcing refers to securing parts or whole products or to contracting production from other manufacturers while the firm buying these maintains its own company or brand name.

Society, as it is often considered in international business, is the nation-state because of the basic similarity of people within national boundaries.

Transnational corporations (TNCs) are those that own, control, or manage production and distribution facilities in at least two countries.

Underdevelopment has varied definitions in different development theories. In the mainstream/modernization view, underdevelopment is the difference between the rich and poor countries. According to this view, underdeveloped countries are characterized by capital shortages. In the structural approaches, underdevelopment refers to a country's or a region's specialization in the production and export of low-wage, low-technology products.

Virtual company is a new organizational model that uses technology to dynamically link people, assets, and ideas.

World-systems theory, which followed dependency theory, emphasizes "the capitalist world economy as one integral system covering the whole globe and being moved by a single dynamic system overpowering the individual states that make up the system; ... this central power, which is in the process of expansion, has forced peripheral areas under its control" (Blomström & Hettne, 1984, pp. 186–188). Immanuel Wallerstein is the scholar best known for extending this approach beyond dependency theories.

SUGGESTED READINGS

Bernstein, A., Konrad, W., & Therrien, L. (1992, August 10). The global economy: Who gets hurt? *Business Week*, pp. 48–53.

This article examines the impact of global shifts of production on workers in the developed countries.

Blomström, M., & Hettne, B. (1984). Development theory in transition. London: Zed Books.

This book emphasizes the importance of dependency theory in the formulation of broader development theories.

Caporaso, J. (Ed.). (1987). A changing international division of labor. Boulder, CO: Lynne Rienner. A volume of papers that focuses on the international division of labor, with special emphasis on the role of the working class.

Dicken, P. (1992). Global shift: The internationalization of economic activity (2nd ed.). New York: Guilford Press.

This book provides an excellent multidisciplinary examination of global shifts in production, with particular emphasis on the role of TNCs.

Edwards, C. (1985). The fragmented world. London: Methuen.

Chapter 1 provides a useful summary of the world division of labor and economic theories.

Ellsworth, P. I., & Leith, J. C. (1984). The international economy. New York: Macmillan.

A study of international economics; the authors blend

theory, history, and policy.

Farrell, C., Mandel, M., Javetski, B., & Baker, S. (1993, August 2). What's wrong? Why the industrialized nations are stalled. *Business Week*, pp. 54–59.

Fishlow, A., Diaz-Alejandro, C., Fagen, R., & Hansen, R. (1978). *Rich and poor nations in the world economy.* New York: McGraw-Hill.

- This book addresses the political economy of North-South relations and includes a useful section on development strategies.
- Fröbel, F., Heinrichs, J., & Kreye, O. (1980). *The new international division of labour*. Cambridge: Cambridge University Press.
 - A study of the new international division of labor; the study focuses on West Germany's textile and apparel industries.
- Goldman, S., Nagel, R., & Preiss, K. (1995). *Agile competitors and virtual organizations*. New York: Van Nostrand Reinhold.

Two of these authors developed the terms agile competition and virtual companies. This book is one of the seminal works on these topics.

- Grunwald, J., & Flamm, K. (1985). *The global factory.* Washington, DC: The Brookings Institution. *An important study on foreign assembly and international trade.*
- Joy, C., & Kniep, W. (Eds.). (1987). *The international development crisis and American education*. New York: Global Perspectives in Education.

A review of challenges, opportunities, and instructional strategies related to development education.

- O'Reilly, B. (1992, December). Your new global work force. Fortune, pp. 52–66.

 An article on how firms are tapping the world's skilled labor pool.
- Pollard, S. (Ed.). (1990). *Wealth and poverty.* Oxford: Oxford University Press.

- A well-organized and illustrated economic history of the 20th century.
- Porter, M. (1990). *The competitive advantage of nations*. New York: Free Press.

The author builds on his earlier works to develop a new paradigm for analyzing international competitiveness that may replace the classic concept of comparative advantage.

Rifkin, J. (1996, March). A new social contract. *The Annals of the American Academy of Political and Social Science*, 544(11), 16.

A focus on the prospects of massive unemployment resulting from workerless factories and virtual companies, and how nations will grapple with these questions.

Schonfeld, E. (1996, April 29). Virtual manufacturing is a painkiller. *Fortune*, p. 205. *Virtual manufacturing as seen from a business point*

of view.

United Nations, Centre on Transnational Corporations. (1987). *Transnational corporations in the manmade fibre, textile and clothing industries*. New York: Author.

A study of TNC activities in textiles and apparel. Ward, K. (Ed.). (1990). Women workers and global restructuring. Ithaca, NY: ILR Press.

An examination of how women workers are affected by global restructuring.

Part III provides a general survey of the textile and apparel industries in the global economy and the global

shifts for these sectors. These chapters are designed to help us understand and appreciate the magnitude of the global textile complex and the role the textile and apparel industries play in virtually every country of the world.

Chapter 5 provides an overview of the global textile complex, including a brief historical perspective. The chapter also considers the stages of industry development in relation to a country's or region's overall development.

Chapter 6 examines global patterns of textile and apparel production, employment, consumption, and trade. We consider the noteworthy patterns that have emerged and some of the implications for producers, workers, and consumers in various regions of the world.

Chapter 7 reviews the textile complex in select regions of the world, particularly in relation to the restructuring that is occurring on a global scale. We consider significant changes that are shaping the nature of the global industry. In this chapter, wherever possible, an effort is made to relate the discussion to various stages of development considered in earlier chapters.

Global Patterns of Development

Textile and apparel production plays a vitally important role in supporting and sustaining human life around the world. Beyond providing clothing as a basic human necessity, the production of textile and apparel goods provides jobs for a large proportion of the world's population. Whether we are considering textile workers in a major industrialized country or those involved in elementary production in the poorest countries, these industries provide employment for a vast number of the world's occupants. Employment in the textile complex is vital to most of these workers, regardless of the region of the world, because individuals may have few or no other options to earn money to sustain themselves and their family or household members.

World trade in textiles and apparel has been given special attention for many years. Global trade in these sectors has become quite sensitive because of the unique role the industries play as major employers. Moreover, because of the important role of these industries in providing employment for workers in virtually every country, trade problems have become quite politicized and difficult to resolve. As might be expected, nearly all countries with a textile or apparel industry want an opportunity to compete in world markets. In short, in-

creased global participation in textile/apparel production has led to an overcapacity to produce for existing markets, and intense competition has resulted. Hence, the attention given to textile and apparel trade may seem disproportionate to the economic contribution of these sectors to the global economy. The fact remains, however, that textile and apparel production is the top manufacturing employer in the world. The significance of these industries would be even more dramatic if accurate reports of **informal sector** (i.e., **cottage industry**) employment could be documented.

This chapter presents (1) an overview of the global textile complex, including a brief historical perspective, (2) a review of global patterns of development for the textile complex, (3) consideration of changes in the textile complex in relation to a nation's development, and (4) a brief reflection on global supply in relation to demand.

BRIEF HISTORICAL PERSPECTIVE

The textile industry led the early industrialization process in regions of Europe and the United States. Similarly, as other countries moved toward economic development, the textile sector played a vital role in industrialization efforts. Later, as apparel production became an industrial activity, both sectors became significant components of a changing global economy. Although we have noted the increased global participation in these sectors, words fail to reflect the chaos and political drama that have accompanied global shifts in production, employment, and trade.

Production and trade shifts for textiles began to occur in the early 20th century. As these changes began to affect the textile industries of the developed countries, global textile activity began to take on turbulent characteristics that would intensify in later decades. A brief historical review of global shifts will provide a helpful perspective as we examine these trends in greater detail in this chapter and the one that follows.

Early 20th Century

At the turn of the 20th century, Britain accounted for 70 percent of the world's textile trade (Aggarwal, 1985). According to Maizels (1963), world textile production increased by about 90 percent between 1900 and 1937, and significant changes in where production would occur began during this era. Although absolute global production increased, the contribution of textiles as a proportion of all manufacturing production in the developed countries began to decrease by 1900. The increased proficiency of a major new producer nation, Japan (a developing country at that time), partly accounted for the drop in the industrialized countries' production as a proportion of total manufacturing activity.

After the Depression began in 1929, challenges to the dominant positions of the textile and apparel industries in the industrialized countries set the stage for what would follow for much of the century. Japan's economic development from the 1920s through the 1950s paralleled earlier patterns in the United States

and certain European countries by relying heavily on textile production to lead the industrialization process. By 1933, Japan had become the primary exporter of cotton textile products in the world (Aggarwal, 1985; General Agreement on Tariffs and Trade, 1984). Japan's textile competitiveness was affected seriously, however, by World War II; more than three-fourths of its textile production capacity was destroyed.

Mid-20th Century

After the war, the U.S. and British industries expanded vigorously, while the textile and apparel sectors in most other countries rebuilt their production facilities. By 1947, the U.S. textile and apparel industries enjoyed an impressive trade surplus and began to consider the surplus as normal. Consequently, U.S. manufacturers willingly supported efforts to help Japan rebuild its industry (Aggarwal, 1985; Destler, Fukui, & Sato, 1979). The struggling nation depended heavily on textile production for rebuilding its economy, and by the 1950s Japan again became a major contender for global textile markets. American manufacturers began to worry about the impact of Japanese imports in U.S. markets. These events set the stage for similar shifts that would occur in the decades that followed.

In the 1950s and 1960s, other developing countries and a few nations in Eastern Europe began to pattern their economic development strategies on those of the industrialized countries. The **newly emerging countries** hoped that similar industrialization would permit them to become important forces in world markets and would bring to their economies some of the prosperity they observed, particularly in the United States and Western Europe. Japan was a role model many developing countries attempted to emulate. (The reader is reminded that the development theories in vogue during this era suggested that the less-developed countries would be able to imitate

the industrialized countries in their development process. Japan was an impressive example of the progress believed to be possible by advocates of the mainstream/modernization approaches.) Japan's rapid rebuilding and economic evolution represented progress other countries hoped to repeat. Of particular significance is the fact that most of the emerging nations chose textile production as a major sector (more often, *the* major sector) in which to concentrate their investments, their efforts, and their dreams for advancing economically.

Textile production was a natural first industry for developing countries to choose. Then and now, the textile complex provided an easy entry for **new producer nations**. Simple textile/apparel production required limited capital and technology—resources in short supply in the developing countries. Portions of the industry are quite labor intensive, and emerging nations usually have an abundance of low-cost labor. Such countries usually have large populations in need of jobs to help the nation earn foreign exchange and improve the local standard of living. In addition, unskilled workers are able to assume simple production jobs in the textile complex with little training.

Following Japan's example, a number of less-developed nations began to produce and export cotton products. (Keep in mind that this was prior to the widespread production of manufactured fiber products.) Soon, Hong Kong, South Korea, India, and Pakistan joined Japan in exporting growing amounts to the developed countries. Although imports accounted for only about 2 percent of the U.S. textile market by 1955, domestic manufacturers became increasingly concerned over the threat from exporting countries (Aggarwal, 1985). Similarly, by 1958, British textile and apparel producers became alarmed that their country, which had launched the Industrial Revolution with textiles, was importing more cotton cloth than it was exporting.

As competition for world markets increased in the middle to late 1950s, early efforts began

in both the United States and Europe to stem the flow of textile products from low-wage countries into the developed countries' markets. Although problems associated with global textile trade began to seem difficult in that era, the 1950s were a mere prelude to the growing clash between exporting and importing nations.

Late 20th Century

The number of nations producing for the international textile and apparel markets has multiplied many times over since the 1950s. As the number of textile-producing nations grew, the competition for market access became increasingly intense. Further, at a time when the number of producer nations increased, textile product consumption slowed in the major markets—those of the developed countries. As a result of the increased competition and the perceived threat of imports, textile and apparel manufacturers in the industrialized nations began to demand trade policies to protect domestic markets. Trade policies related to the textile complex will be presented in more detail later in the book.

GLOBAL PATTERNS OF DEVELOPMENT FOR THE TEXTILE COMPLEX

Although the relative importance of textile and apparel production varies (both in relative terms in global markets and in relative terms within a country), virtually every country in the world produces at least some textile products. These products range from simple textile components (fibers, yarns, fabrics) to sophisticated end-use products. For some nations, production of textile and apparel products represents a vital means of economic survival; for others, this industry has taken on a less important role.

Stages of Development in the Textile Complex

Toyne and his colleagues (1984) have provided a helpful conceptual approach for considering the extent to which the textile complex has developed in various countries or areas of the world. They described different levels of development on a continuum "ranging from embryonic to declining" (p. 20). All the stages of development can be found in various parts of the world today, and the industries in many countries are evolving from one stage to another.

The notion of *stages of development* in textile and apparel production parallels, in many ways, the discussion in Chapter 4 regarding overall development within countries or regions. These parallels will be discussed later in this chapter.

Toyne's stages of development permit us to consider the major stages through which the textile complex is passing on a worldwide scale. Although we will consider specific countries as examples in these stages, it is important to remember that within each stage we would find many countries and regions of the world.

Although these stages of development do embody some characteristics of the mainstream/ modernization development theories and models, these stages are primarily descriptive of the textile complex as we might find it throughout the world today. That is, the stages are descriptive rather than prescriptive. Although the textile and apparel industries in some countries have moved or will move through most or all of the stages, it is unlikely that this evolution will be possible in some nations.

The stages developed by Toyne et al. have been modified and updated from the original scheme. As we consider them, we must keep in mind that a country's or region's textile complex may be represented by more than one level.

1. The *embryonic stage* is typically found in the poorest and least-developed countries. The industry is often little more than a collection of

cottage industries, and most production is for domestic consumption, such as that in Figure 5–1. Production consists primarily of making simple fabrics (usually by hand-produced methods) and garments from natural fibers. These countries typically import component parts if they can afford to do so. Production of natural fibers for export, particularly cotton, may be one of the few ways in which some countries at this stage can earn **foreign exchange**. The textile and apparel sectors in many countries in Africa are presently at this stage of development.

- 2. Early export of apparel occurs because lowwage labor is used for labor-intensive operations to produce garments for which there is a market in other countries. This may involve the assembly of component parts of garments from other countries, the production of ethnic clothing, or the production of products with extensive hand work. Often products from countries at this stage of development are for the low end of the market in developed nations, and in many cases, price is the primary appeal for consumers who consider these products. Often when a nation is at this stage, some of the technical aspects of garment production are not yet perfected and the quality may be unpredictable. Examples of countries in this stage are Nepal, Bangladesh, Sri Lanka, and several Latin American and Caribbean countries. Some of the members of the Association of Southeast Asian Nations (ASEAN) have been in this stage, but other members have advanced to the next levels.
- 3. More advanced production of fabric and apparel occurs at this stage of development. Domestic production of fabric improves greatly in volume, quality, and sophistication, and fabrics may be exported to other countries. As countries become more advanced at this level, they may develop their own fiber production, including manufactured fibers. During this stage, apparel production is expanded and upgraded. Garments may be made from fabrics

FIGURE 5-1

Using primitive tools, this Mazahua Indian woman in Mexico is preparing yarns for weaving.

Source: Photo courtesy United Nations.

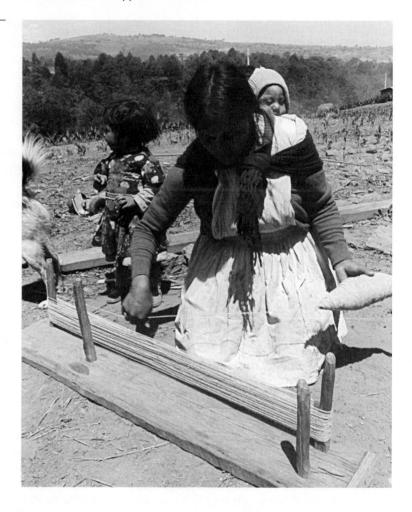

and component parts (intermediate inputs) produced within a country rather than simply assembling components from other countries, which is more typical in the second stage. In general, the textile complexes at this level "become larger, more diversified, more concentrated, and more internationally active" (Toyne et al., 1984, p. 20). Some of the more advanced ASEAN members are in this stage of development. Mainland China is in this stage and is making rapid advances toward self-sufficiency in manufactured fiber production (McMurray & McGregor, 1993).

As Toyne et al. noted, large manufacturers and retailers in more-developed countries pro-

vide assistance at this stage, which fosters advancement from one level to the next. Large manufacturers and retailers assist by investing in the emerging countries' industries, by contracting, and by providing information on technical aspects of production, marketing, and management. Further, movement to this level of production is often encouraged by local government policies that encourage **import substitution** and by initiatives that foster exporting. (We should note that government support also occurs in the first two stages. Often it is government support, however, that permits movement to this third stage.)

FIGURE 5-2

High-tech textile production, such as that required to produce manufactured fibers, characterizes more advanced stages of development in a textile complex.

Source: Photo courtesy of DuPont Fibers

4. The "golden age" stage of development is characterized by increasingly enlarged and sophisticated textile and apparel production as well as large trade surpluses for the sector. Manufactured fiber production becomes more advanced and increases in volume. The domestic textile industry is capable of supplying a good proportion of the fiber and fabric needed to make garments or other finished products. The textile complex diversifies its product mix and in general becomes a more powerful force in international markets.

Rather than being on the receiving end of contractual arrangements with firms in other nations, industry leaders in a country at this stage initiate joint arrangements for their own firms. That is, textile and apparel firms in countries at this stage now invest in the industries in other countries—much as the more-advanced countries once invested in them. Korea and Taiwan are examples of countries presently at this stage. Firms from these major Asian sources have invested in segments of the textile and apparel industries in other countries that are at earlier stages of development.

By this stage, a country's level of industrialization and development may affect the importance attached to the textile complex. Nations with increased sophistication in sectors requiring more technology and capital may start to favor certain other industries and depend less on the textile complex.

5. Full maturity represents the fifth stage of development. Although total output may continue to increase at this stage, employment in the textile complex starts to decline; the drop in employment is particularly noticeable in the apparel sector. The industry may become more concentrated; products and processes tend to be at a fairly advanced level, such as that shown in Figure 5–2. The production of manufactured fibers and relatively complex textile mill products is characteristic of this stage. Production is capital intensive, and large capital investments are used to offset the labor advantages in competing nations and also may be required for more complex products.

Toyne et al. placed the United States, Japan, and Italy in this stage, but some sources would consider each of these as having characteristics of the next stage.

6. Significant decline is characteristic of the final stage of development. Both the number of

firms and the number of workers in the textile complex decrease significantly at this stage. and trade deficits occur in many segments. particularly apparel and fabric. Survival patterns are quite mixed because while some segments remain healthy, others are in serious trouble and perhaps cannot be revitalized. Offshore production increases significantly. Toyne et al. (1984) considered several European countries to be at this stage: the United Kingdom. Germany, France, Belgium, and the Netherlands. Although the textile complexes in all these nations are basically in the declining stage, the decline occurred in differing degrees and sometimes because of quite different approaches by the respective governments. For example, Germany intentionally shifted away from segments of the industry that are labor intensive and require less technical production. As a technologically advanced nation, Germany retained the more sophisticated portions of the textile complex, such as chemical fiber production. A substantial proportion of the labor-intensive apparel production is sent to low-wage countries for the sewing operations.

TEXTILE AND APPAREL STAGES OF DEVELOPMENT IN RELATION TO BROADER DEVELOPMENT

This is another case in which the role of gov-

As we have noted earlier, the stages of development for textile and apparel production generally parallel the developmental stages of a nation or region. The reader may wish to reflect on the discussions on development in the previous chapter. Figure 5–3 provides a graphic way to help us think of these parallels.

Keeping these parallels in mind, we find that examining the stages of development of the textile complex within various regions of the world gives a reasonable indication of the overall economic and other development in these areas. Perhaps this could also be said of some other industries; however, this is particularly true because of the significant role this sector plays in the early development of most

FIGURE 5-3

Stages of development for the textile complex generally parallel the development stages of a nation or region.

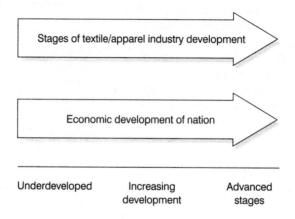

ernment affected dramatically the nature of a country's textile complex. Therefore, the decline in Germany occurred because of government priorities despite the fact that individual firms within the complex may have desired greater government assistance.

¹ Toyne et al. (1984) made these observations prior to the reunification of Germany. They apply only to the mature industry in the former West Germany. A good proportion of the industry in the former East Germany is at much less advanced stages and struggles to remain viable.

countries. Additionally, the parallels are particularly evident in less-developed areas, where the textile complex is often at the forefront of broader economic and industrial development. In many ways, the same may be true for other regions as well.

Developing Stages

Figure 5–4 provides a way of considering the textile and apparel industries in the early development process of a country or region. Although this model may convey the optimism of the mainstream/modernization approach, textile/ apparel production in most countries does evolve through at least some of these stages. For this model, let us consider that the underdeveloped countries are participating in the most elementary forms of textile and apparel production. This might be the production of natural fibers that is, agricultural activities such as growing vegetable fibers (e.g., cotton) or producing animal fibers (e.g., wool)—or participating in simple apparel assembly processes. All of these are labor-intensive, low-capital, low-technology areas of textile and apparel production.

Simple textile or apparel production is often the first attempt toward industrialization in underdeveloped or newly developing countries (the Third-World periphery). Countries with little capital and technology can provide the labor required to grow fiber crops, raise sheep, or assemble garments. Typically, assembly operations are being performed for firms headquartered in the First-World core—which is where the profits go, too. Production occurs in the periphery regions because wages are a fraction of what they are in core states and the activities are labor intensive. At this stage, periphery countries gain little more than jobs paying extremely low wages for performing the assembly operations. (However, we must not minimize the significance of those jobs and the resulting modest wages in terms of what they contribute to workers in poor nations.)

In recent decades, nearly all developing countries that were not already producing textiles and apparel for world markets have become players in this highly competitive sector. As Figure 5–5 attempts to illustrate, a large number of nations at varying stages of development now compete. The newest entrants

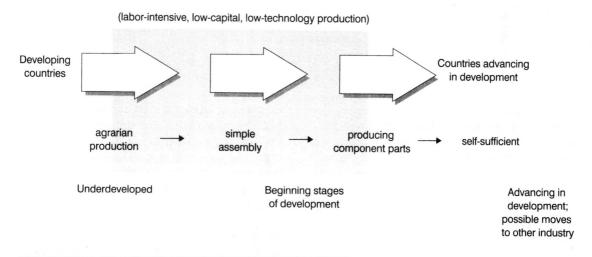

FIGURE 5–4
Textile and apparel production in a nation's early development.

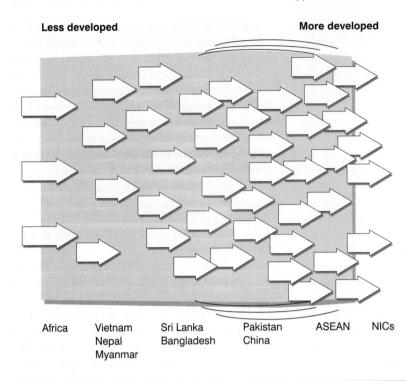

FIGURE 5-5

Developing stages: Nearly all developing nations of the world have entered textile and apparel production and are at varying stages of development for the sector, as this figure attempts to illustrate. The large number of producer nations accounts for the intense global competition. The countries and regions named here are intended only to be illustrative of countries at various stages rather than a complete list.

include some of the most underdeveloped countries with the fewest resources to start and operate their own industry. The large number of participants that we see here adds to the overcapacity of global production, creating a difficult trade scenario for these countries as well as for those at more advanced stages.

If we refer back to Figure 5–4, our model suggests that as countries develop, if they are able to do so, they eventually move to somewhat more advanced levels of textile and apparel production. Fairly predictable changes may occur as a country advances beyond the elementary stages.

First, if the country continues in textile and apparel production, its textile and apparel sec-

tors may become capable of producing their own component parts. Up to this point, the workforce may have simply assembled garments from fabrics and other components supplied by more advanced countries. As the textile and apparel industries in a developing nation begin to produce their own components for production (i.e., the yarns, fabrics, and other intermediate inputs), these sectors not only become more self-sufficient, but the production that occurs is at a more advanced level. For example, the technical aspects of manufacturing yarns or fabrics on a mass-production scale (as opposed to simple hand methods) require more capital and technological expertise than does the simple assembly of garments.

Second, as a nation's textile and apparel sectors develop their technical capabilities, they may become increasingly competitive in a wider range of textile and apparel production. For example, many of the Asian NICs have become competitive in manufactured fiber production; this represents one of the more technologically advanced aspects of the global textile complex. In some of the more developed NICs—for example, South Korea and Taiwan—the fiber production facilities may be owned by local sources. In less-developed nations, the facilities, the expertise, and the capital may be provided by foreign sources.

And, finally, if the nation continues to advance in the development process, a move away from textile and apparel production to other industries may occur. Other industries may command higher wages and yield higher profits. For some of the Asian NIC nations to which textile/apparel production was once so important, other industries such as computers or electronics may provide greater financial rewards.

Whether a country moves to more advanced textile/apparel production or into other industries, generally the country gains more than it did in performing only simple assembly tasks for apparel production. In simple assembly operations, the host nation gains little more than low-paying jobs for its workforce. Few profits remain in the country, and the workforce is given little opportunity to increase its technological capabilities.

The model in Figure 5–4 is based on the assumption that some development will occur over time within a country. Our prior discussion suggests, however, that development may be limited in some nations. That is, textile and apparel production may not advance beyond agrarian production and simple assembly operations. For many underdeveloped countries in the Third-World periphery, the structural model of development suggests that low-wage, low-technology production may become their "specialization" for a long, long time.

On the other hand, some of the NICs such as Singapore, Taiwan, and South Korea have de-

veloped to a stage in which other industries are seen as more promising in their contributions to the national economy. In the latter case, the countries have moved into other industrial production and have less emphasis on textiles and apparel. When the NICs move to other manufacturing sectors, textile and apparel production often shifts to lower-wage locations that may include Mauritius, Vietnam, the Philippines, or Indonesia.

More Developed Stages

As the textile and apparel industries mature and as countries become more developed, several scenarios occur as the industry starts having difficulty competing in the domestic market. Several factors contribute to the problem, with less expensive imports often being a major one. Consequently, critical changes are made to make the industry more competitive. As Figure 5-6 indicates, these changes may include (1) assembly taking place in lowwage nations to reduce labor costs, (2) investing in improved automation and other technology to reduce labor costs and improve production speed and quality, and (3) securing government policies that generally are designed to aid the domestic industry in a number of ways, particularly in shielding domestic producers from the competition of Third-World imports.

Many manufacturers in the more-developed nations (and, more recently, the NICs) have chosen to move their garment assembly operations to low-wage countries. Besides looking for lower wages, companies often turn to production in developing countries that have quota availability (a topic we shall consider in greater detail later in the book). As examples, U.S. apparel manufacturers turn to the Caribbean and Mexico; Western Europeans produce in Central and Eastern Europe; the Japanese have assembly done in China; the Taiwanese turn to Indonesia; and the South Koreans use assembly operations in Vietnam. Often, however, this strategy has ironic side effects.

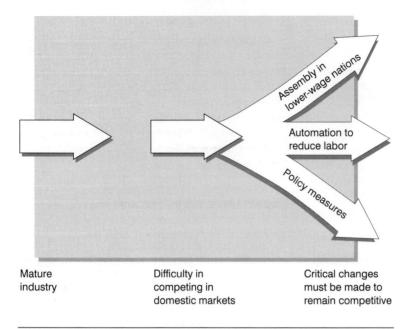

FIGURE 5-6

More developed stages: When the textile complex reaches more developed stages, a variety of strategies may be used to retain competitiveness.

As Figure 5–7 suggests, the strategy of moving production to low-wage countries has been responsible for establishing and expanding production in many underdeveloped countries that would otherwise be less able to participate in textile and apparel manufacturing for the world market. Firms in the more-developed countries provide the investment, production expertise, technology, and marketing knowhow to develop the industry and promote the products. Consequently, this strategy has led to a significant increase in the number of producer nations that have been able to become suppliers for the world's consumers. Although this strategy has benefited workers in the developing nations as well as corporations in the developed economies seeking to lower production costs, the point to be made here is that this strategy has expanded significantly the number and proficiency of competitor countries. Producers in both the more-developed and

less-developed nations are affected by this added competition.

As an example of this point, Dicken (1992) noted the important role of the Japanese textile firms and the general trading companies (the sogo shosha) in starting the first major wave of shifting production to less-developed nations in the 1960s. According to Dicken, the Japanese textile firms had a strongly vertically integrated system in Japan, and the sogo shosha handled a large proportion of Japanese imports and exports through a well-organized international network. In the early 1960s, when the United States started to impose restrictions on Japan's textile products, the Japanese textile producers and sogo shosha established a network for their operations in East and Southeast Asia. Working with local producers to establish manufacturing in those countries for shipment to the United States, Japanese firms were able to avoid the trade restrictions on products from Japan.

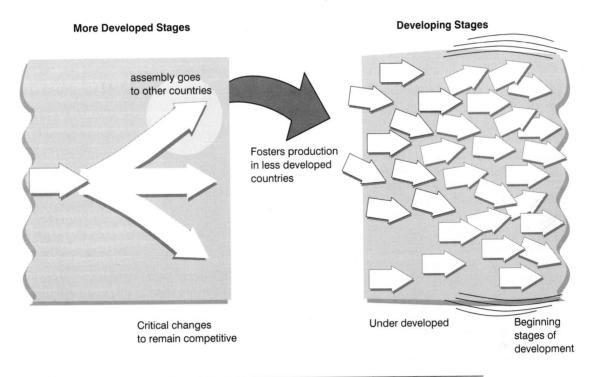

FIGURE 5–7As manufacturers move their assembly operations to less-developed nations, they are also hastening the development of additional proficient competitors.

THE TEXTILE COMPLEX—A GLOBAL BAROMETER OF DEVELOPMENT

As we have indicated, as the textile complex of a nation or region matures, and goes through growth stages and perhaps even eventual decline, the status of this sector is often a fairly reliable barometer of broader development and industrial progress (although keep in mind that this can be altered significantly by various factors such as government policy and other factors).

If one is willing to consider the concept that patterns of development in the textile complex reflect the broader economic and industrial status within regions or nations, this provides an opportunity for interesting observations from a global perspective. Therefore, if we could view the stages of development in the textile complex within countries and regions around the world, this would provide a "snapshot" view of total global economic and industrial development. Admittedly, generalizations are difficult because exceptions are always apparent; however, it may be helpful to consider this approach a bit further as a way of looking at the larger international picture.

In our global overview, for example, we might see that for decades some countries have had the capabilities for certain kinds of textile and apparel production, whereas they may have had limited production capabilities in more advanced processes. In Figure 5–8, we might consider that all of the countries identified here—developed nations, NICs,

and a large developing nation—have had the capabilities for apparel assembly operations for several decades.

On the other hand, if we were to look for more advanced types of textile and/or apparel production, the status of those segments of the industry reflects varying degrees of overall development for the country or countries. In contrast to Figure 5–8, in which we see that all the nations have been capable of assembly operations, we see in Figure 5–9 that these nations have differing histories in manufactured fiber production, particularly when the country was able to produce fiber in volume.

Only when each country had reached a certain level of development—with technological expertise, capital inputs, infrastructure, and other necessary factors associated with development—was that country able to produce manufactured fiber. Hence, our global snapshot tells us something about the coun-

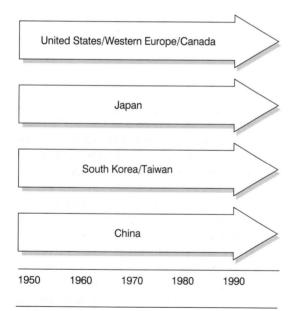

FIGURE 5-8

Apparel assembly and broader development: Nations at varying levels of development may be able to perform certain types of activities in the textile complex, such as apparel assembly.

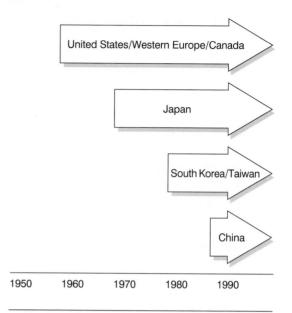

FIGURE 5-9

Manufactured fiber production as a reflection of broader development (volume production): In contrast to Figure 5–8, certain types of activities in the textile complex usually can be performed only when the overall level of development for the nation can provide the elements needed. Manufactured fiber production is one of the most advanced activities of the textile complex and has begun in each of the countries or regions shown as overall development reached certain levels.

tries or regions according to their capabilities for certain types of production.

The textile complex in the major developed countries (the United States, Canada, nations in Western Europe, Japan, and Australia) typically led the industrialization process within each nation. In each country the sector became quite advanced and competitive as a producer for textile and apparel markets and eventually evolved to the full-maturity stage; textile complexes in some of these countries have begun to decline, while others have not. The point of special significance is that the textile complex has been typically one of the earliest sectors to mature in a country. Although other mature in-

dustries such as steel and ship building experience similar shifts, the textile complex has often been the first or one of the first to do so.

Characteristics of the textile complex—such as serving basic human needs, labor intensity, and easy entry because of low capital and technology requirements—account for many of the global shifts that affect both the industrialized and developing countries. If we continue with our snapshot approach, we will see the most elementary textile production taking place in the poorest and most underdeveloped countries. This might be portions of Latin America, Africa, or parts of Asia. In these regions, textile production began because it was perhaps the only possibility for elementary industrialization and economic development for countries with few resources other than a large workforce. Therefore, a profile of the textile sector in a lessdeveloped country gives a fairly accurate reading of where that country stands in its overall economic development. Often this profile for a number of adjoining countries provides an overview of the development of a region or, in some cases, large portions of continents.

Even the nations and regions that seem most remote are no longer isolated. Now that national economies have become increasingly interlinked and interdependent in recent years, the textile complex in any advanced economy is influenced in various ways by its less-developed counterparts in poor, remote villages that may be halfway around the world. For example, the lowwage labor used in the fledgling industries in the less-developed countries is often viewed as a threat to the textile complex in an industrialized country. On the other hand, as we noted earlier, some portions of the complex in developed countries, such as the apparel segment, utilize the less costly labor in the less-developed countries for labor-intensive assembly operations. In this case in the global snapshot, one would see industry segments move to take advantage of certain resources, with the most obvious being the shifts that continually seek the lowest labor costs available. Again, reviewing the status of the textile complex in these global shifts provides insight into the broader stages of development of both the host country for textile production and the investor country whose firms seek low-wage production in the less-developed countries.

In short, our global snapshot permits us to observe patterns that reflect the economic and development theories considered earlier. We can see patterns of production (i.e., who is producing what) that reflect comparative advantage, factor proportions utilization, and Porter's determinants of competitive advantage. Similarly, we can see various stages of development and relationships among countries that reflect the development theories considered previously. Additionally, examples of the new international division of labor are increasingly apparent.

A BROAD PERSPECTIVE ON GLOBAL SUPPLY AND DEMAND

As we reflect on our discussion in this chapter, we note that two major changes have occurred as countries have advanced in their overall development and as the textile complex in various regions has gone through several stages of development: (1) The number of textile/ apparel producer nations has increased dramatically as Third-World countries have used this sector to begin industrialization, and (2) many of the earlier-developing countries that established textile/apparel production became much more proficient producers, capable of manufacturing products requiring a broader spectrum of technical expertise. In short, these two factors have led to an enormous global capacity to supply the consumers of the world. In fact, this large number of producers has led to what could accurately be called a global overcapacity that has resulted in extremely competitive global market conditions.

Moreover, the new textile- and apparelproducing nations—like other less-developed countries that had begun textile and apparel production earlier—have viewed the markets in the industrialized countries as the ideal recipients for their products. Whereas manufacturers in the developed countries had depended primarily on their home markets for growth, producers in the developing countries looked to exports for growth. To producers in many less-developed countries, the markets in the more-developed countries have been perceived as composed of affluent consumers with insatiable appetites for textile and apparel goods. And as we noted in Chapter 4, most of the world's wealth does reside in the more-developed countries. Consequently, the competition for the same markets has grown intense.

In short, we can conclude that the global supply perhaps exceeds the global demand for the textile and apparel sectors. In addition to the fact that consumer spending, particularly on apparel products, has been sluggish in the more-developed countries, it is important to remember that many consumers in the lessdeveloped world do not have the purchasing power to obtain products they may need or desire. If all consumers—in both the developed and developing worlds—had unlimited funds to buy textile and apparel products, perhaps the global production capacity could be fully used without the harsh competitive conditions. However, such is not the case, and those conditions do exist, as we shall explore further in the book.

LABOR ISSUES

Labor issues are central to much of the global restructuring that has occurred in the textile and apparel industries. Except for high-technology textile production, issues of where and how products are made are associated

with labor issues, particularly the *availability* and cost of labor. Scholars have for years debated some of the controversial aspects of labor use, and possibly abuse, within these industries. In recent years, some of these issues have received a great deal of attention in the media. In this section, we will consider briefly the largely female labor force, child labor, and sweatshops. A brief overview of official actions being taken on some of the issues is included. Space does not permit exhaustive coverage; many books are written on these topics alone.

Women Workers

Throughout the world, women constitute the majority of the textile and apparel labor force. Actual statistics are impossible to obtain because of employment in the informal sector that goes unreported. We may safely estimate that at least 80 to 90 percent of the global apparel workforce is female, and half or more of the textile workforce is as well. If, in our global snapshot, we could observe the industry's workforce by gender, we would find that it is overwhelmingly women's hands that produce the garments we wear and many of the textile products we use. Therefore, we find that global industry changes affect women disproportionately.

As textile and apparel jobs move from some countries to others, we find it is largely women who are losing jobs to a workforce elsewhere in the world that is also mostly female—a dilemma that in a sense pits one group of women workers against another for economic survival. Many poignant personal stories are lost in the reports on this phenomenon—women whose families benefit as they gain jobs and others whose families suffer because of job losses (Figure 5–10).

In the more-developed countries, the textile and apparel industries have a long history of employing a higher proportion of women workers than is true for industry in general. Family and domestic responsibilities have often reduced women's geographic mobility,

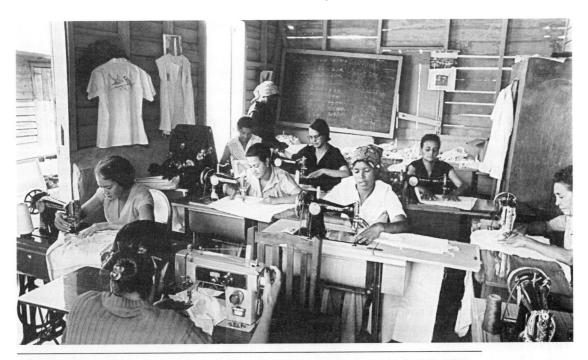

FIGURE 5-10

Crippled by poverty, lack of education, and lack of training opportunities, millions of women around the world are locked into a life of unskilled, underpaid labor. Many spend a good proportion of their lives working in the informal sector in small cottage industries like this one in the Caribbean. As the women are undocumented workers, their labor is invisible on official government records.

Source: Photo by Milton Grant, courtesy of United Nations.

and in the past, many women had limited skills to sell in the job market. As women have found the need to support or help support themselves and their families, the textile and apparel industries have provided ready employment. Many generations of families in the more-developed nations have been supported, in whole or in part, by the incomes of mothers, wives, and daughters who worked in garment factories and textile mills. Despite their contributions, these women are among the most vulnerable to losing their incomes when companies close down plants because a firm fails to be competitive in a global economy or perhaps decides to join the global economy by moving operations to lower-wage nations. Because of their lack of mobility and/or transferable skills, these women who lose their jobs may be among those least likely to find other employment.

Earlier, we discussed the trend for companies in the core regions to send labor-intensive production to companies in the periphery for assembly. In the less-developed countries, the racial and ethnic characteristics of the workforce may be quite different from those of their counterparts in the more-developed countries—but the gender balance is very similar. As economic development spreads throughout the Third World, textile and apparel jobs have provided entry into the workforce. Often young women in developing countries are drawn to these first jobs in the burgeoning cities and **export-processing zones** (or **free trade zones**) where wages are relatively low because there are few or no

other alternatives for employment. Many Third-World governments have established these zones and/or have provided special incentives to attract investors such as TNCs.

A significant body of literature focuses on the status of Third-World women who are employed by TNCs. Many writers consider these women exploited because of their low wages, long hours, and other working conditions. Some writers consider that paternalistic, capitalistic forces take advantage of these women workers who need employment and who have no advocates or power to represent their interests.

On the other hand, some economists and others argue that these factory jobs provide an important first step for workers in poor countries. The well-known economist Paul Krugman asserts that while the Asian Tigers-Hong Kong, Singapore, South Korea, and Taiwantook different routes to their present prosperity, the first stages of development were constant among all of them: sweatshops (Myerson, 1997). Factory jobs are preferable to unemployment in poverty-stricken areas. For example, thousands of young women stream out of the impoverished rural areas of China to seek factory jobs in the country's Shenzhen economic zone, where factories have mushroomed and jobs are plentiful. The jobs are exhausting, the pay is low, and the hours are long, but these jobs offer hope for a better life and are an improvement over the prospects back home. A comparison of wages to those in more-developed countries is unrealistic; instead, it makes more sense to consider legal wages in the country or region as a basis for comparison. After all, the outside investor companies or contracting companies would not bring their business to the less-developed countries were it not for the lower wages. Transferring production halfway around the world is complex and difficult; companies must have an incentive to overcome those challenges.

Third-World women are often employed to make garments and perform detailed hand-sewing operations in their homes through **sub-**

contracting arrangements (this is part of the informal sector discussed earlier). Although these activities permit women to combine work with their domestic responsibilities, it also makes them vulnerable to exploitation. Workers in the informal sector are essentially invisible when it comes to wage and other labor legislation designed to protect workers.

As women toil in the global textile and apparel industries, some scholars debate whether this work brings economic empowerment or further subjugation. Although the jobs provide an income, perhaps a feeling of power, and a sense of being integrated into the development process in poor countries, critics see down sides. Women always occupy the lowestpaying jobs in the industry, while men have the more-skilled, better-paying jobs. For example, in garment factories, women perform sewing and related jobs, while men hold jobs in cutting and other technical areas where pay is higher. In some parts of the world, women are expected to hand over their pay to their husbands. In other regions, high male unemployment means that men are threatened by the economic contributions of women. Family relationships are affected even in the best circumstances. Working conditions in many parts of the world are unhealthy and unsafe (Bonacich, Cheng, Chinchilla, Hamilton, & Ong, 1996; Gannage, 1986; Hamilton & Dickerson, 1990; Nash & Fernandez-Kelly, 1983; Ward, 1990).

Whether employed in the more-industrialized countries or Third-World nations, and whether employed in the formal or informal sector of the industry, women are the unsung heroines of the industry. Many toil for long hours performing tedious tasks that strain their frames and their eyes so that consumers around the world may have products they themselves can never dream of owning. Without the perseverance of these women and their need to work for wages at the bottom of pay scales everywhere, the global textile and apparel industries would not exist as we know them today. As we have noted,

these industries have led industrialization and economic development in countries around the world—which may mean that woman have made disproportionate contributions to those processes. And, all the while, study after study has shown that these same women also perform a disproportionate share of the tasks in maintaining their families and households.

Child Labor

In the early stages of a nation's development, when many income-earning activities are quite labor intensive, child labor is a common practice. When a great deal of labor is necessary in production, every pair of hands is an asset—including those of children. Although most nations have child labor laws, many violations occur. Many of these are in the textile complex (Figure 5–11).

The International Labour Office in Geneva estimated that 250 million children between the

ages of 5 and 14 were in the workforce of all industries in developing countries (ILO, 1996; Ramey, 1996). It is impossible to have an accurate count of children who work in factories; the authorities prefer that they not be seen. India, for example, has termed child labor a necessary evil but has vowed to end the practice eventually. Although Indian law bars work for children under 14, the government estimates that 17 million of them work, mostly in match and glass making, diamond polishing, and carpet weaving. Private estimates put the number at 55 million ("India Defends," 1993) (Figure 5–12).

Reporters from Cox Newspapers traveled all over the world investigating child labor practices, from which they developed a poignant series entitled *Stolen Childhood* (Albright & Kunstel, 1987). The Cox team found shameful demands and conditions for children. In Morocco, they found a factory they described as "one piece of a global shame" (p. 4) in which more than 250 girls and young

FIGURE 5-11

Many children, particularly in some less-developed countries, may have few alternatives for survival. For example, this girl survives in the streets, mostly eating what she can scavenge from the local trash dump. The clothing and cloth scraps are some of her treasures gleaned from the dump.

Source: Photo courtesy of International Labour Office.

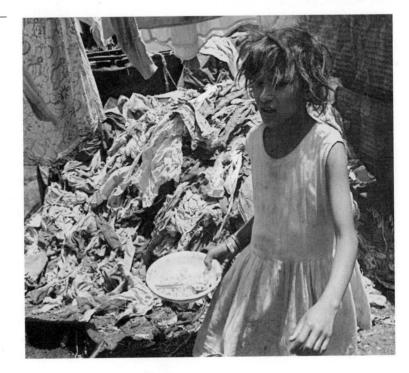

women work 55 hours per week, sitting elbow to elbow in a "one-room carpet factory where the sweet, sickly odor of wool dust hangs in the air" and lighting is so poor that one cannot see without strain. One-third of the workers looked no older than 10. The manager talked to reporters and said, "We prefer to get them when they are about 7. Children's hands are nimbler. . . . And their eyes are better, too. They are faster when they are small" (p. 4). The reporters visited 14 Moroccan carpet factories, were welcomed (unannounced) at 11, and saw large numbers of children in all of them. The operations appeared profitable. Even midlevel managers at some of the factories drove Mercedes Benz sedans.

The Cox reporters found similar shameful conditions in garment factories in the Philippines, Thailand, and other countries. They saw thousands of children working at sewing machines for as many as 90 to 110 hours per week, often so exhausted that they slept next to their sewing machines. Some of the children were ill and suffered from lack of sleep.

One Filipino factory manager commented to the Cox team, "The very sad reality is that we're part of the Third World. . . . We're part of the dumping ground where cheap labor is the main attraction. For investors, cheap labor is the main attraction of the Philippines at this point in time." Cox reporters noted that the factory manager's remarks "reflect the mindset shared by many intellectuals in the Third World: that child labor and child exploitation may be inevitable as the country struggles to keep up with competing Third World nations in the race for development" (p. 11).

Cox reporters commented, "The defect of this argument is that greed and grimness observe no national borders. In the global competition to offer cheap labor, some other country will always hold wages even lower. And the net result is that children are paid so little that their labor often verges on servitude" (p. 11).

Children yield cheap labor and produce merchandise that represents bargains to buyers for

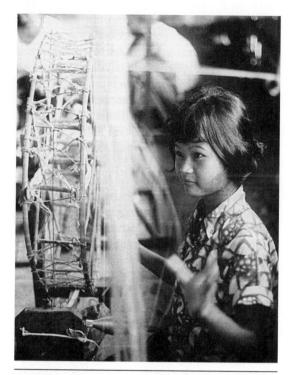

FIGURE 5–12

Child labor is common in many parts of the developing world, and sometimes in the more developed countries as well. This young Asian girl is winding silk yarn.

Source: Photo courtesy of International Labour Office.

fashionable stores in the developed countries. New York department stores carrying the brand of Moroccan rugs found in the factories visited refused to speak to Cox reporters.

A sad dilemma is that attractive alternatives for Third-World children may not be readily available. For many, the work fends off starvation for themselves and their families. For others, work in the grim factories may be preferable to alternatives such as living in the streets or prostitution (child prostitution is common in Thailand, for example). And in many countries there are not enough schools to accommodate the children even if they were not working. Moreover, it is sometimes difficult to establish what constitutes a child worker. For

example, industry leaders in Indonesia spoke of this dilemma to the author. They spoke of the difficulty in deciding if a 14-year-old mother who desperately needed a job should be considered a child laborer.

Unfortunately, child labor has been an ingredient and an outcome of harsh, intense competition in the global softgoods industry. As companies seek to squeeze costs lower and lower and attempt to survive on increasingly narrow profit margins, pressures to reduce costs have meant finding cheaper and cheaper sources of labor. And, of course, the cheapest source of available labor is children, often willing to work for pennies per day and food.

The child labor issue, along with that of sweatshops, gained public attention in the United States and Western Europe in the 1990s as a result of media exposés. Some of these efforts appear to have been politically or union inspired, but nevertheless, the public deserved to know about some of the conditions of the workers who produce their clothes. Most of the media coverage was sensationalized and not very balanced. The lack of alternatives for child workers in poor countries was almost never addressed.

As the publicity on sweatshops swirled into a media frenzy, Charles Kernaghan, a workersrights activist who heads the National Labor Committee, found that some of the garments in the "Kathie Lee" line, produced exclusively for the retail giant Wal-Mart, had been made by very young teenagers in a Honduran factory. (This case added to the negative publicity of Wal-Mart, named in an earlier television exposé on selling clothes made by children in Bangladesh.) Kathie Lee Gifford, the talk-show celebrity behind the Wal-Mart line-whose media success is tied to the wholesome character she projects-tearfully explained her way out of the publicity nightmare by saying she was unaware of the age of the workers and the deplorable working conditions. She joined forces with Kernaghan and then-Secretary of Labor Robert Reich to wage a public media war against sweatshops and child labor. See the following sections for further details.

A number of major firms—both manufacturers and retailers—have developed policies that take a stance against doing business with factories in countries where child labor is common. Further, the International Labour Office in Geneva has been instrumental in working with national governments to establish guidelines.

Sweatshops

Sweatshops have been a dark chapter of the textile and apparel sectors' history since their earliest days. Despite labor reform laws in industrialized countries to protect the wage and safety rights of workers, sweatshops continue to surface, often in shocking numbers. Sweatshops include a combination of several characteristics: payment below the minimum wage, unregulated working hours, unhealthy and sometimes unsafe working conditions (e.g., piles of fabric near boilers and gas burners, with no fire exits), few or no health benefits, sometimes mandatory homework, sometimes child labor, cash payment, and sometimes no pay at all or drastic reductions in pay for small alleged infractions. Many small contractors are fly-by-night operations, often run by immigrants who may not fully know the regulations themselves or who chose to ignore them.

Regulation of this segment of the industry is difficult because of its fragmented, often transitory nature. Today, sweatshops are found everywhere, from the most advanced countries to nearly all of the Third World.

Because garment development and production can be separated into a number of distinct steps and processes, the apparel industry has a history of producing portions of a garment or a garment order in separate locations. This aspect of garment production has led to **contracting**. Contracting, an American version of the British cottage industries, was well developed by 1846, the year a practical sewing machine was introduced (Stein, 1977). Through

the contracting system, companies "farm out" production of garments to factories or small shops in what has been an accepted way of doing business for the industry. One study found that contractors accounted for 54 percent of all employment in the women's and children's segment of the industry in 1967; in 1972, 54 percent; and in 1977, 53 percent (Apparel Job Training and Research Corporation, 1981; Stein, 1977). Today, the percentage is even higher. Most of the largest apparel firms have significant proportions—and, in some cases, all—of their merchandise produced by contractors, including contractors in other countries.

In the United States, the Fair Labor Standards Act (FLSA) regulates minimum wage, maximum hours, and child labor, making employers liable to their employees for violations of the act. An inherent problem in the contracting system, however, has been that no one seems responsible for the contractors' workers. The firms hiring contractors may know little about the conditions under which production occurs. Under the FLSA, the company hiring a contractor is not held responsible for meeting these requirements for the contractors' employees. The initiating firm contracts for the production and later receives the finished goods. Some contractors do only the sewing; others may handle the total process from cutting fabrics to the completion of finished products (known as cut-make-trim [CMT] packages). In the past, the manufacturer was often unaware of the working conditions of the contractor's employees. This situation can be further complicated when contractors send work to other small operations—subcontractors for some of the production.

For unscrupulous companies, either those giving the business to contractors or the contractors themselves, the disconnected, fragmented contracting system may allow abuse of workers, with no party held responsible. Contractors may simply say they work for the firms using their services; the contracting party may plead ignorance of the conditions of

employment in the contractor's shop. Even conscientious, ethical firms that use contractors' services cannot always be sure that the latter complied with labor laws and ethical work practices.

When a clandestine sweatshop operation in El Monte, California, was uncovered in the mid-1990s, the sweatshop issue escalated into national prominence. In the El Monte operation, 72 Thai women had been forced by Thai factory managers to sew garments in slave-like conditions. Most of them were rural women who had left impoverished eastern Thailand and enlisted in the Bangkok sewing trade as a means of supporting their families. As illegal immigrants, they were smuggled into the United States by a Thai smuggling ring with the understanding that the cost of their passage would be deducted from their earnings. However, the workers were held as virtual slaves, paid wages far below the U.S. minimum wage, and sometimes required to work up to 22 hours per day. Unable to speak English or leave the factory compound, the women had no way of knowing how badly they were being treated by U.S. standards (McDonnell, 1995).

The media blitz that followed sensitized the U.S. public to the prevalence and the dirty details of sweatshops, startling most Americans, who did not believe that such conditions could exist in their country in the 1990s. These sweatshops were reminiscent of stories from the turn of the century before labor reforms began.

Nor did the consuming public have insight into the reasons for these oppressive modernday sweatshops. Market pressures were the culprit. The intense competition and profit pressure in the industry—due in part to the high volume of imports from low-wage countries—plus the demands of quick inventory replacements for retail stores have encouraged the survival and growth of sweatshops on U.S. soil. Added to these factors is the number of immigrants—both legal and illegal—in cities such as New York and Los Angeles, who need jobs and are willing to work in the sweatshops. Many of the

immigrants know little English, have few salable skills, and are often hired by shops in their own ethnic communities. Dominican bosses hire Dominican workers, Haitians hire Haitians, and so on. When labor abuses occur, workers often do not know their rights or where to turn; illegal immigrants dare not complain.

In the months that followed the El Monte revelation, the Kernaghan-Reich-Kathie Lee trio championed and sensationalized the sweatshop issue, each with potential gains. For Reich, the sweatshop/child labor campaign made him a labor and human rights star and permitted his boss, President Clinton, to win political points for the 1996 presidential election that followed. For Kernaghan, whose National Labor Committee is closely associated with the industry's labor union, the potential gains for the union's sagging membership were substantial. And, for Kathie Lee, becoming an antisweatshop advocate not only permitted recovery from the poor publicity associated with the Honduran production of her line but also provided a timely social issue to which she could lend her celebrity status.

Reich spearheaded a campaign to identify apparel manufacturers using the services of sweatshop contractors with labor offenses. Sweatshop raids provided ammunition for his reports. Later, Reich challenged retailers to police the suppliers from which they bought garments. His second list included retailers who were found to be selling garments produced under sweatshop conditions. Although retailers have not been held liable if they unknowingly sell illegally made goods, many major retailers have complied with Reich in the hope of ending what they considered a public-relations nightmare (Chandler, 1996). The antisweatshop campaign drew the wrath and skepticism of a number of well-known, image-sensitive companies in the industry, both manufacturers and retailers. Many firms, particularly the largest ones, already had their own monitoring programs well before the Reich campaign. Many resented being pressured to adopt standards created by unions and human rights groups.

All controversy has more than one side to consider. The sweatshop campaign provided a wake-up call to the industry to monitor its use of contractors to be sure there was compliance with labor laws, both in the United States and abroad. No ethical company wants workers abused or exploited. Similarly, it is not reasonable to expect workers to be held in slavelike or unsafe conditions. Nor should workers be paid so little that they can barely survive. On the other hand, the media frenzy turned the term sweatshop into one that was applied casually—an easy label that could be attached to any company, no matter how ethical it tried to be or how small the offense. Many conscientious firms had their names blighted.

Much of the initial controversy related to the conditions in U.S. sweatshops. At various points, however, there were also efforts to focus on sweatshop conditions in other countries. Retailers and manufacturers began to be more sensitive to the working conditions in the factories in other countries where their garments were being produced. Efforts were made to sensitize the U.S. buying public to the offenses. For example, holiday shoppers were encouraged to look for "Made in the USA" labels to ensure that they were not buying goods made by child labor. Well-intentioned as antisweatshop advocates might have been, the strategy sometimes backfired. For example, the young teenager who became a focal point in the Kathie Lee Honduran controversy lost her job as a result of her company's effort to respond to media pressure. The alternatives for that young person were not promising.

Efforts to Monitor and Correct Labor Abuses

The International Labour Office (ILO) is the primary international agency involved in labor issues. It conducts research, establishes guidelines, and works with national governments to

monitor and improve workers' conditions. The ILO estimates the total number of workers in the **formal sector** of the textile, apparel, and footwear industries at around 23.6 million worldwide but believes the number engaged in the informal or **underground economy** to be 5 to 10 times higher.

In a late 1996 week-long meeting, the ILO called for tougher measures to combat sweatshops, child labor, and other abusive conditions in the textile, apparel, and footwear industries. Saying that "the fight against clandestine work should be intensified," the ILO resolution called on its 174 member countries to urge all employers, employer organizations, merchandisers, and retailers to formulate policies and adopt voluntary guidelines to eliminate child labor. It called on the nations to ratify and fully implement the relevant United Nations and ILO conventions for the abolition of child labor and forced labor (this term is usually applied to required labor in prisons). The ILO further said that special attention should be paid to export-processing zones to be sure that they are linked to the rest of a country's economy and that basic worker rights are respected (Zaracostas, 1996).

In 1997, ILO published the report Business Ethics in the Textile, Clothing and Footwear (TCF) Industries: Codes of Conduct (Sajhau, 1997). This report focuses on the growing sense of social responsibility of major firms in developing measures to improve the conditions of workers in far-flung global operations. These ethical codes or codes of practices include a number of principles for the respective firms' internal operations and for work with business partners. Several of these codes of practice are summarized in the report, and a portion of the ILO summary is shown in Table 5-1 on pp. 162-163. Sajhau notes that U.S. firms have been first to adopt these codes, with European firms much slower to do so.

Sajhau cites Levi Strauss & Co. as being the forerunner in establishing a code of practices for its global operations. Levi's 1992 *Business*

Partner Terms of Engagement and Guidelines for Country Selection states: "Use of child labor is not permissible.... We will not utilize partners who use child labor in any of their facilities" (Levi Strauss & Co., no date). Moreover, the company has withdrawn contract arrangements with firms found to violate this policy. On at least one occasion when child workers were identified in a company producing garments for Levi, rather than send starving children into the streets, Levi permitted the young workers to work part-days and provided schooling for them for the remainder of the day.

The U.S. Congress has initiated studies and other efforts to focus on child labor and sweatshop issues. Bills were introduced (but did not pass) in both houses of Congress in 1993 to deal with issues of child labor, using a two-pronged approach: (1) setting criminal sanctions for U.S. employers who violate child labor laws and (2) banning imports from industries abroad that employ children under 15 ("Child-labor," 1993). In 1996, a bill was introduced but did not pass in Congress to extend the FLSA to make apparel manufacturers accountable for labor law compliance in the contractors' shops they employ. A similar bill, the "Stop Sweatshops Act of 1997," introduced in Congress proposed that "Every manufacturer engaged in the garment industry who contracts to have garment manufacturing operations performed by another person as a contractor shall be civilly liable, with respect to those garment manufacturing operations, to the same extent as the contractor for any violation. . . . " The term manufacturer also included retailers engaged in contracting private label lines (Senate Bill 626, p. 3). As of early 1998, none of these bills had been passed.

In April 1997, with much fanfare at a Rose Garden ceremony, President Clinton announced that a coalition of industry, human rights, and labor groups had reached a breakthrough agreement to end sweatshops. Companies that voluntarily adhere to this new code

BOX 5-1

RECOMMENDED CODE OF CONDUCT BY THE APPAREL INDUSTRY PARTNERSHIP (PRESIDENT CLINTON'S ANTISWEATSHOP TASK FORCE)

While developing a program for worldwide monitoring of contract apparel factories, the White House antisweatshop task force has set out a code of conduct for contractors and vendors. The nine-point code:

- · Bans forced labor
- · Bans harassment or abuse of workers
- · Bans discrimination
- Requires companies to provide a healthy and safe work environment
- Requires companies to allow freedom of association and collective bargaining
- Calls for employers to pay at least the prevailing local minimum or industry wage, whichever is higher, as well as legally mandated benefits,

- and to recognize that wages are "essential to meeting employees' basic needs"
- Requires companies to base overtime compensation on a rate equal to regular hourly compensation unless a country legally requires a premium rate be paid
- Limits the workweek to 60 hours, with no more than 12 hours of overtime, except in extraordinary circumstances: when employees are required to work longer to catch up on backlogged orders or the like
- Bans child labor, which it defines as workers under the age of 15, although in countries where it is legal, individuals can begin working at 14 (Ramey, 1997, p. 6)

will be able to tag their products as "sweatshop free." Independent auditors will monitor compliance with a minimum set of workplace labor laws in order to apply a "No Sweat" label to their clothes. Companies that pay at least the legal minimum wage in the country where the work is being done, use no child labor, have a workweek of no more than 60 hours, and give workers at least 1 day off each week will be approved to use the label. The real test for the presidential initiative will be whether consumers make the "No Sweat" label a decisive element when they go shopping for clothes ("A Big No," 1997; Benjamin, 1997).

By July 1997, the antisweatshop task force appointed by President Clinton the previous year unveiled its initial proposal intended to address its mission—"to create a system to monitor apparel and footwear factories worldwide for labor abuses" (Ramey, 1997, p. 6). The task force panel known as the Apparel Industry

Partnership, consisting of representatives from large U.S. apparel manufacturers and retailers, had difficulty maintaining its membership and in securing widespread industry support. The group's work was the first attempt by U.S. industry to establish global labor standards. The basic points unveiled in the task force's "code of conduct" are shown in Box 5–1.

Labor Standards and Trade

In recent years, the United States has attempted to add labor standards to various trade agreements with other countries. Part of this effort has resulted from domestic industry and union pressures that firms in competitor nations should abide by certain minimum labor standards, as is expected in the United States. Other factors have been public pressure following media exposés on sweatshops, child labor, prison labor, and other conditions in

TABLE 5–1 Codes of Conduct^a

	General Reference to Human Riahts	Freedom of Association, Right to Organize and to Collective Baraaining	Child Labor	Forced Labor
)	0		
Levi Strauss	Criteria for selecting supply countries: observation of fundamental human rights.	No explicit reference.	Criteria for selecting trade partners: child labor is not acceptable. A <i>child</i> is defined as a person under the age of 14 or who is under the compulsory schooling age.	Criteria for the selection of trade partners: prohibition of the use of forced or prison labor at any stage in the production process.
Sara Lee (SL)		No explicit reference.	SL will not knowingly recruit persons under the age of 16. Suppliers/subcontractors must not recruit persons under the age of 15 or under the age of compulsory schooling. If national legislation includes higher criteria, these should be applied.	SL will not establish trade relations with suppliers/ subcontractors who make use of forced or prison labor.
The Gap	The Gap will not establish trade relations with suppliers/subcontractors who violate fundamental human rights.	No explicit reference.	Refers to local regulations.	Suppliers/subcontractors must not force someone to work.
Reebok (R)	R will take account of the practices of its trade partners with regard to human rights. The respect of these rights is one of the characteristics of R.	R will seek trade partners that share its commitment to the right of employees to set up and join organizations of their own choosing. R will ensure that no employee is penalized as a result of the nonviolent use of this right. R recognizes and respects the right of all employees to organize and to engage in collective	R will not work with enterprises which make use of child labor. A child is defined as a person: — under the age of 14; or — under the age of compulsory schooling; — all trade partners must respect national legislation defining the concept of a child.	R will not work with enter- prises that make use of forced or obligatory labor, including the forced labor of political prisoners.

Nike (N)	Code of conduct: N will do everything expected of a leader to ensure the respect of human rights.	No explicit reference.	Memorandum: suppliers/ subcontractors must conform to local legislation respecting child labor.	Memorandum: suppliers/ subcontractors must certify that they do not use forced labor in the manufacture of their merchandise.
J. C. Penney (JCP)		No explicit reference.	JCP will not knowingly import goods produced by children, as defined by law.	JCP will not knowingly import goods produced with forced or prison labor.
Sears, Roebuck and Co.		No explicit reference.	No explicit reference.	No explicit reference in the Import Buying Policy and Procedures, but a separate code concerning forced labor in China. The basic principle is the prohibition of the use of forced labor. Sears also refers to United States laws on the import of goods produced by forced labor.
Wal-Mart (W-M)	W-M will seek suppliers/ subcontractors who en- deavor to respect basic standards concerning human rights.	No explicit reference.	W-M will not accept the use of child labor in the manurfacture of goods that it sells. Suppliers/subcontractors must not recruit persons under the age of 15 or below the compulsory schooling age. If national legislation includes higher criteria, these must be applied.	W-M will not accept products from suppliers/subcontractors that make use of forced labor at any stage of the manufacturing process.

Source: Adapted from Sajhau, J. (1997). Business ethics in the textile, clothing, and footwear (TCF) industries: Codes of conduct (pp. 39–42). Geneva: International Labour Office. Reprinted courtesy of ILO. ^a The ILO in Geneva has established conventions (guidelines) for each of the categories considered here.

other countries, as well as the desire to have a role in improving the wretched working conditions in the offending countries.

U.S. demands—whether in the form of Clinton's task force's demands or provisions in trade agreements—have not been well received by U.S. trading partners. Trading partners that have been critical see the labor standards as yet another protectionist measure the United States is attempting to use to restrict their goods. Other critics see these efforts as attempts to impose Western standards on the rest of the world and state that many countries at different levels of development are not yet at a stage to live by U.S. labor standards.

SUMMARY

Global shifts in textile and apparel activity (production, employment, and trade) began to occur in the early 20th century. As Japan and other new textile- and apparel-exporting countries relied significantly on these sectors in their nation's economic development, international relocation of these industries began.

Because of the fragmented nature of the global textile complex, production can be located in almost any part of the world. This means that various regions of the world are engaged in a wide range of textile and apparel activities. A global perspective reveals that the textile and apparel sectors may be found at various stages of development on a continuum "ranging from embryonic to declining" (Toyne et al., 1984, p. 20). The stages of development for the textile complex permit us to consider the major stages through which the textile complex is passing on a worldwide basis. This does not mean, however, that the sectors in all countries will go through all stages. The stages are (1) the embryonic stage, (2) the early export of apparel, (3) the more advanced production of fabric and apparel, (4) the "golden age" stage, (5) full maturity, and (6) significant decline.

Focusing on the stages of development of the textile complex in various regions of the world gives an indication of the overall development in these areas. In many respects, a global "snapshot" of stages of the textile complex in various regions or nations would likely reveal a great deal about the regions or countries themselves—for example, their relative resources or their technological and industrial advances.

Considering the stages of development of the global textile complex also permits us to look at these relative to the economic and development theories considered earlier. These theories help us to see why the resources of certain nations permit some types of production but not others, or we may see why the relationships among nations seem to dictate particular types of production. Theories help to explain, for example, why Bangladesh produces jute and the United States produces polybenzimidazole.

The growing number of producer nations, along with the increasing proficiency of already established textile/apparel producer nations, has led to a massive supply capacity for the world market. Moreover, the developing countries have directed most of their textile/apparel products to the export market, creating intense competition for the same developed-country markets, where consumers have greater spending potential.

Because of the nature of the textile and apparel industries, a number of unique labor issues exist. First, the predominance of women workers, often in the lowest-paying jobs, is characteristic of the industries around the world. Consequently, global restructuring of the industries affects women disproportionately. Media exposés have brought child labor and sweatshop issues to the public's attention, exposing labor offenses domestically and abroad. A number of global and domestic initiatives have attempted to address these violations; however, many U.S. trading partners are skeptical of efforts to impose U.S. labor standards worldwide.

GLOSSARY

Contracting refers to hiring a company or person to do part or all of the work in producing a garment.

Cottage industries are decentralized industries in which production occurs in homes or other small facilities; because the workplace is removed from the more formal manufacturing system, this production is difficult to document in many countries and may operate in ways inconsistent with governmental regulations.

Cut-make-trim (CMT) describes the package contractors may provide in producing garments; the contractor provides the machines, operators, and sometimes components to produce and deliver

completed garments.

Export processing zones are a type of free trade zone where countries permit foreign companies to invest and manufacture products for export. Around the world, a great deal of garment assembly occurs in these zones.

Forced labor consists of workers required to produce goods and given no choice in doing so. Most often, this refers to forcing prisoners to manufac-

ture goods.

Foreign exchange is currency that one country uses to pay for goods and services it buys from another country, that is, an instrument for making payments abroad.

Formal sector is that segment of the economy that is open and visible to authorities, in contrast to the *informal sector*, which is not. Workers and output are counted in the formal sector, whereas they are invisible in the informal sector.

Free trade zone (also called free zone, free port, or foreign trade zone) is an area within a country where goods can be imported, stored, and/or processed without being subject to customs duties and taxes when these goods are reshipped to foreign points.

Import substitution refers to producing domestically

goods that were previously imported. Often, import substitution involves subsidizing the home industry and restricting imports to allow the do-

mestic industry to grow.

Informal sector (also called the underground economy) includes commercial activities invisible to authorities, including sweatshops, cottage industries, home work, and any other activities for which employment and output are not reported. Because these operations are unknown to au-

thorities, they generally avoid labor and other government regulations.

Intermediate inputs, for our purposes, are the textile components used in producing finished or more nearly finished goods. These include the fibers, yarns, and fabrics sold to producers at the next stage of the production chain.

New producer nations are developing countries that have just begun to produce textiles and/or ap-

parel for the international market.

Newly emerging countries are nations that have made some degree of progress in economic and other aspects of development. In reference to textiles and apparel, the term is often used to refer to underdeveloped countries that have become increasingly important producer nations.

ing that occurs in another country. It also includes the practice of exporting finished (component parts) or semifinished manufactures to lower-cost countries for assembly. The finished products are then reexported to the home country for distribution.

Subcontracting refers to farming out work to other businesses (in the garment industry, this may involve small shops) or individuals who produce part or all of a garment. This term is imprecise: sometimes it is used interchangeably with contracting, or it may refer to the further farming out of garment production or specific tasks by the contractor to yet another level in the production network.

Sweatshop is defined by the U.S. General Accounting Office as a business that regularly violates both wage or child labor and safety or health laws.

Underground economy is another term for the informal sector in which business activities are invisible and undocumented.

SUGGESTED READINGS

Bonacich, E., Cheng, L., Chinchilla, N., Hamilton, N., & Ong, P. (Eds.). (1994). *Global production: The apparel industry in the Pacific Rim.* Philadelphia: Temple University Press.

A collection of original essays that examine the social and political consequences of the globalization of the

apparel industry.

General Agreement on Tariffs and Trade. (1984). Textiles and clothing in the world economy. Geneva: Author.

A study of the global textile complex and the sector's contributions to the international economy, as well as the economies of main regions.

General Agreement on Tariffs and Trade. (1987, November 30). *Updating the 1984 GATT Secretariat study: Textiles and clothing in the world economy.* Geneva: Author.

An update of the 1984 textile/apparel study.

Hamilton, J., & Dickerson, K. (1990). The social and economic costs and payoffs of industrialization in international textile/apparel trade. *Clothing and Textiles Research Journal*, 8(4), 14–21.

An analysis of shifts in textile/apparel production and trade and the impact on various players.

Keesing, D., & Wolf, M. (1980). Textile quotas against developing countries. London: Trade Policy Research Center.

A study of barriers developed to prevent the developing countries from exporting textile products to the industrialized markets.

Lam, L. (1992). Designer duty: Extending liability to manufacturers for violations of labor standards in garment industry sweatshops. *University of Pennsylvania Law Review*, [141], 623–667.

A review of existing law and a proposal to hold manufacturers responsible for labor standards in contractors' operations.

Maizels, A. (1963). *Industrial growth and world trade*. Cambridge: Cambridge University Press.

A study of industrial production patterns and their relationship to trade.

McMurray, S., & McGregor, J. (1993, August 4). New battleground: Asia targets chemicals for the next

assault on Western industry. Wall Street Journal, pp. A1, A4.

This article reports on Asia's move toward competitiveness and self-sufficiency in the chemical industry.

Nash, J., & Fernandez-Kelly, M. (Eds.). (1983). Women, men and the international division of labor. Albany: State University of New York Press.

An often-cited volume that provides a global perspective on gender and work.

Sajhau, J. (1997). Business ethics in the textile, clothing and footwear (TCF) industries: Codes of conduct. Sectoral Activities Programme Working Papers. Geneva: International Labour Office.

A report on strategies used by international firms to meet the social challenges of globalization.

Toyne, B., Arpun, J., Ricks, D., & Shimp, T. (1984). *The global textile industry*. London: George Allen & Unwin.

A study of major trends affecting international competition in the textile mill products industry.

United States International Trade Commission. (1985, July). *Emerging textile-exporting countries*. Washington, DC: Author.

A study of textile-exporting nations expected to become increasingly important producers for the global market.

United States International Trade Commission. (1987, December). *U.S. global competitiveness: The U.S. textile mill industry.* (USITC Pub. No. 2048). Washington, DC: Author.

A study of factors influencing the global competitiveness of the U.S. textile mill industry.

Ward, K. (Ed.). (1990). Women workers and global restructuring. Ithaca, NY: ILR Press.

Papers in this edited volume examine the impact of factory work on the socioeconomic position of Third-World women.

6

Global Patterns of Textile and Apparel Activities

This chapter presents an overview of global trends in textile and apparel production, employment, consumption, and trade, with particular attention given to major global shifts for these activities. Most of the information in this section focuses on recent decades for three reasons: (1) the textile and apparel sectors became particularly significant in international commerce in the years following World War II; (2) many important changes affecting the worldwide textile complex occurred since the 1950s; and (3) data on the global industry were either unavailable or of poor quality until after World War II, and although shortcomings are still present, statistics have improved since that time.

Even in years to come, when the situation for the global textile and apparel sectors may change, this period is likely to remain an important one in the history of the global textile complex. The textile and apparel sectors were affected profoundly by the linking of national economies into a global economy that occurred during this period. Related to the globalization of the economy as the rapid worldwide expansion and development of the textile and apparel industries, which created intense competition never experienced prior to this era.

GLOBAL PATTERNS OF PRODUCTION

As noted earlier, the global picture for textile and apparel activity began to change markedly in the 1950s. Both the emergence of a growing number of producer nations and the globalization of the economy created a new environment in which the global textile complex would function.

Changes in worldwide textile and apparel production patterns—that is, who produces for the consumers of the world—have had a dramatic effect on other economic activities for the global sector. Logically, employment and trade patterns are tied closely to production. Consequently, the shifts in production sites—from certain countries and regions to others—have had a tremendous impact on the global textile complex.

Asia emerged as clearly the leading apparelproducing region in the world in the 1990s. In fact, the early stages of most Asian economies were built by these industries. Major producers in the region have ascended in four successive waves:

1. Japan. In the 1950s and 1960s, Japan was a clear leader.

- 2. The "dragons" (Asian NICs). In the 1960s and 1970s, the dragons in the first wave—Hong Kong, South Korea, Taiwan, and Singapore—had a major impact on the world stage through low-cost production and successful export strategies.
- 3. China and Southeast Asia Group I (Indonesia, Malaysia, Thailand, and the Philippines). In the 1980s, investments went to this group as Japan and the dragons experienced rising wages and difficulty in exporting products to the EU and U.S. markets (the quota system will be discussed in Chapter 10). Thus, this group became proficient producers and exporters. India might well be part of this group except that its closed economy at the time did not permit outside investment.
- 4. Southeast Asia Group II (Bangladesh, Pakistan, Sri Lanka, Laos, Nepal, and Vietnam). In the 1990s, this group has attracted investment and technical assistance as the previous group (except China) experienced rising wages and, in some cases, labor shortages.

Textile Production

Although textile production in the developed countries sustained a healthy growth rate (based on average annual rate change in volume¹) between 1953 and 1973, production in the developing areas was growing more rapidly. Between 1963 and 1973, the Eastern European trading area (the former Soviet bloc, now called the *transition economies*) also sustained a healthy growth rate.

In 1973, the global economy was affected severely by an increase in oil prices. *Worldwide* textile production slowed, as well as that in all regions of the world. In many ways, this was

also a critical turning point in global shifts in textile and apparel production.

From the 1950s to the present time, the growth rate for textile production in the more-developed countries diminished while production in the less-developed countries grew rather steadily. The less-developed countries as a group doubled their *share* of global (market economies only) textile production between 1953 and 1980 (from 18 to 35 percent), and this growth has continued to be strong. Keep in mind that the **share** of global textile production (or employment or trade) is not the same as the *absolute level* of production (or employment or trade). That is, a declining share does not necessarily mean a decline in absolute level of production, employment, or trade.

From 1973 on, the strongest textile production growth rates were in the less-developed areas and the transition economies. By the 1980s, however, growth in the former Soviet bloc had fallen behind that of the less-developed countries. By this time, the developing areas exhibited clearly the strongest growth. Table 6-1 shows the shift in manufactured fiber production. One must keep in mind that this is the segment of the industry in which the moredeveloped countries had the strongest comparative advantage. Part of this shift might be attributed to the relocation of multinational manufactured fiber firms in less-developed regions to follow the shift in apparel production that occurred. In one manner or another, investments by the more-developed nations were probably critical to this shift.

Among the major textile-producing nations at the time, Japan's production slowed more than that of any other country. Japan went from the country with the strongest growth rate in the 1950s and 1960s to the weakest from the 1970s on. The reader must keep in mind that we are referring to average annual *growth rates* rather than to absolute levels of production. Japan's slowdown may be attributed to restrictions on Japanese textile products being shipped to the EU and U.S. markets (the Mul-

¹In this usage, *volume* is an economic term referring to deflated values—that is, data in current values adjusted for inflation. This adjustment is made by dividing the current values by the appropriate price indices.

TABLE 6–1Manufactured Fiber Production by Region (1970 and 1996) (million pounds)

	1	970	1	996
	Lb	% Share	Lb	% Share
Synthetics				,
More-developed countries		85.7		35.8
Less-developed countries		6.2		46.9
Eastern Europe and China		8.1		17.3
Total	10,870	100.0	43,180	100.0
Cellulosics				
More-developed countries		65.4		39.8
Less-developed countries		8.6		32.9
Eastern Europe and China		26.0		27.3
Total	7,574	100.0	5,180	100.0

Source: Fiber Organon, 42(6), June 1971, 76, 77, 80, 81; 68(7), July 1997, 116, 117, 118, 119, 124, 125.

tifiber Arrangement, which will be discussed in Chapter 10, became effective in 1974) and to Japan's shift to more technologically advanced manufacturing areas other than textiles and apparel. The less-developed Asian countries experienced the strongest growth rate in textile production from 1973 on.

Despite the global shifts in the share of textile production to the less-developed countries, the industry in most of the more-developed nations has remained viable and competitive at the international level because of high levels of investment, modernization, and restructuring.

Apparel Production

Although the average annual growth for world-wide apparel production grew at a healthy rate in the 1960s, this trend slowed markedly between 1973 and the late 1980s. The more-developed countries dropped to near-zero growth during the 1973–1987 period. While all other geographic areas experienced reduced average annual growth rates over time, the developing areas sustained healthy increases. Although a

similar pattern occurred for textile production, the shift was far more pronounced for apparel production. The labor-intensive nature of apparel production and the ready adaptability of unskilled, low-wage labor to garment assembly accounted for this marked shift.

Less-developed countries began participating in the global textile complex by performing apparel assembly operations, usually for firms headquartered in the industrialized core countries. Risks associated with international marketing were minimized for producers in less-developed countries because contracting importers, retailers, and producers in the more-developed countries (many of these would be considered TNCs) provided manufacturing and marketing assistance.

Although Asia has become the major apparel-producing region of the world, products from this area account for a declining share of both the U.S. and EU apparel markets. Increasingly, apparel firms in the more-developed countries want production to be closer to markets to give them greater control over manufacturing and delivery deadlines. Additionally, trade policies that encourage the use

BOX 6-1

QUALIFYING STATEMENTS ON DATA

Although the data for production, employment, and consumption used in this chapter come from the most respected international and national sources, even the best data have inherent limitations. Perfect data for these global textile/apparel activities do not exist. Therefore, the reader should be aware of a number of limitations associated with even the most conscientiously compiled international textile and apparel data. Limitations include the following:

- The data are subject to frequent revisions.
- Regional definitions can vary among international organizations and over time.
- The EU and the United States changed their methods of collecting trade data beginning in 1993.
- Data from which some regional aggregates are calculated are limited in terms of country coverage and data quality.
- Country groupings have changed markedly in recent years (e.g., the addition of EU member states and the breakup of the former Soviet bloc), making it difficult or impossible to have continuous data for some areas over time. For

example, WTO/GATT began a new country grouping system in 1990 to reflect changes in the former Soviet bloc. Therefore, WTO/GATT data for certain country groupings before and after 1990 are not directly comparable.

For example, the world and centrally planned economies' aggregates used in this chapter *do not include* China. Furthermore, since China is not classified as a developing country by the United Nations or WTO/GATT, it is not included in the less-developed areas in data from those organizations.

Similarly, data from the developing countries are scarce. The only global indicator available is the United Nations index; therefore, any index from this group of countries is rough because of limited data from certain countries or some years. Missing data are statistically estimated time series (usually by regression analysis), as is the case with the United Nations index. Consequently, although these are the most accurate data available in the world today, shortcomings are inherent (Jackson, various years).

of domestic fabrics and other components are providing incentives for both U.S. and EU apparel firms to have their apparel produced closer to home. For U.S. apparel firms, these policies foster apparel assembly operations (identified later in the book as 807/9802) production in Mexico and the Caribbean basin area. Similarly for EU firms, having garments made in Central and Eastern Europe provides cost and proximity advantages over Asia. For both of these major market areas, Asian apparel accounts for a declining share of the market, while the share for the nearby production regions is increasing.

Textile and apparel production in both the more-developed and less-developed countries is affected seriously by the macroeconomic conditions of global markets. For example, the textile complexes in all of the more-developed countries experienced the following recessionary periods: 1974–1975, 1977–1978, 1980–1982, and the early 1990s. In a ripple effect, the industry in less-developed countries also felt the impact of the recessions in the more-developed nations. Slowed consumption in the more-developed areas naturally affects the market potential for products from the low-wage exporting nations.

GLOBAL PATTERNS OF EMPLOYMENT

Although the textile and apparel industries contribute to the international economy in many ways, their important role as a major employer of people around the globe accounts for their prominence and special attention as a sector in global commerce. The textile complex is among the largest sources of manufacturing jobs in both the more-developed and less-developed countries.

As noted in Chapter 5, if comprehensive data were available to review total employment in these sectors, statistics would likely confirm that the textile and apparel industries comprise the largest source of manufacturing jobs. However, employment in cottage industries or other informal arrangements, particularly in the developing countries, is difficult to determine; therefore, employment statistics do not accurately reflect the large numbers of workers employed in these decentralized arrangements such as the one shown in Figure 6–1. The lack of documentation on workers in the textile and apparel industries is not limited to the less-developed countries, however. Unregistered labor may be found in the moredeveloped countries as well. Italy is the most obvious example, but many undocumented workers may be found also, for example, in New York City and Los Angeles. Keep in mind, as global employment patterns are discussed, that large numbers of workers who have never been officially reported are not included. Therefore, most statements about numbers of workers tend to understate total actual workers' contributions.

Although global employment shifts have occurred in textiles, the changes for this segment of the industry are less dramatic than are those for apparel. The investments and technical expertise required for this industry have limited the shifts of the textile segment to far fewer countries compared to apparel production. Further, as the textile sector in more-

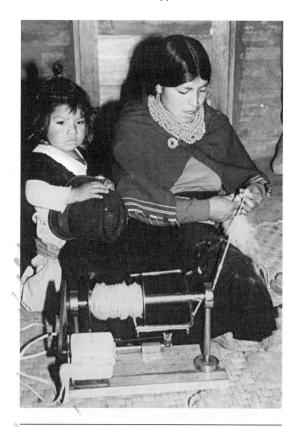

FIGURE 6–1
Workers in informal establishments, such as this one in Ecuador, frequently are not counted in employment figures. These home textile industries provide a living for many people, including children. *Source:* Photo courtesy of United Nations.

developed countries invested increasingly in high-technology manufacturing processes, the skill level required of workers has advanced, giving workers in more-developed countries an added edge over those in lessdeveloped nations. However, as large textile firms from more advanced economies follow apparel production and build plants in the prolific apparel-producing regions, this situation may change.

More than half of the workers employed in the global textile complex are found in the apparel sector. Employment in apparel production has grown more rapidly in recent years than has textile production or manufacturing as a whole.

Employment in apparel production has declined for the more-developed countries from 1963 on, while average annual growth rates for the less-developed countries have been substantial. Although employment growth rates in the less-developed areas slowed during the 1980s, jobs continued to shift to that group of countries.

Apparel employment, perhaps more than any other area of activity for the global textile complex, reflects the shifts that may be explained by the economic theories and development theories considered earlier. As a large number of developing countries attempted to advance, many employed masses of workers in labor-intensive apparel assembly operations. The sector was easy to enter, and large numbers of workers could be employed; wages were substantially lower than in many other countries, thereby resulting in low-cost garments for world markets.

In apparel production, the effects of globalization have caused changes in the *composition* of employment. It is here that we see again the new international division of labor in which activities in the process of producing garments are performed in distant parts of the world. The product development (design and more), marketing, and production-monitoring activities are performed by employees in the more-developed (core) countries. These jobs require more technical expertise and skills, as well as constant updating of knowledge. The other part of the process—the manufacturing—provides jobs increasingly for workers in the less-developed countries. Workers who traditionally held these jobs in the more-developed nations are displaced and may be unable to find other work. At the same time, the processes that are transferred to lower-wage countries provide little opportunity for further skill development or advancement beyond production of defect-free garments.

Major retail chains involved in the development of private-label lines are also actively involved in this segregation of production processes. These retailers often have large staffs who develop the concepts for lines and then contract the production process. Some production may be contracted domestically; however, most goes to low-wage countries. Therefore, we see a division in the levels and locations of employment very much like that for firms generally considered apparel manufacturers.

Nearly all the increases in employment in the global (market economies only) textile complex since 1970 resulted from growth in the less-developed countries. Figure 6–2 pro-

FIGURE 6–2
World textile and apparel employment, 1990 (in percent).

Source: Galli, A. Textile Asia, February 1996, c/o GPO Box 185, Hong Kong.

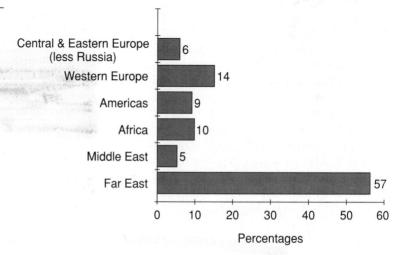

vides a summary of employment in 1990. Both textile and apparel employment declined in the more-developed countries during the period when the number of workers grew in the less-developed countries.

A number of factors account for the decline in textile and apparel employment in the more-developed countries in recent decades. Among the causes are stagnant consumption, use of labor-saving equipment that also increased productivity, and increased imports from the less-developed countries (USITC, 1985a). Although low-cost imports are viewed by manufacturers in the more-developed countries as the primary cause of the decline in employment, a number of sources (e.g., Cline, 1987; Keesing & Wolf, 1980) suggest that productivity gains account for much of the drop in the number of jobs (it is virtually impossible to determine job losses by cause).

Wage Differences as a Factor in Employment Shifts

The high labor content of many textile products, and apparel in particular, accounted for much of the dramatic shift in production to less-developed countries. The labor-intensive aspects of apparel production make garment assembly quite costly in countries where wages are high.

Compared to most other product manufacturing, apparel production typically requires a great deal of processing by human hands to assemble garments from two-dimensional fabric to fit the three-dimensional human body. Automation has not been readily available to handle limp fabrics, the basic component of apparel production. Therefore, a great deal of labor goes into assembling garments. In the United States, for example, labor costs typically account for about 20–25 percent of garment production costs; for France and Germany, labor is over 55 percent (ILO, 1996). Thus, the availability of low-cost labor in the less-developed countries provides an advanta-

geous match for the high labor requirements of apparel production.

Wage differences are a key factor in the global shifts in textile and apparel production, and thus are at the heart of the complexities associated with international trade in this sector. Table 6–2 provides a comparison of hourly labor costs in selected countries for the *textile* industry.

In Table 6–2, the hourly labor cost comparisons developed by Werner International include all worker benefits paid by the employer (but not directly to the worker). These may include vacation pay, holiday pay, medical benefits, unemployment benefits, and so on. These vary greatly from one country to another. In some developing countries, these benefits might even include free meals (author's visits, various years; Verret, 1993).

Although many of the least-developed countries have relatively poor productivity levels in textile and apparel production, typically the hourly costs of labor are so much lower than wages in the developed countries that the lessdeveloped countries continue to have a significant competitive advantage in world markets. Whereas textile productivity rates have increased in the United States, less developed countries have in many cases shown marginal productivity growth. One must keep in mind, however, that less-developed countries continue to improve their productivity rates. Productivity in the apparel industry increased somewhat in the United States but declined in the less-developed areas (Cline, 1987; Wolf, Glismann, Pelzman, & Spinanger, 1984). The entry of new producer nations, most of which rely more heavily on apparel production than on textile production, accounts for much of the drop in productivity rates for apparel manufacturing in the developing nations. Productivity levels are generally quite low in countries that have just begun production. Moreover, for many less-developed countries in the early stages of development, providing employment for a large and otherwise unemployed workforce may be more important than trying to improve productivity

TABLE 6–2
Labor Cost Comparison, Apparel Industry (Including Social Benefits and Fringe Benefits)

Country	Hourly cost (US\$, 1996)	Country	Hourly cost (US\$, 1996)
Denmark	\$20.78	Costa Rica	\$2.38
Switzerland	19.93	Chile	2.33
Belgium	19.00	Poland	2.10
Germany	18.43	Czech Republic	1.99
Sweden	17.59	Brazil	1.92
Netherlands	17.03	Jamaica	1.80
Japan	16.29	Dominican Republic	1.62
Austria	16.28	Turkey	1.49
France	15.13	Slovakia	1.47
Australia	11.13	Peru	1.39
Canada	9.88	South Africa	1.26
Ireland	9.58	Thailand	1.06
United States	9.56	Colombia	1.05
United Kingdom	9.37	Nicaragua	0.76
Spain	7.37	Egypt	0.63
Greece	7.31	Russia	0.58
Israel	5.65	India	0.36
Taiwan	5.10	Indonesia	0.34
Hong Kong	4.51	Vietnam	0.32
South Korea	4.18	China	0.28
Singapore	4.11	Pakistan	0.26
Portugal	3.91	Haiti	0.05
Argentina	3.45		

Source: Data from Werner International.

rates. Further, new technology to improve productivity usually is not an option for manufacturers in the poorer countries. See Box 6–2.

GLOBAL PATTERNS OF CONSUMPTION

Consumer demand (also referred to as *consumption*) for textile and apparel products is the leading force in determining the levels of production and employment discussed in prior sections. Demand for final end-use products such as clothing, home furnishings textile products (e.g., draperies, linens, carpets), and other products containing textiles such as tires, luggage, and sporting goods also affects the

demand for intermediate inputs of fibers, yarns, and fabrics. Consequently, a healthy and sustained rate of consumption of textile and apparel products is critical to the prosperity of the global textile complex.

Changes in consumption levels can have a widespread impact on the global textile complex. First, a drop in consumption leads to a ripple effect backward through several stages in the production chain. For example, a decline in clothing demand reduces fabric demand; this is followed by similar reductions in yarn and fiber demand. Second, in the global fragmentation of the textile and apparel industries, a number of countries may be involved in making "global products" and, consequently, are affected by the changes in demand.

BOX 6-2

LABOR COSTS ARE ONLY ONE FACTOR IN COMPETITIVENESS

Although the low wages in the developing areas provide important cost advantages to the developing countries, other factors affect the competitiveness of the textile/apparel industry. Significant factors include productivity rates and the cost of other factors such as raw materials and energy, plus noncost factors such as market proximity, quality, styling, and services to customers. We see that labor costs are only one factor to consider when we compare the hourly labor costs of the largest exporter nations of textiles and apparel.

Ormerod (1993) gives examples in which wage rates have declining significance in terms of where profitable textile operations are located

(this may apply less to apparel). Similarly, in viewing WTO data for 1996, we see that of the 10 largest exporter nations of textiles* (see Table 6–7), 6 can be considered high-wage countries, three are NICs with escalating wages, and one is a low-wage country. In apparel (Table 6–9), 5 of the top 10 exporters* are high-wage countries and two are NICs with higher wages. The countries are identified and discussed more in detail later in this chapter; the reader may wish to consider those countries in relation to the wages given in Table 6–2.

*These exports include goods for outsourcing.

In the following sections, we will consider two measures for examining consumption patterns: (1) **fiber consumption** data and (2) **consumer expenditure** data. The two types of data may be used in a complementary manner. One measures fiber demand at one end of the textile chain and *demand for final textile products* at the other.

Fiber Consumption Measure

Fiber consumption data may be considered in a variety of ways. We might think of the collective fiber consumption of a country or a region and make comparisons on that basis. Similarly, we might make comparisons among groups of countries such as the more-developed and less-developed countries. On the other hand, we might consider the average fiber consumption of individuals, that is, comparing individual consumption from one country to another.

One definition of **textile consumption** has been offered by Toyne et al. (1984): "The sum of

a region's production and its net trade (imports minus exports) is the amount of a commodity that a region *consumes*, ignoring stocks held in inventory. Consumption on a per capita basis is both a measure of welfare of the consumers of a region and a measure of the potential market from the firm's point of view" (p. 62, italics added). Toyne et al., like many others who analyze global textile and apparel activities, used the term **per capita fiber consumption** to refer to the average number of pounds (or other measures of weight) of fiber consumed per individual on an annual basis. This is usually calculated for a defined area—a country, a region, or the world.

Per capita consumption is affected by general economic conditions. In the early 1980s per capita consumption declined, reflecting the slowed demand for apparel and the reduced demand for such products as carpets, autos, and furniture that contain textile materials. World fiber consumption was depressed in the early 1990s as a result of sluggish economic conditions, particularly in Western

FIGURE 6-3

Per capita fiber consumption in selected areas. (Latest data are for 1993 for developed countries and for 1992 for developing countries.)

Source: Based on information from World apparel and fiber consumption survey, 1995. Food and Agriculture Organization of the United Nations. (1996). Rome: Author.

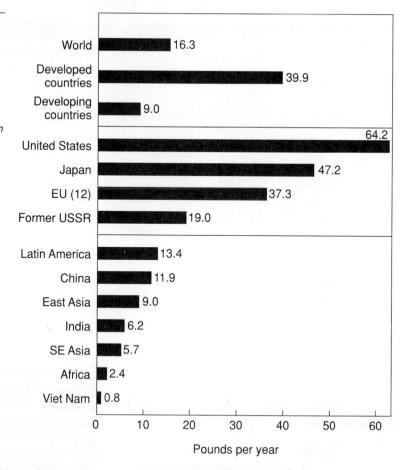

Europe, the United States, and Japan. For example, world fiber consumption grew by only 1.3 percent in 1992; however, this was an improvement over growth in 1991 (Fiber Economics Bureau, 1993).

The per capita consumption measure is useful in making intercountry and regional comparisons. Figure 6–3 shows the relative per capita consumption for select countries and country groupings.² The more-developed countries account for the largest per capita fiber con-

sumption of textile products, with the United States and Japan at the top.

We must keep in mind that the *per capita* data in these comparisons represent only one way of considering fiber consumption patterns. For example, if we look at *collective consumption* for the developed and developing nations, we may arrive at different conclusions. Although the developing countries are relatively marginal consumers on a per capita basis, as shown in Figure 6–3, their *total* consumption was not much below that for the more-developed countries. The less-developed countries consumed 17.1 million tons of fibers compared to 21.2 million tons for the more-developed countries (FAO, 1996). The England-based Textiles Intelligence Limited developed the estimates shown in Figure 6–4 for

² The FAO definition of developed countries includes centrally planned countries in Eastern Europe, including the former Soviet Union. Their definition of developing countries includes China (and this probably also means that Taiwan data are included with those for China).

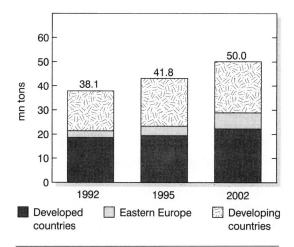

FIGURE 6–4 Final consumption of textile fibers, 1992–2002 Source: Coker, J. (1993, November). World textile and clothing consumption: Forecasts to 2002. Textile Outlook International, p. 37. Reprinted by permission of Textiles

Intelligence Limited.

three points in time. As the figure indicates, estimates project the *total consumption* of fibers for the developing countries to be roughly equal to that of the total consumption for the developed countries by the year 2002 (Coker, 1993).

As we noted, the per capita measure is useful in allowing us to observe certain consumption patterns. For example, the United States and Western Europe experienced serious declines in per capita fiber consumption from 1979 through the early 1980s. During this period the U.S. per capita fiber consumption dropped to the lowest level since the mid-1960s but experienced a healthy recovery by 1986 (Fiber Economics Bureau, 1989). Western European consumption has lagged because of a prolonged recession there.

A few observations might be made in reviewing what occurred during the early 1980s global recessionary period. First, the widespread recessionary patterns illustrate the interlinking of nations in recent years into a global economy. Second, textile and apparel consump-

tion is affected significantly by the broader economic trends. And third, economic changes in the more-industrialized countries have a serious impact on the global textile complex.

As an example of the importance of the economies of the more-developed countries, in 1992 the United States, which had only 4.8 percent of the global population, consumed over 19 percent of the fiber produced worldwide for the year. Together, the European Union (12 members) and the United States accounted for 14 percent of the world's population in 1992 but jointly consumed more than 38 percent of the world's fiber output for the year (FAO, 1995).

In addition to being affected by broad economic changes, two other key factors influence global consumption of textile and apparel products. These are *changes in world population* and *income levels*. Changes in the total population can have a significant impact on consumption; the location of the changes may be equally significant. As we learned in Chapter 4, the world's population is shifting from the industrial nations of the North to the developing nations of the South. The Population Reference Bureau (1993) predicts that by the year 2010, over four-fifths of the world's population will be concentrated in less-developed countries.

Although dramatic population growth may occur in some parts of the world, the economic means for acquiring additional textile and apparel products may be limited. Thus, total personal income is another variable to consider in consumption levels of textile and apparel goods. The following graph (Figure 6-5), developed from the FAO database, illustrates fiber consumption relative to income. A statistical technique called regression analysis was used to show how fiber demand varies with income in a number of countries. Keep in mind that per head is another term for per capita, and because fiber consumption is given in kilograms per head, one should remember that one kilogram is equal to 2.2046 pounds.

FIGURE 6-5

Fiber consumption and income per head for selected countries, 1990.

Source: Coker, J. (1993, November). World textile and clothing consumption: Forecasts to 2002. *Textile Outlook International,* p. 20. Reprinted by permission of Textiles Intelligence Limited.

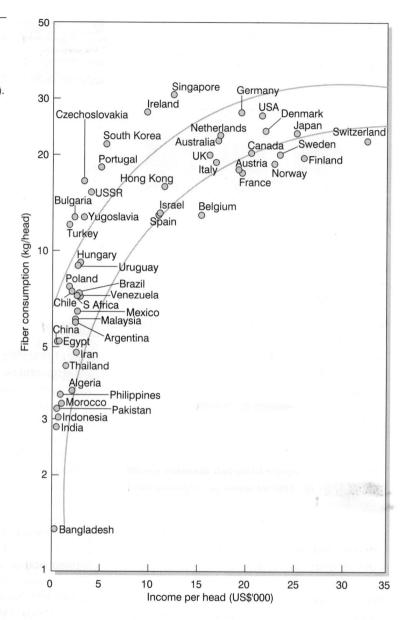

Consumer Expenditure Measure

Although fiber consumption data may be used as an indicator of consumption trends for textile and apparel products, WTO/GATT economists caution against basing the economic analysis of consumption of *finished* textile and apparel products on fiber consumption data

alone. They note that the fiber consumption data omit other inputs (including labor and capital) for all the processing stages up to and including the one that produced the consumer end product. That is, the "other inputs" are much more important in value terms than the fiber content of the final products (Communication with author, various years).

TABLE 6–3Total Consumer Expenditure and Expenditure on Clothing in Selected Developed Countries (Selected Years, 1963–1992)

		Average Annual Percentage Rate of Change in Volume					
7		1963–1973	1973–1992 ^a	1980–1992 ^a	54 - *		
United States	Total Clothing	4.5 4.0	2.5 3.6	2.6 3.4			
Japan	Total Clothing	8.5 7.0	3.4 1.4	3.4 1.5			
EC(12) ^b	Total Clothing	4.5 4.0	2.5 1.7	2.3 1.5			

^a For developed countries as a group, the last year was 1992; for Japan (clothing) it was 1991.

Source: Personal correspondence with GATT economist, based on OECD National Accounts and National Statistics.

Moreover, WTO experts noted that using weight to express per capita consumption fails to consider the differences in the prices and values of different products, treating a pound of one product as equal in value to a pound of any other. For example, the "weight approach" might include comparisons of pounds of silk to pounds of jute—hardly a realistic comparison in terms of the weight/value relationship. Further, the measure does not account for the trading up to higher-quality, higher-priced items that tends to occur. Trading up occurs particularly as a result of quota restrictions, which encourage producers to maximize the value of products that can be shipped in restricted quantities. Similarly, WTO sources have noted that technological innovations have caused a decrease in fiber usage by weight. For example, many manufactured fiber products tend to be lighter in weight and more lasting than similar products made of certain natural fibers; thus the increased production and use of manufactured fiber products would be underestimated in the per capita consumption data based on weight measures.

Although the fiber consumption measures are quite useful, WTO economists also like to

consider a second approach—the use of consumer expenditure data—as a complementary way of studying the demand for textile and apparel products. The WTO staff believes that fiber consumption data and consumer expenditure data are not measuring the same thing. That is, fibers are at one end and consumer expenditure at the other end of the textile chain. In other words, WTO economists believe that although the fiber consumption data are useful, this information is not the same as *final demand* for textiles and clothing.

Table 6–3 shows changes in consumer expenditure on clothing (including footwear) in relation to total consumer expenditure for the United States, Japan, and the EU. Complete, reliable data are not available for the less-developed countries. This table shows the average annual percentage rate of change in volume (real consumer expenditure, i.e., data in current values deflated by price indices).

Changes varied within the three main developed areas shown. The EU and Japan experienced the greatest slowdown in apparel expenditures, whereas similar expenditures in the United States grew faster than total consumer expenditures. Despite more positive

^b Data 1963–1973 refers to the EC (9).

growth in the United States, the slow growth in total clothing expenditures for the more-developed countries from 1973 through 1992 affected seriously the global textile complex.

Figure 6–6 compares the percentage share of consumer clothing expenditure as a part of total consumer expenditure in 1973 and 1992 for three developed areas. We note that clothing's share of total expenditure dropped in Japan and the EU but increased in the United States during this period. Comparable data are not available for the less-developed areas. As we noted earlier, however, the more-developed countries consume the largest proportion of fibers per person. Expenditure patterns paint a similar picture of global disparities. See Box 6–3.

Although the expenditure data avoid the shortcomings of the per capita fiber consumption measures based on weight, many of the consumption/demand patterns shown here

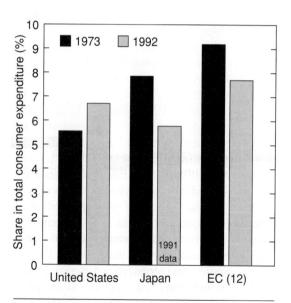

FIGURE 6-6

Share of clothing (including footwear) in total consumer expenditure, selected developed countries, 1973 and 1992 (1980 prices).

Source: Personal correspondence with GATT economist, based on OECD National Accounts and National Statistics.

are quite similar to those noted in the earlier analysis. Both approaches reflect a marked drop in consumer demand for or purchase of textile and apparel products from the early 1970s to the present. A key point to remember is that the *declines in production and employment* discussed earlier were tied closely to this *reduction in consumer spending in the developed countries*.

The Impact of Reduced Consumption

The period of stagnant consumption occurred at a particularly critical time in the broader development of the global textile and apparel industries. It was during these same years that the number of textile and apparel producer nations proliferated as an increased number of newly developing countries looked to these sectors as a cornerstone in their economic development plans. Consequently, slowed consumption of textile and apparel products in the more-developed countries caused competition for world markets to intensify. At the same time that textile and apparel manufacturers in the moredeveloped countries attempted to adjust to the reduced demand in their domestic markets, they found that they had many new global competitors.

Slowed demand coupled with the proliferation of producers led to fierce international competition for market share. Simply put, an overcapacity for production has the potential to create easily a glut of products in relation to global levels of consumption. In short, more and more countries have competed for a share of the market, as depicted in Figure 6–7, while the market has not grown appreciably.

GLOBAL PATTERNS OF TRADE

Whereas textile and apparel producers in the more-industrialized countries depended upon

BOX 6-3

WHO PAYS MORE DEARLY FOR CLOTHING?

Although persons in the developing countries consume a much smaller volume (in pounds, kilograms, and so on) of fiber than do persons in the industrialized countries, another striking comparison should be considered. In the developing countries, a far higher percentage of the household consumption expenditure is required for clothing (and footwear) compared to the developed countries.

As one of the basic necessities of life, clothing—like food—must be obtained before other things may be purchased. Once basic needs are satisfied, relatively higher proportions of income are spent on other goods. For some of the poorer nations of the world, however, the inhabitants never move beyond the necessities. More accurately, many never have adequate amounts of the necessities. World Bank data provide this startling contrast:

Percentage of household

4

consumption on clothing and footwear GNP per capita 10 110 Tanzania 12 170 Nepal 11 310 Rwanda 10 Ecuador 980 15 Turkey 1,630 6 21,790 **United States**

Source: World Bank. (1992). World Development Report, 1992 (Tables 1 and 10). Washington, DC: Author. Reprinted by permission.

32,680

home markets to use the products they manufactured, the developing countries concentrated on exports as the source of their growth. They, too, looked to the markets of the more-developed countries to buy and use their products. Thus, as the developing countries increased their production capacity and could offer many products at lower prices because of reduced labor costs, significant global shifts in trade occurred. Consumers in the more-developed countries saw an increase in the number of products in their markets made in other countries. See Figure 6–8.

Switzerland

Trade shifts are particularly important to examine in a study of the textile and apparel sectors in the global economy. These shifts are at

the heart of the controversy associated with international commerce for the textile complex. As textile and apparel manufacturers in the more-developed countries have experienced declines in production and employment, the trade shifts are typically viewed as the cause. Furthermore, logic would suggest that the domestic textile and apparel industries in the more-industrialized countries would be negatively affected when other producers compete for and successfully acquire a sizable proportion of the home markets. After all, consumption did not grow adequately to absorb the increased worldwide production that occurred.

Another reason that global trade for textile and apparel products merits special attention

FIGURE 6-7

In this illustration, representatives of many countries of the world vie for a piece of the U.S. "pie." As the nation with the highest per capita fiber consumption, the United States is viewed by producers in most exporting nations as a desirable place to sell their textile and apparel products.

Source: American Fabrics and Fashions (cover), issue no. 131, 1984. Reprinted courtesy of Bobbin

Blenheim Media Corporation.

Anthrodom

is that trade is one of the most accurately measured economic activities for the sector. Regardless of how conscientious international agencies attempt to be in their analyses of production and employment data, statistics on those activities often are subject to question. For example, some countries have fairly limited reporting and recordkeeping systems. Moreover, many production and employment statistics are dependent upon producers to report on their own operations, leaving room for omissions and inaccuracies to occur. In contrast, records on trade are more accurate. As products are traded, exports and imports must pass through customs agencies operated by national governments. Records of these transactions are more

precise and provide more comparable documentation of what occurred than is true for some of the production and employment records. Further, a number of international organizations (the WTO, the United Nations, the OECD) collect and publish these trade data in consistent, comparable form, which permits meaningful analyses of trade patterns on a global basis.

A good proportion of world data on textile and apparel trade is classified according to the Standard International Trade Classification (SITC) system. Textiles are classified under SITC 65 (textile yarn, fabrics, made-up articles, not elsewhere specified, and related products), and apparel is classified under SITC 84 (articles of apparel and clothing accessories).

FIGURE 6–8
Consumers see growing evidence of the globalization of the textile complex.

Although it is important to continue studying the most current textile and apparel trade data, a review of a span of years in which there was dramatic change for the complex provides a useful perspective on how the textile and apparel industries are affected by broader economic changes and by the intermeshing of national economies. Charting historical data permits us to discover patterns that are useful for current analysis and prediction. In this sense, studying historical trends is as important as studying current data. Historical trends often provide an important basis for government and business decisions.

This section provides an overview of global patterns of textile and apparel trade and considers shifts in trade that have occurred in the post–World War II years. After an overview,

trade for the two industries will be considered separately. Although trade patterns for textiles and apparel have much in common, for the most part the unique aspects of each sector account for differing trade shifts.³

An Overview of Textile and Apparel Trade

World trade in textiles and apparel, as measured by the value of world exports, grew considerably almost 18 percent—between 1970 and 1980 to \$97.4 billion. However, the worldwide economic recession that began in the early 1980s had a serious impact on consumer demand for all products and severely affected global trade in these sectors. Textile and apparel trade grew slowly during the first half of the 1980s but accelerated considerably by 1986. By 1996, textile and apparel trade had increased to \$313.5 billion, more than 69 percent over 1980 and 28.5 percent over 1990. In 1996, apparel was the 10th largest trade category as a share of all world merchandise trade (exports); textiles was the 9th largest category (WTO/GATT, International Trade, various years). Table 6-4 summarizes global textile and apparel trade as a share of merchandise trade and as a share of total manufactures in trade for 1996.

When we consider textile and apparel trade combined, we see the following distribution

³ In considering textile and apparel trade data, we must keep in mind that the recording of offshore assembly trade (known in Europe as *outward processing trade*) and exports from **free trade zones** is not consistent among countries. This trade may be excluded entirely from recorded export statistics (e.g., Mexico). It may be lumped together with other products in the "not elsewhere specified" section (e.g., China, the Philippines, Sri Lanka), thus escaping inclusion in textiles, apparel, and manufactures on the exports side. It would appear in import figures, however. Thus, for example, U.S. clothing imports from Mexico in 1985 were over double the value reported in the Mexican export statistics. A discrepancy of this magnitude cannot all be a result of valuation and reporting time lag differences (Jackson, various years).

TABLE 6–4Global Textile and Apparel Trade, 1996

Share of Textiles and Apparel in Total (%)						
	Merchandise exports (%)	Exports of manufactures (%)	Value of exports (US\$ billions)			
Textiles	2.9	4.0	\$150			
Apparel	3.2	4.4	\$163			

Source: Personal communication with WTO economist, 1997.

by major areas⁴ in Figure 6–9. It is significant to note that for combined textile and apparel trade, the less-developed countries account for more of the total than the more-developed countries, and that difference is growing each year. Table 6–5 provides an overview of world textile and apparel trade by main areas for 1990 and 1996.

As we study trade shifts in this section, we must keep in mind the effects of changes in currency exchange rates (see Box 6–4). For example, trade for a country may appear high, due in part to the valuation effects of exchange rates. For example, in the mid-1980s, the devaluation of the dollar resulted in textile and apparel growth rates that appeared very high for some of the West European nations whose currencies appreciated against the dollar. In

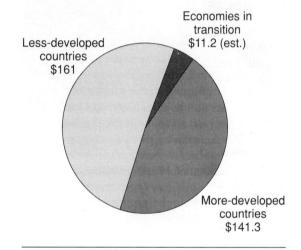

FIGURE 6–9
Textile and apparel trade, 1996 (billion dollars).

Source: Personal communication with WTO economist, 1997.

terms of their national currencies, however, those countries' growth rates for textile exports declined.

The Importance of Textile and Apparel Trade for Less-Developed Countries

Since the 1970s, the most important influences on global textile trade have been the growing number of producer nations and the increased proficiency of the developing-country produc-

Developed countries: Canada, United States, Japan, European Union (excluding former East Germany), and EFTA. Developing countries: Latin America, Western Europe not elsewhere specified, Romania, Africa not elsewhere specified, Middle East, and non-OECD Asia.

Economies in transition: Former Soviet Union and Central/Eastern Europe (without Romania).
Hong Kong reexports are not included.

⁴ The reader must keep in mind that because of major changes in the world, particularly in Eastern Europe and the former Soviet Union, country groupings used in trade data have changed. In 1990 the WTO/GATT began a new system of country groupings, which means that data from similar groupings before that time *are not comparable* with the new system. This prevents us from making comparisons of trade over a period of recent decades up to the present. Current GATT country groupings are:

185

TABLE 6–5
World Textile and Apparel Trade by Main Areas, 1990 and 1996 (billion dollars)

			Destina	lion			
Woi	ʻld ^a	Deve	•	Deve	,		mies in sition
1990	1996	1990	1996	1990	1996	1990	1996
104.75	150.22	65.74	77.86	34.08			8.44
106.45	163.32	93.09	137.22	9.63	19.98	3.59	5.86
65.55	79.59	49.79	52.95	13.50			6.34
45.24	61.67	39.48	48.21	4.47	10.85	1.27	2.56
							4.04
37.85	66.82	15.19	22.46			- 6.7	1.34
58.80	94.11	51.73	81.91	5.12	9.07	1.85	2.98
	1990 104.75 106.45 65.55 45.24	104.75 150.22 106.45 163.32 65.55 79.59 45.24 61.67 37.85 66.82	World ^a Deverous 1990 1996 1990 104.75 150.22 65.74 106.45 163.32 93.09 65.55 79.59 49.79 45.24 61.67 39.48 37.85 66.82 15.19	World* Developed Countries 1990 1996 1990 1996 104.75 150.22 65.74 77.86 106.45 163.32 93.09 137.22 65.55 79.59 49.79 52.95 45.24 61.67 39.48 48.21 37.85 66.82 15.19 22.46	Worlda Developed Countries Developed Countries Developed Countries 1990 1996 1990 1996 1990 104.75 150.22 65.74 77.86 34.08 106.45 163.32 93.09 137.22 9.63 65.55 79.59 49.79 52.95 13.50 45.24 61.67 39.48 48.21 4.47 37.85 66.82 15.19 22.46 20.23	World ^a Developed Countries Developed Countries 1990 1996 1990 1996 1990 1996 104.75 150.22 65.74 77.86 34.08 63.26 106.45 163.32 93.09 137.22 9.63 19.98 65.55 79.59 49.79 52.95 13.50 20.06 45.24 61.67 39.48 48.21 4.47 10.85 37.85 66.82 15.19 22.46 20.23 42.64	Worlda Developed Countries Developed Countries Econo Trans 1990 1996 1990 1996 1990 1996 1990 104.75 150.22 65.74 77.86 34.08 63.26 4.27 106.45 163.32 93.09 137.22 9.63 19.98 3.59 65.55 79.59 49.79 52.95 13.50 20.06 2.19 45.24 61.67 39.48 48.21 4.47 10.85 1.27 37.85 66.82 15.19 22.46 20.23 42.64 1.83

Note: Imports—read down; exports—read across. Example: Less-developed countries exported \$22.46 billion in textiles to developed countries in 1996. Less-developed countries imported \$20.06 billion in textiles from developed countries in 1996.

^a Includes unspecified destinations.

Source: Personal communication with WTO economist, 1997.

ers. As noted earlier, the textile and apparel industries have been particularly important in the economic development of many developing countries. Table 6–6 illustrates the importance of textile exports to a number of these countries.

We see, for example, that in 1996, Pakistan's combined textiles and apparel accounted for 73 percent of all merchandise exports. In some countries (e.g., South Korea), we see that textiles and apparel have declined as a proportion of all exports, while other countries such as Bangladesh, Sri Lanka, and Turkey have experienced substantial increases in textiles and apparel as a proportion of all exports. The reader should also keep in mind that these percentages are even higher when considered as a share of exports of manufactures.

Trade in Textiles

Patterns of Trade

The increased textile production capacity of the less-developed countries has accounted for significant shifts in trade. Textile exports, both in the *value* and in the **share** of trade from the less-developed countries, grew at a faster rate than did exports from the more-developed countries. Although the more-developed countries continued to lose in their combined share of world trade, *they remained the major exporters of textiles—but barely*. Although the more-developed countries still accounted for 53 percent of all textile exports in 1996, this is a decline from 80 percent in 1955, 70 percent in 1980, and 60 percent in 1992. (Please note that

BOX 6-4

THE IMPACT OF EXCHANGE RATES

Many trade shifts for the textile complex may be attributed to the price effects caused by changes in exchange rates among currencies. Ghadar, Davidson, and Feigenoff (1987) noted that the consequences of a strengthening dollar on industries with low profit margins, such as textiles and apparel, are long term. When the U.S. dollar weakens against other currencies, the dollar buys less abroad; therefore, U.S. consumers are more likely to buy domestic products. At the same time, foreign currencies are stronger against the dollar, resulting in greater purchasing power for buying U.S. products. Conversely, when the U.S. dollar strengthens against other currencies, the effects are reversed.

For example, if the U.S. dollar is weak against European currencies, buyers for prestigious stores can buy less than they could if the dollar were stronger. Or, when several Asian currencies tumbled against the U.S. dollar in 1997, this meant that U.S. retailers and importers could buy more Asian goods than was true before the Asian economic problems.

Figure 6–10 summarizes the influence of movements in the exchange rate for the U.S. dollar. Although this graphic summary may be an oversimplification, it is provided as an aid in remembering typical effects of exchange rate shifts related to discussions on textile trade.

Movements in exchange rates create price effects on foreign demand for U.S. textile and apparel exports. Thus, as the dollar weakens against another currency, an increase in U.S. exports toward that currency generally occurs.

Conversely, when the dollar strengthens against another currency, imports grow. Many experts (e.g., Ghadar et al., 1987; Toyne et al., 1984) assert that where exchange rates shift in relation to one another, trade flows are affected significantly.

In terms of impact on a U.S. industry, Ghadar et al. (1987) noted that because of the low profit margins in textiles and apparel, even small increases in the value of the dollar can lead to the failure of firms that might have remained healthy otherwise.

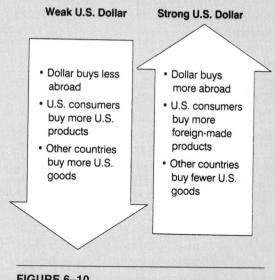

FIGURE 6–10
Typical effects of exchange rate shifts.

after 1990 the country groupings were modified by WTO/GATT, so this is not a precise comparison of the same countries.)

The more-developed countries' share of textile *imports* has fluctuated. In 1955, the developed countries were recipients of slightly more than half of all world exports in textiles; in the early 1990s, this group imported about two-thirds of the worldwide output. In 1996, however, the more-developed countries' share of textile imports was 52 percent. The declining share being imported by the more-developed

TABLE 6–6Share of Textiles and Apparel in Total
Merchandise Exports, Selected Economies,
1973 and 1996^a

		entage Share in erchandise Exports
	1973	1996
Bangladesh	50.0	68.4
Brazil	5.1	2.6
China ^b	4.5	24.6
Colombia	6.2	8.3
Hong Kong, China	41.4	19.9
Domestic exports	na	39.2
Reexports	na	16.6
India	26.7	27.6
Indonesia	0.2	12.9
Japan	na	1.8
Korea (South)	36.8	13.1
Macau	77.1	77.6
Malaysia	1.5	4.7
Mauritius ^c	3.1	52.6
Mexico ^b	7.5	5.0
Morocco	6.8	19.4
Pakistan	48.9	72.9
Portugal	28.3	21.9
Singapore	7.6	2.2
Domestic exports	na	1.0
Reexports	na	2.1
Spain	5.8	4.1
Sri Lanka	0.9	50.1
Taiwan	28.9	13.2
Thailand	8.0	10.6
Tunisia ^c	4.0	46.1
Turkey	11.5	40.0
United States	2.2	2.5
Uruguay	11.3	9.5

a Or nearest year.

Source: Personal communication with WTO/GATT staff, 1988, 1997.

countries does not mean that these markets are importing less in absolute terms. It is more likely a reflection of the less-developed countries' need to import more textiles to support the growth in apparel production in those regions.

Origin and Destination for World Trade in Textiles

Figure 6–11 shows a summary of the origin⁵ and destination for world trade in textiles in 1996. This figure shows the origin and destination by major country groupings, as well as for the major trade regions. This figure permits us to focus on relative trade flows, with trade among major areas shown with arrows (which also indicate the direction and value of trade). The amount of trade occurring within each area is shown within the circle, with relative amounts represented roughly by the size of the circles.

The left portion of Figure 6–11 reveals that more than 35 percent of world trade in textiles was mutual trade among more-developed countries. That is, in 1996, total world exports were \$150.2 billion; of that, \$53 billion was developed-country intratrade (i.e., trade *among* developed countries).⁶ Similarly, intratrade among less-developed countries was very substantial. It is significant to note that the less-developed countries' textile exports were greater *to other less-developed countries* than to the more-developed countries—almost double (\$42.6 billion compared to \$22.5 billion).

Although the less-developed countries have increased in their importance as textile exporters, often trade reports give the impression that nearly all textile trade is flowing *from* the less-developed countries *to* the more-developed countries. These figures tell us that the more-developed countries are recipients of

^b Includes significant exports from processing zones.

c Apparel only; the country exports virtually no textiles, if any.

na = not available

⁵ Origin, as used here, may be where the goods are produced, or it may refer to the country from which the goods are shipped (Jackson, 1989).

⁶ In Figures 6–11 and 6–13, note that Japan is in the more-developed group on the left and in the Asia group on the right.

economist, 1997.

188

Textile trade flows, 1996 (billion dollars).

Source: Based on data from personal communication with WTO

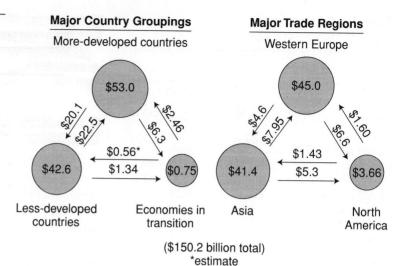

only a proportion of the less-developed country textile exports. As we shall discuss in Chapter 7, many of the more-advanced Asian nations have become proficient textile suppliers to other Asian countries in the region that do not have the technical or financial capabilities for complex textile production. In many cases, however, when intermediate textile inputs are shipped from one less-developed country to another, the second country may be producing

finished products for export to markets in more-developed countries.

The right portion of Figure 6–11⁷ reveals that the intratrade in textiles for Western Europe is substantial (\$45 billion of \$150.2 for the year, or 30 percent of all world textile trade). In fact, Western European countries account for the largest proportion of world trade in textiles. Intratrade in Asia is quite significant for reasons noted previously, and this changed more than any other textile trade figures since 1992—attesting to the growth in Asia. North America is by far the weakest trading region in textiles, in terms of both intratrade and exporting to other trade regions. However, NAFTA trade has boosted these figures somewhat.

Leading Textile Exporters

Table 6–7 provides a more detailed listing of the top 15 textile-exporting nations (using value data) over a period of time. Of particular significance in this table are (1) the shifts in relative importance of various countries over time and (2) the large proportion of all world textile exports provided by only 15 nations.

In 1963 and 1973, except for India and Hong Kong, the top 10 textile exporters were developed countries. By 1996, only 6 of the top 10 were the traditional developed countries (including Japan). For a period in the late 1980s, the United States was no longer among the top 10 textile exporters, but by the early 1990s it was in 10th place, barely making the list. In 1996, the United States had climbed to seventh place. This rise in U.S. textile exports can be attributed primarily to shipments sent to Mexico and the Caribbean region for garment assembly.

The growing importance of the major East Asian countries became quite apparent as Hong Kong (includes reexports), China, and South Korea entered the top 5 and Taiwan entered the top 10. All four of these newer East Asian suppliers had passed the United States, Japan, and the United Kingdom—the earlier textile powers.

 $^{^7}$ Ohmae (1985) refers to these regions as the *power trade triad*.

TABLE 6–7Leading Exporters of Textiles, 1963, 1973, and 1996 (in billions of dollars)

	1963		1973		1996
Japan	0.92	Germany, Fed. Rep.	3.04	Hong Kong, China	14.15
United Kingdom	0.71	Japan	2.45	domestic exports	1.77
France	0.63	France	1.69	reexports	12.38
India	0.54	Belgium-Luxembourg	1.69	Germany	13.56
Germany, Fed. Rep.	0.53	Italy	1.53	Italy	13.17
Italy	0.53	United Kingdom	1.45	Korea, Rep. of	12.72
Belgium-Luxembourg	0.51	Netherlands	1.29	Chinaa	12.11
United States	0.49	United States	1.22	Taipei, Chinese	12.05
Netherlands	0.36	India	0.69	United States	8.01
Switzerland	0.21	Hong Kong ^a	0.67	France	7.30
Hong Kong ^a	0.14	Switzerland	0.64	Belgium-Luxembourg	7.30
Austria	0.11	China	0.60	Japan	6.93
China ^b	0.10	Taiwan	0.56	United Kingdom	5.40
Portugal	0.09	Austria	0.45	Pakistan	4.92
Pakistan	0.09	Pakistan	0.44	India ^b	4.36
A1				Netherlands	3.24
Above countries as a percentage of world				Spain	2.87
exports	84.0		79.0		77.0

^a Includes trade through processing zones.

Note: The statistics of EU member states are affected by changes in the methods of collecting trade data beginning with 1993.

Source: Personal communication with WTO economist, 1988, 1994, 1997.

Although the composition of the list of major textile-exporting countries changed, the top 15 exporters command a fairly constant share of world textile exports, accounting for 77 percent in 1996, close to the share in 1973 (personal communication with WTO economist, 1997).

Leading Textile Importers

In the past, as might be expected, the top importing nations were the major developed countries. As Table 6–8 reveals (using value data), Germany (the former West Germany) and the United States were the major importers; this pattern continued through the late 1980s. However, by 1992, Hong Kong had become the leading textile importer and remains in that lead position, primarily because of textiles being imported for reexporting purposes.

Several observations are helpful in understanding the broad patterns. First, 9 of the top 15 leading textile-importing nations in 1996 were also among the group in 1963; however, relative rankings changed. A few countries dropped off the list, and newcomers moved up to replace them. In 1996 Hong Kong (mostly from reexports), China (includes imports through processing zones), South Korea, Spain, Poland, and the United Arab Emirates were among the group. The top 15 importing countries accounted for a smaller proportion of total world textile imports, going from 67 percent in 1973 to 55.5 percent in 1996. The decline in this percentage indicates that other countries were also importing substantial shipments of textiles.

Japan's presence on the list of leading textile *importers* since 1973 is a point of interest. We

^b 1995 rather than 1996.

190

TABLE 6–8
Leading Importers of Textiles, 1963, 1973, and 1996 (in billions of dollars)

	1963		1973		1996
Germany, Fed. Rep.	0.77	Germany, Fed. Rep.	2.74	Hong Kong, China	16.52
United States	0.68	United States	1.58	retained imports	4.14
United Kingdom	0.41	France	1.40	China ^a	11.98
Netherlands	0.37	United Kingdom	1.26	Germany	11.38
USSRa	0.30	Japan	1.13	United States	10.70
Canada ^a	0.27	Netherlands	1.10	United Kingdom	8.08
Australia	0.24	Belgium-Luxembourg	1.01	France	7.04
Belgium-Luxembourg	0.23	Hong Kong ^b	0.94	Italy	6.10
Sweden	0.22	Italy	0.91	Japan	6.07
Hong Kong ^b	0.20	Canada ^a	0.78	Korea, Rep. of	3.84
South Africa	0.20	USSR ^a	0.63	Belgium-Luxembourg	3.81
France	0.19	Australia	0.62	Netherlands	3.44
Italy	0.15	Sweden	0.51	Canada ^c	3.32
Denmark	0.15	Switzerland	0.50	Spain	2.91
Switzerland	0.15	Austria	0.48	Poland ^c	2.35
Above countries as a percentage of world				United Arab Emirates ^{b, d}	1.99
imports	64.0		67.0		55.5

^a Includes significant shipments through processing zones.

Note: The statistics of EU member states are affected by changes in the methods of collecting trade data beginning with 1993.

Source: Personal communication with WTO economist, 1988, 1994, 1997.

recall from an earlier discussion that Japan had been considered by the more-developed countries as the major threat as a textile-*exporting* nation in the 1950s and 1960s.

China's recent presence among the top importing nations reflects the more active status of the textile complex in that country and its reliance on other countries for certain fibers and other basic textile inputs. Failed cotton crops and lack of sufficient manufactured fiber production facilities largely accounted for this situation. This is a temporary stage for China, however, as its textile industry moves toward a more advanced and self-sufficient level in its development. The other major source of China's textile imports is shipments into pro-

cessing zones such as Shenzhen, outside Hong Kong, where large quantities of garments are produced.

in the state of th

Hong Kong was the largest textile importer in 1996; however, about three-fourths of these textile imports were for reexport. Additionally, because of limited space and environmental concerns, Hong Kong has very limited textile production to support the extensive apparel industry that is coordinated through Hong Kong offices.

A review of the major textile-importer list, particularly in relation to the major exporter list, provides an interesting opportunity to reflect on both the application of economic (trade) theory and the stages of development

^b 1995 instead of 1996.

c Imports are valued f.o.b.

^d Includes United Nations Secretariat estimates.

for the textile complex within various countries. Questions to consider are: (1) why are some countries both major exporters and major importers? and (2) why do some countries appear on one list but not the other? (For example, why is Canada a major importer but not a major exporter?)

Trade in Apparel

Patterns of Trade

Although certain global apparel trade patterns were similar to those for textiles, significant differences also occurred. The labor-intensive characteristics of apparel production, along with the minimal technology and capital requirements, fostered expanded apparel trade in ways that differed from textile trade. In reviewing Table 6–4, we see that apparel was a greater share of total worldwide exports (both merchandise and manufactures) than textiles. The value of total apparel trade (exports) was greater than that of textiles (\$163.3 billion compared to \$150.2 billion).

When we reviewed the relative importance of the major country groupings for textile exports for the post–World War II period, we saw a steady decline in the more-developed countries' share of world exports and a marked increase in the less-developed countries' share. A similar pattern occurred for apparel trade, except that the shift toward the less-developed nations was far more dramatic.

The export shifts favoring the less-developed countries reflected those nations' dependency on the apparel sector for export earnings and the ability of those nations to produce apparel at attractive prices for the global market, principally because of lower wages. Figure 6–12 illustrates the export orientation of the less-developed countries.

The less-developed countries' share of world exports increased from about 10 percent in 1955 to 58 percent in 1996. In contrast, the

more-developed countries accounted for 71 percent of world apparel trade in 1955 and 38 percent in 1996 (periodic communication with WTO staff). The reader is reminded again that these major groupings are not exactly comparable because of WTO/GATT's new data system instituted in 1990.

Another global shift for apparel occurred in the postwar period. The developed countries accounted for a growing percentage of apparel imports, and the developing nations represented a declining share. As the exports from developing countries grew dramatically during this period, the developed countries became increasingly important as the recipients of those goods.

Origin and Destination for World Trade in Apparel

Figure 6–13 shows a summary of origin and destination for world trade in apparel in 1996. The origin and destination are shown by major country groupings, as well as for the major trade triad.

The left side of Figure 6–13 reveals that mutual trade among more-developed countries was also important in apparel, accounting for 30 percent of the total world trade (down from 34 percent in 1992). The figure also supports the assertion that more-developed countries were by far the major recipients of apparel in global trade. In 1996, the more-developed countries purchased more than 84 percent of all world exports in apparel—of which 30 percent came from within the more-developed countries, 50 percent came from the less-developed areas, and an estimated 7 percent came from economies in transition.

Whereas trade among less-developed countries is important for textiles (44 percent of total less-developed country textile exports), trade among these countries is rather limited for apparel (about 10 percent of their total apparel exports). As Figure 6–13 shows,

FIGURE 6-12

A number of less-developed countries have actively promoted their textile and apparel products in the global market. Thailand, for example, has sponsored apparel trade fairs to attract buyers to see the country's products. This advertisement appeared in various trade publications.

 $Source: \ \ \ \ Perinted \ courtesy \ of \ Thail and \ Department \ of \ Export \ Promotion \ (see \ also \ http://www.ThaiTrade.com).$

FIGURE 6–13
Apparel trade flows, 1996 (billion dollars).
Source: Personal communication

with WTO staff, 1997.

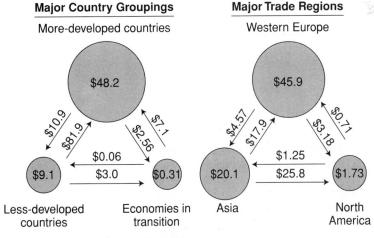

(\$163.3 billion total)

the less-developed countries concentrate on exporting apparel to the more-developed countries, where demand and incomes are greatest.

The right portion of Figure 6–13 reveals that two regions account for more than three-fourths of world apparel exports: (1) Western Europe and (2) the Asian suppliers. A sizable proportion of the apparel trade for Western Europe came from within the region. (U.S. readers may wish to think of this as somewhat similar to trade among the U.S. states, particularly as Western Europe has become a more integrated trade area.) EU apparel firms send growing amounts of cut apparel to Central and Eastern Europe and parts of North Africa for the assembly process. This parallels U.S. apparel firms' 807/9802 production in Mexico and the Caribbean.

By far, the major growth of apparel exports has been from the Asian region. Marked increases in the share of apparel exports have come from China, which is now the leading apparel exporter. Figure 6–13 shows that the major markets for Asian apparel are Western Europe and North America, with the latter as the single most important market.

As for textiles, North America is by far the weakest player for apparel exports among the

major trade regions. North America does not account for a significant share of the supply of apparel for the global market, even for trade within North America. Among the factors accounting for the limited apparel exporting from North America are (1) the relatively higher labor costs compared to those of other regions (although the same could be said for Western Europe; however, shipping costs for Western Europe; intratrade would be to that region's advantage); (2) the strength of the dollar in some years, which made U.S. exporting more difficult to some areas such as Western Europe; and (3) the serious lack of an export orientation on the part of most of the U.S. apparel industry.

Leading Apparel Exporters

Table 6–9 lists the top 15 apparel-exporting nations (using value data) over a period of time. As we review the shifts among producer nations, the reader may wish to reflect on the stages of development discussed in previous chapters to help understand the changing positions of countries involved in apparel trade.

Between 1963 and 1996, the number of more-developed countries among the top 15 exporters went from 11 to 6. (When Portugal

TABLE 6–9
Leading Exporters of Apparel, 1963, 1973, and 1996 (in billions of dollars)

	1963		1973		1996
Italy	0.34	Hong Kong ^a	1.42	China ^a	25.03
Hong Kong ^a	0.24	Italy	1.30	Hong Kong, China	21.98
Japan	0.21	France	1.04	Domestic exports	8.98
France	0.20	Germany, Fed. Rep.	0.91	Reexports	13.00
Germany, Fed. Rep.	0.15	Korea, Rep. of	0.75	Italy	16.07
United Kingdom	0.11	Taiwan	0.71	United States	7.51
Belgium-Luxembourg	0.10	Belgium-Luxembourg	0.57	Germany	7.37
United States	0.09	United Kingdom	0.44	Turkey ^b	6.12
Netherlands	0.07	Netherlands	0.41	France	5.53
Switzerland	0.04	Japan	0.37	United Kingdom	5.18
Austria	0.04	United States	0.29	Korea, Rep. of	4.22
Yugoslavia	0.02	Poland	0.28	Thailand	4.03
Portugal	0.01	Romania	0.25	India ^b	4.11
Canada	0.01	Finland	0.21	Indonesia	3.59
Taiwan	0.01	China	0.20	Portugal	3.59
				Taipei, Chinese	3.21
Above countries as a percentage of				Netherlands	3.05
world exports	75.0		73.0		65.9

^a Includes significant shipments through processing zones.

Note: The statistics of EU member states are affected by changes in the methods of collecting trade data beginning with 1993.

Source: Personal communication with WTO economist, 1988, 1994, 1997.

joined the EU, it was reclassified as a developed country.) Although the number of moredeveloped countries dropped, Italy and Germany were in the top five throughout the period. The ranking of the United States among the top apparel exporters continued to drop. At times in the late 1980s, the United States was not among the leading 15 apparelexporting countries, but in the early 1990s the nation regained a position among the group and was in a surprising fourth place in 1996. NAFTA and Caribbean trade probably account for this rise because 9802/807 production is counted as both exports and imports. Japan was the third highest exporter in 1963 but dropped to ninth place in 1973; by the late 1980s, Japan was no longer among the top 15 exporters of apparel as Japanese policymakers encouraged manufacturers to deemphasize

this segment of the textile complex and focus on areas that took greater advantage of the nation's technological capabilities.

On the other hand, the Asian countries continued to increase their relative rankings (excluding Japan). Of these, China moved up most rapidly. In 1963 China was not among the top 15 suppliers, but by 1996 it was the largest apparel exporter. Since a large proportion of Hong Kong's apparel exports are also from China (and since Hong Kong is now officially part of China), China is clearly the "king" of apparel exporters. Major apparel export growth in Turkey, Portugal, Thailand, Indonesia, and India boosted these countries to the list of top exporting nations. For most of these nations, apparel accounted for a growing and significant share in each respective nation's total merchandise exports.

^b 1995 instead of 1996.

TABLE 6–10
Leading Importers of Apparel, 1963, 1973, and 1996 (billion dollars)

al. s	1963		1973		1996
USSR ^a	0.52	Germany, Fed. Rep.	2.54	United States	43.32
United States	0.39	United States	2.17	Germany	24.10
Germany, Fed. Rep.	0.26	USSR ^a	1.06	Japan	19.67
United Kingdom	0.18	Netherlands	0.86	Hong Kong	13.63
Netherlands	0.15	United Kingdom	0.82	Retained imports	0.63
Switzerland	0.09	France	0.59	France	10.89
Sweden	0.09	Japan	0.57	United Kingdom	9.70
France	0.07	Belgium-Luxembourg	0.56	Netherlands	5.44
Belgium-Luxembourg	0.07	Switzerland	0.50	Italy	4.99
Canada ^a	0.06	Sweden	0.40	Belgium-Luxembourg	4.33
Norway	0.05	Canada ^a	0.33	Switzerland	3.73
Denmark	0.03	Norway	0.20	Austria	3.18
Singapore	0.03	Austria	0.20	Spain	2.96
Italy	0.03	Italy	0.19	Canada ^a	2.54
South Africa	0.02	Denmark	0.18	Sweden	2.17
				Mexico ^{a,b}	1.91
Above countries as a percentage of world		1			
imports	92.0		89.0		81.7

a 1995 instead of 1996.

Note: The statistics of EU member states are affected by changes in the methods of collecting trade data beginning with 1993.

Source: Personal communication with WTO economist, 1988, 1993, 1997.

In addition to the changing composition of the group of top 15 apparel exporters, the share of worldwide apparel exports accounted for by this group has decreased. The top 15 apparel exporters accounted for 75 percent of world exports in 1963 but for only 65.9 percent in 1996. This decline reflects the growing number of countries involved in apparel production, particularly the entry of many newly developing countries in recent years.

Leading Apparel Importers

Table 6–10 provides a summary of the top 15 apparel-importing nations (using value data) from 1963 through 1996.

Several observations from the table are useful in understanding broad apparel trade patterns. First, all the major importers are developed countries, except for Hong Kong, whose

imports are primarily for reexport, and Mexico, whose import statistics are greatly inflated by products being sent there by U.S. firms for assembly. Second, 12 of the top 15 importers for 1996 were also in the group in 1973, although the relative rankings shifted. Denmark was no longer among the top group, and the Soviet Union no longer exists. Hong Kong was a newcomer in the 1990s, due to imports for reexport.

The top 15 countries absorbed a large proportion of all world apparel exports, although the concentration among the top 15 is less than in previous years shown. The most dramatic change was in the increased proportion of world apparel exports absorbed by the United States and Germany, particularly the United States. In 1996, the United States imported 26.5 percent of all world apparel exports compared to only 17 percent in 1973. The United

b Imports are valued f.o.b.

States and Germany together accounted for more than 41 percent of total world imports of clothing.

A review of the major apparel importer list, particularly in relation to the major apparel exporter list plus the similar rankings for textiles, provides additional opportunities to reflect on the application of economic theory and stages of development for the textile complex within various countries. For example, what characteristics distinguish the textile exporters from the apparel exporters? In general, how do apparel exporters differ from apparel importers? Why are most of the major apparel importers developed countries?

Influences on Trade

A number of factors influence trade in general and, therefore, also affect textile and apparel trade. These factors affect what countries produce, what they trade, and what they seek in exchange when they trade. Although some of the influences on trade have been mentioned in this chapter, a summary may be helpful at this point.

General Economic Conditions

Although positive economic growth since World War II fostered trade, the postwar decades were also marked by periods of decline and expansion of trade. When economic conditions are booming, trade often grows more rapidly than production. In a sluggish economy, however, trade increases at a lower rate than production. Moreover, changes in global prosperity affect dramatically the types of products traded and their relative importance in trade. Increased production in a country increases employment; thus the purchasing power of the population increases. As noted in the examples in this chapter, when the economies of the major textile/apparel markets slowed, the consumption decrease caused a ripple effect that led to reduced production, employment, and trade for textiles and apparel globally.

Stages of Economic Development

The stages of development for the various economies of the world range from the poorest, which are at beginning stages, to the most affluent, whose populations enjoy sophisticated products from around the world. Nations at early stages are limited in what they can sell to the rest of the world to gain foreign exchange. These developing countries need the means of gaining foreign exchange so that they can buy advanced equipment and other technology not available in their own countries but necessary to become more industrialized. On the other hand, in the mature economies, consumers have substantial purchasing power and satisfy their needs with products from many countries. These products are from both the more-industrialized and the less-developed countries: therefore, worldwide trade occurs.

Trade patterns shift over time as certain economies mature and newer ones emerge. Some countries, such as Japan and Germany, made conscious decisions to deemphasize certain labor-intensive portions of the textile complex and to give greater priority to more technologically advanced production. As a result of the development and maturing of the economies of many countries, trade shifts have been quite apparent for the global textile and apparel industries. A number of the developed countries that led the Industrial Revolutionwith the textile industry in the forefrontexperienced severe declines in their domestic textile and apparel industries. At the same time, producers in a number of less-developed countries have become significant competitors.

Types of Economy

Market-directed economies permit individual firms to participate in world trade in a variety of arrangements that satisfy consumer demand and render a profit to the firms involved in importing or exporting. Although government policies often influence trade, a market-directed economy permits participation in

world trade according to market mechanisms in ways similar to the participation in domestic markets. Centrally planned economies, on the other hand, monitor trade according to government goals. Both exporting and importing are controlled by central sources rather than by consumer demand or the motivation for profit. Many of the formerly centrally planned economies of Eastern Europe have shifted toward market-directed economies and look to the textile complex in their countries for economic growth. China is an example of a textile- and apparel-producing country with a centrally planned economy that embraces many aspects of a market-driven economy. North Korea, in contrast, is clearly centrally controlled.

Differences in Natural Resources

The earth's resources are not evenly distributed; as a result, trade is the means by which those who do not have all they want or need can secure resources from those willing to sell. In much of the less-developed world, human energy (labor) is one of the most abundant resources; and usually, because of its abundance, it is inexpensive. When textile and apparel goods are produced with this abundant resource, the products therefore are much less expensive than those supplied by countries where human input is more costly. Other natural resources affecting textile and apparel trade include land for natural fiber production, climates suitable for growing fibers such as cotton, and petroleum and chemicals for manufactured fiber production. As we recall from Adam Smith's theory of absolute advantage, these resources represent a natural, as opposed to an acquired, advantage in trade.

Technology

Technological changes, both in the products available and the processes by which they are produced, affect the relative positions of countries in global trade. Demand for new products and for the technology to produce those products provides a ready incentive for trade. In some cases, the new technology provides pro-

duction efficiencies that give a competitive advantage over prior processes in both price and response time. A major textile development of recent decades was the refinement and mass production of manufactured fibers—a development that affected global textile trade. Table 6–11 illustrates the impact of manufactured fiber production on the global textile market.

Manufactured fiber production was a technological advance that clearly favored the developed countries with the expertise and capital to nurture this segment. In contrast, up to that time, countries had been dependent upon natural resources for fiber production. Like most technological developments, manufactured fiber production originated in the industrialized (richer) nations, and few developing countries had the means to expand into this production. Entry into manufactured fiber production is a significant accomplishment for a nation as its textile complex moves through the various stages of development. Overall, however, availability of manufactured fiber production technology had a profound impact on global textile trade.

Traditions of Specialization

Some countries established traditions of specialization and continue to foster skills and talents that enable them to produce distinctive goods in demand by persons in other parts of the world. Although perhaps originally tied to resource endowments, many of these products require expertise that is difficult to duplicate to produce the distinctive items (an acquired advantage rather than a natural advantage). Therefore, countries or regions with these traditions of specialization engage in trade of the products valued by individuals in other parts of the world. Examples of these include stylish, high-quality Italian shoes; British woolen goods; high-fashion women's clothing from Paris; and distinctive batik fabrics from Indonesia.

The trade advantages acquired through traditions of specialization are rarely permanent. Shifts in trade patterns occur for products of

TABLE 6–11World Fiber Production, 1900–1996 (millions of metric tons)

			Manufactured Fibers		
Natural F		Fibers	Artificial (Cellulosic)	Synthetic (Noncellulosic)	
Year	Cotton	Wool	Fibers	Fibers	
1900	3,162	730	1000000	Nego (20	
1950	6,647	1,057	1,608	69	
1960	10,113	1,463	2,656	702	
1970	11,784	1,659	3,579	4,818	
1973	13,738	1,497	3,856	7,767	
1980	14,040	1,599	3,557	10,625	
1986	15,196	1701	3,276	13,765	
1992	18,115	1,676	2,620	17,213	
1996	18,960	1,456	2,861	20,348	

Source: Personal communication with Comité International de la Rayonne et des Fibres Synthétiques, 1987, 1994, 1998.

this type as readily as other trade shifts occur. Froducers of these products must retain the distinctive product qualities and yet respond to global market changes, knowing that other suppliers can replace them.

Political Objectives

Both internal and external political matters can influence dramatically a country's trade. Often governmental influence on trade cannot be justified by economic reasoning. Because of the importance of textile and apparel production in providing employment, political objectives influence trade.

Internally, pressure from domestic industries often influences governments to raise barriers to imported goods. An argument often used to seek protection from imports is that essential domestic industries must be protected during peacetime so that the country will not be dependent upon foreign sources in case of war. (See "Minimum Viable Production" in Chapter 12.) In the United States, for example, industry sources have argued the need for healthy textile and apparel industries to produce uniforms, parachutes, and other textile-related defense items. See Box 6–5.

Externally (i.e., beyond the boundaries of one's country), political concerns may influence trade in a variety of ways. Political allies may receive more favorable trade agreements than countries with fewer advantages (bargaining chips) to offer. As an example, the United States and Western Europe do not impose quotas on textile and apparel products traded with one another (through something called the gentlemen's agreement), although both have extensive restrictions on products from many less-developed countries. As might be expected, this has been a sensitive point to the less-developed countries, whose products are subject to restrictions in both markets. The comparable economies and similar wage structures are given as reasons to justify this policy; however, favorable treatment of political allies appears to be an important issue as well.

Shifts in Exchange Rates

Although earlier we considered the effects of changes in exchange rates, we are reminded here that trade is influenced significantly by these changes.

BOX 6-5

POLITICS AND TEXTILE/APPAREL TRADE

Political objectives have frequently influenced U.S. textile and apparel trade policies. Examples are:

- Cuba. Although Cuba has the potential to become an important apparel production site, trade is prohibited because of U.S. opposition to Fidel Castro's communist rule. Additionally, the United States has attempted to stop allies from trading with Cuba.
- China. Renewal of China's most favored nation (MFN) status (a trade provision that gives favorable tariff rates to exporting countries) is often uncertain because of U.S. Congress members' concerns over China's record of human rights abuses.
- South Africa. For a time, all South African products were banned from U.S. markets because of

- that country's apartheid policy (a government policy that mandates racial discrimination).
- Vietnam. In the early 1990s, as firms from other countries descended on Vietnam to take advantage of its booming growth, low wages, and excellent labor force, U.S. firms were not among them because of trade sanctions. After the Vietnam War and the communist takeover, the United States ended trade relations with the nation. By the early 1990s, many U.S. investors were pressing the government to lift the sanctions so that they might also do business in Vietnam. Trade sanctions were lifted in early 1994.
- Myanmar. In 1991, the United States did not renew its textile bilateral agreement with Myanmar in retaliation for Myanmar's failure to reduce opium production and ease political repression.

SUMMARY OF GLOBAL TEXTILE/APPAREL ACTIVITY

As we reflect on the patterns for global textile and apparel production, employment, and trade covered in this chapter, we find that one common pattern prevails. These textile/apparel activities have shifted increasingly to favor the less-developed countries. Although the nature and magnitude of the shifts vary, in

general the less-developed countries have accounted for a growing share of textile and apparel production, employment, and trade, while the more-developed countries have accounted for a declining share. As many of the more advanced Asian countries have increasing incomes—and, in some cases, wealth—consumption has increased markedly. Figure 6–14 depicts the shift in activity from the more-developed to the less-developed areas.

FIGURE 6-14

Global textile/apparel activity. Note that textile trade and apparel trade indicate greater participation in trade, as well as growing receipt of products by less-developed countries.

More-developed countries

Textile production
Apparel production
Textile employment
Apparel employment
Textile trade
Apparel trade

Less-developed countries

SUMMARY

In this chapter, we have examined global trends in textile and apparel production, employment, consumption, and trade. For each of these areas, we have seen distinct trends and, in most cases, global shifts in these activities.

New countries entered the global textile/apparel markets in the 1950s and 1960s, and production maintained a healthy growth rate between 1953 and 1973. Production slowed in all the main areas after 1973 because of recessionary effects from the oil price hike; however, textile production growth rates in the developing areas far outpaced those in the developed countries. The developing countries increased substantially their *share* of global production.

Similarly, total worldwide apparel production increased at a slow rate after 1973. Global sites for apparel production changed far more dramatically than was true for textile production. Apparel production in the developed countries experienced almost no growth and, in fact, had a negative growth rate in the 1980s. By contrast, apparel production in the less-developed areas continued to increase at a healthy pace, with the developing Asian countries representing a large proportion of the growth.

Although employment data do not reflect the large numbers of undocumented workers, the global textile complex provides one of the largest sources of manufacturing jobs. Textile employment began declining even in the 1950s in the developed countries and continued to have a negative growth rate through the present. In contrast, the less-developed areas experienced increased employment.

The annual growth rate of employment in apparel also declined in the developed countries during this period. Apparel employment, perhaps more than any other area of activity for the global textile complex, reflects the shift to the developing countries. Wage differences are seen as the key factor in the global shifts of both textile and apparel production and employment.

Global textile/apparel consumption patterns have a widespread impact on both production and employment trends. Most segments of the textile complex are affected by consumption patterns, as are many countries involved in this globalized sector. Consumption trends may be examined by two types of measures: (1) fiber consumption data and (2) consumer expenditure data. These use two different types of data, which are complementary in considering textile and apparel consumption. One measures fiber demand at one end of the textile chain and demand for final textile products at the other.

Fiber consumption data show that the total (based on fiber availability) consumed by the less-developed countries is more than three-fourths the amount consumed by the more-developed countries. Although the less-developed countries have modest per capita consumption levels, the total consumption is relatively high because the population in this group of nations accounts for a large share of the world's inhabitants.

Worldwide recessionary conditions affected consumption both in the more-developed and the less-developed countries. Because of the large per capita fiber consumption patterns in the major developed country markets compared to the rest of the world, a decline in consumption in those countries has a significant impact on many exporting nations. In addition, changes in world population and income levels play an important role in global consumption patterns.

Consumer expenditure data provide another means of studying consumption patterns. These data reflect demand for final textile products and clothing. Although all consumer expenditures in major developed countries slowed from 1973–1992 compared to 1963–1973, clothing expenditures (with the exception of the United States) slowed even more. This decline seriously affected the global textile complex.

Stagnant consumption patterns occurred at a difficult time in the broader development of

the global textile complex. At the same time that consumption slowed, a growing number of producer nations entered the global market, adding to the existing problem of overcapacity.

And, finally, we examined trade patterns in this chapter. As the developing nations expanded textile and apparel production, most looked to exports as a means of growth. In contrast to the industrialized countries, where manufacturers focused primarily upon home markets, the developing countries concentrated on exports. Consequently, the volume of global textile and apparel trade has expanded greatly, and producers in both the more-developed and less-developed areas compete for the same key markets—those in the more affluent industrialized nations. Labor cost advantages in the less-developed countries favor production and, therefore, trade for these countries.

Textiles and apparel ranked 9th and 10th among major product groups as a share of world merchandise trade in 1996. Textile exports from the less-developed countries grew at a faster rate than those from the more-developed countries. Although the more-developed countries still account for nearly 53 percent of all textile exports, this group's share has continued to decline while the share from the less-developed areas has increased. Major East Asian suppliers accounted for substantial growth in the latter group.

Western Europe and the United States have been major recipients of textile imports; however, some of the East Asian nations grew increasingly important as textile importers. A good proportion of the Asian increase appears to have been products destined for reexport.

Overall, about 35 percent of world trade in textiles was mutual trade among more-developed countries; 30 percent was intra-EU trade. The less-developed countries were the destination for growing imports of the textile exports from other developing nations.

Patterns for apparel trade were similar to those for textile trade except that apparel's shift toward the less-developed nations was even more dramatic. This shift reflects the dependence of the less-developed countries on apparel production for export earnings (and the tendency for core firms to take advantage of low wages in the periphery). As the apparel exports from the developing countries grew from the 1970s to the present, the more-developed countries became increasingly important as the recipients of those goods.

In 1996, mutual trade among the developed countries accounted for 30 percent of the total world trade for apparel. The more-developed countries received 87 percent of all world apparel exports.

Western Europe and the Asian suppliers accounted for a large proportion of all apparel exports; however, a sizable proportion of Europe's exports were directed to countries within the region. In 1996, the United States and Germany were the leading apparel importers, providing a market for 41 percent of all world apparel exports.

A number of factors influence textile and apparel trade. These include general economic conditions, stages of economic development for countries or regions, type of economy, differences in natural resources, technology, traditions of specialization, political objectives, and shifts in exchange rates.

Overall, less-developed countries are capturing a growing share of textile and apparel production, employment, and trade activities. Members of this group are also increasingly important recipients of textile and apparel products.

GLOSSARY

Consumer expenditure data refers to data on the final demand for apparel and other textile products at the end of the textile chain.

Exchange rates refers to the number of units (i.e., the "price") of one currency required to secure one unit of a currency of another country.

Exports, imports. For customs purposes, exports and imports are defined as the movement of goods

across customs frontiers. Customs data are generally used by governments in recording merchandise trade. Data in this chapter are customs data.

Fiber consumption or per capita fiber consumption refers to the average number of pounds (or other measures of weight) of fiber consumed per individual on an annual basis. Per capita fiber consumption is usually calculated for a defined area—a country, a region, or the world.

F.O.B. means "free on board." This means that the exporter or seller has included in the price of the goods the transportation to port, as well as the handling and loading aboard the vessel.

Free trade zone (also called *free zone*, *free port*, or *foreign trade zone*) is an area within a country where goods can be imported, stored, and/or processed without being subject to customs duties and taxes.

Gentlemen's agreement was an informal agreement between U.S. and EU textile trade officials that they would not impose restrictions on each other's textile/apparel products.

Manufactures are manufactured goods that are referred to by this term to distinguish them in the economic analysis of trade flows as *one* of the cat-

egories of merchandise trade.

Merchandise trade refers to trade in all goods that add to or subtract from the material resources of a country as a result of their movement into or out of the country. In the economic analysis of trade flows, merchandise trade is often divided into broad product groups. The main ones are agriculture, mining, and manufactures. Textiles and apparel are included in the manufactures group.

Per capita fiber consumption is the average volume (pounds, kilograms, and so on) of fiber consumed per individual for a given time period,

usually a year.

Productivity refers to the output produced per unit of input. This frequently refers to labor productivity, measured by output per hour worked.

Share of global production, employment, or consumption refers to a nation's or area's proportion of the total activity (as we use it here, of *global* activity). This is not the *absolute level* of that activity. For example, an area's absolute level may increase while its share decreases.

Textile consumption has been defined as "The sum of a region's production and its net trade (imports minus exports) is the amount of a commodity that a region consumes, ignoring stocks held in inventory. Consumption on a per capita basis is both a measure of welfare of the consumers of a region and a measure of the potential markets from the firm's point of view" (Toyne et al., 1984 p. 62).

SUGGESTED READINGS

Ford, J. (1986). World trade in textiles. *Textiles*, *15*(3), 72–77.

An overview of global textile trade.

Ghadar, F., Davidson, W., & Feigenoff, C. (1987). U.S. industrial competitiveness: The case of the textile and apparel industries. Lexington, MA: Lexington Books.

Although this book focuses primarily on the U.S. textile and apparel industries, it presents the domestic industries in a global context.

Institut Français de la Mode (periodic). Study on employment development and qualification needs in the European clothing industry. Paris: Author. The subject is given in the title.

International Labour Office. (1996). *Globalization of the footwear, textiles and clothing industries*. Geneva: Author

A study of the impact of globalization on employment and working conditions in these industries.

International Textile Manufacturers Federation. (1993). *Overcapacity—the global challenge* (Vol. 16). Zurich: Author.

Proceedings of the annual ITMF meeting, in which overcapacity for global textile production was addressed.

Mersch, M. (1997). *Internationalisation of European textiles and clothing production*. London: Textiles Intelligence and l'Observatoire Européen du Textile et de l'Habillement.

A study of present and future trends and the impact of Europe's political and economic changes on the textile and apparel industries.

Toyne, B., Arpan, J., Barnett, A., Ricks, D., & Shimp, T. (1984). *The global textile industry*. London: George Allen & Unwin.

A study of major trends affecting international competition in the textile mill products industry.

United States International Trade Commission. (1983, September). The effect of changes in the value of the U.S. dollar on trade in selected commodities.

Washington, DC: Author.

A study of the impact of changes in exchange rates on trade.

United States International Trade Commission. (1985). *Emerging textile-exporting countries*. (USITC Pub. No. 1716). Washington, DC: Author.

A study of the textile-exporting nations expected to become increasingly important in global textile/apparel trade.

World Trade Organization. (annual). WTO International Trade. Geneva: Author.

This publication provides useful information on all global trade and includes sections on textile and apparel trade.

7

The Textile Complex in Select Regions of the World

In this chapter, we shall look briefly at the textile complex in select regions of the world and consider its **restructuring**, which continues to occur on a global basis. Although it would be useful to cover regions and countries in far more detail, unfortunately space does not permit. Full books are, in fact, written about the textile complex in individual regions and countries. Therefore, it is our intent to provide a brief overview that gives the reader a basic understanding of the industry in these regions, particularly in relation to previous discussions on stages of development for the textile complex and overall development of nations and regions.

ASIA

We shall begin with Asia for two reasons. First, this has been the fastest-growing part of the world economy for more than a decade, with significant shifts in world textile and apparel production moving there. In fact, nearly all Asian economies have been built on the early success of the textile and apparel industries in each country. Second, parts of this region illustrate vividly some of the concepts discussed in Chapters 4 and 5.

Although growth has slowed in Asia, Naisbitt (1996) writes: "In the 1990s, Asia came of age. And as we move toward the year 2000, Asia will become the dominant region of the world: economically, politically, and culturally. We are on the threshold of the Asian Renaissance. . . . Asia was once the center of the world, and now the center is again returning to Asia" (pp. 10, 15).

By the late 1990s, a number of problems began to surface in parts of Asia, including labor costs that were rising faster than productivity, overbuilding in many industries, weak capital markets, poor infrastructures, widespread corruption, and inadequate training. After more than two decades of an unprecedented economic boom, many of the fast-growing Asian economies had to face a reality check. Although investment rates remained high, Hong Kong, Seoul, Singapore, and Taipei became more expensive places to do business than New York. Other experts believed that although the Asian NIC economies (the "Tigers"—Hong Kong, Taiwan, South Korea, and Singapore) were slowing, the growth of the new tigers— Malaysia, Vietnam, and China—would more than compensate for the shortfall (Dornbusch, 1997; Engardio, Moore, & Hill, 1996; Mead, 1997; Powell & Hirsh, 1997; Torre, 1997).

East Asia

East Asia has been a powerhouse of growth. During the 1980s, the region led the world economy, with annual average growth rates double those for most of the rest of the world. In some areas, rice fields gave way to high-rise factories and cities. A common element in the economic success of the region has been an emphasis on export-oriented industries that rely on large, low-cost labor pools and use the large pools of savings. For all of these countries, the textile complex has been a major contributor to growth and development. However, for the more-developed economies in the region, the industry's role is somewhat less prominent in recent years.

The economies of Asia have been known as the "flying geese." See Figure 7–1. Japan was at

the head of the flock, followed by the "miracle economies" (the NICs). As Japan progressed, it became a model for other Asian nations. Like Japan, these other nations relied heavily on textiles and apparel in early economic development. Japan was the first to move into hightechnology, capital-intensive industries, and other economies gained from Japan's wealth and experience. This happened in all industries, particularly textiles and apparel. Japan was the first to have capital to invest in neighboring countries that were less developed. It was also the first to move away from the laborintensive segments of textiles and apparel and into more advanced production. For example, Japan reduced garment assembly and produced more textiles that required capital, technology, and technical expertise. As Japan shifted to less labor-intensive industries, it benefited

FIGURE 7-1

In the flying geese pattern of development, less-developed nations often perform more of the assembly operations, while more advanced countries are likely to provide the intermediate inputs for production.

Source: Illustration by Dennis

Murphy.

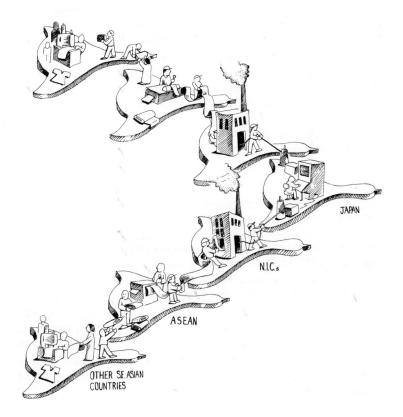

from the demand of the NICs and ASEAN for intermediate inputs, technology, and capital equipment. Similarly, the NICs later restructured to move toward more capital-intensive industries when they experienced wage pressures from less-developed Asian nations and labor shortages in their own countries. The NICs similarly relocated labor-intensive production to the ASEAN region and China. Thus, a pattern was established in which moreadvanced countries provide the components and the capital to those that follow. Further, as the nations toward the front move away from the labor-intensive aspects of production such as garment assembly, these become ideal for the less-developed countries toward the rear. This pattern is continuing, more or less, throughout the region. Other countries have not followed the exact path of Japan, however, because each country has different characteristics.

The time lag between the introduction of new technologies in the developed countries and their diffusion to less-developed countries has been shortened. Moreover, the newly maturing economies, the NICs, are maturing more rapidly than did Japan because the pace of structural change has been compressed as the pace of technological change has accelerated.

Some of the Asian nations more advanced in textile and apparel production have found it increasingly difficult to ship their products to the long-time primary markets in North America and Western Europe. Quantitative limits (quotas) on imports from major Asian suppliers have increased in number. Moreover, the quick response demanded by both U.S. and EU retailers has made the distance between those markets and Asia a growing disadvantage.

In the more advanced economies of East Asia, incomes have been rising, creating an emerging consumer class. Earlier, writers noted that "East Asia is generating its own wealth on a speed and scale that probably is without historical precedent" (Engardio, Barnathan, & Glasgall, 1993, p. 100). This trend, along with high population growth in the region, continues

to make East Asia a major market area. However, prospects for this market growth have declined with the slowing in these economies as they deal with emerging problems.

Japan

Japan was clearly the leader in industrialization and development in this region and continues to be the most technologically and economically advanced. Although Japan's textile and apparel industries were major forces in world markets earlier, major restructuring has occurred. Table 7–1 shows Yeung and Li's (1993) summary of Japan's progression through the various stages of development, using stages outlined by Toyne et al. (1984).

Japan's arrival at the full-maturity stage (i.e., a mature industry) reflects advanced levels of production capabilities, particularly in terms of capital and technology inputs; the value added has been increased. High valueadded products include Shingosen or microfine polyester fiber, germ-resistant fabrics, and high-strength and heat-resistant textiles. Labor shortages are a problem for the apparel industry, particularly in urban areas. As we noted earlier, Japan began to invest in other Asian nations quite early in relation to some other advanced economies. That practice continues to be a major part of Japan's textile and apparel production strategy. Although Japan's textile industry is one of the most technologically advanced in the world, a growing trade deficit plagues the sector. In the 1980s, Japan's manufactured fiber industry—one of its most competitive segments—was the second largest in the world, with the U.S. industry first. By the 1990s, Japan had dropped to fourth place. Faced with rising Asian competition and a drop in exports, many of the major Japanese fiber producers have diversified into medical supplies, plastics, films, and other hi-tech products—now having less than half of their production in textiles (Furukawa, 1995).

TABLE 7–1
Stages of Development of Japan's Textile Complex

Embryonic	Initial Export	Advanced Production		Golden Age	Full Maturity
Manual pro- duction for local con- sumption Silk export Net importer of textile prod- ucts	Infant cotton spinning sector Initial export of cotton yarn	Textile production extended into cotton, rayon fabric, and garments Textile production rose and trade surplus increased Above 50% of total exports	War time	Rapid growth of manmade fiber sector Expanding trade surplus Intensified foreign investment Leading world textile ex- porter	Enhanced top- end textile production technology Sophisticated product de- velopment Employment decline Expanding trade deficit Intensified foreign investment
1890	1910	1940		1970	1990

Source: Yeung, K., & Li, S. (1993, May). Education for a changing world. Paper presented at the meeting of the Textile Institute, Hong Kong. Used by permission.

The appreciation of the yen caused Japan's labor costs to rise, making production in many of its industries uncompetitive. Japan's foreign investment and offshore production increased, first to the Asian NICs and then to the ASEAN region and China, to take advantage of less costly labor.

Taiwan

Taiwan's textile complex has developed in a pattern similar to that of Japan. Even with a much later start, both as a nation and in the textile and apparel industries, Taiwan has made remarkable progress in developing the textile complex, as shown in Table 7–2. Taiwan has gone from being one of the world's largest apparel exporters (for a time in the 1980s, it was the leading apparel exporter to U.S. markets) to one that emphasizes high-technology production and is quickly losing ground in the more labor-intensive segments of the industry.

Rising wages, labor shortages, appreciation of the New Taiwan Dollar, and other problems have created increasing difficulties for Taiwan's apparel industry. To ease the worsening labor shortfall, a long-standing ban on employing foreign workers (within Taiwan) was lifted in 1991. Additionally, increasing amounts of apparel for Taiwanese firms are being sewn in lower-wage Asian nations (Chen, Jackson, & Kilduff, 1996).

The commentary in the Taiwan Textile Federation's (TTF) (1997) industry summary might have been written by industry counterparts in any of the more-developed countries. The report emphasized a focus on technology, research and development, globalization, and a marketing orientation to provide quick response and efficiencies in the marketing channels. TTF has encouraged Taiwanese firms to build establishments in Central America, where industrial growth is expected to be strong.

TABLE 7–2Stages of Development of Taiwan's Textile Complex

Embryonic	Initial Export	Advanced Production	Golden Age
Handicraft and machine production of textiles for domestic consumption Net importer of textile products mainly from Japan Little export of silk cocoons and linen	Substantial development of textile industry under government support Early export of textile products mainly to S.E. Asia	Development of clothing sector Expansion of textile and clothing exports Start of manmade fiber production	One of the leading textile and clothing exporters Expanding textile trade surplus Rapid growth of manmade fiber sector Intensified foreign investment in S.E. Asia
fiber to Japan 1950	1960	1970	1990

Source: Yeung, K., & Li, S. (1993, May). Education for a changing world. Paper presented at the meeting of the Textile Institute, Hong Kong. Used by permission.

In recent years, Taiwan's textile industry has grown into a fully integrated fiber-textile-finishing industry. Because Taiwan does not produce natural fibers, the textile sector has focused on the production of manufactured fibers. Taiwan has developed a sophisticated textile industry; after the United States, it is the second largest producer of manufactured fiber in the world.

Hong Kong

Although Hong Kong is now officially part of China, it is being treated as a separate entity. The Special Administrative Region of Hong Kong will maintain customs regulations, quotas, and statistics separate from those of China. Hong Kong is home to the largest concentration of garment companies in the world. About 16,000 apparel companies are registered with the Hong Kong government's Department of Trade. Of these, more than 11,000 are shell companies and do no business at all. The remainder, slightly fewer than 5,000 companies, are functioning garment agents and

factories. These companies in turn own, operate, or otherwise control production in over 18,000 factories in southeastern China (Birnbaum, 1994).

Hong Kong's textile complex has developed somewhat differently from those of Japan and Taiwan. Originally developed by refugees fleeing the communist rebellion in China in the late 1940s, the Hong Kong industry benefited from leaders who had been industrialists and entrepreneurs in Shanghai with experience in textile manufacturing. Hong Kong became the world's leading exporter of apparel products in the 1970s and 1980s, holding this lead until outpaced by China. Hong Kong's stages of development are shown in Table 7–3. Still, textile and apparel products accounted for nearly 38 percent of Hong Kong's domestic exports in 1995, 16.5 percent of its merchandise reexports (WTO, 1996a).

Hong Kong apparel has been valued as high-quality products desired by major consumer markets in the United States and Western Europe. In recent years, however, Hong Kong's cost advantages have become increas-

TABLE 7–3
Stages of Development of Hong Kong's Textile Complex

Embryonic	Initial Export	Advanced Production	Golden Age
Small-scale cottage- type textile produc- tion for domestic consumption Net importer of textile products	Establishment of cot- ton textile industry Expansion of textile export mainly to developed countries	Rapid growth of the clothing sector Textile production was diversified into cotton/manmade fiber blend products 50% of total production was for export One of the leading exporters of clothing products	World's leading clothing exporter Revitalization of re- export trade mainly in textile and clothing that led to expanding textile trade surplus Intensified foreign investment in S.E. Asia Contraction of the industry
1950	1960	1970	1990

Source: Yeung, K., & Li, S. (1993, May). Education for a changing world. Paper presented at the meeting of the Textile Institute, Hong Kong. Used by permission.

ingly difficult to sustain as real estate and labor costs have increased dramatically. Additionally, Hong Kong has experienced a labor shortage even though the government has permitted limited importation of workers. Therefore, companies have found it increasingly difficult to maintain production. Many other Asian countries have lower wages, as well as greater labor availability; therefore, Hong Kong has had difficulty competing. As a result of these problems plus quota limitations on their exports, Hong Kong firms have made various arrangements with partners in less-developed countries. For example, many Hong Kong firms engage in outward processing arrangements (OPA) (called outward processing trade [OPT] in Europe); these arrangements explain why Hong Kong controls production in the 18,000 plants in southeastern China, as noted above. See Figure 7-2. In addition, many firms have invested in other locations throughout the developing world, from most regions of Asia to the Caribbean and South America. Steele (1990) noted that "Hong Kong

producers sometimes liken themselves to textile gypsies—forever 'moved on' from country to country, forever denied a permanent home capable of accommodating their energies and way of life" (p. 94).

Textile production has always been a challenge for Hong Kong because it has no domestic source of fiber, making it dependent on imports for these materials (Steele, 1990). Much textile manufacturing has become increasingly ill suited to Hong Kong's urban setting, with high land and labor costs and labor shortages, as well as the costs of complying with environmental regulations.

Although Hong Kong's manufacturers have needed **quotas** to ship their apparel products to the United States and Western Europe, the quota for Hong Kong is among the most generous provided to any major textile/apparelexporting economy. The export system is managed by the Hong Kong Trade Department, which must grant export authorization—an export license—to manufacturers before they can export their products. When the author

FIGURE 7-2

This figure illustrates OPA in Asia. Japan and the NICs transfer apparel production to lower-wage countries of Asia. Source: Illustration by Dennis Murphy.

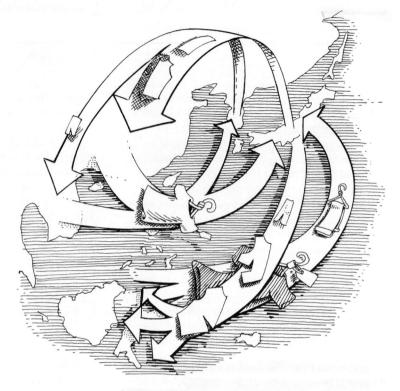

visited the Trade Department, the long lines of individuals representing companies waiting to secure export licenses were hard to believe, but they served as an affirmation of the volume of Hong Kong's textile/apparel trade.

Some individuals have been concerned about Hong Kong's business climate after its return to China in July 1997, which brought the former city-state under China's communist rule. Despite China's promise of "one country, two systems," those who have conducted business in China are skeptical. They fear that as practices of the Chinese government infiltrate Hong Kong, business will be more difficult—perhaps including a system of bribery, bureaucratic entanglements, and a decline in the work ethic. Other observers believe China will do nothing to harm its economic powerhouse (Bow, 1997a; Elliott & Elliott, 1997).

In textiles and apparel, Hong Kong and China have an important complementary relationship. Hong Kong is the fashion marketing center, and China provides the production base. This arrangement ran into difficulty in 1996, however, when the United States changed its country of origin rules for quota purposes to places where the garment is *assembled* rather than where it is *cut*. See Box 7–1.

A substantial proportion of Hong Kong's textile and apparel trade consists of reexports. Nearly all of Hong Kong's current apparel reexports are from China. Moreover, Steele (1990) noted that Hong Kong's growing apparel reexport trade is reminiscent of 19th-century Hong Kong as an entrepôt for China's trade with the outside world. When reexports are included, Hong Kong is the world's third largest exporter of textiles and second largest exporter of apparel (WTO, 1996). The issue of reexports is controversial because some are legal but others are not. Companies with operations in China that do not have a quota to export from China smuggle products into Hong Kong and export them as locally produced—sometimes known

U.S. COUNTRY OF ORIGIN RULES COMPLICATE ASIAN PRODUCTION

The Uruguay Round Agreements Act passed by Congress in December 1994 set out the general principles for determining the country of origin of all textile and apparel products. Currently, apparel's origin is determined by where garments are assembled. The origin of most other products such as fabrics, bed and table linens, and accessories such as scarves is determined by where the fabric is made. Following passage of the Uruguay Round, the U.S. Custom Service was charged with developing the regulations for carrying out this change. Because of the current global nature of the industry and the multicountry processing that occurs today, writing new rules was a complex assignment. U.S. Customs created a whole new section in its regulations (Section 102.21) that covers all textile and apparel products except those made in Israel and those "originating" under NAFTA. The new rules went into effect Iuly 1, 1996.

The new country of origin rules are relatively complex and have significant implications for U.S. trading partners. U.S. manufacturers and retailers dependent on textile and apparel production in other countries have also been affected by these rules. The U.S. government cites two reasons for the change: (1) to have U.S. rules conform with those of other industrialized countries and (2) to help combat illegal transshipment—the practice of bypassing quota limits by using another country's quota.

An unstated goal of the change in the rules was to stifle what the U.S. industry perceived as "quota avoidance production plans." The intent was to curtail outward processing arrangements being used by some of the major Asian textile and apparel producers. The issue at stake was the quota—that is, the country of origin determines which country's quota is used to ship the merchandise to the U.S. market. According to the 1985 rules of origin, the country where "substantial transformation" occurred determined a

product's origin. For garments cut from fabrics, the country where the cutting occurred was considered the country of origin. Under the 1985 rules, major Asian suppliers such as Taiwan, Hong Kong, and South Korea-whose labor was becoming scarce and costly—could cut garments in their home countries. Cut garments were then sent to lower-wage neighboring Asian countries for assembly, and the products were shipped to the U.S. market using the home country's quota. Significantly, Taiwan, Hong Kong, and South Korea have had very generous quota allowances to ship to the United States because, since they were early textile/apparel exporters, their cumulative annual quota growth over time had yielded large quota holdings. In contrast, China had far more modest quota allotments primarily because of tightly negotiated quotas resulting from the U.S. industry's strong concern over the potential impact of massive imports from China.

Under previous rules, as firms in Taiwan, Hong Kong, and South Korea arranged for outward processing in China, for example, this arrangement worked well. Although garments were being sewn in China, China's low quota was not a problem because the quota of the originating country (where cutting was done) was used to allow shipment into the U.S. market. Eventually, U.S. industry sources saw this arrangement as a way to get around quotas on products made in low-wage countries such as China and thus export more products to the U.S. market than the U.S. government intended when the quotas were negotiated.

Under the 1996 rules, the country of origin is the country in which garment assembly occurs. Therefore, Asian manufacturers who did cutting in their domestic facilities and sent cut pieces to other countries to be sewn discovered they could no longer use the home country quota; instead, they had to use the quota of the country

BOX 7-1 CONTINUED

of assembly. Potentially, this change meant that shifting the origin to low-cost countries may cause high-cost countries to get out of the business entirely. Or it may require moving assembly back to higher-cost countries. At any rate, this change caused many Asian producers to restructure cutting and production arrangements that had worked for years. For many, the change was very detrimental to business.

The new origin rules had a significant impact on another group of cut-and-sew manufacturers—those who make items such as bed sheets, linens, and so on. Under the 1985 rules, origin was determined by where the fabric was cut on four sides and sewn, including the creation of elasticized pockets on corners. Under the new rules, the origin is determined by where the fabric

was formed. If the fabric-producing country is subject to U.S. quotas, then a visa must accompany the product to verify the identity of the fabric-forming country, even if sewing occurred elsewhere. This change means that the incentive to move sewing to countries other than the fabric-making country is reduced. Jacobs (1997) reported that Kenya has been a victim of this change in rules. Many Kenyan sheet manufacturing facilities had to shut down because their fabric was obtained from Pakistan.

Policy changes such as these can have a significant impact on where production occurs, what can be produced, and to whom it may be shipped. For the well-being of their businesses, individuals employed in the industry must learn the rules and be alert to changes.

as the *submarine trade* (presumably because it is out of sight). Other countries with quota shortages use Hong Kong to participate in similar **transshipping** activities. U.S. Customs imposed added controls on shipments from Hong Kong to attempt to stop illegally transshipped products from China from being shipped to the United States under the Hong Kong quota (Ostroff, 1996).

Hong Kong has established a growing reputation for high fashion. Many large U.S. and European manufacturing and retail firms have offices there. Fashions are marketed in part by the Hong Kong Trade Development Council (HKTDC), which has a sophisticated system for promoting Hong Kong's products to markets around the world. The HKTDC is funded by a small levy on all Hong Kong exports.

The apparel industry in Hong Kong is undergoing a structural change. Apparel firms are seeking to engage in more value-added

activities in the softgoods chain. Many are developing their own brands. Others are assuming greater responsibility for market research, product development, marketing, and retailing (Au, 1997). The more of these roles Hong Kong manufacturers can assume, the greater their profit. Although Singapore and Shanghai are becoming major apparel marketing centers in Asia, Hong Kong will continue as a major sourcing hub; it will also be a major marketing center, but in many cases for products manufactured elsewhere

South Korea (Republic of Korea)

South Korea, like its neighbors discussed above, represents an economic and development success story. According to Sakong (1993), "Korea in the early 1960s was a typical developing nation caught in a vicious circle of underdevelopment. With an annual per capita GNP of less than \$100, domestic savings were negligible, and

accordingly, foreign aid financed over 50 percent of the nation's investment. Over 40 percent of the population was suffering from absolute poverty" (p. xv). In the late 1990s, after nearly four decades of hard work and careful planning, Korea is the 11th largest economy in the world, with a per capita output that has quadrupled in the past decade. In late 1996, South Korea was invited to join the OECD, sometimes called the "rich man's club."

Korea's textile complex played a major role in the country's development and economic success—its "liberation from poverty" (Kim, 1992, p. 115). For example, in 1970 textiles and apparel accounted for 41 percent of Korea's exports (Sakong, 1993). In 1995 these sectors accounted for nearly 14 percent of Korea's merchandise exports and remain the country's largest employers (Kim, 1996; WTO, 1996a).

As Japan saw the need for industrial restructuring and movement out of labor-intensive industries, it provided significant foreign direct investment (FDI) for Korea's textile complex. As an important first industry, Korean textile and apparel manufacturing evolved through many stages similar to those of its Asian neighbors discussed previously, losing some of its competitiveness in the mid-1980s. However, the chemical fiber industries in Korea have been growing remarkably in both quantity and quality. Proficiency in more complex types of production reflects Korea's overall advanced development. Korea's apparel industry produces increasingly high-quality garments, and is clearly in touch with global fashion-forward trends, as shown in Figure 7–3.

Presently, the Korean textile and apparel industries face two major structural problems—labor shortages and rising labor costs. Recently, Korean firms have been investing in less-developed countries to take advantage of their cheaper labor. Korean textile, apparel, and footwear FDI has been substantial in Asia (45 percent) and in the Central and South American nations (32 percent) (Sakong, 1993).

Korea's textile and apparel exports are not expected to grow as much in the future as they have in the past; however, the textile complex will remain an important export industry for some time. The industry is attempting to improve its competitiveness through restructuring, modernization, and offshore production. A population with increasing income is adding to domestic demand, and the industry is responding with an upward shift in fashion and quality to respond to more fashion-conscious consumers. Sophisticated department stores in Seoul are filled with high-quality, expensive products to cater to droves of affluent, demanding customers. The typical U.S. retailer would envy the traffic and consumer interest seen in Seoul's stores.

China (People's Republic of China)

Although most Asian nations have had a profound impact on the global textile and apparel picture, as we someday read the history of the world textile complex, perhaps none will equal the impact of mainland China—particularly because of this nation's large labor force and production potential, along with its rapid entry into world markets. Until China's economic reform in 1979, textile and apparel production was for the domestic market. The government determined what would be produced, and there was no attempt to tie production to demand; however, that situation has now changed as China has embraced a unique form of market economy. Since its reform, China has placed great emphasis on labor-intensive manufactures to increase exports, a pattern previously discussed as common in a country's development. Now China is the world's leading supplier of apparel (and footwear) products. With a population of more than 1.3 billion persons (about 24 percent of the world's total), its impressive growth in labor-intensive production is not surprising.

FIGURE 7-3

Examples of fashions available to increasingly affluent, fashion-conscious Asian consumers. *Source:* Photos courtesy of Hong-Soon Shin, CEO, L. G. Fashion, Korea.

Since its reform, China's annual GNP growth rate has averaged 9-10 percent, one of the highest in the world. If the Chinese economy continues to grow as fast as it has in the last decade, its GNP will exceed that of the United States by 2010. China's booming economy has made the nation something it never was before—a major economic force, if not the dominant market in Asia in the next century. Two regions have led the country in this economic boom: (1) the Shenzhen Special Economic Zone in southern China near Hong Kong and (2) Shanghai, the largest city, which has long been the most cosmopolitan in the country. However, although media reports tend to focus on the dramatic economic changes in these regions, nearly 80 percent of the population still resides in other areas. In most of these regions, the population is extremely poor. In many parts of China, even the booming areas, the transportation infrastructure is inadequate to meet the demand (Conley, 1996/1997; Engardio et al., 1996; Laris et al., 1997).

China is expected to remain a dominant force in light industries such as textiles, apparel, and shoes. Manufacturing wages will continue to remain low as impoverished workers are drawn from remote rural areas. Young

women from these regions often go to work in garment factories located in more industrialized areas such as Shenzhen. Companies provide dormitories and most of the meals for these workers, who are hundreds of miles from home. See Figure 7–4. Many workers send a large proportion of their modest pay home to their families, much as young workers did in the early days of the U.S. textile mills.

Additionally, foreign investors have been encouraged to establish factories in the countryside, where workers have fewer job opportunities. Therefore, textile enterprises have invigorated the economy in some rural regions and created jobs for the younger generation and the "surplus labor force" (Leung, 1992).

Textile and apparel output has increased significantly in recent years. However, although all experts agree that growth has been dramatic, Chen and Jackson (1996) point out that analysts have difficulty obtaining accurate data on the number of enterprises, the size of the workforce, and the **shipments** (i.e., output) of China's textile complex. Part of the problem is due to the hierarchy of public administration in China, which includes provinces, regions, and municipalities—all of which are subject to

FIGURE 7-4

Young women who come from remote areas of China to work in the Shenzhen apparel industry generally live in dormitories. Residents often decorate their rooms with posters featuring Chinese entertainers.

Source: Photo by Kitty G. Dickerson.

the jurisdiction of the State Council. Provinces are divided into counties; counties are composed of townships; and townships are divided into villages. Some data sources cover some of these areas; others have different coverage. None provides comprehensive data.

Early in China's economic reform, its leaders identified the textile complex as a major sector to expand in the nation's economic development strategy. The textile sector was among the first to attract outside investment. From 1978 to 1995, foreign investment in the textile industry was estimated to be \$8 billion. Exports from foreign-funded plants represented about 27 percent of all China's textile exports (Leung, 1996, 1997b, 1997c).

According to Chen and Jackson's (1996) estimates from combined data sources, about 15 million workers are employed in the industry in about 89,000 enterprises. However, this does not include the large numbers employed in informal cottage industries or in natural fiber production (which are classified as agricultural employment). Massive numbers of workers are required to produce natural fibers, including very large quantities of cotton, silk, cashmere, camel hair, ramie, and flax.

Labor costs in China have been very low, ranging from \$40 to \$80 per month for 6-day work weeks. In the early 1990s, many new workers just out of school, about 15 years of age, sometimes earned only \$10 per month¹ (author's visit to Chinese garment plants, 1991). Workers in remote regions may also earn very low wages—one incentive for companies to locate their plants there.

Textiles and apparel are by far China's leading export sectors, accounting for 26 percent of merchandise exports in 1995. Its textile and apparel exports for 1996 were valued at \$35 billion. The apparel industry exported more than 8

billion items of clothing and accessories, making China the leading supplier worldwide for these items (Leung, 1996, 1997a; WTO, 1996a).

Blind expansion of production capacity has harmed some segments of China's textile industry. Three-fourths of the state-owned textile plants operated at a loss in the mid-1990s. Moves are underway to privatize these inefficient enterprises. Many textile mills are medieval in appearance, using outdated, unsafe equipment. In 1996, 130 of them were allowed to go bankrupt in an effort to curb the overexpansion. Official statistics show that the same blind expansion exists in some apparel categories. For example, in 1996 it was reported that 1.5 billion men's shirts were stockpiled enough to provide three shirts for each male in China! Yet, about 1,000 manufacturers continue to produce about 1 million additional shirts per day ("China Begins," 1997; Leung, 1996, 1997b, 1997c).

China also has a large textile machinery industry consisting of a few hundred factories, only a limited number of which make updated machines. According to Chinese authorities, the technology is ideal for developing countries but the quality has failed to reach advanced international standards. Chinese producers complain that no matter how careful the worker is, the end product can be of only medium quality at best. (The reader should note that this discussion applies to some textiles rather than to apparel.) China's machinery is more affordable for countries that cannot afford to buy expensive, sophisticated machines from Europe or Japan. Chinese textile producers use Chinese machines because most of them lack the capital to do otherwise; however, those with capital buy the high-tech machines produced in Europe or Japan.

China's silk industry is the largest in the world, accounting for 70 percent of the world's output of cocoons and raw silk. Beginning in 1978, the industry grew at an average rate of 10 percent annually. The industry expanded very rapidly in the early 1990s, but in 1994 it went

¹Although this sounds very low, readers are reminded that in China at that time, these wages were much more significant than they would suggest if considered in the United States or Western Europe.

into recession. In 1996, in the 20 major silkproducing cities, more than half of the plants suffered losses. Problems were attributed to blind and chaotic expansion of processing capacity in recent years. In the late 1980s and early 1990s, over 2,000 small reeling mills in towns and villages mushroomed in the major silkworm breeding areas, taking much of the nation's cocoon supply. As a traditional industry, silkworm breeding occurs mainly in villages and rural townships. These producers kept the best-quality cocoons for themselves and sold only their surplus or poor-quality cocoons to large mills in urban areas, generally charging high prices. Thus, the victims of the cocoon shortage have been the large, modern mills in urban areas. Additionally, many mulberry trees-the food source for silkwormshave been cut down across the country to clear land for rice or other crops. Loss of the mulberry trees threatened the very existence of the silk industry, with a 30 percent drop in silkworm breeding in 1995. China plans to reduce output, bringing the country's share to about half of the world production. By the year 2000, output may be less and prices higher. China's silk industry has also been affected by U.S. trade restrictions on silk products (Hui, 1996; Ratti, 1997; Youzhe, 1996).

Nearly all of China's textile and apparel exports face serious trade restraints in the major markets of North America and Western Europe; these restraints will continue to be a problem. Severe restraints on China's products have resulted from the concerns of manufacturers in the developed countries, who fear being overwhelmed by Chinese imports. Moreover, many Chinese exporters' efforts to bypass quota limits on shipments illegally (transshipments) have created ill will in the United States and Western European countries.

The Communist Party's presence is evident in the Chinese textile and apparel industries. For example, when the author visited garment factories in China in 1991, some had armed guards at the entrance (perhaps not uncommon for security purposes in parts of the less-developed world). Another factory displayed awards given by the Party for the establishment's fine work. In **joint venture** operations, if a board of directors is formed for a company, local government officials (who represent the Party) may become members.

The Chinese population has benefited as the textile complex has advanced. Guobiao (1993) noted that China's supply system, which had required coupons for textile products for about 30 years, was eliminated in 1983. He reported that the annual per capita consumption of fibers in 1991 had increased 1.7 times over that of 1978, from about 5 to 9 pounds. He concluded, "Thus, the problem to keep people warm has been solved [sic]" (p. 1).

For many years, China was seen only as a colossal producer of textile and apparel products. In recent years, however, the country has also been considered a large market with enormous buying potential as the spending power of its huge population has increased. Monthly household income in Shanghai and Beijing is \$285 and \$230, respectively; in the hinterlands, it may be only \$500 per year or less. Particularly in big cities, Chinese consumers are learning about fashion. The old state-run Friendship Stores, with their frumpy styles, are being bypassed for modern, fashionable shops and designer boutiques. Particularly in the biggest cities, designer lines are flourishing. Gucci's first stores were so successful that additional stores are opening. A fashion-conscious young man will spend a month's wages on jeans. Both Asian and Western retailers, from Wal-Mart to Louis Vuitton boutiques, are rapidly moving into China, particularly in the major cities. High-profile brand name apparel is popular. Increasing costs of living may dampen spending on fashion goods in the near future, however. Previously, state-provided housing cost only 3 percent of household income; however, these costs will increase to 15 percent by the year 2000. Food costs take half of a family's income (Bow, 1997b; Wheatley, 1996b).

China will continue to be a major influence in world textile and apparel production. Quality will continue to improve, and manufacturing facilities will be upgraded. However, Sung (1993) noted that China lacks the financial base to import large amounts of modern machinery. Therefore, in regard to China in particular, he stated, "Modernization is a long-term business, and the average Asian mill (textiles) will have changed very little of its current appearance by the year 2001" (p. 5). Although many mills will be up-to-date, others will not replace their present machines simply because newer ones are available.

Association of Southeast Asian Nations

As the better-established economies of East Asia moved to more advanced stages, the ASEAN (original members were Singapore,² Indonesia, Malaysia, the Philippines, Thailand, and Brunei³; new members are Vietnam, Myanmar, and Laos) economies benefited. In fact, some of the original members are among the fastest-growing economies in the world. The reader is reminded of the flying geese analogy in Figure 7-1. As the more advanced economies, particularly Japan, Taiwan, and South Korea, restructured their own industrial bases, many began to reduce manufacturing in labor-intensive industries. As a result, many economies began to provide foreign investment in the original ASEAN region where large pools of less expensive labor were available, particularly for apparel production. At the same time, ASEAN members often relied on Japan and the NICs to provide textile and other components needed to make garments.

Although Singapore had started to industrialize and emphasize exporting in the 1960s, other ASEAN members arrived at this stage of development in the 1970s and 1980s—at about the same time their more advanced East Asian neighbors were looking for other locations in which to invest and establish production facilities. The new members of ASEAN are now in the rear of the flying geese formation and are benefiting from investments and other assistance from all the countries ahead of them in the formation.

The ASEAN nations were also attractive locations for textile and apparel production because many had quotas for shipping their products to the North American and Western European markets. Consequently, during the 1980s the textile and apparel industries in most of the original ASEAN group developed rapidly; the newer members benefited in much the same way in the 1990s. Government policies in these countries encouraged the growth of textile and apparel production. These countries have actively promoted direct involvement of foreign textile and apparel corporations and have offered incentives to attract foreign investment. Foreign licensing arrangements and other forms of technology transfer have been encouraged (Finnerty, 1991).

As a result of the various changes, the ASEAN region became an increasingly important contributor to the world textile and apparel market. This led to a greater international division of labor—a concept discussed in Chapter 4. That is, we began to see more specialization in production among Asian countries. Some countries became more specialized in manufactured fiber production, some in garment assembly, some in natural fiber production, and so on.

The ASEAN region is expected to continue to be an attractive destination for foreign investment and textile and apparel production. However, the most rapid growth in investment may have passed for the original members (Fayle, 1993). In the 1990s some of the ASEAN

² Singapore is much more advanced economically than other ASEAN members. It is generally considered an NIC and has a per capita GNP that is exceeded in Asia only by that of Japan.

³ Brunei differs from its ASEAN neighbors because of its relative prosperity from oil. Limited textile and apparel production occurs there.

economies encountered shortages of skilled labor. Much of the region is also hampered in its development by a shortage of managerial talent to lead the rapid growth. The ASEAN region has spent far less in educating and training its population (referred to as human resource development) than have the more advanced East Asian economies previously discussed (Engardio et al., 1996; Fayle, 1993). The shortage of skilled labor has been intensified by accelerated technological change and leapfrogging (adopting an advanced technology without going through the technological stages that preceded it). The ASEAN economies are feeling this in the earlier stages of industrialization and will encounter it even more as they attempt to move out of labor-intensive activities and into higher value-added production.

ASEAN textile and apparel exports will continue to expand for some time and will continue to represent serious competition to manufacturers in North America and Western Europe. ASEAN companies, some of which are owned by firms in more-developed Asian countries, work regularly with retail buyers in the developed countries who seek out the products made there. Additionally, many manufacturers in Western nations have at least explored the **sourcing** possibilities in the ASEAN region or, in other cases, have relocated some of their production there.

Eventually, most of the original ASEAN nations—like their more-advanced Asian neighbors—will move out of labor-intensive industries. As we have seen in other countries, this means that certain segments of the textile complex will shift to other nations—including the newer ASEAN members—with the labor environment desired. As incomes increase in the region, along with population growth (although some nations are trying to control their population growth), the ASEAN region will become an increasingly important market.

Table 7–4 summarizes the conditions of the textile and apparel industries in the ASEAN nations. Although Cambodia is not an ASEAN

member, its status is similar to that of Vietnam and Laos.

South Asia

The Indian subcontinent has many countries (India, Pakistan, Bangladesh, Sri Lanka, Nepal, and Bhutan) that are already major textile and apparel producers for the world market. For most of these countries, these sectors have been vital to overall development, and textile and apparel products account for a significant proportion of their total exports. The large populations in India, Pakistan, and Bangladesh represent large labor pools. In fact, the combined population of these countries exceeds that of China. This group of countries merits much more discussion than space permits.

India

India's population is second only to that of China, with masses of workers in need of jobs. The country has a long history in textile production, but early industry advancement was stifled when the country was under British rule. Textile and apparel exports together constituted more than 30 percent of India's total exports in 1995 (WTO, 1996). India accounts for a large volume of products on the world market.

Although the Indian textile complex is large, internal problems and production short-comings threaten the industry's future as an exporter. Koshy (1993, 1997), an Indian professor at the National Institute of Fashion Technology in New Delhi, surveyed importers in Western countries and found that many of them avoided Indian products for the following reasons: too far behind the fashion wave, fabrics of limited range and quality, slow shipments, problems with documents, and unfamiliarity with the workings of other countries. Koshy works with the Indian industry extensively to help manufacturers understand that India has been significantly underrepresented

Status and Strengths

Difficulties

Indonesia

- A major apparel producer; large population is an asset in labor-intensive segments; T/A sectors employ more than 7 million workers and are top manufacturing export sectors. Very low production wages. Much foreign investment from Japan, Korea, and Taiwan. Produces textiles, including manufactured fibers. Oil production supports fiber production. Also a major production site for active-wear shoes. Jakarta boasts some modern stores, and the number of fashion-conscious consumers was growing prior to the economic crisis.
- A great deal of red tape and bureaucratic delays.
 Corruption. Authoritarian government.
 Cronyism tied to Suharto family. Parts of
 Jakarta very modern, but poor infrastructure
 in much of the country. Large market when
 population has more purchasing power.

Malaysia

- Near-NIC status. Progressive nation. Far-sighted government. Attractive manufacturing site for TNCs in many industries. The T/A industry was restructured in 1980s; now fewer companies but stronger ones exist. T/A industry is smaller than that of some neighboring countries. Range of upstream and downstream segments of T/A. Skilled workforce. T/A is second largest export earner. Malaysian Textile and Apparel Centre developed for training.
- Labor shortages. Other industries may pay higher wages than T/A, creating acute labor shortages in some areas. Across the economy, costs are rising at twice the rate of productivity.

Singapore

- A modern, progressive city-state and major world trade center. Reached NIC status years ago. The major trade hub in Southeast Asia, a base for many TNCs. For T/A, a sourcing and marketing hub. Too costly for much apparel production; textile production unsuited for the small island. Highly trained workforce; excellent facilities; supportive government. Home of TradeMart Singapore, modeled after U.S. trade marts. The mart houses show rooms and sourcing offices for T/A businesses operating in Southeast Asia.
- Very expensive; business costly to conduct. Small domestic market. Rigid social climate of control that hampers creativity. Controls on media limit expression. Education valued, but its rote nature does not foster creativity.

Thailand

- Has potential for NIC status, but 1997 economic crisis was a setback. Developing rapidly, however. The T/A complex emerged in the 1950s and was the largest among the ASEAN nations by the 1970s, with a well-developed industry. Skilled labor force produces high-quality products. Upgrading to higher value-added products. Presence of other competing industries has created labor shortages and rising wages. T/A wages are high compared to those in China, India, Indonesia, and Vietnam.
- Rising wages are making T/A production difficult.

 Declining competitiveness. Attempts are underway to restructure the industry to restore competitiveness. Thai government provided significant funding to help equip the industry with new technology to survive competition from lower-wage Asian neighbors. Poverty continues in many rural areas. Limited education in many areas.

	Status and Strengths	Difficulties
Philippines	T/A is a major export sector, having withstood both local and international adversities. The industry relies strongly on contracting for assembly of precut parts. Work is often further split and sent to subcontractors, particularly for the embroideries, appliqué, and other hand work that have become specialties. Lingerie is another niche market. Large workforce in need of jobs. Textile industry serves mostly the local market but hopes to expand to supply fabrics for the garment export market.	For many years, considered the "poor relation" of the ASEAN group because of an economy in shambles, natural disasters, political instability, and a very poor infrastructure. Significant economic progress made in recent years, but political instability continues to hover over this country consisting of more than 7,000 islands. Government recognizes the importance of T/A for exports and employment and is attempting to bolster the industry.
Brunei	Differs from ASEAN neighbors because of prosperity from oil.	Very limited textile and apparel production because of oil wealth.
Vietnam	Desperately poor but developing rapidly. A large pool of literate, skilled, low-wage workers earning \$1 per day in the mid-1990s. Good economic growth rate in the 1990s. Strong work ethic. Desperate need for jobs and capital. Apparel industry is the primary industry; less success in textiles because of capital and technology needed. Fabrics must be imported. A favored production site for apparel firms in other parts of Asia. Large domestic market as the economy improves. At the back of the flying geese formation.	The Communist Party bureaucracy can be cumbersome and rigid, failing to bring about reforms to facilitate investment. Effects of isolation for years are apparent. Distribution is haphazard; delays result from the poor transportation system. Much distribution is by motorcycle. Cooke (1997) notes that the best distribution network now is for smuggling goods over the border from China and Thailand. The United States was late to enter Vietnam because of an embargo. Vietnam does not have most favored nation status.
Myanmar	A large workforce desperately in need of jobs; a fragmented apparel industry exists, but opportunities for foreign investment and exporting have been limited by a repressive government. Very low wages. On the trailing end of the flying geese formation.	Repressive, authoritarian military rule for 30 years. Years of isolation from most of the world. Overall economic outlook is poor. The United States expressed concern to ASEAN members on admission of Myanmar because of human rights abuses.
Laos	A large, poor workforce in need of jobs to overcome the military and economic trauma related to the Vietnam War and other political strife in the region. Very low wages. Receptive to outside investments. At the end of the flying geese formation.	Very poor and undeveloped, with a poor infrastructure.

in the global market compared to its potential level. He warns Indian garment exporters to assess realistically their performance on cost, speed, quality, design, services, and other elements of the export value chain. China now produces garments 60 percent less cheaply than India (Tait, 1996). Khanna, a University of Delhi marketing professor who studied the Indian apparel industry, also noted that export firms must overcome narrow product specialization. For example, nearly all Indian products are seasonal, with no woolen products for Western winters. Perhaps it is significant that for many years India had a closed economy, making it difficult for foreign investors to establish businesses there. As a result, Indian firms failed to gain the benefits of upgraded production processes and marketing expertise that usually accompany foreign investment in Third-World enterprises. Most experts (e.g., World Bank, 1991) believe that countries develop more quickly as an active part of the world economy rather than in isolation. Various sources indicate that India's recent movement toward a more open economy, plus the importance of the textile complex to the country's economy, has encouraged a new outlook in India's textile and apparel sectors.

A middle class is emerging in India, and these consumers want quality products. The apparel industry will have to change to make its products appealing to this group, even in the home market. There is evidence that products are improving; the average unit value of garment exports increased more than 22 percent between 1993 and 1995.

Pakistan

Pakistan's overall development is tied closely to the textile complex. Cotton production has long been a major source of income, and textile mills to produce fabrics from cotton are important contributors to the economy. In fact, Pakistan is the third largest producer of cotton in the world. Much of the fabric is exported as

greige goods for further processing in countries that have highly developed converting industries. In recent years, Pakistan has emphasized production of apparel for the world market and has promoted these products through highly advertised trade fairs. Manufacturers in some of the developed nations have established joint ventures in Pakistan. For example, Sara Lee has manufacturing in Pakistan. The United States is the largest importer of Pakistan's textiles and apparel.

Bangladesh

Bangladesh is one of the poorest countries in the world, with an annual per capita GNP of \$240 in 1995. The apparel industry is becoming increasingly important in building the nation's economy. Apparel counts for 55 percent of the country's merchandise exports and textiles (mostly jute) for another 14 percent (WTO, 1996a). As in many newly developing nations, apparel quality is often unpredictable. However, because of its extremely low wages, Bangladesh has become a popular site for apparel operations.

Bangladesh is the world's largest exporter of jute. Rural areas of this poor nation depend on a jute sector that will meet increasingly difficult competition from manufactured fiber substitutes.

The growth of the apparel industry has been vital in a country where one-third of the workforce is estimated to be unemployed or underemployed. Until recently, nearly all the fabric used in apparel production had to be imported. However, Beximco, a Bangladeshi conglomerate, has just built textile mills to supply some of the local garment factories. Local production will not only keep profits in the local economy, but will also save time and shipping costs. Previously, all textiles coming from South Asia or East Asia had to be transferred in Singapore to feeder boats for the final trip to Bangladesh.

Beximco is a forward-looking company and the nation's largest employer. It is a large, diversified conglomerate with business segments in marine products, pharmaceuticals, computers, and real estate. Of significance, the company sees textiles as a key to its future growth. The firm is laying the foundation for its global network and is already talking with European manufacturers about beginning direct exports of finished fabrics. Seeing technology as the basis for its global network, Beximco has developed a private telecommunications system that links overseas buyers via Singapore and a satellite to its corporate headquarters in Dhaka and to the Beximco industrial complex. Final plans are being made to install totally integrated manufacturing software permitting customers online access to every stage of production planning (Bow, 1996).

Sri Lanka

Sri Lanka has become a significant apparel producer for world markets. Apparel represents almost 50 percent of Sri Lanka's total trade and more than 27 percent of its employment. The industry is more highly developed than that of Bangladesh, and therefore the quality is usually more consistent. The United States is Sri Lanka's leading market for apparel products. Sri Lanka's textile industry produces for the domestic market, and exports are minimal. The country welcomes foreign investment, particularly for the textile segment, because about 90 percent of the fabrics needed for the garment industry must be imported (Gunawardena, 1993). The reader will recall that this follows the development patterns discussed in Chapter 5, in which developing countries at the early stages of production must obtain components from more advanced nations.

Nepal and Bhutan

These countries have begun producing for the export market. Both have potential for growth, particularly with foreign investment.

AUSTRALIA

The Australian textile and apparel industries resemble those of Western Europe, the United States, and Canada. A unique feature is that Australia is the leading world producer of wool. In general, Australia's industries are well developed, produce for all seasons and all incomes, and are fashion oriented. Although Australia's labor costs are among the highest in the world, the textile and apparel industries are comparatively competitive with those of other OECD counterparts. The Australian industry's challenges for competing globally resemble those of Western Europe and the United States.

Australia's textile and apparel industries are relatively fragmented. The footwear industry is included in most figures on the apparel industry, with more than 3,000 firms employing almost 100,000 persons. Many of the small firms are contractors for the large firms. Another estimated 25,000 to 50,000 contract workers sew at home. The apparel industry accounts for 8.5 percent of the manufacturing workforce. It directly employs 53,200 women, who account for over 20 percent of all female employment in manufacturing. Annual textile/apparel/footwear sales were \$10 billion in 1996. To be competitive, producers have invested in computerized design, cutting, and sewing technology for apparel and computer-controlled systems for many aspects of textile production. Capitalintensive textile production is usually found in larger firms. Distribution networks are good; however, the vast distances within the country can make shipping and travel very costly (Australian Industry Commission, 1997a, 1997b; Council of Textile & Fashion Industries of Australia Ltd., 1997b, 1997c).

Imports are a major influence on the Australian market. China is the source for about half of the apparel imports. In the past, the industry had significant protection from imports

because low-cost imports had been perceived as a threat since the early 1970s. However, more recent government policies have reduced that protection. Australia's quota system was phased out. Although Australia's tariffs were about 50 percent to protect the domestic industry, they are being reduced to 25 percent by the year 2000. The government proposed a scheme to continue reducing tariffs each year to qualify Australia as a full-fledged member of the Asia Pacific Economic Cooperation (APEC) group. To be a member of APEC, tariffs will have to be eliminated entirely by the year 2010. In 1997, a campaign led by the Council of Textile & Fashion Industries of Australia succeeded in convincing the government to keep tariffs at the same level during the period 2000 to 2005. The pause in tariff reductions is intended to give the Australian apparel industry additional time to adjust to global competitive forces; further reductions will occur after 2005 to meet APEC guidelines (Council of Textile & Fashion Industries of Australia Ltd., 1997a, 1997c; Howard & Moore, 1997).

Reducing protection for Australia's domestic industries encouraged other nations to expand their shipments of textiles and apparel; this has taken a toll on the local industries. Many Australians have healthy disposable incomes and demand high quality. Australia imports from all parts of the world and has a high standard of living. In recent years, Australian consumers have realized that their apparel prices have been high in comparison to those of other industrialized countries because of their high tariffs.

Some Australian apparel producers have tested a mix of local production and offshore sourcing. The government instituted a 3-year trial policy called the Overseas Assembled Provision (OAP), which operates much like the U.S. 807/9802 provision. If Australian fabrics are used, cut or knitted pieces may be assembled in low-wage countries and reimported, with duty paid only on the cost of overseas assembly. This is expected to benefit Australia's

industry by reducing labor costs for apparel and by encouraging the use of Australian textiles. In its 1997 announcement of the tariff scheme, the government recommended expansion of the OAP plan. Additional strategies were recommended to assist the industry (Howard & Moore, 1997).

As a member of the British Commonwealth, Australia has been guided by loyalty to Britain; however, in recent years efforts have been made to develop Australian political and cultural independence. At the same time, the country has opened its previously protected and regulated economy to international competition. Moreover, Australia's foreign policy has increased its focus on the Asia-Pacific region, and those relations are becoming more important. More than 70 percent of all Australian exports are now shipped to this area. Although it attracts buyers from around the world, Australia's annual Fashion Week is designed particularly to become the gateway to the Asia-Pacific market ("Doing Business," 1996; Greig & Little, 1996; Huntington, 1997).

NORTH AMERICA

Canada and the United States are major trading partners with one another, as are Mexico and the United States. Trade among the three nations has grown considerably under the North American Free Trade Agreement (NAFTA). The reader may wish to refer back to Chapter 3 for an overview of trade relationships. In this section, we shall focus more specifically on the textile complex in Canada and Mexico, with further discussion on the United States in later chapters.

Canada

Geographically, Canada is the world's second largest country, comprising nearly 4 million square miles. About 30 million Canadians in-

habit this vast country; however, the population is concentrated in a few areas, with an east-west dispersion that causes high transportation and distribution costs. Canada has official bilingualism, with about 20 percent of Canadians speaking French as their first language.

Canada is a trading nation, with over 30 percent of the GDP coming from exports (all sectors). Between 1980 and 1995, Canada moved from being the 10th to the 8th largest trading nation in the world. Canada and the United States are the world's two largest trading partners. For overall trade in 1995, about 80 percent of Canada's merchandise exports went to the United States, and about two-thirds of Canada's imports came from the United States (WTO, 1996).

As an affluent, high-tech industrial society, Canada closely resembles the United States in its market-oriented economic system and patterns of production. The two countries have fairly comparable levels of living and consumer lifestyles (Wall & Dickerson, 1989). In the 1980s, Canada registered one of the highest rates of real growth among the OECD countries. However, in the early 1990s, Canada suffered from a serious recession that affected all sectors, including the textile complex.

Canada's textile complex remains an important industrial sector despite a number of factors that have created difficult competitive conditions. Textile/apparel shipments in 1996 were valued at nearly C\$15 billion (personal communication with E. Barry of the Canadian Textile Institute, 1998). Difficulties faced by the industry included a recession, high labor costs, a 7 percent goods and services tax (GST) imposed by the government in 1991, and cross-border shopping. When the GST is combined with provincial taxes, an average 15 percent sales tax burden has encouraged Canadian consumers to drive to the United States to purchase lower-priced products. Many Canadian consumers are attracted to U.S. apparel brands because they are exposed to the same advertisements as their neighbors to the south.

Canada's textile and apparel industries are concentrated geographically. Production is concentrated in Quebec (mostly Montreal and the Eastern townships) and Ontario (mostly in Toronto and southwestern Ontario). In 1996, Canada's more than 2,000 apparel firms produced shipments valued at more than C\$6.1 billion and employed 103,300 workers. A majority of the firms employ fewer than 100 workers; larger firms (only 12 percent of the total) account for more than 50 percent of the employment and value of shipments. Exports for 1996 grew 21 percent over 1995 to \$1.6 billion (personal communication with Canadian Apparel Federation, 1997; U.S. Dept. of Commerce, USNTDB, 1993).

Canada's textile industry shipped C\$9.2 billion worth of fibers, yarns, fabrics, and textile articles in 1996 and employed 55,000 persons. By Canadian standards, the textile industry is sizable. The United States now receives about three-fourths of Canada's total textile exports of about C\$2.5 billion compared with 56 percent in 1988.

Quebec's large concentration of industry is significant in view of the province's continued discussions about separating from the rest of the country (it is important to remember that this has been a possibility for a long time). This separatist sentiment was evident at the 1992 Winter Olympics, when some Canadian athletes flew the provincial rather than the national flag. Quebec depends heavily on exports to other Canadian provinces; therefore, secession may not be helpful to the industry (Abend, 1992; USNTDB, 1993).

A number of Canadian apparel manufacturers have developed a successful high-fashion niche of well-made, European-style clothing that appeals to fashion-conscious U.S. consumers. Canadian firms producing for this market have created a unique niche for themselves not filled by U.S. apparel makers. These high-end producers have created distinction and respect for the "Made in Canada" label. Consequently, some U.S. retailers have bought these lines because of the forward fashion,

high quality, value, and fast delivery due to proximity. The Canadian Apparel Federation has spearheaded an export market campaign directed to the United States and Japan.

Canadian manufacturers have invested heavily in new technology in the last 20 years. Investments have been largely in textile manufacturing rather than in the apparel sector, however.

Although most Canadian and U.S. textile/apparel manufacturers opposed the Canada-U.S. Free Trade Agreement (FTA) (Canadian textile manufacturers supported it), trade trends indicate that both countries benefited substantially from increased trade resulting from the tariff reductions. Many manufacturers on both sides of the border protested the agreement because they believed it would lead to the demise of their respective industries. Producers in each country believed themselves to be the losers; however, data for Canada-U.S. trade shows quite the contrary.

The United States is the major destination of Canada's textile and apparel exports, accounting for nearly 75 percent of all exports from these sectors. Between 1994 and 1996, Canada's textile and apparel exports to the United States increased 200 percent to \$2 billion. During the same period, U.S. textile and apparel exports to Canada rose 39 percent to \$2.7 billion. According to U.S. Department of Commerce sources, U.S. apparel exports to Canada tripled in the first 3 years of the FTA. Similarly, some Canadian apparel producers credit the FTA for sensitizing them to greater export potential. Moreover, benefits from the FTA helped offset the impact of the recession for Canada's textile complex (Abend, 1992; E. Barry, personal communication, 1998; Ostroff, 1997; Watters, 1992).

On January 1, 1998, textile and apparel trade between Canada and the United States became free of all tariffs. Although Canada and Mexico have had relatively limited textile/apparel trade with one another, the North American Free Trade Agreement is fostering additional

trade. Some Canadian apparel producers are turning to Mexico for lower-wage assembly operations, and Canadian textile manufacturers are seeking markets for their products in Mexico.

Canada's government provided \$5.2 million in 1993 to create the Canadian Apparel Federation. The goal of the Federation is to contribute to apparel industry competitiveness through various means; among them, distributing consumer trade and market information, developing industry partnerships, and enhancing communication between industry and government ("Canadian Group," 1993).

In short, the Canadian textile complex remains a strong sector. This industry has weathered a recession, a period of significant restructuring, and a transition to free trade with the United States. Although some Canadian manufacturers have not survived these challenges, most have shown their resilience and are more viable than before to face global competition.

United States

The U.S. textile complex is discussed in Chapter 8. In Chapter 9, the focus is on production, markets, employment, and trade for the apparel and textile industries.

Mexico

The growth of Mexico's textile complex has paralleled the country's economic growth and overall development. Until the mid-1980s, Mexico remained a closed market, isolated from competitive forces that make industries and firms more efficient. (The reader may wish to refer back to Porter's determinants of competitive advantage in Chapter 4.) The closed market meant that many Mexican industry segments were inefficient, prices were high because competition was reduced, and many products were of poor quality. After 1986,

when Mexico joined the GATT (now the WTO), it began to move toward successful development. However, in 1994–1995 the country experienced a huge devaluation of the peso (about 50 percent) and plunged into a severe recession. This led to widespread unemployment and a sharp decline in real wages and purchasing power.

Prior to the crisis, Mexico's more open economy was reflected in the softgoods industry. Its textile and apparel industries had begun to adjust to competition from other countries, becoming more efficient and producing higherquality products at competitive prices. Before the crisis, about 25 percent of all apparel in the Mexican market was imported. A devalued peso meant that imports became more costly, resulting in an estimated 56 percent decline in imports in 1995. Consequently, apparel imports accounted for less than 10 percent of the market in 1996. The recession reduced the demand for apparel in Mexico. Consumers purchased fewer garments and chose inexpensive, lower-quality merchandise. Although recovery is occurring, the recession has left its imprint on credit markets, consumer spending patterns, and the overall health of the Mexican market (Economic Consulting Services, 1997; International Apparel Federation, 1997).

Mexico's textile complex makes a valuable contribution to the country's economy. Within the manufacturing sector, the textile complex accounts for 9.8 percent of Mexico's GDP. It is expected to play an important role in the next stages of Mexico's overall development. Moreover, since the demand for textiles is closely linked to the GDP, the rise in GDP expected in the years ahead will result in growth opportunities in the textile complex (Mexican Investment Board, 1993).

Mexico produces both natural and manufactured fibers. In the agricultural sector, cotton, wool, and sisal are produced. The manufactured fiber sector segment of the industry is perhaps the strongest in the textile complex, with world-class technology and ties to major

world producers through joint ventures. Mexico's petroleum resources are an asset to this segment of the industry. Manufactured fibers account for about 65 percent of Mexico's fiber consumption.

Certain segments of the textile mill products industry, however, lack state-of-the-art technology; plants are operating at 70 percent or less of capacity. According to some U.S. industry reports, Mexico has modern spinning technology but lacks, for example, state-of-theart finishing capabilities—a segment of the industry in which much of the value is added to yarns and fabrics. The industry is facing pressure to modernize and form strategic alliances or mergers with U.S. producers. Because this segment of Mexico's industry is not competitive, many U.S. textile firms are capitalizing on its market potential. In 1996, NuStart, a privately owned project with a \$70 million budget, began to create the first textile city in Mexico to promote this sector and create 10,000 jobs. The city is located at Ejido Emiliano Zapata, Cuernavaca, in the State of Morelos. Guilford Mills, DuPont, and Burlington Industries are associated with this project. Other state governments are watching this project with the intention of copying it elsewhere if it works. The plan is to tie these projects to existing industrial parks and take advantage of their infrastructure (Economic Consulting Services, 1997).

The Mexican apparel sector is quite fragmented, with over 11,000 establishments. A majority are family run, and over 70 percent have 15 or fewer employees. Most of these small shops lack sophisticated technology, a strong capital base, and a well-developed supply chain. Since Mexico's entry into GATT, many weak textile and apparel companies, once protected by restricted trade, have closed. Many firms suffered from quality problems and structural difficulties such as a lack of capital and skilled technical workers. Larger firms filled the gap to an extent; however, overall domestic production was in decline before

the recession. Large and medium-sized firms account for 80 percent of all textile and apparel production. Large firms are in a much better position to compete in a global economy. They have invested in modern technology, employ international designers and other specialists, use better-quality fabric, and produce good-quality products (International Apparel Federation, 1997; Silva, 1993; USNTDB, 1993).

Maguiladora operations (sometimes called in-bond production), manufacturing plants that assemble components and reexport garments to the United States, are an important component of Mexico's apparel industry. Maguiladora operations are one of the most vibrant and productive segments of Mexico's industrial base. Of the 3,000 maguiladoras in Mexico, 632 are in textiles/apparel. About 75 percent of these firms are found along the U.S. border; however, a growing number are locating in Mexico's interior, where labor and real estate costs are lower. U.S. apparel manufacturers have used maguiladoras to retain proximity to the U.S. market while gaining the advantage of Mexico's lower wages. The peso devaluation resulted in a 25 to 30 percent reduction in maquila labor costs, making production increasingly attractive to U.S. firms. Maguiladoras along the border have a high employee turnover rate because of competition among industries; thus, wages and benefits have risen to keep or attract new maguila workers. Average hourly wages may be 30 to 70 percent above the average for Mexican workers (Economic Consulting Services, 1997).

The Mexican government allows maquiladoras to import, duty-free on an "in-bond" basis, machinery, equipment, parts, raw materials, and other components used in the manufacture of finished or semifinished parts. Previously, all finished maquila products had to be exported. NAFTA changed Mexico's maquiladora program by permitting output from these factories to be sold in the Mexican market, whereas in the past these products had to be exported. The amount of production permitted to stay in the Mexican

market increases annually over a 7-year period. By January 1, 2001, all *maquiladora* production can be sold in Mexico.

When companies export materials to Mexico, these may be stored in customs bonded warehouses to defer payment of duties and taxes until they are delivered to the Mexican customer. Bonded warehouses also assume liability for the stored goods. Although NAFTA provisions allow Mexican trucks unlimited access to the United States, they are currently permitted to operate only in U.S. border states because of safety concerns and opposition from the Teamsters Union, representing U.S. truck drivers. These concerns, and the delays in clearing Mexican customs, encourage shippers to stage their freight through warehouses on either side of the border (Economic Consulting Services, 1997).

Mexican consumers are attracted to U.S. brands and were buying a growing quantity of U.S. products prior to the peso crisis. A study of Mexican consumers commissioned by the U.S. Department of Commerce confirmed Mexican consumers' appetite for U.S. fashions. Mexico's young population is attracted to many aspects of the U.S. lifestyle, including U.S. fashion. The report noted, "Justifiably or not, there is a widespread idea that the quality of Mexican apparel is inferior to American goods. This is capitalized on by Far East manufacturers who label their products in English, which leads many people to believe that the garments are American" (Ramey, 1992a, p. 16). In 1995, Mexico increased its tariff on textiles and apparel from 25 to 35 percent to protect Mexico's domestic industry against low-cost competition from Asia and Latin America. U.S. textile and apparel exports that meet the NAFTA rule of origin are not affected.

A Mexican government-sponsored Program to Promote Competitiveness and Internationalization of the Textile and Apparel Industries offers a wide range of investment possibilities to assist the Mexican textile and apparel industries in acquiring new technology to mod-

ernize. This program promotes exports through trade fairs and other strategies and coordinates joint efforts between different segments of the industry. A Mexican Fashion Institute is being established as part of this program (Mexican Investment Board, 1993).

Mexico's retail sector is fragmented, and distribution channels are different from those in the United States. However, some U.S. retailing firms have expanded into Mexico, believing this market has great potential. Well-known U.S. retail chains such as J.C. Penney, Kmart, Wal-Mart, and Price Club have stores there. It is noteworthy that Sears Roebuck has a chic image in Mexico. Earlier, when the company's U.S. image plummeted, Sears de Mexico waged a successful campaign to woo Mexico's most affluent 10 percent of the population and carved out an enviable niche in the market (Moffett, 1993).

NAFTA has had a significant influence on U.S.-Mexican textile and apparel trade. In 1996, Mexico became the largest supplier to the United States (in quantity—2.2 billion square meters of textiles and apparel), a 41 percent increase over 1995. A large proportion of this was in garment assembly.

NAFTA is not the only free trade agreement of interest to Mexico. Mexico considers itself the hub between its neighbors to the north (the United States and Canada) and its neighbors to the south (Latin America). Mexico is a member of the Group of Three (with Colombia and Venezuela) and has free trade agreements with Chile and Bolivia. Discussions are underway with MERCOSUR, the Central American Common Market (CACM), the EU, and Israel. Mexico clearly is not waiting on its neighbor to the north for an expansion of NAFTA-like arrangements (Economic Consulting Services, 1997).

THE CARIBBEAN BASIN AREA

Early colonization of the Caribbean islands created an economic legacy of dependence that

has been difficult for the region to shed. The reader may wish to review the overview of this region in Chapter 3. After gaining their independence after World War II, many of the new Caribbean nations began industrialization efforts in which the apparel industry (primarily assembly operations) played a major role. For two decades, the Caribbean nations achieved economic progress; however, by the mid-1970s, large national debts, diminished hopes, and widespread discontent were serious problems (Axline, 1979; Balkwell & Dickerson, 1994; Knight, 1990; Sklair, 1989).

Two overriding factors led to the development of the Caribbean basin region as a major apparel-producing area. First, the United States had a strong interest in ensuring the economic and political stability of this strategically important region during the Cold War. Second, the Caribbean had great potential for providing the low-cost production many U.S. apparel manufacturers needed to compete with imports. As low-cost imports increased in domestic markets, U.S. manufacturers found that they, too, had to become active participants in the global economy. At this same time, pressures on the U.S. government to restrict imports had led to increasingly restricted trade policies on products from East Asia—particularly from the Big Three (Hong Kong, Taiwan, and South Korea). As wages in those countries increased and shipping rates grew, the increasing costs of sourcing (also known as outsourcing) from Asia made it important to find cheaper sources of production. As retailers demanded faster delivery, a closer manufacturing location became desirable. Apparel production in the Caribbean became the solution to many of these problems. Cut garments are sent to the Caribbean area for assembly and then returned to the United States as finished apparel items. See Figure 7-5.

The U.S. government's concern for stability in the Caribbean led to several special trade policies to aid these economies. Although apparel assembly had occurred in the Caribbean

FIGURE 7-5

U.S. firms send cut garment pieces to Mexico and the Caribbean for assembly; finished garments are returned to the United States.

Source: Illustration by Dennis

Murphy.

for decades, some of the later Caribbean trade policies ensured that the entire integrated textile-apparel production process would not move from the United States to that region. That is, most Asian imports had been fully assembled garments generally made from non-U.S. fabrics. To ensure that the total garment production process and the use of U.S. textiles in those garments would not be lost in Caribbean production, the trade policies included provisions to encourage the use of U.S. fabrics and to retain part of the production process in the United States. These provisions reinforce the notion that the Caribbean apparel industry and the policies that governed this trade with the United States reflected the requirements of the U.S. market.

The U.S. trade policies relevant to Caribbean production follow.

• 9802 (formerly 807) production. Since 1963, a special provision (paragraph 807, now

9802) in the U.S. tariff regulations permits cut garments to be exported for assembly and reimported into the United States, with the exported garment components excluded from duty charges when finished garments are returned to the domestic market. That is, tariffs are charged only on the value added in the production process, and garments are subject to regular quota rules. Although the 9802/807 provisions are not limited to the Caribbean, this region has become the major user.

• The Caribbean Basin Initiative (CBI) (officially known as the Caribbean Basin Economic Recovery Act). The CBI was enacted in 1983 to boost the economies of 22 Caribbean countries by providing special trade privileges for those nations. In 1987, it was permanently expanded to include 27 nations. Although the CBI provided tarifffree access for most Caribbean products shipped to the United States, tariffs continued on textile and apparel products.

- The Caribbean Basin Textile Access Program (also known as 807A or Super 807). Under this 1986 agreement, Caribbean apparel products are given a more liberal quota system for access to the U.S. market if fabrics are both made and cut in the United States. A similar provision for Mexico, known as the Special Regime, has been replaced by the free trade rules of NAFTA.
- Caribbean Parity. This program refers to efforts on the part of U.S. firms with production in the Caribbean to secure trade privileges for this region similar to those for Mexico under NAFTA. That is, production in Mexico has no tariffs on finished garments returned to the U.S. market, whereas tariffs are still levied on garments (for the value added) from the Caribbean. Numerous U.S. congressional bills proposed this parity for the Caribbean. Without parity, the Caribbean is likely to lose production to Mexico, which has virtually free trade with the United States. U.S. apparel manufacturers with production in the Caribbean have worked hard to get this legislation passed.

Generally speaking, each subsequent trade policy afforded increased privileges for Caribbean apparel production and access to U.S. markets. Consequently, shipments from the region have grown dramatically, particularly since passage of the Textile Access Program. In fact, textile and apparel products have become an increasingly important part of total U.S. imports from the Caribbean.

Of the CBI countries involved in apparel production (very little textile production occurs in the region, particularly for export), the Dominican Republic is by far the largest in terms of annual shipments (by value). Other top contributors in order are Costa Rica, Guatemala, Honduras, Jamaica, and El Salvador. Haiti was an important site for apparel assembly in the past; however, for several years, civil unrest virtually eliminated industry activities there. Companies have begun to return.

Wages in the Caribbean are comparable to those in many less-developed regions of Asia; however, they are considerably lower than those in Hong Kong, Taiwan, and South Korea. As might be expected, wages are much lower than in the United States. In 1993, wages, including benefits, in many of the Caribbean countries were less than \$2.00 per hour and in some less than \$1.00 per hour (Cedrone, 1993). Only the U.S. territories, Puerto Rico and the Virgin Islands, had wages even close to U.S. rates.

A number of East Asian manufacturers, particularly from South Korea and Hong Kong, have also been attracted to the Caribbean region. The Asian firms have sought Caribbean production for many of the same reasons U.S. firms have—proximity to U.S. markets and availability of low-cost labor. However, the Asian producers have moved to the Caribbean for another important reason. As U.S. quotas increasingly restrained major Asian suppliers, these manufacturers established operations in the Caribbean so that their products could be shipped to the United States under Caribbean trade policies rather than under the more limiting policies that applied to their home countries. However, to get the unlimited access to the U.S. market under the 9802A (807A) provisions, garments had to be made of U.S. fabrics and cut in the United States, making the situation less attractive to Asian producers in the Caribbean. As one might guess, this provision was by design. U.S. textile manufacturers influenced trade policy so that Asian producers would not have equal access to the U.S. market. Many U.S. textile manufacturers have opposed Caribbean parity for fear that this may benefit Asian producers who relocate there. Another handicap for some Asian manufacturers is difficulty in persuading Caribbean workers to adopt their work ethic.

Apparel assembly in the Caribbean for U.S. firms typifies the new international division of labor considered in Chapter 4. (For further information on this topic, the reader may wish to consult Balkwell & Dickerson, 1994.) Because

of the nature of apparel production, manufacturing can be broken down into separate processes that can be contracted out to lowerwage countries. Fabric production, apparel product development, and cutting operations are performed in the United States. The cut garments are sent to the Caribbean region for labor-intensive assembly and returned to the United States, where marketing and distribution take place.

CENTRAL AND SOUTH AMERICA

Many Central and South American countries are experiencing significant economic development and either are or may become important textile/apparel-producing nations as well as growing consumer markets. As noted in Chapter 3, many of these countries now have much more open markets. A number of them have established free trade agreements among themselves. Two of the major groups are MER-COSUR (Southern group) and the Andean Group (Northern group, which gets its name from the Andes mountains), with talks underway to possibly merge the two to form the South American Free Trade Area (SAFTA). This economic integration into the world economy has generally boosted productivity growth (Edwards, 1997). Although many of the countries in Central and South America are very dependent on outside investment, their more open economies and more democratic governments in recent years make these regions more attractive to investors.

Several Central American nations have reestablished the Central American Common Market. While this region is open to trade, its economic development is behind that of many South American countries. Agriculture dominates the Central American economies and is likely to do so in the foreseeable future. Among these nations, Costa Rica is more advanced in its economic development, its infrastructure,

and its national unity than its neighbors. Most of the Central American countries are included in the CBI and have special privileges for apparel trade with the United States. Apparel can be sent for assembly in the region, and if U.S.-made and U.S.-cut fabrics are used, these countries have Guaranteed Access Levels (GALs). That is, they receive almost unlimited quotas; tariffs are charged only on the value added when finished products are returned to the United States.

In 1995, four Andean countries in South America—Colombia, Peru, Ecuador, and Bolivia—became the first nations outside Mexico and the CBI to be granted the United State's GAL for apparel. This policy was instituted to entice U.S. manufacturers to relocate apparel production in these countries. However, from 1994 to 1996, these Andean nations' total exports to the United States have decreased. Since the passage of NAFTA, Mexico has attracted business away from these nations.

In South America, several countries have large active industries in some or all segments of the textile complex. Brazil, for example, has a clothing industry that employs more than 780,000 people in 14,000 companies. Textile production is flourishing in two areas: the Itajai Valley has 6,500 companies, and Fortaleza has a fast-growing textile sector where foreign investment has encouraged producers to become internationally competitive. Cotton is an important export for the country. Brazil's textile complex has been affected by the government's decision in the early 1990s to open the country to foreign trade by dropping tariff and nontariff barriers. Before 1990, the 100 percent tariff on foreign apparel made importing prohibitive. The reduction to a 20 percent tariff has opened the door to massive apparel imports. High-income consumers now buy Chanel, Fendi, Christian Dior, DKNY, and other prestigious foreign brands. Average consumers with modest incomes now buy inexpensive imports from the Far East, particularly China. This change in trade policy has had a tremendous

impact on the Brazilian textile and apparel industries. Because of the pre-1990s protectionism, these industries were never forced to modernize or worry about global competition. Consumers had to buy products made by Brazilian firms, and prices were high. The opening of the market is forcing companies to compete with foreigners on price and quality, and in the end will make the Brazilian industry more competitive (Kepp, 1997).

Argentina also has an active textile complex that is smaller than Brazil's. Argentina's open economy has led to an influx of imports, particularly from Asia and Brazil. The wealthy elite of Argentina, like their counterparts everywhere, buy prestigious European and North American apparel. In 1996, Argentina enacted trade barriers on textiles, apparel, and footwear that made it difficult for U.S. and other foreign companies to sell there. This included a 35 percent tariff and a certificate-of-origin procedure requiring that each U.S. shipment be notarized in Washington, D.C., by the Argentine consulate there. The latter requirement caused delays and added as much as \$3,000 to the cost of a shipment. The United States filed a complaint with the WTO (Ostroff, 1996).

Colombia has been an important location for apparel assembly for many U.S. firms. See Figure 7–6. Textiles and apparel (mostly apparel)

FIGURE 7-6

Colombia has been a leader among South American nations in the development of an export-oriented industry.

Source: Reprinted courtesy of INEXMODA.

For additional information contact: INEXMODA Medellin Tel: (574) 311 59 15 Fax: (574) 266 20 50 PROEXPORT, Colombian Government Trade Bureaus:

Caracas: Tel:(582) 9514811 Fac:(582) 9541256 Lima Tel:(51))220024 Fac:(51))2220243 Los Angestes Tel:(1-213)9659760 Fac:(1-213)9655029 Mexico Ciry Tel:(525)2075589 Fac:(525)5250383 - Miami Tel:(1-305)3743144 Fac:(1-305)3729365 New York Tal:(1-212)2231120 Fax:(1-212) 2231325 Quito Tal:(593)2524069 Fax:(593)2222956 S.J.de Puerto Rico:(1809)2731444 Fax:(1809)2737006 Santiago de Crille Tal:(562)3397499 Fax:(562)3397498 Toronto Tal:(1416)5129212 Fax:(1416)5129458 Hamburgo Tel:(4940) 2713237 Facc(4940) 2708093 London Tel:(44171) 4913535 Facc(44171) 4914295 Madrid Tel:(341)5779735 Facc(341)5779636 represent one-fourth of Colombia's GDP. Although the apparel industry is well developed, the opening of Colombia's markets in the early 1990s led to a shakeout and restructuring of the industry. For a time, the Colombian industry was stifled by drug-related sanctions by the U.S. government. In the mid-1990s, the United States did not "certify" Colombia as having taken sufficient steps to stem the flow of drugs, particularly after the revelation that Colombia's president, Samper, had allegedly accepted millions of dollars in political contributions from drug lords. The United States withdrew 50 percent of its aid to Colombia. Although Colombia has been stigmatized by foreigners for its violent drug trade, Marxist guerrillas, and the associated bombings and kidnappings, U.S. companies with production there are generally very positive about the country and its apparel industry. Colombia's shipments declined nearly 16 percent between 1994 and 1997, however, largely because of the greater advantages NAFTA has given to Mexico. If NAFTA parity is granted to the Caribbean countries, Colombia and other Andean nations fear that they will be further disadvantaged if they are not granted the same privileges.

The apparel industry, and in some areas the textile sector, are well suited to the stages of development for Central and South America. At least some segments of these industries are already significant in most of these countries. As the region continues to develop, it should become an increasingly important production and market area. Free trade networks have proliferated among Central and South American countries; however, U.S. trade policies can have a significant impact on the development of the textile and apparel industries there. For example, an expanded version of NAFTA that includes these nations can affect the future of these industries. Other countries see the potential in this region and are positioning themselves to be players in the area. For example, the EU has signed a free trade agreement with MERCOSUR. Similarly, Taiwan's cabinet-level

Council for Economic Planning and Development (CEPD) is urging textile firms to consider Central America as a site for production. In a 1997 report, the CEPD reported that industrial growth in Central America will rival that of Asia in the future, and that by the year 2005 the region could become one of the world's five largest free trade zones. The Taiwan Textile Federation sent a 50-member trade delegation to the region. Taiwan's nine major textile associations will invest in an export processing zone to be built in Central America (Westbrook, 1997).

WESTERN EUROPE

The textile complex in Western Europe has an illustrious past that includes England's launching of the Industrial Revolution with textile production and France's position as the fashion mecca of the world for more than a century. Parts of Western Europe's industry have been pacesetters for fashion trends, the benchmark for quality, the elite users of certain industrial technology, and a dominant force in world trade.

Industrialized countries, in general, have had economic problems since the 1970s, and Western Europe's textile complex reflects the problems in adjusting to new global competitive forces. As a mature industry, the textile complex in Western Europe has much in common with its counterpart in the United States. In this section, most of our discussion will focus on the EU.

Despite some decline, the textile complex still ranks among the largest EU industries in output, employment, and exports. In 1996, the combined textile-apparel-fiber complex in the 12 EU countries (before the addition of Austria, Sweden, and Finland) employed 2.2 million workers, generally estimated to be about 8 percent of the workforce. Additionally, in 1996 the European Council of Ministers approved subcontracting in the industry, recognizing that many firms depend on it for their liveli-

hood. An estimated 200,000 of these tiny shops (cottage *outworkers* or craft shops) exist. To these numbers would be added those employed in the newest EU member states and other Western European countries not part of the EU. Various sources have reported that the EU textile complex lost some 450,000 jobs from 1988 to 1992. An estimated 100,000 jobs were lost in 1996 alone. Nearly 70 percent of the EU's **redundant workers** (a term to describe workers who are no longer needed) in manufacturing during this period were in the textile complex (COMITEXTIL, 1993a; EU Commission, 1993; Gälli, 1993, 1996a; Scheffer, 1994; "Sub-Contracting," 1997; "Trading Trends," 1997).

Production and employment are projected to decline further in Western Europe as companies relocate some or all of their activities to lower-wage countries. The Observatoire Européen du Textile et de l'Habillement (OETH) in Brussels follows these industry shifts. A well-known German research organization, the ifo Institut of Munich, worked with OETH to study the connections between technological development and employment in the 12-nation EU textile and apparel industries since 1994. Two possible projections, Scenario A and Scenario B, give estimates for the future employment outlook in these industries.

Scenario A is based on limited investment in new technology by companies within the EU. This scenario projects a rapid scaling down of production capacity in Western Europe, with a combined total of more than 735,000 jobs lost by the year 2005. For textiles, this scenario suggests that equipment will soon become too outdated and companies will not invest adequately in EU facilities. Textile companies may be inclined to follow the relocation of the apparel industry to Central and Eastern Europe. Apparel companies will produce only high-end niche apparel or will become service companies focusing mostly on design, logistics, and coordination of garment production in low-wage countries. Even the lower-wage countries of the EU will have difficulty competing with less-developed countries.

Scenario B projects more favorable conditions for innovation and production, with an employment decline of about 540,000 by the year 2005. Although this outlook is still bleak, Scenario B assumes that the EU textile industry will invest in the most modern technology and remain competitive. Apparel firms will improve their positions as they become proficient at working with clients, designers, and manufacturers. High-end niche markets will be maintained, but large production runs will be lost to Eastern European and Far Eastern manufacturers. About 80 percent of textile and apparel jobs are in production, while 9 percent are in managerial, technical, or business areas; another 11 percent are in sales and administration. Apparel production jobs will be most affected, which means that women will lose their jobs in disproportionate numbers. As production jobs are moved to other countries, professional workers such as designers, production engineers, marketing specialists, and technicians will increase in proportion to the total employed (Gälli, 1996a).

A Kurt Salmon Associates (KSA) study (1993) of the EU industry reported that as a result of poor domestic market conditions, both the EU textile and apparel industries had cut back on their domestic production. For example, Germany's textile companies were reduced by 207 to 1,097 between 1986 and 1990; the Netherlands suffered the highest proportion of closures—37 percent (Gälli, 1993). Germany lost 135,000 jobs in 1996 alone (Baumann, 1997). Germany's losses are noteworthy in view of the fact that for decades the nation has been the leading textile exporter in the world—with a long history in advanced manufacturing and technology, a strong technical textiles industry, an emphasis on high-technology production rather than labor-intensive processes, and a strong textile machinery industry.

Social charges (or social costs)—the European term for employee benefits, particularly those required by the government (e.g., comparable to U.S. Social Security levies)—are

seen as having a profoundly negative impact on the EU textile and apparel industries. In the 1990s, EU employers were required to pay 33 percent in various social charges compared to less than 14 percent in the United States. When these social charges are added to already high wages, EU textile and apparel manufacturers suffer a tremendous competitive disadvantage. As unemployment in Europe grows, a paradox occurs: the fiscal base decreases, and the tendency to increase social charges increases. Moreover, growing unemployment means that fewer and fewer workers are contributing to the social charges fund from which benefits are paid (author's discussion with government and industry sources, Brussels, 1994; COMITEXTIL, 1993b).

The EU countries are vastly different in their levels of overall development and, consequently, in the nature of the textile complex in each. The EU contains some of the most highly industrialized countries of the world (predominantly in the north—Germany, for example), as well as members (primarily in the south— Greece, Portugal, and Spain) that resemble developing countries in some regard (e.g., wages). These contrasts may be seen in the differences among the textile complexes. Other factors have influenced the nature of the textile and apparel industries in these countries, including the extent to which the government emphasizes and supports the industry (e.g., Germany does not attempt to support its declining apparel sector), the tradition of specialization for the industry (e.g., France's haute couture or Italy's emphasis on high quality), workforce availability, and labor costs. Four countries dominate the European textile and apparel industries: Germany, Italy, Great Britain, and France.

The EU textile complex includes over 220,000 enterprises. In both textiles and apparel, a great many small operations exist. For the EU as a whole, textile firms have an average of 21 employees; the figure drops to 11 for apparel firms. For apparel, small operations

account for over half of the workforce. The proportion of small establishments appears to vary by country, with many firms employing fewer than 20 persons in Italy, for example, compared to much larger companies in Great Britain and Germany (COMITEXTIL, 1993a).

Although the EU textile and apparel industries vary greatly from one country to another, the EU industry as a whole has experienced a growing trade deficit, with a pattern resembling that of the United States, as discussed in Chapter 8. The EU apparel sector has been affected much more by imports than has the textile industry; in 1995, 46 percent of all EU apparel was imported. As might be expected, these are generally imports from low-wage, developing countries. In fact, it is the apparel sector that accounts for a large part of the deficit for the EU textile complex as a whole. EU textile exports grew 57 percent from 1993 to 1995, largely due to the export of fabrics to those countries that ship apparel to the EU market—particularly for outward processing trade ("Imports 2001," 1997).

Textile and apparel trade among West European countries or with others in the region (i.e., intra-Western European trade) accounts for a significant volume of trade from the region. For example, in the late 1980s, slightly more than half of the EU trade in apparel was intratrade (Fitzpatrick Associates, 1991). To consider this in a global perspective, in 1996 all world trade in textiles was valued at \$150 billion; *intra-Western European trade accounted for \$45 billion of the world total.* For apparel, *intra-Western European trade represented \$45.9 of the world total of \$163 billion (personal communication with WTO economist, 1997).*

In the past, *exports* from the EU to outside countries were generally shipped primarily to high-income countries. This is still true for apparel; however, for textiles, the developing countries have replaced the OECD group as the major customers (COMITEXTIL, 1992). EU clothing *imports* generally come from low-cost countries that enter EU markets under

one of four different trade policies (these may include garments that are made fully in other countries, as well as those assembled elsewhere):

- 1. The EU gives preferential treatment to a group of Mediterranean basin countries including Cyprus, Egypt, Turkey, and Morocco. If these countries' textile and apparel products are limited, restrictions are generally more favorable than those for most other supplier countries. Turkey has become one of the top suppliers to the EU market. See Box 7–3 (p. 245).
- 2. The EU also gives preferential treatment to developing countries identified in the Lomé Convention, which describes the EU's financial and technical assistance programs to more than 60 "Associated Countries of Africa, the Caribbean, and the Pacific"—known as the ACP countries (many former European colonies). Goods from these countries enter the EU free of customs duties.
- 3. The EU has special trade agreements with several Central and Eastern European countries, some of which have applied for EU membership. These agreements, such as the customs union agreement with Turkey, give these countries special trade privileges.
- 4. Products from Asian suppliers are controlled under an international trade policy called the *Multifiber Arrangement (MFA)*, which will be discussed in detail later in the book. For a time, the Asian suppliers were the biggest gainers in EU markets in both textiles and apparel; however, products from Central and Eastern Europe are now gaining market share at the expense of Asian suppliers.

Wages are very high in the more advanced West European economies, causing a growing number of EU apparel producers to shift their production operations to lower-wage coun-

tries. The Europeans refer to this as outward processing, outward processing trade (OPT), or sometimes delocalized production. (At this point, the reader may wish to recall the discussion in Chapter 4 on the new international division of labor.) OPT is technically defined as "customs-approved finishing (processing, converting, improving and repairing) outside a particular country, of goods that can be freely imported." In some countries, it is also referred to as "passive improvement trade." OPT is an arrangement similar to U.S. manufacturers' 9802/807 production in the Caribbean basin region. OPT can take two forms: (1) "tariff" outward processing is like 9802/807 trade in that tariffs are payable only on the value added during assembly outside the EU; (2) "economic" outward processing is similar to the U.S. Special Access policy in that special quotas are available for companies using this arrangement, and domestic EU fabrics must be used.

The enormous growth of OPT is one of the most significant factors influencing the Western European textile complex. OPT is being used for textiles as well as apparel; apparel OPT is far more common because wage costs account for a higher proportion of total production costs, making the savings greater. Growth in OPT production is causing a major restructuring of the European apparel industry. As more EU firms engage in OPT activities, the domestic industry will continue to be affected. The growth of OPT trade accounts in part for the dramatic job losses in the EU apparel industry. Western Europe's OPT arrangements are with partners in Central and Eastern Europe, many of the Mediterranean countries, and selected North African countries such as Tunisia and Morocco. The collapse of the Soviet Union was a bonanza to the EU industry, making available large pools of low-cost labor for these arrangements. Countries in Central and Eastern Europe have essentially become the "sewing rooms" for EU apparel manufacturers and retailers who contract their production. See Figure 7–7. Apparel produced under

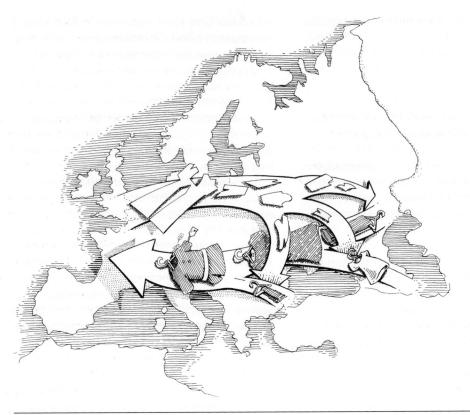

FIGURE 7–7
In OPT, Western European firms have apparel produced in Central and Eastern Europe, with finished garments returned to the home market for sale.

Source: Illustration by Dennis Murphy.

OPT arrangements now accounts for 70 percent of EU apparel imports from Eastern Europe. However, these arrangements will become less attractive as trade between many of the former Soviet countries and the EU is liberalized. Products under OPT from Bulgaria, the Czech Republic, Hungary, Poland, Romania, and Slovakia already enter the EU without tariffs.

Germany has been the leading EU country to use OPT because of its emphasis on high-technology manufacturing rather than labor-intensive industries. Germany is still the largest OPT importer, accounting for two-thirds of textiles and 56 percent of apparel brought into the EU under this arrangement in

1995. Germany's *share* of EU OPT apparel imports has decreased—not because the country is importing less but because many more Western European countries are taking part in these arrangements. Italy, proud of its quality workmanship and long resistant to compromise the "made in Italy" label, has found it increasingly necessary to trade pride for profit by relocating production in lower-wage countries. OPT production has increased for all the more industrialized, high-wage Western European countries.

A disadvantage of OPT is that it reduces the incentive to upgrade technology. Moreover, these arrangements have certain risks. For example, the former Yugoslavia was the largest

OPT clothing producer for the EU, accounting for 31 percent of the EU OPT imports in 1990. However, when political and military turmoil devastated this region, EU manufacturers scrambled to save garment shipments that were at risk of being destroyed or lost. Moreover, EU manufacturers who had established working relationships with contractors in the former Yugoslavia found themselves temporarily without partners to sew their apparel. Most of the OPT arrangements with the former Yugoslavia moved to other parts of Eastern Europe.

The EU's imports and exports have both increased since the mid-1980s; however, textile export figures are distorted because cut garments for OPT production are counted as exports when they are sent elsewhere for assembly. (Similarly, this inflation of U.S. textile export figures occurs for U.S.-cut garments sent to Mexico and the Caribbean for assembly.)

Textile and apparel imports from outside the EU (including OPT imports) will take an increasing market share over the next few years. Kurt Salmon Associates (KSA) predicts that by the end of the decade, 70 percent of the EU's annual consumption of a projected 8.8 million pieces of clothing will be imported, compared to 54 percent of the 6.4 million garments sold in 1991. Already the share is over 90 percent in some apparel categories (Gälli, 1993; KSA, 1993).

Although the EU textile and apparel industries have felt the impact of global competition in these sectors and will continue to do so, it is important to remember that the EU is still a very important international producer and trader, particularly in the high-value market sectors. Subhan (1993) asserts that even in today's **postindustrial** Western Europe, these are still major industries—much larger, for example, than the high-tech office and data processing machinery industry.

Even Western Europe's legacy as the fashion capital of the world is being transformed as a result of globalization, however. Today's international media coverage and instant communications have created consumers who see

television clips from European fashion shows and expect to find the newest fashions in their local stores in the same season. Consequently, Stogdon (1993) asserts that couture has been replaced to an extent by ready-to-wear clothing that is rapidly available for the mass market. This creates the challenge of being able to respond quickly to consumer demand for the latest "look." For EU firms, garment production in Central and Eastern Europe provides speed advantages over Asian production.

European producers are affected by yet another trend. As the EU moved toward unification, firms in other parts of the world saw a unified Europe as potentially a "Fortress Europe." That is, they feared that the EU would become a trade bloc difficult for foreign companies to penetrate. See Box 7-2. Therefore, companies that wished to sell in EU markets established European production bases to be able to produce and sell in those markets. Perhaps the most notable example is the Japanese Toray Textiles Europe Ltd. in England, which represents the largest single investment in a spinning and weaving mill in British textile history. Toray sells not only to British apparel manufacturers but also to apparel producers in other European countries.

In addition to the products from low-wage countries brought into the EU through OPT arrangements, retail buyers add to imports by sourcing or contracting production. Although the apparel retail sector in the southern EU is fragmented, in the central and northern EU it is more concentrated and is dominated by multiple chain stores, buying associations, department stores, and wholesalers. Not only are these massive retailers exerting increased power over manufacturers in determining quality and prices, they are also displacing apparel manufacturers by developing and contracting their own private label lines. For retailers who lack the expertise, buying agents and trading companies are available to handle various stages of manufacturing, from designing to selecting fabrics to overseeing the production process (Mattila, 1996).

BOX 7-2

ISO 9000

ISO 9000 refers to a set of international standards that companies must meet if they hope to sell in Europe. Rather than being product standards, ISO 9000 is a series of standards for *quality management* and *quality assurance* for both manufacturing and service operations. The standards are generic, not specific to any industry. Although legally required only for safety-sensitive products, ISO 9000 certification is seen increasingly as a competitive necessity for international firms. A growing number of European companies will not buy or take bids for products from foreign suppliers that do not meet the ISO 9000 standards.

The International Organization for Standardization (ISO) is the international agency for standardization, composed at present of the national standards bodies of 91 countries. ISO 9000 standards were developed to cover *quality control systems* for product development, design, production, management, and inspection. Companies can benefit by building quality into their product or service instead of costly after-the-fact inspections, warranties, and rework.

Companies may register their quality systems by having an accredited independent outside party conduct an on-site audit of the firm's operations against the requirements of one of the standards (there are several under the ISO 9000 umbrella). Upon successful completion of the audit, a firm receives a registration certificate and is considered certified. ISO 9000 audits can be costly; however, many companies are considering certification as just another cost of doing business. Although some sources believe that the principles of ISO 9000 are credible, others think the standards are another way of keeping other countries' products out of EU markets (i.e., a nontariff barrier, a term discussed in Chapter 10) (author's discussion with industry source, 1994; International Apparel Federation, 1993; Pechter, 1992).

EASTERN EUROPE, BALTIC STATES, AND COMMONWEALTH OF INDEPENDENT STATES (CIS)

The economies of this region became integrated after World War II through the economic and social strategies of the former Soviet Union. Under the Soviet Union's command economic system, state planning agencies—following Communist Party directives—managed the economy, with the production and utilization of goods determined by political objectives that were centrally prescribed. Channels and prices of procurement and sales were determined by the authorities. Products of whatever design and quality were forced on consumers, who had no other choices. Factories were provided the supplies and equipment deemed necessary and were staffed with far too many workers. Plant managers

had no worry about where products would be sold; state retailers took care of that.

Prior to Soviet control, the textile industry had been well developed and, in some countries, internationally recognized (e.g., the former Czechoslovakia and East Germany); however, the Soviet economic system suppressed the industry. Priority was given to **heavy industry** and the manufacture of producer goods (used in the production of other commodities) rather than consumer goods (ECHO, 1991; Thiede, 1992).

Prior to the fall of communism, the countries in this region were members of the Council for Mutual Economic Assistance (CMEA, or Comecon), an organization established by the Soviets to control and integrate trade within Soviet bloc countries. Patterns of specialization developed among many of these countries,

and in many cases the council filled the needs of member nations. However, trade for these countries was most often with one another—not with the rest of the world.

Centrally controlled economies and isolation from the world market had a crippling effect on the region. Its economies became shortage economies in which the ability to generate income was limited; technology and management had not kept up with the rest of the world; and although workers had jobs, earnings and consumption were very low. Infrastructures such as roads, telephones, and energy sources were poorly developed and remain woefully inadequate by Western standards. Particularly in today's information-driven world, communication links are poor. Both transportation and communications are being improved in parts of the region; however, there is great disparity from one area to another.

As a result of the Soviet system, the textile and apparel industries lacked modern technology and relied heavily on unskilled or semiskilled labor. Although these industries grew, quality and competitiveness lagged. Because the textile and apparel industries had been isolated from world markets, they had not experienced the adjustments made by the Western European textile complexes in the 1960s. In short, Eastern Europe's industries lagged 20 to 25 years behind those of Western Europe. Enderlyn and Dziggel (1992) noted that factories and technology in the region for most sectors are comparable to those of Western nations in the 1940s. Many employees have experience and skills needed for textile and apparel production, but management, marketing, and sales expertise is lacking.

According to Gälli (1992), under communism 4 to 5 million people were employed in the textile complex, all in state enterprises. The system also included such things as company housing, hospitals, ambulances, kindergartens, leisure and holiday centers, sports clubs, and canteens—and, of course, political education. That is, the state provided not only jobs, but also a way of life.

Although the end of the communist era was celebrated throughout the region, most citizens were not prepared for the difficulty of adjusting to the realities of a market economy. The old way of life had provided a significant degree of comfort and security that no longer exists. According to Gälli (1992), Western experts project that the textile and apparel output of the region can be achieved with a mere onethird of the former workforce. Therefore, many employees will become redundant workers. Gälli noted that women will be affected disproportionately because of their high concentration in the textile complex. For large proportions of these workers, no alternative employment exists.

The textile and apparel industries in this region are now experiencing painful adjustments and transformations. Through **privatization**, giant state enterprises with thousands of employees have been divided into smaller units, often with direct ties to other countries, not to the state authorities.

Leaders in the textile complex in these countries must make enormous leaps to overcome the stifling effects of a socialist command economy and participate in a global market economy. Many qualities at the heart of market competition must be recultivated—such as initiative, flexibility, business acumen, and specialization. The old system had provided no incentive for workers to be efficient and more productive: workers were not rewarded for extra effort. The author heard a German textile advisor speak of the difficulty of assisting firms in this region, whose executives had no concept of what interest on capital meant. Even modern bookkeeping is unknown to many of them. Other challenges include logistics, marketing, and sensitivity to fashion in international markets. In the past, firms needed only to turn out products that were "inexpensive, warm and lasting"; now they must be "competitively priced, of a quality appropriate to market demand, and 'fashionable' " (Gälli, 1992, p. 116). Competition is a new concept for

business leaders in this region. Many know they have to compete, but they have no concept of what this means or how to do it. Outdated machinery; lack of design and marketing expertise, quality awareness, and quality control; and a chronic lack of capital are handicaps for the industry throughout the region.

Nevertheless, progress is occurring, although it varies greatly among the countries. Products valued at US\$8.5 billion were shipped to the EU from the former Soviet bloc in 1994, rising an average of 9 percent annually in the 1990s (Gälli, 1996b). Some of the Eastern European countries-particularly Poland, Hungary, Romania, Slovenia, the Czech Republic, Slovakia, and the Baltic states-are becoming increasingly important suppliers for the EU market. Generally speaking, the closer the countries are to Western Europe, the more they have recovered from the effects of communism. Countries in this region are taking an increasing share of the EU textile/apparel market previously supplied by East Asian producers. Apparel assembly operations (OPT) account for a large proportion of exports from the region. In Poland, for example, assembly operations account for 93 percent of the country's textile/ apparel exports; 90 percent for Hungary; 88 percent for Romania; and 63 percent for the Czech and Slovak Republics.

Some countries in the region are putting great effort into reviving their traditional light industry, including shoes, leather, and apparel. Many see these industries as the engines of growth for their economies, as was true of the "Four Dragons" of East Asia. Western inputs of capital, technology, and marketing expertise will be necessary for companies in Eastern Europe, the CIS, and the Baltics to fulfill these aspirations. Economic reforms must find a way to rekindle workers' incentive and motivation. The textile complex will play a crucial role in the future economic, social, and political prospects for the region. Already, we know the important role the industry plays in early development in most countries. Given the increasing disenchantment due to difficult adjustments and hardships from the transition to democracy, the industry will play a critical role in maintaining stability in the region.

These countries face grim economic realities of high inflation, declining industrial sectors, and rising unemployment. Consequently, many persons find it difficult to make a living. Those fortunate enough to have jobs typically earn \$25 to \$75 per month; wages tend to be higher in the countries closer to Western Europe. The leaders of these countries face an ongoing challenge from citizens who believe that they were better off under communist rule; many older people feel this way. However, the younger generation believes a market economy will work, given time. Glasse (1993) predicts that the transition to a market economy will take 10 to 15 years even under the best circumstances. The shifts to a market economy have created wealth for a few individuals, who are featured in the media; these consumers are buying high-profile luxury goods. Generally speaking, however, the population as a whole is poor—desperately poor in some places. Even in more advanced parts of the region, most textile and apparel products are of mediocre quality, and street fashion is described by one writer as "tacky" (Wheatley, 1996a).

Eastern Europe, the CIS, and the Baltics will become increasingly important players in the textile/apparel world market. In fact, a textile development "axis" is forming across Central Europe from the Baltic to the CIS (Gälli, 1992). Additionally, the growing trade connections between the East and the West make this a significant region to watch in the future.

Some members of this group already enjoy special trade provisions with the EU called EU Association Agreements. These agreements facilitate trade relationships, as well as broader economic and cultural cooperation. In 1998, all trade restrictions with the EU were eliminated for textiles and apparel from Bulgaria, the Czech Republic, Hungary, Poland, Romania, Slovakia, the Baltic states, and Slovenia. However, this

may have only limited effects on the EU market and the textile complex. Although the EU has progressively lowered barriers to these countries' textile and apparel products, shipments to the EU have not met the full quotas. This is perhaps because of limited production capabilities in many of these countries (Gälli, 1996b; Kallin, 1996).

Several countries in this region have applied for EU membership. In the year 2000, Hungary, Poland, the Czech Republic, Slovakia, and Slovenia are scheduled to join. When this occurs, more EU firms are expected to invest in the region. EU membership is expected to provide greater economic and political stability, thus reducing current risks associated with investing there.

At this point, we shall look briefly at the textile and apparel industries in these countries by group.

Eastern Europe

Eastern Europe now consists of 12 independent countries in an area that contained only 7 sovereign states at the beginning of the 1990s. The westernmost countries in this group are sometimes considered Central Europe. Together, the group is referred to as the *Central and East European Countries* (*CEECs*). The CEECs have much closer ties to the EU than do the CIS or the Baltic states. These countries may replace the Mediterranean countries as lead apparel suppliers to the EU market; however, much of the trade consists of assembly operations.

The countries of Eastern Europe may be divided into three groups in terms of economic development, and the textile/apparel industries parallel the overall development in most cases. The most developed group is listed first; the least advanced, last:

- The Czech Republic, Poland, Hungary, and Slovenia
- Slovakia, Romania, Bulgaria, Albania, and Macedonia

 Croatia, Bosnia-Hercegovina, and the new Yugoslavia (Serbia and Montenegro)

The countries in the first group have greater economic and political stability and are able to take advantage of their position relative to Western Europe. These are the leading OPT sites for EU firms. To look at one example, the Czech Republic's textile and apparel industries, though more advanced than most in the region, still show remnants of the difficulties caused by communist control. The former Czechoslovakia had a well-developed fashion industry long before World War II. With a long history of textile production, it was the textile machinery producer in the CMEA division of labor. However, estimates indicate that in the industrial restructuring that followed economic reforms, some 30 to 50 percent of the textile and apparel producers were on the verge of collapse. Modernization has been limited by financial restraints. Although the textile and apparel industries had developed traditional skills over decades, their weaknesses became more apparent when they were subjected to a market economy. Because these nations are important OPT sites, EU textile and apparel firms have provided some of the expertise needed to be competitive. Another example, Poland, has large textile and apparel industries, but large parts of these industries are still structured as they were under the previous centrally planned economy. Wages in Poland are higher than those in neighboring countries, making it more expensive to locate production there.

The second group of these countries proclaim their intent to dismantle the old communist economic structure but have been slow to do so. Former communists play a strong role in Slovakia, Romania, and Bulgaria, in some cases maintaining a controlling interest in companies. The communist influence has stifled progress in developing a market economy. Still, these countries have become important OPT sites for EU apparel firms.

The third group of countries has suffered severe economic upheaval and dislocation because of their civil war. Economic development is far behind that of neighboring countries. Although this had once been an important area for garment production, its industries must be rebuilt. Textiles and apparel will be important industries in the rebuilding of the economy, particularly as a source of income for the many widows left to support themselves and their families after the war. See Figure 7–8.

The Baltic States

The three Baltic states of Lithuania, Latvia, and Estonia were the first to break away from the former Soviet Union. The textile complexes in these countries were well established before being absorbed into the Soviet empire. Under communism, the textile and apparel industries deteriorated in ways similar to those described for other countries under Soviet control. Fifty years of socialist planning and production for CMEA markets resulted in outdated, out-of-touch industries ill prepared to compete in a market economy.

Technology is inadequate; the lack of raw materials is a serious problem; quantity is emphasized over quality and design; privatization is occurring too slowly to gain the desperately needed capital from outside partners; and the business activities of foreign investors are restrained (e.g., in Lithuania and Estonia, foreigners may not buy property but can only take a 99-year lease). Weighty bureaucracies, poor infrastructures, and little appreciation for the importance of quality and responsibility are also matters of concern for potential partners. The inbred communist attitudes will have to change, with managers becoming more responsive to customers.

Despite the shortcomings, the textile complex remains critical to the economies of these three breakaway states. In the 1990s, Lithuania's textile sector contributed 40 percent of the country's industrial output; Latvia's complex

FIGURE 7-8

Following years of political turmoil that destroyed the economy, this woman from Vlasenica in eastern Bosnia uses her skills to earn money to support herself and her family.

Source: Photo by A. Hollman, courtesy of United Nations High Commissioner for Refugees (UNHCR).

accounted for 82 percent of the country's light industry; and Estonia's industry represented 24 percent of total industrial output. Wages are similar to those in the CIS (Gälli, 1992).

The Commonwealth of Independent States

The CIS is a loose-knit community of independent states (see Chapter 3 for a review of the members) without the legal formalities of a na-

BOX 7-3

TURKEY: EMERGING TEXTILE AND APPAREL DYNAMO

Located partly in Asia and partly in Europe, Turkey is positioned between the East and the West. In January 1996, this country, which aspires to join the EU, began a customs union with the EU—essentially making Turkey part of the single European market. Turkey has become one of the fastest-growing apparel-exporting nations in the world, ranking sixth worldwide in 1995 (WTO, 1996).

The Turkish textile industry began in 1836 under the Ottoman Empire and has been a leading industrial sector ever since. Between 1913 and 1915, 28 percent of the businesses employing more than 10 workers and 48 percent of the employees in those workplaces were in the weaving industry (Yilmaz, 1991). With the end of the empire and the founding of the Turkish Republic, the textile industry was given priority as an industrial sector in the 1930s. The apparel industry developed much later as part of the nation's emphasis on exports in the 1970s. The new exportoriented economic model adopted by Turkey in

the 1980s, along with export credits and other incentives, raised apparel exports from \$130 million in 1980 to \$8.5 billion in 1995—a 65-fold growth in 15 years (WTO, 1995). In 1995, textiles accounted for 11.7 percent of Turkey's merchandise exports, apparel for 28.3 percent—together almost 40 percent of Turkey's total merchandise exports (WTO, 1996).

In the early 1990s, the Turkish apparel industry received a significant boost when both the United States and the EU granted much more generous quota allowances to Turkey. Because Turkey had been an ally during the Gulf War—including the use of Turkish air bases—the additional quota allowances were granted. The additional quota meant that Turkish manufacturers could export much more apparel to both U.S. and EU markets. More recently, however, Turkey's labor costs have risen significantly. As a result, Turkish manufacturers are establishing ties in Eastern Europe, including joint ventures in CIS countries, to take advantage of less costly labor.

tion or commonwealth of nations. Because of its transitory nature, statistics on its industries are difficult to obtain. Although the CIS is 95 percent self-sufficient in manufactured fibers, it faces serious shortages in many other raw materials. As relationships between the former republics have deteriorated, light industries such as textiles and apparel have faced shortages of intermediate inputs and lack the foreign exchange to purchase these elsewhere. Workers are sent home on unpaid leave because the yarns, fabrics, and so on are not available for production. Valentine Lebedev, Vice Minister of Textiles and Light Industry of the Russian Federation, reported that Russia has about 3,000 textile factories, of which only 46 are state owned; 1,400 are joint ventures,

and about 1,300 are private. Half of the 3,000 enterprises are working at half of their potential. More than half of the factories will have to be liquidated because they will be unable to survive. Lebedev noted that the products are of questionable international quality. Russian textile and clothing industry production fell by more than half in some sectors between 1992 and 1994. Garment factories are using only 30 to 40 percent of their capacity. OPT for Western companies is seen as the only solution for the present (Gälli, 1996; Lebedev, 1997).

CIS wages are low by world standards. In 1995, the average hourly wage for a Russian apparel worker was 77 cents in the cities and about half that in rural areas; another 40 percent must be added to cover social costs. Although a few

factories have state-of-the-art technology, most of the CIS industry uses outdated machinery and processes, which are often slow and inefficient. Product quality is low, and product delivery is sometimes unreliable. Some textile mills have employed 5,000 to 6,000 workers, which made them inefficient. The emphasis was on quantity rather than quality.

Glasse (1993) noted that anecdotal stories on doing business in the CIS abound. One businessman reported visiting a CIS plant that produced yarn and sewing thread. "Although the yarn should have been twisted in a different direction from the thread, the factory was twisting both yarns and threads in the same direction. As a result, the thread produced unravelled. When asked why the company was doing this, the spinning mill spokesman said the plant was paid on the basis of the number of kilos of product produced and that it was easier to twist yarns and threads in the same way" (p. 60). This story reflects many CIS manufacturers' lack of understanding of market forces.

CIS textile and apparel firms desperately need capital to upgrade their production technology. Consequently, foreign partners are needed to provide the necessary investment and expertise. A few apparel plants have computerized machinery and computer-aided design/manufacturing (CAD/CAM) technology purchased through a barter system of paying for the equipment with apparel from the factories. Firms from various EU countries, China, South Korea, and Australia have launched operations there, but these are only a modest beginning in the enormous task of rescuing the CIS textile sector.

DuPont has an office in Moscow and has sold Lycra in the CIS since the late 1980s. A DuPont representative noted that it has been harder to do business since the collapse of communism because the company has no direct partner now. Former textile ministries were abolished or turned into trade associations. Identifying decision makers is often dif-

ficult. Now DuPont must deal directly with textile mills that do not have the capital to purchase the products. Although many CIS firms want DuPont's technology and products, they are unable to purchase them (Glasse, 1993).

As former Soviet states gained more autonomy, they asserted their independence even in textile trade. For example, Uzbekistan produces two-thirds of the cotton crop of the former Soviet Union, or about 5 million metric tons (1 metric ton equals 2204.6 pounds). Under the old system, the Soviet Union exported a great deal of cotton, but very little of the proceeds accrued to Uzbekistan. Now Uzbekistan considers the vast cotton crop an asset and is using it in trade, frequently in barter arrangements, to purchase essential imports ("Cotton," 1992).

Although progress is being made, the number of Western European firms in Russia is still relatively small because of the handicaps and risks. These include "general political and economic instability, currency risks, corruption and criminality as well as a labyrinth of customs requirements and ever-changing tax laws. Lack of flexibility in the plants, inadequate supplies, long and risky transport and the necessary finance are also big problems for investors. Despite the availability of well educated specialists, there remains a lack of management level personnel; quality is often inadequate; the infrastructure generally (in particular telecommunications) is still poor and for foreign technical personnel there are often language difficulties." The chairman of Hugo Boss noted that "everything in Moscow is 20 times more difficult than in Prague" (Gälli, 1996, p. 133).

Despite the problems, companies cannot ignore the vast markets in this region. Since the fall of communism, the CIS population has become more aware of what is going on in other parts of the world. Therefore, many consumers want better quality and more fashionable apparel than the CIS industry provided in the past; a growing middle class has money to spend. Chronic drabness is being replaced in

cities like Moscow, one of the few places where the changes of the postcommunist revolution are visible. Boutiques include prestigious names such as Gucci, Givenchy, Fendi, Ermenegildo Zegna, Armani, and Calvin Klein. Consumers with incomes to buy fashionable apparel are looking beyond the former Soviet countries for the products they want to buy. This trend has implications both for CIS producers, who must upgrade their products to retain the domestic market, and for firms in other countries that desire to sell in the CIS markets. Vigdor (1996) asserts that many Russian consumers want U.S. goods but only if they are authentic—that is, made in the United States.

An enormous discrepancy exists in income, brand awareness, and shopping habits between the small fashion-buying Russian elite and the masses. Fashion knowledge is spotty. The globe-trotting elite seek luxury brands, while middle-class working shoppers go to enormous outdoor markets held in sports stadiums where a variety of Turkish and Chinese goods, including fake brand-name goods, are for sale. Despite media attention to luxury boutiques and purchases, most Muscovites are struggling, and clothes are a luxury. Although the official minimum wage is about \$20 per month, the average monthly Muscovite wage is \$120. In some cases, however, wages are very low even in Moscow; in Shirt Factory No. 5, wages are frozen at \$53 per month for the 800 seamstresses (Powell & Matthews, 1997; Singer, 1997). Incomes in most CIS countries are far below the average in Moscow. In many parts of the CIS people can barely afford food, and local doctors speak of watching children die from diseases for which most of the Western world has long had simple cures.

Western-style retailing has emerged in Moscow, including department stores, chains, specialty shops, and boutiques. Gälli (1996b) noted that in the consumer goods areas, particularly clothing and shoes, the notorious Russian mafia not only controls the trade but supports it. The German department store

chain Karstadt opened a branch in Moscow because its owners are convinced that Russians are ready to buy fashion. Moscow's premier department store, GUM, has been privatized and is seeking to establish itself among Europe's best retailers by attracting international brands and investors. GUM is one of the world's largest department stores (actually a shopping arcade), covering an entire block opposite the Kremlin. GUM needs contemporary technology to manage its inventory, but as long as salaries are low, it is less costly to pay people than to buy machines.

AFRICA

A brief overview of Africa's textile and apparel industries is warranted because so little has been written about them and because, at some future time, Africa will probably be the site of substantial industrial development. The movement of parts of the textile complex from developed to developing nations means that Africa will gain. As wages continue to rise in Asia and Latin America, it seems likely that Africa will be seen as the last reservoir of plentiful, low-cost labor for certain labor-intensive aspects of textile/apparel production. Africa's future potential is enormous.

Africa is a huge continent of 53 states, with a population of about 700 million and more than 2,000 languages and dialects. The United Nations predicts that its population will exceed 856 million in the year 2000 and will be more than 1.5 billion by 2025. In rural villages Africans may maintain a traditional tribal way of life, while in urban centers a Western lifestyle is common. Some cities boast skyscrapers and a cosmopolitan outlook. Economic systems range from market economies to those that are centrally controlled. Political systems range from multiparty representation in parliamentary settings to military dictatorships and Marxist governments. On the positive side, Africa has

abundant natural minerals, some emerging market economies, and close ties to major industrial powers; however, the continent also suffers from drought, famine, poverty, disease, political unrest, foreign indebtedness, and poor infrastructure in many regions. Road conditions are often poor; rail systems have breakdowns; and ports often have delays. Some regions are difficult for travel because of security risks (Biggs, Moody, van Leeuwen, & White, 1994).

Despite the global attention focused on Africa in recent years, Werbeloff (1987) noted that relatively little is known about the full extent and structure of its fiber, fabric, and garment sectors of the continent as a whole. A major reason is that collecting comparable, reliable, up-to-date, comprehensive data is difficult because of political bias in official data, nonreporting by industries and governments, and disruption of statistical surveys by civil wars, shortages of government funds, or droughts. In 1997, the United States International Trade Commission published a study on the industry in Sub-Saharan Africa (Africa south of the Sahara Desert), which provided a useful overview of the industry.

Africa has produced cotton since the time of the early Egyptian civilization, and South African wool and Tanzanian sisal have been sold internationally for most of this century. Apparel manufacturing began in South Africa in the early 1900s, and the Egyptian textile industry began in the 1920s. Following the independence of African countries in the 1950s and 1960s, textile and apparel factories began to develop in many regions. Because the African countries had been colonies of various European nations, ties through investments and trade have continued in varying degrees. Today a wide range of yarns, fabrics, and finished products are produced in Africa; however, exporting is still relatively limited. Unless the African textile and apparel industries export, however, opportunities for growth are limited because of the almost nonexistent purchasing power in many of these countries.

Africa's average annual fiber consumption per person is only 2.4 pounds, compared to 64 pounds for U.S. residents (Food and Agriculture Organization of the UN [FAO], 1996).

In a number of African states, the textile complex has played a major role in industrial development, generally outpaced only by food in terms of the total manufacturing value added. However, although some large plants exist, most of the apparel industry is composed of small enterprises, often organized on an informal basis, with fewer than 50 workers (often fewer than 10). See Figure 7–9. Although these operations play a critical role in providing clothing and employment, they struggle to survive. A number of modern textile plants have been built; as a result, much of the smallscale, informal textile production—often making high-quality hand-woven traditional African fabrics—is being replaced. Although modern textile factories exist, Werbeloff (1987) noted that some have been erected with political motives, rather than based on economic feasibility studies; these factories have had chronic underutilization.

Some international development experts have also speculated that the African textile and apparel industries are underdeveloped because the more developed countries' aid shipments of secondhand clothing have stifled the need for local industries to develop to serve domestic markets (author's interviews). In some cases, used garments have depressed the demand for locally made products. U.S. exports of these used products were valued at \$92 million in 1996—the eighth largest U.S. export category to the region.

Africa is a relatively small supplier of textiles and apparel in the global market. Shipments from Sub-Saharan Africa were valued at \$1.7 billion in 1995, accounting for less than 1 percent of world exports of such goods. Very few countries accounted for nearly all the exports. The EU was the primary recipient of these products; the United States was second. From 1991 to 1996, U.S. imports of textiles and

FIGURE 7-9

This small-scale production is typical of much of Africa's industry.

Source: Photo courtesy of United Nations.

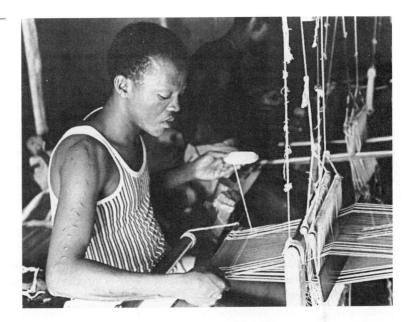

apparel from Sub-Saharan Africa grew by an annual average of 18.8 percent to \$383 million, less than 1 percent of total U.S. imports of these products (U.S. International Trade Commission, 1997).

In African countries with stable policy environments, Biggs et al. (1994) noted that some companies have the potential to compete in the global market with East Asian suppliers. This group of World Bank researchers believes that African producers have an opportunity to supply "authentic African" (also called *Afrocentric*) apparel and textile home products for the U.S. market. Several U.S. retailers have attempted to source these products in response to this growing ethnic market. However, efforts to date have been less than successful. Problems include inconsistent quality and institutional inadequacies such as lack of access to credit to finance material inputs, especially large orders. Market impediments—lack of access, information, and buyer contacts—hamper these exports.

A few African nations demonstrate the export potential of the continent's textile complex. In fact, these few countries account for

most of Africa's exports. Morocco, Tunisia, Egypt, and Mauritius have developed fastgrowing textile and apparel export businesses, particularly with the EU and, to a lesser degree, with the United States. Morocco's and Tunisia's proximity to the EU countries puts them in an advantageous position similar to that of the Caribbean nations in relation to the United States. All these countries have attracted offshore textile and apparel plants and foreign investments that have substantially increased employment and foreign exchange. Western European firms' OPT operations in Eastern Europe may take some of this business, however. Mauritius illustrates the potential value of the textile complex for these countries; for example, employment in Mauritius's apparel sector quadrupled from 1982 to 1991 (International Labour Office, 1993). Apparel exports accounted for 56 percent of Mauritius's total merchandise exports in 1995 (WTO, 1996). The dynamic growth of the industry has raised the standard of living dramatically on this tiny Indian Ocean island off the coast of Africa. More recently, however, Mauritius's apparel industry growth has slowed because

of labor shortages, rising wages, and other factors. Mauritius manufacturers have begun to outsource in Madagascar, where wages are lower.

As our models for economic development and stages of industry development (in Chapter 5) predict, some of the more industrialized Asian nations are moving their production to African nations to take advantage of the labor availability and low costs. Equally important is the freedom from quota limits on shipping apparel to the United States and the EU. For example, Hong Kong, Taiwanese, and Chinese firms have operations in Mauritius (as do France, England, and Germany).

A bill was introduced in the U.S. Congress in 1997 to foster textile and apparel development in Sub-Saharan Africa. The bill, H.R. 1432, would ensure quota-free and duty-free entry for textiles and apparel entering the United States from any of these countries. The bill met resistance from the textile industry and the Union of Needletrades, Industrial and Textile Employees (UNITE) because of concern about massive customs fraud and illegal transshipments of Asian producers who might use Africa to bypass U.S. quota limits. To date, few U.S. firms have ventured into Africa, and those that did had problems because of U.S. trade policies. U.S. quota limits on some categories of garments from Mauritius and Kenya caused significant drops in production and employment in the industries of those countries (Barrett, 1997; Jacobs, 1997).

In sharp contrast to most of Africa, the Republic of South Africa is the continent's most-developed nation. The infrastructure is well developed, and labor costs are high. The South African textile and apparel industries are well established and face many of the challenges confronting these industries in other industrialized nations. The channels of production and distribution are roughly comparable to those in the EU or the United States. Employment in the industries, including the informal sector, is an estimated 200,000, about 9 to 10 percent of

all manufacturing employment. The textile and apparel industries were formerly sheltered by government policies; when this protection was reduced, they were ill prepared to compete in a global market. As companies invested in new technology to reduce production costs, about 77,000 jobs were eliminated in the textile, apparel, and footwear industries. South Africa complains that it must produce within the cost structure of a developed country but must sell in a less-developed market—referring to the relatively large poor black population of a country that was repressed economically and socially under apartheid policies. Now that the South African market is more open, about 25 percent of the apparel market is taken by imports. Additionally, investors in many countries look to South Africa as a springboard to reach other parts of Africa ("A Quality," 1996; Bramley, 1997; Mollett, 1995; Theron, 1997).

SUMMARY

In this chapter, we have considered the textile complex in select regions of the world (1) to gain an understanding of restructuring of the global complex as a whole and (2) to examine the complex in various geographical areas in relation to stages of development for the textile complex and for the overall development of nations and regions.

Asia is the region of most dramatic overall development and growth in the last decade or more. All of the Asian economies have been fueled by export-oriented industries, and the textile complex has led the way in virtually all these nations. Typically, the textile complex accounts for a high proportion of industry output, employment, and exports in the early days of a country's development. Then, as wages rise and labor shortages occur, labor-intensive portions of the production process are sent to less-developed neighbors. The more advanced partners provide the more technically advanced compo-

nents to the less-developed neighbors, who assemble the components into final products. As each nation or group of nations advances, the relationships continue to be much the same; however, the partners change—leading to the flying geese pattern of development discussed in this chapter.

First, Japan's reliance on the textile complex for its economic development led the way. The NICs followed, first performing the least technical aspects of textile/apparel production and then advancing rapidly. As the NICs moved through various stages of development, manufacturers in most of these nations sent a significant proportion of their labor-intensive production to the neighboring ASEAN members. More recently, some members of the ASEAN group have approached NIC status and are losing their competitive advantage in the labor-intensive aspects of production. In the flying geese scenario, some of the ASEAN producers (along with their advanced neighbors) have established assembly operations in the least-developed countries in Asia; among these are Vietnam, Bangladesh, Sri Lanka, and China. Throughout Asia, the international division of labor is evident, and production sites often change quickly as some Asian nations rise rapidly through the earliest stages of development to more advanced stages in which wages increase, labor shortages occur, and other sectors are emphasized more. Additionally, many of the Asian nations have moved into one of the most complex segments of the textile complex: manufactured fiber production.

Australia's textile and apparel industries resemble those in other more-developed nations. Labor costs are high, and low-cost imports are taking an increased share of the market. Australian manufacturers are having to adjust to a dramatic lowering of tariffs on imports and the elimination of quotas. Under a trial program, manufacturers are now permitted to perform assembly operations in low-wage countries.

In North America, free trade on the continent has become a way of life. Despite protests

from manufacturers on both sides of the border, trade figures show that most producers have benefited from NAFTA. Although the Canadian textile complex has faced a number of challenges, it has remained viable and competitive. Apparel manufacturers, for example, have established a successful niche in highquality, European-style clothing. New challenges and new opportunities will develop as the three North American countries move toward free trade under NAFTA. Unlike the Canada-U.S. agreement, with Mexico NAFTA incorporates a partner at a different level of development—a fact that is leading to some restructuring of the textile complex on the North American continent. Mexico has a welldeveloped manufactured fiber industry but needs textile mill products. Mexico's wages are low, and maquiladora operations are common in the apparel sector.

The Caribbean basin has developed as a significant apparel assembly area for U.S. manufacturers under a variety of policy provisions designed to aid the region and U.S. manufacturers at the same time. Caribbean assembly operations represent a classic example of the new international division of labor. Caribbean apparel operations have turned Miami into a hub of activity related to this form of offshore production. Together, imports (mostly 807/9802 production) from Mexico and the Caribbean combined are taking U.S. market share from Asian suppliers. Other Latin American nations also represent market opportunities; however, many of these countries are forming free trade agreements among themselves. U.S. political resistance may eliminate or reduce its opportunities to be a major player in this increasingly important region.

Although the textile and apparel industries in Western Europe have faced problems in adjusting to new global competitive forces, these sectors still rank among the largest in output, employment, and exports, particularly in the EU. The textile complex varies greatly from one EU member country to another, as might

be expected since these countries are very different. Because of high labor costs, and accompanying high social costs in most of Western Europe, many apparel producers are relocating their manufacturing activities to lowerwage countries under a strategy the Europeans call outward processing trade (OPT). Escalating growth of OPT activities represents one of the major restructuring activities of the Western European textile complex. Low-wage locations for Western European manufacturers include several Mediterranean countries, Eastern Europe, parts of North Africa, and Asia. Predictions are that through a combination of OPT garments and imported apparel secured by large-volume retailers, imports will account for 70 percent of EU apparel consumption by the year 2000. Favorable trade agreements will give Eastern European nations a growing role in the EU market.

The economies of Eastern Europe, the CIS, and the Baltic states are making a painful transition from the crippling isolation and central control under the old Soviet system. Although the textile and apparel industries vary considerably among the countries of this region, all lack modern technology and an understanding of how to respond to market forces. Managers are having to learn the basics of business acumen and how to develop a system that provides incentives for workers. Responding to fashion is a new concept for these manufacturers. As enterprises are privatized, high unemployment becomes a problem. However, some countries in the region are placing increased emphasis on light industries such as apparel, viewing these sectors as engines of growth for their economies. For several of these countries, the textile complex already accounts for a significant proportion of industrial output. Many Eastern European nations are becoming increasingly important suppliers to the Western European market; a large portion of the exports represent OPT, however.

Africa already has textile and apparel production in many areas; however, for the most

part, this continent is largely underdeveloped both in a general sense and in terms of the textile complex. Particularly as firms in more-developed nations seek low-cost labor, Africa will likely become an area of growth in the future. Having received outside investment, Morocco, Tunisia, and Mauritius have developed significant export industries; these are largely OPT operations. In contrast, the Republic of South Africa has a well-developed textile complex that faces many of the same challenges as mature industries in other, more industrialized nations.

In summary, textile and apparel production is changing rapidly around the world. This chapter's overview helps us to see not only the emergence of many new, important producer nations, but also the degree of global interdependence that exists among textile/apparel producer nations. Nations and firms no longer look exclusively within their own borders for either production or distribution. Individuals involved in the softgoods industry will have to be aware of global shifts and accompanying competitive conditions to function effectively in the future.

GLOSSARY

Bonded warehouses are warehouses authorized by customs authorities for storage of goods on which payment of duties is deferred until the goods are removed.

Closed economy (or social market) describes a country that uses a variety of measures to restrict the products and services of other countries. Nations that have closed economies generally take these measures to protect domestic industries and to force buyers within the country to buy domestic products (import substitution).

Country of origin is the official designation of a product's origin, which is used to determine the country whose quota is used to ship products (particularly those being sent to the U.S. market).

Entrepôt is a center or warehouse for the distribution or transshipment of goods.

- Heavy industry refers to "manufacturing that uses large amounts of raw materials—such as coal, iron ore, and sand—and that has relatively low value per unit of weight" (Fisher, 1992).
- In-bond production refers to maquiladora production for which components are imported into Mexico duty-free, assembled, and then exported.
- ISO 9000 is a series of international standards for quality management and assurance for both manufacturing and service operations.
- Joint venture refers to the partnership between a foreign-owned firm and a partner in another country. More than two partners may be involved.
- Leapfrogging refers to adopting an advanced technology without going through the technological stages that preceded it.
- Light industry refers to manufacturing that uses small amounts of raw materials and employs small or light machines (Fisher, 1995). Apparel production is considered light industry, whereas automotive manufacturing is not.
- Maquiladora (or in-bond production) operations are assembly plants, mostly along the U.S.-Mexico border, in which garments are assembled from U.S.-cut parts and shipped back to the United States.
- Mature industry refers to an industry in an advanced stage of development. Often these are the industries that were first established in a country and have matured to a stage in which competitiveness is a problem in some respects. Although products and processes may be at a high level, a decline in employment is typical.
- Open economy describes a nation that has few barriers to trade with other countries that attempt to sell products and services there.
- Outward processing or outward processing trade (OPT) is the European term for sending cut garments to lower-wage countries for final assembly. In Hong Kong, the term used is outward processing arrangement (OPA).
- Postindustrial society refers to the major industrialized countries, in which traditional manufacturing activity is replaced gradually by high-technology industry and employment emphasizes services, government, and management-information activities (Fisher, 1992).
- *Privatization* is the process of transferring stateowned industries (and farms) to partial or full private control.

- Quotas are limits on the volume of garments or other products that can be shipped into an importing country such as the United States. Quota limits are generally established through negotiations under global trade policies for textiles and apparel. (Under previous trade policies, the United States may also set quotas unilaterally—that is, without negotiation—and has done so in the past in a limited number of cases.)
- Redundant workers are employees who become unnecessary through industrial restructuring or market changes. Although the term redundant may appear to be unkind, it is common in industrial and economic literature.
- Reexports consist of the outward movement of nationalized goods, plus goods that, after importation, move from bonded warehouses or free zones without having been transformed. Nationalized goods consist of imported goods in free circulation in the home territory that are subsequently exported without transformation (personal communication with R. Jackson, 1989).
- Restructuring refers to a shift in emphasis in economic sectors or activities. For example, restructuring of the textile complex in the developed countries may include transferring some laborintensive operations to low-wage countries. In another example, restructuring in the developing economies may include a shift from agriculture to industrial production.
- Shipments refer to the goods produced by manufacturers; the term is often used to refer to a country's domestic manufacturers' output.
- Social charges (or social costs) include all costs paid by the employer (but not directly to the worker). These may include vacation pay, medical benefits, unemployment benefits, and so on. They vary greatly from one country to another. In some developing countries, they may even include free meals.
- Sourcing refers to the process of determining how and where manufactured goods or components will be procured (obtained). The term has a rather imprecise meaning—sometimes referring to procurement of finished goods, sometimes to components, and sometimes to outward processing arrangements for having assembly operations performed in low-wage countries. The reader should also note the definition of *outsourcing*; these terms are often used interchangeably.

Sourcing is a part of business for both manufacturers and retailers.

Technology transfer, as we will use the term in this book, refers to diffusion of technological developments beyond their country of origin. The transfer may occur through exported products, industrial processes, and skills required for technical improvements or through innovations in production and other operations. Technology transfer can occur domestically, too—from one industry to another, from academe to industry, or in other ways.

Textile mill products industry refers to the conversion of fibers into finished fabrics; this includes spinning and texturing yarns; knitting, weaving, and tufting; and dyeing, printing, and other forms of finishing.

Transshipment occurs when manufacturers in one country ship products to a second country with an unused quota to take advantage of that quota. This strategy is a means of circumventing the producing country's quota limitation in the importing market.

Value added is the value, in dollars or other currencies, added to a product during the last stage of production. It is the difference between the value of goods produced and the cost of the materials and services purchased to produce them—including wages, interest, rent, and profits. The sum of value added of all sectors of the economy equals GDP. Value-added products or value-added production generally refer to products or processes with a high value-added content.

Visas are issued by the quota regulatory authority of the country in which the goods originate. They certify the origin of the goods, specify the product type and quantity, and authorize the shipment.

SUGGESTED READINGS

Bonacich, E., Cheng, L., Chinchilla, N., Hamilton, N., & Ong, P. (Eds.). (1994). *Global production: The apparel industry in the Pacific Rim.* Philadelphia: Temple University Press.

Original research on apparel production in several Pacific Rim countries.

Caribbean/Latin American Action. (annual). Caribbean basin databook. Washington, DC: Author. A handbook of current information on economic and social factors in more than 40 countries in the Caribbean basin.

ECHO. (1991). Textiles and clothing in Eastern Europe. London: The Economist Intelligence Unit. An overview of the industry in Eastern Europe, including the former Soviet Union (written after some of the changes occurred in the region).

Enderlyn, A., & Dziggel, O. (1992). *Cracking Eastern Europe*. Chicago: Probus.

Detailed information for marketers interested in Eastern Europe.

Finnerty, A. (1991). *Textiles and clothing in Southeast Asia*. London: The Economist Intelligence Unit. *An industry overview of several countries in the region.*

Fitzpatrick Associates. (1991). *The clothing industry* and the single European market. London: The Economist Intelligence Unit.

An overview of the EU apparel industry and its future prospects in a unified Europe.

Hill, H. (1992). *Indonesia's textile and garment industries*. Singapore: Institute of Southeast Asian Studies. *A study of the evolution of Indonesia's industry and policies affecting the industry.*

Koshy, D. (1997). *Garment exports: Winning strategies*. New Delhi: Prentice-Hall of India Private Limited. A study of India's garment export industry and winning strategies for the future.

McNamara, D. (1995). *Textiles and industrial transition in Japan*. Ithaca, NY: Cornell University Press.

The first English-language comprehensive look at the Japanese textile industry through the 20th century.

Peterson, K. (1992). *The maquiladora revolution in Guatemala*. New Haven, CT: Yale University Printing Service.

The first comprehensive study of the garment assembly industry in Guatemala.

Pincheson, E. (1995). East European textiles and clothing: An industry in transition. London: The Financial Times.

A comprehensive overview of the East European textile and apparel industries.

Price Waterhouse. (various dates). *Doing business in*_____. Various countries: Author.

Guides to conducting business in various countries, giving a good overview of business conditions in each country presented.

Scheffer, M. (1994). *The changing map of European textiles*. Brussels: L'Observatoire Européen du Textile et de l'Habillement.

An investigation of outward processing and sourcing strategies for European garment production.

Steele, P. (1988). *The Caribbean clothing industry: The U.S. and Far East connections.* London: The Economist Intelligence Unit.

A profile of Caribbean apparel manufacturing.

Steele, P. (1990). Hong Kong clothing: Waiting for China. London: The Economist Intelligence Unit. An overview of Hong Kong's industry, with prospects for the industry as China assumes rule of Hong Kong.

Textile Institute. (1993). Asia and world textiles. Textile Institute Conference Proceedings (Hong

Kong). Manchester: Author.

A collection of papers presented at the Textile Institute's annual meeting; this source provides excellent information on the industry in Asia at the time of the conference.

United States Chamber of Commerce. (1992). North American Free Trade Agreement. Washington, DC: Author. An overview of the agreement and its implications for business.

United States Department of Commerce. (Monthly on CD ROM). *United States national trade data bank* (*USNTDB*). Washington, DC: Author.

A CD series (or on line for a fee) on countries with

general and market information.

United States International Trade Commission. (1997). Likely impact of providing quota-free and duty-free entry to textiles and apparel from sub-Saharan Africa. Washington, DC: Author. This study provides information on the African industry not readily available elsewhere.

Ward, K. (Ed.). (1990). Women workers and global re-

structuring. Ithaca, NY: ILR Press.

An examination of how women workers are affected by global restructuring; includes various industries.

Werbeloff, A. (1987). *Textiles in Africa: A trade and investment guide*. London: Alain Charles Publishing Ltd.

An overview of the African textile and apparel industries. Because of difficulty in securing data on African nations, this may be one of the few sources of its type.

And Street particular contents the company assertion of the scale of

Part IV gives an overview of the U.S. textile and apparel sectors and presents the domestic industries

within the broader international context. More specifically, the objectives of Chapters 8 and 9 are (1) to provide a profile of the U.S. textile and apparel industries, (2) to show the role of these industries as significant contributors to the U.S. economy, and (3) to convey an understanding of the position of the U.S. industries within the global setting.

Chapter 8 provides an overview of the total U.S. textile complex and presents information common to various segments of the complex. Chapter 9 presents an overview of the U.S. textile and apparel sectors, including sections on production, employment, markets, and trade. An examination of these factors will help the reader understand these

unique industries, their role in the domestic economy, and factors that affect their international competitiveness. Emphasis is placed on an economic and performance profile rather than on providing technical details of production.

Although this section focuses primarily on the U.S. textile complex, efforts are made whenever possible to place these industries in a global perspective. Because of today's interlinking global economy, and particularly because of the position of the textile complex in that global economy, no country's textile and apparel industries can be considered in isolation. Since the U.S. textile complex has been shaped profoundly by global market forces, this section is intended to convey a profile of the U.S. domestic textile and apparel industries—which are part of the larger global picture.

An Overview of the U.S. Textile Complex

The textile complex can claim the longest history of any industrial sector in the United States. Moreover, the textile complex's role as a vital segment of the American economy has continsince the early days of cottage industries and mill villages. As a long-established basic industry, the textile complex has contributed immeasurably to the economic development of the United States. The industry has been the means by which untold numbers of families and individuals have sustained themselves with the basic necessities of life. Moreover, employment in the textile complex permitted many to move beyond the subsistence level and enter the mainstream of American life. As a source of employment for many generations of workers engaged in their first industrial jobs, the textile complex has allowed workers to improve their living conditions, send children to college, and enjoy at least a degree of the prosperity that characterizes this country. In many respects, the U.S. textile complex still fulfills this basic role, providing employment for an enormous number of individuals who in many cases have few other job alternatives.

Today the fiber-textile-apparel complex is still the largest manufacturing employer in the U.S. economy, providing jobs for more than 1.5 million workers, or more than 8 percent of the

domestic industrial workforce. When cotton and wool production is included, the number of workers exceeds 1.7 million. Production facilities are located in every state, and the complex is the largest manufacturing employer in nearly a dozen states. Moreover, textile and apparel firms are often the primary employers in rural regions, yet the apparel sector is also a major source of jobs in metropolitan areas, particularly in the Middle Atlantic states and California. Figure 8–2 shows the importance of the textile and apparel industries in providing employment in the United States.

The textile complex, which led the way for widespread employment of women outside the home, is still the leading manufacturing employer of women. The textile and apparel sectors are a leading industrial employer of minorities. Moreover, many new immigrants in the United States still find these industries, particularly apparel production, to be one of the most readily available and most accepting sources of employment.

Not only does the textile complex contribute directly to the U.S. economy in important ways, it also contributes indirectly through close ties with other industrial and agricultural sectors. A number of other industries are closely linked to the textile complex; therefore, the activities and

FIGURE 8-1

The U.S. textile complex plays a vital role in the nation's economy. *Source:* Illustration by Dennis Murphy.

general status of the textile and apparel industries have a significant impact on the economy beyond that of the complex itself. In addition to the number of workers directly employed in the textile complex, it has been estimated that the textile and apparel industries provide jobs for several hundred thousand persons in service and other related support industries (U.S. Congress, Office of Technology Assessment [OTA], 1987). Examples are cotton growing, producing dyestuffs and fabric finishes, and providing merchandise for an area vital to the retailing industry. That is, apparel sales are the most important merchandise category for department stores, mass merchandisers, and specialty stores.

The textile complex is large and highly fragmented. It represents a production and marketing chain in which fiber is made into various fabric products for sale to consumers and industrial users. Major segments include fiber producers, yarn and fabric manufacturers, and finished goods manufacturers, including apparel producers. These segments have unique business structures and unique histories and employ quite different technologies. Yet, many industry segments are integrated with one another in important ways, making producers dependent upon upstream and/or downstream activities for ultimate success.

The comprehensive, yet fragmented, nature of the textile complex is both an asset and a

FIGURE 8-2

The geographic distribution of textile and apparel employment by state, 1996 (including fiber production).

Source: Bureau of the Census, County business patterns. Washington, D.C.: U.S. Government Printing Office.

liability. The flexibility of the system allows products to be matched to markets through a range of changes in styles and production technologies. On the other hand, fragmentation has made the industry more vulnerable in facing global competition. Segments of the textile complex are affected by trade in different ways, yet most producers have a common concern for retaining the U.S. market and for remaining competitive in an increasingly challenging global market, of which they are a part.

Different sectors of the textile complex compete in a variety of markets, ranging from the trade of cotton on exchange markets to the retail distribution of apparel goods. All of these markets have become global in nature. Manufacturers have come to realize that even the domestic market, which they had considered their own, is now an important part of a global market.

This chapter provides an overview of the U.S. textile complex on the following: (1) con-

tributions to the U.S. economy; (2) impact of consumer demand; (3) challenges to the textile complex; (4) changes in the complex; and (5) participation in international trade. For the most part, this chapter examines the textile complex as a whole—that is, common areas affecting most segments of the industry. The following chapter focuses on the textile and apparel industries as separate sectors.

MAJOR SEGMENTS OF THE TEXTILE COMPLEX

Activities of the textile complex include:

- **1.** the processing of natural fibers and the production of manufactured fibers
- **2.** the conversion of those fibers into intermediate textile mill products such as yarns and fabrics
- 3. the manufacture of end-use products from the intermediate components. End-use products include apparel; interior furnishings textile products such as carpets, draperies, and bed linens; and industrial applications such as tires and erosion-control webbing

Traditionally, the textile complex was structured so that each production segment was fairly separate from the others. Producers in each segment provided the intermediate products used by manufacturers in the next phases of the production chain. In the traditional industry structure, for example, a cotton producer sold to a fabric manufacturer, who in turn sold to an apparel producer; then the apparel was sold to a retailer, who sold to the consumer. This production-marketing chain, also known as the **softgoods chain**, has become more integrated in recent years.

As U.S. manufacturers strove for advantages over their foreign competitors, new relationships and new alliances developed within the U.S. industry. Domestic manufacturers, in-

dividually and collectively, have worked to achieve greater speed, efficiency, and highquality production through more integrated relationships within the chain. With more emphasis on fast and continuous flow, **vertical integration** means that traditional links in the chain are more susceptible to either **backward** or **forward integration** efforts than in the past.

Vertical integration led to increased **concentration** within the industry as one segment acquired capacity in other segments. That is, fewer companies accounted for a larger proportion of the industry's output. Although the concentration varies from one segment to another (and remains low compared to other industries), further integration, particularly for fibers and fabrics, will continue. The growth of multinational firms with diversified production capabilities and market-oriented organizations will continue to alter the **industry structure** that existed in the past.

Despite changes in the structure of the textile complex through integration and concentration, the various segments of the complex can be identified by their distinct activities. That is, the basic activities of the different segments remain the same: fibers are made into intermediate products, those products are developed into end-use goods, and the finished products are made available to end-use consumers, including industrial consumers. By contrast, many changes took place in the fiber-fabric-apparel-retail *organizational structures and relationships* through which these activities occurred. This restructured softgoods chain is discussed further in this chapter.

Although industry segments will be covered in more detail in the following chapter, an overview is presented here to provide a broad perspective on the activities in the textile complex.

Production of Fiber

Fibers are the raw materials—that is, the basic components—for all the activities and resulting

products that occur in later stages in the textile complex. In other words, without fibers the textile complex as we know it today could not exist. Figure 8–3 depicts the U.S. textile industry structure and fiber use by end products.

Fibers are categorized into two basic groupings: (1) natural and (2) manufactured fibers (known previously as *man-made* fibers). Production processes vary greatly according to whether the fibers are natural or manufactured. Natural fibers include cotton, wool, silk, linen, ramie, hemp, jute, and several less prominent fibers. Most of these are products of agriculture and play important roles in international trade, particularly for the agricultural sector. Only cotton and wool are produced in the United States at present; however,

products made of other natural fibers (particularly silk, flax, and ramie) became common in U.S. markets in recent years as a result of foreign trade.

Manufacture of Textile Mill Products

The manufacture of textile mill products represents the intermediate segment of the textile complex and consists of three primary operations: (1) yarn spinning, (2) fabric forming, and (3) fabric finishing. This segment also includes the production of a number of finished nonapparel consumer products such as sheets and towels. Although many small firms perform specialized aspects of these operations, a large num-

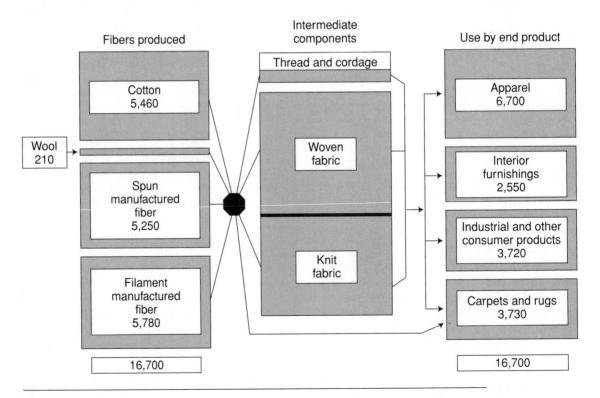

FIGURE 8-3

U.S. textile industry structure and fiber use by end product (1995, millions of pounds). *Source:* C. Priestland, Chief Economist, American Apparel Manufacturers Association (based on data from Fiber Economics Bureau).

ber of textile mills have integrated operations from yarn spinning through fabric finishing.

Yarn

Yarn generally is used in the production of other goods. Most frequently, textile yarn is used to weave or knit fabric or to tuft carpet. Other products include cordage and a variety of strand products.

Fabric

In fabric manufacturing, yarn is transformed into fabric through weaving or knitting; for nonwoven fabrics, fibers are bonded or interlocked by mechanical, chemical, or thermal means to form the fabrics. The resulting fabrics are a fundamental intermediate textile mill product used in a large proportion of the end-use products that come from the textile complex.

Dyeing and Finishing

Newly produced fabric from the loom or knitting machine usually requires additional dyeing and/or finishing from the unfinished (greige) stage to make it desirable for consumer end use. Dyes and finishes add important aesthetic properties, comfort, ease of care, and durability—all of which are critical to customer appeal and satisfaction.

A number of the processes for manufacturing textile mill products are quite knowledgeand capital-intensive; thus, these characteristics differentiate global production sites to some extent. The production of manufactured fiber yarns, and particularly the blending of multiple fibers into a single yarn, require sophisticated manufacturing capabilities. In addition, a number of the finishing processes are knowledge- and capital-intensive, giving the United States and other more-developed countries an advantage in production.

Manufacture of End-Use Products

Manufactured end-use products made from textiles include apparel, home furnishings textiles, and textiles for industrial applications. The apparel industry accounts for nearly half of all textile and apparel sales. Although apparel dominated this category of U.S. production in the past, in recent years finished products for interior furnishings and industrial use have generally experienced stronger growth than domestic apparel.

The apparel segment of the textile complex is the most labor-intensive, fragmented, and price competitive. Whereas other aspects of the industry are shifting from small firms to larger and more vertically integrated operations, apparel production continues to be dominated by small manufacturers (in numbers, but not in the value of production), jobbers, and contractors. Because apparel production tends to be labor-intensive, and because U.S. wages are high compared to those of many other countries, this segment of the U.S. complex is most affected by production in other regions of the world.

A Related Sector: Textile Machinery Manufacturing

The U.S. textile complex is dependent upon the textile machinery industry to provide new equipment, which will not only increase productivity and quality, but will also develop new products and processes. The U.S. textile machinery industry was the primary supplier of domestic machines until the early 1960s. Since that time, other major suppliers have entered the global machinery industry; the most prominent ones include Germany, Switzerland, Italy, and Japan. Although U.S. textile machinery industry exports for 1997 were about \$613 million (37 percent of the machinery produced), imports were nearly \$1.5 billion. Imports account for about 63 percent of the textile machinery used in the United States.

FIGURE 8-4

264

Contributions of some major U.S. industries to the GNP (in billions of dollars, 1996).

Source: U.S. Department of Commerce (Bureau of Economic Analysis) and American Textile Manufacturers Institute (1998).

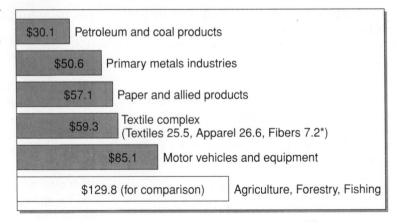

Total U.S. GDP in 1996 = \$7,636.0 GDP for private industry = \$6.639.8

Since 1984, half or more of the U.S. textile machinery market has been supplied by other countries. However, improved export sales resulting mostly from NAFTA have improved the trade deficit for the industry (DRI/Mc-Graw-Hill and Standard & Poor's and U.S. Department of Commerce, 1998).

The last U.S. loom maker, Draper Corporation, was purchased by Texmaco, a large Indonesian firm, in 1996; operations remain in the Carolinas. Similarly, foreign companies supply industrial apparel production equipment to the domestic market. Union Special Corporation and Reece were the last major U.S. suppliers of industrial sewing machines, but both have been bought by firms in other countries in recent years.

CONTRIBUTIONS OF THE TEXTILE COMPLEX TO THE U.S. ECONOMY

Contributions to GNP

The textile complex contributes to the U.S. economy in a number of important ways. The

GNP generated by the textile and apparel industries compared to selected other U.S. sectors is shown in Figure 8–4.

Contributions to Employment

Although growth in employment for the textile complex lagged behind that for the industrial sector as a whole, in recent years more than 8 percent of the U.S. manufacturing workforce has been employed in the textile and apparel industries.

Table 8–1 displays employment statistics for the textile and apparel industries for 1983 to 1992. Note that a net decline in employment occurred for both industries. One should keep in mind, however, that the decline in employment cannot be attributed to negative influences alone. For example, improved technology and other operating efficiencies increased productivity in some segments of the industry; thus, fewer workers were needed to perform the production tasks. Domestic production has increased, in fact. In this sense, these shifts were due to operating efficiencies that made the U.S. industry more competitive globally by reducing labor costs.

^{* 1995} data

TABLE 8–1U.S. Textile and Apparel Production, Employment, and Consumption

	Produ	ction (1992 =	: 100) ^a			sumption er Sp. (bil. \$) ^c
Year	Textile Products	Apparel Products	Industrial	Employment (Textiles/Apparel) ^b (in 000)	Clothing ^d	Semidurable Interior Furns.
1997	109.6	103.8	127.0	1,421	230	
1996	106.7	105.5	120.2	1,488	220	30.1
1995	109.9	107.8	116.0	1,599	213	28.9
1994	110.6	108.1	110.0	1,650	207	27.2
1993	105.2	106.4	103.8	1,664	193	25.0
1992	100.0	100.0	100.0	1,681	184	23.2
1991	92.7	92.8	96.2	1,676	172	21.6
1990	93.2	90.3	98.5	1,728	167	21.2

^a Federal Reserve Board.

Note: Data in the table were compiled with assistance from staff at the American Textile Manufacturers Institute and the American Apparel Manufacturers Association.

The textile complex has played a particularly significant role in providing jobs for women, minorities, and new immigrants. Many segments of the textile complex employ about twice as many women, blacks, and persons of Hispanic origin as all types of manufacturing; the contrast is not as great as it is with all manufacturing of **nondurable goods** (some sources consider these manufacturing areas to require lower skill levels than **durable goods** manufacturing).

Contributions to Other Sectors

Value Added

A number of other important U.S. industries are linked closely to textiles and apparel. According to the Office of Technology Assessment (United States Congress, OTA, 1987), only about one-fourth of the valued added by production and sale of textile goods and fabricated textile products goes to textile and apparel firms, although

about 40 percent of the value added from production and sale of fabrics and apparel remains within the industry. According to OTA, the rest of the value from textile/apparel sales is distributed broadly throughout the economy. That is, many other sectors benefit from the value that is added at different levels of textile and apparel production.

Other Jobs Created

OTA (1987) found that \$1 million in output from the U.S. textile and apparel industries creates 26 to 30 full-time equivalent jobs (depending on the segment of the industry) in other areas of manufacturing, natural resource industries, construction, and so on. The OTA staff noted the important linkages with the service industries, particularly transportation and trade, as well as the highly paid "transactional" services like finance, insurance, and business services.

^b Data for textiles (SIC 22) and apparel (SIC 23), Bureau of Labor Statistics.

^c U.S. Dept. Of Commerce.

d Includes accessories and other related items.

In a study funded by a U.S. textile/apparel industry group, the Economic Policy Institute (1993) found that for every 100 manufacturing jobs in textiles, another 267 jobs were generated in a "multiplier" effect. Similarly, the group found that 100 apparel jobs generated 207 secondary jobs.

Other Contributions

OTA (1987) estimates of full-time job equivalents generated by textile/apparel jobs did not include retailing. Many additional persons in the retail sector depend upon the domestic complex to produce the goods they sell. The OTA estimates also do not include persons employed through new equipment purchases or plant modernization. (As we noted earlier, however, a substantial proportion of the production equipment is secured from other countries.)

Overall, the textile complex is vital to the U.S. economy in a number of ways: by contributing to the GNP, by providing more manufacturing jobs than any other industrial sector, and by contributing importantly to other sectors through a variety of linkages. In addition to its overall contributions to the U.S. economy, the importance of the textile complex and its linkages is intensified in regions such as the southeastern United States, where textile and apparel manufacturing represents one of the primary sources of employment. The industry represents the lifeblood of many of those regions, and its success or decline has a severe impact on those communities and regions.

THE IMPACT OF CONSUMER DEMAND

Consumer demand has a profound impact on the economic health of the textile complex and the total softgoods chain. Consumer spending for clothing and **semidurable** home furnishings products generates the basic demand that extends back through the production and marketing chain—as far back as the initial fiber production. Consumer demand in other areas also affects the textile complex. For example, since automobiles contain many textile components, consumer demand for autos influences the textile complex rather significantly.

As we noted in Chapter 6, which focused on the global perspective, consumer demand is also referred to as *consumption* by certain sources that collect industry data. U.S. consumption, production, and employment data for 1990 to 1997 are given in Table 8–1.

An index is used for production comparisons (based on assigning a value of 100 to production in 1992), whereas consumption is shown in billions of dollars. Of particular note, U.S. consumers spent \$230 billion for clothing in 1997 and \$30.1 billion for semidurable home furnishings products in 1996.

The impact of consumer demand on the total chain might be compared to that of a train in which consumer spending provides the momentum for the overall operation. In other words, consumer spending is the engine of activity for the softgoods chain. Although the industry is becoming more integrated, making it more difficult to identify the distinct segments as clearly as Figures 8–5 and 8–6 suggest, the train analogy may be a helpful way to conceptualize the impact of consumer demand.

In the example depicted in Figure 8–5, consumer spending created demand at the retail level. In turn, the sales activity for the retail segment of the chain required increased production from apparel manufacturers. As apparel manufacturers responded to orders, they required additional textile mill products (going back to the fiber stage) to meet the demand. When business conditions are optimum, different segments of the softgoods chain usually respond and work together with reasonable effectiveness (often with *remarkable* effectiveness), especially considering the volatile nature of fashion products (hence, the speed and

FIGURE 8-5

Using apparel purchases as an example, the train—led by consumer spending (the engine)—moves at a healthy rate, and the segments move together.

FIGURE 8–6This train shows the impact of a sharp slowdown in consumer spending.

timing involved) and the fragmented nature of the chain.

Sometimes, however, a variety of factors can influence consumer spending and create conditions in which the softgoods chain loses its momentum. When consumer demand slows, especially if this occurs rather abruptly, the train analogy might appear as in Figure 8–6.

Just as consumer demand extended backward in the softgoods chain when spending was at a healthy pace, a *decline* had a braking effect backward in this case. As consumer purchases slowed, retailers experienced excessive inventory buildups. Not wishing to add to ex-

isting inventory excesses, retailers reduced orders to apparel manufacturers. Since apparel manufacturers no longer had the anticipated retail orders to fill, they had no need for the textile mill products they had projected using. Like the retailers, the apparel manufacturers did not wish to have an excess of potentially unsalable inventory, so they, too, reduced orders to textile producers. Keeping in mind that several operations occur within the textile production portion of the chain, multiple effects may have occurred within the segment. In short, the change in consumer demand had an adverse effect on the total softgoods chain.

A number of examples, often with different causes, can be given to illustrate the slowdown effect on the total chain caused by a decline in consumer spending. Apparel demand in particular is unpredictable, causing manufacturers to face cyclical patterns of production. Factors influencing demand include shifts in the economy, styles, competing consumer interests, demographic changes in the market, and changes in lifestyle. Examples follow, which illustrate the effect of slowed demand as it extended through the production and marketing chain. The examples are followed by some of the lessons learned.

Slowed Demand Due to Style Changes

Although short skirts were accepted by the early 1990s, in 1988 many independent women consumers rejected the mini-skirt introduced by the apparel industry. These felt the mini was inappropriate for the new professional roles they had worked hard to attain, and they rejected the industry's attempts to shift the preference to a new length. Consequently, apparel retailers found that the mini-skirts remained on their racks. Not only were women's apparel sales affected, but men's purchases were influenced as well. Because women are the primary purchasers of men's apparel, when female consumers were unenthusiastic about shopping for themselves, they also shopped less often for men's apparel. Consequently, ill-fated efforts to change the skirt length created a decline that extended through the various segments of the industry dependent upon apparel sales for healthy growth. Consumers have asserted a new independent spirit toward changing fashions and are now more likely than in the past to choose a "look" that seems right for them rather than following the dictates of fashion.

Moves toward more casual office attire the "casual Friday" or "casual everyday" concepts—have affected segments of the industry in different ways. Producers of both men's and women's suits have seen a decline in sales, whereas companies that produce more casual lines have benefited from the trend. Not only have the apparel makers been affected by this switch, but also the fabric and fiber producers whose components are used in dressy versus casual wear.

Slowed Demand Due to Economic Changes

Economic changes have a tremendous effect on demand—which, in turn, affects the entire textile complex. Various types of economic change affect **consumer confidence**. Consumer confidence, as measured by established survey procedures, provides an indication of consumers' perceptions of general economic well-being at a given time. The resulting consumer confidence index provides a rough indicator of consumers' willingness to spend. Trends in consumer confidence, which affect demand, are particularly notable in the U.S. recessionary periods of the early 1980s and 1990s, as shown in Figure 8–7.

Consumer demand was sluggish in both the early 1980s and 1990s, making these periods particularly difficult for most segments of the softgoods chain. As retailers attempted to respond to erratic sales and carrying costs, they tightened their inventories and placed smaller than usual orders. In effect, this meant that retailers shifted the financial burden of holding existing warehouse inventories to manufacturers rather than securing the inventories themselves. In addition, some retailers were slow to pay manufacturers. Manufacturers' profit margins suffered.

The October 1987 stock market crash was another example of how changing economic conditions affected the textile complex. Consumer confidence dropped, and retailers became cautious about future buying plans. Although consumer expenditures remained high as a result of heavy discounting and promo-

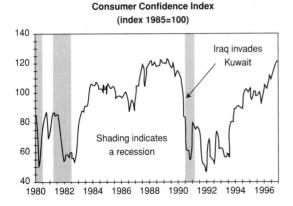

FIGURE 8-7

Consumer confidence, based on an index of 100, in 1985.

Source: From U.S. Industry and Trade Outlook '98 (p.xviii), 1998, DRI/McGraw-Hill and Standard & Poor's and U.S. Department of Commerce/International Trade Administration. Based on data from The Conference Board.

tions on the part of retailers, new orders for textile mill products began to reflect concern over economic uncertainties.

Lessons Learned

More Careful Inventory Management

During economic slumps like those of the early 1980s and 1990s, all segments of the industry became more proficient at careful inventory management. Since manufacturers and retailers often borrowed to finance production or inventory for forthcoming seasons, periods of high interest rates such as those in the early 1980s (interest rates were 14-17 percent) caused carrying charges to be exorbitant. As retailers and manufacturers alike experienced losses associated with the excessive inventories and high interest rates, companies at all levels became sensitive to the need for more careful inventory management. In the textile sector, overproduction and forced liquidation of apparel fabrics taught mill managers to be more sensitive and skilled in scheduling production. Textile manufacturers learned to work more closely with apparel manufacturers and retailers to gauge consumer demand.

Greater Emphasis on a Marketing Orientation

Difficulties experienced by the textile complex in the early 1980s encouraged both textile and apparel manufacturers to focus on a stronger marketing orientation. Although the unsuccessful attempt to promote the mini-skirt in 1988 indicated that the industry can still miscue at times, manufacturers have become much more sensitive to the importance of responding to consumers' needs and desires through improved marketing efforts. More and more companies in the textile complex are learning to put the consumer at the center of their activities.

Although consumer demand influences the production chain in any sector, the consumer's impact on both upstream and downstream segments is exaggerated in the textile complex and in the total softgoods chain. The "perishable" nature of fashion goods and the seasonal characteristics of many of the products mean that excessive inventory from one season can seldom be held for a following season.

Major Trends That Affect Consumer Demand

At best, prediction of the consumer's textile and apparel (particularly apparel) purchases is difficult. To be in touch with consumer demand, the industry must be sensitive to major demographic shifts occurring in the population. Manufacturers must be alert to changes in the age of the population, shifts in households, household composition, geographic shifts, income shifts, and other demographic patterns that affect total consumer spending on textile and apparel goods.

The following sections give examples of major shifts that generally affect the demand for textile and apparel products in U.S. markets.

Population Changes

The growth and composition of the population will shape the apparel market of the future. The U.S. population is expected to reach almost 300 million by the year 2010, with noticeable growth among certain age groups. The birth rate is expected to drop slightly; however, the children of baby boomers entered their teens in the 1990s, ending a 15-year decline in the teen population. When the teen cohort reaches its peak of 30.8 million in 2010, this will exceed the baby boom teen explosion of the 1960s and 1970s in both size and duration. Teens are a powerful force in the apparel market and are likely to have a tremendous impact on spending.

At the same time, the population is growing older. The baby boomers' generation has matured and is now in its 50s. This group looks, acts, and feels younger than previous generations did. After this group's children leave home, the aging boomers will have more years of adult life left than they spent parenting. At this time, consumers generally have their highest spending potential, and their continued interest in remaining active and youthful is encouraging for the apparel industry. The over-65 group accounts for a growing proportion of the population. This cohort also is healthier than ever before, leading active, vital lives, retaining an interest in being well dressed and having the financial means to do so. The trend-setting 25- to 44-year-old cohort will decrease by 2010. Overall, population projections are favorable for the industry but portend changes in textile and apparel products in the future.

The multicultural mix of the U.S. population is increasingly affecting the apparel market. The U.S. Census Bureau forecasts that by the year 2020, Asians, Hispanics, African Americans, and other nonwhite groups could represent 47 percent of the population. A few apparel firms are offering specific lines with bold, vibrant colors to appeal to this group. A few firms have addressed the different fit of

some ethnic groups, creating styles in sizes that fall between misses and petite to appeal to Hispanic women in particular.

Southward Geographic Shifts

The U.S. population continues to shift to the sunbelt—from Virginia to California. This southward shift is expected to continue at least through the turn of the century, with most of the regions to the north of the sunbelt declining in population. Population age groups vary by geographic areas as well. For example, the South will continue to have a high population growth of persons over age 65.

Lifestyle and seasonal apparel needs vary greatly according to regional characteristics. Therefore, producers in the textile complex must be sensitive to geographic shifts because these have a significant influence on both the national and regional markets.

Increases in Education and Income

As the education and income levels of the population continue to increase, the types of textile and apparel products needed and how they are made available have changed and will continue to do so. This shift has been especially significant among women. Since the early 1970s, the increase in the education and income levels of career women has had a significant impact on the women's apparel market. In the 1980s, the shift was toward career apparel such as suits. In the 1990s, consumers seek appropriate apparel for a dressed-down workplace. Time-deprived consumers also seek fast, frustration-free shopping alternatives.

In comparison to recent decades, today's apparel consumer has sophisticated tastes, high income, and a high education level. As a result of these changes, they have become interested in better-quality, more durable garments. The consumer of the 1990s is demanding and value-oriented. This consumer wants a quality product at a reasonable price and is not

easily manipulated by efforts to foster unnecessary purchases.

Changes in Household Formation and Home Sales

Changes in household formation have a significant impact on both the apparel and home furnishings markets. Although the number of households has increased in the 1990s, husbandwife households are expected to increase at a slower rate. During the same period, divorce rates and postponement of marriage are projected to have increased the number of singleadult (both female and male) households substantially. The composition of households affects income levels, sometimes positively and sometimes negatively. For example, the two-career household may have generous spending potential; a single-career household resulting from divorce may have decreased spending potential. In addition, shifts in the presence of children in various household formation arrangements affect the children's-wear market. Shifts in household formation are also particularly important for the home furnishings market. Increases or decreases in household formation have a significant impact on purchases of carpeting, rugs, draperies, upholstered furniture, and other textile goods.

Home sales are somewhat related to household formation; however, trading up from one home to another is not a new household formation. Home sales have been brisk in recent years because of low interest rates. New home sales in 1996 were the highest since 1978. New home sales are particularly beneficial to the textile industry.

Forbes writers Feldman and Levine (1993) assert that the 1990s is the decade for consumers to focus on the home. They believe the 1980s was the decade to "drape the body" and the 1990s is the decade to "drape the home" (p. 64).

Other Competing Factors

At times the textile and apparel industries are affected by other factors that compete for con-

sumers' dollars. For example, in recent years, consumers have invested significantly in computer technology for the home. They have also shown increased interest in travel, particularly international travel. These and other competing factors reduce the funds available for apparel expenditures that were once a higher priority for many individuals.

Consumer debt is also a factor to consider. Escalating levels of consumer indebtedness, which reached more than \$1 trillion in 1996 after more than 3 years of consecutive growth, will surely affect how consumers buy textile and apparel products in the future. A day of reckoning will come when that debt must be faced.

CHALLENGES TO THE U.S. TEXTILE COMPLEX

Recent decades have been difficult, particularly at times, for all segments of the U.S. textile complex. One must also keep in mind that the textile complexes in most other industrialized market economy countries experienced similar periods of growth and decline.

Following World War II and through much of the 1960s, U.S. producers enjoyed a fairly captive market. The large, relatively affluent U.S. market absorbed most of the shipments from domestic textile, home furnishings, and apparel manufacturers. Although foreign competition became a concern to certain segments of the textile complex by the 1960s, U.S. producers generally enjoyed prosperous growth. By the early 1970s, the textile and apparel workforce reached a peak of 2.3 million.

In the 1970s, the competition from producers in other countries began to have a serious impact on the U.S. textile complex (as it did on the industry in virtually all other developed countries). Previously secure domestic markets became threatened by an influx of products from an increasing number of producer nations, many of which offered

products at considerably lower prices than U.S.-made products because of wage differences. As evidence of the increased shipments, the U.S. textile and apparel trade deficit for 1972 was \$2.4 billion compared to \$191 million in 1961—more than a 12-fold increase in slightly more than a decade. During this time, the NICs emerged as major competitors of the U.S. textile and apparel industries. By 1974, imports from Hong Kong, Korea, Taiwan, and China accounted for 56 percent of the apparel imports entering U.S. markets. By the 1970s, Japan had moved toward more advanced industrial manufacturing, accounting for only 8 percent of the U.S. textile/apparel imports in 1974 (Ghadar et al., 1987).

Moreover, imports escalated during the period when U.S. consumption had slowed markedly. For nearly two decades, U.S. expenditures for apparel, for example, rose only slightly. Consequently, the combination of increased import shipments and sluggish demand heightened competition for the existing U.S. market.

As a result of the intense competition during the 1970s, the U.S. textile complex faced the fact that its ultimate survival was in serious jeopardy. Manufacturers who wanted to survive realized that previous approaches to business were no longer adequate. Business failure rates for the textile complex were high, particularly for apparel. In 1975, for example, business failures in the textile complex accounted for almost one-third of all U.S. manufacturing business failures. For most years between 1960 and 1990, textile complex business failures represented about 10 percent of those for all manufacturing.

Although imports were taking a greater proportion of the U.S. market, one must not conclude that all the business failures in the textile complex were attributable to imports. According to Standard & Poor's (1984), the textile complex included more than 15,000 firms in the early 1980s, many of which pro-

duced a rather narrow range of products¹. As a result of the large number of domestic firms, competition *among* U.S. producers was excessive as well. Therefore, many manufacturers in the U.S. textile complex were unable to survive in the increasingly competitive domestic business environment.

Some segments of the industry—the apparel segment in particular—are easy to enter (i.e., they have few barriers to entry) because of limited capital and technology requirements (the same reasons for easy entry for developing countries). Because a number of minimally qualified entrepreneurs start operations, the fallout rate tends to be high. In short, even without the growth in imports, many of the U.S. firms would have failed. However, imports perhaps hastened the failure of marginal firms as foreign competition accelerated changes that were already occurring. In particular, imports placed downward pressure on prices; thus, profit margins of U.S. manufacturers tended to be small, and firms found it increasingly difficult to generate capital for modernization and expansion (Arpan et al., 1982).

Although manufacturers and workers affected by company failures surely would not agree, some business experts concluded that the industry as a whole became stronger and more competitive after market forces weeded out some of the weak companies. In fact, economists might view the loss of the weaker firms as the early stages of industrial adjustment. In efforts to restore competitiveness for an industry, adjustment may occur through the rationalization of existing firms and facilities in order to establish fewer, more efficient producers and a number of specialized companies. Market forces require that firms either adapt or close. For textile and apparel firms, adapting to the demands of market forces required a variety of strategies. Examples included updating

¹ Some sources, such as the American Apparel Manufacturers Association, give a larger number.

273

facilities and production methods, changing product lines, perhaps horizontal or vertical integration, and "otherwise finding means of improving competitiveness or redeploying resources to other industries" (Ghadar et al., 1987, p. 2).

The 1970s and 1980s were critical transition years for the U.S. textile complex. Many changes occurred within the complex as a whole and within individual firms, creating a production and marketing chain quite different from that of the 1950s and 1960s. Although many companies were no longer in business, and although a majority of the firms that survived experienced difficult times, the adjustment process prepared many of the survivors to function more effectively in increasingly competitive markets. The textile complex made changes "affecting the nature of the products produced; how they are produced; how they are marketed; the structure, scale, and scope of the enterprises producing them; and the nature of jobs created directly and indirectly by the industry" (U.S. Congress, OTA, 1987, p. 3).

CHANGES IN THE TEXTILE COMPLEX

During the 1970s, certain segments of the textile complex made significant progress in achieving the adjustment necessary to counter increasing international competition. Adjustment varied, however, in different segments of the textile complex. Because of the textile industry's technology and capital orientation, modernization and efficiency were more readily implemented by that segment than by the labor-intensive and more fragmented apparel industry. Within the textile industry, productivity also grew at a much faster rate than the economy as a whole.

Manufacturers achieved this result by investing in new plants and equipment that in-

creased operating efficiency and produced more sophisticated products with shorter startup times. These changes typically increased specialization and were intended to enhance the U.S. industry's position in market segments where U.S. products already enjoyed strong acceptance.

In contrast, the nature of the apparel industry made change more difficult for that sector. The apparel industry is characterized by a high degree of family ownership and a large number of small companies employing, on average, fewer than 50 workers, with many producing limited product lines; therefore, changes have been more difficult to implement. The process of constructing garments from limp fabrics was more difficult to automate than were most of the textile mill operations. Moreover, the sophisticated production that was being developed for the apparel industry by that time was often so costly that only the largest firms could justify (or afford) the expenditures. Plants (establishments) employing fewer than 50 workers did not have the money to invest in advanced technology to improve productivity.

Although change occurred more slowly, the apparel segment did make strides to improve productivity; in fact, apparel productivity grew slightly faster during the 1970s than manufacturing productivity as a whole. The share of total output produced by larger firms increased; the capital and knowledge intensity of the segment grew; and many firms broadened and upgraded their product lines.

Overall, the textile complex performed strongly during the 1970s, with growth in some segments equal to, or in some cases better than, that of the U.S. industrial complex as a whole. **Shipments** (i.e., the goods U.S. manufacturers produced) increased steadily in value after the 1975 recession, growing by 24 percent for the decade (adjusted for inflation); also, exports doubled.

As foreign competition intensified during the early 1980s, many segments of the U.S. textile complex found it increasingly difficult to

maintain the momentum established in the 1970s. Domestic firms continued their capital investment efforts; for example, the textile segment nearly doubled its investment outlay between 1975 and 1984, going from \$1 billion to \$1.9 billion annually. Despite the increased investments, productivity growth, and, in many cases, improved quality, imports continued to account for an increasing share of the U.S. textile and apparel markets (USITC, 1987b).

Between 1980 and 1992, textile and apparel imports increased 256 percent in volume and 332 percent in value (D. Link, personal communication, 1993). Apparel imports grew substantially, which meant not only that U.S. apparel manufacturers were losing a substantial portion of their market, but also that textile producers who previously had supplied the fabrics for domestic apparel production were losing a major portion of their market as well. Figure 8–8 shows the increase in textile and apparel imports that occurred during this period and the trade deficit that resulted.

Trade figures may be stated in

- · c.i.f. values
- f.a.s. values
- · customs values

According to Ghadar et al. (1987), the rise in the value of the dollar was closely correlated with the dramatic growth in textile and apparel imports. Although some sources (GATT, 1984; USITC, 1983) note that shifts in exchange rates have not been proven to affect trade in specific sectors, patterns of textile and apparel trade were altered dramatically as the value of the dollar began to increase in 1981. Within 18 months, the surge of imports began and, even more quickly, exports began to decline. The inordinately strong U.S. dollar intensified trade shifts already affecting the U.S. textile complex. The strong dollar meant that U.S. importers and retail buyers found foreign buying particularly attractive because the dollar purchased more than ever in many regions of the world (but keep in mind that the currencies in

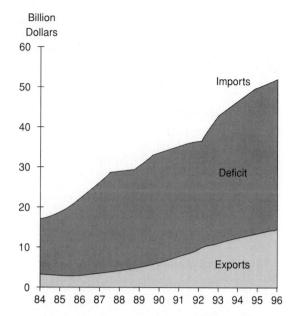

* Export data are f.a.s. values; imports are customs values.

FIGURE 8-8

U.S. textile and apparel trade.

Source: Data from U.S. Department of Commerce, International Trade Administration. Revised data series provided with assistance from M. Ruggiero of American Textile Manufacturers Institute.

several of the Asian NICs are closely tied to the U.S. dollar). Conversely, U.S. textile and apparel products became less attractive to foreign buyers because the change in exchange rates made U.S. goods more costly to purchase.

Although the U.S. textile complex had attempted to improve its competitiveness through increases in investment and operating efficiency, the impact of growing foreign competition and the shift in exchange rates continued to create challenges for the domestic industries. This led to the growing realization that much of the domestic market could not be held on the basis of reducing manufacturing costs alone; attention would have to be given to other competitive factors as well. The textile

FIGURE 8-9

The traditional softgoods chain consisted of predictable, sequential stages of production and distribution.

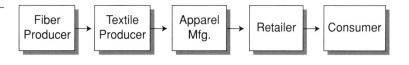

complex's attempts to retain or regain a competitive position included the following efforts (some industry efforts that have been discussed up to this point are included in the summary to provide an overall review).

Closing or Revitalizing Outmoded and Inefficient Plants

Manufacturers closed or remodeled obsolete production facilities. In some cases, market forces eliminated producers who could not compete under existing conditions. In the textile sector alone, for example, more than 350 plants were closed between 1981 and 1986 (Standard & Poor's, 1987).

Restructuring Through Acquisitions, Consolidations, and Mergers

Traditionally, the softgoods chain consists of predictable, sequential stages, as shown in Figure 8–9. Several manufacturers made acquisitions to add vertical stages of the business to their operations (vertical integration). Integration occurred forward or backward to merge production stages in the chain. Figure 8–10 illustrates a more vertical chain, in which firms take on additional stages in the chain.

For example, fabric producers integrated backward to acquire fiber or yarn production capabilities, and apparel producers acquired fabric manufacturing facilities. As an example of forward integration, apparel producers moved into the retail segment of the chain. Many of them developed successful forward integration into retailing through outlet stores.

Moreover, as the linkages within segments altered the industry's structure, the era of a textile complex composed mostly of the small, decentralized, family-owned and -operated firms passed (except in apparel production). Additionally, some companies integrated horizontally (horizontal integration). A number of consolidations occurred to deemphasize import-battered segments of the market. In general, the consolidations and mergers strengthened many companies and therefore improved the overall competitiveness of the industry.

A number of major apparel firms made acquisitions either to move into new product areas or to penetrate different levels of the retail market. VF Corporation did both. It acquired H D Lee, Vanity Fair, Vassarette, Barbizon, Blue Bell, Girbaud, Bassett-Walker, Jantzen, Health-Tex, and several other companies. In addition to the obvious range of products produced by the VF

FIGURE 8-10

In a more vertical chain, firms take on additional stages in the production-distribution process.

companies, many of them provided access to different distribution channels for the same product lines. The latter point is important because brand-name apparel manufacturers have learned that they cannot sell nearly identical merchandise to both department stores and discount stores; once products appear in discount stores, they lose their appeal to department stores. Therefore, VF Corporation's spectrum of jeans companies permits VF to be present in three channels of distribution: Rustler and Wrangler jeans for the discounters; Lee jeans for department and specialty stores; and the Girbaud line for upscale department stores. Similarly, VF's underfashion companies penetrate different channels.

Not all the **restructuring** in the industry was voluntary or beneficial, however. Despite conscientious efforts of Burlington and J. P. Stevens to restructure, both of these industry giants later faced another threat of the 1980s—hostile takeover attempts by other companies. The restructuring that followed meant that these firms no longer remained the sector's leaders that they were in earlier years. As Burlington successfully fought the takeover, its management was forced to sell major segments of the company to pay debts. In its efforts to fend off the takeover, Burlington became a privately held firm and was highly leveraged. The company fought valiantly to recover from bankruptcy and, in 1991, became a publicly held firm once again as Burlington Industries Equity, later emerging once again as Burlington Industries, Inc. J. P. Stevens, which had been the second largest publicly held U.S. textile company after Burlington, did not fare as well. The industry was stunned by the breakup of the company, which split into JPS Textile Group, West Point-Pepperell, and Forstman. Later, Farley Industries (now Fruit of the Loom) tried unsuccessfully to buy West Point-Pepperell; the company eventually emerged as WestPoint Stevens. Changes in these companies reflect the reconfigurations occurring in the industry in recent years.

Not all consolidations and acquisitions resulted from textile or apparel firms buying other companies in the complex. For example, Sara Lee—better known for cakes and pies—became the largest publicly held apparel conglomerate in the United States. Through acquisitions and strategic planning, Sara Lee quietly grew, almost unnoticed by many industry peers, to become an apparel giant with sales in its Personal Products Division of \$7.5 billion in 1997 compared to over \$2 billion in 1988. Sara Lee has such well-known brands as Hanes, Bali, Playtex, L'eggs, and Champion fleece and activewear, as well as a number of international brands.

Forming New Alliances and a "Scrambled Softgoods Chain"

Firms began to work with other companies in relationships that were different in both nature and intensity. As new alliances and new ways of doing business emerged, this has led to what might be considered a "scrambled softgoods chain." See Figure 8–11. Players in the chain have begun to function in new ways—in many cases aided by new technologies, particularly information technologies. Sometimes traditional steps in the chain are skipped. For example, textile producers who make finished end products such as hosiery have gone directly to consumers via the Internet as well as outlet stores. Apparel manufacturers have used these same routes to the consumer. Retailers have become manufacturers as they develop and contract their private label lines. And, at times, rather bizarre alliances have been forged, such as Wal-Mart providing sourcing for a Japanese retailer. We are likely to see more of these unpredictable, nonsequential alliances in the future.

Investing in Advanced Technology

As noted earlier, manufacturers invested substantially in new, more productive equipment.

FIGURE 8-11

In the scrambled softgoods chain, business alliances no longer adhere to the sequential pattern of the traditional chain.

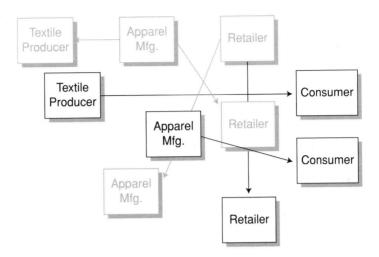

These investments, plus restructuring, accounted for improved productivity in the textile complex. Although plant closings occurred, the textile sector's Federal Reserve production index grew 23 percent from 1980 through 1997 (M. Ruggiero, personal communication, 1998). The installation of more technologically sophisticated, less labor-intensive equipment accounted for this increase. In the last decade, the textile industry has averaged about \$2 billion per year in investments to upgrade production (Standard & Poor's, 1992). The apparel sector's investment in equipment and technology was considerably less than that of the textile industry but has increased significantly in recent years.

In 1993, the Department of Energy (DOE) began a collaborative relationship with the American Textile Partnership (AMTEX) to develop technological advances to help the U.S. industry remain internationally competitive. The DOE project links eight of its national labs with industry at a projected cost of up to \$200 million over the next few years. The largest AMTEX project is the Demand Activated Manufacturing Architecture (DAMA) project, which speeds communications within the entire softgoods pipeline. Through advanced electronic marketing, companies can identify,

compare, and buy and sell resources, products, and services in support of innovative business partnerships. DAMA technologies will permit better forecasting, inventory management, and point-of-sale data analysis. (See DAMA web site at http://www.dama.tc2.com)

Developing Greater Sensitivity to Market Needs

Having been privileged to have a somewhat captive and secure market for decades, many segments of the textile complex had become insensitive to customer needs, including the needs of industrial customers. In many cases, the industrial customers were manufacturers at other stages of the softgoods chain. Some manufacturers who had prospered for many years by producing what they wanted to produce often had not been responsive to customers' needs. As apparel manufacturers approached fabric producers with special product requests, they frequently encountered a "take it or leave it" attitude on the part of textile mills.

By contrast, textile manufacturers in other countries were much more willing to please. This competition helped U.S. manufacturers realize the necessity and benefits of responding more effectively to the needs of the market.

In fact, virtually all segments of the textile complex have placed added emphasis on marketing programs, which help them (1) to serve more effectively their customers at various positions in the chain and (2) to be more efficient in inventory management by anticipating more accurately what will be purchased by those customers.

Developing Closer Working Relationships within the Softgoods Chain

The textile complex is a fiber-to-end-use system composed of many independent enterprises, which, by the nature of the industry and the products produced, need to work together closely. In the past, however, the system did not function at its best because of poor communication among fiber, textile, apparel, and retail operations. In recent years, various segments within the production and marketing chain have come to realize that a more cooperative and helpful working relationship with one another served the interests of all members of the larger complex. *Partnerships* and *strategic alliances* became buzzwords of the 1990s.

In an industry in which intense domestic competition was a fact of life and the relationships between suppliers and buyers were often adversarial, the threat of foreign competition provided an incentive to various segments of the industry to work together more closely. For example, textile producers learned that they must not only be concerned about making their own products competitive with imports but must also strive to help their customers, the apparel manufacturers, be more competitive with apparel imports and to meet more effectively the needs of U.S. retailers.

Although developing a marketing orientation was part of the effort to work more effectively with other segments of the softgoods chain, the improved climate that began to develop represented a new era of more cooperative working relationships. U.S. manufacturers

began to realize that to produce and market textile and apparel goods (particularly fashion goods) quickly, efficiently, and with improved quality—and to compete more effectively with foreign products—new working relationships were required. Examples of cooperative linkages are the following networks:

- The Textile, Apparel and Sundries Linkage Council (TALC/SAFLINC). This network of U.S. apparel, sundries, and textile industries is dedicated to eliminating redundant business operations and decreasing overall response time. The group emphasizes quick response strategies and partnerships as overall critical business issues.
- The Voluntary Interindustry Communications Standards Committee (VICS). VICS is a network of textile and apparel manufacturers and retailers. Its early objectives included establishing standard item identification and a standard data transmission format for computerized data interchange systems within the chain.

Concentrating on Market Segments in Which the United States Has the Greatest Advantages

In a market that is growing increasingly global, many U.S. textile and apparel manufacturers have attempted to specialize and identify competitive market niches. In some cases, domestic manufacturers have focused on capital- and knowledge-intensive production areas for which many of the developing countries are not prepared to compete. Some U.S. producers have found that they may remain competitive where technology can be used to provide efficiencies that offset production costs. In other cases, domestic manufacturers have determined that they cannot be competitive in certain highly labor-intensive areas. For example, the labor-intensive production of women's

bras has forced most U.S. bra firms to move these intricate sewing operations to countries with lower labor costs.

Although focusing on specialized market niches has been advantageous for some U.S. manufacturers, producers have no assurance of retaining those markets. In earlier years, apparel imports generally involved lower-priced lines. Some domestic manufacturers tried shifting to higher value-added lines to avoid the competition from less-developed countries. Over the years, however, as overseas manufacturers attempted to maximize the value of products they shipped to the United States under the quotas allotted to them, they tended to move toward higher value-added market areas.

Shortening the Response Time

Efforts to streamline production and delivery of products within the textile complex are by far the most evident outcome of closer working relationships among segments in the softgoods chain. A variety of strategies known as **Quick Response (QR)** has evolved to shorten delivery times and provide other efficiencies in the production and marketing chain. Global competition and the resulting uncertainty over future markets encouraged domestic producers to develop a number of QR approaches, which enhanced one of their major competitive advantages—proximity to domestic markets.

QR systems combine effective management techniques with new communication and information processing technology, along with new production technology, to reduce delivery times throughout the chain. Through computer linkages, each segment responds with the merchandise or product components needed for a quick response to orders for the end-use customer. The computer linkage system is based upon availability and use of **point of sale (POS) information** that is fed back to successive stages in the production chain. That is, through the use of computerized registers, retailers capture at

the point of sale detailed information on products sold (vendor, style, size, color, etc.). The POS data are captured by stockkeeping units (SKUs).² This information is communicated through computer linkages to apparel manufacturers, who respond by providing the items needed to replenish the stock. Linkages may extend backward to fabric and fiber producers as well. In short, the computer linkages set in motion automatic reordering known by industry terms such as **automatic replenishment** or **justin-time** (JIT) responses. Cooperative efforts such as that of the VICS group have been helpful in implementing QR programs.

The close communication required under QR systems means that each segment of the industry must be closely attuned to the needs of its customers. The primary goal of the whole QR initiative—which, incidentally, was developed by the manufacturing segments of the softgoods chain—was originally focused on efforts to motivate U.S. retailers to buy domestic textile and apparel products rather than imports. For retailers, participating in QR efforts allows them to hold inventories low and avoid overstocking while still ensuring that merchandisers can stock what customers want to buy. Today, fast response increasingly has become a basic expectation of retailers as a condition of doing business with manufacturers.

If we refer again to the train analogy used earlier to illustrate the impact of consumer demand on the flow for the entire softgoods chain, we might think of QR as providing rapid communication back through the individual sections of the train so that each unit

² Universal Product Coding (UPC), often called *bar coding*, plays an important role in QR. Apparel manufacturers affix on their garments a 12-digit UPC bar code that provides details on vendor, style, color, and size. Stores may add price—if they choose not to use the manufacturer's suggested price—and other information, if needed. Retail scanning equipment reads the UPC label, capturing POS information on the products sold. This information is fed back to manufacturer to give an indication of actual consumer demand.

can anticipate the speed of the train. In keeping with the high-technology character of QR, we might think of QR as providing a monitor in each car on which relevant data related to the engine's speed are made available. Consequently, because each segment has been able to anticipate the engine's speed, costly mishaps are less likely to occur.

In addition to helping retailers serve customers more effectively with minimal inventory backlog, firms at all stages of the production chain have the potential ability to reduce costly inventory investments by participating in QR efforts. Ideally, companies at each stage can reduce inventories of whatever they contribute to the production-marketing chain because they can expect fast service from their suppliers.

QR works when products flow quickly through the pipeline to the consumer. When the production pipeline is reduced, stock can be replenished quickly at the retail level and retailers can avoid costly **stockouts** and **markdowns**.

Furthermore, a faster-responding pipeline reduces the investment retailers must make in inventory at a given time. These improvements in the pipeline can greatly improve the financial performance (the bottom line) for retailers. Moreover, QR reduces the retailer's risks because buying decisions are made closer to the selling season. For example, QR advocates believe that with two-season product lines, retail buying decisions might be made as late as 8 weeks prior to the selling season compared to the traditional 5 to 6 months for domestic suppliers. The contrast is even greater in considering suppliers abroad, who may require 7 to 8 months of lead time.

Downsizing and Total Quality Management

The textile and apparel industries, like all industries, follow various timely management trends and approaches. In the 1990s, **downsizing** has been a way to trim costs to make companies

more profitable. Company managements have focused carefully on the firm's core businesses and evaluated the resources needed to support them most efficiently. Extraneous businesses or functions have been eliminated or reduced dramatically; large companies have eliminated thousands of jobs in some cases. Because of the resulting lowered costs, the bottom line has improved tremendously, pleasing the owners or stockholders. For example, DuPont went through massive downsizing to streamline operations and reduce costs to improve sagging profits. Levi Strauss sold its Brittania line to focus on its original company brand.

Total Quality Management (TQM) concepts also swept through U.S. industries in the 1990s. TQM is a system that involves all of a firm's employees in a customer-focused commitment to maintaining quality and doing things right the first time. TQM approaches emphasize teamwork toward common goals and process improvement versus emphasis on results only. Many textile and apparel companies have benefited from applying TQM concepts.

Promoting Domestic Products

As a result of a number of consumer studies that showed a strong consumer preference for U.S.-made apparel, manufacturers in the textile complex joined forces to make consumers more aware of domestically made products. Known as the "Crafted with Pride in U.S.A." campaign, a national labeling and promotion effort developed under the leadership of the Crafted with Pride in U.S.A. Council, which represents several hundred members. The council's statement of purpose is as follows:

The Crafted with Pride in U.S.A. Council is a committed force of United States cotton growers, labor organizations, fabric distributors, and manufacturers of manmade fibers, fabric, apparel, and home fashions, whose mission is to convince consumers, retailers, and apparel manufacturers of the value of purchasing and promoting U.S.-made products.

Figure 8–12 is the certification mark for the Crafted with Pride campaign. Campaign backers designed the mark to be an easily recognized symbol of U.S.-made products.³

In addition to the industry-sponsored Crafted with Pride effort, a federal law has required since 1984 that labels on domestically produced garments show that these items were produced in the United States. Prior to that time, country of origin labeling was required only for products made in other countries.

Influencing Public Policy

Various segments of the textile complex are located in every state, and in total these industries and those dependent upon the complex represent a large number of voters with widespread geographical dispersion. As a result, W. Cline (1987) noted that special interest groups representing the textile complex have strong political power at the national level. According to Aggarwal (1985), Keesing and Wolf (1980), Toyne et al. (1984), and numerous others, the U.S. textile complex has been particularly effective in influencing both national and international trade policies in its efforts to restrict foreign imports. Although the textile complex has felt battered by foreign competition and would like increasingly strengthened trade policies to protect their interests, Aggarwal (1985), W. Cline (1987), Keesing and Wolf (1980), and Toyne et al. (1984) noted that, compared to almost all other industrial sectors, the textile and apparel industries have been successful in acquiring considerable protection in various forms.

FIGURE 8–12
Crafted with Pride in U.S.A. certification mark.
Source: Reprinted courtesy of the Crafted with Pride in U.S.A. Council, Inc.

Agility or Agile Manufacturing

Agility or agile manufacturing is a new approach being used by forward-thinking companies in several industries; a number of firms in the U.S. textile complex are starting to implement agile strategies. Mass production approaches to manufacturing have been the norm for industries since the emergence of widespread industrialization in the 1900s. Emphasis has been on producing long runs of homogeneous products as efficiently as possible. Assembly-line production, repetitive assembly tasks, and economies of scale have characterized this manufacturing.

Today's demanding consumers, globalization of industries and markets, technological advances, and increasingly intense competition have forced companies to reinvent themselves. Some companies are already using agile approaches, although no commonly accepted name or theory currently exists for these strategies. The terms agility or agile manufacturing are

³ Industry leaders who initially developed the Crafted with Pride certification mark intentionally designed it to be somewhat generic, with the expectation that other U.S. industries might wish to join the campaign to promote domestic products. Manufacturers of a number of other product lines have used the certification mark on their products.

used most often; some sources call this *intelligent manufacturing*. Agile companies are able to assemble dispersed resources rapidly in response to changing, unpredictable customer demands. These companies are characterized by the innovation and teamwork necessary for rapid changes (Goldman et al., 1995; McHugh et al., 1995).

In many respects, agile manufacturing—with its emphasis on fast, innovative responses—will foster new alliances and will reflect the notion of a scrambled distribution chain. In the future, companies will forge new, creative relationships—doing whatever, in whatever manner, is required to be competitive, with little concern for how the softgoods industry functioned in the past.

THE U.S. TEXTILE COMPLEX IN THE GLOBAL MARKET

By any measure, the U.S. textile complex is a major force in global markets. Moreover, most other countries look to the United States in one way or another as a major player whose textile and apparel trade activities affect significantly their own sectors, as well as their national economies. For example, the United States is a major market for many countries' products; also, other nations may buy U.S. intermediate textile products to use in the production of their own finished goods. In total, many aspects of the U.S. textile complex's production, consumption, and trade (including trade policies) often have a broad ripple effect throughout the global textile complex.

In addition to the historical strength of the United States in general trade matters, the magnitude of the U.S. market coupled with the size and diversity of the textile complex make these U.S. sectors important globally. Toyne et al. (1984) provided a helpful way of putting the

U.S. textile complex in perspective from a world view:

Although most countries manufacture textile products, most lack the supply and demand conditions necessary to support entire textile complexes. For example, not all countries are endowed with the land or climatic conditions necessary for the production of agricultural products such as cotton or wool. Some countries do not have the indigenous technological or financial capabilities to develop and support chemical complexes capable of producing manmade fibers or textile machinery. Others lack the necessary internal markets required to achieve economies of scale in the production of manmade fibers, chemicals and "mature" textile fabrics. As a result, there is considerable variation between [sic] countries in their manufacturing industries, their dependence upon foreign inputs and/or markets, and their abilities to compete internationally. (p. 8)

The U.S. textile complex encompasses all the elements to which Toyne et al. refer. It also has size, production, and marketing sophistication at most levels, which have made it one of the largest and most comprehensive textile complexes globally.

Many other countries depend upon the U.S. market for the sale of their textile and apparel products. According to data cited in Chapter 6 (Tables 6–8 and 6–10), the U.S. market was the fourth highest recipient of worldwide textile exports in 1996 (\$10.7 billion) and was by far the major recipient of worldwide apparel exports that same year (\$43.3 billion) (WTO, 1997). Figure 8–13 shows the primary sources of textile and apparel imports in U.S. markets in 1996, as well as the source of imports in 1988. An important pattern is noteworthy here. Between 1988 and 1996, the Big Four Asian producers' share of the U.S. market decreased, while the share from Mexico and the Caribbean (e.g., the Dominican Republic) increased. Whereas Japan held 3 percent of the market in 1988, it had less than 1 percent in 1996 and was no longer among the top 20 sup-

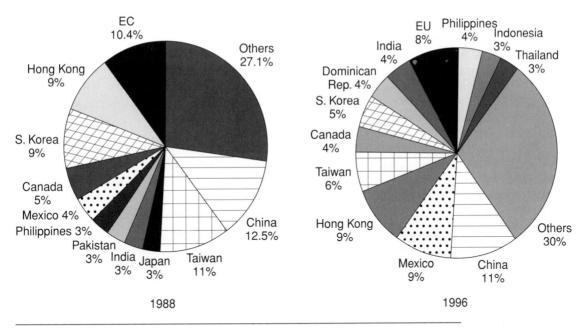

FIGURE 8–13Major sources of U.S. imports of textiles and apparel (based on value), 1988 and 1996. *Source:* U.S. Department of Commerce.

plier nations. Japan's relative importance is significant, however, given U.S. manufacturers' perceived threat from Japan's imports 20 or 30 years ago.

Although the U.S. market is a major recipient of textile and apparel goods from other regions of the world, the domestic industry has not attained a comparable position as an exporter to the markets of other countries. Various segments of the U.S. textile complex differ greatly in their export performance. For example, the manufactured fiber industry has been relatively successful in exporting, whereas the apparel industry has been far less so.

Many U.S. textile and apparel firms have operations in other countries. For decades, some of the major manufactured fibers firms such as DuPont have had multinational operations. In recent years, a growing number of apparel manufacturers have established sewing plants in other countries, particularly in the

Caribbean basin region and along the Mexican border. Most recently, several U.S. firms have acquired companies in other countries as part of their strategy to penetrate markets in those regions. DuPont acquired the nylon operations of ICI Fibers, a British firm, and in exchange ICI acquired DuPont's acrylic operations.

Textile firms have also become more globally oriented. Some major U.S. denim producers established or bought facilities in India following decisions by Levi Strauss and Lee to initiate local production and distribution strategies for the Indian market. Guilford Mills, Inc., and several other U.S. textile firms operate facilities in Mexico.

At least two major apparel firms have made acquisitions to gain access to markets in other countries. Sara Lee has acquired Montreal-based Giltex (a Canadian hosiery manufacturer), Mexico's Mallorca, S.A. de C.V. (the second largest sheer hosiery producer in that

country), Italy's Filodoro Group (a hosiery manufacturer), Maglificio Bellia (the leading Italian men's and women's underwear manufacturer), Dim (a French hosiery line and the largest in Europe), Pretty Polly and Elbeo brands in the United Kingdom, and Nur Die and Bellinda brands in Germany. Sara Lee is now the leading hosiery producer and marketer in Europe (Sara Lee Corporation, 1993). This acquisition strategy provides Sara Lee access to channels of distribution for the company's U.S. brands such as Hanes, in addition to those produced by the acquired companies. VF Corporation has pursued a similar strategy of acquiring companies in other countries.

FOREIGN INVESTMENT IN THE U.S. TEXTILE COMPLEX

The term globalization of the textile industry has taken on new meaning in the United States in recent years as a growing number of foreign firms have invested in the domestic textile industry. Investing in the United States has become increasingly attractive because of current high operating rates and the perception that the United States is an economic and political haven. During 1987, for example, 51 foreign companies moved to or expanded operations in South Carolina alone; the majority were in the textile and apparel industries (Standard & Poor's, 1988). Foreign investment in the U.S. industry accounts for about 2 percent of the establishments and about 5 percent of the employment and shipments of the overall textile industry. Foreign-owned U.S. facilities are somewhat more heavily concentrated in the thread, nonwoven fabric, and cordage industries (U.S. Dept. of Commerce, 1993).

Increased foreign investment is yet another dimension in the restructuring of the U.S. industry. This trend also helps us to understand that we must view textile (and generally apparel) production and trade in a broad global perspective rather than simply as domestic matters.

SUMMARY

The U.S. textile complex has a long history of contributing to the American economy. The fiber-textile-apparel complex represents the largest manufacturing employer in the U.S. economy, providing jobs for approximately 1 of every 11 industrial workers. Production facilities are located in every state.

The textile complex is a major contributor to the U.S. GNP, ranking as one of the top manufacturing sectors in its contribution. Although the number of jobs has declined, the complex remains the leading U.S. manufacturing employer. Textile and apparel manufacturing has played a particularly significant role in providing jobs for women, minorities, and new immigrants. In addition, the complex contributes importantly to other U.S. sectors through a variety of linkages.

Major activities of the textile complex include the production of fibers, the conversion of those fibers into intermediate textile mill products, and the manufacture of end-use products from the intermediate components. In the past, each segment operated more or less separately, producing intermediate products for the next stage of the production chain. Recently, however, more integrated relationships have developed as the domestic industry has sought advantages over foreign competitors. As a result, the U.S. textile complex has experienced significant restructuring. For example, many manufacturers have engaged in vertical integration-both forward and backward-and mergers and acquisitions have led to greater concentration in the industry. The basic production activities remained similar to those in the past (although updated by technology), but major changes have occurred in the organizational structures and relationships through which these activities take place.

Consumer demand (consumption) provides the momentum for activity in the total softgoods chain. Consumer spending fosters activity among all segments in the chain; a decline in spending creates a slowdown in activity in all segments. Factors influencing demand include shifts in the economy, style changes, consumer interests, demographic changes, and changes in lifestyle.

Affected by consumer demand as well as by other factors, the U.S. textile complex, like those in most other industrialized countries, has experienced periods of growth and decline. Increased foreign competition occurred at a time when domestic consumption had slowed markedly. As a result, the combination of increased imports and sluggish demand heightened competition for the existing U.S. market.

The 1970s and 1980s were critical transition years for the U.S. textile complex. International competition and new technology forced the domestic textile complex through "its most profound transformation since the industrial revolution" (OTA, 1987, p. 3). Changes included the nature of the products produced; how they are produced; how they are marketed; the structure, scale, and scope of the enterprises producing them; and the nature of the jobs created directly and indirectly by the industry.

Efforts of the U.S. textile complex to retain or regain a competitive position have included closing or revitalizing outmoded and inefficient plants; restructuring through consolidations and mergers; investments in equipment and technology; downsizing and other current management approaches such as TQM; developing greater sensitivity to market needs; establishing closer working relationships within the softgoods chain; making new alliances; concentrating on market segments in which the United States has the greatest advantage; shortening the response time; promoting domestic products; and influencing public policy. Agility or agile manufacturing is a new approach used by some firms to replace the mass production systems of the past.

In considering the U.S. textile complex in the international economy, we see that the magnitude of the U.S. market—coupled with the size and diversity of the textile complex—makes these U.S. sectors important globally. Moreover, the economies of many other nations are affected by activities of the U.S. complex. And finally, another form of globalization of the industry has occurred as a significant number of foreign firms have bought U.S. textile firms.

GLOSSARY

Automatic replenishment is a sophisticated form of Quick Response in which the supplier automatically replaces an item for the retailer as soon as the item is sold.

Backward integration means that a firm extends its operation to a previous stage of the production process. For example, a fabric producer adds varn production capabilities.

Barriers to entry are those factors that make it difficult to enter an industry. Examples include capital, high-technology demands, or monopolistic market conditions.

C.i.f. values include costs, insurance, and freight. When foreign products are bought under this term, the seller quotes a price including the cost of the goods, the insurance, and all transportation charges to the named point of destination. When two values are given for import shipments, the c.i.f. value is higher than the customs value because the c.i.f. figure includes insurance and freight costs.

Concentration or concentration ratio refers to the portion of total business in a given industry that is handled by a specified number of the largest firms—generally expressed as the percentage of business assets, production, sales, employment, or profits accounted for by the largest firms (usually the largest three to eight firms) (OTA, 1987).

Consumer confidence refers to consumers' outlook on the economy, particularly in terms of how they will be affected by the general state of the economy. Consumer confidence is measured by periodic consumer surveys.

Customs value is essentially the price of goods received by the foreign exporter. When two values are given for imports, this is the lower one.

- Distribution channel, as the apparel industry uses this term, refers to "selling" channels such as department stores versus specialty or discount stores.
- Domestic production refers to production that occurs within one's own country.
- Downsizing is a strategy of focusing on a company's core business and reducing or eliminating unrelated activities. Jobs are eliminated in downsizing efforts.
- Durable good is a good that yields its services gradually over an extended period of time (3 years or more); examples are automobiles and household appliances.
- End-use products are textile products ready for use or application, including apparel, interior furnishings, and industrial/specialty goods.
- Establishment (or plant) is a single productive unit; a firm may have one or more establishments.
- F.a.s. means "free along side." This is a pricing term under which the seller must deliver the goods to a pier and place them within reach of the ship's loading equipment.
- Firm (or company) includes all manufacturing establishments owned by the firm, plus all manufacturing establishments of subsidiaries or affiliates over which the company has acknowledged control.
- Forward integration means that a firm extends its operations to later stages of the production process. For example, a yarn producer acquires fabric manufacturing capabilities or an apparel producer adds retailing operations.
- Horizontal integration occurs when a firm expands into the production of new products that are competitive with older ones—that is, integration of production at roughly the same stages in the manufacturing process. For example, a weaving firm that has produced denim expands to include an operation that produces broadcloth.
- Industrial adjustment (also known as adjustment or structural adjustment) means restoring productivity of an industry so that it remains competitive in the overall industrial scheme of the economy.
- *Industry structure* refers to the number and size of firms in a given industry and the type of competition that exists among them (OTA, 1987).
- *Inventory management* refers to matching inventory as closely as possible to demand to reduce investment costs and losses from excessive stock.

- Just-in-time (JIT) inventory management refers to inventory control systems that control the inflow and outflow of parts, components, and finished goods so that minimal inventory is kept on hand.
- Leveraged refers to having significant loans (debt) against an entity.
- Markdown is a retail price reduction on merchandise. These reductions may be planned for promotional purposes or unplanned for merchandise that does not sell at the original price.
- Nondurable good is one that yields its services within a more immediate or shorter term (less than 3 years), especially in comparison to durable goods; examples are apparel and food.
- Point of sale (POS) information refers to the data captured at the point of sale through sophisticated computerized registers. In Quick Response systems, this information is fed back to successive stages in the production chain.
- *Privately held companies* are those owned privately by individuals or groups rather than shareholders.
- Publicly held companies are those owned by shareholders who have purchased stock in the company.
- Quick response (QR) is an industry initiative that at first focused on shortening the production cycle time based on extensive use of electronic data transmission from the retailer to various segments of manufacturing. The concept evolved into a transformation of the way in which apparel is made and distributed, and is based largely on closer working relationships between suppliers and retailers.
- Rationalization refers to the elimination of excess steps in the labor (production) process. (Also see the Glossary for Chapter 12.)
- Restructuring refers to the changes a sector or a company goes through in its efforts to remain competitive in response to changing market conditions.
- Semidurable good yields its services within a term between that of a durable good and that of a nondurable good; home furnishings textile products such as carpets and draperies may be considered in this category. (Some sources consider apparel to be a semidurable good.)
- Softgoods chain refers to the total textile and apparel production-distribution chain. This includes the manufacturing of products through retailing and other distribution phases associ-

- ated with making products available to the consumer.
- *Stockout* is a term that means customers want merchandise that is not available in the store.
- Total Quality Management (TQM) is a system that involves all of a firm's employees in a customer-focused commitment to quality and doing things right the first time.
- Universal product coding (UPC) is the bar coding used on products so that relevant data may be captured by retail scanning equipment. The 12-digit UPC identification shows the retail price to be charged to the customer. However, capturing other point of sale information on products sold permits the retailer to quickly replenish products in certain styles, sizes, or colors, for example, as items are sold.
- Vertical integration occurs when a single firm operates at more than one stage of production. This might include any combination of stages of production, but the most comprehensive type of vertical integration includes operations from processing the raw material for fiber to the completion and distribution of the finished product.

SUGGESTED READINGS

- American Apparel Manufacturers Association (AAMA). (annual). Focus: An economic profile of the apparel industry. Arlington, VA: Author. Annual industry profile.
- American Textile Manufacturers Institute (ATMI). (quarterly). *Textile hi-lights*. Washington, DC: Author.
 - Quarterly reviews of textile industry performance, with some data on the broader textile complex.
- Arpan, J., de la Torre, J., Toyne, B., Bacchetta, M., Jedel, M., Stephan, P., & Halliburton, J. (1982). The U.S. apparel industry: International challenge, domestic response. Atlanta: Georgia State University Press. A study of the U.S. apparel industry's international competitiveness and how domestic companies responded to global competition.

- Fibers, Textiles, and Apparel Industry Panel, Committee on Technology and International Economic and Trade Issues. (1983). The competitive status of the U.S. fibers, textiles, and apparel complex: A study of the influences of technology in determining international industrial competitive advantage. Washington, DC: National Academy Press.
 - A study of the industry in the 1980s.
- Finnie, T. (1992). *Textiles and apparel in the U.S.A.: Restructuring for the 1990s.* London: The Economist Intelligence Unit.
 - An overview of major factors leading to a restructuring of the U.S. industry.
- Ghadar, F., Davidson, W., & Feigenoff, C. (1987). U.S. industrial competitiveness: The case of the textile and apparel industries. Lexington, MA: Lexington Books.
 - This book examines global and domestic forces that affected the performance of the U.S. textile complex.
- Singletary, E., & Winchester, S. (1996). Beyond mass production: Analysis of the emerging manufacturing transformation in the U.S. textile industry. *Journal of the Textile Institute*, 82(2), 97–116. A summary of the mass production paradigm and
 - A summary of the mass production paradigm and strategies for manufacturing the transformation to agile production.
- Standard & Poor's. *Industry Surveys*. (annual). *Textiles, apparel and home furnishings—Basic analysis*. New York: Author.
 - Annual overviews of industry performance.
- United States Congress, Office of Technology Assessment. (1987). *The U.S. textile and apparel industry: A revolution in progress.* Washington, DC: U.S. Government Printing Office.
 - An overview of structural adjustment in the U.S. textile complex.
- United States Department of Commerce. (annual).

 U.S. industrial and trade outlook. Washington, DC:
 Author.
 - A concise overview of the status of various industry sectors for the current year.
- United States International Trade Commission. (1987, December). *U.S. global competitiveness: The U.S. textile mill industry.* (USITC Pub. No. 2048). Washington, DC: Author.
 - An in-depth study of the U.S. textile mill sector.

9

The U.S. Textile and Apparel Industries and Trade

Within the comprehensive textile complex, the textile and apparel industries are closely related yet distinct sectors. Despite the fact that these sectors have a great deal in common as part of an integrated production and marketing chain, each has distinct characteristics and unique problems—features that position them quite differently in terms of competitiveness and trade. In this chapter, we shall give an overview of each industry, with special emphasis on issues that influence each sector's ability to compete in the global economy.

INDUSTRY/BUSINESS CLASSIFICATION SYSTEMS

Since the 1930s, the Standard Industrial Classification (SIC) system has been used to classify most of the data we have about industries or kinds of business in the U.S. economy. On January 1, 1997, a new system, the North American Industry Classification System (NAICS), replaced the SIC system. The need for the new system is just another reflection of our operating in an international rather than a national economy. An important reason for developing NAICS was to create a classification system in

common with Canada and Mexico to permit review of NAFTA trade. A new system was also needed to include segments of the economy that were not adequately covered in the SIC system. In addition, the NAICS system was designed to strive for compatibility with the two-digit level of the International Standard Industrial Classification (ISIC) of the United Nations, a system to promote comparability of world trade data. One limitation of switching to a new system, however, is the difficulty of tracking data on some specific industries or product areas over a period of time. Although some NAICS codes are simply new numbers for the same categories, many other categories were grouped differently.

North American Industry Classification System

Table 9–1 provides a list of North American Industry Classification System (NAICS) categories for both textiles and apparel. Note that the sequential numbering of industry sectors parallels the stages in the production-distribution process, from fiber to fabric to apparel to retailing. Also significant is that the NAICS system has a *product* orientation, whereas the SIC system had a *process* orientation.

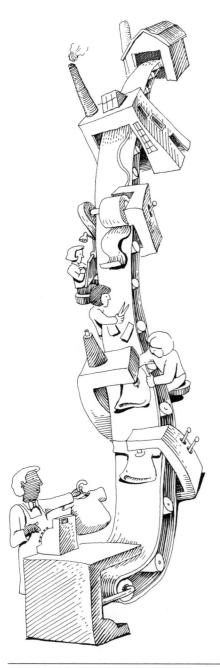

FIGURE 9-1

The U.S. textile and apparel industries represent a large, comprehensive collection of enterprises that includes operations at all stages of manufacturing and distribution.

Source: Illustration by Dennis Murphy.

NAICS industries are identified by a six-digit code, in contrast to the four-digit SIC code. The longer code accommodates the larger number of sectors and allows more flexibility in designating subsectors. It also provides the additional detail not necessarily appropriate for all three NAICS countries. That is, the sixth digit may differ among NAFTA countries, but at the five-digit level the codes are standardized. The digits are as follows:

- First 2 digits = NAICS industry sector (20 exist under NAICS compared to 10 SIC divisions)
- Third digit = subsector (313 is textile mills; 314 is textile product mills; and 315 is apparel manufacturing)
- Fourth digit = industry group
- *Fifth* digit = NAICS industry
- *Sixth* digit = national industry (if applicable)

For textiles and apparel, the country-level six-digit detail for the United States and Canada is comparable where possible, but Mexico chose not to have parallel designations on some of the last two digits. For example, Mexico requested that the NAICS distinction for contractors be dropped since this distinction was difficult for them to make, but the United States and Canada retained it. Table 9–1 provides the NAICS codes for textiles and apparel (Federal Register, 1996).

THE U.S. TEXTILE INDUSTRY

Although the term *textile* was derived from the Latin verb *texere*, which means "to weave," modern usage includes a far more comprehensive interpretation. Our discussion of the textile industry will focus on fibers, textile components, and textile products (textile furnishings and industrial textiles).

• *Fibers* represent the basic component and the initial production phase for the entire

290

TABLE 9–1NAICS Codes for Textiles and Apparel

31	Manufacturing	
313	Textile Mills	
3131	Fiber, Yarn, and Thread Mills	
31311	Fiber, Yarn, and Thread Mills	
313111	Yarn Spinning Mills	
313112	Yarn Texturing, Throwing and Twisting Mills	
313113	Thread Mills	
3132	Fabric Mills	
31321	Broadwoven Fabric Mills	
31322	Narrow Fabric Mills and Schiffli Machine Embroidery	
313221	Narrow Fabric Mills	
313222	Schiffli Machine Embroidery	
31323	Nonwoven Fabric Mills	
31324	Knit Fabric Mills	
313241	Weft Knit Fabric Mills	
313249	Other Knit Fabric and Lace Mills	
3133	Textile and Fabric Finishing and Fabric Coating Mills	
31331	Textile and Fabric Finishing Mills	
313311	Broadwoven Fabric Finishing Mills	
313312	Textile and Fabric Finishing (except Broadwoven Fabric) Mills	
31332	Fabric Coating Mills	
314	Textile Product Mills	
3141	Textile Furnishings Mills	
31411	Carpet and Rug Mills	
31412	Curtain and Linen Mills	
314121	Curtain and Drapery Mills	
314129	Other Household Textile Product Mills	
3149	Other Textile Product Mills	
31491	Textile Bag and Canvas Mills	
314911	Textile Bag Mills	
314912	Canvas and Related Product Mills	
31499	All Other Textile Product Mills	
314991	Rope, Cordage and Twine Mills	
314992	Tire Cord and Tire Fabric Mills	
	All Other Miscellaneous Textile Product Mills	

textile complex, regardless of the form the final product takes.

 Textile components and products include the following groupings: yarn, thread, cordage, twine, woven fabrics, knitted fabrics, carpets and rugs, interior furnishings such as bedding and towels, and other products such as nonwoven fabrics. Two NAICS subsectors, 313 and 314, make these products.

The U.S. textile industry represents more than 5,000 firms (and far more establishments)

TABLE 9-1 CONTINUED

NAICS Codes for Textiles and Apparel

31	Manufacturing
315	Apparel Manufacturing
3151	Apparel Knitting Mills
31511	Hosiery and Sock Mills
315111	Sheer Hosiery Mills
315119	Other Hosiery and Sock Mills
31519	Other Apparel Knitting Mills
315191	Outerwear Knitting Mills
315192	Underwear and Nightwear Knitting Mills
3152	Cut and Sew Apparel Manufacturing
31521	Cut and Sew Apparel Contractors
315211	Men's and Boys' Cut and Sew Apparel Contractors
315212	Women's and Girls' Cut and Sew Apparel Contractors
31522	Men's and Boys' Cut and Sew Apparel Manufacturing
315221	Men's and Boys' Cut and Sew Underwear and Nightwear Manufacturing
315222	Men's and Boys' Cut and Sew Suit, Coat and Overcoat Manufacturing
315223	Men's and Boys' Cut and Sew Shirt (except Work Shirt) Manufacturing
315224	Men's and Boys' Cut and Sew Trouser, Slack and Jean Manufacturing
315225	Men's and Boys' Cut and Sew Work Clothing Manufacturing
315228	Men's and Boys' Cut and Sew Other Outerwear Manufacturing
31523	Women's and Girls' Cut and Sew Apparel Manufacturing
315231	Women's and Girls' Cut and Sew Lingerie, Loungewear and Nightwear Manufacturing
315232	Women's and Girls' Cut and Sew Blouse and Shirt Manufacturing
315233	Women's and Girls' Cut and Sew Dress Manufacturing
315234	Women's and Girls' Cut and Sew Suit, Coat, Tailored Jacket and Skirt Manufacturing
315238	Women's and Girls' Cut and Sew Other Outerwear Manufacturing
31529	Other Cut and Sew Apparel Manufacturing
315291	Infants' Cut and Sew Apparel Manufacturing
315292	Fur and Leather Apparel Manufacturing
315299	All Other Cut and Sew Apparel Manufacturing
3159	Apparel Accessories and Other Apparel Manufacturing
31599	Apparel Accessories and Other Apparel Manufacturing
315991	Hat, Cap and Millinery Manufacturing
315992	Glove and Mitten Manufacturing
315993	Men's and Boys' Neckwear Manufacturing
315999	Other Apparel Accessories and Other Apparel Manufacturing
Others	
325221	Cellulosic Organic Fiber Manufacturing
325222	Noncellulosic Organic Fiber Manufacturing
333292	Textile Machinery Manufacturing

Source: Federal Register. (1996, November 5). Office of Management and Budget. Economic Classification Policy Committee; Standard Industrial Classification Replacement: The North American Industry Classification System. Proposed Industry Classification Structure. Part II.

(various sources give differing statistics) ranging from large, sophisticated companies to small plants performing rudimentary production processes. Products range from technologically advanced fibers to simple products manufactured in plants that have changed little over time. Most firms manufacture intermediate or finished products for mass markets; this market orientation has resulted in long production runs and standardized products. The mass production emphasis has been both good and bad for the textile sector. Although this strategy resulted in products representing high quality for the cost, emphasis on volume runs also resulted in a degree of insensitivity to customer needs.

The textile industry is a large and important industrial sector in the U.S. economy. Despite a number of difficult foreign and domestic challenges in recent decades, most segments of the industry have remained competitive. Although the industry has experienced hard times, some of the resulting adjustments have made it more efficient and more viable for competing in today's international market.

Brief Historic Review

Archaeological evidence suggests that textile products have been basic to humankind for centuries. Because textile production has existed for so long in most regions of the world, the textile industry's history may account for some of the sector's current problems. The industry's long history means that the global market suffers from an overabundance of producers. Moreover, as a leader of the Industrial Revolution, the industry has been developing technically for hundreds of years; therefore, it suffers from certain problems typical of mature industries.

As a producer of goods vital to human life and a provider of jobs for the masses, the textile industry established a powerful place for itself in both the global economy and the U.S. economy. Despite a dramatic technological and social transformation of the industry since its early days, textile production has remained a primary industrial sector in the United States.

For much of its existence, the textile industry has faced a constant need for renewal and modernization. In recent decades in particular, the industry has faced difficult challenges because of intense competition from foreign producers and among domestic producers. Global market conditions and other economic changes have placed intense pressures on the U.S. textile industry to restructure in order to survive. Consequently, the last three decades have been among the most eventful—and trying—in the history of the U.S. textile sector.

Historically the U.S. textile sector has had little product differentiation and a relatively low concentration of manufacturing. The lack of concentration within the textile sector, particularly when compared with other major industrial sectors, accounts for some of the competitive climate in the industry. In contrast to some industries where barriers to entry exist—such as large **economies of scale**, a high degree of product differentiation, high absolute costs, large capital requirements, control of input supplies, ownership of key patents and institutional or legal factors (Toyne et al., 1984)—many phases of textile production are relatively easy to enter.

In short, the combination of (1) producing relatively homogeneous products, (2) developing limited specialization and concentration, and (3) posing few barriers to entry led to intensely competitive conditions for most of the textile sector.

The Fiber Industry

Sectors that produce the two major types of fibers—natural fibers and manufactured fibers—represent a sharp contrast to one another. Natural fiber production is part of the agricultural sector; manufactured fiber production is part of the technologically advanced chemical and allied products sector. Despite the contrasting modes of production, most

fibers can be substituted for each other. Manufactured fibers compete not only with one another but also with natural fibers. Moreover, fashion changes, other consumer preference trends, and various economic conditions have caused fairly dramatic shifts from one group to the other.

Worldwide demand by fiber category varies from that for the U.S. market. In particular, cotton accounts for a much higher market share globally than is true in the United States. U.S. consumption of manufactured fibers exceeds that of natural fibers, but we must remember that these figures reflect interior furnishings and industrial use, along with apparel use. The worldwide demand for cotton relative to manufactured fibers also reflects the availability of cotton compared to manufactured fibers in the less-developed countries.

In today's global economy, worldwide fiber demand can affect the U.S. softgoods industry and the U.S. consumer. As an example, the global demand for cotton may exceed the supply in years when the crop is poor. As a result, availability and prices for cotton and cotton products for U.S. markets are affected.

Natural Fibers

Cotton is the primary natural fiber produced and consumed in the United States, accounting for over 90 percent of the natural fiber used. Wool is produced in limited amounts; other natural fibers are relatively important in the U.S. market but are imported. For the most part, natural fiber production has increased slowly in the United States because of the strong competition from manufactured fibers; however, the resurgence of popularity of natural fibers for apparel since the late 1980s has increased the demand noticeably.

Manufactured Fibers

Manufactured fibers represent a milestone in development for the global textile complex in

the 20th century. The technology and capital requirements for this chemical-based industry determined for at least a time the locations in which world fiber production occurred. In addition to the capital- and knowledge-intensive aspects of manufactured fiber production, this is one segment of the textile complex for which significant economies of scale existed. Another barrier to entering manufactured fiber production has been limited access to distribution channels. As a result of these characteristics, in the past manufactured fiber producers were located in the developed countries and were typically part of large, diversified multinational chemical companies. Also in the past, a large proportion of the manufactured fiber industry used similar manufacturing processes; products were substituted for one another easily, markets were similar, and most companies had comparable research and development (R&D) expenditures.

Manufactured fibers consist of two types: (1) cellulosic fibers (sometimes called artificial fibers)—such as rayon, acetate, and triacetate which come from naturally occurring cellulose sources (generally trees), and (2) synthetic fibers (also known as noncellulosic fibers)—such as nylon, polyester, and acrylic-which are petrochemical derivatives. Manufactured fiber production is so much a part of the chemical industry that within the NAICS system, this segment is grouped with the chemical and allied products series rather than with textile mill products. Cellulosic fibers are NAICS 325221 (titled Cellulosic Organic Fiber Manufacturing; synthetic fibers are 325222 (titled Noncellulosic Organic Fiber Manufacturing).

Presently, the United States is the leading world producer of manufactured fibers, with this segment being one of the most competitive of any in the U.S. textile complex involved in global trade. Yet, the U.S. manufactured fiber industry consists of a small number (approximately 15) of large TNCs that are horizontally integrated. DuPont, Monsanto, and Allied Signal are American-owned companies and are

among the world's largest firms. The top 10 producers in the United States account for more than 90 percent of U.S. production. Manufactured fiber producers compete for the markets of seven distinct fibers: polyester, nylon, acrylic, polyethylene, polypropylene, rayon, and acetate. In 1996, an estimated 69,074 persons were employed in the U.S. manufactured fiber industry, an increase of more than 12,000 since 1993 (DRI/McGraw-Hill, S&P, USDC, 1998).

Trade

Our earlier discussion of fiber markets included several relevant points on trade. Manufactured fibers have been a major export category for the U.S. textile complex, with exports growing from less than \$200 million in 1972 to an estimated \$2.4 billion in 1997. As developing nations have increased their manufactured fiber production capacity, U.S. manufacturers' share of the world market has decreased. As an example, U.S. fiber producers' share of the world market of polyester filament yarn dropped from 30 percent in 1986 to 13 percent in 1996 (DRI/McGraw-Hill, S&P, USDC, 1998; Fiber Economics Bureau, March, 1986).

Overall, the U.S. fiber sector suffers from problems of production overcapacity and saturated markets-conditions evident in many industries in which various segments compete against one another for a share of the market. The saturated and overcapacity market conditions also apply in considering competition between natural and manufactured fibers in a range of product areas. Finally, the glutted market conditions are most evident in considering the mix of domestic and imported products—a situation in which producers from many other countries compete with domestic manufacturers for the U.S. market. DuPont, a leader in manufactured fiber production, has restructured its fiber business in response to this competition. As part of this restructuring, hundreds of jobs have been eliminated.

The global cotton market is intensely competitive because of the large number of countries producing this fiber. U.S. cotton producers supply fiber for both the domestic market and the international market. In fact, the United States is the second largest world producer of cotton—with Japan, South Korea, and other Pacific Rim nations accounting for the major purchases of U.S. cotton.

Developing countries will continue to be major cotton producers because many economies in those nations depend on cotton as a primary source of earnings, employment, and trade. Many of those countries lack the resources for other production. Because of lower production costs, those countries sell cotton at attractive prices in world markets and are likely to continue doing so.

As additional developing countries gain the capabilities for producing manufactured fibers, many are doing so, not only for domestic import substitution but also as part of global trade strategies. That is, as the less-developed countries mature, they strive to produce all the component parts for the end products they export, whereas in earlier stages they tended to assemble products from components made elsewhere. As a result of this maturing of industrial sectors in many less-developed countries, particularly many Asian nations, competition for U.S. manufactured fiber producers will continue to intensify.

In the last decade, the greatest growth in manufactured fiber production has been in the less-developed countries. Western Europe, the United States, and Japan account for declining shares of manufactured fiber production; the greatest increases have been in China and other Asian countries (Fiber Economics Bureau, various years).

The U.S. fiber industry, in its present form, is vulnerable in a number of respects. High investments in equipment intended to enhance competitiveness have been focused on mass production of basic fibers. That is, U.S. producers who have the history and technical ex-

pertise to continue being the vanguard fiber industry of the world have for the most part produced basic commodity fibers, that is, relatively common fibers produced in large quantities. Following this strategy means that U.S. fiber producers have attempted to compete on a price basis for the same high-volume markets as the new entrants in the developing countries. Although the United States has been a leader in developing specialty fibers (new generic groupings as well as highly specialized variations within established generic groupings), most of the industry output has been in the commodity fiber area. In contrast, the industry in Western Europe (the industry most comparable to that in the United States) has placed added emphasis on specialization and service rather than production of homogeneous, standardized products.

Although the U.S. fiber industry has been a leader in manufactured fiber development, the industry is dependent to a large degree upon foreign producers of textile machinery for the equipment required for the production. For both natural and manufactured fiber producers, much of the technology required to maintain a competitive lead in the industry globally comes from producers in Germany, Switzerland, Japan, and Italy. Equipment changes frequently, making technology an important factor in competition and making fiber producers quite dependent on the manufacture of machinery. Moreover, the same modern equipment sold to U.S. producers is also available to the industry in any country with the capital and skills to obtain and use it. In this regard, newly established plants in less-developed countries may start production with state-of-the-art machinery, whereas established fiber producers in the developed countries can seldom start over with all new production equipment.

Problems facing the domestic fiber industry, particularly the manufactured fiber industry, are part of the broader change occurring in the United States. In sector after sector, domestic industries are losing their competitive edge in

world markets, including many of the knowledge- and capital-intensive areas ("Can America compete?", 1987; "Fixing America's," 1992). The fiber segment of the U.S. textile complex, in many ways thought to be the most secure of the sectors within the complex because of its barriers to easy entry (high knowledge and capital requirements, along with other reasons given earlier), appears to be no exception to this difficulty in maintaining global-competitiveness.

The Textile Components and Products Industries

In NAICS subsector 313, the conversion of fibers into finished fabrics requires a variety of complex steps—including spinning and texturing yarns; knitting, weaving, and tufting; and dyeing, printing, and other finishing—resulting in an extensive textile components industry to perform these operations. NAICS subsector 314 consists of mills that produce textile interior furnishings and industrial textiles. These segments of the textile complex account for a majority of the establishments and workers within the textile sector (Figure 9–2). Although the textile segments are quite fragmented, many areas are also highly specialized.

The total number of textile establishments has decreased somewhat since the early 1980s. The overall decrease can be attributed to a number of factors: plant closings as firms leave the industry, plant closings from consolidation of operations by some firms, and the effects of mergers and acquisitions that have restructured the industry.

Although the textile mill products industry is dispersed throughout the United States, its concentration is greatest in the Southeast. The location varies somewhat by sector.

The textile industry's **capacity utilization rate** has been healthy in recent years—generally around 90 percent—exceeding that for all manufacturing. In fact, certain aspects of the textile sector's performance improved so dramatically

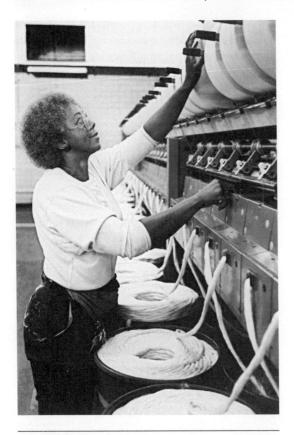

FIGURE 9-2

The textile industry has played an important role in providing employment to hundreds of thousands of workers.

Source: Photo courtesy of Burlington Industries, Inc.

that industry critics began to question why the textile industry needed increased protection from imports.

The recession in the early 1990s caused a significant slump in capacity utilization and corporate profit patterns. Nevertheless, the textile industry fared better on both measures than U.S. manufacturing as a whole.

The textile sector has a commendable record of investing in advanced technology to improve labor productivity. The textile industry's record of investing its profits has been comparable to that for all U.S. manufacturing. Textile production technology advanced dramatically in the

1970s, and forward-thinking companies invested heavily in the new generation of technology.

Although many textile firms have invested heavily in technological advances, not all production facilities use state-of-the-art equipment. In general, however, where newer technology is incorporated into production operations, fewer workers are required.

The textile industry's investment in modernization has improved productivity and, as a result, has generally sustained profits. Increased productivity has aided profit performance primarily by reducing labor requirements and, thus, labor costs. When productivity is improved, employment usually drops. In other words, fewer plants with fewer employees are producing greater output. Although productivity improvements make the industry more competitive, a negative effect is job loss. It is not uncommon to find only one or two workers in charge of large spinning rooms that once would have required dozens of employees to run. Consequently, some structural unemployment has occurred.

The U.S. textile sector's increased productivity helped to position the industry more advantageously in international markets than would have been true without the improvements. Belaud (1985) reported in a European study that the U.S. achievements in productivity have made the country's textile industry quite competitive globally:

Some Western industries—especially the United States'—have achieved considerable gains in productivity thanks to the modernization and automation of the production. In 1980, the U.S. textile industry recorded the highest productivity per employee amongst the major industrialized manufacturing countries, thereby enabling it to achieve the lowest unit production costs amongst the same industrialized countries. . . . The labor cost per unit produced in the United States is therefore closer to that of Portugal than that of the major European manufacturers, and closer to the unit cost in Pakistan than to the unit cost in Belgium or Germany. As a result, U.S. producers have been able to achieve price levels ap-

proaching those of some "low cost" Asiatic or Mediterranean countries. (p. 37)

In the past, U.S. companies in the textile industry focused most of their efforts on the domestic market. In the early 1980s when the dollar was strong, exports accounted for only 3 percent of total industry shipments. Consequently, the domestic market accounted for approximately 97 percent of the business for the textile products industry (USITC, 1987b). More recently, this industry segment (at least *some firms* in the segment) has begun to place more emphasis on exporting. In 1996, textile exports of \$7.8 billion represented 11 percent of the industry's \$68.9 billion in total sales. Exports to NAFTA partners equaled 44 percent of all textile exports.

As might be expected, the U.S. textile market is for the most part mature and saturated—especially in the segments that produce standardized, nonspecialty items.

Additionally, the overcapacity of the industry and the easy substitutability of products add to market problems for the mill products sector. Modest growth in the domestic markets, at a time when imports have increased dramatically, has intensified competition for markets among domestic producers. Many older plants have closed, with attrition particularly high in the apparel fabrics sector. Many manufacturers have shifted to markets in which they expect less foreign competition and improved profits. Examples are the shifts from apparel fabric production to the home furnishings area, in which sales have been healthy, import competition less intense, and automation more readily adaptable to the production processes. Springs Industries has been very successful in making this shift.

Changes in the demand for textile products have had a severe impact on mill **operating rates.** In Figure 9–3, mill operating rates reflect

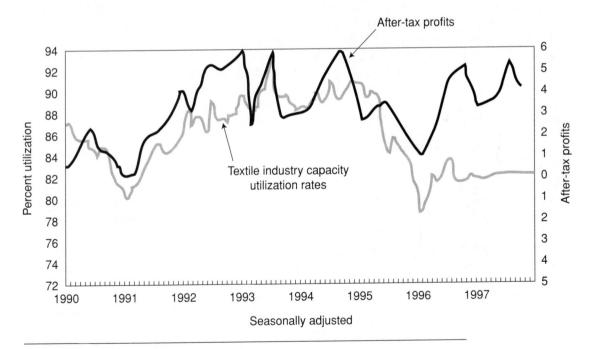

FIGURE 9–3
Operating rates versus pretax margins (in percent, quarterly).
Source: Reprinted courtesy of Standard & Poor's; based on operating rates from Department of Commerce and pretax margins from Federal Trade Commission.

fluctuations in demand; it follows that mill operating rates are reflected in the pretax profit margins for the industry. As Figure 9–3 illustrates, when increases and decreases in demand affected mill operating rates, pretax profit margins generally reflected the overall trend of the fluctuations.

Employment in the textile mill sector peaked at almost 1 million in 1973, fell to 593,000 in 1993, and rebounded to 629,000 in 1996 (U.S. Department of Commerce, 1997). The largest drops in employment occurred in the recession years of 1974 and 1982. Employment in the textile mill products area declined steadily until 1991, when it became relatively stable. The improved employment trend also included increased hours worked and a decline in unemployment. Within the textile mill industry, changes in employment varied within selected industry segments.

Employment declines for the textile mill industry can be attributed to three major causes: (1) the increasing share of the U.S. textile market being supplied directly by imports; (2) the declining demand for apparel fabrics by U.S. apparel producers as imports have taken an increasing share of the U.S. market; and (3) the reduced need for production workers as modern, labor-saving equipment has been installed to improve productivity and competitiveness.

Trade

Although most areas of the U.S. textile mill products industry have experienced the effects of import competition, the domestic industry supplies the bulk of the U.S. market. The U.S. industry has advantages related to distribution costs, expenses associated with travel, communication, and paperwork costs and can provide savings through lower inventories because of the possibility for reordering during a season. U.S. mills also are able to produce large runs of many standard fabrics, which provides economies because of the continuous operations. Many foreign producers find it difficult to compete with the U.S. industry in certain ar-

eas, such as heavier-weight fabrics sold in large volume. Foreign suppliers have been more successful in the lighter-weight fabric market, where transportation is a smaller part of the total cost. These may be low-priced commodity fabrics or high-quality fabrics with distinctive design qualities, often made available in smaller quantities than U.S. mills have been willing to produce in the past.

IMPORTS. Global competition has had an impact on the textile mill sector. U.S. textile mill product manufacturers had a relatively large, secure market for years. Consequently, the loss of portions of the market to imports (refer to Figure 8–8 on p. 274) has been difficult to accept and has required a number of dramatic changes in nearly every aspect of industry operations in order to remain competitive.

Determining the extent to which imported textiles account for a portion of the U.S. market is an issue of great controversy. The import **penetration ratio** is the measure of imports as a percentage of apparent U.S. consumption. Trade data may be examined in different ways, resulting in quite different conclusions about the level of import penetration in U.S. textile markets. The perceived severity of the import problem can vary greatly according to how the issue is examined. Therefore, reports on import penetration levels must be interpreted with care. An understanding of the different ways in which import penetration is reported is important as one begins to consider textile and apparel trade policy issues.

The two primary ways of examining import penetration ratios are:

1. Using physical quantities—usually squaremeter equivalents (SMEs)—previously square-yard equivalents (SYEs), or, in some cases, weight. Industry sources believe this measure is appropriate because imports displace U.S. products in physical amounts. That is, the SMEs in an imported item represent a comparable amount that a

- domestic manufacturer might have produced.
- 2. Using the value of shipments. W. Cline (1987) believes this measure is more appropriate because imports tend to be cheaper products. That is, since imports are usually cheaper products, SMEs overstate the real economic value of imported goods compared to domestic output. This approach generally gives a more conservative estimate of the domestic market taken by imports than measures based on physical quantities.

Textile import data are shared in two forms—(1) to show the levels of import shipments in various product areas and (2) to illustrate how import penetration ratios vary by the approach used.

Import Penetration Based on Physical Measures. Table 9-2 displays import penetration in the total U.S. market for all textile products (including apparel). These figures are based on a physical measure, millions of pounds—an appropriate measure for fiber usage; similar summaries are available using the SME measure. (Here we must remember that trade data based on pounds are reported by major fiber groupings. That is, "fibers consumed" include textile mill products as components in end-use products. Table 9–2 includes mill consumption.) Although not shown in Table 9–2, imports in all textile product areas accounted for 10.6 percent of the quantity of U.S. fiber consumption in 1979, growing to 16.4 percent in 1982. Under the current data system used for Table 9–2, we see that imports accounted for 40 percent of the fiber consumed in the U.S. in 1997. The final column gives the portion of imports consumed (as a percentage of total textile/apparel consumption) in U.S. markets based on this measure.

Figure 9–4 gives a graphic summary of U.S. imports of textile manufactures; this graph is based on SMEs, another *physical* measure. It

provides a quick review of imports by major categories in the 1990s.

Import Penetration Based on Value. Import penetration based on value—rather than volume—appears in Table 9–3. The **nominal** values are the *current* dollar values at the time. The **real** 1982 prices are the adjusted dollar amounts for each year, using the price index for U.S. domestic product shipments (from the U.S. Department of Commerce). That is, the nominal dollar amounts were adjusted to obtain figures that could be compared meaningfully over the time period shown. When this method is used to consider import penetration ratios for textiles, the ratios are significantly *lower than the ratios based on physical measures*.

During the period shown, imports increased rapidly at times from one year to the next; at other times, the increase was slight. Cline (1987) noted that from 1961-1962 to 1972-1973, imports averaged an annual increase of 7 percent, but then declined slightly and slowed until 1980. Imports began to increase in the early 1980s and in 1984 jumped 34.4 percent in real terms. Foreign shipments were somewhat less in 1985 but increased by nearly 18 percent in 1986 (W. Cline, 1987; personal communication with U.S. Department of Commerce staff, 1990). Cline speculated that the large increases resulted from a combination of some remaining impact from the strong dollar plus the anticipation of tighter import restrictions when the major textile trade agreement, the Multifiber Arrangement, was renegotiated in 1986. Import penetration levels continue to be among the highest in history.

Although import penetration ratios are substantially lower when based on value data than on physical quantities, Table 9–3 shows that imports have taken an increasing share of the U.S. textile market even when calculated in *real value* terms.

The import data based on *value*, which are presented in Table 9–3, give imports at the prices valued in processing through U.S. Customs.

U.S. Apparent Domestic Fiber Consumption: Mill Consumption, Imports, Exports, and Apparent Consumption TABLE 9-2

	* 1	Manufactu	Manufactured Fibers			Ö	Cotton		
Year	Mill Consumption ⁷	Imports ²	Exports ³	Apparent Consumption	Mill Consumption	Imports	Exports	Apparent Consumption	
080	9 000 6	1 820 0	740.0	10,089.6	3,985.9	2,353.9	513.0	5,826.8	
066	8,837.0	1.820.0	820.0	9,837.0	4,036.5	2,416.9	664.0	5,789.4	
1991	8.861.2	1.907.0	886.0	9,882.2	4,347.5	2,593.0	722.9	6,217.6	
665	9,498,9	2.060.0	958.0	10,600.9	4,714.7	3,194.1	845.1	7,063.7	
663	9,928.5	2,186.0	978.0	11,136.5	4,921.9	3,574.6	958.7	7,537.8	
994	10,505.5	2,319.0	998.0	11,826.5	5,191.6	3,796.4	1,107.2	7,880.8	
995	10.280.0	2,279.6	1,074.1	11,485.5	5,199.9	4,048.7	1,321.7	7,926.9	
966	10,465.4	2,389.1	1,117.2	11,737.3	5,191.9	4,171.6	1,501.1	7,862.4	
997	11,022.1	2,871.6	1,572.5	12,321.2	5,419.5	4,728.9	1,786.0	8,362.4	.78
		Wool				Total⁴			Ratio of Imports to
	Mill			Apparent	Mill			Apparent	Consumption
Year	Consumption	Imports	Exports	Consumption	Consumption	Imports	Exports	Consumption	(total)(%)
1989	134.7	207.5	61.3	280.9	13,208.0	5,046.9	1,388.8	16,866.1	29.9
066	153.0	197.4	56.4	294.0	13,102.6	5,103.0	1,631.9	16,573.7	30.8
991	172.6	199.7	60.1	312.2	13,459.9	5,347.6	1,762.9	17,044.6	31.4
992	171.5	224.6	67.1	329.0	14,461.8	6,132.1	1,961.0	18,632.9	32.9
1993	179.5	244.9	72.7	351.7	15,103.9	6,716.8	2,107.6	19,713.1	34.1
994	171.9	288.5	84.1	376.3	15,923.8	7,153.8	2,299.0	20,778.6	34.4
1995	161.8	298.2	97.1	362.9	15,707.3	7,333.2	2,607.1	20,433.4	35.9
1996	142.9	313.7	118.0	338.6	15,846.2	7,434.9	2,865.2	20,415.9	36.4
200	1300	7 978	174 5	342 1	16 627 3	8 655 7	3 705 6	21 577 4	40.1

¹ Mill consumption is domestic mill consumption.

Imports are imports of semi-manufactures and manufactures.
 Exports are exports of semi-manufactures and manufactures.
 Includes silk, linen, ramie, and other fibers.
 Source: Fiber Organon, Fiber Economics Bureau, Inc., Vol. 69, no. 3, March 1998. Washington, D.C., p. 46.
 Reprinted by permission of Fiber Economics Bureau, Inc.

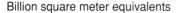

FIGURE 9–4
U.S. imports of textile manufactures (in millions of square meters).

Source: Textile Hi-Lights (March 1997), p. 25. Based on U.S. Census Bureau Data. Reprinted courtesy of American Textile Manufacturers Institute.

Figures for import shipments in these terms represent the customs value. Cline (1987) noted that other costs of obtaining imports must be added to these values in order to make accurate comparisons with the wholesale values of domestic output. Insurance and freight costs must be added to the customs values to permit meaningful comparisons; similarly, tariffs must be added to give the price for domestic consumption. According to the Department of Commerce (1985), in 1984 the c.i.f. values for textiles and apparel were 7.5 percent higher than the customs values. In addition, tariffs averaged 27 percent for apparel and 15 percent for textiles until recent years, when there was a slight decline. Cline's analysis revealed that import values were 37 percent above customs valuation for apparel and 24 percent above customs valuation for textiles after adding tariffs, insurance, and freight. Table 9–4 shows the adjusted import penetration ratios based on c.i.f. values plus tariffs.

Cline's analysis, including added costs for importing, showed that apparel imports accounted for about 31 percent of the value of U.S. consumption for apparel in 1986, somewhat less than 10 percent for textiles, and a combined total of 22 percent. These import penetration levels were considerably greater than those based on value for the same years in Table 9–4.

Textile mill producers have felt most competition from imports in the lower-priced, lower-quality product lines and in the high-priced, high-fashion products. Heavy import penetration into those markets means that domestic manufacturers supply most of the broad middle segment of the market; however,

TABLE 9–3Trade and Domestic Consumption: Textiles (millions of dollars)

		Nor	minal		Real 1982 Prices ^a				Import Penetration (M/C)
Year	M	X	ТВ	C ^b	М	X	ТВ	C ^b	(%)
1961	590	320	-270	13,151	1,016	551	-465	22,657	4.5
1962	699	300	-399	14,435	1,190	511	-679	24,584	4.8
1963	745	307	-438	15,136	1,562	644	-918	31,742	4.9
1964	759	340	-419	16,292	1,532	686	-846	32,885	4.7
1965	858	391	-467	17,547	1,690	770	-920	34,554	4.9
1966	941	405	-536	18,837	1,857	799	-1,058	37,177	5.0
1967	803	377	-426	18,928	1,542	724	-818	36,347	4.2
1968	934	351	-583	21,097	1,679	631	-1,048	37,928	4.4
1969	970	418	-552	22,007	1,686	726	-960	38,248	4.4
1970	1,058	461	-597	21,709	1,910	832	-1,078	39,188	4.9
1971	1,248	465	-783	23,221	2,285	851	-1,434	42,521	5.4
1972	1,345	603	-742	26,644	2,389	1,071	-1,318	47,326	5.0
1973	1,423	926	-497	29,550	2,260	1,470	-790	46,923	4.8
1974	1,407	1,284	-123	31,000	1,944	1,774	-170	42,840	4.5
1975	1,107	1,157	50	29,158	1,585	1,657	72	41,760	3.8
1976	1,392	1,399	7	34,253	1,874	1,883	9	46,106	4.1
1977	1,489	1,345	-144	38,198	1,958	1,769	-189	50,239	3.9
1978	1,855	1,466	-389	40,590	2,351	1,858	-493	51,438	4.6
1979	1,834	2,130	296	42,349	2,205	2,561	356	50,909	4.3
1980	2,034	2,488	454	44,320	2,245	2,746	501	48,922	4.6
1981	2,482	2,326	-156	47,897	2,503	2,346	-157	48,303	5.2
1982	2,225	1,766	-459	45,375	2,225	1,766	-459	45,375	4.9
1983	2,557	1,560	-997	51,482	2,523	1,539	-984	50,796	5.0
1984	3,539	1,541	-1,998	54,256	3,390	1,476	-1,914	51,979	6.5
1985	3,697	1,462	-2,235	52,382	3,575	1,414	-2,161	50,660	7.1
1986	4,225	1,653	-2,572	54,920	4,212	1,567	-2,645	52,701	8.0
1987	4,699	1,891	-2,808	64,167	4,669 ^c	1,891°	$-2,808^{c}$	64,167°	7.3
1988	4,458	2,339	-2,119	65,994	4,400°	2,309°	-2,091°	65,146°	6.8
1989	4,786	2,803	-1,983	72,516	4,501°	2,636°	$-1,865^{c}$	63,691°	7.1
1990	4,888	3,636	-1,252	71,126	4,508°	3,353°	$-1,155^{c}$	61,090°	7.4
1991	5,375	4,101	-1,274	71,915	4,913°	3,749°	$-1,165^{c}$	60,824°	8.1
1992 ^d	5,843	4,467	-1,376	74,630	5,306°	4,056°	$-1,249^{c}$	62,461°	8.5
1993 ^e	6,179	4,690	-1,489	75,312	5,600°	4,250°	-1,349°	62,649 ^c	8.9

 $M = imports; X = exports; TB = trade\ balance; C = apparent\ consumption.$

Note: Updates of figures in this time series are no longer available because of a switch to the Harmonized System for trade data.

Source: Cline, W. (1987). The future of world trade in textiles and apparel (p. 35). Washington, DC: Institute for International Economics. 1986–1993 updates from U.S. Department of Commerce.

^a Deflating by textile product shipments price index, U.S. Department of Commerce.

^b Equals production *plus* imports *minus* exports.

^c Real 1987 prices.

d Estimate, except exports and imports.

e Estimate.

TABLE 9–4Adjusted Import Penetration Ratios, Value Basis^a (in percent)

Period	Textiles	Apparel	Textiles and Apparel
1961-1965 ^b	6.0	3.7	4.9
1966-1970 ^b	5.7	6.0	5.9
1971–1975 ^b	5.8	10.7	8.2
1976–1979 ^b	5.2	16.3	10.8
1980	5.6	18.4	12.1
1981	6.3	19.5	13.2
1982	5.9	19.9	13.7
1983	6.0	21.6	14.4
1984	7.9	27.3	18.6
1985	8.5	29.6	20.5
1986	9.5	31.1	22.0

^a U.S. Department of Commerce Import Data (customs value) adjusted upward for insurance and freight and for import duties. Import penetration ratios are equal to adjusted imports divided by apparent consumption (domestic output plus adjusted imports less exports).
^b For multiple years: averages.

Note: Methodology not available to provide comparable update after 1986.

Source: Cline, W. (1987). The future of world trade in textiles and apparel (p. 49). Washington, DC: Institute for International Economics, Reprinted by permission.

import restraint policies tend to encourage foreign producers to move upward from the lower quality/price ranges into the mid-range as well. Foreign producers also supply products typically not produced in the United States such as hand made carpets, products of certain vegetable fibers, and hand-loomed or cottage industry products. Further, foreign producers have been willing to supply products in small runs, often providing unique design qualities not readily obtained from U.S. manufacturers.

In 1996, the imports of textile mill products to U.S. markets came from the countries and regions shown in Table 9–5.

PRODUCT SHIPMENTS AS A REFLECTION OF A NATION'S DEVELOPMENT. The types of products shipped to U.S. markets by various countries often reflect both the level of overall de-

TABLE 9–5U.S. Imports of Textile Mill Products (select countries and regions)

Value*	Share (%)
\$ 2,074	18.58
1,950	17.45
1,677	15.00
417	3.73
174	1.55
4,883	43.70
11,174	100.00
	\$ 2,074 1,950 1,677 417 174 4,883

^{*} Value in millions of dollars, 1997.

velopment of the supplier countries and the stage of development of the textile complex in those countries. A look at the changes in Asian suppliers of textile mill products to the U.S. market illustrates this point. For example, the East Asian NIC suppliers initially gained shares of the U.S. market by supplying low-cost textile products, usually for lower-priced apparel and household textile markets. Early Asian producer nations supplied low- to mediumquality standard construction fabrics, often as greige goods. As technical capabilities in a particular country grew and as wages increased with the development of competing industries, the country typically moved to the production of more advanced textile products, which provided increased value added as exports. This development within supplier nations has been evident in the types of products shipped to U.S. markets by the Asian countries. Japan and Hong Kong were once the leading suppliers of ordinary greige goods, but both have moved to higher-quality, higher-priced fabrics and other products, often with more distinctive design qualities. (However, Hong Kong's fabrics are mostly reexports.) Similarly, Taiwan, Korea, and even China are moving to product lines that are

^{**} S. Korea, Taiwan, and Hong Kong. Source: U.S. Department of Commerce. 1998, Office of Textiles and Apparel Web Site, Major Shippers Report, and compiled with assistance from Mike Ruggiero. American Textile Manufacturers Institute.

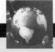

CHOOSING AN APPROACH FOR STATING IMPORT PENETRATION LEVELS

As we have seen in the prior discussion, two different approaches may be used to state import penetration levels. We might ask why it matters which is used or what difference it makes which we choose. For the most part, the answer lies in the message we wish to give. Although certain sources use both approaches, others representing special interest groups tend to report the status of imports in the way that makes the strongest case for that group's position. This means that as textile industry sources attempt to make a case regarding the threat of imports and the need to restrict foreign products, industry leaders generally use import data based on physical quantities. This approach is logical for that group because the physical quantity data indicate that imports have taken a much larger share of the domestic market than is shown in using value data (however, W. Cline's [1987] adjusted ratios in Table 9-4 showed that value data may also reflect high import penetration, especially for apparel).

On the other hand, the special interest groups that want to continue importing substantial quan-

tities of textile and apparel products—without added restrictions—tend to choose the *value approach*. These groups include importers and retailers who wish to minimize concern over the threat of imports in the U.S. market. Thus, those who want to be free of trade restrictions (the *free traders*) like to use import data based on *value*. This approach is logical for the free traders because the *value data indicate that imports have taken a much smaller share of the domestic market* than is indicated by using physical quantity data. We must keep in mind that Cline (1987) generally represents a free trade perspective.

We may ask: Which approach is correct? The answer is, both.

The significance of this point for us is that in politicized areas such as textile trade, we must remember to consider the source of our information and the position represented by that source. We can benefit by considering a wide range of perspectives, but then we must weigh each carefully to determine the approach that appropriately represents our views on an issue.

more sophisticated and have increased value added.

Although U.S. textile manufacturers may be inclined to speak against imports, a significant proportion of the domestic producers are actually importers themselves. In one study, nearly 52 percent of the participating textile CEOs said their firms use some imported textile mill products themselves (Hooper, et al., 1994). This means that textile producers import intermediate inputs to produce their firms' mill products. For example, weaving or knitting mills may import yarns for their production of fabrics.

EXPORTS. As noted earlier, in the past nearly all U.S. textile mill product shipments were directed to domestic markets. Perhaps this do-

mestic focus resulted from a tradition in which U.S. producers were privileged to have a nearly captive U.S. market—that is, before competition from imports became intense. In earlier decades, U.S. producers had no need to focus on foreign markets for their products because of vast opportunities provided by the large, affluent domestic market.

Consequently, few manufacturers acquired an export orientation, and few developed international marketing staffs with the skills and sensitivity to function effectively in foreign markets, where language differences, cultural differences, and varied marketing structures were a challenge. In short, few U.S. manufacturers thought of a global market or developed global proficiencies to perform in those markets.

Many challenges accompany exporting, including fluctuating currency exchanges and red tape. In fact, of the U.S. manufacturers who earlier had developed promising markets in other countries—particularly in Western Europe—many experienced significant losses in the early 1980s because of changes in the value of the dollar against other currencies.

For many U.S. producers, supplying foreign markets requires increased domestic investment in production facilities to provide adequate quantities of textile products. Because many of the export-oriented firms have experienced poor performance in foreign markets, many have been reluctant to invest in additional production capacity. Moreover, many other countries have restricted their markets as a way of protecting domestic textile and apparel industries; thus one must not assume that U.S. manufacturers have had free access to foreign markets.

U.S. textile exports have exploded in the last few years, generally with annual double-digit increases. Exports more than doubled between 1989 and 1996, from \$3.7 billion to \$7.8 billion. Leading export markets have been Canada, Mexico, and the EU. See Figure 9–4. In fact, during these years, export expansion softened the blow of the early 1990s domestic recession in the textile industry. It is important to keep in mind, however, that textile export figures include the value of exported fabrics sent for assembly operations elsewhere (mostly Mexico and the CBI region). When those finished products are returned to the U.S. market, they are also counted as imports.

Textile producers have been assisted by the comprehensive export development program sponsored by the U.S. Department of Commerce that has given added visibility to U.S. textile firms. Companies have been assisted through seminars, overseas trade shows, and

trade missions, and by being matched with potential partners in other countries. This assistance has given U.S. firms added confidence in their ability to sell in other countries.

OUTLOOK FOR THE U.S. TEXTILE INDUSTRY. Although the U.S. textile mill products industry has experienced several traumatic decades as a result of import competition, in many ways it is stronger and more focused as a result of that competition. Industry restructuring has included closing outmoded plants, investing in technology and automation to increase productivity, and focusing on market niches that are less labor intensive and more service oriented to avoid import competition. The industry that has emerged is leaner, more efficient, and more competitive.

The textile industry has invested heavily in sophisticated microprocessor-controlled technology. Technological advances are directed to three goals: (1) reducing labor, (2) increasing product quality, and (3) developing flexibility in production. Productivity improvements have been dramatic, rising at a rate greater than those of all U.S. manufacturing and those of the textile industries in most other industrialized nations (Edwards, 1988).

Although competitive conditions are expected to continue, the present revamped textile industry is much better prepared to hold its own in global markets than was true a decade or two ago.

The Textile Machinery Industry

In 1995, the U.S. textile machinery industry included nearly 500 plants and employed 17,000 workers—about two-thirds of whom are in production (U.S. Department of Commerce, 1997). Although the textile machinery industry is not part of the NAICS Textile Mills or Textile Product Mills subsectors, it is important to the textile industry. This subsector is classified as NAICS 333292, Textile Machinery Manufacturing, which is part of the Machinery Manufacturing subsector.

¹ U.S. export figures include the value of textile exports to offshore assembly operations under a special tariff provision (9802, formerly 807) (discussed later in this chapter) for eventual reimportation into the United States.

The availability of advanced machinery—whether to improve products, to reduce labor, or to speed production—is critical to the competitiveness of the U.S. textile industry. In fact, for the most part, this industry can advance only to the extent that it can obtain increasingly sophisticated equipment. Many of the manufacturing advances in the textile complex have resulted from utilizing new equipment produced by equipment firms.

From its early days, when textile-producing technology was smuggled into the United States from England, and through the development and refinement of domestically produced equipment, the textile machinery industry was one of the first capital goods industries to develop in the United States. The ability of U.S. textile machinery producers to develop and modify production equipment was critical to the major strides the domestic industry made in most of the history of the U.S. textile industry. Moreover, the domestic textile machinery industry supplied most of the needs of U.S. mills until recent decades.

As recently as 1970, U.S. textile machinery manufacturers supplied nearly 70 percent of the domestic market. Their market share dropped to 47 percent by 1984 and to about 35 percent in 1996; and whereas earlier sales had been for new, complete machines, later sales tended to be predominantly for parts. The shift toward supplying parts kept existing equipment functioning; however, servicing a parts market is not equal to the sale of new equipment in terms of the outlook for the domestic textile machinery industry. The heavy sales of U.S. spare parts reflect favorably on the U.S. machinery industry in the past but offer limited prospects for future markets for complete machines.

Although the market for machinery to support the U.S. textile industry is presently the second largest in the world (after that of China), domestic machinery manufacturers continue to lose market share to foreign suppliers. Competitors in other countries take not only more of the domestic market but also the global market, of which U.S. manufacturers once had a larger

share. In short, the U.S. textile machinery industry is no longer a strong force in producing for the textile machinery market. Instead, the United States has become increasingly dependent on producers in other countries to provide the highly specialized equipment necessary to sustain its competitiveness.

Mexico and Canada are the top two customers for U.S. textile machinery, with Mexico topping the list in 1996. The machinery industry is affected by the stages of development in the textile industry in various countries. Mexico needs machinery as it is poised for growth. On the other hand, China had been a major customer, but sales to China dropped 65 percent from 1993 to 1996. This drop can probably be explained by China's efforts to develop its own textile machinery industry to supply its enormous domestic textile industry. As we have discussed in earlier chapters, as countries develop, they desire to be less dependent on other countries for any aspect of production that permits profit and jobs to go elsewhere.

Decline in the U.S. textile machinery industry coincided with—and perhaps resulted from—the structural changes that occurred in the textile industry. The major textile machinery producers were acquired by large, publicly owned conglomerates that later sold the operations as the profits of the parent companies declined. While the domestic industry was **adjusting** to major changes in the 1960s, many overseas firms with technologically advanced products and accompanying customer service orientations took sales from U.S. suppliers (USITC 1987b).

Recapturing earlier positions in the textile machinery market requires significant R&D investment on the part of U.S. manufacturers—a difficult hurdle for most firms that lack either the necessary means or the momentum. The primary cause of the decline of the domestic industry was the technological superiority of foreign machinery, stemming from the R&D investment of the industries in the EU and Japan. In contrast, during the 1960s and 1970s, U.S. manufacturers were devoting fewer re-

sources to developing new equipment. Further, foreign suppliers have representatives who work closely with their customers and reportedly give better delivery and service than U.S. textile machinery manufacturers (U.S. Congress, OTA, 1987; USITC, 1987b).

Debate surrounds the question of whether the competitive status of the U.S. textile machinery industry affects the competitiveness of the domestic textile industry. Dependence on foreign suppliers means that new technology is made available to worldwide producers rather quickly because equipment suppliers want to sell as much of their equipment as possible; however, some suppliers have established research centers in the United States to respond to the needs of some of their major customers. USITC sources (1987b) noted that although the United States has become increasingly dependent on foreign manufacturers, the domestic textile industry's competitiveness does not appear to be affected. At times, however, exchange rate fluctuations have caused the prices of imported machinery to increase significantly.

The U.S. textile industry's increasing dependence on textile machinery produced in other nations illustrates vividly the growing globalization of the textile complex. Although representatives of the U.S. textile industry often

protest against imported products, which they believe infringe on their markets, many are at the same time growing increasingly dependent on foreign machinery for their own production. Further, as the domestic textile industry promotes restraints on imports of foreign textile and apparel products, those same U.S. manufacturers would be severely handicapped if similar limitations were placed on foreign-made equipment.

THE U.S. APPAREL INDUSTRY

Although the apparel industry is part of the textile complex and is closely tied to the textile industry, the apparel sector is a large and distinct segment of the U.S. industrial base. A profile of the U.S. apparel industry and an overview of the apparel sector's competitiveness in the international economy differ markedly from a similar review for the textile industry.

In brief, the U.S. apparel industry is composed of far more firms and has a much larger workforce than the textile sector (Figure 9–5). As a sector that is quite fragmented with a larger number of small firms, the U.S. apparel industry experiences greater difficulty than the textile sector in competing with foreign producers in

FIGURE 9-5

Production workers like this woman constitute a significant proportion of the large apparel industry workforce. These workers are the lifeblood of the industry.

Source: Photo by K. McKenna, courtesy of Kellwood Company.

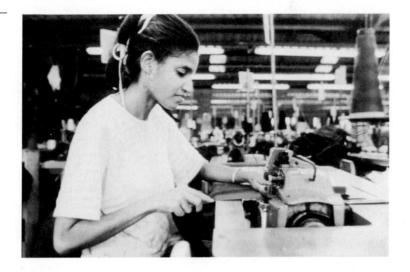

markets both at home and abroad. Since the apparel sector is the largest user of textile products such as fabric, a healthy apparel industry is vital to the textile complex. In 1996, the apparel sector produced shipments of \$50 billion. Apparel firms range from large, highly sophisticated businesses producing a variety of products to small companies operating with limited equipment and expertise.

In 1997, U.S. consumers spent \$230 billion on apparel.² To most consumers, clothing produced by the apparel industry represents the most tangible and most easily recognized aspect of what we consider more broadly as the textile complex. Consumers can identify clothing and understand that an industry produces clothing, whereas most consumers are less likely to understand the term *textiles* or to identify the many ways in which other textile products are part of their lives.

Apparel production includes the manufacture of men's, boys', women's, girls', children's, and infants' apparel and apparel accessories. Other items considered as apparel or apparel accessories (NAICS 315) may be made by cutting, sewing, cementing, or fusing such materials as rubberized fabrics, plastics, furs, and leather. Footwear is not considered part of the apparel sector; however, the footwear industry has many characteristics similar to those of the apparel industry: the products are a necessity, they are influenced by fashion, and both apparel and footwear production are labor intensive.

The apparel industry is by the far the most labor-intensive and most fragmented sector in the U.S. textile complex, with more than 24,000 establishments in 1995. This sector is characterized by many small firms employing an average of 38 workers per establishment. In 1994, approximately 67 percent of the plants (perhaps more appropriately called *shops* in the case of operations this small) employed fewer than 20 workers; these firms represented only

Of the segments of the textile complex, the apparel industry has the lowest entry barriers in terms of capital and technical knowledge requirements, ready access to production equipment, and broad availability of raw materials. The ease of entry also accounts in part for the small size and the rather high failure rate of firms. Traditionally, the apparel sector has been a creative, price-competitive business, with a large number of family-owned firms.

As an Office of Technology Assessment report (United States Congress, OTA, 1987) noted, the apparel industry comes close to representing textbook conditions for "perfect competition," but production operations are kept small, in part because of the specialization of each firm in a narrow product line. Competition is intense—both among domestic companies and with foreign producers. Intense competition has been reflected in apparel prices, which generally have risen less than most other consumer expenditures.

Typically, apparel firms produce narrow product lines. Only the larger firms produce garments in more than one category (e.g., women's outerwear, men's furnishings, and children's sleepwear). Further, most firms produce garments in a fairly specific price and fashion range. For example, firms that produce high-fashion women's suits usually do not produce inexpensive nightwear, and firms that produce inexpensive children's sleepwear typically do not produce trendy men's sportswear.

The U.S. apparel industry is more scattered across the United States than the textile industry. Although most states have a certain amount of apparel production, this sector also

⁹ percent of all apparel workers, however. At the other end of the spectrum, 17 percent of the firms (i.e., the large ones) account for 76 percent of the employment. (U.S. Department of Commerce, Bureau of the Census, 1994, *County Business Patterns* 1994). A relatively small percentage of U.S. apparel firms have sales of over \$200 million per year. In fact, sales of the larger apparel firms increasingly account for a growing share of all apparel sales.

² U.S. expenditure/consumption figures vary according to the source of data; in some cases, the difference reflects inclusion of other categories such as shoes or accessories.

has areas of heavy concentration, particularly in the Northeast, the Southeast, and California. Many apparel plants are located in small towns across the country and play crucial roles in local economies. As we shall discuss in more detail later in this chapter, many U.S. apparel firms are participating increasingly in **offshore production** of their garments.

Characteristics of the Apparel Industry's Products That Account for Unique Challenges in the Industry

Some of the following aspects of garment production offer unique challenges to the industry and perhaps account for some of the fragmented structure of this sector.

Difficulties in Manufacturing Products Made of Limp Fabrics

The manufacture of garments from limp fabrics makes the apparel industry quite labor intensive. The process of making a garment for a three-dimensional human body from two-dimensional fabric requires a large amount of human handling in the production processes. Whereas mechanical equipment has long been available to handle and position rigid metal, plastic, or even paper, similar mechanization has not been developed significantly to pick up single layers of fabric for processing through various production stages. Although automation for apparel production has increased more rapidly in recent years, equipment manufacturers have found it challenging to invent machines that can pick up a single ply of fabric or automatically perform more than a limited number of assembly steps. For example, jean pocket-setting machines have been available for a number of years. For the most part, however, workers still must move the garment pieces from one operation to the next and usually must position the piece for the automatic operation to occur.

Limitations on Large Production Runs

Many aspects of apparel production, particularly of fashion items, discourage the efficiencies of production possible with other products. This occurs in at least two ways:

- The desire for exclusive products. Consumers want, and often demand, a degree of exclusivity in clothing; the more costly the garment, the more this holds true. Even at moderate price levels, consumers want a certain degree of distinctiveness in the clothing they buy and wear. Because clothing is used to express their individuality, most U.S. consumers are seeking more than a uniform look. For the apparel industry, particularly for fashion items, this means that the efficiencies of large-volume runs possible in many other industries are ruled out. For example, the manufacturers of snow shovels or toothbrushes need not be concerned about limiting volume production because consumers would not want to see their neighbors using the same products.
- The changing nature of fashion. The transient nature of fashion poses special challenges to apparel manufacturers. The fashion at a given time may have unique features for which specialized production equipment and specially trained workers are needed. As an example, when monogrammed shirts were a popular fashion item, production was enhanced greatly by the availability of special-purpose machines to perform the monogramming operation. Large firms could easily invest in the equipment to produce the item; however, smaller firms might have had difficulty justifying the investment in special equipment for a passing fashion. Adapting to fashion is a constant challenge that includes producing garments from a wide range of fabrics, as well as using diverse construction techniques that are both functional and decorative and that incorporate style

variations ranging from the use of lace trims to rivets.

The Transient, Unpredictable Nature of Fashion

The fashion areas of the apparel industry are unpredictable, particularly since consumer interests can change quite rapidly. Although the industry as a whole is placing greater emphasis on marketing efforts, and although, even before that trend, well-managed apparel firms were in tune with consumer demands, responding to fashion whims can be difficult. Even if an apparel firm is sensitive to a new fashion trend as it develops, it may have difficulty securing the component parts for the multiple stages in the production chain in time to respond to the rapid fashion change. For example, Sara Lee was not prepared for the instant success of the "Wonderbra" or prepared to deliver the quantity needed. Even more difficult are the times when a firm is in the middle of production on a line, only to learn that the item has gone out of fashion.

The Challenge of Timing

Other aspects of timing related to apparel production represent difficulties for apparel manufacturers. As an example, seasonal production is particularly critical in some areas of the country. Consumer demands for swimsuits and coats are hardly interchangeable. If coat-weight fabric suppliers do not respond on time, coat producers may have difficulty providing coats for the appropriate season. Retailers, who are, in turn, responding to consumer demands, have limited patience if coats are not available from manufacturers when needed. In their attempts to respond to consumers, retailers will seek other coat suppliers to fill their needs. This is another application of the train analogy discussed in Chapter 8; consumer demand sets the pace for the production and marketing chain.

Seasonal concerns are only one aspect of timing for the industry. In general, the industry is a dynamic one in which timing and speed typically are quite remarkable, considering the multiple stages involved in producing and selling garments. Responding to the demands of appropriate timing is a constant challenge, however.

We might also note here that the industry itself has fostered some of these characteristics that pose a challenge. For example, the industry promotes fashion change as an inherent aspect of the business. An emphasis on the latest "new look" generates excitement and sales for the industry. Therefore, coping with the fast turnover of fashion—that is, implementing this emphasis in the production and distribution aspects of the industry—is a natural consequence of the sector's focus on change.

Types of Operations

Apparel production may occur in different types of operations. The U.S. Bureau of the Census divides the industry's firms into three major groupings based on how comprehensive their operations are. However, different criteria and terminology are commonly used today, and in this area of business, as in many others, the census definitions no longer reflect common business practices.

 Manufacturers, according to the census definition, are responsible for the entire range of operations for apparel production, from the initial designs to shipping. Today, however, a multiplicity of domestic and offshore contracting strategies has rendered that definition obsolete. Today, companies considered apparel manufacturers by the industry include any concern that develops garments, controls production, sells to retailers (or directly to end-use customers), and ships and bills for merchandise. Today, many of the top firms considered by the industry to be apparel manufacturers

- perform little or none of their own garment production. In a few cases, companies may have no domestic production at all.
- Jobbers are responsible for their own designs, acquire the fabric and other necessary components for production, and arrange for the sale of finished garments. Jobbers may perform cutting operations but typically contract out most other production processes.
- · Contractors are independent producers who perform sewing operations, and sometimes cutting, for apparel manufacturers and/or jobbers (and increasingly for retailers). Typically, contractors receive cut garments in bundled form and process them into completed garments. Many contractors and manufacturers have long-standing working relationships and function virtually as partners in producing garment lines. Contractors may be located in the United States or in other countries where labor and appropriate skills are available. Additional options for combining domestic and offshore production are considered later in this chapter.

Advantages and disadvantages are present under the different manufacturing arrangements. When manufacturers perform all of their own operations, they maintain greater control over quality and avoid the added demands of moving the goods. On the other hand, this arrangement requires an investment in production equipment and a commitment to retain employees during both peak and slow periods. In contrast, using contractors may give the manufacturer greater flexibility to expand and contract output without the added investment in facilities and equipment and the responsibility of maintaining a production workforce. Contracting requires the physical movement of goods, however, and the manufacturer loses some control over quality and delivery dates. In recent decades, the use of contractors has grown in relation to manufacturing.

Factors Affecting Competitiveness

Since its early development, the apparel industry has been characterized by relatively simple technology and a high degree of labor intensity. Because of the amount of labor involved in apparel production and because of the labor-cost advantages in many developing countries, if industrialized countries are to remain competitive in global markets, increased automation appears to be essential. Automation can reduce labor costs, add production flexibility, and standardize quality. New technological developments and adaptations offer a great deal of potential for improving productivity in the apparel industry.

Computers have transformed virtually every aspect of the industry for those companies that can afford the investment and see the need. New technology permits manufacturers to speed up the product development process, preassembly operations, the assembly process, and finishing operations while reducing the labor time per garment. Computers also contribute to production planning, marketing, sales, financial management, inspection of fabrics, costing, programmable sewing machines, unit production systems that move garments in a conveyor manner from one operation to another during the sewing process, and state-of-the-art distribution facilities.

Earlier, Cline (1987) noted that the apparel sector had invested in capital equipment to improve its operations to a very limited extent. Although an increasing number of apparel manufacturers have undertaken major capital investment programs in recent years, one should keep in mind that major reinvesting may not have been a realistic option for many U.S. apparel manufacturers (including contractors). A significant number of small operators are independent manufacturers, jobbers, and contractors for whom it is unrealistic to think of reinvesting in costly state-of-the-art production equipment. Many small establishments

survive on slim margins. A shop employing 20 workers can hardly afford high-technology equipment; nor can it make adequate use of costly new equipment to justify the expenditure.

Although Arpan et al. (1982) found that limited **production economies of scale** exist for the apparel industry, the very small size of some establishments is a serious disadvantage. Limited opportunities for investment or for employing staff with expertise in major functional areas jeopardizes the success of these small operations.

Foreign competition has placed increased pressure on domestic apparel manufacturers to find ways to reduce costs and enhance productivity. In response, many of the forward-looking apparel firms, which are often the larger companies, have taken bold steps to improve productivity through technological advances. In fact, larger companies with significant production volume are the ones that might use automation and other technology most effectively to improve productivity.

Particularly from a global perspective, however, reinvesting to improve international competitiveness is a matter of serious concern for the U.S. apparel industry. As a mature industry, some of its plants and equipment resemble those established decades ago. Companies are able to function satisfactorily in many cases with basic sewing, cutting, and pressing equipment far short of state-of-the-art quality. In contrast, as garment plants were established in recent years in major competitor countries, some of those operations began with modern equipment—often purchased with outside investments. However, the poorest developing nations often use outdated, second-hand equipment.

"Pattern of Work"

In focusing on the need for modern production equipment to maintain a competitive advantage, we must remember that technical improvements represent only one aspect—albeit an important aspect—of worker productivity.

Another significant component of worker productivity is what Arpan et al. (1982) referred to as the "pattern of work." The pattern of work is tied closely to the employee's commitment to work. Components of the pattern of work are attitudes toward work; willingness to work efficiently on a scheduled, dependable basis; the speed at which work is done; the number of hours worked; absenteeism; turnover; and the quality of work. As Arpan et al. noted, the major Asian exporting countries appear to have work patterns equal to or better than that in the United States. Expressing similar views in a Wall Street Journal article, Stabler (1986) shared Peter Berger's observation on shifts in work ethic in today's global economy:

"The old Protestant ethic, which isn't very significant today in its countries of origin, is alive and well in Seoul, in Soweto and in Santiago de Chile." It is operating there, he added, much as it did in Europe and North America in an earlier period, "by inculcating moral values and attitudes that are conducive to success in a nascent capitalist economy." (p. 1)

U.S. apparel firms have found that newer approaches that empower workers and give them greater control over their work have rekindled worker commitment. Strategies such as modular manufacturing and participatory management have given employees a chance to feel in control of their work lives absent from the old assembly-line and authoritative approaches.

Sourcing Strategies

Sourcing is an industry term used to describe the process of determining how and where manufactured goods, or components, will be procured. The industry also uses this term for having production or assembly done elsewhere. Although both manufacturers and retailers participate in sourcing activities as a normal part of business operations, our focus in this chapter will be primarily on the U.S. apparel firm. For many years, U.S. apparel companies had two options: they could manufac-

ture garments in their own plants or they could contract the work to another producer. Now, however, for many apparel firms, worldwide sourcing strategies are basic to their operations, and a wide range of sourcing options exist both domestically and internationally. Each company must evaluate a number of variables to determine its own strategy; some of these variables are:

- *Investment:* To what extent does the company want to invest in facilities and equipment?
- Production costs: How do costs balance other factors such as risks and speed?
- Labor: What are the costs and availability of labor?
- Quality control: To what extent can the company maintain control over quality?
- *Timing:* How quickly must garments be sewn and delivered to customers? Are contractors capable of meeting the timing demands?
- Risks and reliability: In international sourcing, a number of factors can be problems: language and cultural misunderstandings, political instability, changes in currency exchange rates or freight costs, or problems with such things as local transportation systems in developing countries. Companies must ask how much uncertainty or risk is acceptable.

The nature of the apparel products, the market, the cost of various sourcing options, the company's need for control, **lead time**, **velocity costs**, and the availability of attractive sourcing options determine the sourcing mix.

Domestic Production Options

Domestic options consist of owned domestic production or contracted production.

OWNED DOMESTIC PRODUCTION. Under this arrangement, manufacturers produce garments

in their own plants, with maximum control over the timing and quality of their lines. However, firms need to invest in technology to be competitive, and equipment can easily become outdated. Wages are higher than those in many other countries. The firm has a commitment to a production workforce.

DOMESTIC CONTRACTOR PRODUCTION. As noted earlier in this chapter, contract operations reduce investments and the need to maintain a production workforce. Contractors may produce overflow for manufacturers with limited capacity, may produce specialized products for manufacturers who lack a particular expertise, or may be the primary production site for marketing-oriented firms with little or no production capacity. Control over timing and quality is less than in owned facilities.

International Production Options

Increasingly, firms (both manufacturers and retailers) are taking part in various international production arrangements; the most common types are described here. Generally, the main reason for using international sourcing is reduced labor costs; however, companies must also consider risks, complexity in working in another culture, shipping costs, possibly lower productivity in developing countries, and tariffs. Recourse for poor merchandise or service may be difficult. Many technical aspects of international trade make these arrangements more complex. One example is the quota system. See Box 9–2.

CONTRACTED PRODUCTION IN OTHER COUNTRIES. In this arrangement, the apparel firm buys the services of a contractor, much as it does in domestic contracting, except that the production occurs in a lower-wage region of the world, creating complexities in doing business. Typically, product development occurs in the home country, and most of the manufacturing activities are

THE IMPORTANCE OF ACCESS TO A QUOTA

At least until well into the 21st century, a quota system will affect U.S. textile and apparel trade with many countries. Under sourcing arrangements in which garments are made in another country, shipments often are subject to quota limitations. Foreign apparel producers must have access to some of their country's quota allowance to ship garments to the importing country. For example, a Hong Kong producer must have access to Hong Kong's quota granted by the United States to ship to the United States.

Quotas are distributed to apparel manufacturers in various ways from country to country. Therefore, U.S. manufacturers using sourcing options that involve foreign assembly or total production must take care to work with contractors who have quota rights. Otherwise, garments cannot be shipped to U.S. markets. Quotas must be purchased in certain countries; earlier, as trade restrictions became tighter, quotas became more scarce and more valuable. As a result, rising and unpredictable quota prices have been both a risk and a growing expense when using certain of these strategies.

Under NAFTA, quotas are much less of an issue for Mexican production than in the past. Similarly, the special provisions for the CBI countries mean that quotas are not a factor if U.S. fabrics are used and garments are cut in the United States.

performed by the contractor in the contractor's country. These are either full package or cut-make-trim (C-M-T) arrangements. The contractor may assume responsibility for securing the fabrics, as well as other aspects of producing garments, depending on the nature of the contract. Because of the potential risks related to timing and quality control, the apparel firm may have its own representatives on site frequently to monitor production or may hire an agent in the contractor's country. Since NAFTA has been in effect, Mexico is becoming an increasingly important contracting site. See Box 9–3.

9802 PRODUCTION. Many apparel firms use the 9802 production (formerly 807 production) provision of the U.S. tariff rules to send cut apparel to low-wage countries to have garments assembled for return to the U.S. market. This form of contracting is similar to the contracted international production discussed above; however, certain U.S. trade policies provide advantages on quotas and tariffs for com-

panies that use this form of contracting. See Box 9–4. In recent years, this production has occurred mostly in the Caribbean and Mexico, where close proximity to the United States permits rapid turnaround. This form of production accounts for a growing proportion of U.S. apparel imports. Some 9802/807 plants are owned by U.S. firms; others are contract or joint-venture plants.

OWNED PRODUCTION OVERSEAS. This form of international apparel production in a firm's own plants includes both manufacturer-owned plants and joint-venture arrangements. (See Chapter 12 for further discussion of these arrangements.) Having company-owned overseas plants offers a greater opportunity to control quality than may be possible with foreign contracting, especially if local managers run the plant according to the parent company's expectations. Furthermore, the product cost is lower from owned plants than from foreign contractors, since no contractor profits are included. On the other hand, owning plant facil-

THE NORTH AMERICAN FREE TRADE AGREEMENT

When NAFTA went into effect on January 1, 1994, textile and apparel trade between the U.S. and Mexico took on a new character. For the first time in more than two decades, the United States moved to textile and apparel trade without restraints on products from Mexico. Prior to NAFTA, a great deal of apparel production for U.S. firms occurred in Mexican plants, frequently under maguiladora arrangements. Shipments from the Mexican assembly operations were limited, however, under an agreement called the Special Regime, similar to the Special Access Program for Caribbean nations. To avoid quotas under the Special Regime, garments had to be both made and cut from U.S. fabrics. Tariffs were levied on the value added for finished garments returned to the United States. The Special Regime under NAFTA swept away all quota restrictions if products made in Mexico are from U.S.-formed and -cut fabric. The remaining limitation on trade is that garments must be made from components "from the yarn forward" that originated in North America. This provision of NAFTA was enacted to satisfy U.S. textile producers who wanted to be sure that Mexican garment firms used North American fabrics rather than those from Asian suppliers. And, if textile and apparel products abide by these rules, products may qualify for duty-free entry into the United States.

Once NAFTA became a reality, the Caribbean nations were at a disadvantage in apparel production compared to Mexico because Caribbean production still had to meet the stipulations of the Special Access Program to avoid quotas and had to pay duties on the value-added portion of the garment when they were returned to U.S. markets. The Caribbean nations sought parity with Mexico as a site for U.S. apparel production.

ities adds to the company's investment and risk. In some countries with a volatile political climate, firms have less flexibility in moving operations to another region or country if they own manufacturing plants. Moreover, given certain other (host) countries' investment policies, owning production facilities sometimes has not been permitted (e.g., in India and Indonesia until recently).

Combination Options

Many firms use a mixture of sourcing options, which vary widely from one company to another. Given the uncertainties in the apparel industry and the rigorous global competition, a combination of strategies provides managers with flexibility to shift sourcing as conditions dictate. Mixed sourcing plans give the firm greater stability and control in its own plants

and, at the same time, allow it to assume somewhat more risk in offshore sourcing for other parts of the business. Although a firm may want to have some basic production capacity and own some of its own equipment, it may also want to limit its investment and take advantage of contractor services, perhaps in another country where wages are lower.

Overall, a combination of sourcing arrangements gives the apparel firm a hedge against the uncertainties inherent in apparel production. Companies can monitor investments, control risks to varying degrees, and take advantage of certain low-cost sourcing options.

Markets

Of all the markets in the U.S. textile complex, the apparel market is in many respects the most competitive and most difficult. In no

9802 PRODUCTION

Item 807 of the former, and now nonexistent, Tariff Schedule of the United States (TSUS) permitted the export of garment pieces to low-wage countries for assembly, with the reentry duty paid essentially only on the value of the assembling (the value added). This provision for production still exists, but under a new tariff classification system called the Harmonized Tariff Schedule, often called the Harmonized System. (This program was developed to have a common system for tariff nomenclature and categories usable by a large number of the world's trading nations rather than each nation having its own unique system.)

Although the industry has known this as "807 production" for a long time, the *new classification under the Harmonized Tariff Schedule is 9802*. As before, production under this special provision allows an article that has been assembled in a foreign country "in whole or in part of fabricated components, the product of the United States" (USITC, 1994), to enter the United States with the special tariff concessions. (Under this provision, garment parts must be cut in the United States; fabrics may be from elsewhere.) That is, tariff is paid on the value added rather than on the total value of merchandise produced under other arrangements.

Under this provision, however, merchandise is subject to the *same quota rules* as other apparel from foreign shippers. *Quotas* are limits on the volume of a product that can be shipped into the United States (other importing countries also impose quota limits). This means that when apparel producers in a foreign country ship assembled garments to the United States under the 9802 provision, they are using a portion of the country's quota to do so when a quota exists.

Earlier, U.S. producers used the Far East for 807 production, but more recently, production has shifted to Mexico and the Caribbean basin countries because of their proximity to the domestic market. An added provision in the Tariff Schedule, under a Special Access Program, has been Item 807A—also known as *Super 807* (perhaps to be known as *9802A*). The Special Access Program gives Caribbean countries added quota allowances (known as guaranteed access levels or GALs) when fabric is *both made and cut* in the United States. If foreign-made trim is used, it may not exceed 25 percent of the total value of the garment (Gelber, 1989).

*Now that NAFTA is a reality, provisions of that agreement are more favorable for Mexico; therefore, Mexico uses NAFTA provisions rather than 9802 (807) for its apparel trade with the United States.

other segment of the complex is the potential for overcapacity and oversaturation so great. The potential to produce more than the market can absorb causes intense competition and fosters a "survival of the fittest" climate for producers in this sector. In the United States alone, thousands of establishments compete for the market, although their specialized production areas reduce the degree to which all of them compete against one another. Scores of domestic producers in large numbers of nations also

compete for the U.S. apparel market. In contrast to certain segments of the textile sector, in which only a limited number of countries participate in global markets, virtually all countries are active in apparel manufacturing. The intense global activity in the apparel sector accounts for the extremely competitive conditions both in the international market and in the U.S. market. The U.S. market would be oversaturated, perhaps, even without the added pressure from imports.

This overabundance in the supply of apparel has led to a difficult trend for the industry termed price deflation. In the middle to late 1990s, apparel prices deflated, rather than inflating, for several years in a row. A lengthy depression of the consumer apparel price index had occurred only once before, between 1952 and 1955, but that price depression was shared with other industries. Factors contributing to the 1990s' dilemma were an oversupply from manufacturers, too many stores competing for the consumer's purchases, and consumers who expected high value at increasingly lower prices (and held out until they could get merchandise at low sale prices). This combination meant that all players in the softgoods chain were working harder and earning increasingly slim profit margins (DesMarteau, 1997; Ramey, 1995).

Apparel manufacturers serve the following two markets:

- **1.** The *retail market*, composed of retailers who are the buying agents for their apparel customers.
- **2.** The *consumer market*, composed of those who use the apparel.

The Retail Market

Since retailers are the direct customers of the apparel producer, the relationship between these two industry segments is of special importance. Unless the apparel manufacturer produces garments and offers services that satisfy the retailer, the apparel firm's products may never reach the end-use consumer.

Department stores and department chain stores (including J. C. Penney and Sears) have been the largest sources of retail apparel sales. However, as consumers have become more cost conscious in recent years, they are seeking less expensive clothes at less expensive places. Department stores are losing market share to discount stores and other lower-cost forms of retailing. Apparel specialty stores have felt the

impact of this shift, and a number of them declared bankruptcy in the 1990s.

Moreover, apparel distribution channels have become increasingly complex as retailers have consolidated or otherwise grown into high mass merchandisers. This means that buying decisions are concentrated in the hands of fewer and fewer buyers. Additionally, retailers are demanding increased financial and service privileges. As the largest apparel manufacturers continue to grow, similar to what is happening in retailing, we see a pattern some describe as "the big tending to dance with the big."

The overcapacity and oversaturation in the apparel sector mean that competition is intense for manufacturers to obtain and keep retail accounts. If a manufacturer is unwilling to meet a retailer's needs (and, in some cases, demands), an exceptionally large number of other producers—both global and domestic—are ready to respond with attractive offers. Retailers also have faced difficult competitive conditions in recent years; therefore, they have found it necessary to seek the most attractive prices for the garments they buy for their stores. For many retailers, the choice has been to buy imports for a growing share of the store's apparel selections.

Now major retail firms are taking their international sourcing a significant step further. As they have struggled to be competitive, many have launched ambitious private label programs in which they are functioning in the same manner as firms generally considered apparel manufacturers. That is, they develop their product lines and contract their production directly, mostly in low-wage countries. In some cases, retailers have found foreign suppliers more willing than U.S. firms to respond to their needs. Many domestic textile and apparel firms take the skeptical view, however, that retailers' offshore sourcing is a way of adding excessive markups to extend profits at the expense of domestic manufacturers. However, as a growing number of U.S. apparel manufacturers engage in offshore sourcing, fewer are in a position to criticize retailers.

As domestic manufacturers recognized the powerful position of retailers in bypassing the U.S. apparel sector for their purchases, they made special efforts to improve their service to retailers and to mend relationships. The Quick Response (QR) program initiated by the U.S. textile and apparel industries has been a significant step in this direction. The QR concept offers many advantages to retailers; it has the potential for reducing investments, providing better service to the end-use customer, and enhancing profit margins.

Manufacturers and retailers have cultivated closer working relationships, as both sectors realize that they can serve the end-use customer more effectively by working together. Moreover, apparel manufacturers have placed added emphasis on marketing strategies to aid in responding to customers' needs—an approach that is also useful to retailers. In general, the U.S. apparel industry has made strides toward establishing a partnership with its retail customers.

Consumer Markets

318

Apparel manufacturers have the challenging task of producing garments with style and quality to appeal to end-use customers. Moreover, these garments must be offered at prices that are competitive in both the retail and consumer markets. Apparel must be sold at prices at which retailers can earn a profit. At the same time, items must be offered at prices competitive with those of comparable garments produced by other domestic suppliers and with those made in low-wage countries.

As noted in Chapter 8, demographic shifts and changes in consumer spending have had a tremendous impact on the industry. Consumers' reluctance to spend on apparel in the 1990s has made companies understand that their business activities must center on the consumer.

Marketing Strategies

A major change in the U.S. apparel industry has been the increased emphasis on a **market**-

ing orientation. Earlier, apparel firms tended to have primarily a production orientation and "thought of their business and markets in terms of what their plants could produce" (AAMA, 1984, p. 55). Although the apparel industry's increased marketing emphasis is part of a broader focus in the textile complex, a marketing orientation is especially critical for apparel manufacturers. First, it is the apparel manufacturer who transforms intermediate textile inputs into products that go to retailers and consumers. If the apparel firm miscues, it is the first segment of the production chain to suffer a loss (and, as a result, suppliers share in that loss). Second, a marketing focus took on added importance to apparel manufacturers as it became apparent that retailers were bypassing the domestic apparel industry to buy many of their apparel lines in other countries. Apparel firms realized the increased importance of being sensitive to both retail market and consumer market needs. Consequently, apparel marketing and apparel merchandising have become increasingly important activities in successful apparel firms.

Some of the special difficulties resulting from foreign competition encouraged U.S. apparel manufacturers to develop more thoughtful marketing plans. Increasingly competitive conditions no longer permitted the losses that accompanied the less-focused hit-or-miss approach used by some of them. A number of manufacturers who had failed to tie their apparel production to sound marketing strategies (which, for example, acknowledged imports in their specific markets) found their businesses quite vulnerable to import competition. Many firms that had specialized in a specific product or a narrow product line found that they were unable to respond to an influx of imports by shifting product lines. Similarly, firms that had concentrated production in price-sensitive, high-labor, and low-fashion garment lines, such as men's and boys' shirts, found their domestic markets disappearing because many overseas producers aimed for this market as well.

The Workforce and Wages

The apparel industry employs more than 800,000 workers, the large majority of whom are production employees.³ This large workforce is a reflection of the labor-intensive nature of the apparel industry. Also reflecting the high labor requirements, apparel production workers account for about 85 percent of the total workforce compared to 68 percent in U.S. manufacturing overall (U.S. Department of Commerce, 1993). Women and minorities constitute a large proportion of the apparel workforce, particularly when compared to U.S. manufacturing as a whole.

In short, the apparel industry provides jobs to a large component of the U.S. industrial workforce. Many of those workers would have few or no other source of gainful employment in their regions without the apparel jobs, and many workers lack the financial resources to relocate for other employment. Moving from rural communities to urban environments to take similar jobs hardly seems an attractive alternative. In a sense, the apparel industry makes a social contribution in providing employment for many workers with few job alternatives. One might even speculate that for a significant number of U.S. workers, apparel employment provides the same beginning for those workers who are in their first (and perhaps only) industrial jobs and who have few other alternatives, just as the industry does in many less-developed countries.

Since its beginning, the apparel industry has been known for its low production wages. Work in the needle trades has long been undervalued, as Plant (1981) noted:

The fact that practically every woman and most men could ply a needle, and indeed that even little girls in most families learnt to sew at an early age, meant that for many workers sewing was the only skill they had to offer. The introduction of the hand or treadle sewing-machine did little to change their situation, since it was a simple device to master. One thinks of the penniless immigrants arriving in New York, there to make garments for the new nation, or of oppressed minorities in other countries, not allowed to own land and debarred, as a rule, from practising the more prestigious crafts, starting with little more than a needle and thread. (p. 57)

Data on earnings in the apparel industry show that workers in the sector are paid significantly less than employees in other manufacturing industries and other selected sectors. Average hourly earnings in most segments of the garment industry were only about 60 percent of the wages paid to workers for all manufacturing.

Speculation on the reasons for the large disparity in industrial wages leads to a number of questions. Although economic justification can be given, no doubt, for the large wage differences, one might ask if the skill levels required in the apparel industry are that different from those in the automobile industry. Is the skill required to make a collar that much less than is required to perform routine assembly line tasks to attach a fender in an automobile plant? Yet, most automobile workers earn more than twice the amount paid to garment workers. One might ask to what extent low apparel wages are associated with the predominance of female (and minority) workers. Is it more than coincidental that the manufacturing sector with the highest proportion of women and minority workers is the one with the lowest wages? Given the history of a gender gap in wages in the United States and the probability that a predominantly female workforce was in the past more passive in terms of employment demands, it does not seem unreasonable to speculate on the association between gender (and perhaps other characteristics associated with limited power) and wages for the industry. (If the reader wishes to pursue this topic, a useful source is Leiter's [1986] study of Southern textile workers.)

³ Employment figures from the Bureau of Labor Statistics usually vary slightly from those from the Department of Commerce.

In W. Cline's study (1987) of the U.S. textile and apparel industries, he found that wages in the apparel industry have declined in relative terms over time. Cline questioned the continued decline of relative wages for apparel workers, particularly in light of what he perceived as "healthy" profits at that time for the apparel sector. (Readers who wish to pursue Cline's concern over what he calls the "profits paradox" may wish to read his book. Although some sources find his conclusions useful, others question his access to reliable profit data for making the assertions found in his book.)

Employment in the apparel sector declined gradually from 1972 to the early 1990s. Employment dropped from a peak of 1.4 million workers in 1973 to more than 800,000 in 1997. As the industry began to move its assembly operations offshore, job losses averaged 15,000 to 20,000 per year, rising to more than 50,000 annually between 1993 and 1996. The escalating job loss appears to be related to apparel firms' increased production in Mexico and the Caribbean. For many companies, the use of offshore production is a way to maintain a viable enterprise in which some jobs are retained in the United States.

Apparel firms with production in the United States have worried about the impact of the increase in the U.S. minimum wage that went into effect in the mid-1990s. Although apparel wages are among the lowest in the United States, apparel firms will be further pressed to evaluate the gap between U.S. wages and those in less-developed countries. For apparel firms that have been marginally profitable, the effects of wage increases can be serious.

Industry sources typically view textile and apparel imports as the cause of declining employment in the domestic sector. Basic logic suggests that the large influx of imported goods into U.S. markets in recent years has displaced some of the domestic market share and, hence, affected employment. A number of researchers (Frank, 1977; Grossman, 1982; Isard,

1973; Krueger, 1980; Martin & Evans, 1981) have attempted to determine to what extent imports and productivity influence industry employment. In general, these researchers have concluded that labor productivity growth (and, for textiles, slowed consumption) had a much more serious impact on employment than did imports. However, this may be more true for textiles than for apparel, given the labor-intensive nature of apparel production. Imports and the shift of production to other countries played a more significant role in affecting employment for the apparel sector than for the textile sector.

Labor Union

In 1995, the International Ladies' Garment Workers' Union (ILGWU) merged with the Amalgamated Clothing and Textile Workers Union (ACTWU) to form one union with 355,000 members at the time. The merged group is known as the Union of Needletrades, Industrial & Textile Employees (UNITE) and is one of the largest labor unions in the United States. Although fewer than half of all apparel workers are unionized, the merger gave the union increased strength and visibility. UNITE has been actively involved in the antisweat-shop campaign.

Labor Shortage

The declining employment status of the apparel industry has another dimension. A number of U.S. apparel manufacturers have begun to experience difficulty in securing production workers. In regions where the labor force has various employment options, workers may choose jobs in sectors where wages are higher. A number of farsighted apparel executives have begun to establish day-care facilities and provide other incentives as a possible way to attract and retain the workers needed, a high proportion of whom are women.

Additionally, a number of company executives have complained that the relatively gen-

erous U.S. social welfare system has discouraged workers from taking production jobs. These executives hope that as the welfare system is reformed, many former recipients will consider jobs such as those in their apparel factories.

Trade

Since the early 1960s, the U.S. apparel industry has faced increasing competition from overseas apparel suppliers who offered attractive prices on garments because of lower labor costs in their countries. Although the influx of imports has been detrimental to the domestic industry in several respects, the import threat also provided the stimulus for industry efforts to maintain and enhance the U.S. industry's position—both in domestic and in international markets. In short, although the competition has been painful, the U.S. apparel industry that has emerged is a more viable one.

One way the U.S. apparel industry has become more competitive is *by being more global itself*. Increasingly, apparel firms have shifted their own production to lower-wage countries to reduce costs. As a 1996 publication of the American Apparel Manufacturers Association notes:

Putting apparel's situation in perspective, domestic garment manufacturing remains a \$50 billion industry. Another \$50 billion (landed, dutypaid) wholesale is imported—less than half directly by retailers, with the balance purchased and managed by U.S. apparel companies. (AAMA, Maximizing, p. 3; emphasis added)

The Trade Status of Apparel Compared to Textiles

The trade picture for the apparel sector differs markedly from that for the textile sector. Although the two industries have many common trade concerns, the impact of low-cost imports has been much greater for apparel than for textiles. Two primary explanations account for the more dramatic increases in apparel import shipments:

- 1. Apparel production has been difficult to automate to reduce the amount of labor required to make garments. Other characteristics of the market also reduce the efficiencies that go with the high-volume production possible in other industries. As a result of these peculiarities of apparel production, industrialized countries like the United States are generally at a disadvantage in competing in the international market and even in their own markets.
- The labor-intensive nature of apparel production makes it one of the most suitable early industries for developing countries to enter in their quest for economic development. High labor requirements for apparel assembly are well suited to the "factor endowment" of the developing countries. (The Heckscher-Olin theory suggests that a nation will rely heavily on producing and exporting products that use more of the country's abundant—and cheaper labor factor.) Many developing countries have abundant unskilled labor, with limited capital and technical expertise. Not only is the apparel industry an attractive first industry for many of these countries, it may be the only industry for which they have the necessary factors to enter production, particularly for export.

In contrast, production in the textile sector is less prone to relocate to the developing countries. The capital and technology requirements for textile production, particularly of an advanced nature, make the textile sector less attractive to these countries. Furthermore, textile manufacturers in the developed countries have been able to use technology to reduce labor costs in textile production.

Global Shifts in Apparel Production

Apparel production has become dispersed around the globe, shifting as comparative advantage changes in various regions of the world. Most shifts occur to take advantage of cheaper labor and to avoid trade restrictions that prevent a country's products from entering the U.S. or other importing markets.

Both apparel firms and retailers in the United States and other developed countries have *fostered* the international shifts in apparel production as they seek the benefits of the developing countries' comparative advantage. Moreover, these representatives from the importing countries have provided technical assistance to the producers in low-wage countries so that apparel suppliers can improve the styling and quality features of the garments they make for customers in the developed countries.

Global apparel production and trade patterns cannot be explained entirely by labor costs. (See Chapter 5 for a review of this point.) Although apparel assembly operations continue to spread to newly emerging (in economic development) countries such as Bangladesh, Nepal, and Sri Lanka, where labor is among the cheapest, the major apparel suppliers for the world are China, Hong Kong (whose apparel is now produced largely in China), Italy, and Germany.4 Apparel producers in the NIC and some ASEAN economies have developed successful working relationships with importing apparel firms and retailers in the developed countries, and many have a record of providing responsive, reliable service in delivering good-quality products.

An irony of the global shifts occurring in apparel manufacturing is that now even the NICs engage in offshore production. Particularly as NIC wages have risen and as quota restrictions have limited shipments from the NICs into U.S. markets, apparel firms from those countries have established production operations in

In another type of arrangement, transshipment, the Asian NICs and China, in particular, shipped products to other countries—usually other nearby Asian countries—that had unused quotas. Products were then shipped to the United States or other markets from the second country, taking advantage of the second country's unused quota.

As far as the U.S. market is concerned, the notable change in trade is that Mexico and the CBI countries are gradually displacing Asia for apparel sourcing. China and the Asian NICs account for a decreasing share of the apparel market. In 1996, Mexico became the top apparel supplier to the United States, based on quantity. Asia accounted for 40 percent of apparel imports in 1996; Mexico and the CBI countries were gaining ground at 34 percent. When products are made under 9802 (807) arrangements, they are counted as imports when shipped back to the United States; these products account for a growing share of U.S. imports. It is important to keep in mind that most of this Mexican production was initiated by and for U.S. firms. Because of market proximity and trade policies that provide advantages to U.S. apparel firms (if U.S. textiles are used), production in the region is likely to continue to grow at the expense of Asian suppliers. If NAFTA-like free trade agreements eventually include other parts of Latin America, the trend will grow even more.

In a sense, the movement of the apparel industry to Mexico and the CBI countries is a continuation of a southward shift that has occurred in the industry over time. At one time, the garment industry was concentrated heavily in the northeastern United States. As the industry

other countries that have few or no quota restraints. For example, as the United States tightened quotas on apparel shipments from the "Big Three" Asian exporters, manufacturers from those nations opened sewing plants in Caribbean countries to avoid tight quota limits and also to be closer to U.S. markets.

⁴ Italy, Germany, and France are also top global suppliers of apparel. Much of this apparel is produced, however, through OPT arrangements with contractors in Central and Western Europe. Furthermore, a substantial portion of these apparel exports are for intra-EU trade.

sought less costly labor and other expenses, a significant shift to the South occurred; however, that shift was still within the United States. Today, many of the factors that encouraged that shift are continuing to foster the southward movement into other countries. Figure 9–6 illustrates this movement.

U.S. Apparel Trade Trends

Apparel import shipments into U.S. markets have grown significantly over time, and, with the exception of the garments that apparel firms imported themselves, these imports represented competition for the domestic industry. Apparel trade in relation to domestic consumption is presented in Table 9–6.

According to Cline's (1987) analysis, real apparel imports (value adjusted by a domestic product shipments price index) grew 15.5 percent annually (compared to increases in annual consumption of 3.6 percent) from 1961–1962 to 1972–1973. Increases in imports slowed to 9.7 percent annually (real consumption was only 1.7 percent annually) from 1972–1973 to 1981–1982. Although the annual import growth of 9.7 percent was still quite high, Cline attributed the drop in the growth of

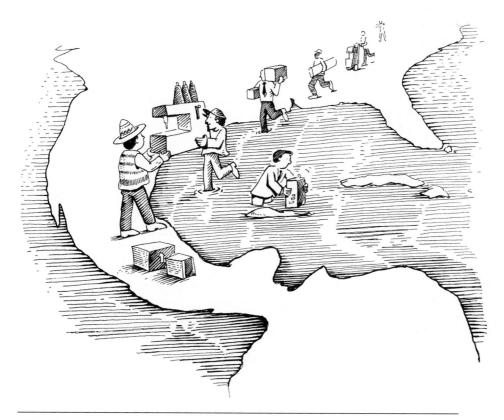

FIGURE 9-6

The southward movement of the apparel industry to Mexico and the CBI countries is a continuation of a shift to the South that began decades ago.

Source: Illustration by Dennis Murphy.

TABLE 9–6Trade and Domestic Consumption: Apparel (millions of dollars)

2 .	Nominal				Real 1982 Prices ^a			Import Penetration (M/C)	
Year		X	TB	C ^b	М	X	ТВ	C^b	(%)
1961	283	159	-124	13,212	648	364	-284	30,273	2.1
1962	374	152	-222	14,170	838	341	-497	31,767	2.6
1963	400	158	-242	15,060	901	356	-545	33,934	2.7
1964	481	196	-285	15,799	1,062	433	-629	34,887	3.0
1965	568	177	-391	16,817	1,254	391	-863	37,135	3.4
1966	637	188	-449	17,757	1,389	410	-979	38,726	3.6
1967	692	207	-485	18,968	1,416	424	-992	38,823	3.6
1968	900	220	-680	20,308	1,764	431	-1,333	39,811	4.4
1969	1,149	242	-907	21,952	2,123	447	-1,676	40,555	5.2
1970	1,286	250	-1.036	21,430	2,192	426	-1,766	36,531	6.0
1971	1,574	258	-1,316	23,003	2,650	434	-2,216	38,726	6.8
1972	1,967	300	-1,667	25,581	3,470	529	-2,941	45,133	7.7
1973	2,261	381	-1,880	27,850	3,773	636	-3,137	46,472	8.1
1974	2,465	593	-1,872	28,727	3,726	896	-2,830	43,425	8.6
1975	2,775	603	-2,172	29,270	4,124	896	-3,228	43,498	9.5
1976	3,912	740	-3,172	33,191	5,516	1,043	-4,473	46,801	11.8
1977	4,393	859	-3,534	38,767	5,796	1,133	-4,663	51,148	11.3
1978	5,722	1,035	-4,687	42,352	7,315	1,323	-5,992	54,372	13.5
1979	5,902	1,387	-4,515	41,865	7,163	1,683	-5,480	50,810	14.1
1980	6,543	1,604	-4,939	45,232	7,428	1,821	-5,607	51,349	14.5
1981	7,752	1,628	-6,124	50,198	8,122	1,706	-6,416	52,592	
1982	8,516	1,236	-7,280	53,961	8,516	1,236	-7,280	53,961	15.8
1983	10,018	1,049	-8,969	58,392	9,918	1,039	-8,879	57,812	17.2
1984	14,001	1,026	-12,975	63,647	13,632	999	-12,633	61,968	
1985	15,711	991	-14,720	65,424	15,044	949	-14,095	62,646	
1986	18,171	1,178	-16,993	68,480	17,445	1,116	-16,329	65,258	
1987	21,503	1,491	-20,012	83,068	21,503 ^c	1,491°	$-20,012^{c}$	83,068	
1988	22,170	1,955	-20,215	85,478	21,570°	1,902°	$-19,668^{c}$	83,165	
1989	25,372	2,362	-23,010	109,829	24,093 ^c	2,243°	$-21,850^{c}$	80,199	
1990	26,602	2,864	-23,738	112,302	24,573°	2,646 ^c	$-21,927^{c}$	79,163	
1991	27,230	3,708	-23,522	113,401	24,616 ^c	3,352 ^c	$-21,264^{c}$	77,898	
1992 ^d	32,462	4,625	-27,837	124,414	28,633 ^c	4,079 ^c	$-24,553^{c}$	81,105	
1993 ^e	35,449	5,556	-29,893	130,803	30,938 ^c	4,849 ^c	$-26,089^{c}$	83,219	c 37.2

M = imports; X = exports; TB = trade balance; C = apparent consumption.

Note: Updates of figures in this time series are no longer available because of a switch to the Harmonized System for trade data.

Source: Cline, W. (1987). The future of world trade in textiles and apparel (p. 40). Washington, DC: Institute for International Economics. The 1986–1993 updates are from the U.S. Department of Commerce.

^a Deflating by apparel product shipments price index, U.S. Department of Commerce.

^b Equals production *plus* imports *minus* exports.

^c Real 1987 prices.

^d Estimates, except exports and imports.

e Estimate.

imports from the earlier decade to the new trade policies that went into effect in the 1970s and 1980s to limit imported textile and apparel products. By 1983–1985, the overvalued dollar contributed to import growth of 16.5 percent in 1983, 37.4 percent in 1984, and 10.4 percent in 1985. Consumption increased 16.1 percent during the period (Cline, 1987). In nominal terms, imports increased at an annual rate of nearly 20 percent during the 1982–1987 period.

In the 1990s apparel import growth varied considerably in both nominal and real values. In nominal values, 1991 imports increased only 2.4 percent over 1990; 1992 imports grew by about 19 percent; and estimated data show a 9.2 percent growth for 1993. In real terms, apparel imports did not increase substantially between 1989 and 1991; however, imports grew by 16.3 percent in 1992 and by 8 percent in 1993, based on estimates. The real prices for 1987–1993 are not directly comparable to earlier real prices. Later data are not comparable because of a switch to the Harmonized System.

A review of apparel exports also is important as we consider trade for the sector. Apparel exports were never great in volume; however, they increased at a healthy pace from 1973 to 1980, growing 16.2 percent annually in real terms. The increase in exports was of somewhat limited significance because the base (the export shipments on which the percentage increases were based) was small. Between 1980 and 1985, exports declined by half, primarily because of the strong dollar (Cline, 1987). From 1986 on, apparel exports began to increase again. Growth has been encouraging in the 1990s, albeit from what is still a relatively small base. In real terms, 1990 exports increased 18 percent over the previous year; 1991 exports represented a 26.7 percent increase; 1992 exports grew by 21.6 percent; and according to estimated data, 1993 exports increased about 18 percent. Exports have not been successful, however, in offsetting the shipments of imports to reduce the trade imbalance for the sector.

The last column in Table 9–6 shows the growing increase of apparel imports as a percentage of U.S. consumption, that is, the import penetration ratio. This ratio grew from slightly over 2 percent in 1962 to more than 37 percent in 1993.

Cline (1987) noted two aspects of the import penetration trends that he considered paradoxes. First, he observed that the apparel sector was successful in getting protection against imports in the early 1960s when the ratio of imports was quite low. Cline attributed this early protection to a strong U.S. textile and apparel lobby. Second, he noted that imports rose quite rapidly despite increased protection through trade restrictions during the period. Cline believed that product upgrading accounted for the strong continued growth. Although trade restrictions continued to tighten, the value of import shipments continued to grow significantly because of product upgrading. That is, tightened quotas encouraged foreign suppliers to produce more costly garments, therefore increasing the value of shipments.

VARIATION IN IMPORT PENETRATION. Import penetration has varied greatly among apparel categories. In some categories, imports represent a small proportion of the U.S. market; in a few other cases, imports account for more sales than do U.S.-made products. The differences in import penetration rates by type of apparel may be explained to a degree as follows:

- Products with high labor requirements are difficult for U.S. firms to produce competitively. Two prime examples are gloves and bras. As a result, high import penetration exists in these product areas.
- Price-sensitive lines of apparel typically have had high import penetration levels. Examples are men's and boy's dress shirts and knit shirts. Arpan et al. (1982) suggested that high levels occurred in these areas because retailers could buy

lower-priced imports and either offer products to consumers at attractive prices or benefit from a higher profit margin by selling the cheaper imports at a price close to that for the U.S. product.

 Success in automating production helped retain significant shares of the U.S. market in certain categories; automation reduced costs and kept domestic production competitive. Hosiery and men's knit briefs are items to which automation has been applied quite successfully. Staple product lines such as socks and underwear also provide economies of volume production and do not face the risks associated with fashion lines. In recent years, however, imports have been taking a growing share of these markets.

Table 9-7 lists the major sources of U.S. apparel imports, ranked by quantity shipped to the U.S. market. Perhaps it is significant that no traditional developed country is among the top group, based on quantity shipped to the U.S. market. The table also gives the value of shipments, but the reader will note that rankings are somewhat different according to the value of imports. For example, Bangladesh is the 6th largest provider of U.S. apparel imports in terms of quantity, but, in value terms it ranks 11th. If countries were ranked according to the value of apparel imports, Italy would be 12th; however, the nation does not provide a quantity of imports comparable to those shown in Table 9-7.

As Table 9–7 indicates, 1996 U.S. apparel imports in value terms were more than \$36.4 billion. Of that, the East Asian NICs provided \$7.2 billion, or 19.8 percent of the total, based on value. When China is added to the East Asian NICs, the "Big Four" accounted for \$11 billion, or 30 percent of all U.S. apparel imports, based on value. More than \$6.0 billion came from CBI countries; most of these would have been from 9802 (807) production (U.S.

TABLE 9–7
U.S. Imports of Apparel (All MFA Fibers) by Major Suppliers, 1996

	Millions of Square Meter Equivalents ^a	Millions of Dollars
World	9,658.5	36,388.8
Mexico	1,099.2	3,560.0
China	862.1	3,769.2
Hong Kong	759.7	3,860.8
Dominican		
Republic	653.1	1,753.2
Taiwan	573.7	1,973.6
Bangladesh	529.4	1,124.8
Honduras	526.5	1,219.4
Philippines	441.0	1,502.7
Indonesia	329.9	1,325.7
India	301.0	1,187.2
El Salvador	287.3	721.1
South Korea	287.2	1,380.7
Sri Lanka	284.5	1,006.6
Costa Rica	266.3	704.1
Thailand	239.1	1,049.3
Guatemala	203.1	796.5
Jamaica	201.2	505.3
Pakistan	161.3	561.3
Turkey	149.9	578.5
Canada	139.8	947.6

^a The square meter equivalent is a common unit of quantity across all categories. Conversion factors are used to convert garments into square meter equivalents for trade purposes.

Source: U.S. Department of Commerce. (1997). Major shippers report (on line).

Department of Commerce report, Major Shippers Report, on line, 1997).

Two points should be made regarding the share of imports in U.S. markets: (1) We noted earlier that the actual degree of import penetration (i.e., to what extent imports account for a share of the U.S. market) is controversial. (2) Of the volume of imports shown for the U.S. market, apparel manufac-

turers themselves accounted for a significant proportion of those products through various sourcing arrangements. When apparel firms import products, this is done to further their own business efforts. Under these circumstances, it seems inappropriate for apparel manufacturers to say that imports have "taken" domestic market share. (Because apparel manufacturers have participated increasingly in foreign assembly and other sourcing operations, American Apparel Manufacturers Association no longer takes a hard-line position against imports.)

EXPORT POTENTIAL. The apparel industry has been criticized for its lack of an export orientation. The U.S. textile and apparel industries were extremely slow in awakening and reacting to the facts of global economic life. Critics believe more active export programs would help to offset the growth of imports. Apparel exports in 1997 were slightly over \$8 billion (U.S. Department of Commerce, 1998, OTEXA Web site); these resulted from the export efforts of only a handful of companies. (For updates on trade data, see http://otexa.ita.doc.gov)

The lack of export orientation is unfortunate because certain U.S. apparel products appear to have appeal in various other parts of the world. Jeans and T-shirts are examples of U.S. apparel that have widespread global appeal, having become the ultimate transatlantic uniform. In many parts of the world, the casual "American look" in apparel is sought and imitated.

Prior to the economic crisis, demand for U.S. apparel with strong brand identity was especially brisk in the rapidly emerging Asian economies of South Korea, Taiwan, Singapore, and Hong Kong, where personal incomes and consumer spending increased. Designer names like Donna Karan, Ralph Lauren, and Calvin Klein are popular. A

number of U.S. apparel firms have developed strategies to penetrate markets in other parts of Asia, Europe, and Latin America where incomes can support growing apparel purchases. In fact, annual GDP growth rates in some of those countries represent opportunities for growth when the U.S. market is sluggish. U.S. brands are seen increasingly in stores in other nations. See Figure 9–7.

Today's global communications media and the export of U.S. films and other entertainment have fostered the appeal of the American look in many regions of the world. Licensed U.S. cartoon apparel is popular, particularly among young consumers in many countries. In the author's trip to the Singapore zoo, at least half of the children wore clothes bearing U.S. cartoon characters. Other popular U.S. apparel includes Western wear, surfwear, military, hunting and fishing apparel, and major league and college sports attire, as well as motorcycle-related apparel, work clothing, and outdoor (camping) products. These U.S. products convey the American lifestyle and are perceived as being casual. fun, and rugged.

Licensing is an alternative to exporting often used by apparel firms unable (or sometimes unwilling) to ship products to countries where demand exists for their garments. Licensing may provide another source of profit to apparel firms. Generally, under the licensing agreement, the U.S. apparel firm agrees to permit foreign manufacturers to use the company's trademark, its production technology, and its marketing skills to produce and sell garments in other countries. Although U.S. firms face the risk of losing control over their trademarks and expertise, carefully controlled licensing agreements may be profitable enough to justify the potential risk. Licensing arrangements require long-term commitments from U.S. firms because of the time needed to develop markets in another country.

FIGURE 9-7

From Jockey undergarments in Vienna to Mickey Mouse children's apparel in Seoul, U.S. brands and cartoon characters appeal to customers in many parts of the world.

Source: Photos by Kitty G. Dickerson.

SUMMARY

Change in the international economy has been influential in reshaping the U.S. textile and apparel industries. Both sectors have changed markedly in the last three decades.

Prior to the 1960s, the textile industry focused on serving a domestic market and had relatively little competition in that market. Even in the 1960s, the textile sector enjoyed buoyant growth, but in the 1970s, stagnating markets and increased raw material prices had negative effects on the industry. Further, as other countries began to produce textile products—particularly mill products—U.S. manufacturers began to feel the impact of foreign competition. Many of the newly developing countries produced with exporting in mind, and U.S. markets were a natural target for those shipments.

The U.S. textile industry's response to foreign competition has resulted in a significantly transformed industry. Textile production has moved from a craft-oriented industry to one of high technology. The industry's willingness to invest in new technology has greatly enhanced its position in world markets. Investments in technology have increased productivity and reduced labor requirements—and, therefore, labor costs. In addition to the capital- and knowledge-intensive nature of the textile industry, productivity improvements and reduced labor costs gave the U.S. industry an improved competitive position in maintaining domestic markets—and in exporting to an extent. Various restructuring efforts, which often included vertical or horizontal integration of businesses, improved the efficiency and profit positions of a number of firms.

The outlook is less optimistic, however, for another sector important to the competitiveness of the U.S. textile industry—the textile machinery industry. As the U.S. textile machinery industry has declined, domestic textile producers have become increasingly dependent on foreign machinery producers. Once a

strong force in the global market for textile machinery, the U.S. industry has now become a supplier of less sophisticated equipment and a source for spare parts. U.S. textile producers must now rely to a great extent on equipment developed by major firms in other countries.

The U.S. apparel industry, like its counterparts in other developed countries, faces a long-term international shift in comparative advantage to developing countries. The primary component in this shift is lower labor costs. Virtually all aspects of the U.S. apparel industry have been affected profoundly by the influence of low-wage imports. In addition to the labor cost differences, other characteristics of apparel products—such as fashion and timing—add to manufacturers' challenges to produce efficiently and competitively for both domestic and global markets.

The U.S. apparel industry has made significant advances in rethinking the manufacturing-distribution system to serve its customers more effectively. Increasingly, marketing strategies are driving the activities of U.S. apparel firms. Many companies now think of manufacturing in terms of global sourcing plans. Forward-thinking companies have invested significantly in technology that improves both production and distribution functions, but many U.S. apparel firms have been slow to invest in their future through capital expenditures. In many cases, firms are too small to have adequate resources to make these investments.

Many apparel firms participate in various types of sourcing strategies, including numerous combinations of both domestic and foreign production. Worldwide sourcing has become basic to many U.S. apparel firms, and offshore assembly known as 9802 production (formerly 807) is one of the most common strategies.

Although overseas competition has posed serious challenges for the U.S. apparel industry, it has fostered advances in production, marketing, and distribution that have made the domestic industry more viable.

GLOSSARY

Adjustment means restoring productivity of an industry so that it remains competitive in the overall industrial scheme in the economy. In essence, adjustment is an industry's response to changing comparative advantage. It may include, as examples, industry contraction (downsizing) in both employment and output, as well as productivity growth through modernization. Restructuring (Chapter 8) of a sector may occur as part of the adjustment process.

Apparel licensing involves an agreement (i.e., a licensing agreement) between a U.S. apparel firm and foreign manufacturers to use the U.S. company's trademark plus the technology and expertise needed to produce and market the garment in those countries. (In addition, an apparel firm may grant other domestic firms licensing privileges; e.g., Levi Strauss & Co. licenses the use of its name on hosiery that is made domestically.)

Note: The reader should also be aware that the term *licensing* is used in another manner in trade as well. *Import licenses* refer to government procedures in certain countries that have been established to regulate the flow of goods. In these cases, potential importers or exporters must secure permission—that is, the *license*—before conducting trade transactions.

Apparel marketing, as defined by Frank (1985), focuses on broadly defining a company's market and characteristics. The marketing function of a firm identifies new opportunities for growth through self-analysis and market research and promotes a company's image and products.

Apparel merchandising in a manufacturing firm is more specific than marketing, focusing on the development, execution, and delivery of the product line. With its close ties to the market segment it serves, the merchandising function is not only able to adjust to market variations rapidly, but is also capable of anticipating and helping to create market changes (Frank, 1985).

Apparent consumption of textiles (and/or apparel) refers to U.S. production plus imports minus exports.

Artificial fibers (cellulosic fibers) come from naturally occurring cellulose sources; examples are rayon, acetate, and triacetate.

Capacity utilization rate refers to the extent to which production facilities are operating, based on the premise that a 100 percent capacity utilization rate represents operating at full capacity. The capacity utilization rate is an important measure of industry activity at a given time. For the textile mill industry, for example, the number of spindles and looms in place, the number of these that are active, and the hours these are operating provide an indication of the capacity and utilization rates for the spinning and weaving segments of the industry (USITC, 1987b). This measure is generally about 5 percent lower than the operating rates (below) because, for utilization rates, the Federal Reserve Board employs a broader definition of available capacity (Ringlestein, 1989).

Economies of scale occur when the advantages of larger, more concentrated production operations account for savings that can be reflected in lower production costs. For example, output or some other measure of productivity may increase as the size of the firm or establishment increases.

807A (or Super 807) (9802A arrangement). Although textiles and apparel were treated as an exception to the CBI, subsequent agreements increased U.S. quota allotments—known as guaranteed access levels (GALs)—to CBI countries and Mexico. Under the GALs, extended quota levels are available to eligible countries assembling apparel from fabric both made and cut in the United States. Eligibility for GALs requires that items be classified under a category that has been negotiated for inclusion in this program by that country (Gelber, 1989).

807 production. Under the former Tariff Schedule of the United States (TSUS), Item 807.00 enabled apparel manufacturers to send *U.S.-cut* garment parts to low-wage countries to have labor-intensive sewing operations performed. Although this term is still used in the industry, this is actually 9802 production now.

Greige goods are unbleached or undyed cloth and yarn.

Import penetration ratio is the measure of imports as a percentage of apparent consumption for a country. Import penetration ratios may be calculated for all textile and/or apparel imports for the country or, more specifically, for product categories.

International Standard Industrial Classification (ISIC) system is an international system introduced by

the United Nations in 1950 to promote international comparability of world trade data. This system is used by the United Nations and a number of other international organizations for collecting and analyzing trade data.

Lead time for manufacturers refers to the time required between the execution of production and

the delivery of finished merchandise.

Marketing orientation for a firm means that the company focuses on the consumer's needs and wants, and this emphasis is backed by an integrated effort within the firm to satisfy the customer. The company's focus on satisfying the customer is seen as the means for achieving the firm's financial return objectives. More recently, the textile complex, and particularly the apparel industry, has placed increasing emphasis on serving both retail and end-use consumers.

9802 production. Under the new tariff classification system, the Harmonized Tariff Schedule, Item 9802.00 permits the same offshore production arrangement that existed under 807 production.

Nominal values are current dollar values at the time.

North American Industry Classification System (NAICS) is the system used to classify North American businesses into groupings on the basis of their primary economic activity. The NAICS system replaced the SIC system and is used by NAFTA partners.

Offshore production refers to having some or all of a firm's apparel lines produced in another country.

Operating rate, like capacity utilization rate, refers to the extent to which plants are operating as a percentage of full operating capacity. As noted above, this measure tends to be higher than the capacity utilization rate because of the definition of available capacity.

Price deflation occurs when the apparel price index declines rather than increases during a period.

Product upgrading occurs when textile trade policies limit the *volume* (SMEs) of import shipments. Since the limits are on the *volume* rather than the *value* of import shipments, this provides an incentive to enterprising producers in other countries to upgrade apparel lines to obtain the greatest value within their shipment limits.

Production economies of scale are efficiencies of production that occur as a result of forming larger manufacturing operations.

Production orientation for a firm means that the company places greatest emphasis on what its plants produce and how it fulfills the production role. Until the mid-1980s, the apparel industry (and, for that matter, the textile complex broadly) focused most of its efforts on refining production processes, believing this approach would be the key to future successes.

Productivity refers to the ratio of output to employment; labor productivity refers to the output per worker.

Real values are the adjusted dollar amounts for a time period, using the price index for U.S. domestic product shipments.

Research and development (R&D) refers to those operations in a firm devoted to developing and improving products, production processes, or other aspects of the business that will make the firm more competitive.

Restructuring refers to the changes a sector or a company goes through in its efforts to remain competitive in response to changing market conditions. Restructuring of a sector may occur as part of the adjustment process.

Square-meter equivalent (SME) is the unit of measure— in physical terms—for imports of textile and apparel products. With the exception of fabric, all apparel and textile products are assigned a conversion factor that converts units into equivalent square meters. For example, a dozen men's or boys' woven shirts represent *x* equivalent square meters. The SME measure is used in trade agreements that set limits on imports from various countries.

Standard Industrial Classification (SIC) system was the U.S. system used to classify U.S. establishments into industry groupings on the basis of their primary economic activity.

Structural unemployment occurs as a result of restructuring or when the decline of an industry or a change in the demand for its products results in reduced demand for workers' traditional skills.

Synthetic fibers (noncellulosic fibers) are in most cases petrochemical derivatives; examples are nylon, polyester, and acrylic.

Velocity costs refer to costs that may not be readily apparent when considering sourcing options, according to Kurt Salmon Associates, Inc. (Silva, 1993). Among these costs are interest on holding inventories, markdowns, and extra handling costs.

SUGGESTED READINGS

Abernathy, F., Dunlop, J., Hammond, J., & Weil, D. (1995). The information-integrated channel: A study of the U.S. apparel industry in transition. In Baily, M., Reiss, P., & Winston, C. (Eds.), *Brookings papers on economic activity* (pp. 175–246). Washington, DC: Brookings Institution.

This paper examines the impact of new information

technologies on the industry.

American Apparel Manufacturers Association. (annual). Focus: An economic profile of the apparel industry. Arlington, VA: Author.

Annual economic profile on the U.S. apparel sector.

American Apparel Manufacturers Association, Technical Advisory Committee. (1997). *The dynamics of sourcing*. Arlington, VA: Author.

A good general overview of sourcing considerations.

- American Textile Manufacturers Institute. (quarterly). *Textile hi-lights*. Washington, DC: Author. *Quarterly update on textile industry performance*.
- Apparel Information Resource. (monthly). *The apparel strategist*. Fleetwood, PA: Author.

A newsletter on the U.S. apparel industry.

- Arpan, J., de la Torre, J., Toyne, B., Bacchetta, M., Jedel, M., Stephan, P., & Halliburton, J. (1982). The U.S. apparel industry: International challenge, domestic response. Atlanta: Georgia State University Press.
 - A 3-year study of the U.S. apparel industry's international competitiveness and the industry's response to the competitive environment.
- Brown, P., & Rice, J. (1997). *Ready-to-wear apparel analysis* (2nd ed.). Upper Saddle River, NJ: Prentice Hall.

This book contains sections on the apparel industry.

- Cline, W. (1987). *The future of world trade in textiles and apparel*. Washington, DC: Institute for International Economics.
 - An economic review of the U.S. textile and apparel industries, with a critical analysis of trade policy for the sectors.
- Craig, J., & Horridge, P. (1995). Characteristics of successful and less-successful manufacturers of women's and children's apparel. Family and Consumer Sciences Research Journal, 24(2), 139–160. Results from a survey of 200 apparel manufacturers.
- de la Torre, J. (1984). *Clothing-industry adjustment in developed countries*. London: Trade Policy Research Center.

- A critical review of adjustment and its costs in the OECD countries.
- de la Torre, J., Jedel, M., Arpan, J., Ogram, E., & Toyne, B. (1978). *Corporate responses to import competition in the U.S. apparel industry*. Atlanta: Georgia State University Press.

An in-depth study of 10 apparel firms' responses to

import competition.

DesMarteau, K. (1997, February). U.S. apparel contractors: Can they beat the odds? *Bobbin*, pp. 32–38.

An overview of the status and concerns of U.S. ap-

parel contractors.

- Dickerson, K. (1998). Apparel and fabricated textile products. In U.S. Industry and Trade Outlook '98, 1998 (Chapter 33), New York: DRI/McGraw-Hill and Standard & Poor's and U.S. Department of Commerce/International Trade Administration. An overview of the current status of the U.S. apparel and fabricated textile products industry.
- Fiber Economics Bureau. (monthly). Fiber Organon. Washington, DC: American Fiber Manufacturers Association.

Statistical update on textile industry performance. Finnie, T. (1992). Textiles and apparel in the USA: Re-

structuring for the 1990s. London: The Economist Intelligence Unit.

An overview of the U.S. industry and restructuring for the 1990s.

- Ghadar, F., Davidson, W., & Feigenoff, C. (1987).
 U.S. industrial competitiveness: The case of the textile and apparel industries. Lexington, MA: Lexington Books.
 - An examination of global and domestic forces that affected the textile and apparel industries.
- Glock, R., & Kunz, G. (1995). Apparel manufacturing: Sewn product analysis. New York: Macmillan. A comprehensive analysis of apparel manufacturing, with special emphasis on factors that determine the cost, price, quality, performance, and value of garments.
- Kotabe, M. (1992). *Global sourcing strategy*. New York: Quorum Books.
 - This book explores the market performance of various global sourcing strategies employed by multinational firms.
- Kurt Salmon Associates. (annual). Textile profile— The KSA perspective. New York: Author. Annual U.S. textile industry performance profile of

publicly held firms.

Lewis, R. (Ed.). (1997, February 24). Strategic alliances. *Women's Wear Daily*, Section II, "Infotracs," all pages.

A special edition on strategic alliances being formed in the industry.

National Cotton Council of America. (annual). Cotton counts its customers: The quantity of cotton consumed in final uses in the United States. Memphis: National Cotton Council of America.

Statistical report on the quantities of cotton and competing materials consumed in textile products manufactured in the United States.

Olsen, R. (1978). The textile industry: An industry analysis approach to operations management. Lexington, MA: Lexington Books.

Overview of process technology and market structure of the industry; includes four case studies.

Redman, J., & Amt, W. (1995). The Tsunami, Phoenix, tequila sunset and Fedex scenarios: Trade policy and the future of America's rural apparel industry. Washington, DC: The Aspen Institute.

A study of the U.S. apparel industry and its prospects for the future, especially in rural regions.

Southern California Edison Company (with assistance by DRI/McGraw-Hill). (1995). Southern California's apparel industry. Rosemead, CA: Author.

A study of the apparel industry in Southern California.

U.S. Department of Commerce. (annual). *U.S. industrial and trade outlook* ("Apparel" and "Textile" chapters). Washington, DC: U.S. Government Printing Office.

Annual review of textile and apparel industry

performance.

U.S. Department of Commerce, Office of Textiles and Apparel. (annual). Foreign regulations affecting U.S. textile/apparel exports. Washington, DC: Author. A summary of the trade requirements and restrictions of 135 countries, which may affect textile and apparel export sales.

As global textile and apparel production and trade increased, the problems associated with growing

international competition led to a complex system of trade policies and structures to "manage" that trade. As one of the most sensitive and difficult sectors in world trade, textile trade came to be managed by a unique international "regime." Both at the international level and at the national level in many countries, textile and apparel production and trade concerns have attracted special attention and provisions to attend to those concerns.

Chapter 10 provides an overview of the evolution of policies affecting trade in textiles and apparel. As the international perspective

is presented in this chapter, special attention is given to the U.S. position within the broader context of global policy development and implementation. Major textile and apparel trade policies are presented; in some instances, these policies are contrasted to those for trade in general.

Chapter 11 presents an overview of the major global and U.S. structures for facilitating or managing the textile and apparel trade. The goal of this chapter is to help the reader understand how the trade policies operate at both the global and national levels, as well as the ways in which the policies and their implementation may be influenced by various groups. Key organizations and their roles in textile and apparel trade are discussed.

10

Textile and Apparel Trade Policies

Textile and apparel production is vital to the economies of both the developed and developing countries. Although the textile complex has declined in the industrialized nations, it remains a top manufacturing employer in most of these countries. At the same time, textile and apparel production may be the only industry through which a relatively large number of developing nations can participate in international trade. For many other developing countries and NICs, textile and apparel products are a main source of export earnings and employment.

In the 1960s and 1970s, growth in the number of textile and apparel producers for the world market led to a growing production capacity that exceeded growth in demand. As a result, global competition grew intense and difficult. As producers in the developed countries attempted to protect their markets from imports from low-wage countries, country-by-country trade policies emerged. Later, global textile trade policies developed in an attempt

to mediate the problems associated with the worldwide surplus. The policies that developed represented a compromise with which almost no players have been satisfied.

Although textile trade policies are changing markedly, a review of the development of these policies is important to an understanding of the complex nature of global trade in this sector. A review of these trade policies and how they developed provides an understanding of the political tensions and drama that have unfolded as nations often have fought bitterly to protect their respective textile and apparel interests—because these industries are vital to most nations' economies. Moreover, textile trade represents one of the most phenomenal studies of trade politics in history. Although textile trade policies are changing, this history may suggest to us that the politics of textile trade will not disappear.

In this chapter, we will review the evolution of policies affecting trade in textiles and apparel. We will consider different types of regulations on textile trade—both at the international and national levels—and how these are implemented. Discussion will also point to the unique trade policies for textile and apparel trade in contrast to those for trade in general.

¹ In trade policy discussions, *textile* or *textiles* is often used as a shortened label when referring to both the textile and apparel industries. If one were speaking of textile trade policies, these would apply to both textiles and apparel.

HISTORICAL PERSPECTIVE

Historically, textile and apparel trade has been a ready target for regulations to restrict or "manage" that trade. First, this may be due in part to the important role textile and apparel products play in satisfying humans' needs to clothe themselves and furnish their dwellings. Consequently, most countries have wanted to have their respective domestic industries supply the needs of the population. Second, the industries have played vital roles in the economic development and economic health of country after country. Countries have wanted to reap the economic benefits from production. In short, the desire of most countries to control production has made textile trade regulations almost as common as the production itself. Broader international relations often have suffered as a result of various countries' efforts to control certain portions of the production and trade of textile and apparel products.

Early Development and Regulation of Textile Trade

One of the earliest recorded efforts to regulate textile trade occurred in England in the late 1600s when the British Parliament prohibited the importing of Indian cloth so that the fledgling English industry might develop. The industrialization that soon followed in England made it possible to produce growing amounts of fabric.

England's early textile industry developed when mercantilism was the common economic philosophy of the day. Governmental manipulation of trade regulations ensured that exports were greater than imports as a means of increasing wealth. By the 1800s, however, merchants and industrialists wanted to broaden their markets through freer trade. Adam Smith's *laissez-faire* philosophy supported the English capitalists' desires to have fewer regulations and to be able to expand more freely to

other countries. The English cotton textile manufacturers took advantage of the changing mood and soon developed a successful export business. The open trade fostered development of the textile industry, making textile goods one of England's major export products by the end of the 1800s.

The American textile industry began to develop in the 1700s, despite England's efforts to prevent its early spinning and weaving technology from being transferred out of the country. The British authorities believed the colonies should absorb products from the mother country. In contrast, the colonists became eager to produce their own textile goods and reduce their dependence on England. Eventually, the colonists secured the necessary technology to do so.

Both England and the United States became protective of their respective textile industries. Because textiles was the first real industry for both nations, a great deal was at stake. England tried to impose laws on the colonists to force them to buy British textiles. In turn, as the American industry became established, Congress imposed a duty in 1808 on foreign textiles to protect the growing U.S. industry. Later, during the War of 1812, foreign textile goods were embargoed.

The textile industries in both England and the United States were boosted in their early development by government policies that provided substantial protection from imports. The trading partner with more power at a given time usually exerted control in trade. England dictated trade policies to the colonies. Later, however, as the United States became independent and more powerful, the new country was in a position to issue its own rules.

The 19th century was an important expansion period for both the English and American textile industries. Boosted by the open trading system that evolved in England, the British textile industry developed an impressive textile trade. By 1900, Britain accounted for 70 percent of the world's textile trade (Juvet,

1967). While Britain's textile industry was expanding in global markets, the U.S. industry was developing and expanding rapidly in its own home market. The U.S. cotton industry was relatively minor at the beginning of the 1800s, but by 1860 it was the country's leading manufacturing industry (Poulson, 1981). In contrast to England's export growth, the U.S. industry grew to a great extent because of import substitution. Tariffs (see Figure 10-1) and embargoes imposed on foreign textiles protected the U.S. industry from competition and encouraged the substitution of domestic textiles for previously imported goods. Although the U.S. textile industry had grown to be one of the world's major textile industries, its focus was primarily on the domestic market.

By 1900, the English and Americans were the world's leading textile producers. By then, however, a number of other countries in Western Europe, plus Canada, had also become important textile producers. In most cases, the industries developed as a result of deliberate government encouragement. Western Europe and North America accounted for 85 percent of world cotton textile output by 1913 (Hanson, 1980; Taussig, 1914). In addition, Japan began to expand significantly during this period. Among these first countries to industrialize and develop important textile industries, only Great Britain and Japan expanded their textile sectors, with exporting as a major goal.

The Early 1900s

In the early 1900s, world textile production grew impressively. Between 1900 and 1937, production increased by about 90 percent in real terms (Maizels, 1963). By this time, however, the developed countries had started to see a decline in their relative share of the textile industry as part of all manufacturing activity. A sharp drop in the developed countries' textile exports occurred between 1913 and 1929.

FIGURE 10-1

A comparison of tariffs and quotas. Tariffs reduce the flow of imports by adding a tax to make imported products more costly and, therefore, less attractive in a domestic market. Tariffs are like a funnel; they may reduce the flow of imports, but products still come through. In contrast, quotas are like gates. After products have been shipped to the maximum allowed under set quota levels, shipments are cut off until a new quota period begins (usually at the beginning of a year).

Source: Illustration by Dennis Murphy.

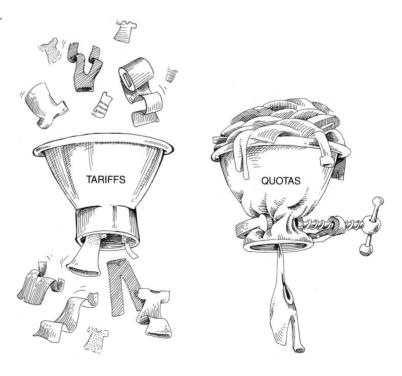

Some of the loss in export markets resulted from increasing competition from Japan. Another factor may have been the import substitution policies in Central Europe and Latin America. This meant that as those countries began textile production, governments promoted the use of their country's textile products rather than imports. As a result, countries that had been selling to those nations lost portions of the markets (GATT, 1984; Maizels, 1963; Paretti & Bloch, 1955).

From the start of the Great Depression in 1929 on, the developed countries began to experience a new era in textile trade. These countries perhaps would never again experience the luxury of dominating world markets in the same way they had earlier. First, textile trade slumped during the Depression. And second, although the Depression had hurt the industry in the developed countries, the strong competition that emerged had an even greater impact. By 1933, Japan had become the leading world exporter of cotton textile products (Japan Spinners' Association, 1982; Juvet, 1967). Other developing Asian countries patterned themselves after Japan and soon made their presence known in world textile markets. These newcomers benefited from import substitution policies in their countries and from the comparative advantage they had in abundant, inexpensive labor (GATT, 1984).

Japan made impressive strides in industrial development and textile competitiveness in the period between World Wars I and II. Japan's active participation in the world textile market soon made it the target of restrictive measures from both Britain and the United States. Both of these early leaders resented Japan's success in taking part of their markets.

In 1932 Britain reacted to the growing competition and loss of markets by passing protective measures to limit Japan's textile products. Other countries followed with similar policies designed to restrict Japanese products entering their markets. Clearly, Japan was perceived as the major threat. By 1936, Japanese exports of

cotton textiles were subject to restrictions on the amounts that could be shipped to 40 of 106 markets (GATT, 1984).

U.S. textile producers became concerned over Japan's textile shipments to the U.S. market. As a result, in 1935, the U.S. Tariff Commission investigated the increased shipments of Japanese cotton cloth. This led to the first known voluntary export restraint (VER) in textiles. The VER was an agreement by Japan to limit its textile shipments to the United States; however, it failed to reduce Japanese textile exports. In 1936, the United States imposed selective tariff increases on Japanese textiles, but these also failed to reduce imports. Finally, U.S. and Japanese trade associations negotiated a formal agreement to limit Japan's textile exports through 1940 (Brandis, 1982; Hunsberger, 1964).

In short, in the period between World Wars I and II, powerful newcomers—particularly Japan—challenged earlier patterns of textile trade. Developed countries responded by passing tighter restrictions to keep textile imports from their markets. This era set the stage for an increasingly difficult textile trade climate that followed for the next half century.

The Early Years After World War II

Although the United States typically had a textile trade deficit before World War II, circumstances related to the war gave both U.S. and British textile and apparel industries an advantage in world markets. The textile industries in most other major textile-producing countries—and particularly in Japan—were seriously damaged during the war. While other countries were rebuilding their industries, the United States and Britain moved aggressively to capture world textile markets. By 1947, the United States experienced its largest textile trade surplus up to that time. American textile producers believed they would continue to enjoy those favorable market conditions. U.S. textile and apparel manufacturers

were so confident that they provided technical advice to assist the rebuilding of Japan's industry. American government and industry leaders supplied technical as well as financial assistance to Japanese industries—including advice on export markets so that Japan might earn foreign exchange, which it desperately needed (Aggarwal, 1985; Destler et al., 1979; Fukui, & Sato, 1979; Hunsberger, 1964; Sato, 1976).

Japan's quick recovery in textile and apparel production soon caused concern among American manufacturers. By 1953, Japan exported textile and apparel products valued at \$746 million compared to \$539 for the United States and \$343 million for the United Kingdom (U.N. Statistical Office, 1953, cited in Aggarwal, 1985). In addition, Hong Kong, South Korea, India, and Pakistan were exporting growing amounts of cotton textile products. Although imports represented less than 1 percent of U.S. textile consumption in the United States, the American Cotton Manufacturers Institute2 became quite concerned and started efforts to limit imports. In addition, textile producers became outspoken against U.S. foreign aid schemes that helped the developing countries (including Japan) build their textile industries (Aggarwal, 1985; GATT, 1984).

The British textile and apparel producers also became concerned about imports from Japan and other developing countries. As a result, in 1950, Britain forced Japan to restrict textile shipments (Aggarwal, 1985). Although other European markets received increased textile imports, the impact of the war had affected European industries so badly that imports were not one of their major concerns at that stage.

A review of overall trade policies during this era will be helpful at this point so that we may consider textile activities in relation to the broader picture for trade. In general, most of the developed countries—especially in Western Europe—had quite restrictive trade policies in place at the end of World War II. Complicated rules and high tariffs were common. Bilateral agreements (agreements between two countries) governed a good proportion of trade. A bilateral agreement limited the volume of products one country could ship to another. That is, bilateral agreements set quota levels that limited the shipments of products to a certain quantity. See Figure 10–1.

Establishment of the General Agreement on Tariffs and Trade

The United States played a leading role in developing a **multilateral** approach (involving many countries) for trying to resolve international trade problems. These efforts led to the formation of the General Agreement on Tariffs and Trade (GATT) in 1947. The primary goal of GATT was to liberalize trade—that is, to free trade from the web of restraints that had evolved. See Box 10–1.

From the time of its establishment through the 1950s, GATT and other organizations made remarkable progress toward liberalizing trade by reducing prior restrictions. In general, the mood had shifted toward liberalized trade. Importantly, textile and apparel trade among developed countries in North America and Western Europe benefited from the general trend toward liberalization.

The same mood did *not* exist, however, for textile trade between the developed countries and their aspiring trading partners—Japan, the Eastern European countries, and the developing countries. While restraints were being eased elsewhere, the developed countries' discriminatory restrictions on textile imports from Japan and the developing countries became more severe during the 1950s.

² The American Cotton Manufacturers Institute (ACMI) was the most important cotton textile producers organization. In the early 1950s, most textile and apparel products were made of cotton, since manufactured fibers were still relatively new and were not produced in large amounts. This group was instrumental in achieving some of the earliest restrictions on imported textile and apparel products.

BOX 10-1

THE GENERAL AGREEMENT ON TARIFFS AND TRADE*

The GATT was both a code of rules and a forum for world trade concerns. About 120 countries were members—officially called *Contracting Parties*; another 30 countries subscribed to the rules but were not members. As a *code of rules*, GATT was the only multilateral body at the time that established rules for international trade. As a *forum*, GATT focused on international trade relations and the reduction of trade barriers. Although the General Agreement was complex, it was based on a few basic principles. Some that were particularly relevant for our study of textiles were:

Trade without discrimination. The "most favored nation (MFN)" clause required equal treatment of trading partners. Although this term seems awkward, it means that all trade must be conducted without discrimination. All members must extend the same treatment on trade matters to all other members. No

- country is to give special trade advantages or to discriminate against another. (Textile trade has been a major departure from this rule.)
- 2. Protection through tariffs. Under this rule, if a country wants to protect a domestic industry, the country should impose tariffs on imports rather than through other means. (Textile trade is an exception here also.)
- **3.** A stable basis for trade. If tariffs are agreed upon, they are **binding** and are published for each Contracting Party. This means that trading partners know what to expect.
- **4.** *Quantitative restrictions on imports.* Quantitative (quota) restrictions were prohibited; however, they were permitted under certain circumstances (e.g., for textile trade).

*In 1995, the World Trade Organization (WTO) succeeded "GATT 1947"; however, the WTO embraces "GATT 1994," which includes these principles. This will be discussed in Chapter 11.

The developed countries were not alone in creating the unfriendly trade climate for textiles and apparel. The developing countries had their own policies restricting trade—but using measures different from those of the developed countries. Developing countries used primarily the following two approaches to restrict textile and apparel products from their markets:

- **1.** *Import substitution* policies promoted the use of the country's own products rather than imports.
- 2. A balance of payments provision of GATT (Article XVIII) permitted a country to deviate from certain GATT rules to remedy serious balance-of-payments problems. Under this provision, a developing country can refuse to import textile products from

other countries because it has balance-ofpayments problems.

It is important to note, however, that the developing countries were applying these restrictions to a wide range of products, whereas textile and apparel products were the *only* nonagricultural areas for which the developed countries did not ease restraints (GATT, 1984). This difference reflects both the politicized aspects of textile/apparel trade and the differing economic climates in the two types of countries.

Textile-Specific Restraints of the 1950s

Two important and contradictory events affecting textile trade occurred in 1955. First,

Japan was admitted to GATT. This meant that Japan became a partner in the liberalized trading climate fostered by GATT. Oddly, however, the second major event was a contradiction of what GATT stood for. Growing pressure from American textile and apparel producers caused the U.S. government to encourage Japan to agree to the first post-World War II textile-specific restriction—a "voluntary" export restraint (VER) to limit certain cotton textile products. Hunsberger (1964) noted that, at this time, imports accounted for 2 percent of the U.S. market. American manufacturers were quite concerned, however, about the potential for import growth if the developing countries continued to develop their industries as rapidly as they had following the war.

One week after Japan agreed to the first VER, U.S. textile producers petitioned the U.S. State Department to consider stronger controls on Japanese textile products, asserting that the first VER placed too much of the responsibility for compliance on the Japanese (*Cotton Trade Journal*, 1955, cited in Aggarwal, 1985). After Japan's textile exports doubled in 1955, U.S. industry leaders doubted Japan's commitment to the VER. (We must also keep in mind that aggressive U.S. importers had an active hand in these developments [Destler et al., 1979].) In the new demands, industry representatives asked for U.S. government control of imports (Aggarwal, 1985; Destler et al., 1979; Lynch, 1968).

By this time, the U.S. textile and apparel industries had become quite skilled at "coalition-building and effective lobbying" (Aggarwal, 1985, p. 11). The industry's power had led to "encouraging" Japan to limit imports, and because of its dependence on the U.S. market, Japan was forced to comply with the new limit in order to retain some of the market. Japan was hardly in a position to argue with American requests for textile export restraints. Japan's trade with the United States was eight times greater than with any other trading partner, and in 1956, 20 percent of Japan's exports went to the United States (Aggarwal, 1985; Destler et al., 1979; Hunsberger, 1964).

As a result of U.S. industry pressure, a second VER with Japan went into effect in 1957, setting a 5-year limitation on cotton textile products. Although Japan had "volunteered" more willingly for the first VER in 1955, the second one resulted more from U.S. industry pressure. Finding a way of forcing Japan to restrict textile shipments-without violating GATT—had been a challenge to the United States. That is, forcing Japan to abide by quota limits would not have been permissible under GATT. Instead, pressuring Japan to sign a VER was discovered as a way to restrict shipments without breaking, at least technically, GATT rules (Aggarwal, 1985; Destler et al., 1979; Hunsberger, 1964).

After the second Japanese VER began to stem the tide of cotton textile and apparel products from Japan, a now-familiar pattern in textile trade emerged. That is, when exports from one country are controlled, textile and apparel products become more abundant from *uncontrolled* countries. Writers described this occurrence as being like "plugging holes in the dike" or "the little Dutch boy and the dike." That is, once the government in a developed country tried to provide protection from imports, "as they plugged holes in the dike, new leaks sprang up" (Aggarwal, 1985, p. 43; Keesing & Wolf, 1980, p. 22). See Figure 10–2.

As Aggarwal noted, restricting imports from one country simply provided room for other countries to enter the competition for domestic markets. Hong Kong and other suppliers responded rapidly to fill the gap left by the restrictions on Japan's textile products. American textile producers attempted to limit Hong Kong's imports in the same manner used to restrict Japanese imports; however, Hong Kong refused to restrain its imports to the United States. Several factors accounted for the U.S. failure to pressure Hong Kong to set limits: Hong Kong was far less dependent on the United States than Japan had been; Hong Kong was shielded somewhat as a

FIGURE 10-2

The textile import control program provides protection from imports only until a new "leak" appears in the form of uncontrolled imports. *Source:* Illustration by Dennis Murphy.

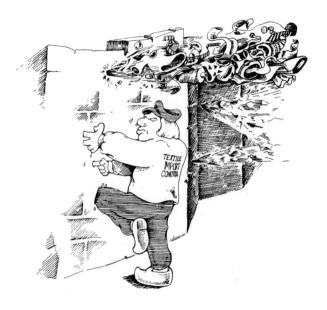

British colony; and, finally, negotiators for Hong Kong were experienced, sophisticated, and tough—they refused to give in (Aggarwal, 1985).

While the United States was concerning itself with the problem of imports from Japan and Hong Kong, Great Britain had similar problems. By the late 1950s, the country that launched the Industrial Revolution was importing more cotton cloth than it exported. Britain had even greater problems than the United States, however, because of special relationships with countries under British rule. Under the Imperial Preference System, cotton textiles from India, Pakistan, and Hong Kong were imported free of duties. By the 1950s, all these countries had become important textile producers (GATT, 1984; Hunsberger, 1964). Britain, too, resorted to having these countries "voluntarily" restrict cotton textile products under an agreement called the Lancashire Pact (Aggarwal, 1985; Blokker, 1989; GATT, 1984).

Other European countries used a variety of measures—both legal and illegal—to pro-

tect their industries from the textile imports from low-wage countries. The Europeans retained their quotas and were willing to be in open violation of GATT rules in order to restrict textile imports from less-developed countries (Aggarwal, 1985; Blokker, 1989; GATT, 1984).

In summary, during the 1950s, the governments of the developed countries initiated a variety of actions to restrict textile imports from the developing countries. These actions set the stage for other stringent measures that soon followed.

Early Development of Textile Trade Policies in the 1960s

U.S. leaders were opposed to the illegal actions taken by the European countries to protect their textile industries, believing the violations would undermine GATT. Acting out of this concern, the United States began to press for a more comprehensive multilateral agreement to resolve textile trade difficulties. (The VERs with Japan and most other textile trade restrictions up to that point had been bilateral agreements.) The

344

continued emergence of important developingcountry exporters led to pressure for other approaches to control low-wage imports into the industrial countries.

Market Disruption

The concept of market disruption grew out of the desire to limit low-wage textile imports in the developed countries' markets. At the 1959 session of the GATT Contracting Parties, the U.S. delegate stated that "sharp increases in imports over a brief period of time and in a narrow range of products could have serious economic, political and social repercussions in the importing countries, and officially proposed that the GATT study the problem posed by 'the adverse effects of an abrupt invasion (by sharp increases in imports) of established markets' " (GATT, 1984, p. 64). A GATT study that followed found that many countries were already attempting to restrict imports they feared might disrupt their markets (GATT, 1960).

A GATT Working Party was established to consider the problem. In November 1960, the Working Party reported that a problem did exist and that it would be called *market disruption*. The report added that "there were political and psychological elements in the problem" (GATT, 1984, p. 64) suggesting that the tendency to use exceptional measures (outside GATT rules) to control textile imports would not stop until more comprehensive policies were in place to handle the problem (GATT, 1984).

As a result, in November 1960 the Contracting Parties adopted "Avoidance of Market Disruption" (GATT BISD 9th Supplement, pp. 26–28), which introduced three important changes into GATT fundamentals:

- The injurious increases of imports need not have already occurred—a potential increase could be sufficient to justify added restrictions.
- **2.** Imports of a product from a *particular country could be singled out* as the source of

- a problem rather than overall imports of the product. This provision meant that restrictions could be applied on a countryspecific (discriminatory) basis rather than according to the MFN rule. (The change in GATT rules applied primarily to exports from Japan and the developing countries.)
- 3. The existence of a sizable price difference between particular imports and comparable goods in a domestic market could be used to justify additional restrictions on imports. That is, the price difference for textile products made in the developing countries—compared to prices for similar product in a developed country—could justify added restrictions on the imports from developing countries. This provision was based on the notion that the developing countries had an unfair advantage because of the disparity in labor costs between the developing and developed countries (discussion of the 1960 document in GATT, 1984).

Establishing the concept of market disruption within GATT may seem like a minor occurrence. On the contrary, however, this change was tremendously important both in the history of the GATT and in what GATT stood for—and for the future of international textile trade policy. As we reflect briefly on each of these points, we might consider the strength of textile interest groups in effecting such fundamental changes in global policies that applied to all trade.

A number of sources believe that accepting the concept of market disruption (which resulted from textile trade concerns) was the beginning of a weakening of GATT power (Aggarwal, 1985; Blokker, 1989; Cline, 1987). GATT had been established to create a climate of openness and equality in trading; it had prohibited discrimination against one country by another (all trading partners were to be treated equally), and quantitative restrictions (quotas) were forbidden. Legitimizing market disruption as a

way of limiting imports violated these fundamental aims of GATT. And, finally, we should not forget that it was the textile complex that was instrumental in introducing these departures into the GATT framework.³

Next, we should keep in mind that the introduction of the market disruption concept was the beginning of implementation of a special set of trade rules to manage the problems of global textile trade. Although textiles and trade were not originally singled out, these are the only two industries to which the Contracting Parties applied the concept (GATT, 1984). In short, the market disruption provision paved the way for what soon would follow in textile trade policies.

THE SHORT-TERM ARRANGEMENT

By 1960, U.S. government leaders found themselves in a dilemma with regard to the growing difficulties posed by textile trade. Representatives of the U.S. textile industry grew increasingly impatient with the growth of imports from low-wage countries in domestic markets. Both U.S. government and industry leaders were angered by the EU's⁴ measures—many of which were illegal under GATT—to restrict developing-country textile imports from the European markets. In other words, the Americans thought the Europeans were not taking their share of low-cost textile imports.

Faced with the growing pressure from industry to restrict imports, U.S. government officials found it difficult to respond to the textile industry's demands without violating the rules of GATT. After all, the United States had played a leading role in the establishment of GATT and wanted to preserve it. Moreover, U.S. government representatives were concerned by the growing restrictions that threatened to undermine the GATT.

U.S. politics entered the picture at this point as well. As a presidential candidate, Senator John F. Kennedy, who was from Massachusetts, a state with a seriously declining textile industry, sought and received the support of the U.S. textile industry. Senator Kennedy was keenly aware of the number of voters employed in the textile and apparel sectors. Prior to his election, Kennedy sent a letter to South Carolina Governor Ernest F. Hollings⁵ on August 31, 1960, which included the following statement:

I agree . . . that sweeping changes in our foreign trade policies are not necessary. Nevertheless, we must recognize that the textile and apparel industries are of international scope and are particularly susceptible to competitive pressure from imports. Clearly the problems of the Industry will not disappear by neglect nor can we wait for a large scale unemployment and shutdown of the industry to inspire us to action. A comprehensive industry-wide remedy is necessary. (*Brandis*, 1982, p. 17)

Having pledged to support the textile industry in his campaign, Kennedy proposed a seven-point program to assist the U.S. textile complex. One of Kennedy's points directed the State Department to convene an early conference of textile-importing and -exporting countries to develop an international agreement governing textile trade (Brandis, 1982). Subsequently, as president, Kennedy charged the

³Although the market disruption feature was discussed and formulated by the Contracting Parties, it never became part of the GATT articles. This is why, although all textile agreements were negotiated in GATT, participation was limited, on the one hand, to those Contracting Parties who accepted the textile rules and, on the other hand, were open to non-GATT countries (personal communication from M. Raffaelli & T. Jenkins, 1993).

⁴Although the European Union was called the European Economic Community at the time, we will refer to it as the European Union (or EU) for consistency.

⁵ Governor Hollings later became a strong textile industry advocate in the U.S. Senate.

undersecretary of state, George Ball, with responsibility for negotiating an international agreement on textile trade.

In an effort both to satisfy the domestic textile industry and to maintain the integrity of GATT, U.S. officials proposed a multilateral arrangement to handle textile trade problems. U.S. negotiators denounced the unilateral approaches being used by the European countries to limit textile imports, charging that quantitative restrictions (quotas) were expressly forbidden under GATT. The U.S. proposal also suggested that in developing an agreement, "Such a mechanism should permit the distribution of cotton textile trade over a larger number of importing countries" (GATT Document L/1592, p. 5, cited in Aggarwal, 1985). That is, the United States believed that European countries should take their share of textile exports from the less-developed countries.

The outcome of the negotiations was the Short-Term Arrangement Regarding International Trade in Cotton Textiles (the STA), which was effective from October 1961 to September 1962. The STA authorized 1-year restrictions on 64 categories of cotton textiles to avoid market disruption until a more permanent mechanism could be developed. The STA covered only cotton textile products. Although U.S. industry sources pressed to have wool included, government officials resisted (Aggarwal, 1985).

U.S. government and industry sources believed they had found the nearly perfect answer to textile trade problems. In referring to the STA, an article in the *Daily News Record* (December 1961, cited in Aggarwal, 1985) noted: "The cotton textile pact is to be cited as an ideal example of how the U.S. can liberalize its trade policies while still protecting specialized industries from market disruption."

Not all countries involved in the STA negotiations viewed the agreement or the negotiations favorably. Some representatives resented the U.S. negotiators' subtle threat to close off

their markets unless the **multilateral agreement** materialized:

There were strong domestic political pressures urging the U.S. Government to take unilateral action and establish import quotas. As action of this type would be contrary to the generally liberal trade policies of the U.S. in recent years, this government has advanced its proposals for a multilaterally acceptable solution. (*GATT Document L/1535*, *p. 3*, cited in Aggarwal, 1985, *p. 85*)

Although the STA was a stopgap measure, its establishment (and the Long-Term Arrangement that followed) represented a particularly significant occurrence in trade history. Textiles and apparel were the only products to be formally exempted from the provisions of GATT and given a special set of rules (a **regime**) of their own. Initially, two criteria were the justification for treating textile and apparel trade as a "special case" and for granting the special status:

- "The challenge presented by 'low cost' imports was, with only minor exceptions, unique to textiles (and later to apparel), and
- 2. "The importance of employment and production in those industries to the country's overall economic activity" (GATT, 1984, p. 10).

In summary, beginning with the STA in 1961, a new set of trade rules for textiles and apparel was created alongside the existing rules of GATT. Beginning with formalization of the STA, we might think of textile and apparel trade policies in the manner depicted in Figure 10–3. The STA—and the Long-Term Arrangement that followed—were significant events in GATT's history. An important part of world trade was formally exempted from GATT rules—in particular the *nondiscrimination* rule and the general prohibition of *quantitative* restrictions (i.e., *quotas* were legitimized under the STA).

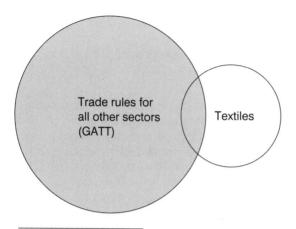

FIGURE 10–3
Textile trade since 1961.

THE LONG-TERM ARRANGEMENT

In February 1962, 19 major trading nations agreed to the Long-Term Arrangement Regarding Trade in Cotton Textiles (LTA), which was effective for a period of 5 years. Like the STA, the LTA included provisions for governments to follow if they claimed *market disruption or a threat of* market disruption from imports. When market disruption (or the perceived threat of market disruption) occurred, importing countries were permitted to (1) negotiate bilateral agreements with exporting countries or (2) impose unilateral restraints if they and the exporters could not arrive at an agreement (certain provisions were required in using unilateral restraints). Most importing countries chose to negotiate bilateral agreements with exporting countries, and by 1966, the United States had bilateral agreements with 18 countries (Aggarwal, 1985; Dam, 1970).

At first glance, one might wonder how the bilateral agreements or **unilateral restraints** permitted under the LTA differed from the measures taken by European countries prior to the STA and LTA. The measures were similar. The difference was that the STA and LTA now

offered a special provision—under the auspices of GATT but *outside normal GATT rules*—that *legitimized* the bilateral agreements (with *quotas*) and conditional unilateral restraints.

The LTA was an international regime that limited volume growth of imports to 5 percent per year for most cotton textile products. In some cases, other agreements might alter this limitation. The allowed annual 5 percent growth rate seemed ironic since the U.S. textile and apparel trade deficit was only 4 percent of value added at that time and the EU had a surplus (Cline, 1987; Keesing & Wolf, 1980). See Tables 9–3 and 9–6 for U.S. import penetration levels at that time.

U.S. politics appeared to have played an important role in the establishment of the LTA. Political realities fostered early protective action for the textile and apparel industries. At that time, these industries employed 17 percent of all manufacturing workers in the industrial countries. This concentration of workers represented significant political power at the domestic level. By contrast, at the international level, the countries whose products were being restricted—Japan and the developing countries—had far less influence in GATT. Furthermore, President Kennedy wanted to launch a major global round of trade negotiations—known as the Kennedy Round to reduce trade barriers. He knew that the powerful U.S. textile lobby would provide strong opposition to such an effort and might prevent it altogether. Therefore, the LTA provided President Kennedy an opportunity to deliver on his campaign promise to assist the industry in its concern over imports and, at the same time, permitted him to proceed with the Kennedy Round with little likelihood of protests from textile industry groups (Aggarwal, 1985; Cline, 1987; Destler, 1986; Keesing & Wolf, 1980).

→ Basically, the LTA permitted importing countries to restrain imports of cotton textiles from the more important low-wage countries. Imports were subject to a slow growth in quota

most &

rates from year to year once a supplier was brought under restrictions (i.e., once the supplier joined the plan). Another key point to remember is that the LTA was limited to *cotton* textiles—defined as textile products in which cotton was over 50 percent of the fiber content. In some countries, the 50 percent was based on weight, but the system in use in the United States at the time was based on value (called the *chief value method*).

The LTA was renewed in 1967 and again in 1970. Although the LTA had its share of critics, its sponsors claimed it to be the lesser of two evils. That is, without the multilateral arrangement, the importing countries would have continued to increase their unilateral restraints on textile imports from Japan and the less-developed countries. Advocates of the LTA believed it provided "orderly growth."

THE MULTIFIBER ARRANGEMENT (MFA) Development of the MFA

By 1973, 82 countries had signed the LTA and participated in textile trade under the cotton arrangement. U.S. textile and apparel imports had grown substantially despite the LTA, however. U.S. textile imports grew from \$1.02 billion in 1961 to \$2.4 billion in 1972; apparel imports increased from \$648 million to \$3.5 billion. Together, U.S. textile and apparel imports grew 11.5 percent annually during this decade. Adding to this growth was an increasingly overvalued dollar during this period (Cline, 1987).

The growth in imports entering the markets of the United States and other developed countries could be attributed to two changes occurring during the 1960s in the global textile industry:

1. A major technological change occurred with the development and increased use of manufactured fibers.

An important economic change occurred as a growing number of developing countries began to produce and export textile products.

The fast growth of global trade of manufactured fibers merits special attention at this point. In the United States, for example, imports of manufactured fiber textiles grew 10fold between 1960 and 1970—from 31 million to 329 million pounds (Davidson, Feigenoff, & Ghadar, 1986). Although the development of manufactured fibers would have affected the global textile industry at any rate, the existence of the LTA encouraged increased growth. In effect, the LTA had fostered another case of the "little Dutch boy and the dike" phenomenon. That is, because the LTA had placed controls on shipments of cotton textile products, many exporting countries shifted to the uncontrolled manufactured fiber product areas.

Earlier, American textile and apparel producers sought to have the LTA renewals include products made of other fibers. Those efforts had not been successful, however. By the late 1960s, growth of imports of other fibers confirmed to U.S. industry leaders that the trade policy arrangements must be broadened to include other fibers (Destler et al., 1979). By the time of the 1968 presidential election, U.S. textile and apparel industry groups had secured the support of all presidential candidates (Richard Nixon, Hubert Humphrey, and George Wallace) to extend textile import restraints to include products made of manufactured fibers and wool. In his campaign, Nixon pledged:

As President, my policy will be . . . to assure prompt action to effectively administer the existing Long-Term International Cotton Textile Arrangement. Also, I will promptly take the steps necessary to extend the concept of international trade agreements to all other textile articles involving wool, man-made fibers and blends. (Telegram to Republican members of Congress who supported textile import control legislation, August 21, 1968; cited in Brandis, 1982, p. 39)

Shortly after Nixon's inauguration, he appointed Secretary of Commerce Maurice Stans to follow through on the campaign textile commitment. Stans began his efforts to develop an arrangement covering all fibers by going first to the EU countries. The Europeans were not interested in a multifiber arrangement for two reasons: (1) The EU member states were controlling the influx of wool and manufactured fiber imports into their markets quite successfully with bilateral and unilateral measures. (2) The EU countries were exporting a substantial volume of textile products to the U.S. market; they naturally resisted an arrangement that might restrain their own products. Even when Secretary Stans tried to explain that the United States was most concerned about Asian imports, the Europeans resisted U.S. efforts to broaden the coverage of the LTA (Aggarwal, 1985; Brandis, 1982; Destler et al., 1979).

Secretary Stans proceeded with an alternative plan for enticing the EU countries to join a multifiber approach for controlling textile imports. Stans believed that by first concluding more restrictive U.S. agreements with major Asian suppliers, textile exports from those countries would be diverted from U.S. markets to EU markets. He anticipated that this strategy would give EU countries an increased interest in a multifiber restraint program (Aggarwal, 1985; Destler et al., 1979).

Proceeding with his plan, Stans tried to secure multifiber textile export restraint agreements from Japan, but the Japanese were unwilling to respond to his requests. The textile and apparel industries were among the most vital sectors in Japan at that time, accounting for a substantial proportion of Japan's total exports. In addition, Japan was a member of GATT and a more established participant in world trade than in earlier years when it had agreed to voluntary export restraints on textile products. Just as the Europeans had refused a broad multifiber plan, the Japanese refused to participate in Stans's plan to enforce comprehensive controls on manufactured fiber and

wool textile products exports (Aggarwal, 1985; Destler et al., 1979).

U.S.-Japanese negotiations over textile trade were intense during the 1969-1971 period, at times moving to the highest levels between President Nixon and Japanese Prime Minister Eisaku Sato. In an extensive study of the U.S.-Japanese textile trade dispute, Destler et al. (1979) noted that efforts included two summit conferences, two cabinet-level ministerial conferences, and at least nine other major negotiations. Textile trade difficulties dominated economic relations between the two countries for the better part of 3 years, straining relationships far beyond the textile issue. Destler et al. reported that President Nixon's resentment of Prime Minister Sato's failure to deliver a textile quota agreement led to Nixon's eagerness to rebuff Japan on other policy issues.

In addition to the fact that a textile agreement was one of Nixon's high priorities, he became worried that negotiations would extend through the election. Therefore, Nixon increased pressure on the Japanese. First, he imposed a 10 percent across-the-board import surcharge and then threatened to invoke the "Trading with the Enemy Act" to impose unilateral restraints on textile and apparel imports. Finally, on the day the Trading with the Enemy provision would have taken effect, the Japanese gave in to a textile and apparel

⁶ The U.S. Trading with the Enemy Act was considered (and used as a threat) by President Nixon in 1971 to force Japan to sign an agreement to limit its textile shipments to the United States. Invoking this act might be viewed as "bringing in the tanks" to pressure Japan. The act was originally signed in 1917, when the enemy was Germany, and amended 11 days after the Pearl Harbor attack to provide that "During the time of war or during any other period of national emergency declared by the President, the President may . . . regulate . . . any . . . importation or exportation of . . . any property in which any foreign country or a national thereof has any interest" (55 STAT, Chapter 593 [Public Law 77-354, December 18, 1941], cited in Destler et al., 1979, p. 293). The textile dispute was interpreted as a "state of emergency" in these 1971 deliberations on how to deal with the Japanese (Destler et al., 1979).

bilateral agreement to limit wool and manufactured fiber products (Aggarwal, 1985; Brandis, 1982; Destler et al., 1979).

During 1971 and 1972, both the United States and Canada resorted to several bilateral agreements that imposed quota restraints to limit shipments of textile goods made of manufactured fibers and wool. These agreements were outside the auspices of both GATT and the LTA. In addition to the Japanese agreement, the United States concluded bilateral agreements with Hong Kong, South Korea, and Taiwan to limit exports of products in these additional fiber categories (Aggarwal, 1985; GATT, 1984).

As a result of the additional U.S. restraints on textile products from the major Asian producers, growing quantities of Asian textile goods were diverted from the American market to European markets. Within the EU member states, the textile and apparel industries began pressuring for protection from exports originally destined for the United States. Soon, EU countries that had refused earlier to consider an expanded textile agreement were willing to negotiate. Stans's earlier prediction that bilateral agreements with major Asian suppliers would encourage the Europeans to change their minds had proven true (Aggarwal, 1985; Cline, 1987; Destler et al., 1979).

Once the EU became a willing participant, a multifiber arrangement seemed inevitable. In 1972, a GATT Working Party began a study of world textile trade. Following completion of that study, the GATT Council asked the Working Party to seek alternative multilateral solutions to the problem of world textile trade. Negotiations followed under GATT sponsorship.

By the time negotiations for the arrangement occurred in 1973, Japan was beginning to experience the loss of comparative advantage to the less-developed countries, as well as the effects of a currency realignment in 1971. Although the Japanese were not enthusiastic about the plan, they were amenable because they considered the arrangement inevitable (Destler et al., 1979).

The less-developed countries participated in the early multifiber discussions in a way that has been characteristic of later textile negotiations. Under the United Nations Conference on Trade and Development (UNCTAD), which provides a forum through which less-developed countries unite to counter GATT measures on trade, the Group of 77 issued a resolution to "demand abolition of all tariffs and quotas on textile imports from developing countries by a fixed target date" (*Textile Asia*, October 1973, p. 11, cited in Aggarwal, 1985, p. 133).

The developing countries presented an outwardly unified position on textile trade, but in reality, maintaining a cohesive position among the group was difficult then and continues to be difficult. The division occurred because the countries varied in their competitive position in textile trade. Countries that had become proficient in production and trade (the major producers in the Far East) and already had large quotas for U.S. and EU markets based on "past performance" (Aggarwal, 1985, p. 130) would retain those quotas, whereas newly developing countries would have little access to the major markets based on their prior exporting records. In a sense, earlier quotas provided guaranteed market access in an intensely competitive market with an overabundance of producers. This division among the less-developed countries has continued throughout the period in which the present textile restraint programs have existed. In general, however, the first multifiber arrangement offered adequate provisions to encourage the developing countries to join fairly readily (discussions with trade ministers from various countries, 1983-1989; GATT, 1984; Keesing & Wolf, 1980).

MFA I (1974-1977)

The multilateral framework to resolve textile trade problems known as the Arrangement Regarding International Trade in Textiles,

and more commonly known as the Multifiber Arrangement (MFA), was concluded at the end of 1973 and became effective in January 1974 for a 4-year period. Approximately 50 countries were in the original group that signed the agreement, which was developed and operated under the auspices of GATT. As the name implies, the new arrangement included products made of manufactured fibers and wool—extending beyond the provisions for cotton in the STA and LTA. In exchange for their willingness to negotiate a new agreement, Japan and the developing countries gained significant influence on the terms and conditions of the first MFA.

In working terms, the MFA was a general framework under which textile and apparel trade would occur—and could be controlled. The MFA was quite general; the bilateral agreements concluded under the Arrangement pro-

vided the specifics of "managing" textile and apparel trade. In other words, the bilateral agreements were the vehicles through which the MFA was operationalized for participating countries. We might think of the MFA as an umbrella arrangement under which the bilateral agreements were concluded. See Figure 10–4.

Although any country would be permitted to establish a bilateral agreement with another country, the realities of textile trade fostered a more predictable pattern. In reality, a bilateral agreement occurs because the importing country (a developed country) determines that specific textile and apparel imported products from a particular country are disrupting (or may disrupt) the importing country's market. The bilateral agreement that results from negotiations between the two countries identifies the export levels agreed to by the exporting

FIGURE 10-4

Under the MFA, each signatory member negotiated bilateral agreements with its trading partners for which textile trade was a concern.

Source: Illustration by Dennis Murphy.

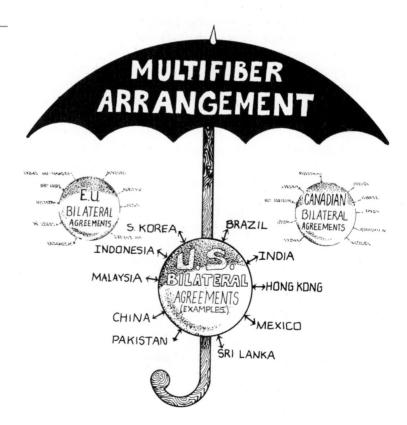

BOX 10-2

THE CATEGORY SYSTEM USED FOR IMPORT CONTROL PURPOSES

The category system used for import control purposes is a completely separate system from the SIC categories used to designate U.S. manufacturing sectors. In the category system for import control purposes, the numbering system designates both the fiber content and the product. All product categories in the 300 series are cotton; those in the 400 series are wool; products in the 600 series are manufactured fibers; and those in the 800 series are silk blends or vegetable fibers other than

cotton. The first digit indicates fiber content, and the second two digits the product line. Category 635, for example, is women's and children's manufactured fiber coats. The fiber of chief weight in the garment generally determines its fiber classification (O'Donnell, 1988). In 1988, the United States changed its category structure to conform with the Harmonized System, which took effect in 1989 (personal communication with U.S. Department of Commerce staff, 1990).

country. In other words, the bilateral agreement establishes the quota restraints on some or, less frequently, most of the exporting country's products. Quotas set limits on the quantity of goods to be exported—by some measure, such as weight or number of items, according to the product description.

In a hypothetical example, let's assume that the United States negotiated a bilateral agreement with Thailand that permitted Thailand to send 300,000 women's cotton sweaters to U.S. markets within a year. In Thailand, the quota allowances are distributed among sweater manufacturers, but all producers must work within Thailand's total allowance—which was spelled out in a bilateral agreement. Similar activities would occur for each product area covered by quotas in the bilateral agreement between the two countries. Quotas cover products of concern in the markets of the importing country. The products are identified by category numbers for defined product groupings. See Box 10-2.

The import control system established under the bilateral agreements is complex. In fact, operational details are more complex than we need to consider here. A few additional terms

may be useful, however, for a general understanding of the types of limits set by the bilateral agreements:

- Aggregate Ceiling: The total number of equivalent square meters a country can export to the United States in any year under the terms of its bilateral agreement.
- Group Ceiling: Within the aggregate ceiling, there is a breakdown into groupings, and each group has a ceiling. This provides greater restrictions on more sensitive categories.
- Category Ceiling: Upper base limits against which a country can export for a particular product category (AAMA, 1980).

Only about half of GATT's Contracting Parties ever participated in the MFA. Only 17 members of GATT, even counting EU member states individually, have ever used the special rules for textiles to impose import restrictions (GATT, 1984). As might be expected, the 17 are the leading textile-importing countries because those are the nations concerned about market disruption.

The MFA added the following features that had not been part of the STA or LTA:

- A Textile Surveillance Body (TSB) was created to monitor implementation of the MFA.
- Stricter rules for determining market disruption were developed to discourage unwarranted claims of disruption.
- Quota allowances were permitted to grow by 6 percent annually rather than the 5 percent under the LTA.
- New provisions for quota flexibility were initiated (although various degrees of flexibility had been possible in earlier agreements); these were:

Swing permitted the transfer of a quota from one category to another. That is, if the quota for a product was not filled, another product could be shifted to take advantage of the unused quota.

Carry forward permitted the exporting country to borrow from the next year's quota.

Carryover permitted the exporting country to add unused quota to that for the subsequent year. Sometimes this provision caused a **surge** in importing markets.

The MFA posed certain challenges for the EU that the United States did not have to face. First, trade rules within the EU permitted free circulation of products among member countries. Some countries had a number of restraints against less-developed country textile imports; others had few. To get their products to countries with greater restraints, the less-developed countries simply shipped to an uncontrolled EU country and had the products redirected to the countries with stricter controls. Therefore, the EU found it difficult to resolve these variations among its member countries to conform to the MFA.

Second, EU countries were faced with the problem they called "burden sharing." This

was the EU term for determining how member countries would share the "burden" of accepting less-developed country textile and apparel imports that came into the Community. A formula was determined to be certain that all countries took their "fair share."

In short, the United States quickly concluded bilateral agreements with the major exporting countries while the EU delayed negotiating agreements because of the difficulty in coordinating internal differences. The first EU bilateral agreements were concluded almost 2 years after the MFA was established. The U.S. and EU differences in the speed of establishing bilateral agreements accounted for a substantial contrast in trade patterns that occurred under MFA I.

The textile and apparel industries in both Canada and Australia⁷ fared poorly during MFA I; consequently, both countries initiated unilateral measures along with their bilateral agreements to deal with their trade problems. For example, in late 1976, Canada imposed quotas on *all* apparel imports for 1977. Canada's approach was controversial within GATT and was not well received in general at the international level (Anson & Simpson, 1988).

MFA II (1977-1981)

Although the MFA was concluded initially for a 4-year period, it was renegotiated in 1977. The renewals of the MFA that followed were "Protocols of Extension"—that is, extensions of the original MFA to which changes were appended.

Although the United States had been the leader in pushing for the original multilateral agreement, the EU took the lead in pressing for an increasingly restrictive renewed MFA. The

 $^{^7}$ Australia was a signatory to the original MFA but did not participate in later renewals.

United States had fared much better than the EU under MFA I due largely to the quick conclusion of bilateral agreements with major exporting nations. The prompt U.S. bilaterals had two effects. First, they protected U.S. markets; and second, they diverted less-developed country textile products to the EU market, where bilateral agreements had been negotiated slowly. Textile and apparel imports in Europe had increased 49 percent between 1973 and 1976. Although similar U.S. imports grew 40 percent, the increase was from a much smaller base (GATT, 1977). Furthermore, the EU had been affected much more severely than the United States by the post-oil shock recession. Consequently, U.S. textile and apparel employment declined only slightly between 1974 and 1977.

As a result of the general economic conditions plus the growth in imports, EU demands influenced significantly MFA II—resulting in a protocol that permitted more restrictive bilateral agreements. EU officials took a strong position in demanding greater restrictions because of the intense pressure being exerted by their industry groups. Additionally, certain EU member countries threatened to refuse to participate further in the MFA and to impose their own unilateral restraints, unless the renewed MFA permitted substantially tougher controls on imports.

Of particular concern to EU representatives was the 6 percent annual growth rate for quotas permitted in the first MFA. Although Annex B of the Arrangement permitted a departure from the 6 percent growth rate in "exceptional cases," the EU had found it tedious to have to prove market disruption in each case. Consequently, the EU wanted to free itself from the MFA's constraints of having to provide proof of market disruption in order to negotiate quota growth below 6 percent in its agreements with exporting nations (Keesing & Wolf, 1980).

U.S. textile and apparel industry sources were also concerned over the 6 percent annual

growth rate—particularly during periods when domestic growth was low. Manufacturers argued that it was unfair for imports to increase 6 percent per year when their own share of the domestic market was increasing sometimes as slowly as 1 percent per year. Industry leaders sought to have import growth rate tied to the domestic growth rate.

The EU achieved its goal, and the MFA that was signed in December 1977 permitted "jointly agreed reasonable departures" from the terms of the MFA. That is, the "reasonable departures" clause permitted participating countries to negotiate bilateral agreements that no longer complied with the provisions of the original MFA that had been agreed upon by all members (GATT, 1984). These were intended to be temporary. The developing countries opposed this highly controversial clause because it meant that "departures" worked to their detriment (e.g., reduced quotas, denials or reductions in flexibility, and growth rates reduced below 6 percent). Nevertheless, the greater power of the importing countries prevailed.

Although MFA II became more restrictive on textile and apparel imports allowed in the developed countries, it is important to remember that the MFA provided only the general framework and basic mechanisms for textile trade. With each revision of the MFA, new bilateral agreements generally were negotiated. Within the MFA framework, negotiators for various countries determined the degree or level of restrictions by the bilateral agreements they signed.

As the EU set about to negotiate new bilateral agreements, the result was "a system of quotas so restrictive as to change everyone's perspective of what was possible. Its aim was 'to achieve a real stabilization of imports, particularly for products with a high penetration rate . . . on the Community market'" (Keesing & Wolf, 1980, p. 64). Many quota growth rates fell below 6 percent; some dropped to zero. See Figure 10–5.

Although U.S. bilateral agreements under MFA II included increased protection for the

FIGURE 10–5
MFA restraints became increasingly tight in an effort to choke off imports.

Source: Illustration by Dennis Murphy.

domestic industry, the U.S. position was far less restrictive than that of the EU. As a result of special U.S. concern over imports from Hong Kong, South Korea, and Taiwan, bilateral agreements with those countries tightened swing and carryover provisions. The United States negotiated new bilateral agreements with the "Big Three" despite the fact that 5-

year agreements had been signed only a year earlier. For products where quotas had gone unused to a significant extent, some of those quotas were abolished and a new mechanism—the "call" mechanism—was instituted. Under the call mechanism, consultations between the governments of the two trading countries on new quotas would be triggered if imports exceeded certain levels—or if the importing country established market disruption or a serious threat of market disruption. In general, however, U.S. agreements froze imports from the "Big Three" suppliers but were more lenient on the new, smaller textile-exporting nations.

In summary, bilateral agreements under MFA II reduced textile and apparel imports in both U.S. and EU markets. The reasonable departures clause of MFA II changed the Arrangement fundamentally. Keesing and Wolf (1980) referred to the reasonable departures clause as a sharp departure from the norms of the MFA. They concluded that this clause provided a "'departure from a departure'—a way of waiving the provisions of an agreement which was itself a derogation from GATT principles" (p. 70).

MFA III (1981-1986)

The 1981 negotiations for renewal of the MFA were particularly difficult. From the perspective of both the EU and U.S. textile and apparel industries, MFA II—despite its increasingly restrictive features—had not been effective in slowing the tide of imports. Both the United States and the EU had growing textile and apparel trade deficits. Apparel trade deficits were

⁸ We must remember that the MFA provided only the framework for the textile import control program. Therefore, the negotiated bilateral agreements determined the level of import shipments. The growth of imports also might have resulted from the growing number of supplier nations not under restraint, as well as from inefficient monitoring programs to ensure that shipments complied with agreements.

particularly significant, since a growing portion of less-developed country exports were in the apparel area (Aggarwal, 1985; GATT, 1984).

More than ever, the development of textile trade policy was dominated by political pressures. Moreover, with each successive renewal of the MFA, the opposing players became increasingly organized and proficient in pressing for their special interests. The textile and apparel industry leaders in both the United States and the EU grew increasingly impatient and vocal in their desires for greater protection. At the same time, a group of the exporting countries (developing countries) became more organized with support from the UNC-TAD and became increasingly vocal. The EU Commission (which handles government matters for the EU) and the U.S. government were pressed on the one hand by domestic industry sources who demanded increased protection and on the other hand by the less-developed countries, which demanded a more liberal approach. U.S. and EU negotiators often found themselves in a no-win dilemma-if they pleased one side, they alienated the other.

Furthermore, the EU complained again that "burden sharing" was not fairly distributed. The EU claimed that its per capita share of developing country imports was much greater than that of the United States and Japan, which by this time had become an important *importing* nation.

As in previous instances in which "burden sharing" has been discussed, this refers to taking a "fair share" of the low-cost textile and apparel imports. Although trade shifts cause various sides to express this complaint at one time or another, concerns over burden sharing always come from importing countries that believe their peer countries are not absorbing their fair share of exports from the developing countries.

American industry sources demanded greater protection, using the argument that "low-cost imports undermined their production" (Aggarwal, 1985, p. 169). U.S. industry

sources believed that the *price differential* between imported products and comparable domestic goods provided justification for added protection from imports.

The coalition of developing countries was successful in having the reasonable departures clause withdrawn for MFA III. Instead, a less restrictive anti-surge provision provided for special restraints in the event of "sharp and substantial increases" in imports of the most sensitive products with previously underutilized quotas. MFA III tightened the definition of market disruption by requiring proof of a decline in the growth rate of per capita consumption. This protocol provided more precision regarding favorable treatment of smallcountry suppliers and new entrants. During MFA III, however, a growing number of countries came under restraints (Anson & Simpson, 1988; GATT, 1987b).

With each MFA renewal, various groups threatened to pull out of the Arrangement by not signing the revised agreement. Usually, this was a ploy to bargain for certain provisions a group wanted in the renewal agreement. The EU threatened to leave the MFA and manage textile trade through its own bilateral and unilateral restraints. The less-developed countries threatened to avoid signing unless they received more liberal provisions. Although threats were made, many persons conceded that total chaos would occur in global textile and apparel trade if the MFA were suddenly dismantled. Although the MFA had few supporters, most sources acknowledged that it provided a certain predictable climate for textile and apparel trade.

Simply put, major players sought to develop trade policies that regulated others' behavior. The United States and the EU were particularly interested in each other's stance. If, for example, the EU took harsh measures to restrict imports, products would be diverted to U.S. markets, or vice versa. Both the United States and the EU wanted to control the less-developed countries' exporting activities and,

hopefully, force them to open their markets to products from the developed countries. Although the developing countries lacked the power to make demands on the developed countries, they sought an MFA that would constrain the demands of the importing countries.

Restraints under MFA III were more extensive and more restrictive than before (GATT, 1987). Although MFA III became somewhat more protectionist as a result of growing domestic industry pressures in both the United States and the EU, the Arrangement was not as restrictive as the industries had hoped. Although the agreement provided far less protection than the American industry wanted, negotiations revealed that the U.S. government found it increasingly difficult to resist strong protectionist pressures from the domestic industry. In the United States, textile industry decline, accompanied by a growing flood of imports, caused textile leaders to condemn MFA III as a failure (Anson & Simpson, 1988).

MFA IV (1986–1991)

While MFA III was in effect, U.S. market conditions took a turn for the worse. Between 1982 and 1984, textile and apparel imports from both high-cost and low-cost sources grew at unprecedented levels. Imports almost doubled in just over 2 years. As a further result of a rapidly rising dollar, exports declined. Domestic textile output dropped by 10 percent. During the years of MFA III, the United States initiated several tightening measures to reduce imports:

- Additional claims for the "presumption of market disruption" resulted in over 100 consultation calls in late 1984 and early 1985. This meant that quotas were being considered for products previously not covered.
- Countervailing duties (added duties) were imposed on textile goods from 20 countries

- that were shown to have subsidized their textile industries. GATT rules prohibit government subsidization of domestic industries; this gives an unfair advantage in trade.
- New rules of origin were introduced in 1984 to prevent transshipment (rerouting products through a country other than where they were produced in order to take advantage of unused quotas). "Substantial transformation" had to occur in a country for that country to be declared as the country of origin for customs purposes.
- Bilateral agreements were renegotiated, on tougher terms, with the "Big Three" 2 years before they were due to expire.
- A bill, known as the Jenkins bill, was introduced in Congress to set additional limits on textile and apparel products because industry leaders believed the U.S. government was ineffective in negotiating workable trade policies. This bill will be discussed later.

The additional restrictive provisions initiated during MFA III indicate the type of U.S. textile/apparel trade climate that prevailed by the time MFA IV negotiations began. As these actions would suggest, U.S. officials went into the 1986 MFA renewal negotiations under heavy pressure from domestic textile and apparel industry sources to provide increased protection from low-wage imports. During this period the EU industries had been less affected by imports, and most of the European industries enjoyed relative health. The EU did, however, join the United States and Canada in presenting a joint statement of the major importing countries' desires for the 1986 renewal.

Although the **exporting countries**⁹ (the NICs and the less-developed countries) were more

⁹ WTO officials use the terms *exporting countries* (primarily the NICs and the less-developed countries) and *importing countries* (primarily the more-developed nations).

organized than in the past, the diverse composition of the group caused a lack of unity. In addition, the exporting group lacked the bargaining power to offset the strength of the developed countries. Because quotas were set on the basis of past performance, the small suppliers (usually the least-developed countries) had little opportunity to obtain substantial quota increases. In an effort to improve the exporting nations' bargaining position, a new body, the International Textiles and Clothing Bureau (ITCB), was organized to represent the interests of the developing countries. (Additional information on ITCB is provided in Chapter 11.)

In general, the exporting countries considered MFA IV to be more restrictive than the previous extension. The most significant new provision of the renewed Arrangement was that it covered additional fibers as well as cotton, wool, and manufactured fibers. Additional fiber coverage resulted because the U.S. market had experienced another example of the "Dutch boy and the dike" phenomenon. As cotton, wool, and manufactured fiber products became increasingly restricted from the markets of developed countries, the exporting nations shifted production to goods made of uncontrolled fibers-ramie, silk, and flax. Consequently, the U.S. market in particular received huge percentage increases of fibers that were not covered by the MFA. For example, 1985 U.S. imports from China made of non-MFA fibers increased 346 percent over 1984. Although the United States was hard pressed to claim market disruption from ramie products because the country produces no ramie, domestic producers believed that these products replaced similar items made of other fibers. For the United States, the extended fiber coverage was the most important feature desired from this renewal. This point was, however, the most difficult one to resolve in the 1986 renewal. See Box 10-3.

The extended fiber coverage applied to products in which the previously uncontrolled fibers exceeded 50 percent of the weight or

value of the imported goods; pure silk was excluded. Coverage did not apply to "historically traded textiles in commercially significant quantities prior to 1982" in product areas such as sacks, carpet backing, cordage, and similar products made from fibers such as jute, coir, sisal, abaca, maguey, and henequen.

Briefly, some of the main provisions of MFA IV were these:

- Unilateral restraints may be placed on uncontrolled products for up to 12 months if market disruption is proven but a bilateral agreement has not been reached in 60 days.
- Some of the poorer developing countries were to be given "significantly more favorable" treatment than the NICs.
- The Nordic countries' clause for preserving minimum viable production was retained. This is an MFA provision instituted by the Scandinavian countries that permits restriction of imports to maintain a healthy domestic industry—so that in wartime a country would be assured of having minimal viable production capacity. This meant that the Nordic restraints were even more restrictive than the MFA norms.
- The anti-surge clause remained; this permitted action to be taken if an underutilized quota was filled in a short time period.
- No cutbacks or tightening of quotas were permitted under MFA IV; that is, growth could not be "negative." Instead, exporting countries were required to accept lower rates of growth and flexibility.
- Cotton and wool production in developing countries continued to receive special consideration (Anson & Simpson, 1988; GATT, 1987; personal communication with M. Raffaelli & T. Jenkins, 1993).

The developed countries pressed to require that the developing countries open their markets to reciprocal trade in textiles and apparel.

BOX 10-3

RAMIE STOPS THE CLOCK

Extended fiber coverage was of the utmost importance to U.S. sources during the negotiations for MFA IV. The U.S. textile industry persuaded American negotiators that this provision must be included. At the same time, certain exporting countries were equally committed to avoiding coverage of additional fibers. Ramie became the stumbling block on which agreement could not be reached, particularly because it had become an important fiber area for China and India.

MFA III was scheduled to expire at midnight on July 31, 1986. Although negotiators had already debated ramie coverage for quite some time, discussions on the last day continued throughout the day and night in an effort to reach an agreement by midnight. Midnight arrived, and no agreement had been reached. At midnight, trade officials stopped the clock at the GATT head-quarters in Geneva, Switzerland, permitting negotiations to continue under the illusion that

MFA III had not expired. As talks continued throughout the night, negotiators found it difficult to proceed because of great time differences and the need to call home to consult their governments. That is, negotiators from China, India, the United States, and other countries needed to confirm their positions with their respective governments, but time differences created difficulties in reaching government officials during waking hours in the home countries.

At one point, the United States threatened to withdraw from the MFA unless the renewal included the additional fibers. China withdrew temporarily to seek advice from Beijing.

Finally, after many long, exhausting hours of discussion, the weary negotiators concluded the renewal of the Arrangement—which included ramie products and other extended fiber coverage—and officials started the GATT clock again.

However, the developing countries maintained the right to close their markets (if desired) under the **infant industry** provision permitted by GATT.

Extensions of MFA IV (1991, 1992, 1993)

By the time MFA IV was slated to expire in July 1991, global trade talks (the Uruguay Round, which will be discussed later in this chapter) had been underway for nearly 5 years. As we shall see later, the global trade talks included a provision that would affect the future of the MFA. Therefore, as MFA IV reached expiration in 1992 and the global trade talks were stalled, an extension of MFA IV was agreed upon rather than going to what might logically have been MFA V. In fact, two additional extensions of

MFA IV were agreed upon in December 1992 and December 1993. In official terms, these extensions were called *Protocols*. See Box 10–4.

For the 1991 and 1992 Protocols, the exporting members of the MFA were not in agreement about how long the extensions should be. They were unanimous, however, in asking that their bilateral agreements be more liberal (i.e., that they be permitted to ship more products to the developed countries). On both occasions, this request was not accepted because of the short periods of the extension. The 1991 and 1992 Protocols did, however, include clauses suggesting that the trading situations of the exporting countries would be improved. At the insistence of the developed importing countries, especially the United States, the 1992 Protocol included a statement to deal with the problems of circumvention, reflecting

BOX 10-4

GLOBAL TEXTILE TRADE POLICIES

The following summary shows major developments in global textile trade policies from the 1950s to the present:

- 1955, December Japan announces first VER on cotton textile products to the United States beginning January 1956.
- 1956, September Japan announces 5-year VER on cotton products to the United States beginning January 1957.
- 1959, February The United States tries to get Hong Kong to agree to a VER on cotton products; Hong Kong refuses.
- 1958–1960 Europeans use various illegal measures to restrict cotton products from less-developed countries.
- 1960, November GATT members agree on a definition of market disruption.
- 1961, July STA agreed upon; commences October 1, 1961.
- 1962, February LTA agreed upon; commences October 1, 1962.
- 1962–1967 Various bilateral and unilateral measures taken under LTA.
- 1963–1964 The United States tries to secure international agreement to cover wool products; efforts do not succeed.
- 1967, April LTA renewed for 3 years; commences October 1967.
- 1969, April The United States tries to get EU to agree to multilateral arrangement to include wool and manufactured fiber trade.
- 1970, October LTA renewed again.
- 1969–1971 The United States gets Far Eastern countries to restrain exports of wool and manufactured fiber products to U.S. markets.

- 1973, December MFA I agreed upon; commences January 1, 1974.
- 1977, December MFA II agreed upon; clause allows "jointly agreed reasonable departures."
- 1981, December MFA III agreed upon; anti-surge provision included.
- 1986, July MFA IV agreed upon; fiber coverage extended.
- 1991, July MFA IV extended to December 1992.
- 1992, December MFA IV extended to December 1993.
- 1993, December MFA IV extended to December 1994.
- 1994, December Uruguay Round concluded. "GATT 1994" became an amended, updated version of GATT 1947, providing the key disciplines affecting international trade in goods. These agreements outline MFA phase-out.
- 1995, January 1 The World Trade Organization established. The Agreement on Textiles and Clothing (ATC) replaces the MFA for the 10-year phase-out of quotas. Stage 1 of the phase-out begins and quota growth levels increase.
- 1998, January 1 Stage 2; additional products integrated; quota growth levels increased.
- 2002, January 1 Stage 3; additional products integrated; quota growth levels increase.
- 2005, January 1 Full integration of textiles and apparel into mainstream trade rules (final elimination of quotas).

Source: For 1955–1981, information based on Aggarwal, V. (1985). Liberal protectionism (pp. 203–204). Berkeley: University of California Press.

the growing concern over this problem (personal communication with M. Raffaelli & T. Jenkins, 1993).

Another point of interest during this time was Sweden's radical change of policy. Sweden left the MFA on July 31, 1991, thus dropping all MFA restraints. Ironically, when Sweden later became a member of the EU, this brought the country back into the MFA.

Reflections on the MFA

The MFA represented a compromise between the interests of the exporting and importing countries. It was, however, an agreement with which few participants were satisfied because, as a compromise, it gave none of the players all the provisions desired.

Further, the MFA had many critics among trade experts and economists not affiliated with any of the special interest groups that have a stake in textile trade policies. (Note: Although the MFA was replaced by the Agreement on Textiles and Clothing [ATC], the quota system remains in effect until the year 2005. This will be discussed in a later section. Therefore, these points are still relevant.) Some of the concerns over the MFA included:

- Removal of a sector of trade from GATT rules.
 Providing special trade rules for textile and apparel products, especially after most fibers were included, effectively removed a large proportion of world trade from the jurisdiction of normal trade rules. The unique feature of the MFA was that it has involved a multilaterally and formally agreed-upon departure from normal GATT rules for the benefit of a particular industry.
- Discrimination was (and is) permitted. The MFA violates GATT's MFN and nondiscrimination principles because it permits import controls that discriminate against particular countries. It permits countries to regulate trade on a country-by-

country basis, primarily through negotiation of bilateral agreements.

- Quotas were permitted. Quota limitations otherwise contrary to GATT—were negotiated on textile products.
- No compensation was/is required. Importing countries are not required to compensate the countries whose products are placed under restrictions (another principle of GATT).
- The concept of "market disruption" was introduced. The concept of market disruption was developed for the textile sector, and although the provision might be used by other trade areas, only the textile sector used it.

In short, the MFA was a departure, often called a *derogation*, from GATT rules. Critics of the MFA believe it went against the basic principles of GATT. See Figure 10–6.

Other criticisms often leveled at the MFA are:

Opposition to the "gentlemen's agreement."
 The MFA established a precedent of imposing quotas on products from the developing countries—but not the developed countries. This strategy was established by the informal "gentlemen's agreement" between the U.S. and EU textile negotiators in 1977, in which representatives agreed to refrain from imposing restrictions on each other's products. This strategy was justified, officials believed, by the similar costs of labor and other production costs in the two areas.

Another justification usually offered for the gentlemen's agreement (which also applied to the EFTA countries and Canada) was that the markets for textile products in these countries were open, unlike the markets of many exporting countries, which had high tariffs or even excluded all imports. While this was the general case during the 1970s and part of the 1980s, the rationale is

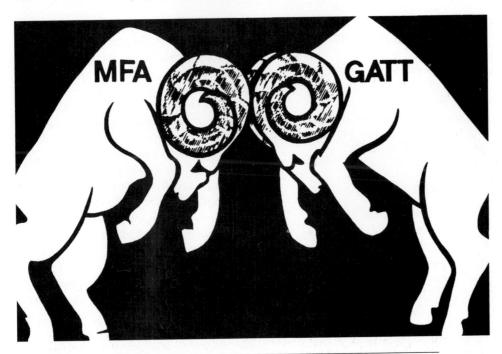

FIGURE 10–6
Many critics of the MFA believed that it went against everything GATT represented.

much less valid today, in view of the opening of the markets of many developing exporting countries (personal communication with M. Raffaelli & T. Jenkins, 1993).

Additionally, in the past, each of the EU countries had its own quota limits on imports. However, with the unification of the EU market, which became effective January 1, 1993, EU quotas are no longer divided into "country shares." Exporting nations considered this a liberalizing step, albeit involuntarily, on the part of the EU. This means that exporting countries can use more of their quotas.

"Temporary" protection was extended. The
original Arrangement was intended as a
temporary measure to provide a "breathing
space" for the industries in the developed
countries to adjust to the increased
competition in global markets. Critics

believe the protection provided by the MFA became addictive, causing the industries in the developed countries to restructure or adjust more slowly than they might have without the added protection.

In sum, the special provisions of the MFA were based on the assumption that textile trade is a special case. A central issue in the 1986 discussions on the renewal of the MFA was whether textile trade should be brought back into the mainstream of GATT policy. The basic question has been: Is the textile sector a special case? *Advocates* argue that no other sector has the special problems that are characteristic of textile/apparel production and trade. *Critics* contend that the problems associated with textile trade simply have been more exaggerated and politicized than similar problems in other sectors.

THE MFA IN OPERATION

In 1994, the MFA had 44 members representing 55 countries (the EU countries counted as 1) compared to GATT, which by then had 117 members (personal communication with GATT staff, 1996). The United States had negotiated bilateral import-restraint agreements with about 40 countries as of January 1994.

Approximately 65 percent of U.S. textile and apparel imports were covered by restraints in 1994 (personal communication with R. Levin, 1994). Similarly, the MFA covers only a portion of world textile and apparel trade. Only about one-fourth of world textile and apparel trade in 1986 was subject to the MFA (39.9 percent for apparel and 14 percent for textiles). When the category of other restraints (bilateral agreements outside the MFA, and so on) was added to the MFA coverage, about 60 percent of global trade in textile and apparel products occurred under some type of restraint. This means that approximately 43 percent of world trade in textiles and 35 percent of the trade in apparel were free from nontariff restraints (Cline, 1987).

Considering the attention given the MFA, why was so much textile and apparel trade outside the Arrangement? Several explanations are relevant:

- Restraints limited to problem areas. Restraints
 have been applied only to specific products
 from specific countries perceived to be a
 threat to the importing countries. Products
 that do not represent a threat are not
 covered. The United States used the
 consultation call mechanism to respond to
 concerns about products from countries
 that suddenly posed a threat.
- Exclusion for industrialized countries. Textile
 and apparel export flows between the
 industrialized countries were free of
 restraints—accounting for the largest
 proportion of trade not covered by the
 MFA. About one-fifth of non-MFA

- textile/apparel trade was among EU countries.
- Nonparticipation in MFA. A few major developed countries did not participate in the MFA or may not do so fully. Three important industrialized countries—
 Australia, New Zealand, and Sweden—did not. Japan and Switzerland were members of the MFA but did not maintain quotas under bilateral agreements as the MFA permits. Although importing countries have bilateral agreements with Taiwan and the Eastern European countries, most of these are outside the MFA. Therefore, trade from these countries would be restrained but not counted in the MFA-covered trade.
- EU preferential treatment agreements. As discussed in Chapter 7, the EU gives preferential treatment to Mediterranean basin countries and the ACP countries.

As noted earlier, only certain products from a country—those perceived to be a threat—are covered by restraints on an importing country. Therefore, as one might guess, a large proportion (often 70 percent or more) of the products exported by the major Asian suppliers were under quota restraints. In general, during the years the MFA was in effect, both the number of countries and the number of product categories subject to restraints increased. For example, U.S. quota restraints on China's textile and apparel products went from 13 categories under MFA II, to 59 under MFA III, to 66 under MFA IV. In many instances, exporting countries do not fully utilize all the quotas permitted; however, most Asian suppliers utilize their quotas fully or nearly so.

The impact of quota controls was demonstrated clearly by the results of the fiber coverage extension to include silk blends, linen, and ramie textiles in MFA IV in 1986. For example, in 1988, U.S. imports of products made of these previously uncontrolled fibers declined about 25 percent over the previous year. Similarly,

U.S. quotas have limited wool imports to a fairly constant level for many years.

The End of the MFA

For years, the exporting nations demanded to have the MFA eliminated and to have textile trade brought back under the normal rules of GATT. This was, in fact, a significant feature considered in the Uruguay Round multilateral trade negotiations. As in previous instances, the political drama associated with those negotiations was staged by a broad cast of international players and directors—all of whom had a great deal at stake in worldwide textile trade. The Uruguay Round, which brought an end to the MFA, is discussed later in this chapter.

ATTEMPTS TO CONTROL IMPORTS THROUGH THE LEGISLATIVE PROCESS

At times, the domestic textile and apparel industries became impatient with what they believed to be ineffective foreign policy approaches to control imported products. In several instances since 1970, industry groups shifted their energies away from international negotiations and have instead attempted to secure solutions through the U.S. legislative process. Believing the industry would not receive the protection from imports it wanted through negotiations with trading partners, producers sought legislation through Congress that would impose unilateral restrictions on imports. Discussions of the legislative approaches follow. These measures are significant in showing the political power of the U.S. textile and apparel industries. (For more detailed discussion on the legislative approach, see the two earlier editions of this book.)

The Mills Bill

In 1970, when the textile and apparel industries were distressed by the failure to secure a bilateral agreement with Japan, U.S. producers turned to Congress. Wilbur Mills, chairman of the House Ways and Means Committee, introduced a bill (H.R. 16920) to restrict apparel, textile, and footwear imports through the use of quotas. The bill would have limited 1970 imports to the 1967–1968 average and would have tied quota growth to changes in domestic consumption. The fiber, textile, and apparel coalition grew even stronger with the addition of the footwear industry.

The Mills bill passed the House of Representatives, and although it encountered difficulty in the Senate, the optimistic outlook for passage of the bill caused the Japanese to feel pressure to come to an agreement. Confident that the bill would pass, U.S. negotiators offended the Japanese with their demands, and talks collapsed. The bill did not pass; however, Mills tried to pursue a unilateral agreement with the Japanese on his own. Although the Japanese were receptive, President Nixon rejected the plan (Aggarwal, 1985; Destler, 1986; Destler et al., 1979).

The Textile and Apparel Trade Enforcement Act of 1985 (the Jenkins Bill)

The U.S. textile and apparel industries experienced a particularly difficult time during late 1984. Imports doubled, exports dropped, and the industry feared increased plant closings and job losses. Many of the countries that shipped textile and apparel products to U.S. markets were unwilling to open their markets to U.S. products. As a result of these circumstances, American manufacturers believed the U.S. government was giving little attention to domestic industry problems, and protectionist sentiment ran high, especially in textile-producing states.

Convinced that imports must be controlled through provisions stronger than those the MFA provided, industry supporters sought a legislative approach. In March 1985, Representative Edward Jenkins (a Democrat from Georgia) introduced H.R. 1562, the Textile and Apparel Trade Enforcement Act of 1985, which became known as the Jenkins bill. The bill would have replaced the existing system based on bilateral agreements with a unilaterally controlled import license program. Through this plan, U.S. sources would have controlled the imports permitted from a country by granting a license to ship a certain volume. Under the bilateral agreements, supplier nations at least have had a voice in designing the restraints. Furthermore, the Jenkins bill would have negated more than 30 bilateral agreements-which were in effect-that the United States had negotiated in good faith with trading partners.

The Jenkins bill included rollbacks of import levels from the major Asian supplier nations of about 30 percent, with lesser cuts for other developing nations. Again, the restraints were to be applied only to the developing countries.

A new industry coalition, the Fiber, Fabric and Apparel Coalition for Trade (FFACT), developed to promote passage of the Jenkins bill. The coalition was composed of fiber, textile, and apparel manufacturers plus labor groups. The industry provided widespread support—money, energy, and talent—to support the objective of FFACT: passage of the Jenkins bill. See Figure 10–7.

By this time, however, retailers had become an active lobbying force as well. Retailers and importers had become increasingly angry and outspoken over the textile and apparel industry's efforts to restrict imported products—products they wanted to obtain for their business. Retailers and importers formed their own coalition, the Retail Industry Trade Action Coalition (RITAC), to oppose the bill.

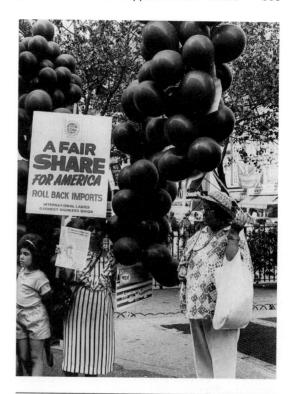

FIGURE 10-7

Textile and apparel workers demonstrated at both the national and local levels in an effort to garner support for the Jenkins bill.

Source: Photo courtesy of UNITE (formerly International Ladies' Garment Workers' Union).

The bill passed the House and the Senate. As expected, President Ronald Reagan vetoed the bill on December 17, 1985. Industry leaders vowed that the efforts to pass the bill were "a good fight that isn't over yet." The bill's supporters scheduled a veto override attempt for August 6, 1986—6 days after MFA III would expire. The strategy would provide additional pressure on U.S. negotiators to secure a "tight" MFA in the renewal. That is, the threat of an override would encourage U.S. negotiators to obtain as much protection as possible for the domestic industry; if not, the industry believed it would succeed in having adequate votes

(two-thirds of Congress) to override the veto of the bill. If the MFA renewal did not provide adequate protection to stem the import tide, supporters believed this would gather additional votes for the override. Negotiators were in a difficult plight. They knew they must come home with a tough package to satisfy the supporters of the Jenkins bill, yet they had to maintain the credibility of the Reagan administration's free trade policy ("Textile Trade," 1985, p. 2; Wightman, 1985a).

Although domestic textile and industry sources were dissatisfied with MFA IV, America's trading partners believed the United States had succeeded in getting its wishes on major points in the MFA renewal—particularly the extended fiber coverage. As promised, supporters introduced the Jenkins bill in Congress again in an attempt to override the presidential veto. The vote was only eight votes short of what supporters needed to overturn the veto. Industry supporters lost—but barely (Schwartz, 1986).

Support for the Jenkins bill attests to the political power of the U.S. textile and apparel industries at the time—that is, that the industry coalition could come close to having an act of Congress passed to protect it from foreign competition.

Needless to say, the Jenkins bill had few supporters abroad. The developing countries were angry over the heavy-handed approach it would represent if the bill passed. Not only would the United States be violating its GATT commitments, but it would also be abandoning trade agreements already signed and in operation to coordinate textile trade with more than 30 countries. Trading partners began to question the integrity of the United States in following through on its commitments. Even the EU and Canada, which were to receive preferential treatment under the bill, did not want it to pass. The protection the bill would have provided to U.S. markets would have diverted the developing countries' textile and apparel products to EU and Canadian markets.

The Textile and Apparel Trade Act of 1987

Early in 1987, congressional representatives from South Carolina introduced the Textile and Apparel Trade Act of 1987 (H.R. 1154). Like the Jenkins bill, this was a legislative approach for limiting textile and apparel imports; however, the strategies proposed for limiting imports differed from those of the earlier bill. Having failed to secure passage of the Jenkins bill, the sponsors of H.R. 1154 attempted to make the Textile and Apparel Trade Act of 1987 more acceptable, and possibly more attractive, to members of Congress and the constituencies to whom the senators and representatives answered.

The 1987 bill provided for comprehensive **global quotas** on imported textiles, apparel, and footwear based on actual 1986 volume. Global quotas set a limit on the total textile and apparel imports permitted into the country during a given period. Quota growth would be held to only 1 percent per year for textiles and apparel; footwear would be held at the 1986 level. This bill did not call for rollbacks in quotas, as the Jenkins bill had done; rather, it based growth rates on the 1986 import level.

The global quota approach would have included the EU and Canada, for the first time, in the import limits. This provision was included to overcome the criticism that the Jenkins bill had discriminated against developing countries. Further, proponents of the bill believed provisions of the 1987 bill were more compatible with GATT and MFA commitments. Opponents of the bill believed it to be more restrictive than the 1985 bill because of its comprehensive (global) nature. The EU was expected to retaliate by introducing additional restrictions to prohibit the diversion of lowwage textile and apparel imports from the United States to EU markets.

The 1987 bill suffered the same fate as the 1985 bill—it passed both the House and the Senate but was vetoed by President Reagan. In

an attempt to override the veto, the bill was only 11 House votes short.

The Textile, Apparel, and Footwear Act of 1990

The Textile, Apparel, and Footwear Act of 1990 was introduced in Congress in April 1990. The proposed bill, based on a global quota plan limiting textile and apparel import growth to 1 percent per year, resembled the 1987 textile bill. This bill would have overturned textile bilateral accords the United States had negotiated in good faith with 38 exporting nations.

Surprisingly, the American Apparel Manufacturers Association did not support this bill. This was the beginning of a significant division in the strong textile-apparel-labor coalition that had long stood united against imports. ¹⁰ For the first time, some apparel firms joined forces with retailers in opposing the measure.

The 1990 bill passed the House and Senate but was vetoed by President George Bush. The vote was only 10 votes shy of overriding the veto (Barrett, 1990a, 1990b, 1990c). Once again, the industry came amazingly close to succeeding in having a congressional bill passed to protect its interests. Although industry leaders and congressional supporters were disappointed by their defeat, they believed the show of support in Congress for the industry would send a strong message to the administration to protect textile interests in the Uruguay Round talks, which were looming as an even larger concern. U.S. industry leaders feared that the textile industry would be "sold out" in the GATT talks.

The override vote on the 1990 textile bill came as the United States sent troops to the Middle East for Operation Desert Storm—the Gulf War. The rapid troop deployment, along with the fact that previous camouflage uniforms were forest green rather than for a desert environment, meant that some troops were sent to the desert in forest-green uniforms. Although the industry had responded quickly, producing new fabrics and uniforms, the U.S. textile industry used this as an opportunity to sensitize the public-and policymakers—to the importance of the domestic industry in the nation's defense. One month prior to the override vote, the industry organized the largest rally in its history in Washington, D.C., around the Capitol. Some 3,000 textile and apparel workers carried Desert Storm uniform fabrics plus banners containing 250,000 signatures in support of the bill.

COMPREHENSIVE TRADE LEGISLATION: THE OMNIBUS TRADE BILL

In August 1988, after 4 years of debate, defeat, and revision, the U.S. Congress passed a generic trade bill—the Omnibus Trade and Competitiveness Act of 1988—designed to open foreign markets and bolster domestic industries. The 1,000-page bill was designed to reduce the growing U.S. trade deficit, which was a record \$170 billion the year prior to its passage. The overwhelming passage of the bill in the final vote (85 to 11 in the Senate and 376 to 45 in the House) indicated the increased sensitivity of Congress to trade concerns—which had come to be described as *competitiveness* concerns.

The omnibus bill was described as the most extensive revision of U.S. trade laws in 25 years. The bill took a strong unilateral approach to controlling trade, in contrast to the multilateral approach the United States had generally taken. Under this policy, the United States could tell trading partners how trade relationships would

¹⁰ In 1989, the American Apparel Manufacturers Association announced a new position on trade. As growing numbers of U. S. apparel firms engaged in offshore assembly operations, the assocation retreated from its strong antiimport position. Its chairman at the time indicated that another reason the association withdrew from the antiimport coalition was that U. S. apparel producers were having to rely increasingly on foreign sources of fabrics and other supplies (Hackett, 1990).

be defined rather than negotiating with other nations. The "muscle" of the omnibus bill was called the *Super 301 provision*, which permitted the United States to identify countries for a "301 list" if they appeared to have unfairly restricted markets. The Super 301 provision was intended to achieve reciprocal access to what the United States defined as unfairly restricted markets. Countries were to be warned if their trade practices appeared unfair, and the United States could retaliate by restricting *all* the products from that specific country if the other country did not improve its practices (Dicken, 1992).¹¹

A number of foreign trading partners were concerned over the passage of the omnibus bill. Some saw the bill as fulfilling mercantilist goals that place a high premium on exports as a source of national wealth and power. A number of U.S. trading partners felt pressured to lower their import barriers as the United States attempted to reduce its trade deficit. And, not surprisingly, major exporting nations did not willingly reduce their shipments to U.S. markets. Many countries were concerned that the bill permitted Washington to decide unilaterally what was fair and what was not (Farnsworth, 1988; Yates, 1988).

Many of the United States's trading partners believed that completion of the GATT Uruguay Round (to be discussed later) represented an end to the Super 301 protection. However, U.S. industry sources who wish to retain this powerful provision are not convinced that Super 301 is dead (author's confidential discussions with various sources).

MULTILATERAL TRADE NEGOTIATIONS

Following the establishment of GATT in 1948, seven *rounds* of multilateral trade negotiations (MTNs) have been held to reduce or eliminate tariffs (and, in some cases, nontariff barriers). Average tariff levels fell progressively and dramatically; see Figure 10–8. The MTN negotiations focus on all trade areas; however, textile and apparel products have secured special treatment in these agreements (for additional detail on these negotiations and textile and apparel trade, see earlier editions of this book). Some of the most widely known GATT MTN trade rounds are discussed next.

The Kennedy Round

In this round, named for President John Kennedy, who initiated the trade talks, 37 nations joined in making tariff (duty) reductions that covered about 80 percent of world trade—mostly on manufactured goods (agricultural products posed difficulty in negotiating tariff reductions). The United States, entering the talks under the authority of the Trade Expansion Act of 1962, reduced tariffs by about 30 percent on nearly two-thirds of its imports subject to duties. Most other industrialized countries also made major tariff reductions (Ellsworth & Leith, 1984; Mansfield, 1983).

It is important to remember that tariffs represent a form of protection against imports—although domestic manufacturers would say that tariffs do not provide effective protection. That is, tariffs add to the price of imports coming into a market, thus increasing prices and making the imported products somewhat less attractive in the importing market.

In general, textile and apparel products were given special treatment in the Kennedy Round. Although textile and apparel products carried some of the highest tariffs on any man-

¹¹ Dicken (1992) notes that the 1974 Trade Act contained a Section 301 clause that met GATT criteria for dealing with unfair trade practices in a specific industry. However, the 1988 omnibus bill transformed this into a strong *unilateral* measure. Dicken calls the 301 provision the "crowbar" of the omnibus bill (p. 170). Critical of the act, Bhagwati (1989) calls it the "'ominous' trade . . . act."

1972

Post-

Kennedy

Round

1987

Post-

Tokyo

Round

1994

Post-

Uruguay

Round

Reducing trade protection

Note: Tariff reductions are for all sectors

1962

Pre-

Kennedy

Round

FIGURE 10-8

1947

GATT's

establish-

ment

0

Tariff reductions resulting from major GATT rounds. *Source:* World Trade Organization, reprinted with permission from *WTO, World Trade Organization: Trading into the future,* 1995, p. 5.

ufactured products entering the developed countries prior to the Kennedy Round, *tariff reductions* were among the lowest for these product areas. That is, textiles and apparel were permitted to retain a high level of tariff protection.

Following the Trade Expansion Act and the Kennedy Round, many types of manufactured imports entered the U.S. market at a growing rate. Domestic industries began to press for measures to limit imports, fueling a shift toward protectionism. The textile and apparel sectors were among those industries, and the Long-Term Arrangement was a response to those concerns.

The Tokyo Round

The official U.S. stance on trade remained comparatively liberal in the early 1970s. In 1974 Congress passed the Trade Reform Act, which contained many provisions of the 1962 act but gave the president authority to make further tariff reductions under certain circumstances. The 1974 act provided for **trade adjustment assistance** to help workers, firms, and communities hurt by more liberal trade measures.

The 1974 act allowed the president to negotiate further tariff reductions; therefore, this act authorized U.S. participation in the Tokyo Round. The Tokyo Round occurred from 1973 to 1979, with more than 100 nations involved. This round focused on negotiation of additional tariff cuts, but the organizers considered the most important feature of these talks to be agreements governing the use of nontariff measures. **Nontariff barriers** include quotas, import licensing programs, technical standards (often contrived standards), and other measures to keep out foreign goods.

At the time of the Tokyo Round, as at the time of the Kennedy Round, textile and apparel tariff rates in the more-developed countries were among the highest for all manufactured goods. The textile fiber category was an exception. As in the Kennedy Round, the textile and apparel industries received more favorable treatment than other sectors.

One must also keep in mind that the Tokyo Round negotiations occurred shortly after implementation of the MFA. Although the Tokyo Round attempted to resolve the problems of nontariff barriers, it followed on the heels of a complex system—the MFA—that was designed to *permit* nontariff barriers, particularly in the form of quotas. Moreover, it was significant that even with the MFA in place, most textile and apparel product areas nevertheless received quite favorable treatment in the Tokyo Round of tariff cuts that followed.

Let's reflect for a moment on the contradictory sequence of events that we have covered. At the same time GATT was developing a special regime to restrict trade in textiles and apparel (the LTA and the MFA), it was also sponsoring the trade rounds to liberalize trade. Why would these seemingly contradictory events occur in this manner? The answer lies, for the most part, in the dilemma posed by world textile trade in most contexts. Because of the surplus global production capacity, the importance of the sectors to most nations, and the political aspects of textile and apparel trade, these sectors have continued to receive special attention. Often, the special provisions for textile and apparel trade have been developed to try to resolve the sector's trade problems and get them out of the way so that broader trade discussions will not be hampered by the difficulties posed by the textile and apparel sectors (author's discussions with global trade officials, 1983–1988).

The Uruguay Round

Trade ministers meeting in Punta del Este, Uruguay, in September 1986 launched a new round of trade talks aimed at strengthening GATT and expanding its coverage to new areas. Whereas the Kennedy and Tokyo Rounds focused especially on reductions of tariffs and nontariff barriers, planners sought to have the Uruguay Round rethink trade policy areas in general. Although most of the negotiations occurred in Geneva, this round of MTN talks was called the Uruguay Round.

Textile and apparel trade was involved in early controversy over whether a new round of trade talks would actually occur. The developing (exporting) countries chafed under the growing restrictions on textile and apparel products—a vitally important export area for most of the less-developed countries. Most of these countries made it clear that they would not proceed with the new round of trade talks unless trade restraints on their textile products

were lowered. U.S. negotiators refused to participate unless new areas of trade in services (such as banking and communications), high technology, and the problem of counterfeiting goods were included. Formal GATT sessions were canceled because of the deadlock between the United States and the developing countries. U.S. representatives hinted that the United States might withhold its \$3.4 million contribution to GATT's 1984 \$22.5 million budget. Finally, the deadlock was broken with promises to have several working parties and GATT studies commissioned to examine the issues prior to the trade talks (Callcott, 1984a, 1984b, 1984c; "Compromise," 1984; "3rd World," 1984).

As GATT representatives met in Uruguay to launch the MTN talks, U.S. negotiators found themselves in a difficult position. If they gave the developing countries too much encouragement on liberalizing textile and apparel trade, this would have increased the chances for the Jenkins bill's passage. Had the Jenkins bill passed, most textile trade officials expected that the MFA would have ended then. The MFA existed primarily to manage textile and apparel trade flow from the developing to the developed countries—particularly the United States and the EU. If either of these major players had withdrawn (perhaps to impose its own unilateral restraints, as in the case of the Jenkins bill), the Arrangement would not likely have continued. Without the MFA, textile trade problems would have escalated to such an extent that the MTN talks would have been unlikely. By the end of 1986, however, MFA IV was in effect, the Jenkins bill had failed, and the Uruguay Round was launched.

In December 1988, a ministerial meeting of the Uruguay Round (which was intended to mark the halfway point of the talks) was held in Montreal. Ministers from the 19 developing countries in the ITCB asserted that they were unwilling to continue participating in the broader MTN talks—unless problems related to the MFA were addressed in the Uruguay Round. The Third-World representa-

tives requested a clear timetable for the phaseout of the MFA restrictions and a reintegration of textiles back into the broader GATT rules. Representatives from the developed (importing) countries found it hard to agree to the demands. In fact, in a report made public at the beginning of the Montreal talks, a U.S. labor advisory committee recommended not only that the MFA be renewed when it expired in 1991, but also that it be more restrictive on imports. Textile discussions in the Montreal meeting ended in a stalemate (Dunn, 1988a, 1988b; Kryhul & Chute, 1988).

As the GATT talks dragged on, various countries offered different proposals for bringing textile trade back under mainstream GATT regulations. Most trading nations agreed to eventually phase out the MFA; however, several years and a great deal of emotion were invested in various proposals and the debates that followed (Chute, 1989b; "Further Trade Talks," 1989).

Deadline after deadline for completing the Uruguay Round passed, with little progress. Textile leaders in the importing nations were relieved when the talks stalled over agricultural and other issues.

Although the broader talks frequently ended unsuccessfully, the Negotiating Group on Textiles and Clothing continued to make progress. Eventually, a draft called the "Agreement on Textiles and Clothing" clarified that textile products would be integrated into GATT (and, consequently, quota restrictions eliminated) in three stages, but the group had difficulty in specifying the time frame and growth rates for each stage. Later, Arthur Dunkel, Director General of GATT at the time, released his own proposals on textile trade and other areas the negotiating groups could not resolve. The Dunkel plan met with a hostile response, however, from nearly all affected industry sectors (textiles, labor, and retailers/importers) in both the United States and the EU (GATT, 1992; "GATT Talks," 1991; Hurewitz, 1993; Ostroff, 1991a, 1991b, 1992b). Readers interested in a detailed, firsthand account of the textile negotiations should see *The Drafting History of the Agreement on Textiles and Clothing* (November 1995) by M. Raffaelli, chairman of the Textiles Surveillance Body, and T. Jenkins, assistant to the chairman.

The global trade talks lumbered along. At various points, when it appeared that an MFA phase-out might occur, textile industry supporters in the U.S. Congress indicated that if a phase-out were proposed, they would modify the agreement when it came to a vote of approval in Congress. Realizing the prospects for influence from many industries when the trade agreement was presented to Congress for approval, President Bush enlisted a cross section of industry leaders from many sectors to assist him by asking Congress to support his request for fast track authority for both the Uruguay Round and the efforts to secure a North American Free Trade Agreement. Bush was successful in getting this authorization. Fast track authority meant that Congress could only approve or disapprove the agreements; it could not amend them. The expectation was that the textile industry supporters would otherwise modify the agreement if they were dissatisfied with the outcome of the GATT talks, and that prospect was very likely ("Bush Asks," 1991). Support for the three textile bills had shown the strength of the textile lobby.

In December 1993, the Uruguay Round talks resumed once again. With troublesome issues still unresolved, many questioned whether the talks could be completed by December 15, when President Bill Clinton's fast track authority would expire. In early December, it was announced that U.S. tariffs on textiles would be reduced far less than had been proposed. (The negotiations had broken down 2 months earlier as the U.S. and EU teams reached a stalemate on tariff cuts.) The EU had demanded that U.S. tariffs on imported textiles be cut substantially. However, as a political payoff to the United States for granting the EU new concessions on farm subsidy levels, U.S.

tariffs on textile imports were to be cut only about 50 percent of what had been proposed (Zaracostas, 1993). This concession reflected similarities to the Kennedy and Tokyo Rounds discussed previously. The reader is reminded that if tariff levels on imports remain fairly high, the price for importers rises, making imports less attractive.

By the December 15 deadline, a landmark GATT accord was agreed upon—after 7 long years and to the surprise of many observers. The long-term negotiations had caused some critics to refer to the GATT as the "General Agreement to Talk and Talk."

The December 1993 textile agreement portion of the Uruguay Round was in large measure a modification of earlier drafts, begun first by the Negotiating Group on Textiles and modified by Dunkel. Although many of the MFA participants were not satisfied with the agreement, a general feeling existed that if Contracting Parties began to tinker with the compromise as it stood, all the progress up to that point would have unraveled (author's conversations with trade officials in Geneva, 1994; Raffaelli & Jenkins, 1995).

The Uruguay Round agreement represented a major change in the global trade environment for textiles and apparel. See Figure 10–9. The agreement called for a 10-year phaseout of the MFA. Under the Uruguay Round, each country's share of a textile-apparel import market, as represented by quotas, would increase once the new provisions took effect. A staged phase-out will occur until all quotas are eliminated at the end of 10 years. For a large number of developing countries, the expiration of the MFA on December 31, 1994, was seen as the single most important result of the Uruguay Round (because of the significance of textiles and apparel in their economies) (WTO Textiles Division, 1996b).

The World Trade Organization (WTO) was established January 1, 1995. WTO is the embodiment of the results of the Uruguay Round

and the successor to the GATT.¹² On this same date, a process began to bring textiles and apparel back into the mainstream of trade rules—that is, to **integrate** textiles back into those rules.

The Agreement on Textiles and Clothing

The Agreement on Textiles and Clothing (ATC) replaced the MFA on January 1, 1995, as the transitional instrument to provide the guidelines to integrate textiles and apparel into mainstream rules. In many respects, the ATC is an extension of the MFA for another 10 years. For example, former MFA quotas are continued until product categories are integrated. The ATC is very different from the MFA, however, in that some of the features of the MFA most objectionable to exporting nations were removed. Among these features, the ATC cannot be renewed. At the heart of the ATC is a carefully balanced transition program for the progressive integration of products over a 10year period and an increase for remaining quotas until they are removed (Bagchi, 1994; Hughes, 1995).

Under the ATC, two changes occur at each stage:

1. Integration of products to occur in three stages. The three-stage quota phase-out schedule for each importing country is based on the country's 1990 import volume and is to be carried out as shown in Table 10–1. Once products have been integrated into the mainstream trade rules—that is, removed from quotas—they cannot be brought under quota again.

¹²Although the WTO is a successor to "GATT 1947," GATT lives on as "GATT 1994," the amended and updated version of GATT 1947, which is an integral part of the WTO agreement and which continues to provide the key disciplines affecting international trade in goods (WTO, 1995). This will be discussed further in Chapter 11.

FIGURE 10–9
The Uruguay Round reduced the restraints on textile and apparel imports.

Source: Illustration by Dennis Murphy.

- 2. Identifying product categories to integrate. Each importing country chooses the quota categories that will be integrated. This means quotas will no longer exist on those product categories. Categories to be integrated must encompass products from *each* of the following groups (equal amounts from the groups are not required): tops and yarns, fabrics, made-up textile products, and
- apparel (GATT, 1994). Table 10–2 identifies the U.S. products chosen for integration at each stage. Countries were not required to specify products for all stages at the beginning of the 10-year period. The United States did so; the EU did not.
- **3.** Expanded quota growth rates. Remaining quotas are allowed to grow at higher rates than the typical 6 percent quota growth

TABLE 10–1The 10-Year Schedule for Integrating Textiles and Apparel into GATT Rules

Stage	% of Products to Be Integrated at Start of Stage (Based on 1990 Trade)	Expansion of Growth Rate for Remaining Quotas	Example of Quota Growth, (to Be Applied Annually), Based on 6% Rate Under Former MFA
Stage 1	16%	Existing growth rate	7%
Jan. 1, 1995,		× 16%	
(to Dec. 31, 1997)			
Stage 2	17%	Resulting growth rate	8.7%
Jan. 1, 1998,		of step 1 $ imes$ 25%	
(to Dec. 31, 2001)	100/	D	11.050/
Stage 3	18%	Resulting growth rate	11.05%
Jan. 1, 2002,		of step $2 \times 27\%$	
(to Dec. 31, 2004)	400/	Demoining quotes are eliminat	od
Stage 4	49%	Remaining quotas are eliminat	.eu
Full integration into			
GATT (and final			
elimination of quotas) (Jan. 1, 2005)			

Source: World Trade Organization. (1997, January). WTO Focus, No. 15, p. 23.

rates that existed under the MFA. This added quota growth is known as the **growth on growth** provision. This is also shown in Table 10–1. Additionally, Figure 10–10 illustrates how a typical MFA growth rate of 6 percent at the start of the phase-out in 1995 converts to an annual rate of nearly 11 percent during the final 3 years. A quota of 100 units compounds to 233 units in the final year (GATT, 1994; O'Day, 1994).

In addition to quota phase-outs and growth of remaining quotas, tariffs will be reduced on an annual basis. After 2005, only tariffs will remain. Figure 10–11 shows the tariff reductions resulting from the Uruguay Round. If a country is not a member of the WTO, then quotas may remain on that coun-

try's textile and apparel products. If, for example, China is not permitted to join the WTO by the year 2005, the United States, the EU, and Canada may continue to place quotas on China's products.

The ATC included a **safeguard mechanism** to be used during the phase-out period. If an importing country determines that imports are causing injury or a threat of injury to the domestic industry, that country will be permitted to impose restraints on the products *from a specific country* and *for a maximum of 3 years* or until those products are integrated into GATT, whichever comes earlier. Manufacturers in the importing countries see this provision as protection against being inundated by imports, but representatives of the developing exporting nations fear it will be abused by the developed

TABLE 10–2Staged Integration of U.S. Textile and Apparel Products

Stages (Integration Date)	Percent of 1990 Imports ^a	Major Products to Be Integrated
Stage 1 (Jan. 1, 1995)	16.21	Silk yarns, fabrics, and made-up textile products; certified hand-loomed fabrics; jute/bast fiber textiles and textile products; monofilament yarn; certified hand-loomed and -knotted rugs; certain coated fabrics; rubberized belts and hoses; plastic- and rubber-coated apparel and accessories; certain down-filled apparel; certain tents, tarpaulins, and sails; worn clothing; umbrellas; seat belts; and parachutes
Stage 2 (Jan. 1, 1998)	17.03	Baby garments; wool and manufactured fiber hosiery; down- filled coats; silk apparel; special-purpose fabrics; carpets and rugs; certain cordage and twine; manufactured staple fiber prepared for yarn spinning; parts of footwear; and cotton brassieres
Stage 3 (Jan. 1, 2002)	18.11	Cotton and manufactured fiber robes; cotton headwear; certain neckties; silk blend and vegetable fiber textile and apparel products; manufactured fiber brassieres; certain gloves; manufactured filament yarn and tow; glass fabric; curtains and drapes; knit fabrics; nonwoven fabrics; soft-sided luggage; table linens; and certain blankets
Stage 4 (Jan. 1, 2005)	48.65	Diapers; most cotton, manufactured fiber, and wool apparel; wool yarns and fabrics; most cotton and manufactured fiber fabric; bed linens; cotton pile towels; and cotton, wool and manufactured staple fiber yarns

^a In 1990, U.S. imports of products listed in the annex to the ATC totaled 17,025,193,817 square meter equivalents. Source: Federal Register. Compiled by Linda Shelton, U.S. Department of Commerce.

FIGURE 10-10

The effects of the "growth on growth" provision of the ATC. Source: O'Day, P. (1994). The U.S. manufactured fiber market under NAFTA and the WTO. (p. 11). Paper presented to the 33rd International Man-Made Fibres Congress, Dornbirn, Austria. Reprinted by permission of Paul O'Day and the American Fiber Manufacturers Association, Inc.

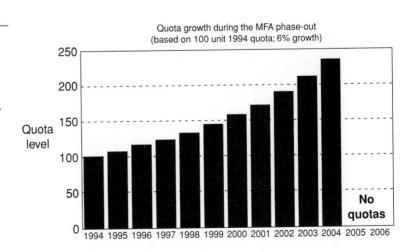

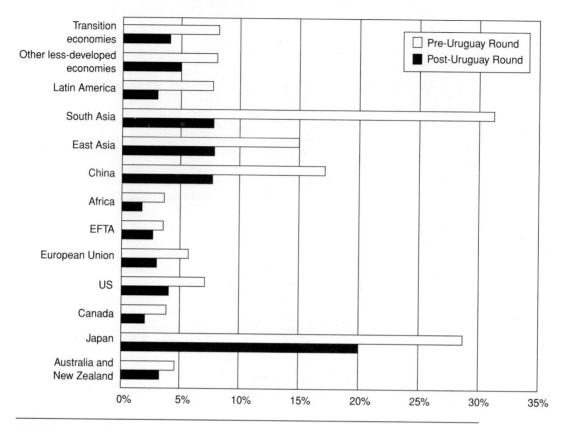

FIGURE 10-11

Tariffs before and after the Uruguay Round.

Source: Spinanger, Textile Asia, July 1995, c/o GPO Box 185, Hong Kong. Reprinted by permission of Textile Asia.

countries. In the first year, the United States invoked the safeguard provisions 24 times against 14 exporting developing countries. The developing countries believe this provision should be applied sparingly and contend that it had been invoked on weak grounds. Moreover, the United States was not successful in bringing some of these complaints before the **Textile Monitoring Body**, the group charged with overseeing the rules of the ATC (WTO, 1997; Ostroff, 1996).

Reflections on the Uruguay Round and the ATC

Although U.S. importers and retailers were pleased with the Uruguay Round textile and apparel agreement, textile leaders and supporters were not. Earlier, in an effort to secure the necessary votes to approve NAFTA, President Clinton had promised textile supporters in Congress that he would seek a 15-year phase-out of the MFA. Therefore, the textile group felt betrayed and believed the industry had been sold out—that is, used as

FIGURE 10-12

The U.S. textile industry has often believed that it is a pawn traded off for concessions in other areas by the government in efforts to secure trade agreements such as the Uruguay Round.

Source: Illustration by Dennis Murphy.

a pawn traded off for concessions in other areas by the administration in its eagerness to conclude the Uruguay Round. See Figure 10–12.

A number of informed individuals have noted, however, that the difference between the 15-year and 10-year phase-out is negligible because of the growth on growth provision. Compounded quota growth rates represent such dramatic increases in imports that by the end of 10 years, restraints will be minimal anyway (author's conversations with government sources and industry consultants in Washington, D.C., April 1994).

Additionally, U.S. textile leaders were angry that negotiators had not secured access to

certain other markets for U.S. exports. EU textile leaders had been vocal much earlier than U.S. leaders on the issue of **market access** (i.e., reciprocity). U.S. industry sources joined their European peers in arguing that if they were required to open their markets more fully to imported products, other countries should reciprocate. Market access was a particular concern for trade with India and Pakistan; both had pressed for the 10-year phase-out but were reluctant to open their markets to U.S. and EU textile products (Ostroff, 1993b).

A significant aspect of the implementing legislation had to do with the *process* for determining the product categories to be

"surrendered" during each stage of the phase-out. For example, the manufacturers wanted the one branch of government more supportive of their interests to be in charge; the retailers wanted a different agency they considered more objective to manage the phase-out. Industry groups were involved in considerable gamesmanship in determining which product categories to surrender. For example, textile industry supporters were successful in having nonquota products count in the categories to be surrendered in the first stage. A number of items containing textile materials that were not covered by the MFA were included, such as umbrellas, parachutes, safety belts, and garments for dolls. As Khanna noted, including non-MFA "junk" products "puts off the day of reckoning" (1994, p. 24). In fact, the January 1995 integration saw only one quota actually removed—a quota imposed on work gloves imported into Canada (1996).

By permitting the importing countries to count non-MFA and what Khanna termed "junk" products, the importing countriesparticularly the United States—surrendered very little to integration in the first 3 years. Similarly, during the next 4-year stage, U.S. quotas will be only marginally reduced. In the short term, the effect of integration will be only modest because the product categories surrendered will be those that are not import sensitive and not under quota control. By the 7th or 8th year, the impact of the MFA phase-out will be felt by many of the players involved. An even more substantial change will occur at the end of the 10th year, when the final 49 percent of textile and apparel trade will become quota free. By using the strategies to postpone the day of reckoning, the importing countries have, in fact, positioned themselves to experience an avalanche at the end of 10 years.

In short, the completion of the Uruguay Round—particularly the plan to phase out

FIGURE 10–13
On January 1, 2005, textile and apparel trade will be incorporated fully into mainstream trade rules.

the MFA—represented a climactic moment in the history of textile and apparel trade. For many exporting nations, it was a supreme victory; for protectionist forces in the importing countries, it represented difficult times ahead. Global trade for the sector would surely change radically from this point on. The rules of textile trade had been rewritten. From the year 2005 on, textile trade will comply with trade rules for all other sectors. See Figure 10–13.

Figure 10–14 provides an overview of major trade policies related to textiles and apparel over 40 years. (See Dickerson, 1996, for a review of these policies.) It is significant to note that even with quotas in place for much of this period, U.S. apparel import growth was significant. Although the import growth (in billions of dollars and SMEs) in Figure 10–14 is for apparel, the trend would be similar if textiles were included.

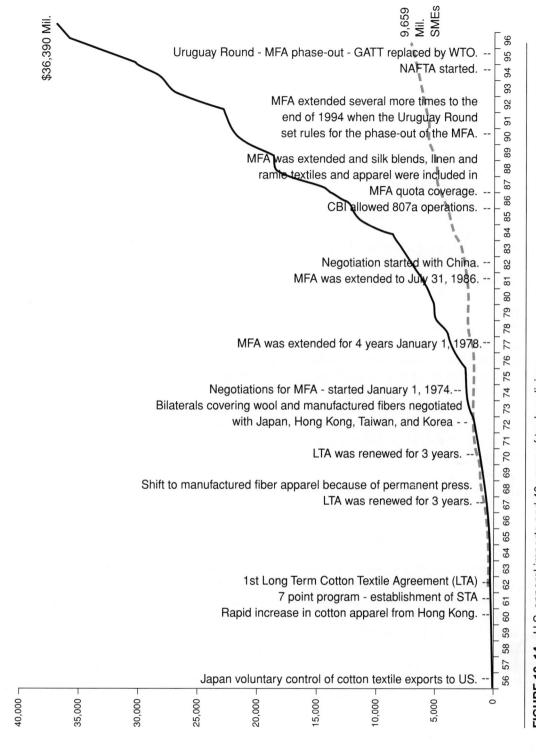

Source: Carl Priestland (1997), chief economist, American Apparel Manufacturers Association, Arlington, VA. Reprinted courtesy of C. Priestland. FIGURE 10-14 U.S. apparel imports and 40 years of trade policies.

GENERALIZED SYSTEM OF PREFERENCES

The generalized system of preferences (GSP) is a system of tariff preferences, agreed to by the OECD countries, designed to encourage the expansion of manufactured and semimanufactured exports from developing countries. In principle, the GSP allows products to enter developed-country markets duty free or at reduced rates of duty to give less-developed countries an advantage over suppliers not granted these tariff advantages.

In 1968, GATT accepted a GSP for developing countries as an exception to the nondiscrimination and MFN principles. The GSP was further legitimized by the Tokyo Round as a special provision to help the less-developed countries. In keeping with the global effort, the U.S. Congress authorized a 10-year GSP scheme under the Trade Act of 1974 (and later extended it under the Trade Act of 1984) to provide duty-free entry on 4,000 products from more than 130 countries.

Under the GSP, the country granting the tariff preferences has the right to determine the scope of the special treatment given, with the understanding that recipient countries may be required to meet certain conditions. The GSP was intended to help developing countries in sectors where they are not already strong exporters. Consequently, it is not surprising that most of the GSP exceptions are in the textile and apparel sectors because MFA products are not eligible for duty elimination under that program. Since most of the textile and apparel exporters from less-developed countries are quite competitive without the GSP benefits, this system has had little influence on the volume of exports in this sector from developing countries (OECD, 1983).

When the GSP was legitimized under the Tokyo Round, the agreement accepted the principle of **nonreciprocity** by the developing countries. That is, the developing countries were not required to reciprocate by making the same special concessions to the developed

countries so that the latter might have access to less-developed country markets. Under the GSP, the developing countries are permitted to use trade restrictions in order to achieve broader development objectives.

In talks to promote more liberal trade, a source of contention in the Uruguay Round was the developed countries' desire to see developing-country markets opened as well as their own. The industrialized countries have grown increasingly impatient with Third-World demands for greater access to the major importing markets while many less-developed countries are unwilling to reciprocate.

NORTH AMERICAN FREE TRADE AGREEMENT

In a first step toward more open markets in the Americas, the United States and Canada signed the Canada-U.S. Free Trade Agreement (CFTA), which became effective January 1, 1989. This agreement called for a gradual phasing out of all tariffs and quotas within 10 years. Although many textile and apparel leaders on both sides of the border were apprehensive about the impact of the agreement on their business, the industries in both Canada and the United States have benefited in general from the freer flow of trade ¹³

Under President George Bush's Enterprise for the Americas Initiative (EAI), the next logical step was the establishment of free trade among the three countries of North America—a North American Free Trade Agreement (NAFTA). President Salinas of Mexico was the instigator of these talks, however. The much-

¹³ For additional information on the development of the agreement, particularly in regard to the perspectives of both Canadian and U.S. textile/apparel manufacturers, retailers, consumers, and policymakers, see Wall and Dickerson (1989).

debated NAFTA accord became effective January 1, 1994, establishing one of the largest and richest markets in the world. As noted in Chapter 3, the three countries already had strong trade relationships before the agreement; NAFTA facilitated more trade—and trade with no (or few) restraints.

Although CFTA had been controversial at times, those discussions were placid compared to the political frenzy that surrounded the NAFTA debates. Pro-NAFTA and anti-NAFTA rallies were held at various sites around the United States.

In the United States, the potential problems of entering into a free trade agreement with a developing country (Mexico) caused the average citizen to be much more aware of these free trade discussions than had been true when only the United States and Canada were involved. Politicians who opposed NAFTA, particularly the former presidential candidate Ross Perot, became quite visible and vocal about potential job losses to a country where wages are a fraction of those in the United States and Canada.

In the final days before the vote in the House, when NAFTA might not otherwise have passed, President Clinton had to bargain hard to put together a majority vote. He did so "vote by vote—and interest group by interest group" until he obtained the necessary votes (Garland, Harbrecht, & Dunham, 1993, p. 35). In these bargaining rounds, congressional textile supporters were promised, in exchange for their votes for NAFTA, that the administration would seek a 15-year phase-out of the MFA rather than the proposed 10 years—in the GATT talks that soon would follow. (As we noted earlier in discussions on the Uruguay Round, textile supporters felt betrayed when the 15-year MFA phase-out was not achieved.)

Surprisingly, U.S. textile industry leaders, who generally *opposed* freer trade, were out front campaigning for NAFTA. Except for executives in a few firms, the textile industry saw free trade with Mexico as the opening of a

large market for their business. As we noted in Chapter 7, the textile mill products sector in Mexico was not well developed; therefore, Mexico represented a potential 25 percent market increase for U.S. textile producers. In an effort to offset concerns over possible U.S. job losses, board members of the American Textile Manufacturers Institute (ATMI) pledged that they would not move their jobs, plants, or facilities to Mexico. The forceful support of textile leaders for NAFTA swayed some members of Congress from the major textile-producing states to vote in favor of the agreement (Barrett, 1993).

Of concern to textile and apparel leaders during the NAFTA debate was the potential for Far Eastern shipments to enter the U.S. market by way of Mexico. In early stages of the negotiations, U.S. textile leaders were successful in gaining a yarn-forward provision (also called the **triple transformation** provision) that would require yarn, fabric, and apparel to have been made in North America to be eligible for free trade. That is, apparel products must have gone through three substantial transformations to qualify as having been produced in North America (National Retail Federation, 1993). The Canadian apparel industry opposed this provision because that sector sources more than 60 percent of its fabrics from other countries. In the United States, in the last days of bidding for undecided votes on NAFTA, President Clinton responded to U.S. manufacturers' continued concerns about Far Eastern transshipment to the United States through Mexico by pledging to strengthen the Customs Service to guard against such violations (Ostroff, 1993a).

Retailers and importers, hearty advocates of free trade, had actively campaigned for NAFTA and were ecstatic over the completed agreement. For them, NAFTA meant added options for buying merchandise and also, for many major chains, the prospects of more easily establishing stores in the Mexican market ("Execs Cheer," 1993).

NAFTA provisions for textiles and apparel take effect in stages. All apparel made from North American yarn and fabric (meeting the substantial transformation rules) was immediately excluded from quota restraints, except for certain suits and shirts that are subject to quotas in varying stages for 10 years. In addition, duties on these products were dropped immediately. In cases where market disruption occurs, quotas and duties may be reimposed on short notice. In addition to quota limitations on most apparel meeting NAFTA rules of origin, all garments made in Mexico under the U.S. 9802/807 and Special Regime programs can also enter the United States both duty and quota free. Limited imported products are permitted to qualify for free trade; these are generally goods not produced in North America. Once NAFTA was a reality, trade experts cautioned that it would take time for companies and their partners in the other countries—to learn the intricacies of the rules. The U.S. Customs Service would monitor shipments coming into the United States, being lenient at first but eventually imposing harsh penalties for offenders (Ostroff, 1993c).

In the end, trade policies such as NAFTA are implemented at the working level, and the impact varies. In all three NAFTA countries, the larger textile and apparel companies appear to be better prepared to face a free trade era than most smaller operations. Larger firms generally have better marketing networks, even within their respective countries, that can be expanded to include neighboring markets. Smaller companies are usually short-handed when it comes to marketing and management specialists who can access the differing economic, political, and cultural systems in other countries. Moreover, the smaller companies are more vulnerable to the competitive forces of business. In the free trade area, small operators compete with producers from three countries rather than one. Therefore, many momand-pop operations, particularly in Mexico, are being viewed as an "endangered species

under free trade" (Fairchild News Service, 1993, p. 5).

In summary, NAFTA represents a new era in trade for the three nations. All segments of the softgoods industry will be affected in profound ways as executives and their companies venture into new partnerships and other business endeavors with their North American neighbors.

SUMMARY

From its earliest beginnings in England, the textile industry has garnered special attention in trade matters. In England, other European countries, and the United States, textile production was usually the first, or one of the first, areas to be afforded special protection from products made in other countries. The industry's vital role in a country's economic development encouraged governments to raise barriers to imported products that might threaten the health of the nation's own industry.

Although England and the United States were the world's leading textile producers in the early 1900s, competitive conditions changed markedly during the Great Depression and thereafter. Japan became a major cotton exporter whose products posed a perceived threat to the more established industries in England and the United States. In the mid-1930s, the United States attempted to restrain Japanese cotton products, beginning a pattern that would continue. As additional textile supplier nations entered the global market, the growing competition fostered increasingly comprehensive and complex policies to deal with these trade problems.

Shortly after World War II, the General Agreement on Tariffs and Trade (GATT) became a force to liberalize world trade by reducing the restrictive barriers that had evolved. The problems of textile and apparel trade, however, taxed the GATT system. Soon,

GATT legitimized several exceptions to the agreement's normal rules to accommodate the problems of textile and apparel trade. First, the concept of *market disruption* altered the GATT ideals. Thereafter, GATT developed a series of special multilateral trade agreements to accommodate textile and apparel trade: the Short-Term Agreement (STA), the Long-Term Agreement (LTA), the original Multifiber Arrangement (MFA), MFA II, MFA III, and MFA IV. Significantly, all of these arrangements removed an important segment of world trade from GATT rules applicable to other sectors and established provisions counter to GATT principles to cover textile and apparel trade.

The MFA represented a compromise to mediate the different positions of the exporting countries (developing countries) and the importing countries (developed countries). As the MFA was a compromise solution, few actors were satisfied with it. The developing countries became increasingly vocal about what they believed to be unduly harsh restrictions on their textile and apparel products.

On several occasions, as U.S. textile and apparel manufacturers became impatient with what they perceived as the government's ineffectiveness in obtaining adequate measures to restrict imports from less-developed countries, producers sought a legislative solution. That is, the industry's supporters in Congress introduced bills to control imports unilaterally. These include the Mills bill in 1970, the Jenkins bill in 1985, the Textile and Apparel Trade Enforcement Act of 1987, and the Textile, Apparel, and Footwear Act of 1990. The last three were passed by both houses of Congress but were vetoed by the president. All three narrowly missed receiving enough votes to override a presidential veto.

Finally, two major multilateral trade negotiations (MTNs), the Kennedy Round and the Tokyo Round, provided special concessions on most textile and apparel products. As tariffs were being reduced for most manufactured goods, those on most textile/apparel

goods were reduced among the least for any product areas.

From the time the Uruguay Round was launched in 1986, textile trade was an issue as the developing exporting countries expressed frustration over growing restrictions on their textile and apparel products. One of their primary goals in this round of talks was to have textile trade brought back under normal GATT rules rather than "managed" under the MFA. For 7 years, the Uruguay Round talks moved slowly; one deadline after another passed with no resolution. Finally, on December 15, 1993, the Contracting Parties of GATT concluded the Uruguay Round, including plans to phase out the MFA over a 10-year period. Agreeing to phase out the MFA meant, in effect, rewriting the rules of world textile trade, replacing a system of managed trade that had begun with the STA in 1961.

When the World Trade Organization (WTO) was established on January 1, 1995, the Agreement on Textiles and Clothing (ATC) became the vehicle through which the MFA quota system would be dismantled over a 10-year period. Developed importing countries were disappointed to find that although they were expected to open their markets, some exporting nations were unwilling to reciprocate.

Another landmark trade agreement, the North American Free Trade Agreement (NAFTA), was signed in late 1993. Effective January 1, 1994, Canada, Mexico, and the United States entered into a free trade agreement that has begun to have a significant impact on the softgoods industry in North America.

GLOSSARY

Agreement on Textiles and Clothing (ATC) is the instrument under the WTO and GATT 1994 to oversee phase-out of the quota system for textiles and apparel.

Arrangement Regarding International Trade in Textiles (also known as the Multifiber Arrangement

[MFA]) was a general trade framework, also called a *regime*, under which textile and apparel trade occurred.

Bilateral agreements are agreements between two countries. Under the MFA, bilateral agreements spelled out the details for restrictions on textile and apparel trade between two countries.

Binding tariffs means that a tariff level for a particular product becomes a commitment (i.e., "bound") of a WTO member and cannot be increased without compensation negotiations with

its main trading partners.

"Burden sharing" refers to the distribution of less-developed country textile and apparel imports among the developed countries. The industrialized countries were aware of the responsibility for assisting the less-developed countries in their development—which required giving them access to their markets. Problems arose as developed countries concerned themselves about whether peer nations were sharing equally in the "burden."

"Call" mechanism or consultation call was a U.S. government provision under the MFA to restrict imports from a country in a category not already under quota restraints.

Canada-U.S. Free Trade Agreement (CFTA) removed tariffs and quotas on Canada-U.S. trade over the 10-year period that began January 1, 1989; a predecessor to NAFTA.

Category is a textile/apparel product or aggregation of similar products for import control purposes. That is, limitations on imported textile and apparel products have been placed on specific categories. Examples include the following: women's cotton woven blouses, men's wool trousers, and boys' manufactured fiber knit shirts. Several thousand types of textile and apparel products are grouped into major categories.

Circumvention refers to activities that bypass quota limits on shipments. The most common form occurs when a country with a limited quota transships products through another country with an available quota. According to technical GATT interpretation, this is the *only* activity considered circumvention. However, in common usage, circumvention often has a broader meaning. It also includes misrepresentation of the product to avoid quota limitations. Examples include giv-

ing an inaccurate item count or mislabeling the fiber content/product category of merchandise, which affects the quota category under which products are imported.

Countervailing duties are added duties levied on an imported good to offset subsidies to producers or exporters of that good in the exporting country. GATT rules permit these duties if material injury to the importing country's producers occurs.

Discriminatory restrictions are trade restraints that discriminate against some countries but not others—as permitted under the MFA. That is, limits are imposed on products from some countries and not on those from others.

Exporting countries are the supplier nations. Although most countries export certain goods, in textile and apparel trade the term exporting countries refers to the NICs and the low-wage developing nations whose textile/apparel industries are exported largely to the industrialized countries.

Fast track authority is a provision whereby trade agreements or other bills that come before Congress may be either approved or disapproved but cannot be amended.

Fiber, Fabric and Apparel Coalition for Trade (FFACT) was a textile and apparel industry and labor coalition formed in 1985 to fight for legislation to restrict imports.

Free trade or liberalized trade refers to trade without restrictions such as tariffs, quotas, and VERs.

Generalized System of Preferences (GSP) is a system of tariff preferences designed to encourage the expansion of manufactured and semimanufactured exports from developing countries.

Global quotas represented a limit on the total textile and apparel imports from all sources combined permitted to enter country during a specific period of time.

Growth on growth refers to the provision of the Uruguay Round Agreement on Textiles and Clothing, which requires additional growth for products still under quota over and above the typical 6 percent quota growth rates that exist under the MFA.

Harmonized Tariff Schedule is a system of tariff classification that replaced the Tariff Schedule of the United States (TSUS) in 1989. The new system, which applies to more than 5,000 overall categories of products, has a standardized six-digit

international code used by all participating trading nations known as the *Harmonized System*.

Import substitution is an effort by a country to encourage substitution of domestic products for previously imported goods. It may be promoted by the government, particularly if the country is encouraging development of its industry.

Importing countries are the recipients of textile and apparel products from exporting countries. Although most countries import certain goods, in textile and apparel trade the term importing countries refers to the developed nations, whose markets are attractive to supplier nations.

Infant industry protection refers to temporary protection (in the form of tariffs or nontariff barriers) to help establish an industry and foster its competitiveness in world markets.

Integration refers to returning textile products to the general rules that apply to all other trade. Under the Agreement on Textiles and Clothing (ATC), importing nations must select a portion of textile imports (by Harmonized System product categories) to be returned to mainstream trade rules. Products that are integrated will no longer have quotas on imports.

Market access is the term used during the Uruguay Round negotiations to refer to the importing countries' desire for reciprocity. That is, the developed countries believed that if they are required to open their markets more freely to the developing exporting countries' textile and apparel products, the developed countries should also have an opportunity to ship to the developing countries. Market access was one of the most contentious issues in negotiations over the MFA phase-out.

Market disruption was a term embraced under GATT (originally in 1959–1960), specifically for textile problems, which fostered the following exceptions to GATT fundamentals: discrimination against a particular country, permitting a potential increase in imports to justify added restrictions and allowing price differences to justify import restrictions when disruption of domestic markets was occurring or threatened.

Minimum viable production allows a country to restrict textile imports on the grounds that it must preserve a certain basic level of production capability for potential domestic defense needs.

Most favored nation (MFN) treatment occurs when one country agrees to give another country the same trade concessions it grants to any other MFN recipients. For example, goods from a country accorded MFN status by the United States would be assessed lower tariffs in the U.S. tariff schedule. The concept may apply to nontariff measures as well. WTO members have agreed to give each other MFN status. Preferential treatment accorded to developing countries, customs unions, and free trade areas all represent allowable exceptions to the MFN concept.

Multilateral agreements are agreements among many countries.

Nonreciprocity has been an accepted principle under GATT whereby the developing countries have not been required to offer fully reciprocal concessions. In general, under GATT provisions, nations extend comparable concessions to each other, but the nonreciprocity principle permits the less-developed countries to impose trade restrictions on products from other countries.

Nontariff barriers are measures other than tariffs imposed by governments that restrict imports, with or without the intent to do so. Examples are quotas, import licensing, labeling requirements, and technical standards.

Protection or protectionism refers to a government's efforts to limit or exclude those imports that compete with the country's own production.

Quota flexibility refers to the degree of variation permitted under the MFA and bilateral agreements in the physical volume of products that can be shipped in the aggregate, in group ceilings, and in categories with specific limits. Flexibility includes swing, carryover, and carry forward (AAMA, 1980).

Regime or international regime is a set of governing arrangements that affect relationships of interdependence among countries. The Multifiber Arrangement was considered an international regime.

Retail Industry Trade Action Coalition (RITAC) was a coalition of retailers and importers formed in 1985 to oppose trade restraints, particularly on textiles and apparel.

Rules of origin are laws, regulations, and administrative practices that are applied to ascribe a country of origin to goods in international trade. The U.S. rules of origin for textile and apparel trade

were modified in 1984 to prevent transshipment and again in 1996 to prevent outward processing by Asian NIC firms.

Safeguard mechanism is a provision of the Uruguay Round ATC to be used during the phase-out or transition period. It permits an importing country to impose restraints on products if that government believes imports are causing serious damage or the threat of serious damage to the domestic industry. The importing country is permitted to impose restraints on products from a specific country and for a maximum of 3 years or until those products are integrated into mainstream trade rules.

Surge is a sharp increase in imports from a country from 1 year to the next, usually in specific product areas. Domestic manufacturers consider surges disruptive to markets.

Tariffs are taxes on imported goods; tariffs are also known as *import duties*. Often, tariffs are designed to protect domestic producers from for-

eign competition.

Trade adjustment assistance is funding granted under the U.S. trade acts to those individuals and firms proven to have suffered injury as a result of the U.S. government's policies to promote freer trade. Firms that are "certified" as having suffered injury may obtain technical and financial assistance. Individuals who lose their jobs may obtain compensation, retraining, and, at times, relocation at government expense.

Triple transformation or triple rule of origin is another way of stating the yarn-forward provision of NAFTA. Apparel, for example, must have undergone three substantial transformations (i.e., yarn processing, fabric formation, and apparel assembly) to qualify as having been produced in

North America.

Unilateral restraints are restrictions imposed by one

country against another.

Voluntary export restraints (VER), also known as voluntary restraint agreements (VRAs), are agreements in which an exporting country agrees to limit exports so that the importing country will not formally impose quotas, tariffs, or other import controls. VERs are referred to euphemistically as "voluntary," but they are not truly voluntary; they are in fact quotas.

Yarn-forward provision is a facet of the NAFTA accord that requires textile and apparel products to be made of North American components "from the yarn forward" to qualify for free trade. The intent of this provision is to require the use of North American intermediate inputs. Also see *triple transformation*.

SUGGESTED READINGS

Aggarwal, V. (1985). Liberal protectionism: The international politics of organized textile trade. Berkeley, CA: University of California Press.

A study of the evolution of the international regime for textile trade (through the 1981 MFA renewal), including the political and economic factors affecting regime development and change.

Bagchi, S. (1994, December). The integration of the textile trade into GATT. *Journal of World Trade*,

28(6), 31–42.

A review of major issues related to the MFA phase-out and return of textile trade to the mainstream; written by the executive director of the International Textiles and Clothing Bureau (ITCB) in Geneva.

Blokker, N. (1989). *International regulation of world trade in textiles*. Dordrecht, the Netherlands: Martinus Nijhoff.

A study of international textile trade policies from a legal perspective.

Brandis, B. (1982). *The making of textile trade policy,* 1935–1981. Washington, DC: American Textile Manufacturers Institute.

An industry-sponsored review of the development of textile trade policies.

Choi, Y., Chung, H., & Marian, N. (1985). *The Multi-Fiber Arrangement in theory and practice*. London: Frances Pinter Ltd.

A review of the MFA developed by representatives for the developing-country exporters of textile and apparel products.

Cline, W. (1990). The future of world trade in textiles and apparel (revised edition). Washington, DC: Institute for International Economics.

This study, an update of Cline's earlier work, analyzes the costs and benefits of MFA phase-out plans for different countries and groups.

Cortes, C., & Tulloch, C. (translator). (1997). *GATT,* WTO and the regulation of international trade in textiles. Aldershot, UK: Dartmouth Publishing.

- A study of some of the legal aspects of textile trade policy under GATT and WTO.
- Dickerson, K. (1996). Textile trade: The GATT exception. St. John's Journal of Legal Commentary, 11(2), 393–429.

A review of special trade policies under GATT textile and apparel trade.

- Friman, H. R. (1990). Patchwork protectionism: Textile trade policy in the United States, Japan, and West Germany. Ithaca: NY: Cornell University Press. A study of protectionist policies using a comparative analysis of U.S., Japanese, and German textile trade policies.
- General Agreement on Tariffs and Trade. (1984, July). *Textiles and clothing in the world economy.* Geneva: Author.

A GATT analysis of textile trade policies.

- General Agreement on Tariffs and Trade. (1994). Agreement on textiles and clothing, MTN/FA/Corr. 8. Final Act Embodying the Results of the Uruguay Round of Multilateral Trade Negotiations. Geneva: Author.
 - The textile and apparel section of the Uruguay Round agreement spells out the terms of phase-out of the MFA and other matters pertaining to trade for the sector.
- Hamilton, C. (Ed.). (1990). The Uruguay Round: Textiles trade and the developing countries. Washington, DC: World Bank.
 - A collection of papers from academic researchers, textile experts, and negotiators addressing the effects of the MFA on the trade of developing countries.
- Hughes, R. (1995). The Uruguay Round: New approach for the textiles and clothing sector. *ITC International Trade Forum*, 4, 4–29.
 - An excellent summary of new trade provisions for textiles resulting from the Uruguay Round; written by the counselor of the WTO Textiles Division.
- Hurewitz, L. (1993). *The GATT Uruguay Round: A negotiating history* (1986–1992): *Textiles.* Deventer, the Netherlands: Kluwer Law and Taxation Publishers.
 - A negotiating history of the textiles portion of the Uruguay Round through 1992.

- Keesing, D., & Wolf, M. (1980). Textile quotas against developing countries. London: Trade Policy Research Center.
 - An early work on controversial aspects of the textile quota system.
- Khanna, S. (1991). *International trade in textiles: MFA quotas and a developing exporting country.* New Delhi: SAGE.
 - A case study in India of the effects of the MFA on developing countries.
- Martin, W., & Winters, L. (Eds.). (1995). The Uruguay Round and the developing economies. Washington, DC: World Bank.

A review of the implications of the Uruguay Round for the less-developed countries.

- Raffaelli, M., & Jenkins, T. (1995). *The drafting history of the Agreement on Textiles and Clothing*. Geneva: International Textiles and Clothing Bureau.
 - A definitive, firsthand report on the negotiation process and the provisions of the ATC written by key players in GATT textiles policy areas.
- Silbertson, Z., & Ledic, M. (1989). The future of the Multi-fiber Arrangement: Implications for the UK economy. London: Her Majesty's Stationery Office. An evaluation of the effects of the MFA on the U.K. economy; however, the conclusions are helpful for textile and apparel trade more broadly.
- Sweet, M. (1994, February). Recent trade treaties likely to stimulate continuing changes in global sourcing of apparel. *Industry, Trade, and Technology Review* (published by the U.S. International Trade Commission), 1–8.
 - Implications of NAFTA and the Uruguay Round for apparel sourcing.
- United States International Trade Commission. (1978). *The history and current status of the Multi-fiber Arrangement.* (USITC Pub. No. 850) Washington, DC: Author.
 - A review of the historical development of U.S. textile trade policies and an overview of the implementation of the Multifiber Arrangement.
- World Trade Organization. (1995). WTO (World Trade Organization): Trading into the future. Geneva: Author. An overview of the WTO and provisions added to GATT 1994 as a result of the Uruguay Round.

11

Structures for Facilitating and "Managing" Textile and Apparel Trade

As global textile and apparel production and trade became increasingly competitive and difficult, a number of unique trade policies and other provisions evolved to provide special treatment for the problems of trade in these sectors. Chapter 10 provided an overview of the development of the major textile and apparel trade policies.

The complex system of textile and apparel trade policies has required an equally complex array of structures for the implementation of those policies. The term *structure* is being used generically to include organizations, networks, and other systems associated with the development and implementation of textile and apparel trade policies. Most of these structures are devoted to operationalizing the existing textile trade policies at global and national levels; however, in a few cases the organizations we will consider are devoted to the dismantling of those trade policies. In short, a great many entities are involved in textile trade matters. See Figure 11–1.

In this chapter, we will examine various structures associated with textile and apparel trade policies (those that develop and implement the policies, as well as those that seek to dismantle them). We will consider these structures at both the international and national lev-

els, with primary emphasis on the United States. We will review both the official governmental structures and those of **special interest groups**. Although the return of textile and apparel to mainstream WTO trade rules will change or eliminate some of them, these structures are expected to remain in place well past the turn of the century.

A discussion of all the organizations involved in textile and apparel trade would be too lengthy. Therefore, key organizations and structures are presented, with the acknowledgment that many worthwhile efforts cannot be included.

STRUCTURES AT THE INTERNATIONAL LEVEL

Official Governmental Structures

The World Trade Organization

When the Uruguay Round was signed in December 1993, the agreement included the establishment of the World Trade Organization (WTO). The WTO is the successor to GATT 1947 and embodies GATT 1994, which provides the key disciplines (rules) for interna-

FIGURE 11-1

The number of players involved in textile trade matters may bring to mind the old adage that "too many cooks spoil the broth." *Source:* Illustration by Dennis Murphy.

tional trade. WTO provides a permanent forum to address new issues facing the international trading system (Figure 11–2).

WTO implements the trade agreements reached in the Uruguay Round by bringing all agreements under one institutional umbrella. The WTO extends and refines the responsibilities that were under GATT by covering more areas of trade. This organization has greatly increased powers to set rules and resolve problems in international trade disputes. In the past, GATT was often criticized for lacking real power to resolve trade disputes.

Two new areas are covered by the WTO that previously were not covered by GATT. In addition to covering traditional trade areas of agriculture and manufactured products, the WTO's responsibilities include trade in (1) services and (2) trade-related intellectual property rights (TRIPs).

Until the establishment of the WTO, GATT was the principal international structure concerned with trade, which, of course, included textile and apparel trade. Although textile and apparel trade provisions were (and still are, during the phase-out of the quota system)

atypical, they occurred as a GATT-sponsored exception to the General Agreement.

As we learned in the previous chapter, the trade policies that evolved for textiles and apparel under the auspices of GATT represented a significant departure from the rules that apply to other sectors. In effect, textile and apparel trade was singled out from the general principles of GATT and given a special regime of its own. Initially, special trade rules for textiles and apparel were justified for the following reasons: (1) the challenge presented by low-cost imports was unique to textiles and apparel, and (2) the production and employment in those industries were seen as critical to the importing countries' overall economic activity (GATT, 1984).

Since 1961, multilateral arrangements negotiated under the auspices of GATT provided a framework for regulating textile and apparel trade. First came the Short-Term Arrangement Regarding International Trade in Cotton Textiles (STA) and the Long-Term Arrangement Regarding International Trade in Cotton Textiles. These were followed in 1974 by the Multifiber Arrangement (MFA), which was renewed six

times (three of those were extensions of MFA IV). Under the MFA, textile trading nations negotiated bilateral agreements that partially regulated the flow of textile and apparel imports from exporting countries to the importing markets. On January 1, 1995, when the WTO began operations, the MFA ended and the Agreement on Textiles and Clothing (ATC) became the instrument to oversee the 10-year phase-out of the quota system.

Logically, it follows that the special policies for textile and apparel trade have required unique structures to implement those arrangements. Within the WTO, one division exists specifically to deal with textile and apparel trade issues: the Textiles Division. Another body, the Textiles Monitoring Body, is charged with supervising the implementation of the WTO textile agreement.

The Textiles Division

The Textiles Division, previously the Special Projects Division under GATT, is the only division that exists to handle trade matters for *a specific sector*, other than one for agriculture.

FIGURE 11-2

Headquarters of the World Trade Organization (WTO), formerly the General Agreement on Tariffs and Trade (GATT), Centre William Rappard, in Geneva, Switzerland. Source: Photo courtesy of WTO.

The Textiles Division manages a wide range of concerns related to textile and apparel trade. An important role of this division is to service the Textiles Monitoring Body (to be discussed in the following section). Additionally, the division services ad hoc committees concerned with textile trade matters.

Prior to the agreement to phase out the MFA, this division also serviced the Textiles Committee, consisting of representatives of the more than 40 parties (the EU was considered as *one* party) of the Arrangement. Since the Textiles Committee was the MFA's political forum for evaluating its effectiveness and considering renewals, the committee was eliminated as the MFA phase-out began (author's personal communication with GATT sources, 1986, 1988, 1994).

Textiles Monitoring Body

In the Uruguay Round negotiations to bring textile trade back under mainstream trade rules, the ATC called for a Textiles Monitoring Body (TMB) to be established. The purpose of this body is to supervise the implementation of the agreements, to handle disputes, and to conduct a major review before the end of each stage in the integration process.

The TMB replaces the Textiles Surveillance Body (TSB), which was established by an article in the MFA and operated until WTO began and the ATC replaced the MFA. The TSB was a "multilateral surveillance institution to supervise the implementation" of the MFA (GATT, 1984, p. 75). The TSB was responsible for ensuring that all bilateral agreements were consistent with the MFA, and handled all routine problems and complaints related to textile and apparel trade under the MFA. In effect, the TMB assumes many of the same functions of the TSB.

If two or more trading nations have a dispute regarding textile trade, they may bring their problem before the TMB for dispute resolution. Although the TMB cannot force any

party to comply with its recommendations, efforts are made to resolve problems. Findings of the TMB are not binding if a member country considers itself unable to conform to the organization's recommendations. After extended deliberations, if a matter is still not resolved, the member may bring the matter before the Council for Trade in Goods or the Dispute Settlement Body.

The TMB is composed of 10 members, as shown in Figure 11–3. The membership is structured to provide a variety of perspectives on textile and apparel trade. Members rotate at appropriate intervals. Although TMB members come from the national delegations, individuals are expected to function as impartial participants rather than serving their own nation's interests. The group works in strict confidentiality, which encourages countries to share data and makes it easier for members to move from a national position to one of consensus (WTO, 1996c).

Other International Organizations

A number of international organizations may become involved in specific aspects of textile and apparel trade. Two examples are:

1. The United Nations Conference on Trade and Development (UNCTAD), whose main offices are in Geneva, is part of the United Nations framework. Its aim is to further the interests of the developing countries in matters related to their economic development, including trade aspects. UNCTAD has followed international trade in textiles and has long opposed the restrictions on textile and apparel products. UNCTAD was instrumental in the establishment of a separate organization of developing exporting countries, the International Textiles and Clothing Bureau, which focuses specifically on textile/apparel trade concerns. UNCTAD remains.

Chairman Ambassador Andraś Szepesi

1	Latin American and Caribbean members		
	India Egypt/ Morocco/ Tunisia		
	Hong Kong South Korea		
	Pakistan Macau		
	ASEAN		
	Turkey Switzerland Czech Republic/ Hungary/ Poland/ Romania/ Slovak Republic		
	Japan		
	Canada Norway		
	United		
	European Union		

Where multiple countries are shown, the countries rotate in representing that group.

FIGURE 11-3

The WTO Monitoring Body, as constituted in October 1997. Source: Author's communication with WTO staff, 1997.

- however, an important trade forum for the LDCs.
- **2.** The International Labour Office (ILO), also located in Geneva and under the United Nations, conducts research on global production and trade shifts for various sectors, including several related to textiles and apparel. Studies focus on international labor standards, working conditions, employment and development, shifts in comparative advantage, and other topics relevant to the global textile and apparel sectors. The ILO Textiles Committee focuses on timely issues related to textile and apparel employment, working conditions, training, workers' rights, and similar issues related to work in the industry. As controversy over sweatshops and child labor became major issues, the ILO Textiles staff actively assessed these issues and made recommendations (personal communication with ILO staff, 1994-1997).
- 3. The International Trade Center (ITC), also located in Geneva, is jointly under the United Nations system and the WTO. The primary role of the ITC is to assist developing countries in their trade promotion efforts. This includes developing national trade promotion strategies, working with national governments to establish institutions and services within the country to facilitate exporting, and helping countries find export markets for their products (personal communication with ITC staff, various dates).
- **4.** The Organization for Economic Cooperation and Development (OECD), located in Paris, conducts research and publishes studies on various aspects of the textile and apparel sectors from time to time as part of the ongoing work programs cited in Chapter 3.

National Missions

Since WTO headquarters (as well as many other important international organizations)

are in Geneva, most countries that are members of the WTO have diplomatic representations (typically called *missions*) in that city. Within each mission, the size and backgrounds of the staff who represent trade interests vary a great deal. Usually the major industrialized nations have fairly large, specialized staffs, while many of the less-developed nations have limited staff to represent all of the country's interests.

The U.S. Trade Ambassador to the WTO (who is Deputy U.S. Trade Representative) is located in a separate office in Geneva. Rita D. Hayes, who had a distinguished career as a textile official, holds this position. See Figure 11–4. Several staff members handle specific trade issues. William Tagliani, U.S. Trade Attaché, handles textile trade matters along with trade for other sectors. See Figure 11–5. Tagliani receives policy guidance and technical support as necessary from U.S. government agencies in Washington, D.C.

Special Interest Groups

The International Textiles and Clothing Bureau

In the mid-1980s, the International Textiles and Clothing Bureau (ITCB) developed as a result of earlier efforts by exporting countries to form a coalition to oppose increasing restraints on their textile and apparel exports. Now a formal organization recognized by the Swiss government, the ITCB coordinates the interests of approximately 20 textile/apparel-exporting nations. The ITCB has been the strongest force representing the interests of the developing countries in dismantling the MFA. The organization is supported by member governments that contribute according to the percentage of import markets taken by that country (if Country X supplies 15 percent of the textile and apparel market in the importing countries [combined], then Country X provides 15 percent of the ITCB's budget) (personal communication with S. Bagchi, 1988).

FIGURE 11-4

Rita D. Hayes is the U.S. Trade ambassador to the WTO. Steeped in textile policy, Ms. Hayes has served as chairman of CITA and as Chief U.S. Textile Negotiator.

Source: Photo by Kitty Dickerson.

The ITCB provides a forum in which member countries can become more fully informed on textile and apparel trade matters, particularly since a number of the members do not have specialized trade assistance. ITCB members share information and exchange views to become more informed individually and collectively. Skeptical of data provided by their more-developed country trading partners, ITCB staff conduct a certain amount of research on their own. Finally, the ITCB provides members an opportunity to speak with a unified voice on trade matters (personal communication with S. Bagchi, 1988, 1994).

One of the ITCB's primary efforts was to work for the elimination of the MFA. Very early in the Uruguay Round discussions, the ITCB submitted a strong statement to the Negotiating Group for Textiles and Clothing,

FIGURE 11-5

The U.S. official who handles textile trade matters in Geneva is William Tagliani, U.S. Trade Attaché. Mr. Tagliani works closely with government agencies in Washington.

Source: Photo by USTR staff.

which, in effect, said that the original intent of the MFA had been far exceeded. The ITCB noted, "the Arrangement and subsidiary bilateral agreements have become increasingly restrictive in extent and intensity, accentuating the discriminatory character of the existing trade regime in textiles." The statement added, "exports of textiles and clothing of developing

FIGURE 11–6
Sanjoy Bagchi, retired Executive Director of the International Textiles and Clothing Bureau (ITCB), led exporting nations in the efforts to insist that textile trade be returned to mainstream trade rules. Source: Photo by Kitty Dickerson.

countries have been subject to discriminatory restrictions which have imposed intolerable burdens on their economies" (International Textiles and Clothing Bureau, 1988, pp. 1, 2).

International Industry Federations

The following are federations of industry associations from member countries. These federations include both importing and exporting

nations as members; therefore, these groups do not take positions on trade. The federations provide an opportunity for industry leaders to establish international networks and to consider matters of common concern to the industries in member nations. In many respects, these federations provide opportunities to build relationships among representatives of countries that may otherwise be at odds over textile and apparel trade problems.

INTERNATIONAL APPAREL FEDERATION. The International Apparel Federation (IAF) includes the national apparel associations of nearly 40 countries (counting the EU member countries separately). The American Apparel Manufacturers Association, for example, represents the United States in this federation. IAF headquarters are located in London.

INTERNATIONAL TEXTILE MANUFACTURERS FEDERATION. Like IAF, the International Textile Manufacturers Federation (ITMF) includes national associations from member countries. For example, the American Textile Manufacturers Institute represents the United States in the ITMF. This federation's headquarters are in Zurich, Switzerland.

RETAILING. No international federation appears to exist for retailing. Instead, activities are coordinated through national and regional retail groups.

STRUCTURES AT THE NATIONAL LEVEL: THE UNITED STATES

Official Governmental Structures

At this juncture, as we begin discussion on structures for facilitating and managing trade at the U.S. government level, a review of the international structures and of how U.S. policies and structures relate to them will be helpful. Figure 11–7 provides an overview of these relationships.

FIGURE 11–7 Structures for the U.S. textile import control program in relation to the international program.

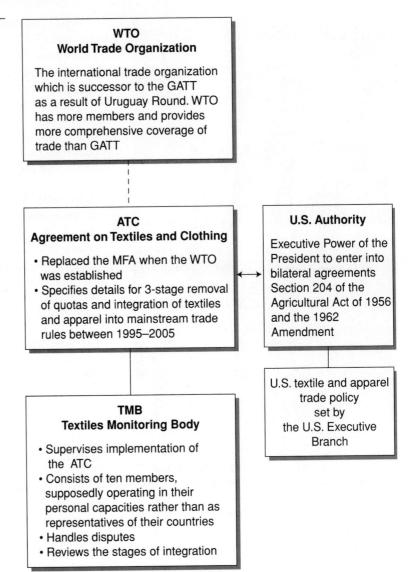

Figure 11–7 reviews the hierarchy of WTO bodies under which the ATC is administered. At this point, it is appropriate to consider how the U.S. system meshes with functions at the international level. To begin, we shall consider the two portions of Figure 11–7 not covered previously.

Section 204 of the Agricultural Act

Although this provision may seem an oddity in present-day textile trade policies, it was quite significant to U.S. involvement in global textile policies. This provision was the cornerstone of U.S. participation in the MFA and the quota system that is being phased out under the ATC.

BOX 11-1

SECTION 204 OF THE AGRICULTURAL ACT

U.S. authority for establishing textile quotas was extended when the Agricultural Act of 1956 was amended in June 1962, to provide

that the President may, whenever he determines such action appropriate, negotiate with representatives of foreign governments in an effort to obtain agreements limiting the export from such countries and the importation into the United States of any agricultural commodity or product manufactured therefrom or textiles or textile products, and the President is authorized to issue regulations governing the entry or withdrawal from warehouse of any

such commodity, product, textiles, or textile products to carry out any such agreement. In addition, if a multi-lateral agreement has been or shall be concluded under the authority of this section among countries accounting for a significant part of world trade in the articles with respect to which the agreement was concluded, the President may also issue, in order to carry out such an agreement, regulations governing the entry or withdrawal from warehouse of the same articles which are the products of countries not parties to the agreement. (Brandis, 1982, pp. 22–23; original source: U.S. Code Annotated, Title 7, Sec. 1854)

In the 1950s, when cotton was the primary fiber in both U.S. production and the growing volume of imports, U.S. textile industry advocates sought relief (or protection, depending upon one's perspective) from imports under Section 22 of the Agricultural Adjustment Act. That provision authorized the president to impose import fees or quotas to restrict imports of agricultural commodities (or the products thereof) if those imports interfered with U.S. agricultural programs. Although several textile industry efforts to secure special assistance under Section 22 failed, a provision in the Agricultural Act of 1956 (Section 204), which established cotton export subsidies, also authorized textile import quotas. This act authorized the negotiation of bilateral agreements; the first one negotiated was the 1957 5-year agreement with Japan. Section 204 of the Agricultural Act of 1956 was amended in June 1962 to extend U.S. textile quota authority even further.

Although the original focus was on cotton textiles, consistent with an agricultural policy, textile industry proponents were able to secure coverage for all textiles, regardless of fiber. Moreover, it is the 1962 amendment that permits the United States to apply *unilateral restraints* on imports from any country that is not part of a multilateral agreement. In contrast to the MFA, which permitted unilateral restraints against countries that were parties to the MFA, Section 204 of the Agricultural Act permits unilateral restraints by the United States against countries that have not been parties to the MFA quota system (AAMA, 1980).

In 1980, for example, the United States imposed unilateral restraints on seven apparel categories from China under Section 204 of the Agricultural Act. At that time China was not a participant in the MFA. After China became a participant, the United States negotiated bilateral agreements with the Chinese to limit textile and apparel shipments. Later, as the WTO came into effect, China was included in the ATC provisions. However, if China is not a WTO member by the end of the quota phaseout period (the year 2005), the United States is likely to continue to impose quotas on Chinese

textiles and apparel. In another instance, Section 204 of the Agricultural Act has provided the basis for the U.S. bilateral agreements with Taiwan, which is not a member of GATT/WTO and the former MFA quota system.

U.S. Executive Branch

U.S. textile and apparel trade policy is set by the executive branch. Although the president has the power to set trade policy, the United States Trade Representative (USTR) is the chief official—with cabinet-level and ambassadorial rank—responsible for representing the president in coordinating U.S. foreign trade matters. The USTR coordinates and represents the U.S. position in international trade negotiations. The USTR designation also refers to the White House office, which the representative heads.

The Chief U.S. Textile Negotiator (and assistants) are located within the USTR complex. Significantly, the textile and apparel sector is the only one with its own institutionalized negotiator within USTR (Samolis & Emrich, 1986).

We have discussed the linkage of the U.S. textile and apparel trade structures to those at the international level. At this point, we will focus more specifically on the structures and mechanisms within the United States devoted to managing textile and apparel trade interests. Figure 11–8 displays major U.S. structures that provide liaison with international authority. A brief discussion follows.

Committee for the Implementation of Textile Agreements

The Committee for the Implementation of Textile Agreements (CITA) carries out the day-to-day operations of the U.S. textile and apparel import control program. CITA is an interagency committee, chaired by the Deputy Assistant Secretary of Commerce for Textiles, Apparel, and Consumer Goods, the top textile official at the U.S. Department of Commerce.

Most of CITA's daily work is handled by Commerce personnel. CITA agencies are as follows:

- The United States Trade Representative
 (USTR) is responsible for trade policies.
 USTR is represented in CITA because the textile negotiations are handled by that agency's staff. Moreover, it is important to coordinate CITA's work with USTR's broader trade policy efforts.
- The U.S. Department of State (DOS) represents the broader diplomatic interests of the country. That is, if textile trade policies endanger political relationships, the DOS provides a diplomatic perspective to balance the pressures that may be exerted by domestic special interest groups.
- The U.S. Department of Commerce (DOC) represents U.S. commercial interests. The DOC, perhaps more than any other cabinet-level structure, is concerned about the economic health and international competitiveness of U.S. industries. Therefore, the DOC representative in CITA may have more of an industry-advocacy stance than others.
- The U.S. Department of the Treasury (DOT) represents a free-trade perspective within the CITA group. The U.S. Customs Service is under the DOT.
- The U.S. Department of Labor (DOL)
 represents the interests of domestic labor.
 The DOL provides input on trade policies
 that may affect the U.S. workforce.

As Figure 11–8 illustrates, CITA receives information from a number of sources. The U.S. Customs Service controls the entry of products under quota agreements; therefore, Customs works closely with CITA. The Department of Commerce's Office of Textiles and Apparel (OTEXA) is the central office within the government responsible for monitoring trade and tracking each category from each controlled country.

Although quotas are technically being phased out, the United States requested 26

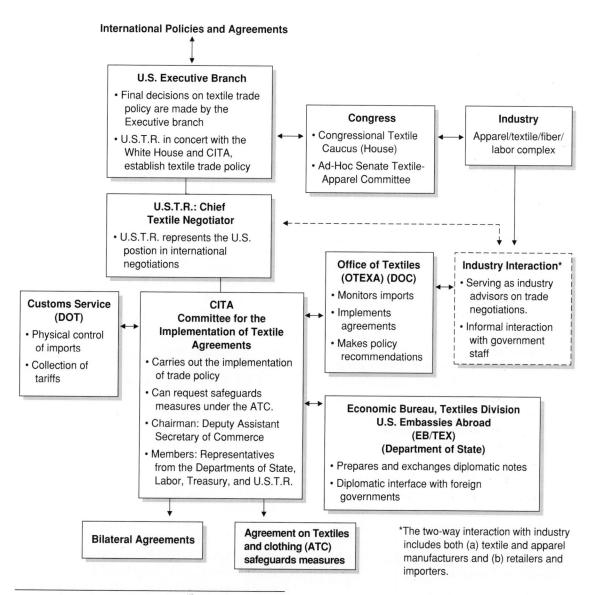

FIGURE 11–8
Structures for the U.S. textile import control program.

consultations on products during the first stage of the ATC, using the "safeguards" measure that permits consultations if the domestic industry is believed to be injured by imports. In these cases, OTEXA does the work and may make recommendations; however, CITA makes determinations of market disruption for actions taken under the ATC (previously the MFA) and Section 204 of the Agricultural Act. Once CITA makes a decision, a cable is sent to notify the foreign government of CITA's decision. That country is then given a period of time in which to respond before action is taken. Efforts of OTEXA will be discussed in greater detail in sections that follow.

A study by the General Accounting Office (GAO) reported that the CITA process was generally adequate but that actions were weighted somewhat toward protecting the domestic industry (Davidson et al., 1986). We must remember, however, that this was the purpose of the textile import control program, of which CITA is a key part. Long the bane of importers and retailers for setting quotas on foreign-made textile goods, CITA came under attack in the mid-1990s. Reporting on an updated GAO study, CNN newscasters described CITA as "a little-known but very powerful government agency . . . that operates with an unusual degree of autonomy." Rep. Dick Chrysler (R-Michigan) described CITA as "acting like a federal lobbyist for the textile industry" (Emert, 1995, p. 21). CITA survived the review, due in part to strong support from textile advocates in Congress.

U.S. Congress

The U.S. Congress plays an important role in influencing textile trade policy. This may occur through passage of trade legislation or in more informal ways. As Figure 11–8 indicates, the industry has input into congressional activities. This occurs primarily through the **Congressional Textile Caucus**, a group of nearly 90 members of Congress who are supportive of textile and apparel trade interests. As might be

expected, most members of the Textile Caucus are from states in which textile and apparel production contributes significantly to the economy and to employment. Former Caucus Chairman Rep. Derrick Butler (R-SC) noted, "The mission of the Caucus is to promote the textile, apparel, and fiber industries across the country" (LaRussa, 1989b, p. 15).

The bipartisan Textile Caucus has been quite influential, boasting among its members many powerful leaders of both the Senate and the House. Members of the Textile Caucus were instrumental in introducing and promoting the Jenkins bill, the 1987 textile bill, and the 1990 textile bill in Congress. In addition, the caucus represents industry concerns on other matters that may affect U.S. textile and apparel interests; examples include the NAFTA accord and legislation pertaining to the CBI.

The Office of Textiles and Apparel

OTEXA has the largest concentration of government staff devoted to textile and apparel trade matters. As part of the DOC International Trade Administration, OTEXA has a specialized staff who coordinate a variety of functions related to trade in the sector. Figure 11–9 displays the major divisions within OTEXA. A brief discussion of the functions of each follows.

INDUSTRY ASSESSMENT DIVISION. The Industry Assessment Division (IAD) compiles and monitors data (originated elsewhere) on production and employment in the U.S. textile complex. This unit groups production data to conform to the import category system so that the two can be compared. One of the primary concerns is the impact of imports on the domestic industries. Data on domestic industry performance are reviewed to assess the impact that imports may have on the U.S. industry. Another function of the IAD is to interpret movements within the industries and to assess change in the competitive status of the U.S. textile and apparel industries.

BOX 11-2

THE HARMONIZED SYSTEM

The Harmonized Tariff Schedule is a system of tariff classification that went into effect in the United States in January 1989 as part of an international effort, the Harmonized System (HS), to develop a similar system used by trading nations that choose to participate. The HS was implemented to facilitate foreign trade and to standardize, to a degree, the collection and use of trade data. In the United States, the HS replaces the Tariff Schedule of the United States (TSUS).

The new system, which applies to more than 5,000 overall categories of products, has a standardized six-digit international code used by all trading nations to designate the same merchandise classifications. Textile and apparel products account for the largest number of categories for any single trade area—a reflection of the sensitive nature of international trade in textiles and apparel. The HS categories have precise descriptions for products, which are used by customs officials to monitor product shipments.

The HS brought about several substantial changes in U.S. tariff treatment of imported textile and apparel products. For example:

- Prior to HS, products were classified on the basis of the *chief value* of the fibers in the article. The HS classification is determined on the basis of the *chief weight* of the fibers. Under HS, a 60/40 cotton/linen blouse is classified as cotton, although the linen component may be of more value.
- The metric system is used for all measurements—length, weight, and so on.
- The concept of *ornamentation* is no longer considered under HS. Tariffs were higher for ornamented items under the prior system.
- Sizing classifications changed, particularly in certain infants' and children's categories.

Both exporters in the producing country and U.S. importers were responsible for adapting shipments to the new system or risk having merchandise embargoed by the U.S. Customs Service.

Note: The reader may view the HS category system in detail on the OTEXA Web site (http://otexa.ita.doc.gov).

FIGURE 11-9

Organizational structure of the U.S. Department of Commerce Office of Textiles and Apparel (OTEXA).

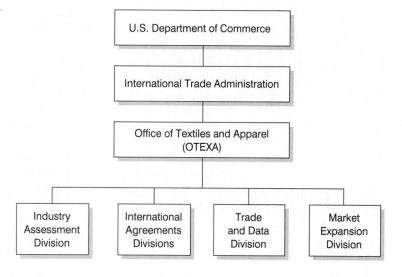

INTERNATIONAL AGREEMENTS DIVISION. The International Agreements Division (AD) has not only provided preparation for negotiating bilateral agreements but has also played an important role in the actual negotiations. Within this division are country specialists who are intensely familiar with U.S. textile and apparel trade with various countries. During negotiations on a bilateral agreement with a particular country, the AD country specialists who know the status of quota categories and shipments help to determine allowable levels of imports to be permitted under new agreements (personal communications with R. Levin, 1994). Now that quotas are being phased out under the ATC, few new agreements are being negotiated; thus the work of this division has been greatly reduced. The AD would have been involved in negotiations with China, a notable exception.

TRADE AND DATA DIVISION. The Trade and Data Division (T&DD) recommends and implements trade classification schemes to carry out the ATC and bilateral textile agreements, initiates and participates in fraud and transshipment investigations, participates in negotiations and consultations related to free trade agreements and WTO agreements, and brings investigation issues to CITA. This division ensures import data quality by reviewing the data, identifying problems, and working with the Census Bureau and the U.S. Customs Service. The T&DD conducts data investigations with foreign governments and helps those governments to resolve differences in data, handles visa matters, obtains descriptions and samples of imported textile and apparel products, and operates the Textile Information Management System (TIMS), a computer textile data system (personal communication with P. Martello, 1994).

MARKET EXPANSION DIVISION. The Market Expansion Division is geared to assist U.S. textile and apparel manufacturers in expanding their markets to other countries. This division

organizes trade missions and international trade fairs for U.S. producers, develops market analysis studies to help U.S. manufacturers better understand specific foreign markets and their potential for success in those markets, and serves in a general advisory capacity to domestic producers who seek to export.

The U.S. International Trade Commission

The U.S. International Trade Commission (USITC) was established in 1916 as the U.S. Tariff Commission. It was created to monitor trade, provide economic analysis, and make recommendations to the president in cases of unfair trade practices. The ITC responds to Congress the Senate Finance Committee and the House Ways and Means Committee, in particular and to the executive branch through the Office of the USTR. The special status of USITC removes its activities, to some extent, from the political pressures of special interest groups. Interest groups such as trade associations, however, may petition to investigate the trade practices of other countries to determine whether "material harm" has resulted from imports or other trade concerns.

Although USITC's responsibilities include wide product coverage, this agency's Textiles and Apparel Branch focuses specifically on trade issues pertaining to these product areas. When concern arises regarding the material harm (essentially "market disruption") caused by imports to certain segments of the domestic textile, apparel, or leather products industries, this division is responsible for investigating those claims. In addition, this division conducts and publishes studies on the U.S. textile, apparel, and leather products industries, as well as on the production in competing nations (particularly exporting nations). For example, in 1997, following concerns that textile trade from Sub-Saharan Africa would have a negative impact on the U.S. industry, USITC's Textile and Apparel Branch conducted an exten-

BOX 11-3

U.S. CUSTOMS' HEADACHE: CIRCUMVENTION

One of the most troublesome trends for the major importing countries has been the efforts of firms in certain exporting nations to bypass the quota system by misrepresenting merchandise. In common usage of the term, *circumvention* includes (1) misrepresenting the *country of origin by transshipping* textile and apparel goods to the importing markets by way of a third country with available quota or (2) misrepresenting *product identity in other ways* (*item count, fiber content, type of product*) to affect the quota category under which merchandise is imported. Technically, GATT sources consider only the first activity to be circumvention (conversation with GATT sources, 1994).

Widespread circumvention, particularly on the part of China, has angered many U.S. manufacturers and government officials involved in textile trade. Even the Congressional Textile Caucus planned to draft a bill to deal with transshipment. The U.S. Customs Service estimated that China illegally transshipped more than \$2 billion worth of textiles and apparel to the United States annually in recent years through some 40 third-party countries or territories that disguise the country of origin. In response to these activities, in late 1993 the U.S. government

enacted measures to strengthen enforcement of transshipping. These included (1) inspecting factories in other countries and (2) inserting a circumvention provision in all bilateral agreements negotiated (Emert, 1993b; Jacobs, 1993a).

The U.S. Customs Service was authorized to force foreign countries to allow inspection teams to visit their factories. The intent of this provision was to determine if production was occurring in countries from which products were being shipped. Although the 1993 policies strengthened Customs' authority to make inspections, similar efforts had occurred, to a degree, earlier. In 1991, for example, inspection teams found that the tiny city-state of Macau had only a fraction of the ability to produce all the merchandise shipped from there, and virtually everything being shipped in certain categories was found to be of Chinese origin. The conclusion was that Macau did not produce enough products to require such extensive quota; therefore, Macau's U.S. quota was reduced. Pakistan's quotas in some categories were reduced because of transshipping. Moreover, China's quotas have suffered chargebacks (i.e., reducing a year's quota by the amount overshipped).

sive study and found no evidence that the U.S. industry would be affected.

U.S. Customs Service

The U.S. Customs Service is responsible for processing imported goods coming into the U.S. market. The primary duties of Customs are making sure that proper tariffs are paid on imports and, for textiles and apparel, that the proper goods are admitted in proper quantities. In other words, the U.S. Customs Service, on instructions from the head of CITA and

through a visa system, is responsible for scrutinizing shipments of imports from around the world as they enter the United States and for monitoring compliance with trade agreements and other regulations. The United States can determine whether its trading partners are complying with bilateral agreements only to the extent that shipments are monitored by the Customs Service.

Customs may embargo products shipped to the United States. For example, China has often shipped more textile goods than quotas permitted; therefore, shipments that arrive after quotas are filled for relevant product categories for the year are embargoed and placed in bonded warehouses until the start of a new quota year. Such embargoed goods create difficulty for retailers expecting merchandise for seasonal promotions.

Although the U.S. Customs Service processes imports of all products from around the world, officials regard textile and apparel imports as among the most difficult. First, U.S. imports of textile and apparel products account for several million Customs entries each year. More critically, however, the complex system of import restraints on textile and apparel products has taxed the Customs Service's capacity for monitoring shipments to the degree the domestic industry would like. To put this task in proper perspective, one must consider that more than 5,000 types of products are grouped into categories for import control purposes, and nearly 200 countries produce textile products for world markets. Although not all countries ship products in all categories to the United States, and many that are shipped do not pose a concern to the domestic industry. Therefore, only a portion of all U.S. textile and apparel imports are under quota restraints. However, monitoring shipments at varying category levels from a large number of countries is a mammoth task.

Furthermore, the Customs Service is charged with monitoring fraudulent shipments (falsified paperwork), transshipments, mislabeled products (fiber content, care, country of origin), counterfeit trademarks and copyrights, and various other illegal practices. In 1987, for example, the U.S. Customs Commissioner reported that more than half of the 1,000 textile visas shipped from China that had been checked by inspectors turned out to be counterfeit (Honigsbaum, 1987b).

Monitoring shipments of counterfeit luxury items and well-established trademark goods is also a challenging task for the U.S. Customs Service. According to reports, the importing of phony designer goods into the United States

has mushroomed in recent years. Counterfeit products include everything from fake Louis Vuitton handbags and luggage, Cartier and Rolex watches, Gucci bags, Chanel fragrances and accessories, Tiffany products, and Hermes scarves to Ray Ban sunglasses. Other products often counterfeited are jeans, athletic footwear, merchandise with the logos of hot brands, and well-known athletic team apparel. The International Chamber of Commerce, based in Paris, estimates that worldwide counterfeit trade in all types of goods is a \$70-billion-dollar-a-year business. A group exists to help companies fight counterfeiting of their products. The Washington, DC-based International Anti-Counterfeiting Coalition (IACC) estimates that counterfeit goods can cost apparel makers an average of 2 percent of their total annual sales. The U.S. Customs Service and firms whose products are being "knocked off" have been aided by at least one state, New York, that has passed laws to deal seriously with the counterfeit trade. In November 1992, the sale and manufacturing of counterfeit products in New York State changed from a misdemeanor to a felony if the value of the confiscated goods exceeds \$3,000. Very high fines and prison sentences accompany highervalued product confiscations (Feitelberg, 1996; Meadus, 1992; Ozzard & Feitelbert, 1996).

Similarly, the Customs Modernization and Informed Compliance Act (the so-called Mod Act), which became effective in December 1993, imposes harsh fines for misrepresented import shipments. The new act is the most extensive revision of the U.S. Customs regulations in decades. Attached to the implementing legislation for NAFTA, the Mod Act permits the fining of importing firms up to \$100,000 for failure to give the Customs Service documents for postentry audits. The intent is to prevent importers (or their import brokers) from misstating the value or origin of goods and then claiming that the incriminating documents were lost or accidentally destroyed. The Mod Act gives the Customs Service a stronger "enforcement weapon." The fines are part of a new system to make importers more accountable for complying with trade laws. At the same time, U.S. Customs is required to work with businesses closely and to be sure they understand the regulations. Importers are first advised of possible concerns about their transactions and are then given an opportunity to resolve the problems within the company before Customs begins an investigation. To implement this act, the top 1,000 importing firms—which account for 61 percent of the value of all imports entered-have received most attention from Customs' 400 auditors. The customs process is faster and simpler than before for importers with well-documented recordkeeping and compliance systems. Companies with poor systems receive extra scrutiny from Customs personnel (Emert, 1993a; Jacobs, 1996).

In addition, the U.S. Customs Service has established a sophisticated multi-million-dollar computer system with ties to all American ports and to a large number of import brokers. This system, known as the Automated Commercial System, permits tracking of import shipments and eliminates the painstaking documentation of cargo by hand. The system is able to select "high-risk" shipments for examination—based on stored data on the importer's reputation, the country of origin of the merchandise, the manufacturer of the products, and the type of merchandise being imported.

In late 1993, the U.S. Customs Service began trial use of a new electronic visa information system (known as *ELVIS*) intended to facilitate faster processing of imported textile and apparel shipments through Customs. The electronic transmission of visa information from a foreign government to the U.S. Customs Service may replace paper visas from a number of countries if the system proves satisfactory and is accepted by industry sources. The ELVIS system has the potential to reduce the heavy paperwork burden that textile and apparel

shipments represent for the U.S. Customs Service (Jacobs, 1993b).

Figure 11–10 provides a simplified overview of the steps through which textile and apparel products under import quota restraint (1) originate in the exporting country, (2) are processed through the U.S. Customs Service, and (3) later reach U.S. consumer markets.

Tariffs are levied on the imported products, with the importer being responsible for payment of the tariffs. However, tariffs are passed on to consumers, who pay these added "taxes" in the higher price of goods purchased. Tariffs on textile and apparel products vary by type of item, but most are relatively high compared to those on other products.

Figure 11–11 provides an added explanation of the steps that occur as merchandise is processed through U.S. Customs; this diagram may be helpful in understanding the involvement of other government agencies.

Embassies for Other Countries Located in Washington

A number of the textile-exporting nations that have a great deal at stake in textile and apparel trade have trade counselors or other officials in their Washington embassies to attend to textile interests. In some cases, these individuals are quite familiar with textile trade and interact with U.S. officials themselves. In other cases, foreign embassy officials secure-with the support of their home governments-the services of Washington lobbyists to represent their textile trade interests in interacting with the U.S. government. In recent years, when a number of textile-exporting nations have been especially concerned over tightened restrictions in the U.S. market (e.g., during debates over the three textile bills), a number of these countries worked together to fight against further restrictions. These representatives from textile-exporting nations employed U.S. lobbyists to represent their countries' textile/apparel interests.

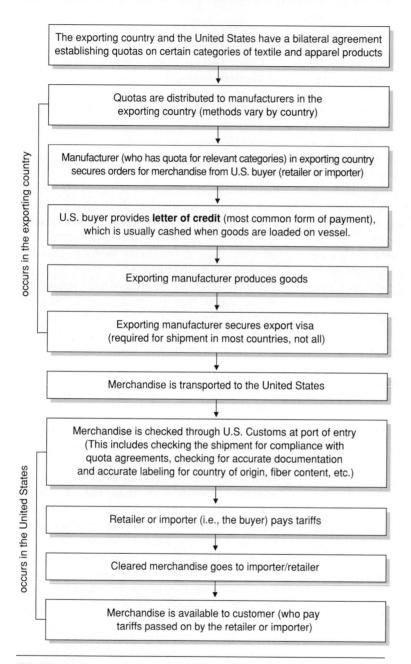

FIGURE 11–10

Simplified flow chart for textile and apparel products entering the United States under import restraints.

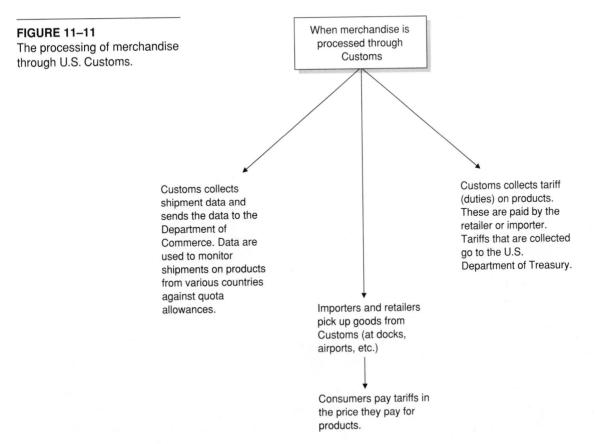

Special Interest Groups

Although many other import groups are involved in representing various perspectives in the textile trade dilemma, space permits discussion of only those that are more comprehensive in membership and scope and are among the most influential in trade matters. Because of their roles in representing the interests of their constituencies in the policymaking arena, the following organizations either are located in Washington or have offices in Washington. These organizations serve members in a variety of roles—such as providing educational services to members, acting as spokespersons for members on a host of subjects, and coordinating other in-

dustry activities. In recent years, however, textile and apparel trade concerns have demanded increasing time and energy from most of these groups.

American Textile Manufacturers Institute

The American Textile Manufacturers Institute (ATMI) represents manufacturers primarily in the textile mill products industry. Of the industry associations, ATMI is one of the strongest and most influential. With offices in Washington, the ATMI staff assists association members in establishing and maintaining a strong presence in Congress and in other areas in which textile trade policy is considered.

American Fiber Manufacturers Association

The American Fiber Manufacturers Association (AFMA) (formerly the Man-Made Fiber Producers Association) represents the producers of manufactured fibers—both artificial and synthetic. Representing nearly 20 major producers of fibers, this association's members constitute one of the textile complex's most competitive segments of global markets. A number of these fiber producers are part of large chemical conglomerates. Although this association represents a small number of firms, because of the member companies' size and competitiveness, AFMA is an influential group in the trade policy arena.

American Apparel Manufacturers Association

Of all the segments of the textile complex, apparel manufacturing is the most fragmented and has the largest number of firms (24,204 in 1994)—many of which are quite small. The American Apparel Manufacturers Association (AAMA) represents this segment of the industry; however, many U.S. apparel producers are not members. Member firms are those that understand the collective advantages of membership, whereas many firms are so small that they are either unaware of these advantages or feel they cannot afford the luxury of participation. One must keep in mind that the average number of employees in apparel establish-

FIGURE 11-12

As a growing number of U.S. apparel firms engaged in offshore activities, the American Apparel Manufacturers Association (AAMA) left the strong textile and labor anti-import coalition. After the break from the anti-import group, the apparel manufacturers' position (especially the position of the largest firms) on trade sometimes resembles that of the retailer/importer/exporter coalition that does not want imports limited. *Source:* Illustration by Dennis Murphy.

ments is 40 persons, and 66 percent of U.S. apparel establishments employ fewer than 20 workers. Although AAMA is one of the strongest associations, if all apparel manufacturers were members, it would be even stronger. AAMA is no longer active in the U.S. industry coalition that seeks trade restraints.

U.S. Apparel Industry Council

The U.S. Apparel Industry Council (USAIC) is a coalition of apparel manufacturers who have 9802 (807) manufacturing operations. The group was formed in 1985 to represent the interests of these manufacturers, who felt that their interests were not being represented in policy matters pertaining to apparel trade. Although most members of this relatively small group are also members of AAMA, organizers established USAIC as a separate organization because AAMA's policies at the time did not consider or support 9802 (807) production. AAMA considered 807 products to be imports. In addition to making sure that their members' views are heard on policy matters, USAIC leaders keep members apprised of matters that affect their 9802 (807) operations: government legislation, customs interpretations, and foreign trade negotiations.

Union of Needletrades, Industrial & Textile Employees

In 1995, the International Ladies' Garment Workers' Union (ILGWU) merged with the Amalgamated Clothing and Textile Workers Union (ACTWU) to form the Union of Needletrades, Industrial & Textile Employees (UNITE). At the time of the merger, UNITE represented 355,000 workers, making it one of the largest U.S. unions. With lobbyists located in Washington, UNITE is active in matters pertaining to textile and apparel trade. Although the unions often have little in common with industry management, they share similar concerns on many issues pertaining to trade for these sectors. If

contributions for political action committees (PACs) can be used as a gauge of political activity, this union ranks fairly high. In a report of spending for the 1996 elections, UNITE spent nearly \$325 thousand to support their favorite candidates compared to slightly more than \$1.6 million for all the textile/apparel manufacturing and retailing associations plus individual major firms combined (Federal Election Commission, 1998).

Fiber, Fabric and Apparel Coalition for Trade

Although the fiber, textile, apparel, and labor groups have had a strong coalition for many years that worked together on trade concerns, the Fiber, Fabric and Apparel Coalition for Trade (FFACT) was formed in 1985 specifically "to fight for textile—apparel import-curbing legislation being drafted on Capitol Hill" (Wightman, 1985b, pp. 1, 19).

FFACT was formed to promote passage of the Jenkins bill, the 1987 bill, and the 1990 bill. The group still exists on paper but is not active (personal discussion with ATMI source, 1994).

American Association of Exporters and Importers

The American Association of Exporters and Importers (AAEI) is a coalition of exporters and importers of products in many sectors organized to lobby against protectionist trade policies and legislation that limit foreign trade. Since the livelihood of the members of this group depends upon trade, this group is vocal on behalf of free trade. The Textile and Apparel Group of AAEI has been especially critical of textile and apparel producers' efforts to secure increased protection for the domestic industry and was one of the first groups to pose organized resistance to manufacturers' strategies to influence trade policy.

In 1989, after losing a number of AAEI members to a new organization (USA-ITA, dis-

cussed next) formed to represent exclusively the interests of textile and apparel importers, AAEI moved to target funding from its 300 textile/apparel-related members more specifically for activities related to this sector, including lobbying (Orgel, 1989).

United States Association of Importers of Textiles and Apparel

In December 1988, a group of major importers and retailers of textiles and apparel announced formation of this group, devoted exclusively to the interests of textile and apparel importers, the United States Association of Importers of Textiles and Apparel (USA-ITA). Most founders had been active in the AAEI, which represents all product areas. Members of the new group asserted, "A strong and independent Association devoted exclusively to the protection of textile and apparel importing is essential to defend the interests of textile and apparel importers. We have established USA-ITA to meet this need" (Hartlein, 1988, p. 2). The new organization was formed primarily to represent textile and apparel importers on trade policy and U.S. Customs problems confronting the segment.

National Retail Federation

In 1990, the National Retail Merchants Association (NRMA) and the American Retail Federation (ARF) merged to form the National Retail Federation (NRF). The new organization has two operating divisions: (1) the Retail Services Division, which provides advisory, educational, and research information, and (2) the Government and Public Affairs Division, which represents the interests of retailers on trade and other policy matters. This merger permits a stronger presence in Congress for the large U.S. retailing constituency. Prior to the merger, NRMA had over 4,000 members who operated more than 45,000 department and specialty stores in the general merchandise retail industry. The ARF brought broad representation from its 50-state retail associations, 22 specialty retailing associations, and hundreds of corporate members (Ostroff, 1990).

Retail Industry Trade Action Coalition

The Retail Industry Trade Action Coalition (RITAC) was composed of the major retail industry trade associations, as well as a large number of leading retail firms. RITAC might be described as the retailers' answer to FFACT. Although tensions had grown for quite some time between manufacturers who sought restrictions on textile/apparel imports and retailers who wanted unrestricted imports, these clashes heightened with the introduction of the Jenkins bill in Congress in 1985. As supporters of the bill gathered a startling number of cosponsors in Congress, retailers and importers formed RITAC as a defense against FFACT's efforts to pass the bill. RITAC's efforts were instrumental in the bill's defeat after the president vetoed the legislation. RITAC was also an active force in the defeat of the 1987 and 1990 textile bills and continued to fight textile and apparel trade restrictions. NRF now handles most of the activities previously handled through RITAC (contact with RITAC board member, 1993).

Various Consulting and Lobbying Firms

A number of firms in Washington represent trade interests. These are commercial operations available for hire to represent groups with various positions on textile trade. As one example, the International Business and Economic Research Corporation (IBERC) is a consulting and lobbying group representing the free trade interests of importers, retailers, and exporting countries. According to Roboz (1981), IBERC is registered under the Foreign Agents Act as an agent of a number of less-developed countries that seek to export textiles and apparel to the United States. IBERC conducts and publishes studies to show the prob-

lems associated with the U.S. textile and apparel industries' protectionist measures and provides other services for its clients concerned with reducing import restraints.

Attention has focused in recent years on former high-level U.S. government officials who leave their positions and become lobbyists for foreign governments to influence U.S. policy. Choate (1990) calls these individuals agents of influence. A significant example occurred in the textile and apparel sectors. Walter Lenahan, former Deputy Secretary of Commerce for Textiles and Apparel, left his government position, in which he was privy to the highest levels of U.S. government information on textile trade, to become an IBERC lobbyist for foreign governments seeking to increase their access to the U.S. market (communication with government officials and industry leaders, various years).

Textile Trade Associations for Exporting Nations

The textile/apparel industries in certain nations, which have a great deal at stake in trade with the United States, have established U.S. offices to represent their interests. These offices represent industry, in contrast to trade ministers in embassies mentioned earlier. An example is the Korean Textile Federation, which has an office in Washington. In addition, certain countries have trade development or trade promotion offices in a number of major U.S. cities to promote products from the home country.

Brief View of Other Structures in North America

As member players of the North American Free Trade Area become more acquainted with one another and establish working relationships, it is likely that a number of NAFTA structures will form to coordinate textile and apparel trade interests within the continent. To date, the following has formed.

North American Textile Council

Heads of the major textile associations in the three nations (the American Textile Manufacturers Institute, the Canadian Textile Institute, and the Mexican Cámara Nacional de la Industria Textil) met in January 1994 to take the first steps in forming the North American Textile Council.

Canada

Within Canada, we will examine briefly the structures involved in textile and apparel industry matters, particularly those related to trade.

OFFICIAL GOVERNMENT STRUCTURES. In the 1960s, the Canadian textile and apparel industries began to feel the impact of low-cost imports. This led to the establishment of an official textile policy and the formation of the Textile and Clothing Board (TCB) in 1970 to monitor policies and to make recommendations to the Canadian government. Pestieau (1976) described the history of these developments in Canada.

Canadian International Trade Tribunal. On December 31, 1988, the Canadian International Trade Tribunal (CITT) became operational and replaced the Textile and Clothing Board, the Tariff Board, and the Canadian Import Tribunal, forming a body similar to the U.S. International Trade Commission.

SPECIAL INTEREST GROUPS. Like the United States and the EU, Canada has a variety of trade groups to represent specialized segments of the textiles complex.

Canadian Textiles Institute. The textile industry's association is the Canadian Textiles Institute (CTI), representing manufactured fiber producers, yarn producers, fabric producers, and manufacturers of household and industrial textile products. The carpet sector's association is the Canadian Carpet Institute (CCI). Both are located in Ottawa.

Textile Federation of Canada. The Textile Federation of Canada (TFC) is made up of a number of associations and societies offering membership to individuals, with scientific or technical qualifications, who are employed in the textile industry or who represent suppliers. The main purpose of these groups is professional development and the encouragement of technical education.

Canadian Apparel Federation. The clothing industry's association is the Canadian Apparel Federation (CAF), formed in 1993 to replace the Canadian Apparel Manufacturers Institute (CAMI). CAF's headquarters are located in Ottawa. Its members are the various provincial and sectoral associations representing clothing manufacturers.

Mexico

The textile and apparel industries in Mexico are represented by separate "national chambers" instituted by the National Chamber of Commerce and Industries Law. Membership is compulsory. In addition to the national chambers, there are subordinate "district" chambers.

CÁMARA NACIONAL DE LA INDUSTRIA TEXTIL (TEXTILES). This is the national chamber for the textile industry, which includes yarn production, weaving, and finishing. Mexico has nearly 2,250 textile mills spread throughout the country. The Cámara Nacional de la Industria Textil represents about 1,400 companies in 18 states. In addition to this national chamber, three major district chambers represent the industry:

- Cámara de la Industria Textil de Puebla y Tlaxcala, representing about 460 companies located in states by the same names;
- Cámara Textil de Occidente, representing about 300 companies in the states of Colima, Guanjuato, Jalisco, Michoacán, Nayarit, and Sinaloa; and
- Cámara Textil ael Norte, with about 25 companies in the states of Chihuahua,

Coahuila, Durango, Nuevo León, and Tamaulipas.

ASOCIACIÓN NACIONAL DE LA INDUSTRIA QUÍMICA (CHEMICAL INDUSTRY). The manufactured fiber sector belongs to the chemical industry and is represented by this group.

CÁMARA NACIONAL DE LA INDUSTRIA DEL VESTIDO (APPAREL). Organized in 1944, the chamber is a private organization that represents the interests of the apparel industry, promotes the development of the industry, and interacts with the government on behalf of the industry. The chamber represents all manufacturers, garment assemblers, and their affiliates. It is governed by elected officers. A staff provides assistance to manufacturers on trade matters, taxes, working conditions, and other matters of concern to the industry.

Brief View of Structures in the EU

Although it is difficult to review the structures in other countries due to space limitations, a brief review of the EU may be useful. Apart from the United States, the EU is the other major importing market in the present textile and apparel trading scheme.

Official Government Structures

The 15 member countries in the EU govern themselves quite independently of each other, with only certain policies—particularly those pertaining to trade—determined at the community level.

Several levels of government are involved in the official business of the EU. We shall consider each of these very briefly.

EUROPEAN PARLIAMENT. The European Parliament, one of the bodies involved in making EU policy, consists of elected representatives from the member states (with a designated number of seats that vary from one member

country to another). The Parliament has powers on matters such as the internal market, the EU budget, and the accession of new member states. The Parliament's Secretariat is located in Luxembourg, with sessions generally held in Strasbourg and committee meetings in Brussels.

EUROPEAN COUNCIL. The European Council brings together the heads of state or government of member states and the president of the Commission (discussion follows); this Council meets at least twice a year. The European Council has provided political impetus on issues related to direct elections of the European Parliament, accession of new members, financial reform, changes in the common agricultural policy, and other strategic matters.

COUNCIL OF MINISTERS. The Council of Ministers is the EU's decision maker. Laws—including textile policy—are formulated by this body after going through preliminary approval in other governmental bodies. The Council of Ministers is composed of the representatives of the governments of member states, generally the ministers for whatever subject area is on the agenda (e.g., economic or financial affairs, agriculture). The presidency of the Council of Ministers passes to each member state in turn for a period of 6 months. Meetings of the Council of Ministers take place behind closed doors.

COMMISSION OF THE EU. The Commission of the EU serves as the community's executive. The Commission initiates EU policy and acts in the general interests of the collective EU. The Commission is the guardian of the treaties that established the EU by monitoring the application of EU law and has the responsibility for regulating competition. Members of the Commission must be independent beyond doubt, and neither seek nor take instructions from any government or from any other body in carrying out their duties. Most international policymaking for the EU has been delegated to

the Commission, whose headquarters are in Brussels. See Figure 11–13.

Within the Commission, primarily two divisions deal with the textile and apparel sectors:

- The Directorate-General for External Relations (known as DG I). This division deals with EU textile trade policy.
- The Directorate-General for Industrial Affairs (known as DG III). This division focuses on matters pertaining to the competitive status of EU sectors. As an example, DG III works closely with the following organization.

THE EUROPEAN OBSERVATORY FOR TEXTILES AND CLOTHING (L'OBSERVATOIRE EUROPÉEN DU TEXTILE ET DE L'HABILLEMENT OR OETH). The European Commission established OETH as an independent organization in 1991 to increase objective knowledge of the economic conditions of the textile and clothing sectors, especially in the EU countries. OETH conducts research by its own staff and in collaboration with the EU Commission. OETH works closely with textile/apparel and retail industry leaders.

In summary, policymaking is complex and slow in the EU because of the layers of government, not only at the EU level, but also because governmental bodies in the member states must weigh the impact of EU policies on their respective nations. Therefore, the process of formulating textile policy in the EU is much more complex than in the United States. Before EU diplomats go to the negotiating table in Geneva or elsewhere with a common policy to present on behalf of the Union, long and difficult debates often have already occurred within the EU.

Formulating common textile policies is particularly difficult for the EU because the industries vary greatly among member states, ranging from sophisticated manufactured fiber production in some countries to simple apparel assembly (similar to that in developing

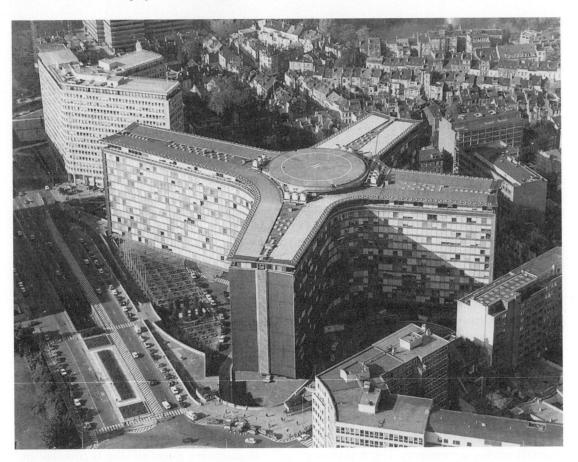

FIGURE 11–13Berlaymont Center, official headquarters of the Commission of the European Union. *Source:* Photo courtesy of the EU Commission.

countries) in others. To a great extent, this is a reflection of the stages of development of the different member countries, ranging from an advanced industrialized country such as Germany to Portugal, which has characteristics of a developing country. Moreover, great disparity exists among the member states' stance on protecting the textile and apparel industries. Germany, with other highly competitive export industries, wants virtually no protection for the textile/apparel sectors for fear of retaliation by trading partners. Other member states desire a strong protectionist policy and have subsidized their industries (which is ille-

gal under both EU and GATT/WTO guidelines). These differences must be compromised within the Council of Ministers so that one common policy or position goes forth from the EU as a whole.

Special Interest Groups

EUROPEAN APPAREL AND TEXTILES ORGANI-ZATION. On January 1, 1996, the European textiles and apparel groups merged to form the European Apparel and Textiles Organization (EURATEX). EURATEX represents and promotes the interests of the European textile and

BOX 11-4

U.S. TEXTILE AND APPAREL TRADE COALITION WEAKENS

For decades, the U.S. textile and apparel industries and unions had a solid and very powerful coalition that represented a unified front against imports. The AAMA was an important player. By the late 1980s, however, many AAMA member firms were actively involved in a range of offshore activities, particularly 9802 (807) production. For this reason, AAMA's traditional anti-import position was no longer tenable. Consequently, at the 1989 annual AAMA meeting, the group announced that it would not support legislation to limit imports further (Chute, 1989a). This was the beginning of a crack in the

coalition that had been steadfast on restricting imports (Figure 11–12). Additionally, the new AAMA position was not supported by all of the group's own members; quite a number were still opposed to offshore activities. AAMA was reported to have lost one key member firm because the association had become *too liberal* on trade; at about the same time, the group lost another because it was *not liberal enough* (personal communication with industry sources, 1990). After a while, however, most AAMA members appeared to accept the new position on trade.

apparel industries to government bodies, institutions, and international associations. This new mega-association has two types of members: (1) the textile and apparel associations for all member countries (plus associate members from EFTA countries and other countries that have applied for EU membership) and (2) the EU organizations representing specific segments of the industry.

FOREIGN TRADE ASSOCIATION. The Foreign Trade Association (FTA) represents the trade policy interests of European retailers. The FTA leaders meet regularly with European government bodies and officials to discuss trade matters of concern to Europe's retailers. Members include national and EU-wide trade organizations, as well as a number of department stores and mail-order houses that hold direct membership.

The FTA advocates free international trade and opposes all efforts to impede or distort trade; they also seek reductions in tariffs. The Association represents the interests of its members in multinational trade negotiations. Additionally, FTA provides information to help members transact business abroad in the consumer goods sector.

ASEAN Federation of Textile Industries

As regional trading blocks develop, the textile and apparel industries in the region are likely to form alliances. For example, the textile and apparel industries in five of the original members of ASEAN established in 1978 the ASEAN Federation of Textile Industries. These original members were Indonesia, Malaysia, the Philippines, Singapore, and Thailand. As additional countries join ASEAN, industry associations from those nations will likely join. The group was formed to develop closer working relationships among industry groups in the region and to represent a collective voice on policy matters that affect industries in the region.

REFLECTIONS ON STRUCTURES FOR FACILITATING AND "MANAGING" TEXTILE AND APPAREL TRADE

After the development of GATT's first multilateral arrangement for international trade in cotton, the STA in 1961, the number of structures to "manage" textile trade increased. As textile trade policies grew in number and complexity, so did the organizations and mechanisms to implement and monitor those policies—at both the international and national levels.

Furthermore, the increased politicization of textile and apparel trade has fostered the development of a large number of organizations to represent the special interests of groups involved in this sector's trade. In fact, one might even say that the politics of textile trade have spawned a form of trade drama: Certain organizations represent the interests of nations against other nations; others represent manufacturers against retailers and vice versa; some groups represent consumers against industry; others represent industrial sectors in adversarial relationships with their governments; and some groups represent the interests of governments and industries in other countries against those in their native countries (e.g., the U.S. retailer-importer coalition works closely with lobbyists who represent textile-exporting countries and the industries in those countries). Each interest group has the right to represent the concerns of its members, and yet, many of these efforts cancel one another. Often, the special interest groups most successful in achieving their goals are those that have political or financial power to press hardest for their demands.

And finally, we might consider for a moment the combined global energies and expenditures invested in implementing and maintaining the present policies and supporting the structures that exist to manage or facilitate textile and apparel trade. The management of global textile and apparel trade has

become a small international "sector," of sorts, of its own.

The existence of present-day textile and apparel trade policies and the plethora of organizations and structures to implement or influence those policies attest to the global importance of the textile complex. Because of the sectors' significant contributions, particularly to employment, in both more-developed and less-developed countries, a complex system has evolved to mediate the interests of the large number of individuals whose livelihood is at stake. Although there are those who would argue that the complex regime has resulted from the politics of protectionism, nevertheless, the policies and structures would not have evolved without widespread support in the political systems of the importing countries.

Although changes in trade policies may alter the governmental structures to manage textile and apparel trade, and although the political climate may alter the number of special interest groups involved, the prospects for reducing these structures in the near future appear slim.

SUMMARY

A complex system of structures has existed to facilitate and manage textile and apparel trade. From 1960 to 1994, textile trade was under the auspices of GATT, with a trade policy, the MFA, that was unique because it was outside the normal GATT rules. Because it was unique, textile trade had its own structures to handle trade for this sector.

Upon completion of the Uruguay Round, which included a 10-year phase-out of the MFA, the structures were changed at the international level. The World Trade Organization (WTO) began to replace GATT as a more comprehensive, more powerful body to handle world trade. The Textiles Division and the Textiles Monitoring Body became the major bod-

ies concerned with textile trade. Additionally, representatives of national missions located in Geneva are involved in textile trade matters. An important special interest group at the international level is the International Textiles and Clothing Bureau (ITCB), a coalition of developing (exporting) countries that opposed the developed countries' trade restraints on their textile and apparel exports.

At the U.S. national level, trade policy is a responsibility of the president. The United States Trade Representative (USTR) is the cabinet-level official responsible for representing the president on trade issues; therefore, USTR plays an important role in textile trade policy matters. The Committee for the Implementation of Textile Agreements (CITA) implements the textile-apparel import control program, with most of its daily work handled by the U.S. Department of Commerce Office of Textiles and Apparel. The U.S. Customs Service plays an important role in processing and monitoring import shipments. A significant array of special interest groups is involved in textile and apparel trade, representing various segments of the industry and different positions on trade.

Completion of the NAFTA accord triggered the beginning of continentwide North American trade groups. The first group for textiles and apparel was the North American Textile Council, launched by the textile trade groups in the three partner nations.

In Canada, the government structure involved in textile trade is the Canadian International Trade Tribunal (CITT). Major trade groups are the Canadian Textiles Institute (CTI), the Textile Federation of Canada (TFC), and the Canadian Apparel Federation (CAF).

In Mexico, the industries are represented through national chambers; companies are required to be a member of a chamber. Separate national chambers exist for the textile, apparel, and chemical industries. Additionally, at least three major district chambers exist for the textile industry.

EU trade policy is handled by multiple layers of government at both the EU and member state levels. Most international policymaking for the EU has been delegated to the Commission located in Brussels. One umbrella organization, the European Apparel and Textile Organizations (EURATEX), represents manufacturers' interests for a broad range of industry segments and member-nation associations. The Foreign Trade Association (FTA) represents the interests of European retailers on textile and apparel trade matters.

As regional trading blocs develop, the textile and apparel industries among member nations are likely to form regional groups or federations. The ASEAN Federation of Textile Industries is an example. Another example is the North American Textile Council.

GLOSSARY

Congressional Textile Caucus is a bipartisan group of senators and representatives concerned about the economic well-being of the domestic textile and apparel sectors. The Caucus has promoted legislation to limit imports.

Import brokers coordinate the details of importing foreign-made products for buyers in the United States.

Interest group or special interest group is an organized body of individuals who share some goals and who try to influence public policy (Berry, 1984).

Letter of credit is a financial document authorizing the importer's bank to extend credit to the importer and to pay the exporter. When a U.S. buyer contracts with a manufacturer in another country to produce textile/apparel items, a letter of credit typically is cashed when goods are loaded on the vessel.

Textile visa (also called *export license*) is an endorsement in the form of a stamp on an invoice or an export control license executed by a foreign government. Visas are used to control the export of textile and apparel products to the United States and to prohibit unauthorized entry of textile products into the country.

Visa System is a method of tracking and controlling the quantity of textile products exported to the United States. This system monitors compliance with restraint levels agreed upon in bilateral agreements or consultations.

SELECTED READINGS

American Apparel Manufacturers Association. (1980). *Apparel trade primer.* Arlington, VA: Author.

A summary of textile and apparel trade terms and an overview of the structures for implementing global trade policy for the sectors.

Berry, J. (1984). *The interest group society.* Boston: Little, Brown.

This book focuses on how interest groups operate within the context of a democratic society; the discus-

sion also relates interest group politics to broader developments in the American political system.

Brandis, B. (1982). *The making of textile trade policy,* 1985–1981. Washington, DC: American Textile Manufacturers Institute.

A review of the development of textile trade policy, written and published by textile industry sources.

Choate, P. (1990). Agents of influence. New York: Alfred A. Knopf.

This book focuses on the hiring of former U.S. government officials to lobby for foreign governments in Washington.

U.S. Department of the Treasury, United States Customs Service. (1984, May). *Importing into the United States*. Washington DC: U.S. Government Printing Office.

An overview of procedures involved in importing into the United States, written for importers.

Textile and apparel trade issues are difficult to resolve because, in many cases, the interests of one set of

players are directly contrary to those of another. If one group achieves its demands, its success is often at the expense of players with different needs.

Part VI provides an overview of the varying perspectives that must be considered in balancing the interests of various groups with a stake in global textile and apparel production and trade. This part focuses on the perspectives of specific groups in the United States whose interests must be considered in the formulation and implementation of textile trade policies. Space limitations necessitate a focused presentation of these perspectives; therefore, the following chapters relate primarily to the U.S. setting. Although the U.S. market and the country's

governmental system are different from those in other industrialized countries, in most of these countries equally disparate objectives exist among groups with a stake in textile and apparel trade.

Chapter 12 focuses on the interests of U.S. textile and apparel industry and labor groups. Various adjustment and policy strategies are considered, with attention given to arguments that have been used to justify special policies of protection for the textile and apparel sectors. Included in the chapter are the concerns of U.S. industry and labor groups for reciprocity, or a "level playing field." In addition, Chapter 12 considers some of the unexpected outcomes of protectionist measures that have produced undesirable consequences for the industry. Further discussion focuses on new marketing initiatives of the U.S. industry, as well as on a

variety of international production and marketing arrangements now being employed to enhance global competitiveness.

Chapter 13 focuses on the interests of U.S. retailers and importers in textile and apparel trade. The opposing objectives of retailers and manufacturers, with respect to trade for the sector, are considered. A summary of retailers' advantages and disadvantages in global sourcing is presented. In addition, Chapter 13 focuses on changes in the softgoods industry, which have led to a more integrated softgoods chain and improved channel relationships. A brief review of global retailing is included.

Chapter 14 considers the consumer's perspective in relation to textile and apparel trade. The chapter begins with an examination of consumer expenditures and the influence of global competition on those

expenditures. Additional consideration is given to consumers' gains from textile/apparel trade. Various types of trade restraints are evaluated from the consumer's perspective. Estimates of the costs to consumers and estimates of welfare, or "dead weight," costs are considered; summaries of these costs from several studies are included. The chapter ends with a discussion of consumers' lack of an organized voice on textile trade matters.

Chapter 15 examines the role of policymakers in textile and apparel trade. As textile/apparel trade matters have become politicized, policymakers are pressured to represent the views of various interest groups. This chapter considers ways in which policymakers have found themselves caught between the political demands of industry groups and the need to represent broader diplomatic concerns.

12

The Interests of Industry and Labor in Textile and Apparel Trade

Previous chapters have provided an overview of the textile and apparel industries, and throughout the book, the perspectives of these sectors in the United States and other more-developed countries have been considered. This chapter provides an overview of the interests of industry and labor, especially in relation to globalization of the textile and apparel industries and trade policies for these sectors. Therefore, this chapter builds upon a prior understanding of the U.S. industry and its relative standing in global trade.

The U.S. textile and apparel industries have been among the first industrial sectors to experience severe international competition. A similar pattern has occurred in other more-developed countries. The nature of the industries made them forerunners in an era when many other sectors followed with similar problems. The limited capital and technology requirements, along with the high labor demands of certain segments of the textile and apparel industries, made these basic industries particularly attractive to developing countries. Many less-developed countries started textile and apparel production first for import substitution and later as a primary export area for earning foreign exchange. For those countries, textile and apparel production became leading sectors to gain earnings for each nation's broader economic and social development.

Therefore, as we consider the interests of manufacturers and labor on trade policy issues, it is important to remember that the textile and apparel industries have a longer history of facing severe international competition than most other U.S. sectors. Although many other sectors now face similar problems in global markets, textile and apparel's longer history (as well as unique characteristics of the global textile/apparel market) may account for some of the present system for responding to that competition. The textile and apparel sectors in most other OECD countries have experienced similar competition and, within the context of differing political systems, the concerns and responses of industry and labor in those countries have been similar to those in the United States.

In this chapter, we will consider the positions of industry and labor in the United States and other more-industrialized countries as they have responded to changing global competition in the textile and apparel sectors. We will consider **industry strategies** for adjustment, policy strategies, new marketing initiatives, and various types of international production and marketing arrangements being

used by industry and labor in the moredeveloped countries.

References to labor in this chapter include both unionized and nonunionized workers. The Union of Needletrades, Industrial & Textile Employees (UNITE) is a vocal force on behalf of U.S. industry members. UNITE's major concern is to protect the domestic textile and apparel workforce by preventing further erosion of the market by imports.

BRIEF HISTORICAL PERSPECTIVE

The textile and apparel industries in most developed countries prospered during the 1950s and 1960s; however, by the late 1960s and early 1970s, market conditions had changed dramatically. Particularly by the mid-1970s, as the impact of increased oil prices affected most of the world economy, industrialized market growth slowed dramatically.

At the same time that the growth of domestic markets slowed in the industrialized countries, a growing number of developing countries chose the textile and apparel sectors as a primary means for economic development. By the 1970s, difficult global market conditions forced many U.S. manufacturers to change their strategies. Ghadar et al. (1987) noted that most OECD countries began to emphasize increased production and mass marketing, hoping that economies of scale would help them retain their competitiveness. The development of large firms, particularly in textiles, resulted in production that became less flexible. Firms were less able to respond to changing fashion demands. Furthermore, the economies of scale, particularly in some segments, still were inadequate to offset the lower developing-country wage rates. Employment in both the textile and apparel industries declined.

In the 1970s and 1980s, the textile and apparel sectors in the United States and most

other OECD countries pursued two strategies in their quest to retain markets: (1) adjustment measures and (2) increased trade restraints to protect the domestic industries from imports. During these years, substantial adjustment occurred in these industries. In addition, textile and apparel trade policies grew increasingly complex and institutionalized. Also, during this time, a number of producers in the OECD countries began to establish various forms of global production-marketing arrangements. In some cases, these arrangements provided access to local markets in other countries; in other cases, access to low-cost labor was the primary motivation.

ADJUSTMENT STRATEGIES

Adjustment, also called structural adjustment, is considered at both the national and international levels (Ghadar et al., 1987). At the national level, adjustment refers to restoring the competitiveness of an industry within the domestic economy. A rationalization process occurs, which results in fewer, larger, and more efficient firms plus some specialized suppliers. See Figure 12-1. As Ghadar et al. note, rationalization occurs as a result of government policy or market forces. Although public policy (i.e., the government) has directed textile and apparel industry rationalization in some European countries, the U.S. approach is largely market driven.1 Under a market-driven approach, the market forces firms to alter products, production methods, and company structures to remain competitive.

At the *international* level, adjustment refers to the relationship of the national economy to that of its trading partners. In this sense, adjustment

¹ Over the last 25 years, U.S. public policy has become increasingly important, however, as an influence on corporate behavior.

FIGURE 12-1

Emptied of people and machines, a closed-down textile mill is a lonely place. Plant closings, which may be part of the adjustment process, take a toll on workers and their communities. Particularly when plants are located in small towns and rural areas, the impact of the closing is especially difficult.

Source: Photo by J. Maillard, courtesy of International Labour Office.

occurs through changes in exchange rates and through the regulation of trade (Ghadar et al., 1987). Adjustment also considers the relationship of a sector to the international market. The national and international aspects of adjustment are interrelated. As Ghadar et al. note:

Industrial sectors that increase productivity faster than the overall national economy should

become more competitive in the international economy. However, exchange rate movements can dramatically affect the competitiveness and trade performance of national economies and individual industries within an economy. An overvalued dollar can cause intrinsically healthy sectors to register losses and can even lead to their elimination. During these periods, government policy may turn to trade regulation to give these industries time to cope with changes in the international economy. (p. 2)

The Goal of the Adjustment Process

Textile trade experts generally agree that the MFA was intended originally to allow the more mature textile and apparel industries in the developed countries time to adjust to the growing low-wage competition. The industry in the more-industrialized countries was believed to have a competitive advantage in high-quality and/or capital-intensive goods, permitting the developing countries to produce other goods in which they could be competitive. Most countries have been unwilling to vacate any part of the sector, however.

Further, the adjustment process was expected to include both firm and industry reorganization, which would promote more efficient operations. The U.S. industries and most other developed-country industries have made significant strides in adjustment through restructuring and investment in new technology (particularly textiles). Despite these shifts, the less-developed countries asserted that the textile and apparel sectors in the more-industrialized countries became too comfortable with the protection provided by the MFA and moved too slowly in the adjustment process.

Adjustment Progress

A number of changes have occurred in the U.S. textile and apparel industries; similar adaptations have been made in the European and Canadian industries. Although the firms involved would not think of these actions as

part of an adjustment process, when viewed from a broader, objective perspective, these changes can be considered part of a restructuring of these industries. Among these changes are mergers, consolidations, acquisition of smaller firms by larger ones, the shift to vertical operations, investment in new production technology and processes, and the shift to a stronger marketing orientation. In addition, the textile and apparel industries are part of an important change in the softgoods industry—the rethinking and reorganization of the production and distribution processes to reduce response time for merchandise delivery.

European countries vary a great deal in their textile/apparel industry adjustment processes and end results. Since the mid-1970s, nearly all EU countries, as well as the EU itself, have developed schemes to aid various textile and/or apparel sectors (Anson & Simpson, 1988; Arpan et al., 1982). For example, Germany provided little support for the industries in the adjustment process (however, regional governments have assisted the industry extensively). The German government's strategy was based on the belief that companies that responded effectively to existing market forces would remain competitive in global markets. As part of this strategy, a great deal of German apparel is produced through outward processing.

France, Britain, and Italy have given varying degrees of governmental guidance in the adjustment process, with differing end results. The British and French industries have lost a substantial number of textile and apparel jobs in spite of the government's supportive position. At times, Italy has provided extensive support for these industries (Anson & Simpson, 1988; Arpan et al., 1982), and the Italian industries remain among the most competitive globally. Some of the European countries' schemes to subsidize the textile and apparel industries in the adjustment process have been declared illegal by the European Commission (e.g., the Belgium program was ruled illegal in 1987). Certain EU treaty regulations prohibit trade restraints, subsidies, or other measures

that would give one country an unfair competitive advantage over other member states.

In comparing the adjustment strategies of the European, Asia Pacific, and U.S. textile and apparel industries, Toyne et al. (1984) found the following common elements:

- All countries used protectionist measures (tariff and nontariff restrictions) against imports;
- 2. All countries, both more developed and less developed, sought to balance the impact of wage increases with productivity increases and with strategies to minimize wage increases (e.g., the use of immigrant labor in the EU and offshore investments by Japan and the Asian NICs);
- All industrialized and maturing developing countries sought some degree of specialization at the company or national level;
- 4. All countries sought to integrate (or link) their textile complexes vertically and/or horizontally (although Toyne et al. listed the United States and the Netherlands as exceptions, a great deal of integration has occurred in the U.S. industry since the writing of Toyne's book); and
- **5.** All countries sought to upgrade their technologies and manufacturing processes.

Toyne et al. added, "However, the results have been quite mixed when measured in terms of performance and international competitiveness" (p. 161). Although Toyne's group did not include the Canadian industry in their study, the industry adjustment in Canada has been roughly parallel to that in the United States.

Often industry investments associated with the adjustment process have resulted in both positive and negative outcomes. Employment declines usually follow adjustment measures. As firms merge to form more efficient operations and as more sophisticated machinery and processes are introduced, employment is usually reduced. See Box 12-1. In

BOX 12-1

DEATH OF A TEXTILE PLANT

The harsh sound of silence hangs heavy over the empty textile plant on the edge of town. It is a huge, cavernous place, 16 acres under one roof.

Once 1,000 people worked there, handling up to 2 million yards of textile goods daily. Now, only 23 people remain on the payroll at the Old Fort Finishing Co.

They have one job—to close the place down.

"It's pretty lonely now," plant manager Thurmond Padgham sighs. "I'm going on 38 years here. It feels just like your family broke up. You get close to everyone. You know their families, their situations. It's very saddening."

The plant, owned by United Merchants and Manufacturers Co., halted production July 31 [1984], sending shock waves through this town of 752 along the Catawba River at the foot of Black Mountain in western North Carolina.

The same scene has been repeated in dozens of towns across the South in recent months. In 1984, 61 textile plants shut down in North and South Carolina alone. The industry as a whole shrank by 19,500 workers.

There is a certain irony in the closures, a painful lesson for an entire region.

The textile industry originally moved south seeking cheap labor. Now it is leaving for pretty much the same reason. Cheap labor in the form of foreign imports has undercut the market for American-produced textiles.

Now some southern towns are undergoing the same trauma that old textile centers in the North experienced decades ago. And an industry once viewed by some as the salvation of the region has come to be viewed as a curse in places like Old Fort, named after a frontier fort built in 1756.

There is little hope of improvement in the near future. Apparel imports have more than doubled during the last three years, and some textile spokesmen say the industry faces its most difficult days in a quarter century.

It is hard to exaggerate the upheaval caused by the closing of Old Fort Finishing Co., which dyed and finished cloth for apparel manufacturers.

The move eliminated 492 jobs. The average worker was paid about \$7 an hour, considered a good wage here, and had 20 years of seniority, according to the company.

Since then, a supermarket, a general store, a tire distributorship, a florist and a cafe have closed in Old Fort, according to Mayor Robert Wilson, the former night superintendent at the plant.

The shutdown announcement last May caught almost everyone by surprise. People knew about problems in the textile industry, but United Merchants had embarked on a \$17.5 million modernization program here and workers thought their jobs were secure.

"It hit us all like a lightning bolt, or a death in the family," said Jim Settles, 51, who was hired

the EU, employment in the textile and apparel sectors declined by a third from the mid-1970s to the mid-1980s; job losses were extensive but somewhat less in the United States compared to the EU. To the frustration of industry leaders, most economists tend to view the shrinking labor force as a positive indication of adjustment for industries having difficulty remaining globally competitive. That is, economists consider that labor and other resources are shifting to more viable sectors. This theo-

retical perspective on adjustment does not take into account, however, the toll on workers, their families, and their communities.

As part of the adjustment process, mechanization resulting from advanced machinery has accounted for productivity increases that have reduced jobs. In most cases, it has been difficult to determine the extent to which job losses have resulted from competition from low-wage imports or from productivity increases accompanying the installation of ad-

BOX 12-1 CONTINUED

soon after he graduated from high school and never worked anywhere else. "It still hurts. There are times you get mad. You feel the company let you down because you gave them so many years of your life."

Wilson and others estimate that about 150 of the plant's former workers have found other jobs. The rest have retired or are living on unemployment benefits.

With three other textile plant closures in surrounding Marion County, "it has gotten to the place where nobody is hiring," said Wilson, who has joined other local leaders in an effort to find another industry to take over the Old Fort Finishing plant.

Several firms have visited the facility, and Wilson thinks that eventually someone will take it over. But, he said, "I'm afraid things are going to get worse before they get better."

Settles and his wife, Jan, a plant secretary, have applied for about 15 jobs in the surrounding area.

"The county has become too dependent on the textile and furniture industries," he said. "We didn't make much by national standards, but it was good money here. Every time you apply for another job they ask, 'What did you make at your last job?' You tell them and they laugh at you."

Settles has resisted applying for unemployment benefits, but now is resigned to doing so. "That's something I never wanted to do," he

said, sitting on a living room sofa. "I really don't know what to do. It's like your whole life is in limbo. You're physically able to work, you want to work, but you can't find anything to do."

Settles, who has been living on severance benefits, is luckier than many here. Unemployment benefits for many are running out, and the Labor Department has rejected company claims that foreign imports caused the shutdown. If the department had accepted the claims, workers would have been eligible for extended unemployment benefits beyond 26 weeks.

Joe Allison, his wife and his daughter all lost their jobs when the plant closed. Another daughter is a freshman at North Carolina State University in Raleigh, a four-hour drive away.

Allison, 47, worries that his daughter may not be able to finish her education.

"My brothers and my sisters, all my nieces and nephews all worked at that plant. That's all we ever knew," he said, shaking his head. "I stayed there 28 years. The only thing I've ever done is finish cloth. All I know is textiles."

"To get out and hunt another job is hard, real hard," continued Allison, a wiry, energetic man. "When they slide the rollers under you like this, it's not a good feeling. They hurt us bad. They hurt the whole community when they closed that plant."

Source: Bill Peterson. Reprinted by permission of *The Washington Post*, January 31, 1985.

vanced production machinery and processes. Nevertheless, as the textile and apparel sectors in most developed countries have participated in various forms of structural adjustment, job losses have resulted.

In the not too distant future, textile mills may become so highly automated that they may become "lights-out" plants. That is, weaving mills will be unattended, and workers will not have to be on hand to take care of repairs, creeling, or doffing. Even now, many

mills are attended by very few individuals, who are directed to problems by a computer. Figure 12–2 shows the contrast in the number of workers required in a modern high-technology plant compared to an unautomated one in a less-developed country. The advances in technology enhance productivity and lower manufacturing costs, but the contrasting photos clearly depict the impact on employment.

Investments in new production machinery have resulted in another peculiar outcome. As

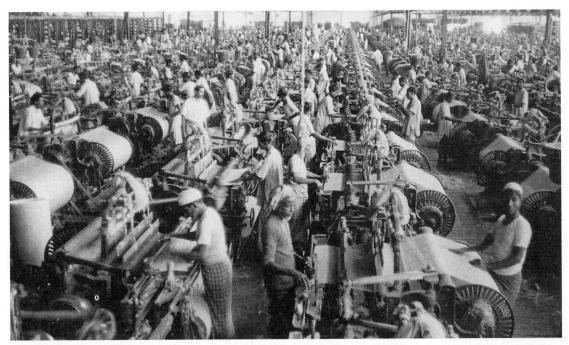

(a)

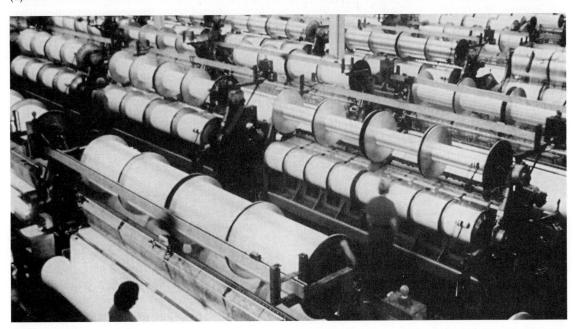

(b)

FIGURE 12-2

Technology and automation improve productivity but *reduce employment*, as seen by contrasting these two textile mills. The less modern weaving factory (a) requires many workers to tend the machines, but the modern automated operation (b) uses few workers to produce a large quantity of fabric.

Source: (a) Courtesy of International Labour Office; (b) Courtesy of Guilford Mills, Inc.

these investments (capital deepening) helped to reduce the unit labor content of textile and apparel goods, manufacturers assumed that this strategy would preserve markets threatened by low-cost imports. Ironically, the domestic industries that spent large sums to implement the latest production technologies began to feel an increased need for market protection in order to protect the large investments.

POLICY STRATEGIES

In the 1960s, textile and apparel manufacturers in the United States and Europe became alarmed by the increasing entry of low-wage imports into their domestic markets. Although the volume of imports was modest at that time compared to the quantity that would later enter, manufacturers were successful in securing the groundwork for a multilateral system for controlling the entry of low-wage imports into their markets. Earlier chapters of this book provide a detailed discussion on the development of the STA, the LTA, and later the MFA with its subsequent renewals.

Several factors accounted for the increased emphasis on policy strategies as a means of aiding the textile and apparel industries in the more-developed countries. Among the influential factors are the following.

Substantial Import Growth

Of all the consumer-oriented manufacturing industries, textiles and apparel (especially apparel) have been among the most affected by low-cost imports. Although various sources give differing data for imports entering U.S. markets, all show substantial growth in recent decades. Frequently, rates of import growth exceeded growth in domestic output. Data from the U.S. Department of Commerce Office of Textiles and Apparel summarize the increase in imports in U.S. markets.

The data in Table 12–1 are given in dollars, which Cline (1987) believes to be more appropriate for reporting import penetration than volume data. In Cline's analysis of import penetration rates, reported in earlier chapters, he adjusted data by using the Department of Commerce's domestic product shipment price index. Cline's adjusted data show less dramatic rates of import penetration than those displayed in Table 12–1.

Market conditions in most other moredeveloped country markets were similar, with periodic shifts between the United States and the EU in terms of which country accepted larger portions of low-cost imports.

A Growing Protectionist Mood

As the developed countries experienced growing trade deficits, and at times increased unemployment, public sentiment for erecting trade barriers intensified. As a result, the textile and apparel industries' interest in securing tighter import restraints was reinforced by the general mood that prevailed in the country. In the United States, numerous measures for protecting domestic industries were introduced in Congress, including the 1985, 1987, and 1990 textile bills. In fact, the 1985 textile bill was one of the first sector-specific bills introduced in Congress that year; the bill was seen at times as a test case for other sector-specific legislation that followed.

Employment Losses

Textile and apparel job losses in most developed countries have been severe. The EU experienced dramatic loss of employment, which dropped by approximately one-third within 10 years—from 4.5 million workers at the time the MFA was developed to 2.2 million in 1996 (based on 12 countries of the EU). In the United States, textile employment was 980,000 and apparel employment was 1.4 million in 1973. However, by 1995, textile employment was 629,000 (plus another 69,074 in manufactured fiber produc-

TABLE 12–1U.S. Imports, Exports, and Trade Balance of Apparel and Textile Mill Products (millions of dollars, unadjusted)

	Apparel			Textile Mill Products			Textile/ Apparel Trade
Year	Imports	Exports	Balance	Imports	Exports	Balance	Balance
1983	8,872	694	-8,179	3,320	2,327	-993	-9,173
1985	13,745	638	-13,107	4,973	2,302	-2,671	-15,778
1987	18,809	1,000	-17,809	6,466	2,846	-3,620	-21,429
1989	22,221	1,811	-20,410	6,607	3,602	-3,005	-23,415
1991	24,149	2,924	-21,225	7,463	5,157	-2,306	-23,531
1992	28,828	3,806	-25,022	8,353	5,543	-2,810	-27,832
1993	31,153	4,552	-26,601	8,878	5,746	-3,132	-29,733
1994	33,926	5,191	-28,735	9,667	6,276	-3,390	-32,126
1995	36,794	6,180	-30,614	10,480	6,910	-3,570	-34,184
1996	38,644	7,042	-31,602	10,704	7,478	-3,226	-34,828
1997	45,349	8,178	-37,171	12,461	8,545	-3,916	-41,086

Note: Figures may not add exactly due to rounding.

Source: Textile & Apparel Trade Balance Report—computer printout and OTEXA Web site (1983–95). U.S. Department of Commerce and personal communication with Department of Commerce analyst Linda Shelton. 1998.

tion) and apparel employment had declined to 823,000 (personal communication with U.S. Department of Commerce staff, 1997). Although the introduction of advanced machinery accounted for some of the job losses, nevertheless industry and labor groups in the developed countries understandably viewed the dramatic employment losses with alarm.

Protection of Investments

As noted earlier, the industries (particularly textiles, and apparel to some extent later) in the developed countries invested substantially in advanced equipment and processes to reduce unit labor content and thereby become more competitive with low-cost imports. Manufacturers invested with the assumption that markets would be preserved; consequently, the industries became increasingly concerned that import restraints be put in place to protect these investments.

Competitive Disadvantages

U.S. textile and apparel manufacturers are at certain competitive disadvantages in competing in world markets; a number of these "disadvantages" result from government regulations that increase the cost of doing business. Among these regulations are such measures as minimum wage requirements, social benefits such as Social Security programs, environmental protection measures, and health and safety regulations imposed by the Occupational Safety and Health Act (OSHA). For example, OSHA regulations on cotton dust and noise standards are estimated to cost the textile and apparel industries millions of dollars.

Although most of these regulations have resulted from a broader social commitment to American workers, these programs or requirements add to a firm's cost of doing business. Although most U.S. citizens would not wish to return to an era when these regulations were

nonexistent, they nevertheless affect the international competitiveness of the domestic industry. Similarly, regulations in the other developed countries affect the global competitiveness of their textile and apparel industries. Additional costs of government regulations become an issue when developed-country manufacturers are competing with products produced in low-wage developing countries that typically have no similar requirements.

In addition, U.S. industry and labor sources believe they have received far less government assistance than many of their counterparts in competitor nations. For example, the industries in a number of other countries have had advantages such as closed domestic markets (i.e., they accepted few or no textile and apparel goods from other countries), government aid and subsidies in a number of forms, advantageous tax structures, and various assistance efforts such as government-supported export organizations to promote and sell products in other markets.

Concerns for "Burden Sharing"

Once early measures were established to "manage" textile and apparel trade, the industrialized countries soon realized that provisions were needed to ensure that all developed countries "shared the burden" of low-wage imports. At times, the United States and the EU have each felt that the other was not accepting an adequate share of the low-cost imports and that, as a result, a disproportionate quantity was being diverted to the respective domestic market. Similarly, prior to the EU integration, burden sharing was an issue among the EU member states. Therefore, as the global system for managing textile and apparel trade developed, the multilateral trade policies that evolved ensured that the major markets would share fairly in "bearing the burden" of low-cost imports.

Political Prowess

Finally, policy strategies have been pursued by the U.S. textile and apparel sectors because industry and labor leaders have learned to be effective in securing policies to restrain imports. Leaders have been aware of the power inherent in the size and geographic dispersion of these industries. That is, nearly 2 million workers represented a large number of votes, and the textile and apparel industries are located in virtually every state. Therefore, few members of Congress can ignore these industries' concerns over trade. Similarly, the textile and apparel industries and labor groups in other more-developed countries have been able to exert political pressure because they represent large numbers of workers relative to the total workforce.

ARGUMENTS TO JUSTIFY POLICY STRATEGIES FOR SPECIAL PROTECTION

Industry and labor groups in the developed countries offer several arguments to justify import restraints to provide special protection for domestic industry. Among these arguments are the following.

Maintaining Employment

If increased imports result in reduced sales for an industry, protecting that industry can help—at least in the short run—to maintain employment. In view of the job losses experienced by the textile and apparel sectors in more-developed countries in recent decades, industry and labor leaders have been able to make persuasive arguments using this justification. More-developed countries have faced political problems in coping with job losses in textiles and apparel. Especially because of the geographical concentration of these industries in many nations, job losses can become a politically sensitive issue. Therefore, policymakers, who must respond to their constituencies, find job losses to be a compelling argument. Similarly, large employment declines readily capture the public's sympathy and support.

Providing protection to save jobs has inherent risks, however. Other industries may be affected. For example, if the protected industry provides intermediate inputs to other industries, then import restraints may raise costs and reduce employment in industries using the protected input materials. In addition, trading partners may retaliate against the protective measures by imposing their own trade barriers. A result of retaliation is that the protection to save jobs in one industry may reduce employment in another. Occasionally, the retaliation may affect another segment of the same industry. As an example, in the early 1980s, as the United States attempted to tighten restraints on Chinese textile and apparel imports, the Chinese canceled orders for U.S. textile mill products that were being used to produce their goods for export.

Slowing the Pace of Adjustment

Industry and labor groups have argued that protection is needed to provide a cushion from the hardships resulting from adjustment that occurs too quickly. That is, if U.S. textile and apparel markets were opened suddenly to all imports, massive unemployment would occur in the domestic industry. Although this argument is a variation of the one to maintain employment, it is generally more acceptable to policymakers. This argument advocates temporary import restraints because resources cannot be shifted easily. That is, time is required to retain workers and to allow investment to effect changes.

The MFA was established on this premise. The MFA was developed in part to provide temporary protection to the industries (and labor) in importing markets to allow more time for adjustment to occur without causing hardship to firms and workers. The GATT acknowledged this argument as valid; however, critics of the MFA felt the protection originally intended to be temporary was extended too long.

Preserving the Incomes of Certain Groups

This argument has been one of the primary justifications for protecting agriculture in industrial countries. Subsidies for producers of cotton, mohair, and other wool fall under this category. A variation of this argument is used also for maintaining U.S. textile and apparel jobs. A large number of persons with few other job alternatives are employed in textile and apparel production. These individuals include a large number of women (these industries employ more women than any other), minorities, new immigrants, persons with limited training for other employment, and individuals with little or no mobility. The argument that the textile and apparel industries play a special role in providing incomes for these groups is quite valid. For many of these workers, other employment alternatives are limited or nonexistent, particularly in certain regions.

Protecting Domestic Labor Against "Cheap Foreign Labor"

Although this argument is related to those concerned with maintaining employment and preserving the income of certain groups, it is often a separate justification for trade restrictions. Nearly all economists see this argument as unjustified because they believe that letting the principle of comparative advantage prevail gives mutually beneficial end results for all countries. At the same time, considering the perspective of the domestic producer in moredeveloped countries makes this concern understandable. Responsible textile and apparel leaders are concerned about the potential longterm impact on their workers when competing against wages in the less-developed countries, which are a small fraction of those in the United States and other developed countries.

Preserving Key Industries

A number of sectors have argued that they need special protection because they have strategic importance. Typically, this argument focuses on the importance of maintaining a domestic industry for defense purposes. That is, the domestic industry argues that in case of war, the country should be self-sufficient in producing goods of strategic importance for defending itself. In the case of textiles and apparel, U.S. industry leaders argue that the country should not let its domestic industries erode to the point that the country would be dependent upon other nations for its military uniforms, shoes, and textile goods such as tents and parachutes.

Figure 12–3 is a *Washington Post* advertisement based on the argument for protecting strategic industries. Advertisements of this type ran when the textile bills came to a vote in Congress.

Under the Berry amendment, the U.S. Department of Defense is required to purchase textile and apparel products from domestic manufacturers. Industry leaders voiced strong support for the amendment, saying that it "preserves the defense industrial base for certain critical products that are vulnerable to foreign competition and essential to U.S. military preparedness" (ATMI, 1993). Although the Berry amendment has been included in defense appropriations bills every year since World War II, the provision was an annual one. Because both the Reagan and Bush administrations proposed to weaken or eliminate the amendment, textile supporters in Congress secured permanent passage of this provision in October 1992 (ATMI, 1993).

Supporting New (High-Technology) Industries

This is a variation of the "infant industry" argument used to secure protection for new industries to give them time to become established and competitive in global markets. Inherent in this argument is the need to assist new industries during the learning period, when the domestic firms cannot compete with

foreign firms that have been operating for a longer period of time. Typically, this argument is used for high-technology industries in the more-developed countries.

In general, the textile and apparel industries in the more-developed countries have been established for so long that this argument is rarely used to secure protection. On the other hand, the textile and apparel industries in less-developed countries often use the new industry argument to justify restraints on products from other countries.

Using Protection as a Lever to Open Markets

Sometimes in recent years, certain industrialized nations have used the threat of protection as a means of securing access to markets in other countries. Particularly in cases in which a less-developed country may rely heavily on exporting to a more-industrialized market, a threat of this type can provide considerable leverage if pursued seriously. World Bank (1987) sources note that this is "yet another step down the road to managed trade" (p. 144). Each restraining measure invites a similar action in return.

Combating Unfair Trade

Increasingly, industries in the more-developed countries have demanded "fair trade" rather than free trade. By this, industries have desired similar conditions and rules for trade in selling to the less-developed countries that they have been required or have chosen to provide to these countries. More-developed country concerns for a reciprocal trade climate are presented in greater detail in subsequent sections of this chapter.

THE DESIRE FOR A "LEVEL PLAYING FIELD"

The less-developed countries have chafed under importing-market trade policies that have be-

A message to Congress:

neir bare essentia

countries that could be making By 1995, these are the G.I. Joe's uniform.

emergency, this is what G.I. Joe will be wearing. And, in a national

fade in Hong Kong

Made in Taiwar

Made in Italy

Made in Brazil

footwear industries are not "industries of the future," When President Reagan vetoed the Textile Bill last week, he said that the U.S. textile, apparel and and should not be maintained.

Administration disagree. Ambassador William Brock, abor said, "Every U.S. industry insists it is essential ormer U.S. Trade Representative and Secretary of or national security. Textiles is the only one we But former trade officials in the Reagan accept, and that goes back 20 years."

The Department of Defense also agrees with us industry as the second most critical to maintain our because they have ranked the U.S. textile/apparel national defense. (The steel industry is first.)

So consider this sobering thought:

a soldier could march without the U.S. textile, apparel remaining 45% of our textile/apparel industry and 18% and footwear producers. There are over 300 different combat-essential items utilizing textile products. The of this country. Doesn't it make sense to preserve the Not a truck could roll, not a plane could fly, not cold, hard, unavoidable facts are that the textile/ apparel industry is vital to the very life and safety of our footwear industry?

IS AVOTE FOR AMERICA'S DEFENSE! AVOTE FOR H.R. 1154

A MESSAGE FROM THE AMERICAN SECURITY COUNCIL WASHINGTON, D.C. WASHINGTON, D.C. 2003, 202 494-1677

FIGURE 12-3

purpose of the advertisement was to show the potential threat to the nation's defense system if the U.S. textile FFACT ran this advertisement in the Washington Post in the final days before the vote on the Jenkins bill. The complex was decimated by imports.

Source: Reprinted courtesy of the Fiber, Fabric and Apparel Coalition for Trade.

come increasingly restrictive. At the same time, however, textile and apparel manufacturers in the more-developed countries have become outspoken regarding what they believe to be unfair trade. These manufacturers advocate fair trade rather than free trade and have begun to demand that trade take place on "a level playing field." That is, manufacturers in the more-developed countries believe international textile trade policies have provided many generous concessions to the less-developed countries and that manufacturers in the more-industrialized countries are short-changed by nonreciprocal treatment (Figure 12–4).

In short, manufacturers in the more-developed countries have demanded **reciprocity**, the principle of WTO/GATT under which governments are expected to extend comparable concessions to each other. Many developed-country producers have begun to tell the less-

developed countries to open their markets if they wish to have greater access to markets in the more-industrialized countries. In the Uruguay Round, this issue of market access was a major demand by the more-developed countries. India and Pakistan, in particular, have resisted opening their markets. Although many newly developing countries may be able to justify closed markets on the basis of protecting infant industries and problems of indebtedness, many of the NICs and ASEAN members in the Far East have graduated from the lower stages of economic development. Therefore, many industry and government sources in the more-developed countries believe reciprocity should be expected from the more-developed Asian countries.

In their quest for fair trade, textile and apparel manufacturers in the more-developed countries have found a number of trade practices trouble-some. Examples include the following.

FIGURE 12-4

U.S. textile and apparel manufacturers believe they are losing a significant portion of the domestic market because trade practices give what is perceived as unfair advantages to the developing countries.

Source: Illustration by Dennis Murphy.

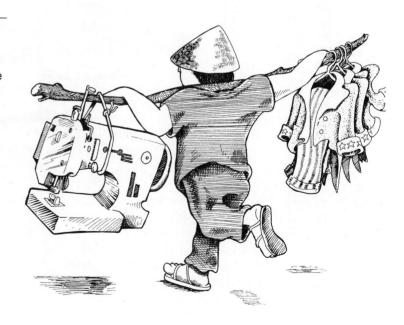

BOX 12-2

DUMPING CHARGES: ASIAN SWEATERS AND CAPS

Sweaters. In 1990, the U.S. National Knitwear and Sportswear Association (NKSA) filed charges against specific sweater firms in Taiwan, Hong Kong, and Korea for allegedly selling their sweaters in U.S. markets for less than their fair market value. In a highly publicized case, the Asian firms were fined antidumping duties as high as 24 percent on Taiwan sweaters and lower levels for the Hong Kong and Korea firms involved. Two years later, the U.S. Court of International Trade ordered the International Trade Commission to reconsider its decision. In the end, the decision was reversed, and the Asian firms that had paid penalties were reimbursed. Taiwan sweater manufacturers reported that the dumping claims were very damaging to their industry, almost de-

stroying it (author's interviews, 1993; Farnsworth, 1992; Ostroff, 1992a; Taylor, 1990).

Caps. In 1988, the Headwear Institute of America filed an antidumping petition against Chinese exporters for dumping baseball caps in U.S. markets for one-fourth to two-thirds their true value—selling them for half the price of other Asian caps and about one-fourth of the U.S. production cost. Between 1982 and 1987, Chinese cap sales went from 579,000 to 5.9 million as a result of dumping, according to the Institute. Although this, too, is a typical antidumping petition, an investigation by the U.S. International Trade Commission found no probable harm (Honigsbaum, 1988; personal communication with R. Wallace, 1990).

Dumping

Dumping occurs when a product is exported at a price below its fair market value. This may mean that the product is sold for less than the cost of production or it may mean that the product is sold abroad for less than the price in the domestic market. See Box 12–2.

Dumping may be a means of disposing of a capacity surplus of products; it permits producers to recapture a portion of the costs of production while maintaining a position in export markets. Sometimes, *predatory dumping* occurs. In this form of dumping, products or commodities are sold at below cost or at a lower price to capture the business that previously went to producers in other countries. The intent of this form of dumping is to drive foreign competitors out of business to acquire a monopoly on the market, after which prices are raised.

Diversionary dumping occurs when foreign producers sell to a third-country market at less than fair value, after which the product is processed further and shipped to another country. Wolf et al. (1984) noted that Hong Kong, Singapore, and Macau have little fiber or fabric production, but they secure these input products from China, Taiwan, and Korea (or from Europe or Japan for high-quality fabric). Wolf et al. asserted that much of the fiber and fabric produced in East Asia is subsidized or dumped, or that it must be priced to compete with subsidized or dumped products. They believe this enables the garment producers in Hong Kong, Singapore, and Macau to obtain their inputs at a very low cost. These low costs, along with low labor costs, have made these three city-states major producers in world markets.

BOX 12-3

SUBSIDIES IN TEXTILE AND APPAREL TRADE

The U.S. International Trade Commission reported that the rapid expansion of China's textile exports to the major developed-country markets appeared to result primarily from government incentives. Because the textile complex is China's leading export industry, the government has provided tremendous support, including a system under which export enterprises are awarded bonuses based on the value of exports. This incentive is in addition to a subsidy system that repays producers for losses they incur in filling export quotas assigned to them by the government. Apparently, the Chinese government has been so intent on building a strong export business that the textile complex has been given many special favors, including lowered taxes (USITC, 1987a).

Moreover, the entire Chinese textile bureaucracy appears to have been reorganized to avoid the appearance of providing subsidies. Because of China's interest in joining the WTO/GATT, the previous Ministry of Textiles that made all decisions pertaining to textiles was changed. The government support of China's textile industry through the ministry would have signaled that textile exports were state-subsidized and, therefore, should have been subject to countervailing duties. To avoid hurting the country's chances of joining the WTO/GATT and also possibly having to pay countervailing duties, the Ministry of Textiles became the China National Textile Council, and a number of large corporations were established to handle various segments of the industry ("More Corporations," 1987).

Subsidies

A **subsidy** is a financial benefit conferred by a government on an industry or a firm. A significant number of countries make grants or low-interest loans to their textile and apparel industries to encourage expansion and/or modernization. In addition to the subsidies provided to firms in many developing countries, this form of assistance has occurred in several Western European countries (France, Sweden, Belgium, and Italy) and in a number of British Commonwealth and East Asian countries (Canada, Australia, Thailand, Indonesia, and China).

Subsidies may be granted to facilitate restructuring and to prevent unemployment and social unrest. **Export subsidies** are granted to foster an export strategy for an industry or a firm within a country. They are any form of government payment or benefit to a manufacturer or exporter that is contingent upon exporting

products. Export subsidies are in a sense a form of dumping and are seen as a strategy that distorts normal market conditions. See Box 12-3.

The Tokyo Round produced an agreement on subsidies and countervailing duties on manufactured and semimanufactured goods. Countervailing duties are duties levied on imports to offset subsidies to producers or exporters of those products in the exporting country. That is, if it can be proven that the government in Country X has subsidized producers (or that merchandise was dumped), the importing country may place an added duty on the products. The countervailing duty is intended to raise the cost of the exported goods closer to what a reasonable price might have been initially.

In addition to distorting market conditions, subsidies may foster the expansion of the textile and apparel industries where economic theory would suggest that expansion should not occur. Sometimes subsidies bol-

ster inefficient firms, permitting them not only to survive but also to expand. Further, subsidies can provide cost advantages to less efficient firms compared to more efficient but unsubsidized competitors. Although export subsidies are illegal by international agreement, "many nations provide them in disguised and not-so-disguised forms (such as the granting of tax relief and subsidized loans to potential exporters, and low-interest loans to foreign buyers of the nation's exports)" (Salvatore, 1987, p. 224).

Salvatore notes that all major industrial nations give foreign buyers of domestic products the "incentive" of low-interest loans to finance purchases through agencies such as the U.S. Export-Import Bank. Although these lowinterest credits finance about 10 percent of U.S. exports, they account for as much as 40 percent of Japan's and France's exports. This practice represents a major complaint of the United States against other developed countries. On the other hand, other countries consider the U.S. Domestic International Sales Corporation (DISC) program to be a form of subsidy and a violation of WTO/GATT. The DISC program was basically tax legislation to stimulate U.S. exports by reducing the effective rate of taxation on income from exports. In the Tax Reform Act of 1984, Congress replaced the DISC provision with three new entities (one of which is the interest-charge DISC, or IC DISC) to benefit exports sales activities yet remain within WTO/GATT guidelines.

Although U.S. industry leaders may be quick to look for instances of dumping and subsidies on the part of trading partners, a close look at U.S. production of natural fibers reveals that subsidies are prevalent in that sector. (In fact, subsidies are prevalent for many agricultural sectors in both more-developed and less-developed countries.) U.S. examples include:

• *Cotton.* In the 1991 crop year, the government paid \$700 million in subsidies

to growers and another \$75 million to U.S. textile mills and exporters when the average cost of U.S. cotton was higher than the average world price. The rationale was that the subsidies maintained the quantity and quality of cotton while lowering the price for mills, leading to increased consumption. The subsidy was said to help mills compete with imported cotton fabric from China and other countries that could tap into inexpensive cotton markets forbidden to U.S. mills. U.S. producers insisted that without the subsidy, they could not exist.

- *Wool.* In 1991, the U.S government paid \$134 million in wool subsidies.
- Mohair. Subsidies were \$52.1 million in 1991, or more than \$50,000 to each grower. Although 33 states have mohair producers, 86 percent of this product comes from 4,000 ranchers in Texas. Ninety percent of U.S. mohair fiber is exported, much of which comes back to the United States in finished apparel. In the Clinton administration's budget-cutting efforts, this highly publicized example of subsidies illustrated to many citizens the startling extent to which they were unknowingly supporting various sectors. As a result, mohair subsidies were phased out in stages and completely eliminated by 1996 (McNamara, 1993; Ramey, 1993).

Highly Restrictive Tariff Levels

Although the more-developed country producers resist the lowering of tariffs on textiles and apparel under the Generalized System of Preferences (GSP), many resent the highly restrictive tariffs placed on textile and apparel products by a number of developing countries; the high tariffs discourage exporting to those markets. Manufacturers in the more-developed countries feel that the less-developed countries want special concessions on many aspects of trade but, in return, have placed high tariffs

on products entering their markets. In the 1980s and early 1990s, Pakistan levied more than 120 percent tariffs on textiles and apparel; Egypt, India, and Brazil were not far behind.

As in the more-developed countries, tariffs tend to be higher on apparel and fabrics than on other textile products. For example, Pakistan levied nearly 200 percent tariffs on apparel in the 1980s; Egypt, India, Brazil, Morocco, and Colombia levied about 100 percent. With those tariffs, garments cost three times the amount they might have in Pakistan and double in the other countries named. A number of less-developed countries have reduced tariffs to some extent since that time.

Closed or Partly Closed Markets

A number of countries partly close their markets: Apparel is not permitted to enter, but textile goods are accepted. Apparel may be blocked but textiles permitted when the level of development in a country does not support the apparel industry's input needs. That is, the country may have an apparel industry dependent upon obtaining component parts from other countries because the nation has not developed textile production (or that for other components) to support its needs. Markets may also be virtually closed by techniques such as the following:

- Comprehensive systems of import licenses, often awarded only after the "demonstration of non-availability of local substitutes and/or adequate bribes."
- Outright import bans.
- State monopoly purchasing bodies.
- Domestic content rules for downstream products.
- "Eccentric" labeling or other bureaucratic requirements.
- Administrative sabotage, such as losing license applications.
- Use of foreign exchange controls that discourage imports and create

unpredictable changes in regulations (Anson & Simpson, 1988, p. 153).

In recent years, many of the less-developed countries have moved toward much more open trading policies for accepting textiles and apparel produced in other countries. Countries that resist opening their markets will be subject to increasing pressure from trade partners.

Foreign Aid

The United States provides generous support to aid developing countries; this money is funneled through a wide range of organizations and projects. U.S. textile and apparel industry supporters have taken exception, however, to providing support to aid the textile and apparel industries in less-developed countries.

Members of Congress who represent regions where textile and apparel production is heavily concentrated have led the protests against loans and other aid being granted to develop or expand the textile and apparel industries in low-wage countries. When these concerns began to surface, critics asked for an accounting of loans that went to develop textile manufacturing. The U.S. Treasury secretary supplied official figures, which showed that between January 1980 and December 1982, international lending institutions had loaned over \$500 million to finance Third-World textile projects (Hosenball, 1984).

Loans were made by such institutions as the World Bank, the International Development Association, and the Asian Development Bank. Grants between 1980 and 1982 went to Bangladesh, Egypt, Turkey, Nigeria, Thailand, Sri Lanka, Zambia, Pakistan, the Philippines, China, and Malawi (Hosenball, 1984).

In 1984, the powerful U.S. House Appropriations Committee advised the Reagan administration to instruct U.S. delegates to international lending institutions such as the World Bank to "strongly oppose" loans to textile and apparel projects in the Third World. The com-

BOX 12-4

FROM "60 MINUTES" TO "NIGHTLINE" TO CAPITOL HILL IN FOUR DAYS

U.S. funding of textile and apparel production in developing countries came to the attention of taxpayers and members of Congress when "60 Minutes" televised a segment on A.I.D. (U.S. Agency for International Development) funding of the apparel industry in the Caribbean and Central America. Two segments followed on "Nightline." Prompted by a group called the National Labor Committee, representing unions, the TV segments reported on the use of A.I.D. funds to establish garment assembly plants in less-developed countries to lure manufacturing to those nations, taking jobs from U.S. taxpayers. As the reporters presented it, U.S. citizens were being expected to pay millions of dollars to fund manufacturing in the Caribbean and Central America (to aid those economies), as well as promotional efforts to encourage U.S. apparel firms to close domestic plants and move their manufacturing to those regions. Since 1981, well over \$1 billion of U.S. tax monies had been spent for the programs critics termed as "luring U.S. jobs overseas" (most of which were in apparel).

Within 4 days, the controversy was considered in Congress. Legislation followed quickly that eliminated all A.I.D. money spent on providing incentives to U.S. industry to relocate out of the United States if the move costs U.S. jobs. Also, money for developing foreign export processing zones would be eliminated unless the president could certify that the zone would not cost U.S. jobs (Barrett, 1992a, 1992b; Ramey, 1992b; "Senate Nixes," 1992).

mittee reported that it was "extremely concerned" about the growth of U.S. imports of textile products and added that the "World Bank and other regional developmental institutions are contributing to this rate of growth by providing subsidized funds to developing countries to expand their textile imports" (Hosenball, 1984, p. 2). See Box 12–4.

Textile and apparel industry supporters in Congress were outraged to learn later that the U.S. delegation to the World Bank, under the Department of the Treasury, had been instructed by an interagency group to vote to approve a \$175 million loan to China—which included a commitment of \$8.1 million to develop China's textile industry ("Congressmen Seek," 1984). These funding practices have continued to some extent. For example, the United Nations provided funds to assist India's industry in 1996.

Given the adaptability of the textile and apparel sectors to the economic development

strategies of less-developed countries, our discussion in prior chapters helps us understand why these countries sought loans to develop or expand these industries. Ironically, however, many developing countries have entered textile and apparel production on the recommendations of Western advisors from organizations such as the World Bank and others.

At the same time, one can easily understand the frustrations of U.S. textile and apparel manufacturers (and labor groups) when they learn their tax monies are helping to *finance their competition*. As taxpayers, U.S. citizens help to support a number of international organizations such as the World Bank, an apolitical international lending institution that makes loans to Third-World countries. Although the World Bank is supported by over 100 nations, the United States is a chief contributor, supplying about 20 percent of the bank's funds. The United States influences World Bank disbursement decisions through weighted voting and has

additional influence through congressional appropriations to the institution.

Encouraging increased Third-World production of textile and apparel products appears to be a questionable practice from the perspective of the less-developed countries themselves. That is, loans from the World Bank or other institutions prepare a nation with few resources to invest in a sector for which a global overcapacity already exists. Moreover, as the lessdeveloped country producers attempt to sell their products, they encounter an increasingly difficult system of trade restraints designed to manage the excessive supply of products in the international market. Although the quota system will be phased out, many less-developed countries may have difficulty competing with large, experienced exporting nations.

UNEXPECTED OUTCOMES OF PROTECTION

As textile and apparel producers in the more-developed countries secured additional protection from less-developed country imports, many of the restrictions had unforeseen consequences. Many of these consequences were quite different from what industry leaders desired initially, and some of them provided benefits for the *less-developed country producers*. In many respects, the import control system can be compared to the "Dutch boy and the dike" dilemma. As soon as one "leak" is stopped, another occurs. Among the unexpected consequences of the import control system for textiles and apparel are the following.

Development of New Suppliers

Ironically, the MFA quota system fostered the development of textile and apparel production in a number of less-developed countries. As controlled countries exhausted their quota availability, many of the Asian suppliers, Japan and

the NICs in particular, established production facilities in less-developed countries to take advantage of lower (or nonexistent) quota restraints (and usually lower wages as well). In some cases, these were the first textile/apparel production facilities in the poorest developing countries; in other cases, the outside investment from NICs fostered the expansion of the industries in newly developing countries. As a result, the quota restraints on leading suppliers caused a proliferation of producer nations. See Figure 12–5. Although the textile and apparel sectors would have been likely first industries for most of the developing countries, the quota system caused the spread to those countries to occur more quickly than it might have otherwise. Consequently, as the developed countries applied quotas to limit the imports from major Asian suppliers, the net result was a larger number of supplier nations.

Shifts in Product Lines

In addition, the "holes in the dike" phenomenon discussed previously affected product lines. As importing countries placed restrictive limits on various product categories perceived to be a threat, the exporting nations simply shifted to uncontrolled or less controlled categories. These shifts continue to occur. For example, if import controls on men's dress shirts are tightened, the producers in an exporting country may shift to women's dresses or raincoats to avoid quota restrictions. In other words, quotas have encouraged diversification of product lines among the growing number of producers in the world market.

Diversification fostered by the quota system may create more difficulties for manufacturers in the importing countries than allowing a slow increase in already established lines. Under the latter circumstances, manufacturers in the importing countries are able to predict more realistically the categories in which import increases will occur. When an exporting country's producers quickly shift production

FIGURE 12-5

An unexpected outcome of the quota system has been a proliferation of exporting nations. When more advanced Asian nations' exports were blocked by increasingly restrictive quota limits in the major developed markets, firms in those countries relocated production to other nations—providing capital, manufacturing expertise, and marketing networks—creating a growing number of proficient producer nations in the global market.

Source: Illustration by Dennis Murphy.

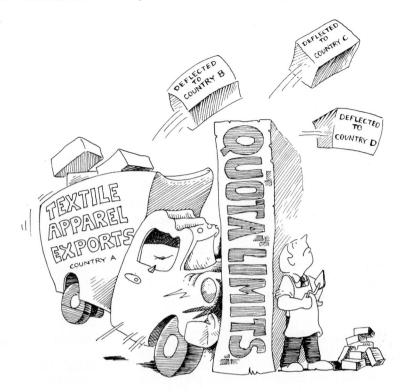

from one category to another, competitive market conditions are much less predictable for producers in the developed countries. That is, if producers in Country Z suddenly shift from shirt production to coat production to avoid quota restraints, then the coat manufacturers in an importing country suddenly face market uncertainties because of the new and unexpected competition from the low-cost source.

Shifts in Fiber Categories

In addition, quota restraints affected import shipments by *fiber* categories. Prior to MFA IV, silk and the natural vegetable fibers other than cotton were not controlled. Consequently, a number of exporting countries began making and shipping large quantities of ramie, linen, and silk items because no quota limits had been imposed on products made of these fibers. Because of the widespread use of this strategy

to circumvent quota restraints, the importing countries pressed to have the additional fiber categories covered under MFA IV (where previously uncontrolled fibers exceed 50 percent of the weight of the imported goods; pure silk was excluded).

Upgrading

Because quotas limit the volume, but not the value, of imported apparel, exporters found it advantageous to upgrade products to maximize the value added per unit. Therefore, manufacturers in less-developed countries continued to upgrade their products. In many respects, this was advantageous to the developing countries. In addition to maximizing profits, this shift permitted a country to compete in a more diversified market. Furthermore, it bolstered the development of a more sophisticated industry within that country. Rather than producing

inexpensive, low-quality products, the quota system encouraged the industries in exporting countries to advance more rapidly than they might have otherwise.

Again, ironically, the consequences of the quota system were hurtful to certain producers in the more-developed countries. Earlier, as low-cost imports began penetrating the markets of the developed countries, a large proportion of the products could be described as moderate in quality and low in price. Believing that they would have a competitive advantage in lines of higher quality and price, many manufacturers in the more-industrialized countries shifted to upper-price markets. As the quota system encouraged upgrading on the part of the less-developed countries, this competitive advantage for the developed countries diminished.

Guaranteed Market Access

Although most textile/apparel-exporting nations publicly protested against quota restraints, officials in a number of countries actually considered quotas a form of *security* for market access. Many countries wanted increased quotas but, at the same time, acknowledged that existing quotas have been a form of *guaranteed market access* up to the agreed limits. Surely this perspective on quotas was not a predicted end result for industry leaders in more-developed countries who worked to secure quota restraints.

The security of access provided by quotas has benefited two groups of exporting nations. First, the "Big Three" producer nations (Taiwan, South Korea, and Hong Kong) have large quotas as a result of their history. These countries have held large quota allotments due to normal growth on quotas for those countries that were major exporters early in the days of import controls. (This growth may be compared to the growth of an individual's savings account as a result of compound interest accrual. Moreover, when fewer nations competed for markets, quotas were less restrictive.) Therefore, the "Big Three" countries with large

quota allotments sought to retain the market access those quotas provide. The second group of countries, the newest global market entrants, also benefited from the security of access provided by quotas. Many of these nations would have found it extremely difficult to participate in today's intensely competitive global markets without the access provided by quota allotments. In other words, the quota system holds back the more experienced nations, giving newcomers a chance to compete.

The quota system provides another form of security. Many textile- and apparel-exporting countries fear their ability to compete with the mega-exporter China if or when China becomes a member of the WTO and is no longer subject to quota limits on textile and apparel shipments.

Establishment of Foreign-Owned Plants in the Importing Markets

Perhaps the most startling boomerang effect of import restraints has been the establishment of foreign-owned plants in the United States and other major importing countries. A number of Asian producers, in particular, who felt hampered in their export operations because of increasingly tight quota limits, established their own production operations in the importing countries to avoid those restraints and gain immediate market access. Rather than protecting domestic markets, the tightened quota system encouraged foreign producers to invest and compete face-to-face in the developed-country markets.

In effect, international competitors have become backyard neighbors and now compete in the same market. A significant number of textile firms that are owned by parent firms in other countries have moved to the United States. Among the countries that have made significant U.S. textile investments are Korea, France, Germany, Switzerland, and Japan. In apparel, for example, Hong Kong-based Odyssey International Pte. Ltd. (which produces sportswear, skiwear, and camping equipment for com-

panies such as The North Face, Eddie Bauer, and Lands' End) acquired Cal Sport in Yuma, Arizona, as part of its plan to build or buy 10 to 12 manufacturing facilities in the United States ("Odyssey Begins," 1991). The EU has also experienced this trend; for example, Japan's textile giant, Toray, built a plant in England that is one of Europe's largest textile facilities.

TEXTILE/APPAREL INDUSTRY MARKETING INITIATIVES

In addition to adjustment and policy strategies, the U.S. textile complex has undertaken marketing initiatives in its continued efforts to compete against producers in other countries.

Marketing Orientation

A number of large firms, particularly apparel firms, have become marketing-oriented companies-in some cases eliminating the manufacturing role partly or altogether. A marketing orientation emphasizes strategies built around the customers' needs rather than what the company can produce. In a few cases, an apparel firm may do no manufacturing, but rather develops the concepts for its lines and focuses on marketing efforts that build the brand image. Liz Claiborne is an apparel firm of this type. Fruit of the Loom trimmed significantly its domestic manufacturing base and expanded its brand marketing efforts. In 1996, Fruit of the Loom boosted its advertising and promotional budget more than 15 percent, spending more than \$130 million on these strategies in 1997. That same year, mammoth Sara Lee surprised the industry by announcing that it was "deverticalizing." That is, the company made the decision to have no manufacturing of its own, but rather to focus on brand building and marketing.

A Service Commitment to Retailers

In the 1990s, many major apparel manufacturers began to take the Quick Response concept even further to expedite deliveries to retail customers through inventory replenishment strategies. Through electronic interfaces, manufacturers can deliver merchandise rapidly by using electronic data interchange (EDI). As consumers purchase merchandise, retailers can notify suppliers that they need replenishment, and manufacturers (often called vendors by retailers) can provide rapid deliveries. Not only does this rapid replenishment system prevent stock-outs on basic merchandise the customer may always expect to find at a certain store, it also reduces the inventory and, consequently, the investments that accompany large inventories on the part of the retailer.

Therefore, a new era of relationship building has occurred in the apparel industry, often with top-level executives working directly with retail CEOs. Although this relationship may later be implemented between the vendor's sales representative and the retail buyer, it is forged at the highest levels of the partner firms. The retailers know they have the commitment of the vendors, from the highest levels down, to provide what the retail firm needs.

Promotional Campaign for Domestic Products

As noted in Chapter 8, the Crafted with Pride campaign was launched to increase awareness of U.S.-made textile and apparel products and to motivate consumers, retailers, and apparel manufacturers to buy domestic goods rather than products made in other countries. Industry leaders initially launched the Crafted with Pride in U.S.A. campaign in 1983 and in 1984 formed the Crafted with Pride in U.S.A. Council, funded by member organizations and firms.

BOX 12-5

REQUIRED COUNTRY-OF-ORIGIN LABELING

In contrast to the Crafted with Pride labeling, which is a voluntary industry effort, federal legislation requires all textile and apparel products sold in the United States to carry a country-oforigin label. The law became effective December 25, 1984.

Earlier labeling laws required that the country of origin be identified for items made in other countries; however, labeling was not required for U.S.-made items. Consumers who preferred domestic textile and apparel products were left to assume that if no country of origin was given, the product was American made. The lack of domestic labeling left most consumers in doubt.

The 1984 legislation took the form of an amendment to the Textile Fiber Products Identification Act and the Wool Products Labeling Act. Although regulations pertaining to the labeling of consumer products are under the jurisdiction of the Federal Trade Commission (FTC), the FTC origin rules are compatible with the U.S. Customs country-of-origin regulations, which cover imports controlled under the Agreement on Textiles and Clothing (ATC) (formerly the MFA).

The 1984 labeling legislation stipulated that a product is considered misbranded unless it is prominently labeled or tagged as to the country of origin. Labels must be placed on the neck of a garment or in another easy-to-find place. Manufacturers may label small items like stockings on the package rather than on the actual item. All mail order catalogs are required to provide country-of-origin information on the products offered for sale.

Global products, which result from manufacturing operations in several different countries, pose the greatest difficulty in defining and labeling the country of origin to meet U.S. labeling requirements. Labeling is particularly difficult when various steps in fabric production, for example, occur in different countries. If a garment is made of fabric from another country or was assembled in another country, the label must say "made of imported fabric" (sometimes the country is named) or "assembled in Country X" (the country of assembly must be named). The 1996 rules stipulate that country of origin is where garment assembly occurs. See Chapter 7 for further details on the 1996 rules.

In the early stages of the Crafted with Pride campaign, spending was directed largely to media efforts to reach consumers. A number of commercials featured celebrities who promoted the merits of U.S.-made garments. Later, commercials began to publicize the "dying industry because of imports" theme that created a poor image of the industry in the minds of viewers.

Although manufacturers' participation in the Crafted with Pride effort was purely voluntary, many firms affixed labels bearing the Crafted with Pride logo or other forms of "Made in the U.S.A." identification.

GLOBAL PRODUCTION AND MARKETING ARRANGEMENTS

Increasingly, U.S. textile and apparel producers are realizing the importance of participating in global production and marketing activities as competitive strategies for survival. A number of U.S. firms have long, profitable histories of participation in the global economy, but these companies have been exceptions. Many manufacturers became so concerned by the influx of imports into domestic markets (and directed their energies to controlling those imports) that they gave little attention to how they might participate in

BOX 12-6

SUCCESS STORIES: INTERNATIONAL TEXTILE AND APPAREL OPERATIONS

- · Jockey International's brand is known virtually all over the world. One may see this familiar brand advertised on the wall in an airport in Germany or on a billboard in Mexico. Jockey International markets its products in over 100 countries and has manufacturing facilities in a number of countries. The company has used licensing as a means of selling more abroad, with some 1,000 registrations of its trademarks and patents in 135 countries. Nearly half of Jockey's annual sales are overseas. Jockey International's commitment to global marketing is evident in the multilingual staff in its offices in Europe, Hong Kong, and Brazil and its headquarters in Kenosha, Wisconsin; staff travel constantly.
- Kellwood Company has evolved from a firm that once served not only the U.S. market alone, but also mainly one customer—Sears, Roebuck and Company—to a large multinational corporation. Kellwood is a marketer, merchandiser, and manufacturer of apparel and recreational camping softgoods products. With 1998 sales of \$1.8 billion, Kellwood serves every retail channel of distribution and more than 25,000 retail customers. Kellwood's emphasis on value-oriented products has meshed well with the interests of the new, value-conscious consumer of the 1990s. The company gives high priority to advanced technology and communications systems to coordinate its global network

- and to provide service to customers (author's visits with Kellwood executives).
- Sara Lee Corporation's Personal Products Division has pursued an aggressive strategy for international expansion. Sara Lee has purchased companies in other countries, such as the Mexican hosiery firm Mallorea SA de CV (Mexico's second largest hosiery manufacturer); an Italian hosiery manufacturer, Filodoro; the French manufacturer of the Dim line; and many others. Through these acquisitions, Sara Lee not only sells the products of the acquired company but also gains access to those markets for its brands that are better known in the United States, such as Hanes, Playtex, Bali, and L'eggs. Sales in other countries accounted for one-third of the division's more than \$7 billion in sales in 1996.
- Levi Strauss & Co (LS&Co.) is one of the world's most geographically dispersed firms in the textile complex, in part because of the "pull" of its products. To consumers in many parts of the world, Levi jeans epitomize American popular culture and the American lifestyle that many wish to imitate. Complementing the appeal of the products, however, is one of the most culturally sensitive and socially conscious executive teams in the industry—taking seriously the social responsibilities of being a global corporation. Of LS & Co.'s 114 facilities (production, distribution, and sales offices), more than half are outside the United States.

the markets beyond their borders. This situation is changing, however; a number of global initiatives will now be discussed.

New "Globalization" Theme in the U.S. Textile and Apparel Industries

A growing number of U.S. textile and apparel firms are joining their European and Asian

competitors in assuming a more global orientation in their operations. The Uruguay Round appears to have had a significant impact as U.S. industry leaders began to see that after the year 2005, their sector will no longer have quotas to help protect the domestic market. Therefore, many industry executives began to think of the potential markets for their firms' products beyond the U.S. borders. See Figure 12–6.

FIGURE 12-6

Many U.S. textile and apparel executives are looking beyond the domestic market and seeing global opportunities.

Source: Illustration by Dennis

Murphy.

In the 2 years following signing of the Uruguay Round, "globalization" was the theme at annual meetings of AAMA, ATMI, the Bobbin Show (the leading trade show for the apparel industry), and others. In many companies, a new generation of executives is leading the charge to think in terms of trade beyond the U.S. borders.

Global Sourcing

Perhaps more than any other form of global linkage, sourcing strategies have been used by many U.S. manufacturers. Through these methods, apparel manufacturers, in particular, have taken advantage of the low-cost labor in developing countries. This strategy may include securing finished products or may involve assembly operations only (9802 [807] or, to Europeans, outward processing). Particularly as legislation made production in the Caribbean basin attractive, these offshore assembly operations have been used increasingly by U.S. apparel manufacturers. More than half of the \$50 billion (wholesale) volume of 1996 apparel imports

was purchased and managed by apparel firms (AAMA, Technical Advisory Committee, 1996). Since sourcing strategies are discussed in greater detail in Chapter 9, the reader can refer to that discussion.

Multinational Enterprises

Multinational enterprises (MNEs) or firms are those with an integrated global approach to production and marketing and those that have both domestic and overseas operations. (MNEs are also called *transnational corporations;* these were discussed briefly in Chapter 4 in relation to development.) Some of the large chemical-based manufactured fiber firms have been leaders in assuming a global orientation. For example, DuPont has fiber production in various regions of the world.

International Licensing

As discussed briefly in Chapter 9, international licensing involves an agreement between a U.S. firm (firms from other countries grant licens-

ing arrangements as well) and foreign manufacturers to use the U.S. company's trademark. The U.S. firm receives agreed-upon royalties and provides technical, merchandising, and promotional support to the licensing company to produce and market the brand in the licensing company's market.

Licensing is a way of achieving market expansion abroad and may be the only practical means for doing so in certain countries in which regulations restrain imports or foreign investment. In other words, licensing is an alternative to exporting. In many countries (particularly Latin American nations and other developing countries), however, royalties are limited by the government (to 1–3 percent) and for only a short duration for an agreement (E. Ott, personal communication, 1989).

A number of apparel firms derive 3 to 10 percent of their earnings from licensing their trademark in other countries. For the licensor, relatively limited investment is required. However, for the arrangement to be successful, the licensor must continue to give something new and innovative. Often, when a licensing arrangement provides a designer's name and little else, those efforts are not as successful as lines for which continued innovation is supplied (E. Ott, personal communication, 1989).

Although Jockey International has an outstanding track record in its use of licensing, not all firms have been as successful. Problems have occurred in protection of trademarks and collection of payments for the use of those trademarks, particularly in developing countries. Producers in some less-developed countries believe they have a right to secure and use trademarks and technology with little cost to them. For example, some countries have laws that prohibit payment of royalties for the use of a trademark; in certain countries, the length of time in which trademarks are protected is shorter than in the United States.

Foreign licensing requires a long-term commitment from manufacturers to develop a market for their products in other countries. To

FIGURE 12-7

Jockey International's products sell quite successfully in many countries. The name and logo are recognized in many places where consumers may not read English.

Source: Photo courtesy of Jockey International.

be successful, licensors must provide design, merchandising, and other expertise over the lifetime of the contract. Although licensing can expand markets and generate additional income, manufacturers must be aware that developing markets in other countries takes several years.

Direct Investment

Direct investment refers to ownership of a substantial interest in a foreign operation. Investing in a foreign operation in this manner represents the highest level of commitment to operations in another country and usually includes transfer of significant technology and personnel by the firm. Direct investment and joint venture operations are used by apparel manufacturers for offshore production to take advantage of lower wages. Both types of ventures represent forms of *owned production overseas*, which were discussed in more detail in Chapter 9. Often direct investment occurs when a firm wants access to a market for its

products. Manufactured fiber plants in regions beyond the home country have often been established for this reason; for example, DuPont spent well over \$1 billion in the 1990s to build nylon plants in Asia to ensure DuPont's place in a region where consumption is growing far faster than the world average. Conversely, foreign textile and apparel manufacturers are using this strategy to establish operations in the United States to gain access to the U.S. markets.

Joint Ventures

A **joint venture** results when a firm goes into business with a partner located in another country. The local partner offers the advantage of understanding the market and how to function in it. Various joint venture arrangements exist, often including more than two partners. The proportions of ownership are not necessarily equal, and in some cases, the extent of foreign ownership is regulated by the local government. Sometimes, local governments are a partner in joint ventures. The advantages and disadvantages of owning production operations in foreign countries were considered in Chapter 9.

Exporting

In many ways, direct exports are the simplest way of entering the markets of other countries. Earlier, however, we considered a number of restrictive measures that may pose difficulties for companies seeking to export to other markets. As a result, other production or marketing arrangements have provided alternative means of participating in the markets of those countries.

Exporting is an obvious means by which U.S. textile and apparel producers can expand their markets. As we noted earlier, the potential for exporting has not been adequately explored by most U.S. firms, particularly in view of the appeal of many U.S. products in other countries. Although exchange rates have at

TABLE 12–2U.S. Apparel Exports, 1997 (\$US millions)

World	\$8,178
All OECD	1,230
Canada	664
Japan	632
EU (total)	487
South America	249 ^a
Belgium/Luxembourg	95
France	77
Germany	63
ASEAN	48
Netherlands	46
Switzerland	28
Singapore	27
Spain	20
Italy	19
Russia	16
Kuwait	11

^a Includes shipments of cut garments to be assembled under 807/9802 provisions.
Source: U.S. exports of textile and apparel products.
(1998, March). OTEXA Web site (for updates, see

http://otexa.ita.doc.gov).

times posed serious difficulty in exporting, looking beyond the U.S. borders offers the potential both to expand sales and to offset the growth of imports in domestic markets. Table 12–2 shows sample exports from U.S. apparel firms in 1997.

The apparel exports shown in Table 12–2 indicate that U.S. apparel manufacturers *can* sell their products in other markets. See Figure 12–8. The reader should note that Japan is one of the two largest apparel customers of the United States, accounting for \$632 million in sales in 1997. It is ironic to think of Japan as one of the United States' leading apparel *customers*—after having considered Japan to be the country's major *threat* as a textile and apparel exporter only 30 years earlier.

Most textile and apparel firms that have a serious commitment to exporting have sales organizations in other countries. Sales operations may consist of a company's own sales

FIGURE 12-8

The Minnie Mouse sweatshirt worn by this employee in a Hong Kong apparel factory attests to the appeal of U.S. products in other markets. *Source:* Photo by Kitty G. Dickerson.

force or may utilize sales agents who represent several companies. Obviously, direct representation has many advantages if a company is in a position to commit the required resources. A number of U.S. apparel firms are successfully establishing their own stores in other countries. These include Ralph Lauren, DKNY, and Calvin Klein, whose brands are becoming popular worldwide. See Figure 12–9.

Successful export markets take time to build and require ethical business practices to establish a long-lasting export business (See Box 12–7 on p. 451). A number of U.S. textile and apparel

FIGURE 12-9

This Calvin Klein shop in Sydney, Australia, illustrates the manner in which some U.S. firms are successfully entering the markets of other countries.

Source: Photo by Kitty G. Dickerson.

firms have created poor images for the American industries by viewing overseas markets as a dumping ground for leftovers. Sources in other countries have reported practices known as seeding the goods, in which poor-quality products are included in shipments, and dropping by container, in which large shipments (containers for tractor trailers) worth \$150,000 or more are exported with poor-quality merchandise intentionally mixed with that of more desirable quality (anonymous industry source).

U.S. textile and apparel firms missed a number of opportunities when doors were opened to them but industry executives passed them by. For example, when the author was in Hong Kong in the early 1990s and met with a number of industry and government leaders, person after person described an incident that had left them puzzled about the interest of U.S. textile producers in securing business.

Hong Kong produces very limited quantities of fabrics (because of space and environmental considerations), so Hong Kong apparel makers must purchase most of their fabrics elsewhere. Now that Hong Kong produces primarily high-quality garments, its apparel firms need superior fabrics. Many apparel companies were much more dependent on Japanese textiles than they wished to be. Therefore, when a major trade fair for textiles and apparel was held, Hong Kong leaders issued personal invitations to textile manufacturers in the United States and Western Europe because they wanted to purchase more fabrics from those countries. The Hong Kong industry leaders who had issued the invitations were baffled by the fact that not one U.S. textile firm accepted the invitation. In contrast, a number of European firms accepted and participated in the trade fair.

In sharing their concerns about the lack of interest on the part of U.S. firms, Hong Kong leaders related that, a few years earlier, one large U.S. textile firm established an office in Hong Kong but abandoned it after a relatively short time. They contrasted this to the Japanese determination to establish their sales offices for the long term (Hong Kong industry and government leaders' discussions with author, various times).

INTERNATIONAL MARKETING CONSIDERATIONS

Although the study of international marketing is an extensive subject on its own, we will identify a few basic considerations relevant to our study of the marketing of textile and apparel products globally.

International marketing is "the multinational process of planning and executing the conception, pricing, promotion, and distribution of ideas, goods, and services to create exchanges that satisfy individual and organizational objectives" (Onkvisit & Shaw, 1997, p. 7). This definition is similar to the American Marketing Association's definition of marketing, except for the added *multinational* focus. Although the mechanics of marketing differ little for the global setting, it is the varied environments in which the marketing plan is implemented that makes international marketing a greater challenge than domestic marketing.

Cateora (1996) considers that "the task of marketing managers is to mold the *controllable* elements of their decisions in light of the *uncontrollable* elements of the environment in such a manner that marketing objectives are achieved" (p. 6). A number of elements in the marketing operation may be controlled within the company, including product, price, promotion, and channels of distribution. In Cateora's model, these elements are shown in the center (Figure 12–10).

Beyond the four elements identified as "controllables," most other influences are external to the firm and beyond the control of the firm's decision makers. Figure 12–10 illustrates the added challenge in international marketing because the marketer must deal with *two levels* of "uncontrollables" rather than one—the domestic environment uncontrollables.

The second circle represents the uncontrollable elements of the domestic environment that have an effect on foreign operations: the political forces, the competition, and the economic climate of the home country. For example, a U.S. (or any country's) foreign policy decision might alter drastically the marketing climate for a company's products in a particular country or competition from another U.S. company may affect a firm's ability to perform successfully in a foreign market. Similarly, domestic economic conditions affect the ability to invest in efforts to pursue international markets.

BOX 12-7

ONE MANUFACTURER'S DETERMINATION TO EXPORT: FROM THE SUITCASE UP

Today Riverside Manufacturing Company, with headquarters in Moultrie, Georgia, is the largest privately owned uniform company in the world. The company manufactures uniforms for businesses that want to project a certain company image. Although Riverside Manufacturing now exports to 185 countries, this is not merely the result of good luck. Riverside's stellar export record happened as a result of hard work and the willingness to take risks.

In 1975, Jerry Vereen, who is now president, treasurer, and CEO, took a courageous step that launched Riverside's export efforts. The family-owned company already shipped to all 50 states and sold to several multinational customers—but only for those accounts in the U.S. markets.

In an effort to expand Riverside's international business, Mr. Vereen set out for Europe with four suitcases of samples. He started in Frankfurt, Germany, and started calling on accounts across the continent and on to England. Mr. Vereen called on the London marketing director of a major multinational soft-drink bottling company, who was not enthusiastic about doing business with Riverside but did agree to have two employees test the uniforms. Later, Vereen went on to Dublin, Ireland, and, among others, called on an executive with a major security firm who was lukewarm about the ability to get a fast response from a U.S.-based firm.

Within a month of his return to Georgia, Vereen had a call from the bottling company's British marketing director, who said he had "a real problem." He reported that workers in the company's 28 plants were demanding uniforms like those tested by their co-workers within 30 days or they were going out on strike. Riverside filled that order.

Shortly afterward, on a Thursday morning, the Dublin executive from the security firm called to say that his company had a new contract with a major automobile firm and needed uniforms for 200 guards by the following Monday morning. He had been unable to find a manufacturer in Europe who would help him. Vereen asked for each worker's name and size and told the executive to have a representative at the Dublin airport on Saturday morning to meet the plane. Guards were to try on their uniforms and, in the event that some did not fit, another shipment would arrive the next day. The shipment arrived in Ireland on Saturday morning, and every uniform fit. Moreover, the Dublin security firm's executive was a speaker at a European security conference shortly afterward and shared the story with conference attendees.

Riverside's international business was launched. Today, the company provides uniforms to firms around the world. Accounts include the major bottling companies (soft drinks and beer), as well as transportation, security, and product and package delivery firms. According to one Department of Commerce source, Riverside exports American-made products to more countries than any other U.S. firm.

Riverside's export business began because one man had the courage to try.

The outer circles represent the uncontrollables in other markets—the elements of the other countries' environment in which the marketer operates; a different set of these elements exists for each country's market. These elements include political forces, economic forces, competitive forces, level of technology, structure of distribution, geography and infrastructure, and cultural forces. Each of these elements represents uncertainty for firms entering a new market, and success depends on the ability to interpret the influence and the impact of each of the uncontrollable elements on the marketing plan. A comprehensive study of international marketing considers these dimensions in greater detail.

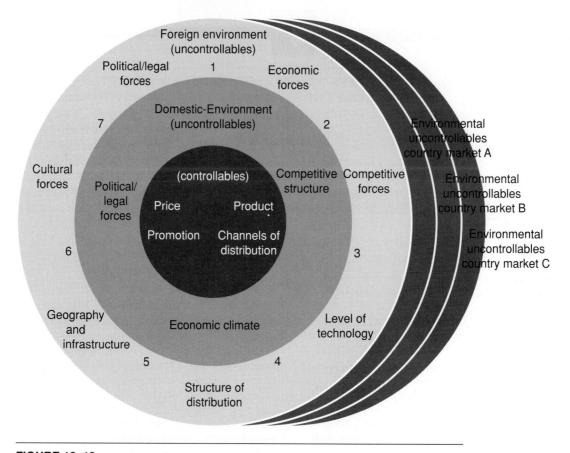

FIGURE 12-10

In international marketing, the elements that cannot be controlled are present at two levels—in the domestic environment and in the environment in other countries. Source: Cateora, P. (1996). International marketing (9th ed., p. 8). Homewood, IL: Richard D. Irwin. Reprinted by permission of Richard D. Irwin.

Sensitivity to environmental differences is among the greatest challenges to textile and apparel manufacturers who attempt to enter other markets. Unconscious reference to one's own cultural values is often the root cause of international business problems overseas. Cateora (1996) noted:

The task of cultural adjustment is, perhaps, the most challenging and important one confronting international marketers; they must adjust their marketing efforts to cultures to which they are not attuned. . . . When a marketer operates in

other cultures, marketing attempts may fail because of unconscious responses based on frames of reference acceptable in one's own culture but unacceptable in different surroundings. (p. 14)

As an example of cultural differences, in many parts of Asia, individual behavior is bound by constraints that force compliance with norms of various groups. The primacy of group identity over individual identity can have a powerful impact on one's dress. In some settings, uniforms or attire that nearly fulfills the role of a uniform (e.g., formal business suits for

the managerial class) reflects the power of group norms compared to more individualistic dress in the West. For example, female dress that could be considered provocative or revealing is not allowed. Practical limitations of the setting come into play as well. In Japan, for example, women who travel to work on trains. where commuters are packed like sardines, may feel compelled to choose conservative attire since they may involuntarily be pressed against an unknown male for the entire trip (anonymous industry source, 1993). Consequently, a manufacturer who intends to sell in certain Asian markets must keep in mind that low necklines and other features that might be considered provocative will severely affect garment sales.

Similarly, cultural differences may have been a factor in the story reported in the previous section about the lack of U.S. textile producers' participation in the Hong Kong trade fair. When the author related this story to a U.S. textile industry leader, he indicated that the fair's organizers had "asked a lot of information about our companies that was none of their business." This is, in fact, how most U.S. citizens would react to questions about privileged information concerning their businesses. To Asians, however, the inquiry about the textile firms may have been simply part of the honest openness many Asians have about matters that the typical American would consider private. In preparing for a trip to Asia, the author had been cautioned that one should not be offended, for example, if asked about personal matters such as one's income, age, and so on. This was wise counsel because the author was asked many times about her height (which, incidentally, is much above the U.S. average for women). On one occasion in Taipei, a group of Chinese girls (who were probably looking for an opportunity to practice their English) asked the author's height; after receiving an answer, they burst into giggles and ran away. The Hong Kong request for information from U.S. textile firms may have been as innocent and

harmless as the queries about the author's height. The key is to accept practices that may be quite different from those in one's own culture. A good rule of thumb is to give others the benefit of the doubt.

International Marketing Philosophies

As firms consider participation in overseas markets, they may subscribe to one of several international marketing philosophies:

- 1. We sell what we make.
- 2. We make what we sell.
- 3. We adapt what we make to the needs of consumers in other markets (Daniels & Radebaugh, 1986, p. 625).

A company's adoption of one of these marketing philosophies makes a great deal of difference in the decisions the company makes regarding its products for the international market.

- We sell what we make. This philosophy may exist when a country begins exporting in a passive manner when buyers learn about the product and order it. Under this approach, companies typically do not adapt products to markets in other countries and often sell what is left over from the domestic market. In some cases, other nations' markets are considered too small or the expense too high for the return involved to justify product adaptation. This philosophy has a production orientation.
- We make what we sell. In this case, a
 country's market is identified but the
 product is varied (although some
 standardization of products for the global
 market may occur). This philosophy may
 prevail when a firm wants to penetrate the
 market in a certain country because of the
 nation's size, growth potential, desirability
 of the market location, or for other reasons.

This philosophy has a consumer marketing orientation.

• We adapt what we make to the needs of consumers in other countries. This philosophy combines the other two. The company retains some standardization in which it has established expertise and efficiencies but adapts to the needs of markets in other countries in order to retain long-term business (Daniels & Radebaugh, 1986).

In the future, as an increasing number of U.S. companies assume an international orientation in their business operations, success will depend upon their ability to develop multicultural sensitivities and skills.

SUMMARY

The textile and apparel industries in more-developed countries have been among the first to experience severe international competition. The relative ease of entry by less-developed countries into textile and apparel production has created intense competition for the industries in the developed countries—both for retaining their own domestic markets and for competing in global markets. As industry and labor in more-developed countries attempt to defend their interests and compete in the international market, these groups use a number of strategies.

First, adjustment strategies have included both firm and industry reorganization to promote more efficient operations. The textile and apparel industries in most developed countries have made substantial progress in restructuring through mergers, consolidations, vertical integration, investment in new technology, and shifts to a stronger marketing orientation. Governments in these countries have given varying degrees of support in the adjustment process, and results have been quite

mixed in terms of performance and international competitiveness. Many adjustment strategies have resulted in job losses. Despite significant structural adjustment in the industries in the more industrialized countries, manufacturers find it hard to compete with low-cost producers.

Policy strategies represent another common response to increased global competition. Initially, trade policies designed to restrain low-wage imports were justified to give the textile and apparel industries in the developed countries a "breathing space"—that is, time to adjust to the growing competition. The less-developed countries, many economists, and free traders have asserted that industry restructuring occurred too slowly because producers relied on trade restraints to protect the more-developed countries' markets.

Several factors led to increasingly complex and institutionalized policies to control imports from the developing countries. Among these factors were substantial import growth, a growing protectionist mood, employment losses, a concern for protecting industry investments, competitive disadvantages, concerns about burden sharing, and the industry's political prowess. Arguments to justify increased use of protective policy strategies included the need to maintain employment, slow the pace of adjustment, preserve the incomes of certain groups, protect domestic labor against cheap foreign labor, preserve key industries, support new industries, use protection as a lever to open markets, and combat unfair trade.

While the less-developed countries have protested against the restraints on their textile and apparel exports, producers in the developed countries have begun to demand reciprocity in trade matters—that is, a level playing field. Many U.S. manufacturers are troubled by practices such as dumping, subsidies, high tariffs, closed or partly closed markets, and the granting of foreign aid to assist the development of the textile and apparel industries in less-developed countries.

Ironically, the policy strategies of the developed countries designed to restrain imports resulted in unexpected consequences. In many cases, restraints led to the development of new suppliers, shifts in product lines, product upgrading, guaranteed market access, establishment of foreign-owned plants in the importing markets, and circumvention of quotas.

Whereas restructuring and policy measures are responses to global changes, the U.S. textile and apparel producers launched *proactive* marketing efforts as an offensive approach in countering foreign competition. Manufacturers learned that they must assume a stronger marketing and service orientation to regain and retain retailers' business. Inventory replenishment strategies, made possible through electronic data interchange (EDI), have resulted in a closer working relationship within the domestic company.

In addition, a number of developed-country textile and apparel producers have realized the importance of participating more actively in the international arena. These firms have become aware of the advantages of international linkages for both production and marketing operations. Among these global initiatives are global sourcing, multinational enterprises, international licensing, direct investments, joint ventures, and exporting. A number of basic international marketing considerations must be taken into account to ensure success in differing cultural environments.

In summary, industry and labor groups in the developed countries have used a number of strategies to defend their interests in an increasingly complex and demanding global market. Many of these strategies have helped increase global competitiveness, while others have protected domestic markets.

GLOSSARY

Antidumping duties are duties that may be levied against dumped goods if dumping causes injury

to the industry in the importing country. These duties may be equal to the difference between the export price of the products and their fair value in the export market.

Capital deepening refers to an increasing investment in a firm or in the industry in general.

Countervailing duties (See glossary in Chapter 10.) Direct investment refers to ownership of a substantial interest in a foreign operation.

Dumped products are products exported at prices below their fair market value or products sold abroad for less than they sell for domestically. Dumping is considered an unfair trade practice.

Electronic data interchange (EDI) is the electronic exchange of business data between two parties to facilitate ordering, manufacturing, or distribution of goods.

Export subsidies are government payments to a manufacturer or exporter contingent upon the export of goods. Export subsidies are also a form of dumping and are illegal under international agreements.

Fair trade is a term used by the textile and apparel industries in more-developed countries as they seek reciprocal trade privileges with the lessdeveloped countries. The more-developed country industries have argued that trade should take place on a level playing field.

Industry strategy refers to the prevailing or dominant strategy adopted by an industry's larger and more progressive firms; it does not mean that all firms within an industry have adopted identical strategies, and combinations of strategies are common (Toyne et al., 1984).

International marketing is "the multinational process of planning and executing the conception, pricing, promotion, and distribution of ideas, goods, and services to create exchanges that satisfy individual and organizational objectives" (Onkvisit & Shaw, 1997, p. 7).

Inventory replenishment refers to using Quick Response (QR) or other programs based on EDI systems through which manufacturers can respond quickly to retailers' need to have inventory replenished as it sells.

Joint venture refers to the partnership between firms at the corporate level. Joint venture partners may be domestic or international. More than two partners may be involved. This is one way of entering the market in another country.

Market access refers to permitting foreign companies outside a country to sell in the domestic market. U.S. and European textile and apparel firms want market access (i.e., reciprocity) for their products in less-developed countries.

Mechanization refers to the replacement of human la-

bor with machines.

Multinational enterprises (MNEs) are firms with an integrated global approach to production and marketing, and with both domestic and overseas operations. Also see *transnational corporations* in Chapter 4.

Rationalization refers to the elimination of excess steps in the labor (production) process. In industrial terms, this also refers to eliminating the weak (or "irrational") components of a business

or a sector.

- Reciprocity is a principle of WTO/GATT under which governments are expected to extend comparable concessions to each other. However, the less-developed countries have not been required to offer fully reciprocal concessions; this is referred to as nonreciprocity.
- Retaliation in trade occurs when one country responds to another's trade restraints by enacting measures intended to be detrimental to the country imposing restraints (e.g., by refusing to buy certain products because restraints were imposed on other products or services).
- Subsidies are financial benefits conferred on a firm or industry by the government. Providing subsidies is considered an unfair trade practice.

Vendor is an industry term for the manufacturer or supplier.

SUGGESTED READINGS

Bernstein, A., Konrad, W., & Therrien, L. (1992, August 10). The global economy: Who gets hurt? *Business Week*, pp. 48–53.

This article discusses the impact of the global economy and global shifts of production on the U.S. workforce.

Congress of the United States, Congressional Budget Office (1991, December). *Trade restraints and the competitive status of the textile, apparel, and nonrubber-footwear industries*. Washington, DC: Author.

An evaluation of the status of these industries, particularly in terms of the potential impact of the Uruguay

Round and NAFTA agreements.

Ghadar, F., Davidson, W., & Feigenoff, C. (1987). U.S. industrial competitiveness: The case of the textile and apparel industries. Lexington, MA: Lexington Books.

This book reviews global and domestic forces that have affected the performance of the U.S. textile and ap-

parel industries.

Standard & Poor's (published periodically). *Industry* surveys: Apparel and footwear. New York: Author. An analysis of the industry and recent business performance.

U.S. Department of Commerce (published periodically). A basic guide to exporting. Washington, DC.:

Author.

Basic information on how to start exporting and to have export efforts succeed.

U.S. Department of Commerce, International Trade Administration (published annually in most years). *U.S. industrial and trade outlook*. Washington, DC: Author.

An overview of the domestic industry and its competitive position globally.

13

The Interests of Retailers and Importers in Textile and Apparel Trade

Retailers and importers, like textile and apparel manufacturers, have a great deal at stake in textile and apparel trade matters. Representing positions on textile/apparel trade as seemingly incompatible as oil and water, the importing/retailing sector and the manufacturing sector¹ have been at odds in recent years and have taken their differences to the public and political arenas.

Although conflict between suppliers and retailers is not new, the complexity and the intensity of the conflict between the two sectors regarding textile and apparel imports have added an especially tense dimension to these relationships. Many U.S. textile and apparel manufacturers consider imported products as the primary reason for the decline of the domestic industry; therefore, industry and labor leaders have been strongly committed to restricting imported products. On the other hand, as retailers have experienced a difficult competitive period themselves, they have found imported products to be quite helpful to sales and profits. Consequently, most retailers and importers have favored imports as much as most manufacturers and labor have opposed them. Because of these conflicting positions, it is easy to see why manufacturers and retailers have become adversaries on textile and apparel trade.

U.S. textile and apparel industry leaders believe retailers have played a key role in creating the large trade deficit in these sectors in recent years. Since retailers are the "gatekeepers" in determining what merchandise ultimately reaches the consumer, most domestic manufacturers believe that imported products would not be available for consumers to buy if retailers did not offer them for sale.

Friction between the manufacturers' and the importer/retailers' groups might be expected. Each of these sectors employs large numbers of persons across the nation. Each provides lifeblood for communities—both large and small. Both are intensely competitive sectors in which an overcapacity exists: Overcapacity for production has occurred at the global level, and a U.S. overabundance of retail space—that is, "over-storing"—has developed at the national level. Both are highly competitive sectors in that profit margins tend to be lower than those of many other business and industry areas.

Global market conditions have affected each sector in important ways and have intensified the ill will between suppliers and retailers. In

¹ We must keep in mind that many apparel manufacturers are also importers; therefore, those manufacturers are not included in the anti-import group.

fact, imports have been the most important influence on the U.S. textile and apparel markets since the early 1960s. In recent decades, as U.S. manufacturers have experienced intermittently sluggish markets because of declines in the economy, they have also felt the impact of a growing number of new global suppliers who took an increasing share of their markets, particularly for apparel. The global proliferation in the supply of textile and apparel products created a "buyer's market" in the truest sense of the word. Low-cost products and other favorable market conditions began to encourage retailers and importers to bring increasing amounts of textile and apparel imports into U.S. markets (Figure 13-1). As importers and retail buyers sought greater variety, exclusivity, and attractive prices in their merchandise selections, they soon considered global sourcing as a normal strategy. Buyers' proficiency in tapping into the international array of products has not enhanced their

popularity within textile/apparel industry circles, however.

Many U.S. manufacturers see textile and apparel imports, unless controlled, as leading to the demise of these industries. Retailers and importers, on the other hand, find increased import restraints both frustrating and devastating to their business interests. In recent years, each side has devoted increasing time, energy, and funding to furthering its position on textile/apparel trade policies.

In this chapter, we will consider the special interests of retailers and importers on textile and apparel trade and trade policies. In the softgoods industry, retailers account for about half of the importing of apparel; therefore, most of this discussion will focus on retailers. One should remember, however, that there are also import firms that purchase significant quantities of products and sell them in turn to retailers.

FIGURE 13-1

Retailers and importers buy textile and apparel products from many countries to bring to the U.S. market.

Source: Illustration by Dennis Murphy.

Our discussion will consider retailers' reasons for buying imported textile and apparel goods and the types of problems associated with buying from other countries. In addition, new strategies that are improving U.S. supplier-retailer relationships will be considered.

IMPORTERS

Although the title of this chapter identifies retailers and importers, the focus will be primarily on retailers because the two groups have very similar concerns on matters related to textile and apparel trade. And, in fact, retailers are considered importers of record for customs purposes. However, importers may also be companies that function as "middle agents," buying from overseas producers and selling to retailers in the United States or elsewhere. Many importers specialize in a particular type of product such as sweaters, expensive hand-tied rugs, or hand-beaded evening attire. They generally have a well-devèloped network of overseas producers.

Another important group of importers are firms generally considered apparel manufacturers. Apparel firms that import some or all of their garments have a position on trade very similar to that of retailers. That is, they are against protection of the domestic industry that results in restrictions on imports.

RETAIL SECTOR OVERVIEW

Retailing (all types combined) is a major industry in the United States, employing over 21.5 million persons, roughly 18 percent of the nation's workforce. Annual retail sales are over \$2.4 trillion, which amounted to 32 percent of the U.S. GDP (DRI/McGraw-Hill and Standard & Poor's and U.S. Department of Commerce/International Trade Administration, 1998). Although these statistics refer to all

types of retailing combined, apparel sales alone represent the *most important merchandise* category for department stores, mass merchandisers, and specialty stores.

Department stores and department chain stores (including J.C. Penney and Sears) have been the largest source of retail apparel sales; however, other types of retail outlets are now taking some of the apparel market. Shifts have occurred in the *types of stores* where apparel and other softgoods merchandise are sold as the major discounters and other off-price retailers gradually take market share from department and specialty stores. *Retail consolidations* are a fact of life that affects softgoods companies. In 1992, the eight largest softgoods retailers accounted for 28 percent of all retail apparel sales (National Retail Institute, 1997).

The number of U.S. primary retail companies selling apparel and accessories in 1992 was as follows:

	National Population N
General merchandise stores	10,264
Apparel and accessory	
specialty stores	63,020
Source: National Retail Institute, 1997.	

Sales by major types of stores (in billions of dollars) that sell softgoods products are as follows:

	1992	1994	1996	
General merchandise				
group	245	278	307	
Apparel group	103	109	115	
Source: DRI/McGraw-Hill and Standard & Poor's				
and U.S. Department of Commerce/International				
Trade Administration (1998)				

Despite consolidations in retailing, a substantial proportion of retail firms carrying apparel/accessory lines are relatively small, using the number of employees as a measure. We

must keep in mind that retailing—like apparel manufacturing—is quite fragmented and consists of a large number of small operations, along with firms that are quite large. Representatives of many of these small retail firms are not likely to be vocal or politically active in representing the interests of the retailing sector on trade matters.

A number of broad retailing trends have had an impact on apparel retailing. Discussion of a few particularly important trends follows.

Excess Selling Space

As a result of many retailers' aggressive expansion strategies, the U.S. market is "overstored," creating intensely competitive conditions for retailers. From 1968 to 1993, shopping center footage increased at a rate four times the increase in retail sales. In 1995, shopping space averaged 19 square feet for every man, woman, and child in the country. Despite the glut of retail space in the late 1990s, an average of 10 new shopping malls were built per year. As retailers have attempted to cope with excess selling space, some have vacated marginal locations, consolidated, scrutinized investments carefully, shifted resources to areas where they received the best returns, and enhanced their marketing efforts. A number of retailers tried repositioning strategies.

Retail Business Failures

Given the intense competition brought on by over-storing and other factors, it is not surprising that many bankruptcies and liquidations have occurred in the retail sector. In 1996, there were 13,426 retail business failures (all types), up 3.7 percent over 1995.

Long-established department stores such as the Woodward & Lothrop, Abraham & Straus, and John Wanamaker chains went out of business. Even full-line discount stores filed petitions under Chapter 11 of the U.S. Bankruptcy Code to restructure and try to become profitable again; these included Bradlee's and Caldor. Woolworth Corporation closed its full-line stores to concentrate on its specialty stores. Specialty chains in difficulty or out of business have included Edison Brothers (5-7-9 Shoppe, J. Riggins, JW/Jeans West, and many others), Merry-Go-Round, and Charming Shoppes. These are just a few of the retailers among many that have experienced difficulties in the 1990s.

Restructuring

As a result of mergers, takeovers, and consolidations, apparel retailing has changed dramatically. Of the seven companies comprising the Standard & Poor's Department Store Index in 1986, only three are in business and in the index today. For example, Federated Stores bought Macy's. Similarly, May Company, Profitt's, and Dillard's have acquired other regional or smaller chains. Additionally, Federated and May Company consolidated divisions and centralized operations to reduce costs.

Now, more and more power is concentrated in the hands of fewer retailing firms. Department stores, mass merchandisers, and a few specialty chains have become increasingly powerful. The concentration of buying power means that an increasingly small pool of megamerchant buyers will be working with suppliers, both globally and domestically. This means that retailers are in a position to make more and more demands of their suppliers. They may expect cooperative advertising funds, preticketed merchandise, and even floor-ready merchandise.

Emergence of Power Retailers

Power retailers (some are known as "category killers") are fast-growing chains that attract customers with superior merchandise, sharper pricing, or greater convenience than their competitors (examples are Wal-Mart, Barnes and Noble, Home Depot, and Toys "R" Us). They are revolutionizing the retailing industry with performances that far exceed the industry av-

erage. The collective share of the market being taken by the power retailers, plus the consolidations of other large retail firms, mean that the gulf is widening between the megamerchants and the smaller, less-competitive retailers. In 1996, for example, Wal-Mart accounted for about 16 percent of all U.S. general merchandise, apparel, and furniture sales.

Repositioning Strategies

The intense competition in retailing has caused many retailers to reposition their companies—either in the types of merchandise sold or, in some cases, in the markets sought. J.C. Penney, for example, used both of these strategies, shifting to softgoods lines and away from household durables and automotive products. Then, within softgoods lines, Penney traded up from the "mass merchandiser" image to higher-cost product lines to lure the traditional department store customer.

In contrast, in 1989, Sears assumed a discount store orientation and to an extent reduced its emphasis on apparel. Having difficulty in defining who and what it was, within 3 years Sears decided to become primarily a softgoods merchandiser, which included ending the catalog business and revamping stores to draw the apparel customer in particular. The "Softer Side of Sears" strategy has been a successful shift for a retailer that faced a bleak future not very long ago.

Nonstore Retailing

Although nonstore retailing accounted for 15 percent of retail sales in 1994, consultants at Kurt Salmon Associates predict that by the year 2010, 55 percent of retail sales will be through a nonstore medium. Although the demise of the Sears catalog seemed for a short time to signal a decline in nonstore retailing, the Quality Value Convenience (QVC) channel soon became one of the hottest topics in the softgoods industry, with sales that astounded

manufacturers and retailers alike. Despite the fact that QVC is considered a major retail force, other retailers such as Saks Fifth Avenue, Spiegel, Macy's, and Neiman Marcus contracted for blocks of time and had remarkable sales. Manufacturers began to see the tremendous potential for television shopping. Together, QVC and the Home Shopping Network had total sales estimated to be over \$5 billion in 1995.

Similarly, the Internet has tremendous potential, particularly when consumers can be assured that their credit card information is secure. Estimates for potential Internet sales by the year 2000 range from \$7 billion to \$16 billion. Some retailers such as Amazon Books, with a database of 2.5 million titles, have moved aggressively into Internet sales. (Greenberg, 1997; conversations with industry sources).

Catalog sales to consumers climbed to \$38.6 billion in 1995. This included a range of merchandise; however, apparel is one of the most popular product categories for catalogs. Familiar catalogs featuring apparel are J.C. Penney, Spiegel, Lands' End, Eddie Bauer, and L.L. Bean.

A number of factors have led to the growth of nonstore retailing. Some of these include time pressure, concerns for security, frustration with stores and malls, and other matters related to convenience.

Private Label Programs

Private label lines are merchandise lines manufactured for specific retailers and sold exclusively in their stores. Private labels have been used as merchandising tools, particularly in apparel merchandising. When private label lines originated, these goods were used to reflect a store's originality (or, in many cases, good value for the price). Soon, however, they became important sources for improved markups. In many cases, private label retailers have been major users of lower-cost imported products to provide healthy markups. Imports

for private label use will be discussed further in a later section.

Matrix Buying

As retailers have scrambled to survive in the difficult economic environment of recent years, many have concentrated their purchasing power on a much more limited group of vendors in a strategy called matrix buying. Called "the matrix" in the industry, this preferred vendor list consists of suppliers who can supply the products, service, and pricing that retailers need to execute their respective strategies. For example, Federated Stores centralized its former divisional men's tailored clothing and reduced the number of vendors from 52 to 11. A Kurt Salmon Associates study revealed that half of the top retailers planned to reduce their supplier lists in most categories. As a result of this trend, apparel manufacturers will find it increasingly important to develop close relationships with retail customers.

BACKGROUND ON CHANNEL RELATIONSHIPS

For several decades, scholars in the fields of marketing, management, and retailing have studied relationships among members within the supplier-retailer channel of distribution. Although many different definitions exist, Bucklin (1966), one of the early writers on channel relationships, defined the **channel of distribution** as a set of institutions that performs all the functions required to move a product and its title from production to consumption.

Literature on channel relationships helps us to realize that the conflict between manufacturers and retailers is not new. Therefore, as we consider the difficulties between manufacturers and retailers pertaining to textile and apparel trade, we might think of these as late-20th-century global chapters in a saga

that has persisted for decades. Admittedly, several changes in the global business environment have intensified the difficulties in supplier-retailer relationships.

Although channel relationships are basically economic in nature, social relationships underlie economic connections. Sturdivant and Granbois (1973) asserted that channel complexity and dynamism make economic and quantitative models inadequate. Therefore, a large part of the theoretical and empirical work in this field has focused on the behavioral aspects of channel relationships such as power and conflict. Conflict and struggles for leadership or power are natural in working relationships and are inevitable in distribution channels; therefore, power and conflict have been among the most commonly examined dimensions of channel relationships (Etgar, 1976; Frazier, 1983; Lusch & Brown, 1982). Stern (1969) considered a social systems approach for channel relationships, which had the following major implications: (1) each member of a distribution channel is dependent upon the behavior of other channel members; (2) a behavior change at any point in the channel causes change throughout the channel; and (3) the whole channel must operate effectively if the desires of any one member are to be realized (p. 2).

Most experts have concluded that retailers inevitably have a large degree of power in the channel relationship (i.e., channel control) because merchants provide access to the consumer. Most consumer goods pass through a channel of distribution, through various suppliers early in the channel and retailers at the end (Mallen, 1963). Since merchants represent the means through which suppliers get their products to consumers, harmonious working relationships with retailers are critical to manufacturers. If retailers do not buy a manufacturer's products for their stores, the producer has limited opportunity to get the company's merchandise to end-use consumers. This power puts retailers in a position to make increasing demands on manufacturers if they choose to do so. Retailers may make quality, price, or timing demands that are difficult for the supplier to meet—yet, manufacturers must comply to retain accounts. Brown (1981) found that in more formalized marketing channel relationships, retailers tended to make greater demands of their suppliers than is true in less formalized relationships. Shootshtari, Walker, and Jackson (1988) found that members of the three retail trade associations perceived their associations as a modest source of power in relation to their suppliers.

In short, as each segment of the channel pursues its own business strategies, often these are not in the best interests of that segment's traditional channel partners. Although this has been true traditionally, global market conditions have intensified the difficulty in apparel supplier-retailer relationships. As retailers turned increasingly to low-cost imports for their apparel lines, U.S. manufacturers felt the impact of lost sales. Traditionally, retailers have had greater power in the supplier-retailer relationship; however, the added option of being able to turn to producers in other countries for lower-cost products or for other reasons has increased retailers' power in channel relationships.

RETAILERS AND IMPORTS

In recent years, most retailers have been attracted increasingly to the purchase of textile and apparel products, particularly apparel, made in low-wage countries as part of their **sourcing** strategies. Data from the American Apparel Manufacturers Association (1984) indicate that as recently as 1975, only 12 percent of the apparel sold by U.S. retailers was imported. Today, well over half is imported; in some product lines, virtually all is imported. In earlier years, retailers bought and sold imported apparel in a relatively limited number of product lines, including inexpensive shirts,

blouses, sportswear, and decorative infants' wear. Later, however, retailers expanded both (1) the new garment lines, in which imports became an important part of inventories (imports are now found in virtually all lines) and (2) the number of countries from which they sourced apparel. Now retailers carry varying proportions of imported apparel in most product lines and from a wide range of countries around the world. Moreover, a majority of retailers consider overseas sourcing or international sourcing a fact of life in today's competitive retailing environment. As a result, a typical U.S. clothing store (or department) now resembles an international apparel shop when one considers the array of countries in which the garments were produced.

Textile and apparel retailers became part of a larger economic shift away from self-sufficient national economies to an integrated system of worldwide production. In our earlier discussions on trade theories, the critical question was: Where can products be produced most efficiently in terms of resource availability and relative cost of resources compared to production in other countries? For apparel production, the labor costs involved in assembling garments were at the heart of the issue.

Just as apparel firms are manufacturing more of their lines in less-developed countries, retailers too have taken advantage of the choices and prices available to them in this global market. As a growing number of countries began to produce apparel for the world markets, retailers found overseas suppliers eager to cater to merchants' needs. Producers in less-developed countries offered garments produced by workers earning as little as 25 cents per hour, in contrast to those produced by much higher-paid workers in U.S. (or other more-developed country) factories.

Eager to attract business, overseas textile and apparel producers were willing to produce according to retail buyers' wishes which might include special design features, smaller production runs than many U.S. firms would consider, or other special requests. And, significantly, retailers' global sourcing options increased dramatically during an era when U.S. retail competition became more intense. Therefore, as over-storing and more difficult retail competition occurred, overseas sourcing provided merchants with alternatives for variety, exclusivity, and attractive prices. In short, retailers secured overseas-made textile and apparel products because these served their interests well. Conditions of the market economy attracted retailers to suppliers in other countries—with no intent to injure the U.S. textile and apparel industries.

Types of Global Sourcing

Retailers secure textile and apparel products from other countries through a variety of arrangements. Business relationships range from those in which the retailer is involved minimally in the production of the merchandise to those in which retailers have assumed more and more of the production responsibilities, essentially becoming manufacturers themselves. In general, sourcing options for retailers (which also include domestic sourcing options) are as plentiful and varied as they are for manufacturers. A review of apparel manufacturers' sourcing options in Chapter 9 may be helpful at this point.

Figure 13–2 depicts a common change taking place in the retailing industry today. The upper part of the figure depicts retailing when **overseas buying offices** (also called *foreign buying offices*) played a major role in retailers' sourcing in other countries. A retailer's buying office in another country played a major role in helping the buyers (in the home office) find appropriate merchandise from manufacturers in that country. Then the buying office was responsible for being sure that the merchandise met certain standards and was shipped in a timely manner.

The overseas buying office is now becoming a thing of the past. Instead, as retailers have

taken on manufacturing responsibilities (vertical retailing) to produce private label lines, a new strategy is becoming common. Now, for a growing proportion of the private label merchandise in their stores, retailers develop their own lines and hire contractors to produce them. See the lower half of Figure 13-2. Although retailers' overseas offices may still assist some buyers in the buying functions, more and more these offices are taking on manufacturing responsibilities. As staff in these overseas offices work with product development staff in the home office, they may be involved in some aspects of styling or designing, overseeing fabric purchases, developing garment specifications, hiring contractors, providing quality control, and arranging for the packaging and shipping of merchandise to their stores. Together, the retailer's product development staff in the home office, in concert with the staff in the overseas offices, is performing all the manufacturing activities except for sewing the garments-and the latter are responsible for overseeing that. See Box 13-1. Thus, we see that vertical retailers are performing virtually the same operations as many companies that are generally considered apparel manufacturers. These retail private label operations are similar to those of Liz Claiborne, for example, which has no production facilities of its own.

In many instances, U.S. retail firms have trained overseas producers to be more competitive by helping them to be sensitive to American expectations of style and quality. Often, this has included technical assistance in producing garments to meet these expectations. In these arrangements, retail agents have played a role in transferring expertise (and sometimes accompanying technology) to overseas producers. In particular, technical assistance has been required by producers in countries first entering apparel production; however, as a nation and its industry become more advanced in technological and other skills, outside advice is required less and less. For exam-

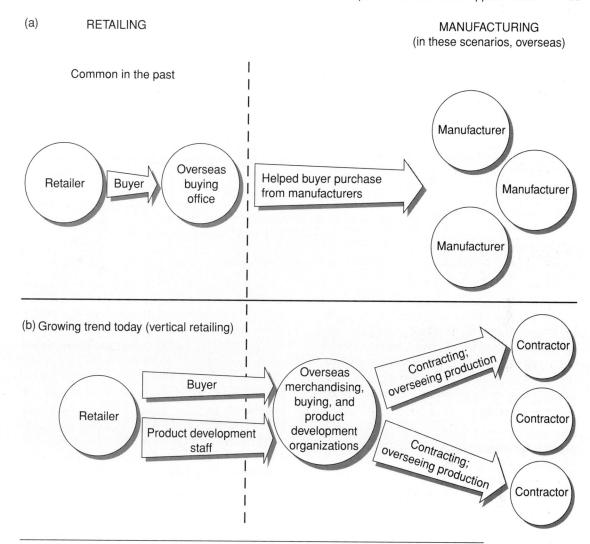

FIGURE 13-2

In their private label programs, retailers are taking on increasing production responsibilities. (a) At one time, overseas buying offices helped retail buyers find merchandise produced by a variety of manufacturers. (b) Today, retailers' overseas offices are actively engaged in production functions and in monitoring contracted sewing (and other) operations.

ple, agents in locations that have advanced to the level of the NICs are providing technical assistance themselves. Retail firms are likely to have their offices for activities described above in Hong Kong (for example, to coordinate production in China, or in Singapore to oversee production in Southeast Asia. See the bottom of Figure 13–2.)

Regardless of the types of business relationships U.S. retail firms have established with manufacturers in other countries, these overseas suppliers have benefited from production,

BOX 13-1

WHO IS A RETAILER AND WHO IS A MANUFACTURER?

Private label production has spawned new sights in the softgoods industry.

- Among the crowded lofts of New York City's garment district, a large department store group has its own design studio, fully equipped with CAD terminals that are the envy of its apparel manufacturer neighbors.
- On the classified pages of industry publications, retailers' large help-wanted ads com-
- pete with those of manufacturers for the same designers, production coordinators, and quality assurance people.
- At apparel industry trade shows, retailers now inspect garment components and production equipment alongside apparel manufacturers.
- In Asia, representatives of U.S. manufacturing and retailing firms are contracting production with the same garment plants.

marketing, and other expertise provided them. As might be expected, many U.S. textile and apparel manufacturers have resented having U.S. retail firms "train" foreign competitors. (On the other hand, manufacturing firms often do the same thing when they contract for offshore production.)

Retailers' Reasons for Buying Imports

Most retailers buy and sell imported textile and apparel products (most of our discussion will focus on apparel) for a variety of reasons. Some of the more common reasons will now be discussed.

Lower Costs—and Possibly Higher Markups

As noted earlier, the lower costs of imported apparel have been an asset to retailers during difficult competitive periods. In the 1970s, retailers in most developed countries turned to imports for a growing proportion of their apparel inventories. Maas (1980), a member of the Board of Management of Herma BV of Amsterdam (one of Holland's larger chain stores)

and past president of the European Foreign Trade Association in Brussels and Cologne, defended retailers' heavy purchases of imported items by saying: "The trade is forced to supply the best possible value at the lowest possible prices. Such supplies must increasingly be purchased in those Third [-World] countries which provide good quality products at reasonable prices because of the advantages they have over others" (p. 179). Maas reflected the sentiment of a large number of retailers in more-developed countries.

A U.S. study by Pregelj ("When Free Trade," 1977) was the first to call attention to retailers' markup practices on lower-cost imported apparel. Pregelj's "Library of Congress Study on Imports and Consumer Prices" concluded that many retailers, not consumers, benefit financially from apparel produced in low-wage countries. Pregelj's findings triggered many questions regarding retailers' higher markups on low-cost imports from developing countries.

The National Retail Merchants Association (NRMA, 1977) replied to the Pregelj study, detailing the added costs involved in importing, which necessitate higher markups. Cited were (1) higher buying expense; (2) longer lead time; (3) absence of recourse to return defective ship-

ments; (4) uncertainty of costs due to currency fluctuations and freight rate changes; (5) absence of cooperative advertising funds and promotional packages; and (6) difficulties associated with sensitive timing for fashion items in relation to the unpredictable nature of importing. The report also emphasized the competitive nature of the department store business, which resulted in a 3 percent average net profit on sales during the 10 years prior to the report.

A fact of life in today's retail climate is that most merchants feel the need to find ways to offset downward pressure on profit margins. As Van Fossan (1985), a consultant to the softgoods industry, noted to manufacturers: "The search for higher initial mark-on, followed (in theory) by higher gross margin, is a critical factor in any sourcing decision. . . . Remember the buyer's perspective; he can land merchandise at 60% to 70% mark-on² and still play the promotional game with better than average gross margin results. There is a real benefit in being able to plan off-price events without giving away the store" (p. 1). Some retailers also believe that the higher markups on imports help to offset the greater risks of importing.

Attractive Prices to Customers

If the savings associated with production in low-wage countries are passed on to customers, rather than absorbed in higher retail markups, imported products may be offered at attractive prices. Many mass merchandisers (and other retailers as well) whose reputations are based on offering good quality at affordable prices do, in fact, pass the lower costs on to consumers. In addition, imported apparel products offered for sale in these stores may feature complex production details possible only where labor costs are quite low; examples

are smocking, hand embroidery, piping, and intricate tucks and pleats. Labor costs in more-developed countries such as the United States would make garments with labor-intensive details of this type exceedingly costly—perhaps outside the price range of mass market customers.

In short, many retailers believe imported apparel has been a good buy for their stores and for their customers. Sternquist and Tolbert (1986) found that a majority of retail buyers believed imported merchandise "provided better quality for the price than domestic apparel" (p. 8). Department store buyers, in particular, acknowledged higher markups on imported apparel. In many cases, retailers assert the higher markups are used for **price averaging.**

Variety and Exclusivity

Retailers argue that overseas-made products provide important variety and exclusivity for their inventories. Fashion retailing thrives on variety. Furthermore, the demand for uniqueness is critical so that retailers can distinguish their merchandise and their stores from their competition. Because apparel retailers require a steady flow of new and distinctive products, global sourcing yields more variety than a national market can provide.

Often retailers have gone offshore for their apparel lines because they have been unable to get the design and fabrication they wanted from U.S. manufacturers. As we discussed earlier in chapters pertaining to the domestic textile and apparel industries, this sector of U.S. manufacturing has been geared to volume production. Moreover, the large, captive domestic market of earlier decades had not required the U.S. industry to pursue a serious marketing orientation. Manufacturers produced what they believed they should produce, and in the days before increased overseas competition, the U.S. market generally absorbed the merchandise. As a result of this earlier lack of a marketing orientation, retailers have claimed

² Markup or markon figures used in this chapter are based on retail sales unless stated otherwise.

468

that American manufacturers have not been receptive to merchants' requests for special styling, fabrication, or other features that provide variety and exclusivity. In short, many retailers have felt that the high-volume orientation of U.S. suppliers has provided too much sameness and that U.S. suppliers are not close enough (i.e., sensitive enough) to the consumer.

Private Label Lines

As competitive conditions of retailing fostered the development of private label lines to provide distinctive merchandise, apparel retailers became primary users of this strategy. Both department stores and specialty stores have made increasing use of private label programs. The Gap and The Limited (all of its stores, such as Victoria's Secret, Lerner, and Structure), sell virtually all private label merchandise. Private label apparel represents a major retailing trend that has permitted stores to develop their own lines. The apparel line is developed by the retailer and bears a label adopted by that retail firm for its private label or "branded" lines. Examples of private label lines are J.C. Penney's Arizona jeans, St. John's Bay and Hunt Club, WalMart's Kathie Lee line, May Company's Valerie Stevens line, and The Gap's Old Navy line.

Strong private label programs permit retailers to differentiate themselves from their competition. Private label merchandise is manufactured (contracted) by retailers and sold exclusively in their own stores or specialty shops. Private label lines create new brand names in a customer's mind, providing a measure of exclusivity to the retailer. Although department stores have long produced a number of house brands, most were staple merchandise. Now, however, updated private label lines are taking business away from wellknown designer lines. Private label goods constitute well over one-fourth of all apparel sold today. At J.C. Penney, private label merchandise makes up over 60 percent of the women's apparel volume and is the fastest-growing part of the chain's merchandise mix. At Saks Fifth Avenue, 30 percent of women's sportswear, excluding designer goods, is private label (Perman, 1993).

Although private label lines can be produced for retailers by U.S. contractors, more often than not, they are produced in less-developed countries. See Figure 13–3. In fact, private label programs have accounted for a substantial proportion of retailers' increased purchase of goods made in other countries. In most private label programs, the retailer bypasses the U.S. producer and goes directly to the overseas manufacturer.

Retailers often feel that they have more "ownership"—that is, they can be more creative and exercise greater control—of their private label programs that use imports compared to merchandise bought from domestic resources. Although it is a sensitive subject, experts generally agree that private label merchandise carries higher than usual markups another reason for the healthy growth of private label programs. The move to private label lines represents a significant shift in merchandise procurement in the softgoods industry that appears to be permanent. Retailers have already shifted millions of dollars to private label lines, and the trend is expected to continue. Consumers are said to like private label merchandise because it gives them more choices. Consumers have now come to consider many well-established private label lines as "brands" (Lewis, 1995).

Certain Products Are Not Available from Domestic Producers

Retailers say that certain products either are not available or have been increasingly difficult to secure domestically. Here, retailers are referring to products other than those for which they seek variety or exclusivity. In some cases, these are products for which domestic firms have abandoned production because of

FIGURE 13-3

These work order boxes in the product development department of a major retail chain indicate the countries where its private label contracting occurs.

Source: Photo by Kitty G. Dickerson.

difficulties in competing with overseas competition. The following products are examples.

- Shoes are a prime example. As the labor-intensive U.S. shoe industry finds it increasingly difficult to compete with lower-cost imports, American shoe factories continue to close their doors. Currently, about 80 percent of all shoes sold in the United States are imported. Retailers can no longer secure an adequate domestic inventory of shoes for their customers, even if prices are comparable and they choose to do so.
- Gloves have become increasingly difficult to buy from U.S. suppliers. Again, the labor-intensive aspects of glovemaking pose difficulties for manufacturers in higher-wage countries. Consequently, few U.S. glove producers remain in business.
- Standard-quality dress shirts (and some other shirts as well) are becoming increasingly difficult to buy from U.S. suppliers. The labor-intensive nature of dress shirts—with the characteristic banded collars, placket cuffs, yokes, and placket

- fronts—has caused a great deal of this production to shift to low-wage countries. In fact, retailers may have some difficulty securing domestically produced shirts from U.S. apparel firms—because they, too, have taken advantage of lower wages and have their own lines produced in other countries.
- In most high-wage countries, a supply gap has occurred in domestically produced children's wear, particularly at lower prices. Because wages represent a high proportion of the production costs in children's wear (this is also true for adult clothing, but it is more so for children's clothing), manufacturers in high-wage countries have found it difficult to produce inexpensive children's clothing.

Overseas Producers' Service and Willingness to Please

Eager to secure and maintain the business of U.S. and other developed-country retailers, manufacturers in the textile- and apparel-exporting nations make a special effort to serve retail customers. Many foreign producers are

keenly aware of the global oversaturation of textile and apparel products and know that if they are to succeed within that climate, they must not only offer good prices but also be willing to accommodate the wishes of the customer. Therefore, manufacturers in other countries often are more receptive to retailers' styling and other requests than domestic producers were. Similarly, retailers have reported that overseas producers have been willing to provide short production runs and exclusivity, whereas most American manufacturers have turned their backs on these orders.

Inertia

One consultant speculated that "inertia" accounts for some direct importing by retailers. As he noted, it is last season's or last year's performance, good or bad, that provides a direction or course of action for many retailers. *Inertia* refers to the established way of looking at things or doing things. The consultant's point was that if buyers secured their apparel lines overseas the previous year, they probably continued doing so without a thorough review of long-term costs and benefits available through a wide array of sourcing options (Van Fossan, 1985).

A Survey of Retailers' Reasons for Buying Imported Apparel

In a study of U.S. retailers' practices in buying and carrying imported apparel, merchants were asked to identify their reasons for buying imported clothing. Retailers' answers, which were generated in response to open-ended questions (in other words, options for answers were not presented), are summarized in Figure 13–4.

Findings from the study supported the assumption that retailers carry imports primarily because of attractive price differences; however, the results also show that greater variety, exclusivity, and better quality were important reasons.

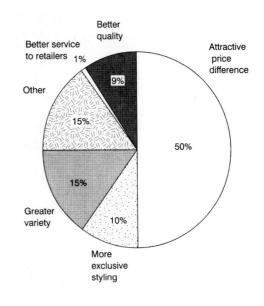

FIGURE 13–4 Retailers' reasons for buying imported apparel.

In this same study, retailers were also asked to share their views on the quality of imported apparel compared to that of U.S.-made clothing. Of the respondents, 10 percent saw imported apparel as better in quality; 31 percent saw the quality as the same; 51 percent believed imports to be of lesser quality; and 7 percent were undecided (Dickerson, 1989).

Problems for Retailers in Buying Imported Apparel

Although retailers have found a number of advantages in overseas sourcing, they have also encountered many problems and disadvantages. For many retailers, imported products have been a mixed blessing. Some of the more common problems will now be discussed.

Poor or Unpredictable Quality

Particularly when Third-World countries are in the earlier stages of development and when

they first enter production in the industry (generally in apparel assembly operations), products often are of poor or unpredictable quality. Also, garment design is often unsophisticated and inconsistent with current style trends. Although quality generally improves as the country's industry develops, large quantities of products are shipped to the importing markets of the United States and Europe before production skills and other expertise reach the level to produce merchandise consistently acceptable to discriminating consumers in more-developed countries.

Workers in less-developed countries who have never owned—or perhaps never even seen—quality garments according to Western standards may have difficulty understanding the need for straight stitching and other perfected details. Even plant supervisors who are natives of the exporting country may fail to recognize the types of flaws that will cause a garment to be considered of poor quality in more-developed countries.

As a result, many retailers and many consumers have experienced poor quality in imported apparel. Particularly in earlier years, many Asian imports were poorly sized; the sizes

seemed more appropriate for smaller Asians than for Western customers. Major shortcomings were prevalent; for example, children's knit shirts often had crew necks that would not go over a child's head without hurting the child. Stitching has continued to be a major problem, especially for new producers. Puckered and crooked stitching are telltale signs of a beginning country's level of production skills. Shirts with two front pockets may have asymmetrical placement on both sides. At times, stitching will be good but poor-quality thread is used, which shrinks dramatically in laundering or breaks easily with wear. Similarly, poor-quality interfacings and other component parts yield poor end products. At times, the component parts are acceptable until the garment is worn or cleaned; then interfacings shrink and buttons crack.

Negative experiences with imported products may leave a disproportionately unpleasant memory in the mind of the consumer or the retailer. When this happens, one may have a tendency to consider imports in general as being of poor quality. For retailers, disappointing products may lead to **markdowns** (Figure 13–5).

FIGURE 13-5

In a well-known vacation area where T-shirts are popular souvenirs, a merchant plays on customers' recollections of unsatisfactory experiences with imported garments. (We should note that in recent years Pakistani producers have made a concerted effort to upgrade the country's textile products. Often, however, negative impressions remain with the consumer.)

Source: Photo by Kitty G. Dickerson.

Adept retailers learn how to guard against risks. Proficient buyers establish and maintain relationships with foreign producers who provide consistently acceptable merchandise. Moreover, retailers have trained overseas producers to aid them in making garments of acceptable quality. At times, retailers believe that the attractive pricing in a developing country makes the gamble on obtaining acceptable products worthwhile. Staff in the inspection department of a major retailing firm remarked to the author that their merchandise from Bangladesh had many quality problems. This country fits the description of a poor, developing country struggling to develop; consequently, buying products made in Bangladesh carries with it the risks we have discussed. Retailers may, however, find that the attractive price differential (e.g., hourly wages for workers in Taiwan are several times those for workers in Bangladesh) makes it worthwhile—even with the risks and headaches involved—to secure products from Bangladesh rather than from a more proficient country.

Up to now, we have discussed the circumstances that tend to produce poor-quality imported merchandise. However, although retailers list poor quality as the major problem in buying imports (Figure 13-6), this does not mean that a majority of imports are poor in quality. In particular, some Asian countries have developed sophisticated apparel industries that generally produce very good quality products. This does not mean that every manufacturer in those countries produces firstclass products-just as not all U.S. manufacturers produce top-quality merchandise. In general, these countries and many others have perfected their production skills, so quality is not a problem.

In fact, the *quota system has led to improved quality*. Since quotas limit the volume (equivalent square meters)—but not the value—of products shipped from a country, exporting nations have found it to their advantage to "trade up" to higher value-added garments. When

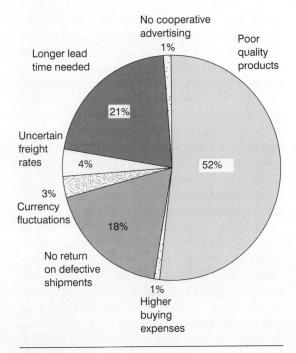

FIGURE 13–6
Problems encountered by retailers in buying imported apparel.

quota limits are tight, a country finds it advantageous to produce \$50 garments rather than \$5 items. Given competitive market conditions, quality increases must accompany this trading up in price; therefore, imported products—particularly from the NICs—have improved significantly in styling and quality to get maximum value under the quota. This upgrading has been common among NIC and other more advanced developing countries, but it is less common among the most underdeveloped countries.

Longer Lead Times Are Required

When retailers buy merchandise from overseas suppliers, long lead times are common. Lead time refers to the time between ordering the merchandise and having it arrive in the store. Although producers in some countries are striving to shorten lead times, a 6- to 9-

month wait is common.³ The following disadvantages are associated with the long lead times.

FASHION CONCERNS. Given the fickle, unpredictable nature of fashion, a number of risks accompany the long lead times required for imported merchandise. Since retailers must make commitments for apparel long before a selling season, buyers risk ordering merchandise that fails to mesh with fashion trends by the time it arrives months later. Or the opposite may occur when buyers fail to sense an important trend and, because of their reliance on imports, can get neither imported nor domestic merchandise in time to take advantage of it. Because of the difficulties associated with synchronizing imports with current fashion trends, some retailers have limited their use of imports to more staple or more classic product lines rather than trendy lines.

FINANCIAL CONCERNS. Long lead times for imported merchandise place serious constraints on buyers' financial operations for an extended period. When a buyer places an order with a domestic supplier, payment does not occur until after merchandise is delivered. In contrast, letters of credit (which represent payment) are required from retailers at the time an order is placed for overseas sourcing. A letter of credit is a document from the importer's bank that extends credit to the importer and agrees to pay the exporter. Consequently, retailers' funds are committed for long periods of time when imports are purchased. For buyers, the limitation on open-to-buy funds for a long period of time poses a serious handicap. Retailers profit from frequent stock turns; with each turn, funds are freed to buy new merchandise to sell. When funds are tied to long-lead-time commitments for imported merchandise, buyers have re-

Slow, Unpredictable Deliveries

Many factors account for slow, unpredictable deliveries of imported textile and apparel goods. Among the reasons are the following.

A DIFFERING SENSE OF URGENCY. Because of cultural differences, business life in many developing countries may not function with the same sense of urgency for meeting deadlines and being on time-characteristics that are both valued and expected in business dealings in the United States and most other importing (more-developed) countries. In some cases, lack of familiarity with the timing demands of fashion in the importing country may mean that the manager of a local garment plant in a remote developing country (where clothing may have mostly functional value) has difficulty comprehending why garments are needed by a certain time to meet the whims of fashion.

ensure prompt, predictable deliveries, manufacturers must have a sound infrastructure. This means that roads, transportation systems, and communication systems must be developed to a level that provides dependable service. In many developing countries, even if the apparel producer completes production on time, the nation's infrastructure may not support the supplier by ensuring safe, predictable delivery of products to major ports for shipping to importing countries.

POLITICAL INSTABILITY. A number of Third-World countries have an unstable political climate, which makes both production and delivery of merchandise uncertain. Orders have

duced or eliminated their opportunities for more frequent stock turns. Even though the services of **factors** may be used in international sourcing, retailers' funds are committed for long periods of time.

³ The Limited is said to charter its own 747 airliner to bring merchandise from Asia to its Columbus, Ohio, distribution center as a way of avoiding long lead times.

been delayed or permanently lost when factories were burned, when workers were afraid to report for work because of military takeovers, or when transportation systems were seized in political riots. In these circumstances, representatives from the importing firms in the developed countries are reluctant to visit production sites to check on quality or other progress. Consequently, most firms in the more-developed countries soon lose patience in trying to deal with political upheaval and find other production sites. In these cases, domestic political battles take an economic toll on the countries that can least afford to lose business opportunities. For example, U.S. apparel firms with contract operations in Haiti stopped doing business there in the mid-1990s when the democratic government was overthrown and terrorism was common.

OTHER UNPREDICTABLE EVENTS. Just as many unpredictable events may affect prompt shipment of domestic merchandise, the same is true for import shipments. A flood in Bangladesh or a typhoon in the Philippines can play havoc with delivery dates. The loss or delay of import shipments may seem more dramatic, however, because of the long lead time and great distances involved. A classic case is the story told by a divisional merchandise manager for a major department store chain. A large portion of this divisional manager's business was in the sweater area. Her division had committed a majority of its sweater open-to-buy for the forthcoming season to imports from an Asian country (and the orders had been placed 6 to 9 months earlier). The sweaters were completed and shipped on time by boat. Then the ultimate disaster occurred the boat sank. The division's sweaters for the season were gone. Timing did not permit reorders from another overseas supplier, and U.S. manufacturers already had commitments to retailers who had ordered from them initially. Moreover, domestic suppliers had little sympathy for a divisional manager and buyers who lost their imports in a sinking boat. As a result, this major retailer had difficulty finding sweaters for the season.

Uncertainties Related to Trade Regulations

As U.S. textile and apparel industry representatives have pressed for increased protection from imports, retailers have experienced a number of additional barriers in securing imported merchandise. Examples follow.

LACK OF QUOTA. Although the quota system established by the MFA is being phased out by 2005, a great deal of textile and apparel merchandise is still under quota. If a category of products is under quota limits from an exporting country, a manufacturer in that country must have access to a quota to ship products to a retailer in the importing country. To illustrate, a Sri Lankan sport shirt supplier may take orders from The Gap and produce the garments, but if the manufacturer has not secured a quota⁴ to cover the shipment, the products cannot enter the United States. Experienced Sri Lankan suppliers, who wish to retain The Gap's account, will have taken precautions to have an adequate quota to cover shipments; however, less experienced or less ethical producers may try to take their chances on shipping merchandise anyway.

Previously, the U.S. Customs' workload prevented close monitoring of **overshipping** (exceeding the country's quota limit for certain categories). Therefore, in the past, overseas producers who lacked a quota sometimes succeeded in shipping merchandise anyway. More recently, however, tightened U.S. Customs controls would likely **embargo** the mer-

⁴ Governments in exporting countries allocate the quota among their manufacturers in a variety of ways. In Hong Kong, the quota is sold and traded. In other countries, it may be distributed by a quota council or another entity that works with the government and manufacturers.

chandise. This means the merchandise must then be reexported or placed in a bonded warehouse until the quota for that period expires or a new quota allowance is in effect.

In recent years, merchandise from China has been embargoed in December because Chinese suppliers had used all the quota in certain categories for the year. While distraught retailers waited for their shipments for the holiday season, the merchandise from China was embargoed in a U.S. Customs warehouse. At the beginning of January, a new quota year began; Chinese shipments were released, but not in time for the holiday season for which retailers had ordered them. Retailers who had planned their seasonal lines around these products lost valuable sales and later received merchandise they no longer wanted.

EMBARGOES BECAUSE OF FAILURE TO COM-PLY WITH OTHER REGULATIONS. The U.S. Customs Service monitors imported products for fraudulent shipments (those with falsified paperwork), transshipments, products mislabeled according to fiber content or country of origin, and counterfeited trademarks or copyrights (fake Gucci bags, fraudulent Rolex watches, etc.). Merchandise in violation of any of these regulations may be embargoed, leaving retailers without the merchandise they ordered. The massive problems with circumvention in the early 1990s and the U.S. government's resolve to deal with these violations mean that retailers and importers must be certain they are dealing with reliable overseas suppliers. Shipments in violation of circumvention regulations may be embargoed and the importer or retailer fined.

ESCALATING QUOTA COSTS. In the past, as quotas tightened, particularly for major Asian suppliers, the scarcity of quota made this authorization to export a valuable commodity. Although quotas will not exist after 2005, they are still required to ship many products. At times in the past when quotas became scarce

and demand increased, the prices of quotas escalated. Although it is unlikely to happen now, the buying and selling of quotas at times became a profitable business on its own in Hong Kong. At times when quota prices were high, some manufacturers were reported to be earning as much from selling their quota rights as from manufacturing and selling apparel. Although garment manufacturers in Hong Kong were willing to pay a high price for a quota, this does not mean they were willing to absorb that cost. Therefore, quota costs add to the cost of apparel shipped under a quota.

Uncertainties of Cost

A number of other factors lead to uncertainties about the cost of imported products. Currency fluctuations can make a great difference in what the retailer pays for shipments. In addition, freight rates may be unpredictable. Because of the unpredictable costs of buying imported merchandise, retailers may not know the status of these expenses until the goods are shipped. Even retailers with extensive importing experience may be unable to avoid these uncertainties.

Lack of Recourse for Poor Service

Unless retailers have established successful working relationships with overseas suppliers who value their business, they run the risk of lack of recourse—particularly when products and their delivery dates do not meet expectations. The privilege of returning unsatisfactory merchandise, which is expected in dealing with domestic manufacturers, is uncommon in doing business with overseas suppliers. To put it more bluntly, the retailer is usually stuck with import shipments, even if they are unsatisfactory. See Box 13–2.

Similarly, retailers have found service lacking on problems such as incomplete orders or delayed shipping. Language and cultural differences often account for miscommunication.

BOX 13-2

THE HIGH COST OF A "BARGAIN"

The men's shirt buyer for a major department store chain purchased a large quantity of imported men's casual shirts. He found the shirts at an exceedingly attractive price and felt he had secured a true bargain. Shortly after the shirts arrived in the store, he began to question his "good buy." Within a short period of time, as customers picked up the shirts to examine them, the buttons cracked and fell off. He found himself the proud owner of a large shipment of shirts with

defective buttons. Returning the defective shipment to the overseas supplier was out of the question. Few customers seemed interested in shirts that lacked buttons. The buyer took massive markdowns to sell some of the shirts and later sold most of the remaining supply to a rag dealer. The buyer's bargain was an expensive lesson on the lack of return privileges for imported merchandise (story told to author by confidential source).

Distances and time differences pose problems in resolving difficulties.

In addition, retailers miss the special services or concessions they receive in dealing with domestic suppliers. As an example, advertising rebates are out of the question when buying apparel from overseas suppliers.

Buying and Shipping Expenses

As retailers look more seriously at the total costs of sourcing overseas, some have found importing to be less cost effective than was first believed. That is, the **first cost** is only part of the total cost of securing the products. Although the initial costs of direct imports are considerably less than the prices for domestic merchandise, additional expenses reduce some of the advantage. Among these additional costs are the following.

COSTS OF BUYING TRIPS. Several trips per year for buying staff members, particularly to Asian destinations, can add substantially to the cost of merchandise secured.

SHIPPING CHARGES. Composite industry data on shipping charges are hard to obtain. The top

apparel executive for a major mass merchandising chain stated that shipping costs for imports are roughly three times those for domestic purchases. For that company, domestic shipping charges are 0.7 percent (based on retail sales) compared to 2.0 percent for imports (confidential retail source). While this may seem a relatively small difference, it would be quite significant for retailers who purchase millions of dollars' worth of merchandise.

TARIFFS AND OTHER IMPORTING FEES. Tariffs on apparel (more than other textile products) are among the highest on imported manufactured goods. U.S. apparel imports carry an average tariff of about 20 percent. As the importing agent, the retail firm is responsible for payment of tariffs on imported merchandise as it enters the United States. Although retailers pay the tariffs initially, they cannot absorb these added expenses; therefore, tariffs are passed on to consumers in the prices they pay for imported products. Retailers must be concerned, however, with the amount by which tariffs inflate the selling price of imported merchandise. Added tariff charges should be a consideration in weighing the costs of imported versus domestic merchandise.

Tariffs can be a problem in other ways. One major retail chain reported receiving garments with the incorrect fiber blend. When the duty is more than that on the product ordered, questions arise as to who should pay the difference.

Negative Customer Reaction

As concern has mounted over the U.S. trade deficit, some consumers have begun to oppose the proliferation of imports in U.S. stores. A number of retailers have reported hostile comments from shoppers who were concerned that apparel lines, particularly in certain product areas, were composed of predominantly imported garments. For example, a manager of a specialty store told of a woman shopping for a blazer who walked out, expressing displeasure that all the store's blazers were imported. A number of retailers have had consumers express similar disapproval.

A Survey of Retailers' Problems in Buying Imported Apparel

In the study reported earlier on retailers' buying and stocking of imported apparel, retail participants were asked if they had experienced difficulties in buying imported garments for their stores; 58 percent reported having had problems, while 42 percent had not. Respondents who had experienced problems were asked to identify the types of difficulties they had encountered. Their responses are summarized in Figure 13–6.

In the retailer study, in most cases, merchants who viewed importing of apparel less positively reported that imports represented a limited proportion of the store's inventory. Although 58 percent of the retail respondents had experienced difficulties in buying foreignmade products, all but 13 of the sample of 182 (out of the total sample of 191) carried varying levels of imported apparel in their lines. Apparently, the attractive price differences of imports offset the disadvantages many had experienced (Dickerson, 1989).

RETHINKING DISTANCE

In recent years, retailers have begun to look more carefully at the long-term costs and benefits of their sourcing options. Instead of basing buying decisions on the simple initial cost advantages of imported merchandise, retailers are looking at a broader range of variables.

As mergers, buyouts, and other forms of restructuring in the retailing sector have increased competitive pressures, merchants are finding *speed of delivery* for merchandise to be increasingly critical. The long lead times required for production in the Far East have become a handicap, despite cost differences. Many stores have come to view operations as too costly when they tie up funding in long lead times and large inventories and result in large markdowns. Retailers are relying increasingly on apparel manufacturers who can deliver merchandise quickly—whether they are domestic producers or those close by.

Consequently, shifts in the retail climate have created a receptive environment for Quick Response (QR) or rapid replenishment initiatives. Although QR is based on computerized systems of data interchange, the QR effort represents a much more important change in the working relationships within the softgoods industry. More important, QR represents a marketing orientation on the part of U.S. producers who are committed to serving their customers, the retailers, more effectively.

As U.S. manufacturers continue to reduce lead times on domestic merchandise, domestic suppliers (or those with production in Mexico or the Caribbean) gain an added advantage in meeting retailers' needs, particularly compared to Asian producers. Retailers can order much closer to the time merchandise is needed and can order a much smaller quantity. Then reorders can be placed as needed. This strategy cuts inventory, reduces the investment in inventory at a given time, and results in fewer markdowns. Under the QR system, markdowns are reduced because retailers follow customers'

demands closely rather than ordering massive quantities of merchandise 6 to 9 months ahead of the season.

A MORE INTEGRATED SOFTGOODS CHAIN

Competitive forces of today's economy have fostered a much closer working relationship between manufacturers and retailers, creating a more integrated softgoods chain—a chain that has little room for the animosity that existed between these two industry segments in the past. Much of this integration goes back to serving a changing consumer, the higher costs of doing business today, and the intensity of competition.

Consumers have become more conservative in their spending on apparel. Lacking time for shopping, the consumers of the 1990s have been value-oriented and want products to be available when they are ready to buy.

Retailers, including some American stalwarts such as Macy's, have experienced bankruptcies, takeovers, consolidations, buyouts, mergers, and closings. More than 13,400 retailers went bankrupt in 1996 (National Retail Institute, 1997). Many suffered from heavy debt loads as they recovered from their respective traumas. As they have attempted to reduce overhead, many have consolidated their buying staffs. As we noted earlier, many have gone to matrix lists of suppliers, who have become their preferred vendors.

Many retailers have moved increasingly toward working with apparel manufacturers who can provide the quality, service, and price they desire for their respective strategies. This is particularly true if the retailer uses a matrix system; some use it but do not wish to discuss it publicly.

Retailers need suppliers who know and understand their needs. Therefore, a new era of relationship building has begun in the industry as rapid replenishment systems tie retailers and suppliers into high-level trust relationships. These partnerships have led to a new openness and sharing among many retailers and vendors. Thus, both segments of the softgoods chain benefit from being able to share customer and sales data. Both segments win when the customer makes purchases and is satisfied.

The new relationships are critical for the soft-goods industry. Often, these relationships are the difference between the winners and the losers in both segments of the industry. However, it is costly for companies in each segment to participate. Retailers must be prepared to capture consumer data through bar code merchandise marking. Firms in both segments must invest in technology that facilitates retailer-vendor data exchange. And manufacturers must invest in EDI systems that permit the rapid replenishment of their retail customers' demands. Firms that are too small to afford the investment will be seriously disadvantaged.

RETAILERS WHO HAVE ACTIVELY SOUGHT DOMESTIC MERCHANDISE

Marks and Spencer, Britain's largest and most successful retailing firm, with over 260 stores in the United Kingdom plus stores in other parts of Europe, was one of the first major retailers to establish a policy of buying domestic merchandise. Marks and Spencer garnered about 15 percent of the United Kingdom's clothing market, where it sells about one-fourth of all women's trousers; one-third of all underwear, pajamas, bras, and nightgowns; and one-half of all ladies' slips.

In the United States, Wal-Mart Stores, Inc., has made a commitment to buying U.S.-made merchandise whenever possible. Under the

leadership of its late chairman, Sam Walton, Wal-Mart's "Buy American" program developed out of concern for local economies in its trading area. The company's phenomenal success resulted first from a strategy of locating stores in towns too small to attract other major retailing chains. Concern for employment and other aspects of the economy in those small towns was an important stimulus to Wal-Mart's "Buy American" policy. Mr. Walton and other company executives were acutely aware of the importance of local manufacturing plants in those regions. Often, one or two factories are the only major sources of nonfarm employment in rural areas, and much of the economy in the town or region is supported by that employment. Too often, when a factory closes, it closes permanently. Wal-Mart executives understood the scenario clearly—if people are not working, they can buy little or nothing.

Given this background, Wal-Mart's "Buy American" program encountered negative publicity when NBC's "Dateline" broadcast a scathing report on the company's foreign sourcing efforts. Reporters went to a Wal-Mart store where clothing racks with "Buy American" signs held clothing made entirely in underdeveloped Asian countries. Reporters also visited Asian factories that were allegedly producing merchandise for Wal-Mart Stores and emphasized the number of children employed there. Moreover, reporters intimated that Wal-Mart Stores also knowingly purchased transshipped merchandise from China ("SA Sees Little," 1992).

Additionally, the "Dateline" exposé raised the consciousness of U.S. consumers regarding child labor and other labor conditions in the developing countries from which growing quantities of imported softgoods products are originating. This concern caused several manufacturing and retailing companies to establish policies and issue public statements assuring the buying public that they would not do business with foreign firms guilty of these labor infractions.

RETAILERS AND TEXTILE TRADE POLICIES

In recent years, many retailers and importers, favoring unrestricted trade so that they will be less hampered in buying imports, have become vocal in campaigning for greater representation in the U.S. government's textile and apparel trade policy, charging that they have been "virtually ignored" when crucial decisions are made by the government. Retailers charged that they play only a tangential role in developing textile and apparel trade policy, while textile and apparel manufacturers represent "favored interests." The following statement expresses the frustration of retailers and importers.

For the most part, the process for the formulation of U.S. policies on textiles and apparel has been closed and one-sided. While the domestic textile and apparel industries are consulted, other affected domestic industries are not. Restrictions are imposed on imports without notice, an opportunity to comment and other appropriate forms of due process. Further, while representatives of textile and apparel industries are invited to attend U.S. multilateral and bilateral negotiations, representatives of other industries traditionally have been excluded. NRMA [the National Retail Manufacturers Association] believes that the U.S. policy process should be opened to all affected parties, including the retail community. (Rosen, Turnbull, & Bialos, 1985, p. vii)

Retailers and others feel a lack of due process on textile and apparel trade matters. See Box 13–3. Problems include the imposition of new trade regulations on imports without notice or without an opportunity for retailers and importers to comment, as noted here:

There are virtually no limitations on the discretion of the Executive Branch to impose restrictions on textile and apparel products under domestic law and virtually no procedural protections for parties affected by such U.S. actions. Thus, ironically enough, while the U.S. cannot impose the

BOX 13-3

RETAILERS STARTLED BY NEW ORIGIN RULES

In August 1984, retailers and importers were startled by the sudden announcement of new country of origin regulations designed to prevent circumvention of certain quota rules. As a result of the U.S. textile/apparel sector's concern over transshipment of goods (discussed in Chapter 9) to take advantage of some countries' unused quota, revised country of origin rules, known as the "Origin Rules," were hastily imposed on import shipments (Daria, 1984).

Under the earlier rules, for example, sweaters made of panels knit in China but sewn together in Hong Kong counted as part of Hong Kong's quota (which is relatively much more generous than China's quota). Under the new Origin Rules, the sweaters were counted against China's much smaller allotment. Hong Kong officials and U.S. importers and retailers estimated very high potential losses (Resnick, 1984).

Retailers and importers were irate over the Origin Rules. Not only had this sector not been given advance warning that the rules were about to be implemented, but even worse, the new regulations were scheduled to go into effect within 1 month of the announcement. Retailers and importers with outstanding overseas orders were gravely concerned over the implications for their merchandise. After all, various types of multiple-country processing had been accepted business practices up to that point. Suddenly, overseas suppliers who relied on transshipments were unable to use this

strategy and be assured that their merchandise would be permitted to pass through the U.S. Customs Service (Kidd & Ehrlich, 1984).

Although the enforcement deadline was extended as a result of protests from retailers, importers, and the governments of exporting nations, the affected retailers and importers experienced delays and losses of shipments. Moreover, in retaliation against the Origin Rules, China canceled an order for 273,700 metric tons of wheat ordered from U.S. farmers ("China Cancels," 1984).

Despite retailer/importer protests that the new quota rules were "unconstitutional, arbitrary, capricious and contrary to previous rulings," the Court of International Trade ruled that the U.S. Customs Service was not required to provide any prior notice or comment period before issuing the regulations (Resnick, 1984, p. 1).

The 1984 Origin Rules provided perhaps the primary early stimulus for the mounting retailer/importer campaign to organize and to become a stronger political force to oppose textile and apparel protectionist measures.

Another Chapter in the Saga. Although the 1996 change in country of origin rules were not imposed with the haste of the 1984 ruling, the more recent change required retailers and importers to reorganize business operations to comply with the new rules. See Chapter 7, Box 7–1, for a review of the 1996 changes.

lesser sanctions authorized under other trade remedy laws unless such sanctions are truly justified and all parties' views are considered, it can nevertheless impose the severe trade sanctions under the MFA (e.g., embargoes) on an *ad hoc* basis without any process whatsoever. The absence of such safeguards lends itself to substantial errors by CITA and gives the Executive Branch unfettered discretion to control textile imports with no check whatsoever from other branches of government. (*Rosen et al.*, 1985, p. 49)

Retailers have felt that the same lack of due process also prevailed in the *formulation* of major textile trade policies. Authors noted that for the first time in the history of textile trade policy, the U.S. Trade Representative's Office invited a retail representative to serve as an advisor during the 1986 MFA renewal negotiations. Prior to that, only textile and apparel manufacturers were invited to attend in an advisory capacity. On that point, the report

added: "The previous exclusionary policy has given the domestic textile and apparel industries unprecedented input into such negotiations while other affected industries, namely importers, retailers, and consumers, played no role whatsoever in the negotiations and have little opportunity to comment on the decisions being reached therein as they occur" (Rosen et al., 1985, p. 50).

Retailers generally opposed the MFA (now ATC) quota system and asserted that it is a protectionist measure that favors U.S. manufacturers.

- Retailers believe the quota levels restrict flexibility in responding to changing fashions and trends.
- Merchants believe that restrictions on textile and apparel imports seriously limit their ability to secure the best variety and price for their customers.
- Retailers are keenly aware of the added costs both to them and to consumers that result from tariffs, quota costs, and so on.
- Merchants believe trade restraints add to the burden of doing business, requiring them to become familiar with the complex quota system.
- And finally, retailers resent the risks they
 experience because of the import control
 system—for example, the risk of having
 merchandise embargoed when they need it
 in their stores.

Frustrated by consultation calls, embargoes, and other restrictions that create what retail leaders believed to be "an unreasonable rate of uncertainty" (Lockwood, 1984), retailers and importers launched several initiatives to counteract industry and government policies. Retailers and importers decided to become more active politically to have their interests represented on textile trade policy matters. Thus, if we consider the textile and apparel industry as a **pressure group** (i.e., organized to influence policymakers), we might think of retailers and importers as a **counterpressure group**.

Retailers Become Politically Active on Trade Matters

As retailers grew increasingly frustrated with tightened restraints on imported textile and apparel merchandise, the Retail Industry Trade Action Coalition (RITAC) was formed in 1984 to lead the counterattack. RITAC was formed specifically to fight for freer trade in apparel, footwear, and possibly other consumer products. A basic tenet of the group was "Free trade means economic expansion and that economic growth means greater prosperity for the American consumer, translating to greater prosperity for the retailer" (Colgate, 1987, p. 90).

Composed of 7 retailing industry associations and 50 large and small retail companies, the coalition asserted that they intended "to do everything within our power to oppose protectionism, whether legislative or administrative" (Wightman, 1984). Like the manufacturers, RITAC collected substantial funds from members to make their presence felt in Washington and to influence public opinion.

RITAC was formed at the time when the Fiber, Fabric and Apparel Coalition for Trade (FFACT) was organized by the textile and apparel industry to promote the passage of the Textile and Apparel Trade Enforcement Act of 1985 (the Jenkins bill). In fact, RITAC was a counteroffensive to FFACT and the Jenkins bill.

Soon after the Jenkins bill was introduced in Congress, the increased political prowess of retailers became apparent. RITAC members heavily lobbied members of Congress and formed a coalition with agricultural and financial services industries, sectors that stood to lose from retaliation by countries affected by the proposed U.S. textile restraints. Retailers' and importers' efforts were successful. Defeat of this bill was seen as a major victory by retailers; they had played a significant role in its defeat (Arlen, 1985; Greene, 1985; "House Fails," 1986; Mullin, 1985; Spalding, 1985).

When the second and third bills, the Textile and Apparel Trade Act of 1987 and the 1990 bill, were introduced in Congress, retailers and

importers were as opposed to them as they were to the earlier bill. RITAC lobbied against both textile bills, and the bills were defeated. For a second and a third time, RITAC successfully deterred passage of a bill considered detrimental to retailers' interests.

Although RITAC was officially disbanded in 1993, this does not mean that retailers will assume a less active political role on trade policy matters in the future. Now retailers' political activism is coordinated through the National Retail Federation. Retailers carry many products other than textile and apparel products and might logically be active on trade issues for other industries. However, retailers and importers acknowledge that most of their efforts related to trade have been tied to the textile and apparel sectors because of the complex quota system and other barriers that the domestic textile and apparel manufacturers have managed to erect to protect their industries.

In short, retailers and importers have learned that lobbying Congress can pay off. In the past, perhaps retailers were not very active politically because they were unaware of their potential power. Retailers are a lobbyist's dream because they employ more than 21.5 million Americans, or almost 18 percent of the nation's workforce. Of this number, about 4 million are employed in retailing segments that sell textile and apparel products (National Retail Institute, 1997). Retailers are located in every congressional district. Having discovered its lobbying potential, the National Retail Federation hopes to harness the political force of its members to help educate members of Congress on other key issues of concern to the retailing community, such as labor issues and tax measures.

Retailers mounted a strong offensive on the trade front during the 1990s. In 1993, for example, the National Retail Federation announced that it would triple its lobbying efforts in that year alone. More than 150 meetings were scheduled between retail executives nationwide and their congressional representatives in Washington and in their home districts. Just

as the textile industry leaders had done for years, key retail executives went in small groups to visit members of Congress, particularly those serving on committees related to trade. In 1997, the National Retail Federation announced that it would be adding two additional lobbyists to its staff.

The 1990s gave retailers many opportunities to flex their new political muscles—always on the issue of freer trade. In addition to helping defeat the third congressional textile bill, retailers became actively involved in talks to conclude the Uruguay Round. As textile manufacturers lobbied for a 15-year phase-out of the MFA, retailers and importers lobbied equally hard for a shorter phase-out. Retailers and importers also lobbied strongly for NAFTA and against the yarn-forward provision of NAFTA.

Similarly, retailers and importers were strongly opposed to any efforts to restrict China's most favored nation (MFN) trade status with the United States. Although many in the United States believed that China's MFN status should be tied to human rights issues (stemming first from the time Chinese officials executed leaders in the democratic movement), retailers and importers lobbied for China to retain MFN status. The reader is reminded that if an exporting country has MFN status, that country's products are subject to much lower tariffs than would be true without the MFN status. Therefore, retailers and importers who are buying products from China would have to pay considerably more for merchandise if higher tariffs were required without MFN status. For example, an executive at one major retailing chain told the author that, for his company, the difference in whether China had MFN status accounted for well over \$1 million dollars on shoes alone.

Now that retailers have discovered their power in the political arena, chances are slight that they will choose to abandon their new skills. Retailers have learned that they must educate and influence policymakers to understand their perspective on textile and apparel trade matters.

A MOVE TOWARD IMPROVED CHANNEL RELATIONSHIPS

Although suppliers and retailers have experienced frequent conflict in their relationships, difficulties related to textile and apparel trade pitted the two sectors against each other as never before. In a sense, the trade problems were unfortunate for both sectors. Both manufacturers and retailers operated in intensely competitive markets. Overall, both industries are quite fragmented. Both have undergone dramatic restructuring as a result of changing competitive conditions. Both are major U.S. employers vital to the country's economy. And although there are stellar performers in each sector, in general, earnings over the last decade or more have been relatively lean for both sectors. Therefore, the battle over imports has been unfortunate both to retailers and to suppliers. The diversion of energy and funds for each sector's battle against the other might have been used more productively in strengthening each industry's competitive status—in ways other than in political skills.

The tide has begun to shift, however. As the key participants in a shared broader industry—the softgoods industry—manufacturers and retailers have a great deal in common. Although each sector has a different objective in the channel relationship, the end goals of each are the same: supplying the right merchandise to the customer at the right time and at the right price and, in the process, earning a profit to sustain the firms involved.

Restructuring in both textile/apparel manufacturing and retailing has created a new business environment for each sector. Each is faced with increasingly competitive conditions for survival and success. Ironically, as we noted earlier, the difficult climate faced by

each sector has led to improved working relationships between softgoods suppliers and retailers. U.S. textile and apparel producers have learned that they must assume a more serious marketing and service orientation with their customers, the retailers. Domestic manufacturers have learned that retailers can bypass them and have their needs met by willing suppliers in other countries. Therefore, growing numbers of U.S. textile and apparel producers have become sensitive to retailers' needs and are willing to assist retailers in their business activities. Rapid replenishment initiatives on the part of manufacturers help retailers work closer to their markets (in timing), reduce inventories (and therefore investments), and permit merchants to have merchandise when they need it without the burden of excessive markdowns.

Similarly, **restructuring** within the retailing sector has made working with domestic suppliers more attractive to U.S. retail firms. Mergers, buyouts, and other forms of retail restructuring have intensified competition. Overstoring is a serious problem for retailing in general. The proliferation of off-price and discount retailers has tightened markets for both department and specialty stores.

In general, the changes in the U.S. retailing sector require that firms be exceedingly sensitive to customers' needs and that retail firms be managed efficiently in order to survive. More than ever before, this efficiency and sensitivity to customers' needs depend on faster turnaround and delivery in responding to the whims of fashion. Retailers who can respond quickly to changes in consumer demands will be more successful. (An interesting question to ponder is whether consumers need this fast turnaround or whether the industry is proficient at stimulating "needs.") Therefore, retailers have developed a new appreciation for domestic producers who can provide merchandise quickly and who can shift product lines as consumer demands change. A number of retailers have found that working with domestic producers (or those with production nearby) requires not only less lead time but also less investment at a given time. In addition to responding more effectively to the customer, working with U.S. suppliers may be beneficial to earnings through more frequent stock turns, fewer stock-outs, and fewer markdowns.

In short, the increasingly difficult business conditions in both retailing and textile/apparel manufacturing have helped each sector to have a growing appreciation for the other. Perhaps, as the two sectors continue in their efforts to work together more effectively toward common goals, retailers and producers can continue to nurture a partnership interaction rather than perpetuating the adversarial relationship that heightened over trade issues. The term relationship building was added to retailers' and manufacturers' vocabularies in the 1990s.

Mutually advantageous supplier-retailer relationships are now seen as the means by which both segments of the industry will move successfully into the next millennium. Firms in either segment that lack the foresight to develop and nurture such relationships may be added to the growing list of casualties.

GLOBAL RETAILING

Although most of our discussion has focused on the retailer's position with regard to global aspects of *production*, today's global economy brings with it another phenomenon—**global retailing**, the expansion of retailing operations on a global or international scale. See Figure 13–7. As a result of improved transportation and communication systems, retailing—like

FIGURE 13-7

Global retailing is another outcome of today's global economy.

Source: Illustration by Dennis Murphy.

manufacturing—has entered the global age. Compared to most other industrial and service industries, retailing was relatively slow to expand globally, however. The growing number of retailers that have launched plans to expand into new regions of the world suggests that this trend is changing rapidly.

Global retailing may be considered from two perspectives:

- First, we may consider it as the international flow of retailing concepts or know-how. The concepts of self-service and the supermarket moved to several countries as a result of interchanges at international meetings on food distribution. Transfer to the United States of the West European hypermarket concept by Wal-Mart and Kmart is another example (Kacker, 1988).
- The conscious development of a *global* retailing strategy is the second way of considering this change in the international marketplace. This planned globalization of retailing results from a company's intent to establish its operations in several countries, or it may result from a business agreement between two companies (or sometimes governments) for a management contract or joint venture.

Our discussion will focus primarily on this latter way of viewing global retailing.

Management Horizons⁶ writers suggested that one of the reasons retailing has expanded slowly on a global basis has been retailers' focus on the local nature of business in order to know and understand customers and their needs. These retailing experts suggest that new technology will now permit **micromarketing** on a global scale. Large retailers, well

equipped with technology that facilitates micromarketing, cost reduction, and efficiencies in the distribution pipeline, are applying these strategies to *global* operations.

Until recently, most retailing beyond national borders has been in the form of investment by a limited number of retail firms that are seeking to expand in other markets on a fairly conservative scale. The U.S. market has attracted retailers from other countries for many of the same reasons that foreign manufacturers want to ship their products to American markets. The U.S. market is large, both in geographic size and in the size of the population, and consumers have an exceptionally high level of disposable income (relative to the rest of the world), along with a hearty appetite for consumer goods. Because many retailers from other countries have outgrown their domestic markets, and particularly when the currency exchange rate has been favorable, the U.S. market has become attractive as a site for expansion.

Similarly, as the U.S. market has become saturated by over-storing and as U.S. consumers have become more conservative in their spending, U.S. retailers have begun to look at the markets of other countries as offering potential for growth and expansion. Among the most aggressive, Wal-Mart opened six stores abroad in 1997, bringing the number of its international units to 207, with 136 of those in Canada and 49 in Mexico. Wal-Mart sees tremendous potential in meeting the needs of underserved consumers throughout Latin America and Asia. For example, the company already has stores in China, Indonesia, Brazil, and Argentina. The Gap has franchised stores in the United Kingdom, Woolworth has a successful business in Germany, and Talbot has stores in Japan. J.C. Penney has embarked on an ambitious plan for global growth that includes new stores, catalog outlets, and licensing arrangements to sell Penney's private label merchandise. Through various approaches, Penney already sells in Aruba, Bermuda, Japan, Malaysia, Mexico, the Mideast,

⁶ Management Horizons, a retail consulting firm, is part of the Price Waterhouse global network, which gives the company greater access to retail markets around the world.

486

Portugal, Puerto Rico, Russia, Singapore, and Spain (Seckler, 1997; Wal-Mart, 1997).

Various sources have analyzed what it takes to succeed in retail multicountry or global expansions. Kacker (1988) noted that retailers who have succeeded have been those with unique concepts or techniques that enable them to find a specific market niche and win the clientele without much waiting. Loeb Associates, a retail consulting firm, has emphasized the importance of knowing the customer and adapting to the local market (Black, 1992). Management Horizons's staff believe that successful global retailers must create a strong franchise with customers through image and service, develop loyal shoppers, use technology to reduce costs and engage in micromarketing, develop strong networks with global suppliers, and have a flexible management style (1993).

A Profile of Global Retailers

Through its network of international offices and contacts, Price Waterhouse/Management Horizons follows the top 100 retailers of the world. U.S.-based Wal-Mart and Sears, Roebuck and Co. are the *first and third* largest retailers worldwide. The Price Waterhouse/Management Horizons study (1998) included all retailers, of which supermarkets are an important category. Table 13–1 identifies the world's top 10 retailers and their respective shares of worldwide sales in 1996.

The regional distribution of companies and sales of the top 100 retailers globally is shown in Figure 13–8. Although Europe accounts for more of the top 100 retailers' sales than the Americas, when 1996 and 1991 sales are compared, we see that retailers in the Americas have a growing share, whereas Europe has a declining share.

TABLE 13–1
Top 10 Retailers Worldwide, 1996

Rank	Retailer	Country	Sales (US \$Bil)	Percent of Top 100	Cumulative Percent of Top 100
1	Wal-Mart Stores, Inc.	USA	\$104.8	7.2%	7.2%
2	Metro AG	Germany	\$41.3	2.8%	10.0%
3	Sears, Roebuck and Co.	USA	\$38.2	2.6%	12.6%
4	Rewe-Gruppe	Germany	\$37.6	2.6%	15.2%
5	Tengelmann Warenhandels- gesellschaf	Germany	\$33.8	2.3%	17.5%
6	Aldi Group	Germany	\$32.8	2.2%	19.7%
7	Promodes Group	France	\$32.8	2.2%	22.0%
8	Kmart Corporation	USA	\$31.4	2.1%	24.1%
9	Carrefour	France	\$30.3	2.1%	26.2%
10	Edeka Group	Germany	\$30.2	2.1%	28.3%
Total top 10		,	\$413.4	28.3%	28.3%
Total top 25			\$773.3	52.8%	52.8%
Total top 100			\$1,463.2	100.0%	100.0%

Source: Personal communication with G. Wissman of Price Waterhouse/Management Horizons, Columbus, OH, January 1998.

1991 Sales

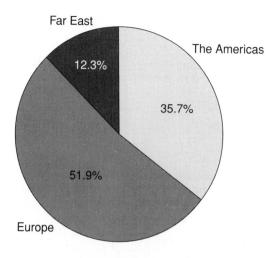

1996 Sales

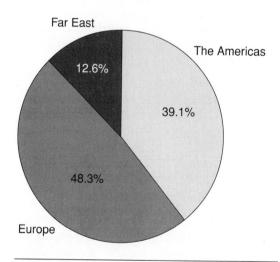

FIGURE 13-8

Sales of top 100 retailers by trilateral regions. Source: Personal communication with G. Wissman of Price Waterhouse/Management Horizons, Columbus, OH, 1998. Price Waterhouse/Management Horizons found that 66 percent of the top 100 global retailers had expanded retail operations outside their base country. Management Horizons distinguishes between global retailers, international retailers, and single-country retailers. Table 13–2 gives a summary of the geographic concentration of the top 100 retailers.

European retailers have the highest concentration of firms that operate outside their base country. An important factor to keep in mind, however, is that many European countries are relatively small. That is, a retailer selling in several other European countries can be compared to a U.S. retailer that sells in several states. Nevertheless, retailers in the Americas are significantly behind their counterparts in the other two regions of the world: Only 41 percent of American top 100 firms are active outside the United States, and fewer than 18 percent are global.

Price Waterhouse/Management Horizons staff found advantages to retailers in expanding operations well beyond the home country. They found that retailers with global operations have a higher average annual growth rate in sales compared to international retailers or single-country retailers.

In summary, global retailing represents a phenomenal new and growing dimension to the globally interdependent softgoods chain, offering additional challenges and opportunities to both manufacturers and retailers. The expansion of global retailing holds the potential for reshaping conventional patterns of business relationships in the softgoods industry on a worldwide scale. Price Waterhouse/Management Horizons staff believe that a narrow window of opportunity exists for moves into international retail expansion. Globally oriented firms are likely to move quickly in market expansion; those that hesitate are likely to be left behind.

TABLE 13–2Top 100 Retailers Worldwide—Geographic Concentration, 1996

Economic Bloc	Number of Top 100 Companies	Percentage of Single- Country Operations ^a	Percentage with Operations Outside Base Country ^b	Percentage with Global Operations ^c
The Americas	38	52.6%	47.4%	31.6%
Europe	49	24.5%	75.5%	40.8%
Far East	13	15.4%	64.6%	46.2%
Total top 100	100	34.0%	66.0%	38.0%

a Within home country only.

Source: Personal communication with G. Wissman of Price Waterhouse/Management Horizons, Columbus, OH, January 1998.

SUMMARY

Although conflict between retailers and suppliers is not new, the increased entry of textile and apparel imports into U.S. markets has heightened the conflict greatly in the last decade. Retailers have been attracted increasingly to apparel and other textile products produced in low-wage countries, using imports from many additional countries and in a wider range of products than in the past. Many retail buyers found overseas producers eager to respond to their needs. Moreover, as retail conditions became increasingly difficult, merchants found that sourcing outside the domestic market provided alternatives for variety, exclusivity, and attractive prices. In addition, private label programs have relied heavily on products made in low-wage countries.

As retailers contracted directly with overseas manufacturers to produce their merchandise, merchants began to assume more of the manufacturing responsibilities. Particularly for private label lines, retailers assumed nearly all the responsibilities for creating and controlling production of the apparel. In sum, retailers increasingly bypassed domestic textile and apparel producers to secure merchandise.

Although many retailers found overseas sourcing to be a helpful strategy, problems have been common. Among them are poor or unpredictable quality, long lead times, slow and unpredictable deliveries, uncertainties related to trade regulations, and poor service or lack of recourse on defective shipments.

For some time, U.S. textile and apparel manufacturers have considered retailers and importers responsible for the large growth of textile and apparel imports in domestic markets (often failing to mention manufacturers' own offshore production). After all, retail operations represent the conduit through which merchandise passes to the consumer. In other words, manufacturers reasoned that imports would not be taking substantial portions of the domestic market if retailers were not bringing the products from other countries to consumers. As retailers assumed manufacturing functions and bypassed domestic producers, U.S. textile and apparel industry leaders became increasingly aware of the power of retailers.

Two important shifts in the softgoods industry have meshed to foster an improved working relationship between retailers and domestic textile and apparel producers. First, U.S. manufacturers saw that retailers were becoming increasingly self-sufficient in contracting manu-

^b Outside home country (includes global retailers).

^c Outside own economic trade bloc.

facturing overseas and bypassing them altogether. As a result, a growing number of domestic manufacturers realized the importance of assuming a stronger marketing orientation and making a special effort to assist their retail customers. Thus, the QR/rapid replenishment initiative resulted, and suppliers and retailers are now working together more closely in their efforts to serve the same consumer.

Second, retailers have found it increasingly necessary to consider factors other than the initial cost of the merchandise in making buying decisions. Growing competitive pressures resulting from the mergers, buyouts, and other forms of restructuring in the retailing sector have necessitated fast deliveries on merchandise. Some U.S. retailers have determined that overseas buying can be costly because it ties up capital and requires long lead times, it results in large inventories, and the resulting markdowns can be devastating to profits. By working with domestic producers or those nearby who can deliver merchandise quickly, retailers have developed rapid replenishment programs to give improved service to customers and, at the same time, permit a reduction of inventory and markdown costs.

A few retailers have developed merchandising programs that focus especially on domestically produced merchandise. The British firm Marks and Spencer and the U.S. company Wal-Mart have used this strategy.

In general, retailers and importers believe they have been given unequal representation in textile and apparel trade policy matters compared to the attention given to domestic textile and apparel manufacturers' concerns. Retailers and importers have witnessed the effectiveness of the industry/labor pressure groups (lobbies) in persuading policymakers to provide increased protection against textile and apparel imports. Consequently, retailers have also become politically active to oppose trade restraints.

Global retailing is another reflection of today's global economy. In some cases, this involves an international flow of retailing concepts from one region of the world to another. More recently, global retailing refers to the conscious development of worldwide retailing strategies, that is, the establishment of operations in several countries. Global retailing appears to represent a potential new area for growth for firms with the capital to support expansion and the courage to try it.

GLOSSARY

Channel control occurs when one member of a distribution channel can dominate the decisions made in that channel via the power it possesses (Berman & Evans, 1995).

Channel of distribution refers to a set of institutions that performs all the functions required to move a product and its title (legal right to the possession of goods) from production to consumption (Bucklin, 1966).

Counterpressure group is a term that might be used to describe retailers and importers in their political efforts to limit restraints on imported textile and apparel products encouraged by manufacturers and labor (who were the earlier "pressure group" and who possessed greater experience in the political arena).

Embargoes, as we shall consider them in our discussions, occur when more goods are presented for entry into the United States than the quota level allows, and the U.S. Customs Service denies entry of the merchandise. In addition, products may be embargoed because of improper documentation or for lack of compliance with labeling or other regulations.

Factors are intermediary credit agents who finance goods while they are in various stages of manufacture, remanufacture, or assembly. Factors usually relieve the selling company, and often the buying company, of credit risks. They perform these functions at both the domestic and international levels; however, because of the complexity of international credit, factors may play a particularly important role in global transactions.

First cost is the price a retailer pays to the overseas vendor for products; it is the cost *before* freight, insurance, and tariffs are added.

Global retailers, as defined by Price Waterhouse/ Management Horizons (1994), are those firms that operate outside the company's own regional trade bloc.

Global retailing is the expansion of retailing operations on a global scale.

Gross margin (also known as gross profit) is the difference between net sales and the total cost of goods sold.

Importers are individuals or firms that secure products from other countries for sale in the domestic market.

International retailers, as defined by Price Water-house/Management Horizons (1994), are firms that operate outside the base country but within the company's own regional trade bloc.

Landed cost for imported products includes the cost of the merchandise, transportation, and duty.

Lead time refers to the difference between the time the retailer places an order for merchandise and the time it is delivered to the store.

Markdown is the amount by which a retailer decreases the price of merchandise if it is not sold at the initial retail price. Markdowns occur because of competition, overstocking, leftover or incomplete lines, or, in some cases, as a promotional tool to increase store traffic.

Markup is the difference between the cost of an item to a retailer and the retail price for which it is sold. The markup covers both business (overhead) expenses and profit for the retailer. The term markon is used in a variety of ways; often it is used interchangeably with markup. Lewison (1994) considers a markon to be an additional markup after the initial selling price has been established to either (1) cover increased wholesale prices or operating expenses or (2) correct consumers' perceptions of the quality of merchandise. That is, if consumers believe the quality of a product is questionable because of its low price, retailers may correct the misconception by increasing the price.

Mass merchandisers are retailers with large numbers of stores and powerful buying potential. Typically, they sell a large quantity of any one item. As the name suggests, these retailers target mass markets—consumers in the middle and low income ranges.

Matrix buying, a strategy used by retailers, consists of developing a list of preferred vendors who can

supply the products, service, and pricing that retailers need to execute their respective strategies.

Micromarketing is a marketing approach in which a company focuses on meeting the needs of very narrow or specialized target market groups.

Open-to-buy is the retail buyer's "account," or available funds, to buy merchandise for a period of time. The term refers to the buyer's balance of the account open to buy merchandise at a given time; that is, it is the amount left to spend during any point in a season (or month). Open-to-buy is the difference between planned purchases and purchase commitments made by a buyer during the period and is reduced each time a purchase is made.

Overseas buying offices are offices maintained in the past by large retail firms in a region from which merchandise is sourced. Particularly for private label lines, retailers' "buying" offices are being replaced by operations actively engaged in various aspects of the production process.

Overshipping is the term often used when exporting firms (or countries) knowingly ship in excess of quota limits. Although overshipping may result from honest mistakes, when the U.S. Customs Service was staffed less adequately to monitor shipments, a number of foreign exporters knew they could overship and probably not be caught. Tightened Customs enforcement has reduced overshipping.

Power retailers are fast-growing chains that attract customers with superior merchandise, sharper pricing, or greater convenience than their competitors and are revolutionizing the retailing industry with performances that far exceed the industry average.

Pressure groups consist of those who are organized to influence policymakers.

Price averaging occurs when retailers mix merchandise from multiple sources. The costs are different for merchandise from different sources, but the selling price is the same for all. For example, retailers assert that they save on the costs of imported products that, when averaged with the costs of domestic goods, yield savings that are passed on to the consumer.

Private label lines are merchandise lines (most commonly apparel) manufactured for specific retailers and sold exclusively in their own stores.

Relationship building (or partnering) is an industry term for developing close working relationships between manufacturers and retailers.

Restructuring in retailing refers to the changes in the industry resulting from mergers, buyouts, and other consolidations that have reshaped the U.S. retail sector. One of the most significant aspects of restructuring has been the concentration of retail power in the hands of fewer, but larger, retail conglomerates.

Retailers are businesses that secure merchandise for the purpose of reselling it to consumers at a profit. If a merchant secures merchandise from other countries, this makes the retailer an importer as well.

Sourcing, for retailers as well as manufacturers, refers to the process of determining how and where manufactured goods will be procured (obtained).

Vertical retailing, like vertical production, means that a firm takes on an additional stage or stages of operations in the production-distribution chain. Retailers use the term vertical retailing when retailers also assume the role of manufacturer.

SUGGESTED READINGS

- Berman, B., & Evans, J. (1995). *Retail management: A strategic approach* (5th ed.). New York: Macmillan. *An excellent basic retailing textbook.*
- Davies, R. (Ed.). (1996). *The outlook for West European retail*. London: Financial Times.

A look at pan-European retail industry trends.

Deloitte & Touche LLP. (1998). Global powers of retailing. *Stores* (section 3, special supplement). Washington, DC: Author.

A survey of global retailing.

Dickerson, K. (1989). Retailers and apparel imports: Variables associated with relative proportions of imports carried. *Journal of Consumer Studies and Home Economics*, 13, 129–149.

A study of retailers' buying of imported apparel. Greenberg, E. (1997). Retail trade. In *U.S. Industry & Trade Outlook* '98. Lexington, MA: DRI/McGraw Hill and U.S. Department of Commerce, pp. 42–1

to 42-8.

Current status of the retail industry.

Hughes, J. (1987). A retail industry view of the Multifiber Arrangement: How congressional politics influence international negotiations. Law and Policy in International Business, 19(1), 257–261.

A retail perspective on the politics of textile and apparel trade policy.

Kacker, M. (1985). *Transatlantic trends in retailing*. Westport, CT: Greenwood Press.

A study of international transfer of retailing concepts and expertise.

Kurt Salmon Associates. (annual). Financial profile for (annual): The KSA retail 100. New York: Author. A performance review for the top 100 largest public retailers.

Management Horizons. (1993). *Global retailing* 2000. Columbus, OH: Author (A Division of Price Waterhouse).

An overview of global retailing.

Peterson, R. (Ed.). (1992). The future of U.S. retailing: An agenda for the 21st century. New York: Quorum Books. A book of edited papers by leading retail academicians and retailing executives on a variety of perspectives for the future of U.S. retailing.

Price Waterhouse/Management Horizons. (1994) Retail world: Window of opportunity. Columbus,

OH: Author.

An excellent overview of global retailing developments.
Retail Industry Trade Action Coalition. (1987, July 30). Prepared statement of the Retail Industry Trade Action Coalition (RITAC) in Opposition to S. 549, The Textile and Apparel Trade Act of 1987. Unpublished statement presented before the Committee on Finance, U.S. Senate.

A summary of RITAC's view of the 1987 textile bill and retailers' reasons for opposing the bill.

Retailing in Central and Eastern Europe. (1997). London: Financial Times.

A study of the dramatic changes in retail structure for a region in transition.

Retailing in Latin America. (1997). London: Financial Times.

Examination of market potential and changes in retail structures in Latin America.

Rosen, S., Turnbull, B., & Bialos, J. (1985). The renewal of the Multi-Fiber Arrangement: An assessment of the policy alternatives for future global trade in textiles and apparel. Washington, DC: National Retail Merchants Association.

Retailers' and importers' views on the MFA.

Standard & Poor's (annual). Standard & Poor's industry surveys (retailing basic analysis). New York: McGraw-Hill.

An annual retail industry overview.

Sternquist, B. (1997). *International retailing*. New York: Fairchild.

An overview of international retailing.

14

The Interests of Consumers in Textile and Apparel Trade

The U.S. softgoods industry is consumer driven. In market economies, such as that in the United States, the consumer determines ultimately what sells and what does not. As one may recall from the train analogy presented in earlier chapters, the interrelated segments of the softgoods industry must respond effectively to consumer needs for the overall complex to function efficiently and profitably.

Similarly, the consumer perspective in global textile and apparel trade is a vitally important one. As we consider various consumer perspectives on textile and apparel trade, the reader will see that a number of consumer concerns parallel those discussed earlier for retailers. Yet, the interests of consumers are distinctive and exceedingly important to consider as textile and apparel trade matters are debated. First, consumers represent by far the largest U.S. group of individuals affected by textile and apparel trade and trade policies for the sector. Second, consumers are affected as much as or more than any other group by whether textile and apparel trade occurs and what that trade costs. If imports are restricted, consumers are affected by limited choices and potentially higher domestic product costs. If imports are permitted to enter the United States under the present system of controls, consumers are affected by tariffs and other costs.

Although consumers are affected as much as or more than any other group with a stake in textile and apparel trade, the consumer's perspective is perhaps the least represented in policy matters. Consumers are not organized with effective organizations and spokespersons to present their case.

Most economists believe that free trade ensures that consumers get the best-quality goods at the lowest prices. Similarly, most economists would argue that consumers, like retailers and importers, benefit from trade and are disadvantaged by trade restraints. See Figure 14–1.

In this chapter, we will examine some of the consumer gains from textile and apparel trade and will consider some of the costs to consumers associated with various aspects of that trade. Although most of our discussion will focus on U.S. consumers, similar points could be made for consumers in a majority of more-developed countries.

CONSUMER TEXTILE AND APPAREL EXPENDITURES

Trends in consumer apparel expenditures can be followed more easily than similar trends in consumer textile expenditures. Textile prod-

FIGURE 14–1
Today's consumer has a choice of products from many countries.

ucts may be either components or finished goods in apparel, interior furnishings, and other product areas—for which total consumer end-use consumption is difficult to track consistently. Apparel, on the other hand, is a more easily defined product area, which permits examination of expenditure trends over a period of time. Similar comparisons may be made for textiles if specific areas such as interior furnishings are defined as to the products included.

Apparel Prices

Since the early 1960s, apparel has been a good buy for consumers. Apparel prices have risen more slowly than overall producer or consumer prices. Figure 14–2 depicts the consumer price index for apparel during the early 1990s and shows the comparison for apparel in

relation to all items. The comparisons are based on an index that puts 1982–1984 prices at 100, with changes shown in relation to that level. In addition, the accompanying table provides specific price indexes for various consumer expenditure categories.

Overall, the consumer price index for apparel and textile interior furnishings rose less than that for most other expenditure categories. We note in the table in Figure 14–2 that prices for women's and girls' apparel fluctuated more than prices for men's and boys' clothing.

In many respects, the competitive global and national market conditions that have made business difficult for U.S. manufacturers and retailers have resulted in apparel prices (and those for some categories of textile interior furnishings) that might be considered bargains for consumers compared to price changes for other consumer goods and services. Additionally, the U.S. consumer has perhaps the greatest variety and the most value for the price of consumers anywhere in the world. Although the typical consumer is unlikely to think of apparel or textile interior furnishings prices as bargains, government statistics support this assertion when changes in the prices of these products are compared to those for most other consumer expenditures.

Apparel Expenditures

Measured in dollars of purchases, personal spending on apparel has increased, as shown in Figure 14–3. Figure 14–3 depicts another equally important trend. Although apparel expenditures increased, the percentage of disposable personal income used to buy apparel decreased. A number of factors appear to

¹ The reader may recall higher percentages given for apparel expenditures in Chapter 7 (see Figure 7–7). The percentages in Figure 7–7 are a portion of total consumer expenditure, whereas the percentages in Figure 14–2 are a portion of disposable personal income.

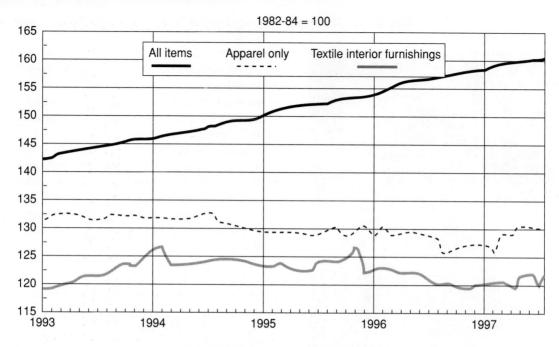

COMMODITIES AND/OR SERVICES

Seasonally unadjusted 1982-84 = 100	1993	1994	1995	1996
All items	144.5	148.2	152.4	156.9
Food	140.9	144.3	148.4	153.3
Housing	141.2	144.8	148.5	152.8
Transportation	130.4	134.3	139.1	143.0
Medical care	201.4	211.0	220.5	229.1
Apparel and upkeep	133.7	133.4	132.0	131.7
Seasonally adjusted				2
Apparel less footwear	131.7	131.0	128.8	128.0
Men's and boy's apparel	127.5	126.4	126.1	127.6
Women's and girl's apparel	132.5	130.9	126.6	124.4
Textile interior furnishings	121.8	123.5	122.7	121.1

FIGURE 14–2 Consumer price index for apparel and textile interior furnishings compared to all other items.

Source: American Textile Manufacturers Institute (1997, September). Textile Hi-Lights (p. 20). Based on data from the U.S. Bureau of Labor Statistics.

FIGURE 14-3

Consumer apparel expenditures, 1975–1997.

Source: 1975–1989: graph reprinted by permission of Standard & Poor's Industry surveys (1994). Updated with assistance by C. Priestland (personal communication), American Apparel Manufacturers Association, 1998.

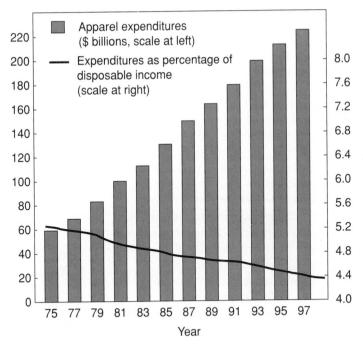

*Includes accessories and related items.

have influenced the decline in apparel expenditures as a percentage of disposable income. Among the factors are the following:

- Other consumer expenditures rose rapidly, as shown in the table portion of Figure 14–2. In particular, housing expenditures, energy costs, and medical expenses increased rapidly, leaving less disposable income for personal expenditures. Consider, for example, the consumer price index for medical costs in 1996 compared to textile and apparel costs.
- Many new consumer products that were not readily available in the 1960s (e.g., home computers and home video equipment), along with increased personal travel, compete for disposable income.
- Apparel prices have declined in relative terms since the 1960s as a result of the following:

- Lower costs for imported apparel.
 Evidence suggests that consumers have benefited, at least to some extent, from less costly imports produced in low-wage countries.
- Competitive pressure from imports has led to reduced prices for U.S.-made apparel.
 Domestic producers have been forced to keep prices competitive to retain markets.
 In addition, pressure from foreign competition has encouraged restructuring within the American industry. This restructuring has fostered efficiencies that have been passed on to consumers in the form of attractive apparel prices.
- In addition, sharp domestic competition has kept U.S. apparel prices low.
 Competition among a large number of U.S. apparel producers, even without the added threat of imports, would keep prices at attractive levels compared to prices in other product and service areas.

Textile Prices and Expenditures

Although consumer textile expenditures are harder to track because of the difficulty in identifying clear categories of "consumer" textiles, data are available on prices and expenditures for select categories of interior furnishings textiles. The table with Figure 14–2 provides a summary of the consumer price index for textile interior furnishings. Often the price index for these products from the early 1990s on has been below that for other categories and even lower than that for apparel. U.S. Department of Commerce data on personal expenditures for textile interior furnishings goods show a healthy increase for a period of more than three decades. Figure 14–4 illustrates these expenditures since 1986.

Textile home furnishings expenditures in the first 15 years after World War II were relatively limited as the U.S. economy went through a recovery period. Although large numbers of households were formed during that era, funds for expenditures beyond the basic necessities were quite limited for many individuals and families. By the 1960s, however,

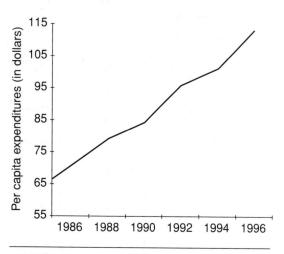

FIGURE 14–4
Personal consumption expenditures on semidurable home furnishings, per capita.

Source: Based on U.S. Department of Commerce data, Bureau of Economic Analysis (BEA, 1997).

overall U.S. economic prosperity was reflected in the rapid rise of per capita expenditures for textile household goods. Although expenditures have fluctuated, in general the higher spending levels have continued. Consumers placed greater emphasis on spending for the home in the 1990s compared to the 1980s.

Until relatively recently, most interior furnishings textiles were domestically produced. In recent years, however, certain portions of this market have been increasingly attractive to foreign producers.

CONSUMER GAINS FROM TEXTILE/APPAREL TRADE

As we examine the consumer's position on issues related to textiles and apparel in the international economy, we will consider consumer gains from global trade in textile and apparel products.

An Increased Range of Products Available

The apparel industry and, to a somewhat lesser extent, the home furnishings industry thrive on variety. For many of these products, consumers make choices that promote self-expression through distinctiveness or uniqueness. Similarly, retailers attempt to attract customers to their stores rather than those of their competitors by offering lines that provide variety and distinctiveness. Domestic manufacturers also try to offer lines different from those of other producers to attract business. Thus, in more-developed country markets, the softgoods industry is based on a constant flow of new and distinctive merchandise in response to consumers' appetites for these goods.

International trade offers a far greater range of products to consumers. Logically, purchasing from a global market offers a far greater variety than is possible from a domestic market. Examples of products available as a result of trade follow.

Goods Not Available in One's Home Market

In the United States, for example, certain natural fibers are not produced at all. The silk industry is virtually nonexistent in the United States today. The highly specialized hand production that silk manufacture requires does not exist in the United States; only limited processing of silk produced in other countries occurs here. Yet, many U.S. consumers are attracted to silk as a luxury fiber for a variety of uses. Other fibers available only through trade are linen, ramie, angora, and a number of less-common natural fibers.

Products with Distinctive Design Features

Buying foreign-made goods in order to obtain items with distinctive design qualities is not a new idea. In fact, for many decades, affluent U.S. consumers have bought apparel made in other countries as they sought to be among the fashion elite. The purchase of European high-fashion apparel has been a way of life for a small segment of the population.

Increased global trade in textile and apparel products has brought distinctive products from other countries within the range of a much larger segment of the U.S. population. Looking to imported products for variety may result from several factors. Consumers (and retailers) have welcomed the relief from the high-volume, mass production runs characteristic of certain segments of the U.S. industry. A number of overseas suppliers have been willing to produce smaller runs that offer more assurance of uniqueness than American producers have wanted to provide in the past.

In addition, certain types of products with distinct style qualities are both available and affordable to U.S. consumers of average means only because they are made by individuals in low-wage less-developed countries (Figure 14–5). Among products of that type are the following:

 Hand-woven items. Many hand-woven textile products are valued for their distinctive qualities. An example is handwoven Indian madras (plaid) fabric. These attractive multicolored, handloomed fabrics, which have been popular in U.S.

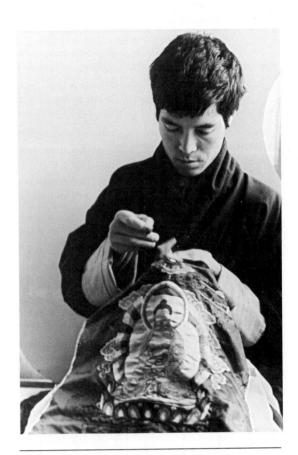

FIGURE 14-5

Consumers in more-developed countries may own intricate, hand-decorated items made by Third-World workers, such as this young man doing embroidery work in Bhutan.

Source: Photo by John Isaac; courtesy of United Nations.

markets periodically, would be prohibitively expensive if produced by workers earning U.S. wages.

Hand-knitted sweaters and other items. U.S.
consumers have purchased large numbers
of hand-knitted sweaters, often with
complex color and stitch variations. Handknitted sweaters offering the design
complexity of many of these popular styles
would carry exorbitant price tags if
produced at U.S. wage rates.

 Distinctive hand-decorated items. Handembroidered and hand-printed products offer variety to today's consumer. These products may be native designs from a particular country or they may be produced according to the specifications of a U.S. buyer. At any rate, various techniques result in products that are unique, distinctive, and affordable when produced in low-wage countries. See Figure 14–5.

 Hand-crafted rugs. Hand-woven or handtied rugs from certain parts of the world are highly valued. Hand-tied rugs in particular are exceedingly labor intensive to produce because each yarn is hand-knotted. Because of the labor involved, it is unlikely that these rugs would exist if production occurred other than in the low-wage developing countries.

(Although these imported products add variety in our selections, these examples also offer potential for reflecting on the development theory we presented briefly in Chapter 4. The reader might reflect on the relationships between the core and the periphery countries for the production and sale of these items and might also ponder on the extent to which the workers profit from production of these items.)

Products No Longer Produced Domestically

Certain products may be available only from suppliers in other countries. In some cases, these products once were produced by domestic firms that abandoned the markets; in some cases, this was because of intense overseas competition that the U.S. firms felt they could not match. Shoes are a prime example, with fewer and fewer domestic shoe producers in operation. Similarly, a number of labor-intensive apparel lines (e.g., dress shirts and men's trousers), including many sold under familiar American brand names, are being produced elsewhere in growing proportions. In many cases, shoe firms and apparel companies import for distribution under their brand names. In short, a limited domestic supply exists in certain product areas.

Over the years, consumers have grown increasingly dependent on suppliers from around the world to produce the variety of products they desire. Today's consumer in industrialized countries has come to expect the array of products that is currently available only through global sourcing. Careful scrutiny of a typical U.S. consumer's apparel, shoe, and accessory possessions might uncover an international consumer such as the one depicted in Figure 14–6.

Potentially Lower Prices

As we noted in Chapter 13, certain sources have questioned the extent to which retailers pass the savings of low-cost imports on to their customers. Arriving at a conclusion on this point is difficult because retail practices vary greatly from one company to another. Dardis (1988) noted that although some retailers may take higher markups on imported products in the short run, this practice is unlikely to continue in the long run because of the competitive conditions of retailing.

Evidence suggests that consumers *have* benefited. For example, Cline (1978) found imported products to be on average 10.8 percent cheaper than comparable domestic products. Moreover, the affordable prices on imported merchandise in certain stores, particularly the discount and mass merchandise chains, are an

FIGURE 14-6

Today's "man of the world." *Source:* Illustration by Dennis Murphy.

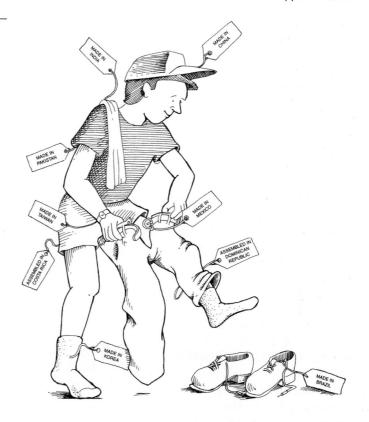

indication that customers are benefiting from the low initial costs of the merchandise.

Increased Global Production and Consumption

All nations—and the consumers in each nation—have a higher standard of living as a result of international trade. International trade allows greater specialization, and all countries reap the benefits of this practice. A nation produces goods and services for which it has a comparative advantage and trades with other nations for the things it needs. Thus, the gains of trade permit all countries to have more goods and services than they would if they tried to be self-sufficient.

Consumers buy imported textile and apparel goods when they find inherent benefits in doing so. The most common benefits for

purchasing imports in these product areas are price differences and variety. Seldom are choices among products so limited that consumers are *forced* to buy imports.

International trade accounts for the presence of overseas products and services in a domestic market—brought into that market because of some apparent benefit or advantage over domestic products or services. And the consumer purchases the good or service because of those apparent advantages. However, the presence of the foreign-made product—especially when it has displaced a domestically made product—is generally viewed as a threat by the domestic producer.

Domestic producers can respond to overseas competition in a variety of ways. Some firms may be determined to improve their product, their production efficiency, or whatever it takes to compete effectively against the foreign-made product. When this happens, not only has the consumer gained from an improved domestic firm (or industry), but also the firm (or industry) has strengthened itself to be more competitive in global markets. Moreover, the competitive threat that accompanies trade fosters a climate in which manufacturers are more responsive to consumer needs. On the other hand, another common response from textile (and some apparel) manufacturers in the more-developed countries has been to influence domestic trade policies to provide protection for the domestic industry. Most economists and consumer advocates consider that this approach is not in consumers' best interests.

THE CONSUMER PERSPECTIVE RELATED TO TEXTILE AND APPAREL TRADE RESTRAINTS

As we have discussed in earlier chapters, the United States and most other more-developed countries have extensive and complex mechanisms in place for controlling the flow of low-cost imports into their markets. As the number and proficiency of less-developed country producers have increased dramatically, so, too, have the measures to control entry of imports into the markets of developed countries.

Although consumer advocates may decry the "evils" of pressure-group power in influencing textile and apparel policies, we must keep in mind that this phenomenon is not unique to the textile and apparel industries. Political science scholars have observed the growth of interest groups in recent years. In a respected study on foreign trade legislation between 1953 and 1962, Bauer, Pool, and Dexter (1963) wrote:

We note...how few were the congressmen who had heard anything from the major pressure groups and how many there were who were genuinely puzzled as to how they should vote and who would have appreciated clear indications of

where their constituencies stood and what the issues were. (p. 351)

In contrast, in Berry's (1984) study of interest groups, he noted:

Two decades later it is inconceivable that anyone doing research on any important public policy issue would find many congressmen who had heard nothing from interest group lobbyists or the constituents they represent back home. By any standard, the amount of lobbying in Washington has expanded significantly. Many previously unrepresented interests are now represented before the government by recently formed organizations. Interests that were already represented in Washington tend to be even better represented today. (p. 44)

Berry concluded that the growing strength of interest groups represents both an expression of freedom and a threat. In a statement that critics of the present system of textile and apparel import controls would consider particularly relevant to the consumer perspective on trade, Berry wrote: "In a system such as ours, interest groups constantly push government to enact policies that benefit small constituencies at the expense of the general public" (p. 1).

Textile industry leaders in the United States and most of the other more-developed countries have been successful in pressuring governments to enact policies to protect the domestic sectors from imports. Several sources (Cline, 1987; Toyne et al., 1984) consider the U.S. textile and apparel sectors to have been two of the most protected in the country. Later in this chapter, we will consider how these protective measures affect consumers.

U.S. textile and apparel trade restraints consist primarily of tariffs and quotas. Although tariffs on certain categories of apparel products are among the highest for any U.S. imports, they are seldom a barrier to shipping goods to U.S. markets. Quotas (established under the MFA),² on the other hand, are far more restrictive.

² Although quota restraints are not *legislated*, the import control program under the MFA resulted from interest group pressures.

Although the United States was not perceived to have high overall import restrictions in the past, the protectionist mood in the country fostered by concerns over the trade deficit gave rise to tightened restraints. Prior to completion of the Uruguay Round, pressure had increased both to deepen and to widen restraints—to cover additional product and services areas and to intensify restraints. Pressure for additional protection came from virtually all sectors—with textiles as one of the most vocal and most politically active sectors.

Many different types of import restraints are applied. Each type has a distinctive impact on trade, with different effects on the availability of products and on consumer prices. First, we will identify the common types of import restraints and their impact on trade. Second, we will review research findings on consumer costs related to U.S. trade restraints.

Restraints That Involve Costs to Consumers

Tariffs (Duties)

Tariffs are taxes levied on imports. As such, they add to the final cost of consumer products. In addition, as a tax, tariffs produce revenue for the U.S. government. Tariffs may be of two types:

- **Specific tariffs** are determined by levying a certain charge per unit of the product; the primary purpose is to raise *revenue* for the government.
- Ad valorem tariffs are a percentage of the price of the product; these are levied to provide protection. Our discussion focuses primarily on tariffs of this type.

U.S. tariff rates average only 4.4 percent (some sources give 4.3 percent) for all industrial products—a rate comparable to the average rates for other more-industrialized countries. The relatively low average rates have resulted from the multilateral trade negotiations

(MTN)—in particular, the Kennedy Round and the Tokyo Round—sponsored by GATT since the 1950s. Although tariffs for most product areas were lowered substantially as a result of the MTNs, tariffs on most textile and apparel products were reduced only to a limited extent (Hickock, 1985; Wolf et al., 1984).

In the Uruguay Round, tariffs on all U.S. industrial products except textile were reduced by 34 percent. However, textile and apparel tariffs were reduced by only 12 percent. In addition, the preferential tariff treatment—the Generalized System of Preferences (GSP)—normally given to less-developed countries is widely excluded for textile and apparel products.

For most countries, clothing is subject to considerably higher tariff rates than textile categories. Higher tariff levels indicate that imports are a greater threat to those product categories; the higher tariffs are levied in the hope of discouraging imports. The United States was required to reduce textile and apparel tariffs less than some other countries in the Uruguay Round; thus, U.S. tariff rates on these products are high relative to those of other OECD countries.

Although textile and apparel tariffs are relatively high for most OECD countries, and although GSP concessions are often withheld for these product areas, tariffs have not been a significant deterrent to imports.

Figure 14–7 shows average tariff rates on imports.

Quotas

Although tariffs are intended to make imports more costly and therefore less appealing to purchase, they provide a minimal barrier to entering the more affluent markets. Quotas, on the other hand, block imports. The reader will recall the funnel and gate comparisons made in Figure 10–1. With tariffs, the flow may be slowed somewhat, but the products still go through. By contrast, quotas establish limits on the *volume* of products that may be shipped; when the limit is filled, the gate is closed.

FIGURE 14-7

Average tariff rates on imports. Average rates were calculated by dividing total tariff revenue collected by customs value of imports. Products are classified according to Schedule A, SITC-Based Statistical Classification of Commodities Imported into the United States.

Source: Congressional Budget Office. (1991). Calculations based on data from Highlights of U.S. export and import trade, Report No. FT990, U.S. Bureau of the Census, various issues.

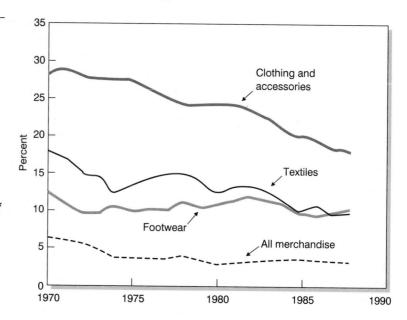

Using a quota system of import restraints, rather than tariffs, represents a revenue loss to the U.S. government. Hickock (1985) estimated that in 1984 the United States lost potential tariff revenue of \$1.8 billion to overseas apparel producers by using quantitative restraints rather than tariffs. Similarly, the International Business and Economic Research Corporation (IBERC)³ estimated that the government would have lost nearly \$800 million through reduced tariff revenues if the Jenkins bill had passed (Hays, 1985).

Although the principles of GATT prohibited the use of quantitative restraints—quotas—to limit trade, the MFA legitimized quotas for textile and apparel products. Furthermore, the MFA permitted a violation of the MFN provision of GATT and allowed importing countries to establish quotas that varied from one country to another.

Although quota limits were negotiated through bilateral agreements between trading

partners, the umbrella framework of the MFA established maximum annual growth rates for import shipments. In the early years of the MFA, exporting countries were permitted annual quota growth rates of around 6 percent. As global market conditions became more competitive, the later renewals of the MFA included provisions that permitted lowering of the annual growth rates. Textile and apparel producers, particularly in the United States and the EU, felt that import growth of 6 percent per year was inappropriate because domestic markets grew at much lower rates. Growth rates for the major Far Eastern exporters were reduced to 2 percent or less at times; some categories were permitted no growth. Because quotas place limits on the amount (volume) of textile and apparel products shipped, this form of restraint produces side effects that will be discussed in the next section.

Other Nontariff Barriers

In addition to quotas, other nontariff barriers (NTBs) may impede the flow of imported products available to consumers in a country.

 $^{^{\}rm 3}$ The reader is reminded that this consulting firm represents free trade interests.

These barriers occur in many forms. In the United States, certain labeling or other regulations (in some cases, not developed with the intention of barring imports) may restrict foreign goods or require compliance with regulations. Examples are the following: U.S. fiber content, care, and country of origin labeling requirements, U.S. anticounterfeiting regulations, and U.S. flammability requirements for children's sleepwear.

Consumers in other countries also experience the limiting effects of their countries' NTBs. For example, in the past, Japanese consumers may not have had a chance to consider the fullest possible range of potential product choices because Japan's market was difficult to enter.4 A few organizations controlled the Japanese trade channels; the resulting distribution system was complex, making it difficult for producers in other countries to enter. In other cases, countries may have domestic content laws, which require that a certain percentage of the component parts of products be made in the country where the product is sold. In Chapter 12, as we discussed nonreciprocity, we considered a number of other obstructive measures that function as NTBs. Consumer choice is limited by these obstructive measures (which, of course, is the reason the measures are imposed).

Costs Associated with Trade Restrictions

Trade restraints that protect domestic textile and apparel industries are typically supported by the following two arguments: (1) it is necessary to ensure fair competition in the face of foreign subsidies, and (2) it is necessary to save domestic jobs.

Many opponents of textile and apparel trade restraints—including most economists consider that the array of costs resulting from trade restrictions are quite high for the aid provided to the domestic industry. Moreover, the costs of protection are complex. World Bank sources (1987) asserted that most analysts have measured only the simplest costs of protection, and those are high enough. The World Bank writers noted that estimates generally ignore the effects of competition in influencing management efficiency; in addition, trade encourages acquisition of new techniques, economies of scale, and investments to improve performance. In that sense, the World Bank authors consider that most of the estimates are probably too low. Further, the authors noted that most studies do not include the adjustment costs incurred when protection is removed—unemployment, worker displacement, and so on.

Dardis (1987) used the following categories as a way of distinguishing between the more immediate costs of textile and apparel trade restraints and those that have broader, long-term consequences:

- Static effects. Static costs and benefits refer
 to the short-term impact on consumer
 prices and choices. Static effects also
 include the output and employment gains
 in the protected industries.
- Dynamic effects. The dynamic costs of trade restrictions refer to the reduced incentives for producers in the importing countries to become more efficient and competitive. In this sense, protection does more than protect; it also insulates the industry to some extent from international competition.

The following are among the consumer costs of protection.

Increased Prices

The consumer cost of protection can be considered the extra amount consumers pay for

⁴ Some of Japan's trading partners, including the United States, have pressed Japan to make its market more accessible to products from other countries. Progress has occurred. In recent years, Japan has been the U.S. textile and apparel industry's leading export market, after Canada/Mexico and the EU. When apparel only is considered, Japan often has been the leading export market.

goods because of protection-induced price increases. According to a report published by the Federal Reserve Bank of New York (Hickock, 1985), there are three aspects to the change in a protected good's average consumer price: (1) the increase in import prices that accompanies trade restrictions; (2) the price differential consumers may pay when trade restraints force them to buy domestic goods, which may be higher in price, rather than imports; and (3) a possible rise in the price of domestically produced goods if import competition is reduced. Increased prices may result from the following.

INCREASES FROM TARIFFS. Price increases from tariffs are relatively easy to discern, since tariff rates are public information. Consumer prices are raised by the amount (percentage) of the tariff. Although retailers and importers are the initial agents who pay tariffs on imported merchandise, those costs are passed on to consumers in the price of garments or other textile products.

INCREASES FROM QUOTA PREMIA. A quota premium (the plural form is premia) is the price exporting manufacturers must pay to secure quota rights in some countries to be able to export. When the MFA quota system was in full operation, allotted quotas grew scarce for some nations, particularly the major Asian suppliers. As quotas grew more scarce—because of tightened import controls—generally they became more valuable. Required of manufacturers in an exporting country in order to ship products to importing markets (for those product categories under control), quotas have become a valuable commodity on their own. In the exporting nations in which quotas may be sold-Hong Kong was the most notablemanufacturers paid relatively high prices for the quota. (This is called the quota premium). Producers pay the quota premia because they know they cannot ship their products without the appropriate quota authorization.

A decade or so ago, the value of the quota license (i.e., the premium paid to obtain the license) was sometimes as much as three to four times as great as the profits to be earned by the firm purchasing the quota and producing the garments. Sometimes the quota premium was as much as 50 percent of the value of the goods exported. Depending on how the quota is administered abroad, quota premia go to the foreign government, quota brokers, or foreign suppliers. At any rate, for goods produced where quota premia are part of the system, the consumer pays a price that incorporates these costs.

INCREASES FROM QUOTA "RENT" (SCARCITY RENT). Scarcity rent is equivalent to a tariff revenue, except that it may be obtained by either the exporting or importing country. Quota premia are an example of a scarcity rent obtained by the exporting country (personal communication with R. Dardis, 1989). See Box 14–1.

Reduced Selection Available to Consumers Due to Quotas

Variety tends to be more limited when trade restraints reduce the products that may be imported into a market. Retailers have charged that controls on textile and apparel goods prohibit them from providing the best possible array of products for consumers.

Children's clothing is an area in which import controls have reduced the choices available to consumers. The quota system encourages foreign producers to obtain maximum value from items produced for export; therefore, many overseas manufacturers are unwilling to use their quota for children's garments when they might, instead, ship higher-value adult apparel. (As we noted in Chapter 13, some manufacturers in high-wage countries have shifted away from children's clothing lines because wages represent such a high proportion of production costs compared to adult apparel. What might be the potential com-

BOX 14-1

THE COST OF BUYING QUOTAS

When the United States renegotiated bilateral agreements with the Asian "Big Three" in 1986, import restraints were tightened. As quotas became scarce, exporting manufacturers faced unprecedented costs to secure quotas to ship to the U.S. market. The high 1987 costs reflected the scarcity. By January 1993, however, the future of the quota system was uncertain, and quota prices were rela-

tively low compared to the 1987 prices. However, in January 1994—after the conclusion of the Uruguay Round 1 month earlier and the decision to end the MFA after 10 years—the quota prices were even lower, as shown. Most quota prices dropped even more by 1998. Although quota prices had dropped, it is important to keep in mind that these must be added to the cost of the garments:

	1987	January 1993	January 1994	June 1998
Women's cotton jackets	211.54	40.16	27.20	2.84
Men's cotton jackets	83.33	41.45	29.15	2.58
Women's cotton skirts	141.03	19.43	9.72	3.87
Women's cotton sweaters	54.49	37.56	29.79	58.06
Women's wool skirts	262.82	51.81	36.27	5.80

Note: All prices are US\$ per dozen.

Source: 1993 and 1994 prices: personal communication with W. Fung in Hong Kong, 1994. 1998 prices: personal communication with Jesse Zee in Hong Kong, 1998.

bined effect of these two shifts? Or, why is it unlikely that the cumulative effect of these two shifts will cause a diminished availability of children's clothing?)

PRODUCT UPGRADING. The quota system affects the availability of products for consumers in another way. The present system imposes limits on the quantity—but not the value—of products that may be shipped to the importing country. Therefore, exporters find it advantageous to increase the value of the goods exported to increase the return per unit. As a consequence of the quota system, foreign manufacturers have produced more and more high-value goods to maximize sales and profits from shipments to the importing markets. Smallbone (1986) reported

that the Hong Kong and Taiwan governments actively encouraged exporting producers to shift to higher-value lines to maximize profits under the available quota. This practice leaves a gap in the low end of the market, particularly since new entrants (new developing-country producers), which typically produce less expensive products, are locked into the smallest quota limits (Keesing & Wolf, 1980; Wolf et al., 1984).

Trading up to maximize quota values hurts lower-income consumers most. This group of consumers spends a larger proportion of their income on low-cost imported goods than those in higher income brackets. Consequently, when the quota system reduces the supply of products in the lower price range, those who can afford it least are affected most.

Other Ways in Which Consumers Are Affected

REGRESSIVE EFFECTS OF COSTS OF PRO-TECTION. Costs of protection tend to be regressive (the poor pay more relative to their means because the tax rate decreases proportionately as the tax base increases). In one of the most extensive studies on the costs to consumers (in this case, Canadian consumers) resulting from the textile and apparel import restraint system, Professor Glenn Jenkins of Harvard University found that poorer families were affected most (Jenkins, 1980). Import restrictions cost low-income families over three times as much relative to their income as they cost high-income households. Jenkins also found that poor families purchased a greater than average proportion of their clothing from the categories covered by quotas.

COSTS OF OPERATING THE TEXTILE/APPAREL IMPORT CONTROL SYSTEM. The present import control system—the quota system—has been complex and costly to operate. The costs of staffing at both national and international levels have been substantial; however, total costs are difficult to estimate. The tariff system is far less costly to administer than the quota system. As examples of the costs of operating the quota system, representatives of governments require time, travel, and varying degrees of backup staff assistance to negotiate quotas in the bilateral agreements. Then importing countries require complex monitoring and compliance systems to follow the shipment of goods to check for conformity to the agreements. In addition, staff are required at the international level to coordinate trade policies for the sector and to resolve difficulties.

LOBBYING COSTS. As textile and apparel trade has grown increasingly politicized, various interest groups have spent substantial sums to make certain that members of Congress hear their views. As one example, textile

and apparel firms, retail firms, trade associations, and industry unions spent more than \$2.1 million in political action committee (PAC) monies to support their favorite candidates in 1996 elections (Federal Election Commission, 1998). See Table 15–1. Other lobbying costs include employment of consultants such as law firms, public relations agencies, and firms that develop publications to document trade statistics and other relevant information. Travel and other expenses associated with calling on policymakers or presenting testimony before congressional committees must also be considered.

Lobbying is costly. These expenses must be covered by businesses participating in political activities. Although PACs and other political contributions may be tax deductible, firms must cover these expenses in some manner. Data are not available on the extent to which these costs are passed on to consumers in higher prices for products; however, the likelihood is great that consumers involuntarily support these activities to an extent. An irony of these costs is that the consumer may be supporting (through higher costs on consumer products) lobbying efforts that are at cross purposes-manufacturers' efforts and retailers'/importers' efforts, each of which offset activities of the other. Unwittingly, the consumer is providing financial support for both sides in the textile/apparel political tug of war.

costs of retaliation. Policies that impose restraints on imports to protect domestic industries create the potential risk of retaliation by other nations that purchase U.S. products. And since U.S. consumers employed in other sectors stand to lose from retaliatory trade efforts, this is another potential concern. For example, in 1983–1984 the Chinese retaliated for textile trade restraints by boycotting U.S. wheat, substantially injuring the wheat growers through loss of trade (an estimated \$500 million in sales), jobs, and farm income (RITAC, 1987; Rosen et al., 1985).

LOSS OF THE GOODWILL OF OTHER NATIONS. Protectionist restraints always pose the potential risk of injuring broader political relationships with trading partners. U.S. consumers—in this case as citizens—have a stake in maintaining harmonious global relationships in a world that has grown increasingly interdependent.

U.S. textile and apparel industry advocates would add, however, that maintaining international goodwill is a two-way street. Domestic manufacturers have resented the protests against U.S. trade restraints when they have come from nations whose markets are closed to U.S. textile and apparel goods.

Estimates of the Costs of Protection

A number of scholars have analyzed protective measures in textile and apparel trade to determine the costs to consumers and to the economy more broadly (the welfare effects). Numerous studies have focused on various aspects of the costs of protection, and researchers have employed an array of methodologies to analyze costs; therefore, results from one study to another may not be comparable. The following tables, based originally on World Bank information, summarize results from several studies (taken from a more comprehensive list that included other industries; newer studies have also been added). Among the studies are several published since 1980; the list is not intended to be exhaustive.

Estimates of the Costs to Consumers

Studies cited in Table 14–1 focused on the costs to consumers. As a review, these consumer costs of protection refer to the extra amount consumers pay for goods because protection has increased prices.

In a similar effort, Wolf et al. (1984) compared a number of analyses from the 1970s,

which included studies by the Council on Wage and Price Stability (COWPS) (1978), Morkre and Tarr (1980), Bayard (1980), and Pelzman and Bradberry (1980). In particular, the COWPS study showed that in 1975 high protection costs were passed on to consumers—approximately \$175 a year per household. In Pelzman's (1983) review of studies on the costs of textile and apparel trade restraints, he concluded that the protective measures are costly to consumers. Spinanger and Zietz (1985) arrived at a similar conclusion in their case study for West Germany. Results of a study by Silbertson and Ledic (1989) showed the same was true for UK consumers.

Estimates of Welfare ("Deadweight") Costs

While the studies identified in the previous section focused on the cost of protection to consumers, another group of studies have addressed the welfare costs of protection. Welfare costs refer to the extra cost to the economy as a whole of producing more goods domestically rather than importing them. Some sources refer to this as deadweight losses—that is, the income lost in the process of increasing domestic production and reducing domestic consumption of the protected items. These are the aggregate national costs of protectionthat is, the losses in a nation's welfare because of inefficiencies in production and distortions in consumption. Table 14-2 identifies several analyses of the welfare costs of textile and apparel trade restraints.

In a study by the U.S. International Trade Commission (1993a) that was unveiled just prior to the completion of the Uruguay Round talks, ITC staff evaluated the economic effects of significant U.S. import restraints on the domestic economy. The study considered several manufacturing sectors, agriculture, and services and was based on 1991 data. For each sector reviewed, ITC staff analyzed the welfare

TABLE 14–1Some Estimates of the Costs to Consumers of Protection (in millions of dollars)

Sector and Country	Year and Source	Cost
Clothing	. (34)7	
United States	1984 (Hickock, 1985)	8,500–12,000
United States	1984 (Hufbauer, Berliner, & Elliott, 1986)	18,000
United States	1980 (Dardis, 1988)	13,113 (low estimate) 13,527 (high estimate)
Canada	1984 (Morton & Dardis, 1989)	(C)\$923 (low estimate) (C)\$1,462 (high estimate
Australia	1980 (Australian Industries Assistance Commission, 1980)	(A)\$235 per household*
Textiles		
United States	1980 (Munger, 1984)	3,160 ^a
United States	1981 (Wolf, 1982)	2,000-4,000 ^b
Textiles and Clothing		
United States	1980 (Consumers for World Trade, 1984)	18,400
United States	1991 (Congressional Budget Office, 1991)	39,000–74,000* for each job saved

a Tariffs only.

Source: Assembled by the author. Some information from World Bank (1988).

gains to the economy if restraints were removed, as well as estimates of the effect on employment, output, and trade. Results showed that if restraints were dropped for all the sectors, the economy would have a \$19 billion gain. Of the total estimated gain, a major portion would come from the textile and apparel sectors if that trade were liberalized—an estimated \$15.3 to \$16.4 billion. The apparel sector was projected as the sector most affected by eliminating import restraints, resulting in a 24.5 percent increase in imports and a loss of nearly 47,000 jobs.

After analyzing earlier studies, Wolf et al. (1984) observed that "the costs of protection, especially of clothing, are considerable and the transfers from consumers even larger" (p. 112). This observation seems applicable to most of the studies considered in Tables 14–1 and 14–2. In fact, two conclusions may be drawn. First, the costs of protection are generally more significant for apparel than for textiles. Second, the total costs to consumers generally far exceed the welfare costs (deadweight losses). A study by Dardis and Cooke

b Quotas only.

^{*} Not in millions, but in dollars as shown. Note: (C) = Canadian; (A) = Australian.

TABLE 14–2
Some Estimates of the Welfare Costs of Protection (in millions of dollars)

Sector and Country	Year and Source	Cost
Clothing		
Canada	1979	(C)\$92
	(Jenkins, 1980)	
Canada	1984	(C)\$73 (low estimate)
	(Morton & Dardis, 1989)	(C)\$356 (high estimate)
EU	1980	1,409
	(Kalantzopoulos, 1986)	
United States	1980	1,509
	(Kalantzopoulos, 1986)	
United States	1980	736 (low estimate)
	(Dardis)	1,150 (high estimate)
Textiles and Clothing		
United States	1984	6,650
omiou otatos	(Hufbauer, Berliner & Elliott, 1986)	
United States	1991	9,000-38,000* for each job saved
Sintou States	(Congressional Budget Office, 1991)	
United States	1991	15,300-16,400
Simod States	(U.S. International Trade	
	Commission, 1993a)	

^{*} Not in millions, but thousands as shown.

Note: (C) = Canadian.

Source: Assembled by the author. Some information from World Bank (1988).

(1984), which focused on the costs of trade restrictions on apparel in 1980, reinforced the notion that costs to consumers far exceed welfare losses. See Box 14–2.

Estimates of the Costs of the Congressional Textile Bills

Several studies evaluated the consequences of the 1985 Jenkins bill and the 1987 Textile and Apparel Trade Act. Those are not included in the tables because they focus on the potential impact of specific bills that did not pass. In addition, some of the studies were commissioned by special interest groups. Two analyses of the potential impact of the 1987 bill received considerable attention. The IBERC group prepared an analysis for RITAC that estimated that U.S. consumers would pay an additional \$8.1 billion annually on textile and apparel purchases and another \$2.3 billion on footwear (Baughman, 1987). The IBERC study estimated that the cost of protecting each textile and apparel job under the bill would be \$262,000. In an ICF Incorporated study, commissioned by the Fiber, Fabric and Apparel Coalition for Trade, analysts concluded that the bill would add \$1 billion to the GNP in 1987 and another \$1.7 billion in 1988 (ICF Incorporated, 1987).⁵

⁵ Contrasting findings of the two studies are not surprising. IBERC represented the interests of retailers and importers; ICF represented the interests of U.S. textile and apparel producers.

BOX 14-2

WELFARE LOSS FROM TARIFFS OR QUOTAS

Dardis (1988; personal communication, 1989) has provided the following model to show consumer losses from tariffs or quotas; the model also illustrates scarcity rent.

A comparison of the impact of tariffs and quotas is shown in Figure 14-8. The domestic demand and supply curves are given by DD and SS respectively. The world supply curve, P_1P_1 , is horizontal, indicating that the world supply is perfectly elastic as far as imports for this particular country are concerned. In the initial situation the domestic price is P_1 , with imports accounting for Q_E-Q_A units and domestic production accounting for Q_A units. Imposition of a tariff shifts the world supply price from P_1 to P_2 with a resulting decline in imports to Q_F – Q_B . The loss in consumer surplus from the price increase is equal to the area P_1P_2FE . Part of the loss, however, is returned to the government in the form of tariff revenue—area CBFG. In addition there is a gain in producer surplus from the higher prices which is equal to the area P_1P_2BA . The welfare loss from the tariff is equal to the two areas, ABC and EFG. The first area represents a production efficiency loss when domestic production replaces lower cost imports. The second area represents a consumption efficiency loss as some consumers who are willing to buy low-cost imports are forced out of the market due to higher prices. These areas are often called the deadweight production and consumption losses.

Imposition of a quota limiting imports to $Q_{\rm F}$ – $Q_{\rm B}$ could achieve the same price increase from P_1 to P_2 and entail similar gains and losses to producers and consumers respectively. However, the area *CBFG*, which is called the scarcity rent, may go to either the importing or exporting country. If the importing country auctions quotas, then the scarcity rent will accrue to the government in the same manner as tariff revenue. If the importer is free to select his source of supply among exporters, then the importer, as opposed to the government, will gain the scarcity rent. Mintz comments, however, that both these developments are unlikely and notes that "when quotas

are assigned to specific countries, the exporters in these countries typically control the allocation of the quota and pocket the profit. This is always true of voluntary quotas which means high profits for selected foreign exporters—profits which are, of course, a pure burden on the importer's economy" (Mintz, 1972). Voluntary quotas will thus result in a higher welfare loss than tariffs due to the loss of scarcity rent. (*Dardis*, 1988, pp. 340–42)

FIGURE 14-8

Welfare loss from tariffs or quotas: homogeneous product. The shaded area represents scarcity rent. This quantity is similar to a tariff revenue, and it may go to the exporting country (as, e.g., quota premia) or to the importing country. Welfare loss = (ABC) + (EFG) + scarcity rent (if retained by the exporting country).

Source: Dardis, R. (1988). "International trade: The consumer's stake." In E. S. Maynes and ACCI Research Committee (Eds.): The frontier of research in the consumer interest (p. 341). Columbia, MO: American Council on Consumer Interests. Reprinted by permission.

Cline (1987), an economist at the Institute for International Economics, developed estimates on the costs of the 1987 bill and also evaluated the IBERC and ICF analyses. Cline noted methodological shortcomings in the two earlier studies, particularly the ICF study. Cline's estimates plotted the costs of protection that would result from the bill against jobs saved for a 10-year period. He estimated that consumer costs per job saved in 1987 would have been \$48,403, increasing to \$62,887 by 1996. Similar studies also focused on the 1990 textile bill.

Weighing the Costs of Protection Against the Alternatives

Although this subject was treated in more depth in Chapter 12, we must keep in mind a fundamental question regarding the consumer position on textile and apparel trade. That is, are the costs of preserving jobs for the textile and apparel sectors—through various import restraint measures—justified in terms of the costs borne by consumers for these restraints? Findings from most of the studies on the costs of protection have indicated that consumers have paid high prices to protect textile and apparel jobs.

For example, Hickock (1985) concluded that the increase in tariff and quota costs has caused imported apparel prices to be 17 to 25 percent higher than would have been the case without restraints. Jenkins (1980) estimated that Canadian consumers paid (C)\$32,959 to protect each job in that country's industry. A U.S. Federal Trade Commission study concluded that each American job protected by quotas on textile and apparel products from Hong Kong costs \$40,000 (Daily News Record, 1985). In short, most empirical studies have concluded that the costs of protecting textile and apparel jobs are high.

Textile and apparel industry leaders object, however, to the results of these analyses of the alleged costs to consumers, charging that estimates have been exaggerated. Industry objections to estimates of consumer costs related to trade restraints center on these concerns:

- The assumption that quota rent is passed on in its entirety to consumers
- The belief that, if quotas or tariffs were removed, prices would drop
- The idea that the number of jobs saved by present restraints is inconsequential. (Ghadar et al., 1987, p. 68)

Similarly, Wolff, Howell, and Noellert (1988) asserted in a publication developed for the textile industry that the studies on consumer costs are questionable, charging that the models "apply a simplistic approach and assume that all quotas will restrict U.S. imports and drive up domestic prices" (p. 31). Wolff et al. noted that these conclusions are inconsistent with actual trade patterns. That is, U.S. "quotas are applied on a product-specific basis by country rather than in the aggregate"; therefore, many of the "quotas are actually nonbinding (versus measures that are binding) and have no consumer costs associated with them" (p. 31). Wolff et al. suggested that the rapid growth of imports from controlled countries is evidence of this. As a result, they concluded that by failing to account for the nonrestrictive effects of the U.S. import control system, most of the studies have overestimated consumer costs. Examples of the "nonrestrictive effects" of the system include the following: not all countries or products are under quota restraints, and many exporting countries do not fully utilize their quota.

Although one might expect a textile industry-sponsored publication to question the results of studies showing high costs to consumers, a government study also challenged the claim that import restraints add to consumer costs. A 1985 study by the House Government Operations Committee found no evidence that import restraints resulted in higher apparel prices. Moreover, the committee found

little evidence that consumers benefited from lower apparel prices as a result of the import surge. The committee concluded that in several instances where domestic producers were forced out of business because of cheaper imports, prices subsequently increased to previous levels after the domestic competition was eliminated ("House Committee," 1985). In Sweden, the quota system was eliminated in 1991. At least initially, clothing prices did not drop as expected (personal communication with Swedish apparel executive, 1992).

In addition to industry critics, other sources have suggested that the United States must evaluate other long-term considerations in establishing trade policies. In general, many of these sources are less critical (than those just presented) of the costs of protecting the U.S. industry. Professor John Culbertson, an economist who views free trade quite differently from most of his economist peers, asserted:

Today the evidence should be clear to anyone who wants to look at it: our blind allegiance to free trade threatens our national standard of living and our economic future. By sacrificing our home market on the altar of free trade, we are condemning ourselves and our children to a future of fewer competitive businesses, fewer good jobs, less opportunity, and a lower standard of living. (*Culbertson*, 1986a, p. 122)

In another instance, Culbertson noted:

When imports from low-wage nations undersell our manufacturing production, they necessarily undercut our domestic wage level and the productivity of the American worker. Thus, eventually, the shift of our industries and jobs to other countries (to produce goods for our market) reduces American incomes and productivity just as would the migration of workers from low-wage countries to take jobs in the United States. (*Culbertson*, 1986b, p. 1)

Although Culbertson's views emphasize national interests, he is not alone in his concern over the status of American industry and the resulting **adjustment costs**. Business analysts

and writers have also become concerned over the decline of manufacturing in the United States and the impact on the U.S. economy. Jonas (1986) noted that in industry after industry, manufacturers are closing or curtailing their operations and becoming marketing organizations for other producers, mostly foreign. As U.S. manufacturers lose their market dominance, a new form of a company has evolved-manufacturers that do no manufacturing. Termed hollow corporations because they lack a production base, these new companies perform design, marketing, and service functions only. Invariably, hollow corporations have production done in low-wage countries. Some worry that the deindustrialization will leave the U.S. economy with an empty manufacturing shell, that America's valuable technology and engineering skills crucial to innovation will be transferred overseas, and that the shift to service-sector jobs will reduce the country's standard of living (Dreyfack, 1986; Ionas, 1986).

Many business writers have considered the impact of the global economy on manufacturing workers in the more-developed countries. As a majority of the world's population, located in the less-developed regions, strives to advance economically, many less-educated, lower-skilled workers in the industrialized nations have found that they are losing jobs to overseas rivals. In a feature issue on "The Global Economy: Who Gets Hurt," Business Week writers note that global competition results in lower pay for lower-skilled workers, widening the gulf between rich and poor (Bernstein, Konrad, & Therrien, 1992; Farrell, Mandel, Javetski, & Baker, 1993). Generally, these concerns are not taken into account as economists calculate the costs of protection. The U.S. International Trade Commission (1993a) study on the costs of import restraints to the U.S. economy did include estimates of the job losses if restraints were removed. Although the apparel industry was identified as the sector projected to lose the most jobs, when estimated job losses were combined for all segments of the textile and apparel industries, a total of 71,723 jobs may be lost if all trade restraints are removed. Most of these are likely to be production jobs. If workers in industry after industry are affected in this manner, this, too, changes consumers' potential ability to purchase other goods and services. Consumer spending in the early 1990s was indeed affected by the economic uncertainties felt by consumers.

In short, although protecting jobs is costly to consumers, a number of sources are beginning to question the long-term consequences of losing the domestic manufacturing base. As with most other issues related to textile and apparel trade, no easy answer exists for this aspect of the dilemma.

CONSUMERS' LACK OF AN ORGANIZED VOICE

Although consumers are the largest group with a stake in textile and apparel trade, they generally lack the organization of other interest groups. To a great extent, consumers are not aware of the various issues affecting them on matters related to trade. Since most consumers are not sensitive to the issues at stake, they express little concern for having their interests represented when trade policies and trade legislation are debated. In the U.S. political system, in particular, in which interest groups have grown increasingly vocal in order to have their positions represented, the "quiet" consumer perspective is underrepresented on trade matters.

When McRobert and Smallbone (1980) were invited to represent consumers' interests in a Brussels Conference on International Trade in Textiles and Clothing, they noted the rare opportunity to represent a consumer perspective on textile trade concerns. The authors, who

were employed by the Consumers' Association of the United Kingdom, noted:

Consumers in industrialized countries are the subjects of international textile arrangements, since it is these arrangements which seek to influence their pattern of behavior. The ostensible aim of any protectionist policy such as the Multifiber Arrangement and the bilateral agreements permitted by it is to force consumers to buy home-produced goods. This results in restrictions on consumer choice, more expensive goods, inflation and a decline in living standards; or increased pressure for higher wages to maintain living standards, and hence inflation. That is why consumer organizations in Europe and Australia campaign against the international trend towards greater restrictions on trade.

On the other hand, consumer organizations in America have not made their views on protectionism known so forcefully. The association of sections of the consumer movement with the labor movement may be part of the reason for this. (p. 170)⁶

The International Organization of Consumers Unions

The International Organization of Consumers Unions (IOCU) represents consumer interests at the global level, with offices in Europe, Asia, and South America, linking the activities of some 180 groups that serve consumer interests in 64 countries worldwide. At the group's world congress in 1991, IOCU called for eliminating the MFA. IOCU's position was based on the grounds that (1) the agreement hurts low-income consumers in the more-developed countries who cannot benefit fully from imports from low-wage countries, and (2) many impoverished workers in Third-World countries

⁶ For example, labor unions are actively involved in the Consumer Federation of America. Since many unions (and certainly those for the textile and apparel industries) are actively involved in seeking protectionist measures for their respective industries, union members of consumer groups are quite unlikely to take a stance against trade barriers.

desperately need the income from exports that are restrained by the quota system (IOCU, 1991).

In general, however, consumer groups such as those listed below have not been aware of the issues involved in textile and apparel trade, nor have they taken a position on this trade.

Examples of consumer organizations in the industrialized countries include:

- The Bureau Européen des Unions des Consommateurs. This umbrella consumer organization for the EU included growing protectionism among its five most important areas of concern.
- The Consumers' Association in the United Kingdom. This group is one example of a consumer group within a specific EU country. This is an independent organization financed by the sale of its research-based consumer magazine, which has over 700,000 subscribers. The group campaigns for consumers' rights and responsibilities on various issues.
- Consumer Federation of America. This is a nonprofit umbrella organization for 240 member organizations including grassroots consumer groups, senior citizens' groups, labor, cooperatives, and state and local consumer groups.
- Consumers for World Trade (CWT). CWT is a nonprofit organization established in 1978 that

supports expanded foreign trade to help promote healthy economic growth; provide choices in the marketplace for consumers; and counteract inflationary price increases. CWT believes in the importance of increasing productivity and competitiveness through the efficient utilization of human and capital resources and the expansion of international trade. CWT conducts its educational programs to keep American consumers informed of their stake in international trade policy and speaks out for the interests of consumers when trade policy is being formulated. (*Brown*, 1987, p. 1)

- Citizens for a Sound Economy (CSE). CSE is a
 U.S. "public interest advocacy group
 dedicated to returning economic decisionmaking to citizens. With an active
 membership of 250,000 citizens, CSE
 promotes initiatives which reduce
 government interference in people's
 economic affairs" (Alexander, 1987, p. 13).
- Consumers' Association of Canada (CAC). CAC is a "non-profit, voluntary organization with a national membership as of April 1985 of approximately 150,000 Canadians. The Association's objectives include bringing to the attention of federal tribunals the consumer perspective on various issues" ("Consumers' Association," 1985, p. 62).

These consumer organizations represent a range of commitments to consumers' perspectives on trade. And, although the organizations report large memberships, the numbers may be an overstatement in terms of active participation. Most of these consumer organizations have small staffs and limited resources for representing their constituents effectively, particularly against the broadbased, well-funded efforts of manufacturers and retailers.

GLOBAL CONSUMERS

Today's electronic communications has spawned a new breed of young consumers—perhaps the first generation of truly global consumers. Through satellite TV and the Internet, young consumers in many regions of the world share a remarkably common lifestyle. They drink Cokes, eat Big Macs, listen to similar music, watch many of the same TV shows and movies, and are tuned in to the latest variation of jeans—wide legs, narrow legs, or whatever a season holds.

FIGURE 14-9

Although the new care label symbols were developed in the United States, they have the potential to reduce the need for multilingual care labels in today's global market.

Source: American Society for Testing and Materials. Reprinted by permission.

	GUIDE TO CA	ARE SY	MBOLS	
	Machine wash cycles		Hand wash	Warning symbols for laundering
Wash		delicate or gentle	30C	do not wash
	temperatures ven	y hot hot warm 40F) (120F) (105F)		do not bleach
Bleach	any bleach only when needed	non-chlorine bleach when needed		(used with do not wash) do not iron
	Tumble dry cycles O O		Hand dry line dry or hang to dry	Additional instructions (in symbols or words)
Dry	Tumble dry temperatures any high mediu	or gentle	drip dry	do not wring do not tumble dry
Iron	(390 F) (3	110 C (230 F) Iow		in the shade (added to hand dry) iron no steam
	Dryclean - normal cycle	8	Dryclean - additional in	nstructions
Dryclean	any any solvent petroleum except solvent trichloroethylene only	do not dryclean		ow no steam
A STATE OF THE SECOND SECOND		SALEDSATILITY SAVEN	D5489-1996a. American Society	CARROLL STREET,

Reprinted, with permission, from D5489-1996s. American Society for Testing and Material 1996 Annual Book of ASTM Standards

Note: This Figure illustrates the symbols used for laundering and drycleaning instructions. As a minimum, laundering instructions include, in order, four symbols washing, blackfind, ordring, ording, and, drycleaning instructions include one symbol. Additional symbols or words may be used to clarify the instructions.

Although national and regional differences are vitally important for marketers to respect, the common interests and tastes tied together through a worldwide media web represent an important phenomenon to watch. This trend will be further propelled as both manufacturers and retailers expand their global networks, establishing brand names and retail stores in many regions.

As an indication of expanded global activities, the American Society for Testing and Ma-

terials (ASTM) developed new care labeling symbols that will convey information on the necessary care for garments. See Figure 14–9. The U.S. Federal Trade Commission (FTC) permitted clothing manufacturers to start using the care symbols in place of written instructions beginning July 1, 1997. Many manufacturers welcomed the symbols, which have also been accepted by NAFTA partners Mexico and Canada, to eliminate the need to write care instructions in three languages. The director of

the FTC's Bureau of Consumer Protection noted, "We believe this is a first step to a global label that can be used around the world" (Owens, 1997, p. 18).

SUMMARY

Although consumer apparel expenditures have increased in recent decades, apparel has been a good buy. Consumer textile expenditures are more difficult to track because of the diverse range of products under the *textiles* term. Prices for apparel and textile interior furnishings have risen more slowly than other consumer prices. Apparel has taken a smaller proportion of disposable personal income over a period of 30 years. Low-cost imports and pressure on domestic producers to compete account for some of these expenditure patterns.

Consumers gain from textile and apparel trade by having greater variety, and if savings are passed on to consumers, low-cost imports usually represent a good buy. Most economists believe, however, that the present system of textile and apparel trade restraints reduces the potential benefits of trade for consumers.

Trade restraints, primarily tariffs and the MFA quota system, are intended to encourage consumers to purchase domestic goods rather than foreign-made products. The intent of trade restraints is to save jobs and to protect the domestic industry from what is perceived as unfair foreign competition. Economists generally believe, however, that these measures to protect the domestic industry are costly to consumers. Most economists believe that the import control systems seriously limit consumer choices and add to prices. A number of studies have estimated the dollar costs to consumers and to the economy more broadly. Nearly all the estimates have shown high costs to consumers. Most of these studies, however, have not considered the adjustment costs to workers and to the economy if the protection were removed. Moreover, a number of concerned individuals, including several business writers, have begun to question the long-term impact on the U.S. economy if manufacturing continues to shift to low-wage countries.

Although consumers have a great deal at stake in textile and apparel trade matters, this group's interests are generally represented minimally in decisions on trade policies or trade-related legislation. Several consumer organizations exist in the industrialized countries; however, they are relatively weak in terms of resources and grass-roots participation (particularly on matters related to trade) compared to the more powerful organizations representing manufacturers and retailers.

A new generation of global consumers share interests in similar lifestyles and products as a result of the worldwide communication networks spawned by satellite TV and the Internet. Manufacturers and marketers must take note of this trend as it develops further.

GLOSSARY

Adjustment costs are the costs to a country and to individuals when competitive global market conditions force a sector to adjust to the competition. Adjustment costs may include the demise of inefficient firms or job losses for workers.

Ad valorem tariffs (duties) are levied as a percentage of the value of the goods imported.

Binding (or bound) tariffs are those under the mostfavored-nation provision of GATT/WTO, which represent a reduced rate or a commitment not to raise the existing rate.

Consumer cost of protection is the extra amount consumers pay for goods because of protection-induced price rises.

Domestic content laws require that a certain percentage of the component parts for products be made in the country where the product is sold.

Dynamic costs of trade restraints include the impact of decreased competition on firms in the importing country.

Gains from trade refers to a country's advantages, through trade, in obtaining goods in which that nation does not have a comparative advantage compared to what it would have if the country tried to produce all of its own goods.

Quota premium is the price manufacturers pay to secure quotas in those exporting countries in which quota allocations are openly bought and sold. Where a nation's exports are limited by MFA bilateral agreements or other measures, manufacturers must have access to quotas to ship goods to the importing market. Thus, where quotas are bought and sold, exporting firms pay quota premia to secure a portion of the quota allowance.

Regressive taxes are those that cost the poor more proportionately; that is, the tax rate decreases proportionately as the tax base increases.

Retaliation occurs when one nation responds to restraints imposed on its products in an importing country by refusing to buy products from the country enacting the restraints.

Scarcity rent is the higher price paid by consumers due to the quantity restrictions on imports (quotas). It may accrue to the exporting or importing country (personal communication with R. Dardis, 1989).

Specific tariffs (duties) are flat charges per physical unit imported.

Static costs of trade restraints refer to short-term effects on consumer prices and choices, as well as output and employment gains in the protected industries.

Welfare costs of protection are the costs to the economy as a whole of producing more goods domestically rather than importing them. These deadweight losses represent production inefficiencies and reduced consumption due to higher prices, and may also include transfers to foreign manufacturers due to quotas if the scarcity rent from quotas is retained by foreign manufacturers (personal communications with R. Dardis, 1989).

SUGGESTED READINGS

Blackhurst, R. (1986). The economic effects of different types of trade measures and their impact on consumers. In *International trade and the consumer*.

Paris: Organization for Economic Cooperation and Development.

This paper identifies the effects of trade policies on consumers.

Cline, W. (1978). *Imports and consumer prices: A survey analysis*. Unpublished report. Washington, DC: Brookings Institution.

A market study indicating that prices were lower on imported products than on comparable domestic products.

Cline, W. (1987). The future of world trade in textiles and apparel. Washington, DC: Institute for International Economics.

This book considers the consumer costs of the Textile and Apparel Trade Enforcement Act of 1987; in addition, it evaluates studies conducted for RITAC and FFACT.

Congressional Budget Office. (1991). *Trade restraints* and the competitive status of the textile, apparel and nonrubber-footwear industries. Washington, DC: Author.

Results of a study requested by the House of Representatives' Subcommittee on Trade.

Dardis, R. (1987). International textile trade: The consumer's stake. Family Economics Review, 2, 14–18.

A concise review of the impact of textile trade restraints on consumers.

Dardis, R. (1988). International trade: The consumer's stake. In E. S. Maynes & ACCI Research Committee (Eds.), *The frontier of research in the consumer interest* (pp. 329–359). Columbia, MO: American Council on Consumer Interests.

A study of the impact of trade restrictions on consumer welfare; this paper includes economic models for estimating consumer losses.

Dardis, R., & Cooke, K. (1984). The impact of trade restrictions on U.S. apparel consumers. *Journal of Consumer Policy*, 7, 1–12.

An estimation of the costs of U.S. trade restrictions.

Hickock, S. (1985). The consumer cost of U.S. trade restraints. *Federal Reserve Bank of New York Quarterly Review*, 10(2), 1–12.

A study of consumer costs associated with trade protection; includes clothing.

Hufbauer, G. & Elliot, K. (1994). Measuring the cost of protection in the United States. Washington, DC: Institute for International Economics.

An analysis of the cost of protection.

Jenkins, G. (1980). Costs and consequences of the new protectionism: The case of Canada's clothing sector. Ottawa: North-South Institute.

- A study of costs to consumers resulting from protectionist measures.
- Morton, M., & Dardis, R. (1989). Consumer and welfare losses associated with Canadian trade restrictions for apparel. *Canadian Home Economics Journal*, 39(1), 25–32.
 - A study of the economic losses associated with Canadian textile trade restraints.
- Organization for Economic Cooperation and Development. (1986). *International trade and the consumer*. Paris: OECD.
 - A collection of papers on consumers and trade.
- Pelzman, J. (1983). Economic costs of tariffs and quotas on textile and apparel products imported into the United States: A survey of the literature and implications for policies. *Weltwirtschaftliches Archiv*, 119(3), 523–542.
 - This article provides a review of a number of studies that have examined the costs of trade restraints for consumers.
- Silbertson, Z., & Ledic, M. (1989). The future of the Multi-Fiber Arrangement: Implications for the UK economy. London: Her Majesty's Stationery Office.

- This study includes a section on the impact of textile and apparel trade restrictions (the MFA in particular) on UK consumers.
- United States International Trade Commission. (1993, November). *The economic effects of significant U.S. import restraints*. Investigation No. 332–325. (Pub. No. 2699). Washington, DC: Author.
 - A study analyzing the economic effects of U.S. import restraints on the U.S. economy; the study considers several sectors. Textile and apparel restraints were found to be the most costly.
- Wolf, M., Glismann, H., Pelzman, J., & Spinanger, D. (1984). Costs of protecting jobs in textiles and clothing. London: Trade Policy Research Center.

A study of the costs of protection to the importing countries weighed against jobs saved.

World Bank. (1987). The threat of protectionism. In World Development Report 1987 (Chapter 8). New York: Oxford University Press.

A review of the increase in protectionist policies and costs associated with those policies.

15

Policymakers and Textile/Apparel Trade

Especially in the last three decades, textile and apparel trade has posed a particular challenge to policymakers at both the national and international levels. Although these problems have intensified in recent decades, the difficulties are not new. As noted in historical reviews in various chapters, textile and apparel trade posed problems more than a century ago. In this century, as early as the mid-1930s, producers in the more-developed countries were concerned over textile and apparel imports.

Although trade in many sectors has been a problem for policymakers in recent years, resolving global trade problems associated with the textile and apparel sectors has been a special challenge. Establishment of the MFA as a departure from GATT rules was evidence of the special treatment given textiles and apparel in trade. Controversy surrounds the question of whether textile and apparel trade was ever a special case meriting departure from GATT rules, as well as other exceptions to general trade rules. Regardless of whether textile trade should be a special case, the fact remains that, as a result of political activity, textile trade has been treated as a special case. Textile trade has been a "separate province . . . of trade policy with its specialized governmental agencies, international agreements, and industry-oriented participation" (Olson, 1987a, p. 16).

Many experts have come to view textile and apparel trade as a *political* problem rather than an economic one. Giesse and Lewin¹ (1987) asserted, "It is not the economic condition of this industry that determines its level of protection. Rather, politics dictate policy choices in the realm of U.S. textile and apparel trade" (p. 81).

Textile and apparel trade problems have long represented a dilemma for many policymakers. See Figure 15–1. Frequently, policymakers have found themselves caught between textile interest groups pressing for added protection against imports and the need to uphold broader economic and foreign policy concerns for the sake of international goodwill. Not all policymakers have been faced with this dilemma, however; some who represent textile and apparel interests have been strongly committed to support restrictions against low-cost imports.

In this chapter, we will consider the special dilemma that textile and apparel trade has

¹ Although Giesse and Lewin (1987) are cited in this chapter, the reader should be aware that these author-attorneys are affiliated with the firm Mudge, Rose, Gutherie, Alexander & Ferdon, a lobby group known for representing free trade textile and apparel interests. The Giesse-Lewin paper is carefully written and documented but, as might be expected, represents a critical perspective regarding the political activities of the textile and apparel industries.

FIGURE 15-1

Resolving the problems associated with the textile trade has posed a dilemma for many policymakers.

Source: Illustration by Dennis

Murphy.

represented for policymakers at both the international and national (United States) levels. After examining some of the reasons why policymakers give special attention to the industry, we will consider specific ways in which U.S. policymakers have been influenced by industry pressures. Additional discussion will focus on the conflict policymakers experience in being expected to represent both sectoral and diplomatic interests. Because of space limitations, this discussion is not intended to be an exhaustive analysis of policymakers and textile and apparel trade.

A REVIEW OF TEXTILE/APPAREL TRADE AS A SPECIAL PROBLEM

Textile and apparel production is among a number of established industries in the more-developed countries that have experienced difficulty in remaining competitive in global markets. Among the others are the shipbuilding, steel, and shoe industries. Often these established industries are called the **smokestack** or **sunset industries** because of their long existence and the belief (by some sources) that these are declining industries in the more-developed countries.

The textile and apparel industries have faced a variety of problems for several decades. Some of these difficulties are a result of changes in the international arena; other problems are domestic in origin.

Particularly after the worldwide recession in the mid-1970s, competitive difficulties in the international arena were exacerbated by increased competition from low-wage less-developed countries. Producers in the industrialized countries experienced difficulty in retaining domestic markets that they had taken for granted up to that time. Despite increased trade restraints in the more-developed countries, the volume of low-cost imports continued to grow substantially.

Considered from the domestic perspective, the U.S. textile and apparel industries (along with similar industries in more-developed countries) have been suffering from what Anson and Simpson (1988) term "long term structural decline" (p. 107). Structural decline is a term used to describe the decline of an industrial sector, particularly in terms of global competitiveness. Structural unemployment is often a by-product. Textile and apparel industries in the more-developed countries that are successful today have undergone substantial restructuring and updating with modernized equipment and production processes. In some cases, this restructuring has occurred with government assistance. Or, as Anson and Simpson noted, the industries in some developed countries are successful because they have been more heavily protected by trade barriers against imports than their industrialized competitors.

Political Problems Related to Employment

Concern over employment losses related to imports is the most common way that a troubled industry secures the attention of policymakers. Unemployment is a political problem that policymakers cannot dismiss lightly. Although employment declines may be related to improved productivity resulting from the introduction of advanced technology, competition from low-cost imports is generally seen as the reason why the industry needs special protection. Special protection refers to exceptional restraints on imports implemented through high tariffs, quotas, or other limitations. Arguments for special protection are not unique to the U.S. textile and apparel sectors. Similar arguments have been used by a number of other domestic industries experiencing problems in international competitiveness. And, furthermore, the approaches for securing added protection are amazingly similar from one industrialized country to another, despite the differences in political systems.

In a large number of the more-developed countries, textile and apparel employment is a sensitive issue. Often, employment is geographically concentrated, frequently in areas of already high unemployment. (Although the U.S. industries are located in every state, manufacturing is concentrated in certain areas.) Moreover, social concerns add to the arguments that the textile and apparel sectors are special cases, in need of protection. Examples of *social arguments* follow.

- As one of the oldest established industries, textiles and clothing are often an established part of a country's infrastructure, employing large numbers of people, many, typically, from ethnic minorities.
- Employment is often geographically concentrated and in locations where no alternative employment is available.
- Textiles and clothing employ relatively more females than males, and any reduction affects females disproportionately. (Anson & Simpson, 1988, p. 159)

In addition to the social arguments for maintaining employment in textiles and apparel, *economic reasons* add to the arguments for special treatment for these sectors. In most developed countries, the textile and apparel industries remain major contributors to the economy. In addition to their contribution to employment, these industries typically contribute substantially to value-added manufacturing and exports. Moreover, a number of other related industries are affected by the conditions within this sector.

As Anson and Simpson (1988) noted, governments have tended to write off these industries as sunset industries and to place expectations on newer *sunrise* industries, such as microelectronics and biotechnology. However, altogether, these newer industries employ far fewer persons than textiles and apparel. Furthermore, the microelectronics industry has

been another field in which the international division of labor occurred rapidly. Therefore, this newer industry has experienced many of the same problems in global competitiveness that occurred earlier in the textile and apparel sectors. Other mainstay industries have experienced similar problems that led to reductions in domestic output and employment.

And although developed countries such as the United States may shift increasingly to becoming *service* economies, that shift is not without problems. A number of experts believe this change will result in a lower standard of living for U.S. citizens, since many of the service industries are the low-paying industries in general. Moreover, the question remains as to whether service industries can absorb workers from all the manufacturing sectors experiencing structural decline (Culbertson, 1986b; Dreyfack, 1986; Jonas, 1986).

In short, arguments for the importance of maintaining viable textile and apparel industries-particularly in view of the number of workers (voters) represented and other contributions to the economy—have not been lost on policymakers. Consequently, policymakers from the areas where the industries are concentrated have been their strongest advocates in securing advantageous trade and other policies. At the same time, the geographic dispersion of these industries, particularly apparel, has accounted for widespread support for textile and apparel trade concerns. In most cases, supporters of protectionist policies have argued for protection as a means of sustaining employment.

TEXTILE TRADE AND THE U.S. POLITICAL PROCESS

American presidents since Franklin D. Roosevelt have proclaimed the virtues of free trade. Most have promoted international initiatives (e.g., the establishment of GATT and

MTN trade rounds) to promote free trade through reduction of tariff and NTBs. However, at the same time, while promoting bold international programs to reduce trade barriers, these same presidents have been granting special concessions to protect troubled industries. The resulting trade policies reflect these contradictory approaches. While tariff barriers are greatly reduced from the Smoot-Hawley tariffs of 1930 (from 53.5 percent in 1933 to 4.4 percent in the 1980s), a number of special protection regimes have been developed to protect problem sectors from foreign competition (Hufbauer & Rosen, 1986).

Although the United States was a leader in efforts after World War II to develop GATT to facilitate global trade, ironically, during this same time, special protection grew to protect industries facing severe import competition. We recall from an earlier discussion that textile trade accounted for landmark departures from mainstream trade rules. As special protection for a number of sectors grew more common, it also became more accepted in trade policy circles.

How Policymakers Become Involved in Originating Special Protection

Constitutional responsibilities, as defined for the executive branch and for Congress, indicate why both of these branches of government become involved in setting international trade policy. The regulation of *foreign commerce* is entrusted to Congress; the conduct of *foreign affairs* is entrusted to the president (Tribe, 1978). Since trade incorporates both of these elements in international relationships, both the president and Congress may seek to participate in trade matters—or, in some cases, both try to avoid the problems. Often the drama is intriguing as policymakers alternately avoid and take credit for trade-related actions.

Although this section focuses on policymakers within the U.S. political system, similar scenarios may be found in other industrialized

countries. The scenery, the language, and the faces may differ, but the strategies of both the industrialists and the policymakers are quite similar to those that occur in the United States.

Hufbauer and Rosen (1986) suggest that common scenes unfold as the U.S. executive and legislative branches of government are confronted by industries seeking special protection.

- In the first scene, the president generally resists protectionist solutions. He points to the costs of protection, America's international commitments, and the virtues of self-help. If the industry is politically ineffective or recovers its economic health, that usually ends the drama. However, if the industry is politically strong, yet continues to feel the competition from imports, congressional pressure for relief often builds.
- In the second scene, key members of Congress urge the industry's case. To emphasize their interest, the lawmakers may attach riders to legislation needed by the administration.
- In the third scene, the president sees his
 political goals endangered and grudgingly
 comes to accept the case for the trade
 restraint. But the president tries to build
 maximum flexibility into the regime so that
 restrictions may be liberalized as economic
 and political winds change.
- The fourth scene is an apologia, in which the president defends his program as less protective than the solution threatened by Congress. (pp. 5–6)

The Executive Branch and Textile/Apparel Protection

Giesse and Lewin (1987) asserted that the special protection afforded the textile and apparel sectors is primarily a result of the executive branch's eagerness "to satisfy the demands of a powerful, special interest group" (p. 82). Similarly, Hufbauer and Rosen (1986) attribute

major policy concessions for the textile and apparel sectors to presidential desires to please the large constituency represented by these industries. After all, the industries, because of their size and their concentration in key regions, have provided critical support in presidential elections. Thus, as Giesse and Lewin noted, these industries have been able to obtain commitments from presidential candidates in exchange for political support.

Perhaps the most significant example of a political trade was John F. Kennedy's establishment of special protection through the Short-Term (STA) and Long-Term Arrangements (LTA) Regarding Cotton Textiles—the first official trade policies that removed a major portion of world trade in manufactured goods from general provisions of the GATT (GATT, 1984). In pursuing the STA and the LTA, President Kennedy fulfilled campaign promises that secured for him the political support of the textile-producing states (Destler, 1986).

Similarly, President Richard Nixon fostered development of the Multifiber Arrangement (MFA) (see Chapter 10), and later, President Jimmy Carter further tightened restraints on textiles and apparel. During the 1980 presidential campaign, candidate Ronald Reagan gave these industries personal assurances that he would work to protect them from imports. Aware that they were dissatisfied with his progress, as the election year approached, the Reagan administration attempted to be more supportive of tightening textile and apparel trade restraints (Destler, 1986; Pine, 1984).

Although the textile and apparel industries continued to believe that President Ronald Reagan defaulted on campaign promises to assist them, retailers and importers considered that MFA IV favored the domestic industry by allowing further restraints on imports. In addition, under the Reagan administration, renegotiation of U.S. bilateral agreements with the "Big Three" resulted in significantly tighter restraints. With the exception of George Bush, recent presidents have been helpful to the U.S.

textile and apparel industries. As the volume of uncontrolled imports continued to grow, however, sector leaders often felt that the assistance was inadequate (Schwartz, 1984; "Textile Trade Bill," 1985; Wightman, 1986a).

Congress and Textile/Apparel Production

A Large Constituency

The size of the textile and apparel workforce is a major influence in the sectors' record of securing special trade protection. The U.S. fiber, textile, and apparel complex is the single largest manufacturing employer in the country. In addition to the more than 1.5 million workers directly employed by these industries, including workers in every state, additional large numbers are employed in supporting industries. For example, farmers are involved in cotton and wool production for the industries. Employment in the textile and apparel sectors represents slightly under 9 percent of the U.S. industrial workforce-more than the U.S. automobile or several other major industries. Thus, large numbers of workers are dispersed throughout several hundred congressional districts. As Giesse and Lewin (1987) noted, "Few legislators in these districts, therefore, can be totally indifferent to the political demands of this industry" (p. 83).

Geographic Location

Historically, the textile and apparel industries have been concentrated in politically strategic geographic regions of the United States. The heaviest concentrations are in the Southeast and the Mid-Atlantic regions. In several Southeastern states (North Carolina, South Carolina, Georgia, Alabama, Tennessee, and Virginia), the textile and apparel industries are one of the leading manufacturing employers. In South Carolina, as an extreme case, this sector in the 1980s accounted for nearly 50 percent of all manufacturing employment and 40 percent of all indus-

trial output (author's conversation with congressional aide, 1986; Giesse & Lewin, 1987).

The South has the greatest concentration of apparel employment, with plants often located in rural areas where little or no other nonfarm employment exists. The Mid-Atlantic region (New York, New Jersey, and Pennsylvania) accounts for nearly one-fifth of the country's apparel workers, with apparel manufacturing located both in rural areas and in cities, especially New York City and Philadelphia. California alone now accounts for another one-fifth of the U.S. apparel workforce.

Conditions That Facilitate Political Activity

The size and distribution of the U.S. textile and apparel industries have made it possible for manufacturers and labor groups to organize effective political strategies. See Figure 15-2. Moreover, these industries have been among those with a long tradition of political activity. In the early 19th century—perhaps before the word lobbying was popular—the industries sought congressional protection from imports. Thus, when their history of political activity is added to their size and distribution, this combination makes the textile and apparel sectors, in Giesse and Lewin's (1987) words, "perhaps the U.S. industry most effectively organized for political action" (p. 86). Similarly, Goldstein (1983) noted, "Benefiting both from an historic precedent and regional concentration, the textile lobby had long been a formidable political force in American politics" (p. 175). And, finally, Cline (1984) concluded that the textile and apparel sectors would receive special protection—even if import penetration were nil because of the large share of the country's manufacturing employment in these industries.

Active Industry and Labor Organizations

Textile and apparel industry trade associations and labor unions have provided the leadership and coordination arms for the industry's polit-

FIGURE 15-2

Prior to the vote on a textile bill, textile and apparel workers marched on the Capitol with petitions containing thousands of signatures.

Source: Photo courtesy of UNITE.

ical activities. Key groups have been the American Textile Manufacturers Institute (ATMI), the American Fiber Manufacturers Association (AFMA), the National Cotton Council, and the Union of Needletrades, Industrial & Textile Employees (UNITE). Collectively, these organizations and their members are a powerful force.²

Minimal Opposition

In contrast to the long record of political activity of the textile and apparel industries and labor organizations, until the mid-1980s no group(s) had developed strategies that had an

impact in providing opposing views. That is, no group was organized or had similar strength to provide counter views to the textile and apparel sectors' position that greater protection against imports was needed. Consumers have never been well organized on trade matters. Although retailers had potential strength through the widespread distribution of stores throughout the country, they had not given high priority to trade issues. Retail political activity up to the 1980s had focused primarily on safety, wage, and other labor issues. Consequently, policymakers heard mostly the textile and apparel labor views on trade matters.

Opposing Groups Emerge

In the 1980s, other groups whose interests are affected by textile and apparel trade became more organized, more vocal, and quite active in presenting their concerns on trade to the

² Until 1989, the American Apparel Manufacturers Association (AAMA) was part of this coalition. However, in 1989, AAMA announced a change in its position on trade. As a result of increasing member usage of various offshore sourcing arrangements, AAMA departed from its earlier anti-import position.

526

executive branch and to members of Congress. Among the vocal groups are the National Retail Federation and the American Association of Exporters and Importers' Textile and Apparel Group (AAEI-TAG). The Consumers for World Trade is a U.S. group that argues for consumers' stake in trade.

Together, the retailer, importer-exporter, and consumer groups have asserted their presence in the textile/apparel trade arena. Policymakers no longer hear only the industry-labor views.

VARIOUS TEXTILE/APPAREL POLITICAL TUGS OF WAR

Since the mid-1980s, many policies and legislative bills affecting textile and apparel trade have come before policymakers at the national level. The primary ones include

- The 1985, 1987, and 1990 congressional textile bills,
- Approval of the Canada-U.S. Free Trade Agreement (CFTA),

- Renewal of China's most favored nation (MFN) status,
- Approval of the North American Free Trade Agreement (NAFTA),
- Efforts to secure Caribbean parity,
- Approval of the Uruguay Round agreement, and
- Identification of product categories to be integrated in various stages of the ATC quota phase-out.

For virtually all of these, the stakes have been very high for the players involved. In most cases, industry and labor groups have maintained one position, while retailers and importers have held another. On other occasions, players shifted alliances and groups were reconfigured. For nearly all of these policy or legislative issues, harsh political battles ensued over matters pertaining to textiles and apparel. For most of these trade matters, both sides expended enormous amounts of funding and energy. To illustrate the political tugs of war (Figure 15-3), we shall focus on some of the efforts listed above. The specific techniques used and the intensity of the battle depended upon the particular matter(s) at stake.

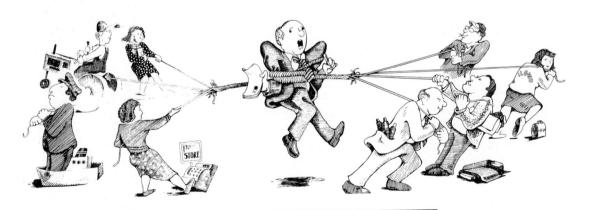

FIGURE 15-3

At times, textile trade issues have caused policymakers to feel pulled between the demands of opposing interest groups.

Source: Illustration by Dennis Murphy.

Although these trade concerns have been discussed earlier, our focus here is on the *political strategies* associated with the debates. A study of these efforts provides insight into the political activity associated with the U.S. textile and apparel sectors. Moreover, a review of political activity helps us to understand the positions of policymakers in the tug of war over textile and apparel trade.

Taking the Legislative Approach

As noted earlier, the textile and apparel industries had been successful in securing special trade protection through the *executive* branch of government. For nearly two decades, the rallying of industry votes for U.S. presidential candidates paid off in special trade provisions for the sector (Destler, 1986; Giesse & Lewin, 1987; Hufbauer & Rosen, 1986).

By late 1984, textile and apparel industry and labor groups became disenchanted with the executive route as a means of securing special protection for several reasons and decided to intensify their already active congressional lobbying. Thus, industry leaders decided to develop legislation to be introduced in Congress to further restrict textile imports, and efforts were launched to build widespread support for the 1985 bill known as the Jenkins bill. It was during the efforts to promote this bill that each faction learned to develop, orchestrate, and refine lobbying to try to sway policy in its favor. Keep in mind that portions and modifications of these activities would have been used throughout the decade. These same tactics were used in debates over the 1987 and 1990 textile bills as well.

For all of the trade issues in the prior list, political power was exerted on members of Congress to affect the outcomes for textiles and apparel. Domestic manufacturers knew how to work the system, while retailers and importers improved rapidly in political finesse.

A Growing Climate of Concern Over Trade Matters

The textile and apparel industries were adept at playing on the country's growing concerns over trade, which created a receptive climate for debates related to textile and apparel trade. Increasing media attention in the 1980s to America's economic decline in the global economy sensitized citizens to trade problems; unemployment rose; consumers became aware of their growing purchase of imports; and policymakers began to focus on trade concerns.

Redefinition of Foreign Trade

According to Olson (1987b), another significant shift occurred. Foreign trade was redefined. As Olson stated, "The already broad issue was transformed from trade to the capacity of the American economy to compete internationally" (p. 11). Furthermore, Destler (1986) observed that issues of trade and competitiveness took on a partisan character (with Democrats generally more protectionist because of support from labor and Republicans more free-trade oriented because of ties to big business), which increased the stakes and elevated the issue to the highest levels of Congress and the executive branch. Trade had become a high priority both among various constituencies and among policymakers.

Coalition Building

For each of the trade issues named on our list, affected players attempted to build coalitions to enhance their chances of support. Bills might go through many drafts to be broad and inclusive enough to appeal to a wide constituency. The broader the constituency, the greater the pool of members of Congress to be plied for support. Coalitions usually consisted of manufacturers and their allies against retailers/importers and that group's supporters. Each side sought to incorporate a wider range

of participants than might be associated typically with the respective groups. For example, on the textile bills, retailers formed alliances with consumer groups and others believed to benefit from less-restrictive trade. Similarly, retailers sought the support of agriculture groups that feared retaliation if textile restraints were tightened further (i.e., that U.S. agricultural sales would be affected). In addition, retailers included exporters in their coalition.

The development of the two coalitions to influence policymakers' vote on the textile bills, and the activities associated with each side's approach, provided a near-classic case in the study of interest group politics. Furthermore, the development of an active and powerful counterlobby group representing free trade interests changed decidedly the relative ease with which U.S. textile and apparel interest groups could influence policymakers to provide special protection against imports.

Tactics for Influencing Policymakers

A review of the tactics used to influence votes on various bills gives insight into the strategies used by interest groups to attempt to influence policymakers. In the case of the textile bills and other policies affecting the softgoods industry, as each coalition attempted to influence policymakers to understand its respective positions on textile/apparel trade—and to vote for that position-both sides used basically the same set of tactics. As Olson (1987a) made the following observations on common tactics (which have been condensed and modified somewhat for our purposes), he noted that these efforts are consistent with findings of Schlotzman and Tierney (1983), who asserted that interest groups use any and all strategies available to them.

Work with Government Officials

Members of a special interest coalition must possess skills and knowledge of the political actors in Congress and the strategies required to maneuver bills through (or around) hostile committees. Shepherding bills through the "legislative labyrinth" requires that proponents have a network of skillful, well-placed contacts who are able to negotiate with both congressional and executive branch officials at critical times. Although the retailers and importers have learned to use this tactic as well, because of their shorter history in political activity, this latter group has at times lacked the extensive network cultivated over time by the textile proponents.

Provide Numbers and Talking Points

Coalitions must work hard to provide data and other documentation to support their side of the argument. Each side may commission elaborate research booklets to provide trade statistics and other documentation. Data on import penetration, employment patterns, the trade balance for the sector, and other measures of the sector's performance may be cited as proof by congressmen, representatives of the administration, and witnesses appearing before committees.

Employ Consultants

Because full-scale lobbying requires many types of skills, coalitions often employ law firms and/or public relations firms. Often the coalitions rely heavily on these commercial public relations and campaign management services; some of the consulting firms further "subcontract" specific tasks such as economic studies and mass mailings.

Go Public

Although trade issues have not been taken to the public generally, Americans were sensitive to trade concerns at the time the textile bills were introduced. Similarly, the NAFTA debate received intensive publicity. Coalitions have launched public advertising campaigns at the national and local levels for some of these issues.

Lobby Other Private Groups

A coalition often tries to find allies to strengthen its own base and, hopefully, weaken the other coalition. Retailers have sometimes sought support from consumer groups and from lobbyists representing the interests of textile-exporting countries. At times there are incentives to draw agriculture into the manufacturers' camp. In the NAFTA debate, for example, the coalition that opposed the pact solicited the support of African Americans, who feared they would be hurt most by job losses.

Intensify Lobbying by Group Members

In addition to the concentrated efforts of the organized groups (trade associations, unions, etc.) within each coalition, corporations on each side may give extensively of their executives' time and other resources to influence policymakers' votes. Individual firms have at times opened offices in Washington; some have assigned executives or their own lobbyists to devote extensive efforts to the trade measures under debate.

For one of the textile bills, a leading textile "chieftain" rented a Washington hotel ballroom and converted it into a telephone calling center. Dozens of telephones were installed, and textile executives were expected to work for a time in the "telephone ballroom." Textile executives focused on calling individuals who could influence members of Congress to vote in favor of the bill. Large display boards in the ballroom tracked the congressional supporters, opponents, and those who were undecided.

Coordinate Lobbying

Regardless of the trade issue under debate, coalitions coordinate their respective members' lobbying efforts, working with each side's governmental allies. Generally, each coalition has a close count of supporters and opponents, focusing most efforts on legislators

who may yet be swayed. Textile lobbyists generally work in concert with the Congressional Textile Caucus, watching closely the status of anticipated votes (see Box 15-1).

Lobby Locally

Coalitions are often active in having members of Congress approached by firms and employees within policymakers' home districts. Although members of Congress may not know about a national coalition and its objectives, politicians are far more receptive to a case presented by voters in their home districts. Coalitions often orchestrate carefully the personal visits to policymakers to be sure each member of Congress had been "properly informed."

On one occasion during debates on one of the textile bills, the textile industry coalition even decided to try to use professors in their efforts to "bring around" the members of Congress who appeared to be unsupportive of the bill. The author was called and asked to contact select members of Congress from her state, particularly one well-known senator who appeared to oppose the bill. When the author indicated that her university would not wish to see her involved in lobbying, the caller suggested that the contact "wouldn't be lobbying." After the author attempted to decline graciously, the caller suggested that the author would regret it "because when the textile industry goes down the drain, if we don't get this bill passed, your program will go down the drain, too" (conversation with anonymous industry caller). (Incidentally, the bill did not pass, yet the textile industry and the author's department are very much alive and well!)

Election Finance

In addition to the substantial funds raised by each coalition for general lobbying efforts, participating companies and member associations often have their own PACs. See Box 15–2 and Table 15–1. The intent of PAC financing is to tie

BOX 15-1

A NOTE ON LOBBYING

Earlier in this chapter, as well as in other chapters, we have referred to the political power of the textile/apparel lobby. As our discussions have indicated, the lobby has used its strength to secure increasingly restrictive measures against low-cost textile and apparel imports.

We must remember that the political actions of the textile/apparel lobby have occurred within the U.S. democratic system, in which an industry or another group has a right to represent and defend its interests. Lobbying is certainly not unique to the textile and apparel sectors. In fact, Berry (1984) reported on the growing number and strength of groups representing a wide array of commercial as well as noncommercial special interests. Today, the

textile and apparel industries would be unique if they had *not* cultivated their own special interest networks. We must remember that these sectors have felt abused by the influx of low-cost imports and the nonreciprocity in global markets. Therefore, these industries have become proficient in using the political system to their advantage to respond to these concerns.

Perhaps the crux of the concern is that, in the eyes of retailers and importers, the textile/apparel coalition has been *too* effective in using the political system to its advantage. Present trends suggest that rival special interest groups will continue to strengthen their own political expertise and power to attempt to match that of the textile/apparel lobby.

BOX 15-2

SUPPORTING POLITICAL SUPPORTERS

Political action committees (PACs) related to the textile, apparel, and retail industries and trade unions contributed more than \$2.1 million for the 1996 elections and spent it on their favorite candidates in a variety of congressional and state offices (Federal Election Commission [FEC] printout, 1998). These expenditures reflect the various sectors' emphases on supporting candidates who will represent their respective interests in legislative and policy matters. Table 15–1 provides a summary of funds raised and campaign expenditures by the various groups. Contributions in the table do not include individual contributions from industry executives, designers, or other leaders who may be donors.

Contributions from the group of major retailers were higher than those from the manufacturing group. As a reflection of retailers' growing political activism, the National Retail Federation PAC contributions were almost 20 times what they had

been for the 1992 federal elections. The industry labor union UNITE supported a large number of candidates. A lobbyist for the union once noted, "We contribute to candidates and incumbents who have a good record on our program. . . . We don't give excessive amounts, but we give to a lot of members or candidates" (Pullen, 1988, p. 7).

Both retailers and manufacturers gave most heavily to Republican candidates for federal office, showing favoritism by a 2:1 or 3:1 ratio in most cases. A few companies were even more skewed in their preference for Republican candidates. For example, the PAC affiliated with Wal-Mart Stores, Inc., supported 140 Republican candidates, 6 Democratic candidates, and 1 other candidate. In contrast, the PAC associated with organized labor (UNITE) gave its support largely to Democrats: 195 Democratic candidates, 4 Republican candidates, and 2 others (FEC, 1998).

TABLE 15–1Business and Labor PAC Monies, 1996
Federal Flections

Federal Elections			
	Contributions		
Labor			
UNITE	\$ 324,629		
Retail			
National Retail Federation	\$ 100,374		
Dayton Hudson Corporation	94,550		
Federated Stores	17,000		
J.C. Penney	243,050		
Kmart	39,150		
May Department Stores	110,250		
Montgomery Ward	80,250		
Sears, Roebuck and Co.	7,750		
Spiegel	52,000		
The Con	127,000 3,000		
The Gap Wal-Mart Stores, Inc.	166,100		
Total (for group identified)	\$1,040,474		
	ψ1,010,171		
Manufacturing			
Atlantic Apparel Co. Assn.	\$ 200		
American Apparel Mfrs. Assn.	0		
American Textile Mfrs. Inst.	160,000		
Avondale Mills	500 143,915		
Burlington Industries, Inc.	2,000		
Cone Mills Fruit of the Loom	49,000		
Greenwood Mills, Inc.	2,925		
Guilford Mills	2,329		
Hoechst-Celanese	143,500		
Inman Mills	6,500		
Levi Strauss & Co.	0		
Liz Claiborne	0		
Milliken & Company	0		
Pendleton Woolen Mills, Inc.	3,300		
Russell Corporation	14,325		
Springs Industries, Inc.	51,650		
Total (for group identified)	\$577,815		
Other			
National Cotton Council	159,226		
Textile Machinery Good Govt. Cor	mm. 4,500		

Source: Federal Election Commission (1998).

support for a political candidate to the candidate's support of a group's goals. For example, lobbyists noted that votes on the 1985 textile bill would determine who received their group's support in the 1986 elections (Olson, 1987a).

Committee Testimony

Although interest groups generally testify for relevant congressional committee hearings, at times coalitions are selective in their participation in hearings. Groups participate in testimony when it is relevant to their goals to do so. Moreover, coalitions must understand the timing on the routing of the bill and know when testimony will be most useful. Coalition representatives might be more inclined to testify at Senate hearings, for example, if Senate votes appear less certain than those in the House, or vice versa.

Multiple Pressures on Policymakers—Examples

As congressional policymakers assume their responsibilities for the regulation of foreign commerce, trade problems in sectors such as textiles and apparel create multiple pressures. Trade issues are sensitive and complex, most actors have persuasive cases, and no easy answers exist.

Figure 15–4 illustrates the types of pressures placed on congressional policymakers during debate on the textile bills and other trade-related issues such as NAFTA or Caribbean parity. A similar figure could be developed to show pressure on the executive branch. Moreover, similar scenarios exist for efforts to secure protection for other sectors. The types of pressures are intended to be illustrative and not exhaustive. In this scheme, we might think of the pressures in two categories: the groups representing sectoral interests and the individuals and the groups representing broader diplomatic and economic interests of the country.

 Sectoral interests refer to the interests of various industries or other sectors such as agriculture. Each of these groups is

FIGURE 15-4

Here we see how the legislative branch, as an example, might receive multiple pressures from various sectoral interest groups, as well as pressure from sources representing broader diplomatic and economic interests.

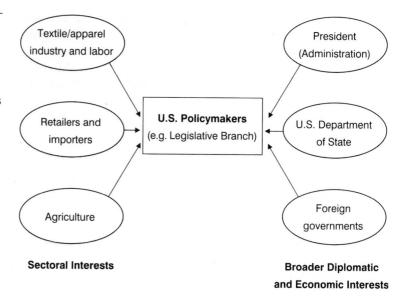

concerned with the well-being of its own sector.

Broader diplomatic and economic interests refer
to the interests associated with representing
the nation more broadly as a member of the
global community. Persons or groups
representing diplomatic interests want to
maintain favorable international
relationships. This group considers the
issues beyond the immediate trade
concerns of sectoral groups.

As we have seen for textile/apparel trade issues, there may be intense conflict among the sectoral interest groups. Nevertheless, in the broader picture, each of these represents a sector that stands to gain or lose by the outcome of policymakers' actions. Therefore, interest groups place a great deal of pressure on policymakers. In some cases, sectors may develop alliances with each other; the retailer/importer alliance with agriculture is an example. Typically, pressure on policymakers increases as broader alliances are formed.

In these days of increased global participation by a number of U.S. firms, it is not unusual to find a conflict over trade policies within a

single segment of the industry. For example, the American Apparel Manufacturers Association has a division between the group of large, internationally focused firms favoring free trade and the majority of their members who represent small, U.S.-based firms favoring protectionism. A similar split on trade matters has occurred within the American Textile Manufacturers Institute. At the April 1994 ATMI board of directors meeting, the textile industry's "father of protectionism" and a few other members of similar persuasion tried to encourage other CEO board members to attempt to derail the Uruguay Round/World Trade Organization (WTO) legislation when it was presented to Congress. Although most of the industry appeared to have been disappointed over the terms of the Uruguay Round, the majority of the ATMI board voted not to follow the protectionist faction's suggestions (author's conversations with various industry leaders, 1994).

Among the individuals or groups representing broader diplomatic and economic interests, alliances are natural, particularly since most of them represent a free trade position. For example, on the textile trade issue, the

president and the U.S. Department of State would likely have similar foreign affairs interests in that both are concerned with representing the nation on all foreign affairs matters—not simply trade for one sector. In addition, representatives of foreign governments (often through the embassies located in this country)—the exporting nations—may become involved. As an example, these representatives of other countries may advise U.S. policymakers how textile trade restraints will damage the political relationship between their country and the United States.

Alliances may also exist between certain sectoral interest groups and those representing diplomatic interests. In the case of the textile bills, the retailer/importer coalition worked with the administration to attempt to defeat the measures. Similarly, the retailer/importer group worked with representatives of textile-exporting countries. In fact, the same lobbyist law firm that represented the retailer/importer coalition was retained by a number of textile-exporting countries.

Alliances often change, depending on the issue at hand. For the heated battle over NAFTA, textile manufacturers, retailers, and importers worked with the Clinton administration to secure passage. In this instance, labor groups were adamantly opposed to the bill for fear of losing jobs to Mexico. Apparel manufacturers varied in their positions, depending on whether they had or planned to have production in Mexico.

Support for NAFTA was a new position for the domestic textile industry. Up to that point, the textile manufacturers generally had not favored free trade on any issue that involved textiles. In the case of NAFTA, however, the U.S. textile industry leaders saw excellent market potential for their companies in Mexico and were strong advocates for passage of the agreement. Favoring more open trade was such a new posture for the industry that some of the long-time strong congressional supporters of the industry appeared a bit confused at first.

Finally, persuasive textile leaders helped their congressional supporters understand the positive side of NAFTA for them. In fact, textile leaders were instrumental in bringing in congressional votes for NAFTA from delegates that may not have voted for the bill otherwise. See Figure 15–5 and Box 15–3.

TEXTILE TRADE AND THE GLOBAL POLITICAL PROCESS

We know from prior chapters that global textile trade has been managed under GATT for more than three decades, but now under the WTO it is in a transition to bring that trade under mainstream trade rules. We know that the MFA provided the structure under which participating countries negotiated bilateral agreements that established quota limits and other terms of textile and apparel trade. Despite (or, some would say, *because of*) the special mechanisms for textile and apparel trade, global commerce in this sector has been one of the most difficult for GATT/WTO officials.

Policymakers at the global level, like those at national levels, receive pressure from nations and factions seeking to influence policies to their advantage. The politics associated with global trade policies are complex and have been the subject of extensive studies.³ For our purposes, we will focus on two simplified perspectives on the roles of policymakers as they coordinate and mediate textile trade policies at the global level: (1) the conflicting demands of exporting and importing countries and (2) the demands from within a nation participating in the global agreements (focusing in this case on the United States) to influence global policy.

³ See References for Ansari (1986), Avery and Rapkin (1982), Blake and Walters (1983), and Destler (1986, 1992).

FIGURE 15-5

Guilford Mills, in Greensboro, North Carolina, hosted a pro-NAFTA rally shortly before the congressional vote on NAFTA. In the upper photo, Secretary of the Interior Bruce Babbitt tells the crowd of textile executives and operators to encourage their friends to vote for NAFTA because of the advantages it will bring to the economy. In the lower photo, textile workers from a number of companies in the region demonstrate their support for the agreement.

Source: Guilford Mills, Inc. Used by permission.

Conflicting Demands of Exporting and Importing Countries

As we discussed earlier, the textile/apparel trade dilemma has been a division between the more-developed and less-developed nations. This division among nations and the resulting efforts to influence textile/apparel trade poli-

cies represent a continuing source of conflict to come before global policymakers.

For the last three decades, textile/apparel trade problems at the global level have become increasingly difficult to resolve. As a growing number of producer nations have entered the global market, and as other exporting nations

NAFTA: THE POLITICAL FRAY

One of the most highly politicized battles facing U.S. policymakers in recent years involved the congressional passage of NAFTA. Although the NAFTA pact covered free trade in all sectors (after a phase-in period for some products) among Canada, Mexico, and the United States, the textile and apparel industries were important players in that debate.

Because of the issues of wage differences and possible job losses along with environmental concerns, an unusual coalition of NAFTA opponents emerged that included labor unions, African Americans, and environmental activists. Some apparel manufacturers, along with leaders in other industries who wanted to retain production in the United States, were opposed to the agreement. Ross Perot spoke of the "sucking sound to the South" in reference to anticipated jobs lost to Mexico. Partisan politics were scrambled in a most unusual manner on the NAFTA debate. Many Democrats in Congress (including Democratic House Majority Leader Richard Gephardt) opposed President Clinton and voted against NAFTA, creating a deep division in the president's own party.

Supporters of NAFTA were equally diverse. Oddly enough, the textile manufacturers were on the same side with retailers and importers; in this case, manufacturers had an eye toward expanding markets in Mexico. The successful vote of 234 to 200 in the House⁴ occurred *only* because of the support of Republican members. Republican Senate Minority Leader Robert Dole (usually a critic of Clinton) played a vital role in garnering support for NAFTA. Prior to the vote, all former presidents came out to show bipartisan solidarity for the trade accord.

In the last few months before the NAFTA bill went to Congress for a vote, trade was the drama: NAFTA was the leading act, and the United States was the stage. The level of grass-roots involvement

was unique for a trade policy because the issue had been politicized as costing U.S. jobs. Alliances worked hard to influence members of Congress to vote in a certain way for the agreement. Early on, a close vote was expected. Therefore, all factions went the extra mile in an effort to "wring out" as many votes as possible.

The National Retail Federation launched a letter-writing drive to have retailers around the country send letters to members of Congress. On Labor Day, several weeks prior to the vote, the AFL-CIO staged "NAFTA No" marches in about 75 cities around the country. Pro-NAFTA rallies were held, often featuring key leaders in the administration who traveled to various regions of the country to try to build support for the agreement. Banners, posters, T-shirts, caps, and buttons told the message of each side through these efforts staged around the country. The media were involved: Some groups ran advertisements, and persons representing every possible position were interviewed.

In the final days before the vote on NAFTA, when the House vote was still uncertain, President Clinton engaged in "horse trading" to secure the votes needed for passage. At this point, textile industry leaders were promised that Uruguay Round negotiators would seek a 15-year phase-out of the MFA rather than the proposed 10-year phase-out—if textile leaders could help assure passage of NAFTA.

In the end, grass-roots efforts, campaigning, rallies, and horse trading paid off; NAFTA passed with a House vote of 234 to 200. As expected, the agreement passed comfortably in the Senate.

⁴ The Senate vote had appeared favorable for NAFTA, particularly with the support of Senator Dole and other Republicans. Therefore, the passage or defeat of NAFTA depended on the House vote.

have become more proficient in their production and marketing efforts, the developed countries pressed for additional restraints to limit the exporting countries' products in their markets. In fact, the quota system is a monument to the developed countries' ability to press for special policies—policies contrary to the fundamentals of GATT.

Global pressure regarding textile and apparel trade can be reduced to two simple sets of demands. The exporting countries press for increasing opportunities to sell their products to the more-developed countries. And, conversely, the domestic sectors in importing countries press for increasing restraints to limit the flow of low-cost products from the less-developed countries. The obvious incompatibility of these two sets of demands accounted for the difficulties in developing trade policies acceptable to all the players.

As we recall, the textile and apparel sectors constitute the leading global manufacturing employer. Because of the importance of these sectors in both the more-developed and less-developed nations, officials at the global level cannot dismiss lightly the political pressures related to international trade of these products. From any perspective, as global policy-makers attempt to resolve textile/apparel trade problems, political pressures occur at that level as well.

Since many nations have a great deal at stake in textile/apparel trade, conflicts in this sector often have spilled over to broader trade concerns. For example, when the 1985 textile bill was being considered in Congress, Hong Kong's senior trade official warned a group of U.S. congressmen touring Asia in August 1985 that passage of the bill would create "rapid and damaging retaliation" against U.S. exports and would injure U.S. trade relations with developing countries throughout the world. The congressional delegation had gone to the Orient to discuss numerous trade issues; however, the protest against the pending textile bill dominated most trade conversations in Asian host countries (Ehrlich, 1985a, p. 2; 1985b).

In fact, for many global trade initiatives, progress on a broader agenda has been possible only after textile trade problems are disposed of prior to a general trade initiative. Cline (1987) and Destler (1986) speculated that the Kennedy Round of trade talks materialized *only* because textile trade problems had been resolved beforehand through establishment of the STA. Similarly, Cline, Destler, and others have noted that participating nations were able to move ahead with the Tokyo Round *only* because the MFA had been established to handle textile trade problems.

On matters related to textile trade, officials find themselves juggling the demands of the more-developed and the less-developed countries. As officials attempt to juggle the opposing demands, each group of nations makes a compelling case. The more-developed countries wield far more power in global commercial policy, although there are far fewer nations in this group. Of considerable significance, too, is the fact that the more-developed countries contribute a substantial portion of the funding for WTO (GATT) operations. On at least one occasion, the United States threatened to withhold its contribution if other contracting parties were unwilling to consider American demands. See Box 15-4.

Although the less-developed nations have had far less power in global economic and policy matters, this group represents a much larger number of countries. Moreover, these countries have grown increasingly vocal in their demands for a new international economic order (NIEO), which would allow an increased share of the world's industrial production to occur in their countries.

Demands from within a Participating Nation

Another form of pressure on policymakers at the global level is that generated from within each nation participating in the MFA (now ATC) quota system. That is, as various groups in a country—including those representing state

BOX 15-4

PRESSURE WHERE IT HURTS MOST

As the 1984 annual meeting of the GATT Contracting Parties convened, initial planning was expected to begin for a new round of trade talks (which eventually became the Uruguay Round). The United States wanted to have trade in services (such as banking and insurance), high technology, protection of intellectual properties, and the counterfeiting of goods included in discussions in the new round of trade talks.

Textile-exporting countries took this opportunity to oppose growing textile trade restraints in the major importing markets. Third-World nations vowed to resist a new round of trade talks until and unless the United States and other countries reduced restraints on their textile and apparel goods.

Subsequently, the head of the U.S. trade delegation hinted that Congress might withhold the U.S. contribution to the GATT budget, nearly 15 percent of its total budget, if the additional trade concerns were not included in the new round of talks. Formal sessions of the annual GATT meeting were canceled until the deadlock was resolved. Finally, delegates reached a compromise, and the United States contributed its share to the GATT budget (Callcott, 1984a, 1984b, 1984c).

We now know that both U.S. demands and Third-World demands were included in the Uruguay Round agreement. Services and intellectual properties are now under WTO rules, and the MFA is being phased out.

interests (the nation itself)—seek to gain certain advantages for the nation and its industry, pressure is applied at the global level.

Pressure from within a participating nation may vary considerably according to the type of government and the freedom of various groups to influence policy; however, in most market economy countries, at least some of this activity appears to occur in relation to textile trade. In discussing national pressure on global policymakers, we will focus on the United States as an example.

In the United States the democratic political system permits this activity to influence policy. Moreover, the strength of special interest groups concerned over textile and apparel trade accounts for a great deal of political pressure for policy concessions at the global level. Destler (1986) asserted that the U.S. textile/apparel coalition has had "sufficient political power to threaten the general trade policy-making system unless its specific interests were accommodated" (p. 23). Figure 15–6 provides a sim-

plified representation of pressures on policymakers at the global level. This figure illustrates the national pressures applied to policymakers who function at the international levels. For this discussion, global policymakers are limited to two groups:

1. Trade negotiators. A special staff of trade negotiators within the U.S. Trade Representative's (USTR) office negotiate textile trade agreements at the global level. Although these negotiators represent national interests, they function in a global capacity. Since the USTR is part of the executive branch of government, these negotiators must try to represent the broader interests of the country on issues related to textile trade. As quotas are being phased out, there are few bilateral agreements to be negotiated. However, as long as China is not a member of WTO, this will continue to be an important (and sensitive) agreement to be negotiated.

FIGURE 15-6

Policymakers at the global level may receive pressure from groups at the national level, representing sectoral as well as state interests, who attempt to influence textile trade policies.

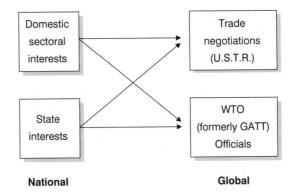

2. WTO (formerly GATT) Officials. The officials associated with WTO (GATT) are global facilitators of policymaking and implementation, attempting to represent fairly the interests of all the member countries in textile trade. WTO officials are those individuals affiliated with the WTO Secretariat who oversee WTO operations. In addition, at times we may use this term for delegates to WTO who are functioning in policymaking roles.

Among the officials we will consider in our discussion are the individuals within the overall WTO Secretariat, as well as those identified specifically with textile trade: the Textiles Division and the Textiles Monitoring Body. For our discussion, we will consider first the pressure on international-level officials, which comes from two types of sources at the national level.

a. Domestic sectoral interests. As one might guess from prior discussion, these are the special interest groups representing the sectors with a great deal at stake in setting global trade policy for the textile sector. These groups include, in particular, the U.S. textile industry/labor coalition and the retailer/importer groups. At times, if relevant interests are at stake, agriculture or other sectors may contribute to textile industry efforts to sway global policymakers.

b. State interests. Various U.S. groups or individuals attempt to influence policymakers on textile trade policy issues when these national representatives believe that broad interests of the state (country) are at stake. Persons concerned with state interests may include the president, members of Congress, representatives from various U.S. agencies, or even public interest groups dedicated to monitoring and influencing policy matters.

In the following sections, we will follow Figure 15–6 as we consider briefly how each of these groups at the national level may attempt to influence policymakers (both groups) at the international level. This discussion is intended to be illustrative rather than comprehensive.

How National Pressure Is Applied to Global Policymakers

Pressure from U.S. textile industry and labor groups represents the most common and most powerful example of the use of political strength within the country to influence global policy—and, hence, global policymakers. The retailer/importer coalition appears to be developing similar influence; currently, it is refining and bolstering its political strategies.

Pressure on Global Textile Trade Negotiators

First, although the U.S. textile negotiator represents the executive branch of government at the global level and is expected to represent broad diplomatic interests of the nation as he or she negotiates policies, in reality this is difficult to achieve. The influence of the textile lobby has been readily apparent in negotiators' efforts at the global level.

PRESSURE FROM SECTORAL SOURCES. Regardless of negotiators' intent to represent the broad diplomatic interests of the country, they must worry about appeasing the domestic textile lobby and the retailer/importer lobby. Industry pressure results in part from the U.S. textile coalition's fear that the industry's concerns will be put aside in favor of other interests in broader diplomatic negotiations. That is, textile industry leaders worry that governmental concern for maintaining harmonious relationships with other nations will cause negotiators to ignore the sector's concerns for healthy survival (and their belief that import restraints are needed to achieve that survival).

The textile lobby influences the negotiators' roles in a number of ways. First of all, an individual's initial appointment to the negotiator position is influenced by lobbying inherent in the political process of the appointment. Since the chief textile negotiator is appointed through the executive branch but must be approved by Senate confirmation, the domestic lobby has numerous opportunities to influence this process via the Textile Caucus. Moreover, once a negotiator is appointed, the lobby's demands are not subtle. The negotiator is expected to maintain a position helpful to the domestic industry. In addition, U.S. industry advisors have accompanied the USTR staff on negotiating missions and have been available to influence decisions whenever possible.

In recent years, in using their growing political skills, retailers and importers have taken a

position on the appointment of the chief U.S. textile negotiator. See Box 15-5. Also, retailers and importers have been permitted to send advisors to textile negotiations; this group too has attempted to influence policymakers. Often, retailers and importers have combined forces with representatives of foreign textile-exporting interests in opposing trade restraints. This joining of interests has occurred rather easily because the same lobbyist and consulting organizations (e.g., the International Business and Economic Research Corporation, IBERC) has worked for a number of these free trade groups.

PRESSURE FROM STATE SOURCES. Second, because textile negotiators must represent the broad diplomatic interests of the state, they also receive pressure from individuals or groups representing those interests. For example, the president or State Department officials may be concerned about how textile restraints will damage diplomatic relationships with another country. Concerns expressed to textile negotiators may dictate actions contrary to those desired by the textile lobby. In a few cases, negotiators have been required to consider defense concerns. For example, if the United States has military bases in a country with growing textile exports, state interests must be weighed against sectoral interests. Turkey was awarded substantial quota increases for being an ally of the United States in the Persian Gulf War. At times, ideological concerns enter into the negotiating process. As an example, the executive branch of government (representing the state) may believe that allowing textile and apparel production to expand is important to the economic development and political stability of certain regions.

CONFLICTING PRESSURES ON NEGOTIATORS. In short, U.S. textile negotiators must cope with many powerful advocates of differing positions. Both the sectoral interest groups and the representatives of state interests wield tremendous political power. Negotiators are caught between

BOX 15-5

POLITICAL ONE-UPMANSHIP

When Rita Hayes (see Figure 11–4) was nominated to be chief U.S. textile negotiator, the politics surrounding the appointment were a classic display of political one-upmanship between the interests of manufacturers and the retailer/importer group.

The Clinton administration nominated Hayes for the position—an ambassador rank position requiring Senate confirmation. Normally, public hearings are held prior to sending nominees' names to the full Senate for a vote. However, in this case, the Senate Foreign Relations Committee decided to send Hayes's nomination forward without holding hearings. That is, textile industry proponents in the Senate attempted to get approval for the nomination by sending it forward with several other diplomatic appointments by unanimous consent without a roll call.

Along came supporters of the increasingly adept retailer/importer camp. One or two senators (from states where retailers and importers

have significant political clout) put the nomination on hold and refused to have it swiftly and blindly approved without the proper protocol. Although Hayes was later confirmed and rose to even higher diplomatic levels, the newfound retailer/importer influence was felt.

The executive director of the U.S. Association of Importers of Textiles and Apparel noted: "When there are bills in Congress to eliminate the textile ambassador position and a textile program itself that costs American consumers billions of dollars a year because of protectionism, the cynical attempt to sneak Hayes's nomination through in the middle of the night before Christmas, when nobody's supposed to be paying attention, is underhanded.... The import community has taken it on the chin with this [textile] program for many years, and we won't do this anymore. We are a big industry that employs millions of people, and we should be able to have our say before our government" (Ostroff, 1995, p. 9).

conflicting sets of demands: The manufacturing lobby wants greater protection; retailers and importers want a greater voice in matters; and those persons representing state interests want to protect diplomatic relationships with other countries. Even the most skillful negotiators find it impossible to meet these three sets of demands; consequently, few textile negotiators remain in the position for more than 2 or 3 years.

Pressures on Global Officials

For our discussion, the WTO officials will include those with duties specifically identified with textile trade: the Textiles Division and the Textiles Monitoring Body (TMB).

Global officials experience many of the same pressures as U.S. textile negotiators. A major

difference, however, is that global officials are individuals from all regions of the world. Although these individuals sometimes represent home interests, typically they assume a diplomatic perspective that permits them to look at issues from a global vantage point. Assuming a global perspective does not, however, shield these individuals from the types of sectoral and state pressures discussed earlier.

PRESSURE FROM SECTORAL SOURCES. The existence of a complex set of controls on textile and apparel imports is evidence that the textile and apparel sectors in the more-developed countries have been successful in exerting pressure on the global trading system. Often, however, pressure on global officials from the industry sector occurs indirectly. Although industry representa-

tives from a country may make direct contact with global officials, industry pressures are applied more commonly to the home country's trade representatives or other diplomats who are expected to seek the provisions the industry wants. Generally, protocol does not permit industry representatives to be present and visible during negotiations or other policymaking sessions; however, the textile and apparel industries in nearly all countries have been successful in applying pressure through existing diplomatic channels.

Since the 1960s, textile and apparel industries in the more-developed countries have applied pressure within the global framework to achieve special policy concessions to control imports. A review from our discussion in an earlier chapter includes these notable historic examples:

- Establishment of the concept of market disruption—a first-time departure from GATT rules (GATT, 1984).
- Establishment of the STA, LTA, and MFA which removed textile trade from GATT rules that applied to all other trade (GATT, 1984).
- In GATT-sponsored MTN trade rounds, textile and apparel tariffs have been permitted to remain much higher than tariffs in general (GATT sources, 1994; OECD, 1983)

At times, the policies developed for the textile and apparel sectors were contrary to broader initiatives being undertaken. For example, the MFA (which permitted the use of NTBs) became effective at about the same time that GATT sponsored the Tokyo Round negotiations to reduce NTBs.

We recall that GATT was established in the late 1940s to foster *more liberal trade* among the countries of the world. Yet, almost from its beginning, GATT provided special policies that *restricted* trade in textiles and apparel. How and why did this occur? These exceptions to GATT rules resulted from textile and apparel sectoral pressures from the more-developed countries, exerted through an understanding of and access to appropriate diplomatic channels.

PRESSURES FROM STATE SOURCES. Despite the idealistic aims of GATT for liberalizing world trade and "placing it on a secure basis, thereby contributing to economic growth and development and to the welfare of the world's peoples" (GATT, 1985, p. 1), the demands of various countries or groups of countries often altered this idealism. A changing global economy and increasingly difficult international competition in many sectors eroded much of the original idealism of GATT. Only time will tell whether WTO can resist similar pressures.

Earlier, we discussed the conflict between sectoral and diplomatic interests in attempting to sway policymakers within the United States. Not surprisingly, these conflicting agendas are extended to the global level. At the national level, we recall that textile/apparel industry groups exerted pressures for special trade protection, which was frequently inconsistent with the wishes of those representing state interests. With regularity, these inconsistent demands were sought under GATT.

In using the United States as a case, we may observe that "state interests" can assume varied forms when brought to the global level. First, we recall that the textile sector uses established diplomatic channels to exert pressure for greater trade protection; therefore, some representatives of the state may reflect a strong pro-industry position. On the other hand, another representative of the state may dismiss industry pressures and seek only broader diplomatic interests on behalf of the country. The president and the U.S. Department of State typically represent this latter category.

To illustrate these two types of pressure from state interests, we might consider the demands of select members of Congress with quite different agendas for U.S. interaction with WTO.

Although each congressional faction might consider its agenda to be in the best interests of the state, the perspectives on how textile trade policies should be handled at the global level would be quite different. Since Senator Strom Thurmond (R-SC) and Senator Ernest Hollings

BOX 15-6

TEXTILE PRESSURES AT THE GLOBAL LEVEL

The following are examples of efforts to exert pressure at the global level to influence textile/apparel trade policies.

- At the TMB level. As the unit that handles all routine problems and complaints related to textile trade, this group receives documentation and other persuasive assistance from countries whose disputes are being considered. Typical problems occur between an importing country and an exporting country. In these cases, the textile and apparel sectors in each of the two countries may attempt to provide evidence to persuade the TMB to see their respective sides in the dispute. Although TMB members come from national delegations, these officials endeavor to function as impartial diplomats rather than simply serving their own nation's interests. Nevertheless, pressure is directed to members of this monitoring group. The pressure may come from an industry within a country involved in a dispute, or it may come from coalitions representing North or South interests.
- During negotiations. In July 1990, as the Negotiating Group on Textiles prepared to develop a proposal on how to integrate textiles into GATT rules, representatives of various sectors descended on Geneva. Concerned over the potential plan, the Retail Industry Trade Action Coalition's (RITAC) delegation was one of the largest this group had sent to trade talks. During their stay, RITAC, along with the Foreign Trade Association, a group of European retailers, jointly sponsored a reception and dinner for about 100 people. Guests include GATT negotiators and representatives of developing countries (Chute, 1990a).
- During Uruguay Round negotiations. In the final days of Uruguay Round negotiations in Geneva, industry advisors for the textile sector, as well as those representing the retailer/importer group, assembled to advise U.S. negotiators on concerns affecting their respective sectors as the final agreement was concluded. Similarly, industry advisors from other sectors and other countries were on hand to advise their negotiators.

(R-SC) are from an important textile-producing region and are active members of the group of U.S. congressional advocates, they would seek to have global textile trade policies provide increasingly tight restraints on textile imports directed to the markets of the more-developed countries. In contrast, Senator John Ashcroft (R-MO) and Representative Jim McDermott (D-WA) would attempt to establish a trade system at the global level with as few restraints as possible. Senator Ashcroft looks after the interests of the powerful May Company in St. Louis, which imports most of its private label products. Representative McDermott has a free trade orientation because his state has more ties to the Pacific

Rim than any other state. In short, these powerful factions, the protectionists and the free traders, each attempt to influence global trade policies according to what is believed to be in the best interests of the country. The only problem is the two factions have directly opposing views on what will represent state interests best.

Similar conflicts involving state interests occur within textile-exporting countries. For example, certain sources representing the state may demand more open markets for textile products because of the importance of the sector to the country's economic development. In contrast, other national officials might be more concerned with maintaining international political

FIGURE 15-7

A business executive surveys the new landscape in which many of the past barriers and special forms of protection are beginning to crumble.

Source: Illustration by Dennis

Murphy.

goodwill. In short, in the politicized arena of textile trade, the demands from state interests may or may not represent broad diplomatic concerns.

REFLECTIONS ON POLICYMAKING AND TEXTILE TRADE

The 1990s ushered in a new era of more open trade in the global arena. Although support for these changes in the United States is by no means universal, the executive branch, under the leadership of President Clinton, has taken a strong, proactive position in leading the nation in these initiatives—often at considerable political risk. First, the passage of NAFTA was a milestone in opening markets, even when this required opposing organized labor groups to secure passage of the agreement in Congress. The NAFTA accord was soon followed by the of the Uruguay successful completion Round—after the GATT negotiations had labored along for 7 years. In short, these two landmark agreements appeared to signal a dramatic shift in the U.S. position on trade. Figure 15–7 illustrates the crumbling of protectionist measures that characterized the U.S. economy in the past. Despite these major changes, however, political forces have succeeded in preventing the expansion of NAFTA-type agreements with other parts of Latin America.

As we reflect on the role of policymakers and textile trade, a number of observations may be useful to consider. Although some of these observations apply to trade in general, they are especially relevant to textile and apparel trade. A common thread among these observations has been the political aspect of trade for the textile and apparel sectors.

Goldstein (1983) concluded that political ideology—not social forces or international shifts in power—has dictated American commercial policy. She noted that the U.S. political system does not foster decision making that may be in the best long-term interests of the nation. According to Goldstein, our system's limited power for economic intervention and the need to please voters make it "impossible for central decision-makers to use rational decision-making criteria to create policy" (p. 427).

In the absence of a national umbrella policy for trade, Goldstein (1983) concluded that "certain industries for anomalous and different reasons have been excepted from liberal policy and certain industries who are in decline but who employ large numbers of workers may get more aid than would be expected" (p. 427).

Similarly, Hufbauer and Rosen (1986) noted that special protection is inequitable among industries. Large industries with political clout—like textiles and apparel—"are able to shake the U.S. political system for massive benefits" (p. 27). In contrast, small industries with only regional influence—like footwear—get far less protection.

In addition to concerns about pleasing the electorate, Aggarwal (1985) asserted that the fragmentation of power among the legislative, executive, and judicial branches has provided the state only limited opportunities to influence policymaking. Furthermore, he noted that the most unified branch, the executive branch, has numerous divisions with distinct constituencies. Aggarwal suggested that the fragmented state is no match for the strong and previously cohesive political organization of the textile and apparel industries. Therefore, according to Aggarwal, the United States has been too fragmented organizationally to establish a national policy or to resist industry and labor demands.

Policymakers who were not textile/apparel proponents at times feared that the model of managed trade that evolved for textiles might be copied by other sectors. Policymakers feared that other sectors might secure similar institutionalized regimes that would have been additional exceptions to GATT rules. Other cases might have included, for example, a "Multi-Steel Arrangement" or a "Multi-Automobile Arrangement."

Overall, we may conclude that world trade in textiles and apparel has been regulated extensively through means other than simple market forces. Governmental intervention has been common, and the actions of national governments have often reflected political pressures

from sectoral interest groups. In the United States, embattled officials found themselves expected to demand more of foreign trading partners and to offer less in return (Destler, 1986). In short, textile and apparel trade has posed a long-term and persistent challenge to policymakers.

SUMMARY

Although in recent years trade in general has been a problem for policymakers, both at the international and the national levels, textile trade has been a special challenge. The importance of textile and apparel production to most nations and the growing competitive market conditions have led to intense political activity related to global trade in these sectors. Policymakers have found themselves caught between the political demands of industry groups pressing for added protection and the need to represent broader diplomatic and economic concerns.

Textile/apparel trade issues have become highly politicized in the more-developed countries. This has resulted in part from the concerns over job losses in two sectors that constitute the major manufacturing employer in most industrialized countries; therefore, large constituency groups cannot be ignored. In addition, groups representing textile/apparel interests have become quite proficient in securing the sympathy and support of policymakers to gain increasing restraints on low-cost imports.

In the United States, the textile lobby has generally been successful in securing presidential support in their concern over imports. Most recent presidents have provided important trade concessions for the textile and apparel sectors in exchange for their support in elections. Moreover, more than 1.5 million industry workers are dispersed throughout several hundred congressional districts, giving many members of Congress reason to take notice of their trade and employment concerns.

Textile and apparel interests were at stake in a number of trade policies and bills in the 1980s. In most of these cases, manufacturers had views opposite to those of retailers and importers; however, coalitions were formed and rearranged according to the issues involved.

Previously, the textile/apparel lobby encountered minimal opposition in its efforts to secure protection. However, the 1985 textile bill stimulated rapid emergence of a broad retailer/importer coalition. Each of the two coalitions has engaged in extensive and costly lobbying to influence policymakers on issues important to its business interests.

Similar strategies were used by various special interest groups for more recent trade issues; however, the alliances sometimes took different forms, depending on the issues. For NAFTA, textile manufacturers and retailers found themselves on the same side for a change. Nevertheless, the NAFTA debate resulted in a political flurry of protests, rallies, and letter-writing campaigns.

At the global level, pressures on policymakers result from the conflicting demands of exporting and importing countries and from within the nations participating in global agreements. The exporting countries demand greater access to markets; the importing nations demand more restrictions to protect home markets. The incompatibility of these two sets of demands results in trade policies that fall short of each group's expectations.

In addition, policymakers at the global level are subject to demands from various factions within a specific nation. This was the case during negotiations to conclude the Uruguay Round. In the United States, domestic sectoral interest groups seek special concessions in trade policies that often are contrary to the demands of groups or individuals pursuing the interests of the state. The MFA quota system has been a monument to the success of sectoral groups in the more-developed countries in securing their demands.

A number of scholars have questioned the manner in which political pressures have in-

fluenced trade policies, especially for textile and apparel trade. Some of them believe that political ideology dictates commercial policy, making it impossible for decision makers to use rational criteria to create policy. Strong import-sensitive industries such as textiles and apparel have tended to receive favorable trade concessions. Some scholars believe that the fragmentation of power in the U.S. system of government has not permitted the establishment of unified trade policies that would resist sectoral demands. More recently, however, the conclusion of NAFTA and Uruguay Round pacts have signaled the beginning of an era of more open trade. Nevertheless, domestic protectionist forces have successfully resisted the expansion of NAFTA-like agreements with other Latin American countries.

GLOSSARY

Smokestack or sunset industries are long-established, mature industries in the more-developed countries; often, these terms are applied to industries that some persons consider to be declining.

Special protection refers to exceptional restraints on imports implemented through high tariffs, quotas, or other limitations.

Structural decline is a term used to describe the decline of an industrial sector, particularly in terms of global competitiveness.

Structural unemployment refers to job losses resulting from an industry's inability to respond to competitive market conditions; the inability to compete may result from changing technological developments or a change in the demand for products. Structural unemployment differs from widespread general unemployment.

SUGGESTED READINGS

Aggarwal, V. (1985). Liberal protectionism: The international politics of organized textile trade. Berkeley: University of California Press.

This book provides useful insights into the role of policymakers in the development of textile trade policies.

Berry, J. (1984). *The interest group society*. Boston: Little, Brown.

A study of how interest groups operate and how they relate to broader developments in the American political system.

- Blackhurst, R., Marian, N., & Tumlir, J. (1977). Trade liberalization, protectionism and interdependence. Geneva: General Agreement on Tariffs and Trade. An analysis of trade policies in an interdependent world.
- Choate, P. (1990). Agents of influence. New York: Alfred A. Knopf.

 This book examines the influence of foreign governments, especially through hired U.S. lobbyists, in

shaping U.S. economic policy.

Destler, I. (1986). *American trade politics: System under stress.* Washington, DC: Institute for International Economics.

An examination of the political pressures on American trade policies.

- Destler, I. (1992). American trade politics. Washington, DC: Institute for International Economics. This is an updated edition of Destler's 1986 book, with somewhat different conclusions on the status of U.S. trade politics.
- Friman, H. (1990). Patchwork protectionism: Textile trade policy in the United States, Japan, and West Germany. Ithaca, NY: Cornell University Press.

- An analysis of the pressures and constraints that influenced policymakers in placing growing restrictions on trade in the 1980s.
- Giesse, C., & Lewin, M. (1987). The Multifiber Arrangement: "Temporary" protection run amuck. *Law and Policy in International Business*, 19(1), 51–170.

A critical assessment of current textile trade policies; this includes discussion on the influence of textile/apparel interest groups on policies.

Hufbauer, G., & Rosen, H. (1986). *Trade policy for troubled industries*. Washington, DC: Institute for International Economics.

A review of existing trade policies with respect to troubled industries; recommendations for policy changes are included.

Raffaelli, M., & Jenkins, T. (1995, November). *The drafting history of the Agreement on Textiles and Clothing*. Geneva: International Textiles and Clothing Bureau.

This book is a firsthand report on the development of the ATC quota phase-out plan, including some of the

political aspects involved.

of protection.

Wolf, M., Glismann, H., Pelzman, J., & Spinanger, D. (1984). Costs of protecting jobs in textiles and clothing. London: Trade Policy Research Center. This book includes a discussion of the political aspects

Chapter 16 provides a brief reflection on the difficulties associated with global production

and trade of textiles and apparel. We are reminded of the difficulty in arriving at the right answer for the problems associated with this sensitive area of trade.

The chapter includes observations on the future outlook for the more-developed

countries in textile and apparel trade; similar observations are made for the less-developed countries. One section focuses on the future prospects for textile and apparel trade policies. The chapter concludes with an emphasis on the importance of a global perspective for persons involved in all segments of the soft goods industry.

16

Conclusions: A Problem with No Answer

Many academic courses conclude with a resolution of the questions or issues considered. The content may be summarized and/or issues resolved in such a manner that the student leaves the course with a sense of resolution. Often, however, toward the end of a course on textiles and apparel in the international economy, students ask, "But what is the answer to problems related to global textile and apparel production and trade?" Typically, students are seeking the professor's stance on that rocky continuum between free trade and protectionism. Unfortunately, neither a right answer nor an easy answer exists. And the more one studies the complexities associated with economic, political, and social concerns for trade in the sector, the more one becomes aware that easy answers are not likely to occur in the near future.

An inherent difficulty in finding an appropriate answer to textile trade problems is that the "right" answer is defined differently by each group with an interest at stake. As we have determined up to this point, many individuals and groups have a great deal at stake in the textile trade dilemma. Often, the concerns and demands of one group are directly contrary to those of another. In these cases, positions are often irreconcilable. For example, the demands of the less-developed countries for greater access

to the major importing markets directly contradict the demands of most manufacturers in the more-developed countries to reduce imports. Similarly, domestic manufacturers' efforts to restrict imports are directly opposed to the interests of retailers and importers. Therefore, an attempt to provide a right answer may provide one that is right only for those representing a particular perspective.

In this chapter, we will reflect on the difficulties associated with global production and trade of textiles and apparel, which we have considered in earlier chapters. In addition, we will summarize a number of relevant considerations regarding the present status and future prospects for production and trade for these sectors. The chapter is intended to highlight major issues and to encourage reflection on the content rather than to provide a comprehensive summary of the book.

THE DILEMMA: A BROAD VIEW Shifts in Global Production

Profound structural changes in the world economy are causing a reorganization of production on a global scale, with increased produc-

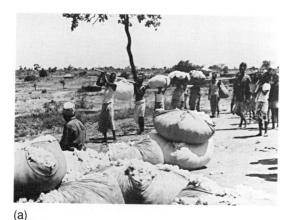

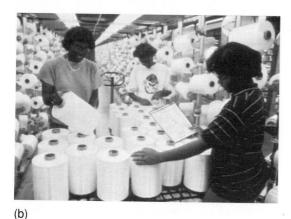

FIGURE 16-1

No easy answer exists for the question: Who should produce textiles for the world market? Source: Photo (a) courtesy of International Labour Office; photo (b) courtesy of Du Pont.

tion in the less-developed countries. Economies are in a state of constant flux because structural forces—technological advances, accumulation of capital, growth of skilled labor, changes in taste—alter international patterns of comparative advantage. A country's earlier ability to carry out various industrial activities can change over time. Developing countries acquire new capabilities, and the more-developed countries' ability to compete efficiently in global markets may change.

As less-developed countries strive for economic development, the textile complex is often the first one targeted for growth. Because textiles and apparel are labor-intensive industries that require limited capital and technology (particularly the apparel industry), developing countries enter these sectors when they can enter few others. Moreover, manufacturers and importers in the more-industrialized countries have sought the abundant, lowwage labor in the developing countries for the labor-intensive portions of textile and apparel production. As evidence of this trend, more than half of U.S. apparel imports are targeted for domestic manufacturers (AAMA, Technical Advisory Committee, 1996).

Thus, the structural movement known as the new international division of labor (new relative to the theories of the 1700s and 1800s) has been both an advantage and a disadvantage to the textile and apparel industries in the moredeveloped countries. Although many manufacturers and importers in these countries have taken advantage of the low-cost labor of lessdeveloped countries, the dramatic shift in production to these countries has created political friction at both national and international levels. Often the shift has engendered a political ripple effect that has extended far beyond the textile and apparel sectors. For example, the governments of other countries may retaliate against domestic textile trade policies in ways that hurt domestic sectors unrelated to textiles and apparel.

Use of Policy Measures

In general, theories of comparative advantage, accompanied by the system of free trade that blossomed after World War II, have been refuted by many industrial sectors experiencing difficult global competition. International shifts in comparative advantage entail the contraction of some industrial sectors, and as a consequence, these shifts are being resisted through policy measures.

Perhaps more than any sector, textile trade epitomizes the conflicts that arise from a shifting international division of labor. Consequently, many of the players have looked to policy measures to resolve the resulting difficulties. The outcome has been one of history's most intricate and complex set of trade rules devised to manage world trade in a specific sector. As authors of the GATT study *Textiles and Clothing in the World Economy* (1984) noted:

More so than any other industries, trade in textiles and clothing—and thus the pattern of production and employment of those industries around the globe—has been influenced by government intervention. This holds whether we view it in terms of length of time that restrictions have been widely used . . . or in terms of the level of restrictions in force at any point in time . . . or in the number of different policies simultaneously influencing the level of imports. (p. 53)

In sum, no other world merchandise trade has been as comprehensively regulated as that in textiles and apparel (Anson & Simpson, 1988). Moreover, textile trade regulations have been an aberration, or oddity, among global trade rules.

Although a primary principle of GATT was the elimination of discriminatory restraints on trade from certain countries, the MFA permitted discrimination through quota limits. At the time the MFA was developed, policymakers acknowledged that it violated the principles of GATT; however, the special circumstances of textile and apparel trade were believed to merit exemption. The belief prevailed that the longer-term interests of both exporting and importing countries could be served best through temporary mutual agreements to limit imports in the developed countries.

Problems Have Changed Over Time

Problems associated with textile and apparel trade at the time the STA, LTA, and MFA were developed have not diminished. Rather, they have changed in nature and grown even more complex. As increasing numbers of new producer nations compete for world markets and as the already established less-developed countries have become more proficient producers, competition has intensified.

As a result, the importing countries enacted increasingly restrictive measures to limit textile and apparel products from developing countries. In response, the exporting nations became increasingly agitated and vocal, demanding that restrictions be reduced. In particular, the less-developed exporting countries (along with many economists and other scholars who believe in free trade) called for dismantling the MFA. Today, that is in fact happening.

Textile and apparel producers in the moredeveloped countries have their complaints, too. As these producers have watched products from the less-developed countries and NICs take significant portions of their domestic markets, many assert that a majority of textile trade has been a one-way flow. Consequently, both producers and government officials in a number of more-developed countries are demanding market access (i.e., reciprocity); they believe that the producers in the more-industrialized countries should have greater access to less-developed and NIC markets. At times, the issue of reciprocity becomes a matter of how different groups perceive the rules of trade, as Box 16-1 suggests.

The MFA Quota System— The Gradual Demise of an Imperfect Compromise

The MFA—which began as a compromise and a means of resolving textile trade problems—became an agreement considered effective by

 $^{^{\}rm 1}$ One critic of the MFA termed it "the Mount Everest of protectionism."

BOX 16-1

RESTRICTING TEXTILE TRADE "LEGALLY" VERSUS "ILLEGALLY"

An impartial GATT official observed:

The developing countries believe that restricting textile imports from their own markets—by use of the GATT balance of payments provision—is *legal*. On the other hand, these same countries

believe that when the developed countries use provisions of the MFA to restrict imports, those are *illegal* (i.e., that MFA provisions violate the rules of GATT).

Source: Confidential comment to author.

almost none of the global players. Producers in the less-developed countries believed the MFA was used to strangle their textile and apparel exports. Conversely, producers in the more-developed countries viewed the MFA as an ineffective mechanism for regulating the entry of imports into their markets.

As the quota system (now under the ATC) is phased out and textile trade is brought under the trade rules for all other sectors, this will represent a major adjustment for the textile complex in many countries. Returning textile trade to mainstream WTO/GATT rules will not resolve the difficulties associated with a global overcapacity for production in these industries. See Figure 16–2.

As we have noted numerous times throughout the book, persons in nearly all regions of the world rely on textile production to fulfill clothing and home furnishings needs—some of the most basic needs of humanity. Of equal importance, the wages from the production of textile goods provide a livelihood for masses of people around the globe. The stakes are high.

FUTURE OUTLOOK FOR THE MORE-DEVELOPED COUNTRIES IN TEXTILE/APPAREL TRADE

The global economy has spawned a global system of manufacturing that has transformed production worldwide. Broad shifts in global

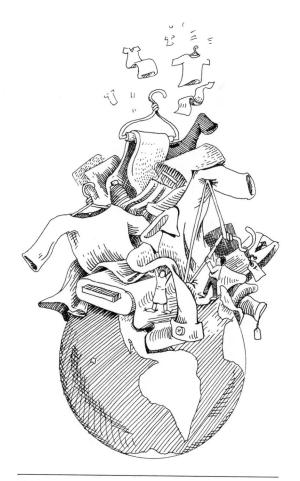

FIGURE 16-2

The global overcapacity for production will continue to make textiles and apparel difficult sectors of trade.

Source: Illustration by Dennis Murphy.

production have occurred in most manufacturing sectors, and the textile and apparel industries are on the forefront of this broader global change. Over the last four decades, the more-developed countries' share of world manufacturing output (all sectors) has declined, while that of the less-developed countries has increased. This trend, which is fostered in part by multinational firms based in the moredeveloped countries, is expected to continue. As a result, the more-developed countries have imported a growing share of labor-intensive manufactures from the less-developed countries. In Table 16–1, we can see, for example, that the more-developed countries imported more than 84 percent of all apparel imports in 1996.

In United Nations projections for the changing structure of all manufacturing for the year 2000 and beyond, the more-developed countries will account for a declining share of *consumer goods* output (mostly traditional laborintensive items). These countries will account for a growing share of *capital goods* (including

many high-tech items). More-industrialized countries' share of *intermediate* goods (materials required to make finished products) is expected to remain constant (United Nations, 1990).

The position of the more-developed countries in textile and apparel trade will depend increasingly on the ability of the industries in those countries to be competitive in the world market. As we learned in Chapter 6 and may review in Table 16–1, the more-developed countries continue to account for more than half of the world's *textile* production and trade (i.e., exports); however, their relative importance has continued to decrease. More-developed countries are behind the less-developed nations in world *apparel* production and trade.

The protection of the complex quota system will fade away. Therefore, the ability of the textile and apparel industries to compete will depend on the extent to which these industries can excel at producing and marketing their products. Globalization means that any given firm is competing with all the other firms in the

TABLE 16–1Shares of World Trade: A Brief Overview^{a,b}

	Textiles		Apparel	
	1990	1996	1990	1996
Exports				
More-developed countries ^c	62.6	53.0	40.0	37.8
Less-developed countries	36.1	44.5	55.2	57.6
Economies in transition	n.a.	n.a.	n.a.	n.a.
Imports				
More-developed countries ^c	62.8	51.8	87.4	84.0
Less-developed countries	32.5	41.9	9.0	12.2
Economies in transition	4.0	5.6	3.3	3.6

^a A comparison over a longer period is not possible because of WTO's change to a new system of country groupings.

b Figures may not add up to 100 due to rounding.

^c Includes EU intratrade.

n.a. = not available.

Source: Personal communication with WTO/GATT staff, 1993, 1997.

THE GOAL: ADJUSTMENT WITHOUT SUFFERING

We are looking through a magnifying glass at a problem that is characteristic of our type of society at the stage of economic development through which the world is now passing.

The problem, in principle, is not new. It is the old one of adapting to changing times. From the beginning of the Industrial Revolution, in particular, the challenge of adjusting to new inventions, new production methods, new markets, new competitors, and changing population patterns has never been absent. The pressures may

have abated at times, but they have never ceased. In the past, adjustment problems have been overcome many times, but too often at a cost of deep human suffering. Without a planned approach, the suffering today, the dislocation of men's lives, could be even greater, precisely because the pace of change is greater. To effect the adjustment without the suffering is indeed the essence of the matter.

Source: Plant (1981, p. 5).

world that produce and sell the same product lines. Just as in any domestic market, those companies that do the best job of responding to customer needs, and do so competitively, will be the ones that survive and prosper.

Industrial transformation in the more-developed countries is occurring through information technologies. Only through the use of these technologies, in many cases, can sectors continue to survive in the more-developed countries. Flexible manufacturing systems based on computerization of all stages of production (design, control, and manufacturing) are expected to continue to bring about profound changes in production processes. However, the more high technology (i.e., automation) is incorporated into the manufacturing process to compete in the global arena, the more employment is affected. See Box 16–2.

The textile and apparel industries in the industrialized countries have had varying degrees of success in facing structural adjustment. Most have attempted to implement adjustment strategies; the sectors in some countries have improved their competitive positions, while others have not. Technological changes have helped bring these industries "back from the grave" in

many cases, rejuvenating the industries in the more-developed countries through labor-saving technology. See Figure 16–3. These technological advances have given the more-industrialized countries an advantage difficult for many developing countries to match. On the other hand, although technological changes were notable in recent years in the apparel industry, these advances have not yet offset the low-cost labor advantage found in the less-developed countries. This low-cost labor advantage must be balanced by the demand for faster delivery of merchandise. That is, Quick Response strategies favor producers in close proximity to markets.

Technological changes, and the productivity gains that accompany them, will continue to account for job losses in the textile and apparel industries in the developed countries. In addition, competition among domestic producers is a fact of life in a market economy. Therefore, competition is not just from imports, but also from other domestic producers. And job losses will result from productivity gains, not from imports alone.

When structural changes affect the way in which people earn their livelihood, profound social changes often occur in tandem. Regardless

FIGURE 16-3

Outdated production facilities like this French textile mill can no longer compete in a challenging global market.

Source: Photo by Jacques Maillard, courtesy of International Labour Office.

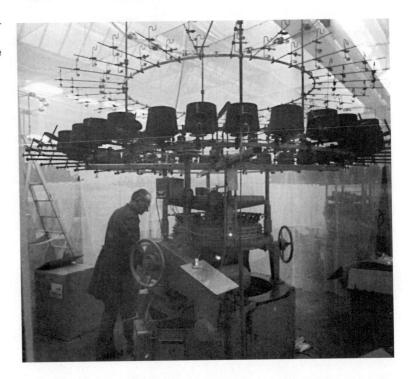

of whether economic changes are perceived as positive (in this case, gaining jobs) or negative (losing jobs), the resulting social change may be disruptive. For example, change causes strain on the family unit and alters the way individuals' roles are defined. In the case of job losses, the strains are tremendous. The more-developed countries must grapple with ways of solving unemployment problems that result from the global shifts in manufacturing and manufacturing jobs. In 1995, for example, unemployment in the OECD countries was about 35 million persons (8 percent of the labor force); however, these countries were not all affected equally (World Bank, 1995).

When global structural changes cause production to be transferred elsewhere, workers in the more-developed countries bear the brunt of this shift. Job loss is a selective process. Different social groups experience different levels of unemployment, with women, young people, older workers, and minorities being most vulnerable to job loss; most of these are un-

skilled or semiskilled workers. Women are affected more than men. The geographic spread is uneven, with some regions affected much more than others. All of these are potential repercussions of global restructuring in textile and apparel production. The reader must keep in mind, however, that a substantial amount of this transfer of production in the textile complex has resulted from the activities of transnational firms based in the moredeveloped countries, some of which may not have survived or remained competitive without taking the steps to move some or all of their production elsewhere (Dicken, 1992; Glenday, Jenkins, & Evans, 1980; Grunwald & Flamm, 1985).

A continued decline in the textile and apparel workforce in the more-industrialized countries is occurring for yet another reason. Social-anthropological influences may foster a decline in industry employment, which, in a sense, adds to the momentum for structural adjustment. That is, many pro-

duction workers in the textile and apparel industries want their children to aspire to higher forms of employment than those available in this sector. Because textile and apparel (particularly apparel) production jobs are among the lowest paid in all sectors, workers aspire to a more economically rewarding future for their children. In addition, the repetition of tasks and the pressure to reach certain production goals result in work that is demanding and exhausting. In short, many textile and apparel workers

who have had few other employment alternatives tend to encourage their children to prepare for other jobs. As a result of these changes, manufacturers in certain more-developed nations have already experienced a labor shortage, particularly in some regions, and anticipate an even greater shortage in the future.

Table 16–2 provides a few summary points on the potential impact of globalization of the industry in both the more-developed and less-developed countries.

TABLE 16–2
Potential Economic and Social Impact of Globalization of Textiles and Apparel

	Impact on More-Developed Countries (MDCs)	Impact on Less-Developed Countries (LDCs)
Economic Impact	 Lower-cost production in LDCs for MDC apparel manufacturers, retailers, importers. Production flexibility for firms. Lower-cost products for consumers (provided that savings are passed on). Shifts in MDCs to higher-skilled employment. Deployment of resources to the manufacture of higher value-added consumer goods and capital-intensive products. 	 The nature of employment changes. Employment for the local workforce. Employment earnings reduce poverty and improve the standard of living. Opportunity to earn foreign exchange, which is often used to buy products from the MDCs. Opportunity to learn how to participate in trade. Exposure to new technology. Intense competition in a global marker with production overcapacity.
Social Impact	 Likely decline in employment; potential decline in quality of jobs and real wages. Displaced workers in some regions are particularly hard hit. Women, minorities, new immigrants, low-skilled workers, and those in rural areas are among the most vulnerable to lose employment and are less likely to find jobs at comparable pay. As globalization intensifies, fewer and fewer jobs will be available for low-skilled workers. 	 Employment may offer little promise beyond low-skilled assembly jobs. Relocated manufacturing may lead to disruptive social conditions such as urban-bound migration. Workers are vulnerable to having production move to other LDCs, creating competition among LDCs for jobs. LDC governments may compromise labor standards (especially in export processing zones) to be competitive with other countries bidding for industry.

FUTURE OUTLOOK FOR THE LESS-DEVELOPED COUNTRIES IN TEXTILE/APPAREL TRADE

The less-developed countries are expected to increase their share of world industrial output (all sectors), mostly at the expense of the more-developed countries. Shifts in textiles and apparel are far more pronounced, however, because of the reliance of so many lessdeveloped economies on these industries. When we consider all sectors, a very limited number of countries is expected to account for the major proportion of industrial activities among the less-developed group: Brazil, China, Hong Kong (now part of China), India, South Korea, Singapore, and Taiwan. Only 10 less-developed countries produce more than two-thirds of the manufacturing output of the less-developed nations.

As we know by now, however, textile and apparel production in less-developed countries is spread over a far greater pool of producer nations. Although the "Big Four" Asian producers account for a very significant share of textile and apparel production for the world market, we also know that virtually every less-developed country has textile and apparel sectors.

The more advanced less-developed countries, particularly the NICs, will undergo structural changes that resemble those occurring in the more-developed countries. United Nations experts predict that although the consumer goods category will still be the largest proportion (38 percent) of industrial output for the less-developed countries, that category will account for a *decreasing share* of manufacturing value added. Growing shares will occur particularly in the capital goods area and, to some extent, in the intermediate goods category.

We must also consider the importance of textile and apparel manufacturing jobs in the less-developed countries. See Table 16–2. The NICs are rare in the broader group of less-developed countries to be experiencing labor shortages; this is not true in a majority of the

developing world. The Third World's single greatest problem is poverty, together with a lack of adequate employment opportunities. According to the World Bank (1995), more than 120 million people are unemployed worldwide and millions more have given up hope of finding work. About 99 percent of the 1 billion workers projected to join the world's labor force in the next 30 years will live in what are today's low- and middle-income countries. Having a way to earn a livelihood is at least as critical in the developing world as it is in the more-industrialized countries; in most of the developing world, there are no social programs to provide a safety net for times of unemployment. Unemployment is a way of life not by choice—in much of the Third World.

As Table 16–1 indicates, the less-developed countries increased their textile imports in the early 1990s. Much of this increase may have been used in producing garments and other finished goods that were then exported to the more-developed countries. The developing countries imported only about 12 percent of the world's apparel in 1996. The limited importation of apparel may be explained by a number of factors:

- 1. Much of the less-developed world cannot afford to buy any imported apparel product; families must produce for themselves whatever they have.
- Import-substitution policies in many countries encourage the population to buy apparel from newly established domestic industries rather than from foreign producers.
- Many countries have had a variety of policies that restricted imports.

As we know, the latter two points have been of serious concern to manufacturers in the more-developed countries, who expect the less-developed countries to provide greater access to their markets if the more-developed countries are expected to do so. Provisions of the Uruguay Round are intended to encourage reciprocity by the less-developed countries; however, a few nations are still resistant.

Population Changes and Demand

The world's population of approximately 5.5 billion persons increases by about 93 million per year. Between 1995 and 2000, growth is expected to peak at about 98 million annually (United Nations Population Fund, 1993). As we noted earlier, population growth is far greater in the developing world than in the developed countries. To help us grasp the differences, consider that in the time it takes to read this paragraph, roughly 100 children will be born—6 in the developed countries and 94 in the developing nations (World Bank, 1991). The reader should refer back to Figure 4–10 for a review of the United Nations population projections by area.

The continued population growth in the less-developed areas is expected to affect both the demand for and the availability of workers in future decades. Population growth represents only one indication of the potential demand for clothing and other textile products, however. Of more importance is the per capita expenditure on these products. And, of course, expenditures are determined to a great extent by the patterns of per capita income.

During the past 40 years, several less-developed countries progressed at an impressive pace. Some have seen their average incomes rise more than fivefold—a rate of increase that is extraordinary by historical standards. Many countries have fared poorly, however, and for some, living standards have *declined* during the past 30 years. Millions of people have yet to experience economic progress. The real income gap between the more-industrial countries and some less-developed economies, notably the Asian NICs, has narrowed dramatically since World War II. However, the gap between the more-industrialized and less-developed countries has widened. The last two decades of the 20th century have

been difficult for most less-developed countries (World Bank, various years).

Although most of the less-developed world will be unable to increase its consumption appreciably in the near future, an interesting phenomenon has occurred in many of the Asian NICs. Taiwan, Singapore, Hong Kong, and South Korea, which were on the leading edge as producer nations in textiles and apparel, have now become increasingly important consumer nations. Moreover, at the stages in which the NICs have become more important consumer nations, textile and apparel production has declined in relative importance. As in other moredeveloped nations, production has been sent to less-developed regions through various foreign investment and outward processing arrangements in neighboring Asian countries where wages are lower.

General Observations about the Outlook for the Less-Developed Countries

Textile and apparel production and trade will continue to be important in the economic development of most less-developed countries. However, although the availability of low-cost labor will continue to be a major competitive advantage for these countries, certain global changes occurring in both manufacturing and marketing will have a potential impact on the industry in these countries. First, as technological innovations are used increasingly in production in the more-industrialized countries, the less-developed countries whose competitiveness is based on low labor costs may find their cost advantage reduced. See Box 16–3.

Second, as retail customers in the developed countries demand increasingly fast response times on deliveries, manufacturers in those countries (or nearby areas) will have an obvious advantage in being able to respond quickly. Some retailers and importers in the major importing markets have begun to weigh broader

LOW WAGES ALONE ARE NOT ENOUGH

 The following observation by management expert Peter Drucker reinforces the notion that the less-developed countries may lose some of their competitive advantage based on low wages:

Lower wage levels alone won't make offshore manufacturing profitable. Blue-collar wages now account for only 18% of the total domestic manufacturing costs [for apparel production, the percentage is higher], so it takes a 50% wage differential to make up for increased transportation, communication, insurance and other costs. Competitiveness depends less and

less on labor costs, more and more on productivity, quality, procurement, design, product innovation, customer service and marketing (*Drucker*, 1989).

 Allan Ormerod, a British textile management consultant, also noted that despite a 30-year trend to consider textile manufacturing as a labor-intensive activity, he believes wage rates are of declining significance in determining the location of new plants (keep in mind that he refers to textiles, not apparel). He cited Italy and Switzerland as two successful high-wage countries (1993).

costs and benefits against the earlier attraction to low-wage production. Together, the technological improvements and the demand for fast deliveries in the more-developed markets are likely to continue to reduce to an extent the earlier competitive advantage of some less-developed countries.

In many ways, the plight of the textile/apparel-exporting countries is unfortunate for all players in the sector's global trade picture. Perhaps too many less-developed countries have been encouraged to enter the textile and apparel sectors—often on the recommendation of Western advisors from international development agencies. Although the characteristics of these sectors make them appropriate first industries for newly developing nations, producers are being encouraged to enter a global market already characterized by an oversupply.

When Third-World countries embark on production for global markets, they are pitted against formidable competition. A vast proportion of the products are aimed at mass markets—the segment experiencing the great-

est oversupply. In addition, some imports from the least-developed countries suffer from a poor quality image in foreign markets. And, in the past, as the newest entrants became proficient at producing for the glutted global market, importing nations imposed restraints to protect domestic markets.

Consequently, fostering the development of textile and apparel sectors as a means of economic development in a developing country often dooms the nation's producers and policymakers to disappointment and frustration. Economic development aspirations have been thwarted by import restraints and other problems. Further, many persons in less-developed nations perceive the developed country markets to be composed of affluent consumers with an insatiable appetite for goods. Thus, the representatives of less-developed countries find it difficult to understand why an affluent country such as the United States has been unwilling to take all of their country's textile and apparel exports. Many seem unaware that a significant number of other countries are focusing on the same markets.

Leaders in most of the major industrialized countries have a genuine benevolent concern for the development of Third-World nations. Moreover, most of the more-developed nations have directed substantial financial aid to the developing regions. Altruism is dampened by politics, however, as policymakers in the industrialized nations are caught between the development goals of Third-World governments and the pressure from domestic industries that fear excessive import competition.

FUTURE OUTLOOK FOR TEXTILE/APPAREL TRADE POLICIES

The MFA, originally developed as a temporary measure, had its shortcomings; however, a more acceptable system for moderating the difficult problems in textile and apparel trade did not emerge for the many years of its "reign." We must remember that the MFA was a compromise agreement; as such, it satisfied few, if any, of the signatory nations. Typically, compromises are unpopular because players are unable to obtain their full demands.

Although representatives of many developing countries publicly decried the evils of the MFA, many of the major suppliers enjoyed the guaranteed market access it provided. Similarly, the quota system has provided market access to newly exporting countries, which may have difficulty penetrating global markets at all because of the intensely competitive global conditions. Many less-developed exporting countries now worry about how they can compete alongside the giant China when there are no quotas to ensure that they will have a share of the major markets.

In the past, representatives of less-developed countries formed coalitions to protest formally against the continuation of the MFA. At critical points (such as the renewal of the MFA), however, the diverse positions of the less-developed

countries became apparent. That is, as representatives of each country pursued national interests, the coalition became fragmented. Consequently, when these representatives—the most vocal opponents of the MFA—failed to maintain a united position, the prospects for the group's plan to end the MFA often appeared slim.

Exporter opponents of the MFA forget that it replaced a system that was even less desirable for them. Under the previous system, major importing nations had far greater liberty to impose harsh unilateral restraints than was possible under the MFA. Moreover, the MFA provided a "transparency" to textile trade restraints. Prior to the MFA, textile and apparel import restraints were often handled "under the table." In addition, the MFA provided a relatively predictable climate for textile and apparel trade. Although many individuals may take exception to this statement, predictability is far greater than would have been true without the MFA. Consequently, in spite of its shortcomings, the MFA provided certain advantages to the exporting nations.

Increasingly, however, the exporting nations believed that their products were unduly restrained; as a result, they presented a unified front for a gradual dismantling of the MFA. Pressing collectively through the International Textiles and Clothing Bureau (ITCB), these nations were successful in achieving their goal in the Uruguay Round trade talks. Removal of the quotas in the three stages of the phase-out is occurring more slowly than they wished, however.

Public policy initiatives represent one approach to dealing with trade problems for textile and apparel, as well as for other industries. Protectionist trade regulations grew in popularity in the 1980s—with the textile and apparel sectors as the leading users of protectionist strategies. However, although the textile and apparel industries have looked increasingly to protectionism as the answer to trade problems, policy measures should not be considered as the long-

term solution. As many scholars, including Ghadar et al. (1987), have noted, "Long-term protectionism reduces overall industrial efficiency, isolates industry from the forces of progress, and increases costs to consumers" (p. 102).

If the textile and apparel industries in the more-developed countries are to remain viable in global markets, the ultimate response must come from within the industries themselves. In the United States, the EU, and other developed countries, the textile and apparel industries have made a number of significant strides in adjusting to foreign competition. Specifically, a number of forward-thinking firms have launched strategies to ensure their continued success not only in domestic markets but in global markets as well.

Although special policies have evolved to mediate textile and apparel trade problems, we must remember that trade for these sectors occurs within the much broader context of economic shifts and policies. The textile and apparel sectors may be leaders in some of these changes, but the interests of many other sectors and groups must be considered as well. That is, textile and apparel trade is part of a much larger picture. Policy decisions made for particular industries must also consider the impact on other sectors, national interests, and the consuming population.

In sum, the MFA quota system for regulating world textile trade was a *political* approach for dealing with an *economic* issue. As a result of the Uruguay Round, the MFA will be phased out in stages, with quotas on all products removed by the year 2005. (If countries are not members of WTO, quotas may still be imposed on those products.) If we reflect on our symbolism in Figure 10–4 and think of the MFA (now the ATC) quota system as an umbrella, we may begin to think of it as an umbrella that will slowly close over a period of 6 years; by 2005, it will be completely closed. For its sup-

FIGURE 16-4

Globalization of the textile and apparel industries will occur at an increasingly rapid pace in the years ahead.

Source: Illustration by Dennis Murphy.

porters, the MFA quota system should be buried with dignity as the crown jewel of protectionism. For its critics, the end would perhaps mean going to a long-overdue rubbish bin.

Although the textile and apparel industries were already rapidly restructuring on a global scale, the end of the quota system will escalate this restructuring. For example, apparel manufacturers and retailers from more-developed countries will no longer limit their sourcing locations to those with available quota. Phenomenal changes in textile and apparel production and trade will occur in the years ahead-and with greater speed than in the past-as we have attempted to portray in Figure 16-4. The manufacturers who have already faced the reality of globalization and who have taken steps to participate in the global economy will have an advantage during the eventful transition vears ahead—as well as for life after the quota system.

GLOBALIZATION OF RETAILING

As we noted in Chapter 13, the same forces that have propelled the manufacturing segment of the softgoods industry into a global era have also fostered an expansion of global and international retailing. However, retailers in the Americas lag behind those in Europe and Asia in expanding beyond their own borders or hemisphere. Retailers may have been slow to expand globally for the same reason manufacturers have thought little about exporting until recently. A large captive market had not required them to look beyond their borders.

As consumer spending rates increase more rapidly in Asia and other parts of the world, retailers have an opportunity to expand into new markets. Technology is available to facilitate that expansion. Trade barriers are fading away, making it easier to sell in other markets. However, although some retailers have expanded

into the global market, this commerce was relatively untapped until recently. Staff at Price Waterhouse/Management Horizons have encouraged retailers to consider global expansion in the near term while opportunities are open. These retailing experts also advise companies to be prepared to establish their firms for the long term. That is, it will take a substantial investment of capital, energy, and time to become established in new markets and build relationships before the payoffs accrue. Patience and an eye on the *long term* will be critical.

As we see an increased globalization of manufacturing—and of retailing—these two changes will perhaps be complementary in the years ahead. As a result of these changes in both manufacturing and retailing, we may soon see much more integrated channels of distribution—not just on a national level but also at the global level.

HOW TIME CAN CHANGE THE GAME

We must keep in mind that dynamic changes in textile and apparel production and trade patterns occur over time. Neither nations nor firms can presume that the present status will last. The future for these sectors in a particular country depends upon changes not only within that country, but within other countries as well. A country may be a global leader at one point in time but may lose its competitive advantage later. For example, England's textile industry led the Industrial Revolution, but more recently, this industry has had difficulty remaining globally competitive. Similarly, France has a long history as the fashion capital of the world, yet its textile and apparel sectors have struggled to remain prosperous in recent years.

Perhaps no country can equal Japan, however, in terms of dynamic changes in these sectors in the 20th century. During the early 1900s, Japan concentrated on building a strong textile industry, using the sector as a primary foundation for the nation's economic development. By the 1930s, its became the world's primary exporter of cotton textile products. Japan's success made the country a major threat to other textile-producing nations, and by the mid-1930s, Japanese textile products were limited in 40 of 106 markets (GATT, 1984; *Monthly Record*, 1936).

Although more than three-fourths of Japan's textile industry was destroyed during World War II, the nation's textile producers made a rapid recovery and soon became a threat once again to the industrialized countries. During the 1950s, Japan's proficiency in textile production led to many new measures to bar its products from the markets of the developed countries. Many of these restrictive measures paved the way for trade policies that would be applied more broadly to textile and apparel products from all developing countries.

Within a few decades of Japan's defeat and destruction in World War II, Japan changed from a developing country to a sophisticated leader of the industrial world. During this time, the importance of the textile and apparel industries in the country's economy diminished markedly. Today, Japan's textile and apparel sectors are being challenged by soaring competition from other Asian countries.

In the 1990s, imports forced Japanese textile manufacturers to close plants, reduce working hours, and lay off workers. According to the Japan Spinners Association, 25 of 53 members closed their cotton spinning plants. The flood of imports from other Asian countries caused great concern. The Japanese textile industry demanded increased protection, but the government called on the industry to continue restructuring (IAF, 1993).

In a scenario repeated in all of the moredeveloped countries, as part of the Japanese textile complex bemoans the influx of imports, other sectors are rapidly investing in production in other Asian countries and establishing operations there to export back to the Japanese market. For example, a wave of Japanese investment has poured into China to establish apparel production, partly to ship to the Japanese market and partly to have access to the Chinese market.

And, finally, in the greatest ironic twist of all, Japan is buying a substantial quantity of imports from the other more-developed countries. Because very high wages in Japan, products from the traditional high-wage countries (Western Europe, the United States, and Canada) are in demand in the Japanese market. For example, Japan is one of the leading export markets for U.S. apparel. That is, the textile complex in the country that spurred the development of policies to protect the textile industry in developed countries now *buys* from the countries that considered Japan a major threat.

THE SOCIAL DIMENSIONS OF GLOBALIZATION

As responsible global citizens, we must always keep in mind the *social* dimensions of globalization. Perhaps economic and technological forces have moved us toward global interdependence more quickly than we were ready for it socially. As global citizens, we must appreciate, not just tolerate, diversity. We must acknowledge that there are many "right" ways of doing things and that we can learn other "right" ways from those whose live in other parts of the world.

Acknowledging the interdependence that exists in the world means acknowledging that our actions affect one another (See Box 16.4). Our economic decisions are not made in a vacuum; what individuals in one part of the world do affects those in other regions. For example, U.S. mohair growers were distraught when annual government subsidies of over \$50,000 per grower were phased out. Yet, these subsidies had a serious impact on mohair growers in other parts of the world—whose families' lives

REVISITING OUR THREE FACES OF GLOBALIZATION

In Chapter 1, we discussed three workers whose lives are interwoven in the far-flung network of the global textile and apparel industry:

- Maria, who works in a maquiladora plant just inside the Mexican border, moved her family to Cuidad Juárez in the hope of a better life through her job in the garment factory.
- Evelyn, who is losing her job in a South Carolina jeans factory and who hear rumors that the company is moving production to a lowwage country.
- Huang, who works for a major U.S. retail chain as a quality control inspector in Hong Kong. He is an important liaison between the retailer and production facilities in China.

The lives of these three people reflect some of the changes taking place in the global industry today. This book has focused on issues that affect Maria, Evelyn, and Huang, as well as their employer firms. Each of these individuals—and millions of others—are affected by the globalization and global restructuring occurring today. Although Maria, Evelyn, and Huang will probably never know one another, the future job security of each hinges on the next stages of global restructuring of the textile and apparel industries. Individuals with limited skills—such as Evelyn and Maria—are most vulnerable.

• Evelyn is about to feel the personal impact of globalization. Are there other job opportunities for a person of Evelyn's limited skills? If she were able to move, would the move improve her job prospects? Is a worker in another country the recipient of Evelyn's job?

- What happens to Maria when the large firm contracting production in Cuidad Juárez decides to move to an inner region of Mexico to seek wages lower than those along the border? Should Maria feel guilty when she hears about the closing of U.S. garment factories as companies move production to Mexico?
- How long will Huang have a secure position?
 When China's Guangdong Province near
 Hong Kong is filled with industries that may
 pay more than garment assembly, where will
 his U.S. company contract to have garments
 made? Or what if Huang's U.S. employer
 wants orders filled more quickly and decides
 to contract production in Mexico rather than
 China?

Globalization and global restructuring of the textile and apparel industries *will continue*. Particularly as the quota system is eliminated, competition will be even more dramatic than in the past. Therefore, significant changes will continue in the years ahead.

Individuals who have expertise and advanced skills to offer will be among the fortunate ones. Additionally, individuals with a global perspective—particularly those who look at the "big picture" for the global industry—will be better prepared to respond to and participate in these changes.

are affected seriously by distorted market conditions. For South African (and also neighboring Lesotho) mohair farmers, the U.S. mohair subsidies meant that no matter how low the world price fell, their American competitors could undercut them and still make a handsome profit.

Globalization has social responsibilities that businesses may not have been required to consider in the past when they worked within their own borders. Consumers, now sensitized by various television exposés, are beginning to question the working conditions under which products are made. Perhaps some

manufacturers and retailers in the past scrutinized the working conditions of firms in the developing nations with which they did business, but for many, it may have been easier to turn away when seeing child laborers or learning that prison laborers produce goods to be exported to U.S. markets. Now, however, activist groups, television reports, socially conscious investors, and consumers have helped businesses to enforce their global consciences. Even before the media attention, many companies had written policy statements on their firms' ethical, environmental, and human-rights codes. Many are refusing to do business with firms that use child labor or prison labor or participate in unethical business practices. Additionally, the U.S. Congress has taken an interest in the child labor issue and may pass legislation to prohibit merchandise produced by children from entering U.S. markets. As we discussed earlier, however, this approach may not be a panacea if there are no suitable alternative activities for the children.

Wages are often a controversial issue because wages in many of the less-developed countries seem so low that critics consider them exploitive. Nike received poor publicity when Harper's magazine ran a feature analyzing the pay stub of an Indonesian woman who netted the equivalent of \$37.46 per month. Later, an article in Far Eastern Economic Review reported that Indonesians who make Nikes earn far more than most workers lucky enough to get factory jobs in that impoverished country (McCormick & Levinson, 1993). The wage question is another of those for which there appears to be no easy answer. Judging wages in less-developed countries by the standards of more-developed countries may lead to erroneous conclusions. In many cases, workers would have no other jobs. The parent firm probably would not be there at all except for the competitive wages; therefore, the country would not have the jobs. Nevertheless, the parent firm has a responsibility to treat the workers it employs in other countries as well relative to their setting as it does its domestic workforce relative to the home country setting. And many do. Many U.S. apparel firms, for example, with production in less-developed countries provide benefits not available to the U.S. workforce; examples are free meals and free transportation to and from work. Dormitories also are often provided.

Separating economic issues from social and political issues is often impossible. For example, the U.S. renewal of China's MFN status has been uncertain in light of China's humanrights policies. Whether China has MFN status has a serious economic impact on business in China, as well as on U.S. firms buying Chinese goods, because countries with MFN rights have much lower tariffs on their products shipped to U.S. markets. Many in the United States have not favored renewing China's MFN status because of China's slaughter of pro-democracy leaders, the persecution of citizens for political differences, and the use of forced prison labor in producing export goods. Some members of Congress attempted unsuccessfully to tie the renewal of China's MFN provision to demands for a change in its human-rights policies. So far, MFN status has been extended by U.S. officials-but with warnings that human-rights violations must be reduced to retain MFN status.

The privileges of globalization include opportunities to extend businesses around the world and to enjoy the fruits of trade that bring us products from other nations. However, nearly all privileges have accompanying responsibilities, and this is true in globalization. The social dimension of globalization includes being sensitive to the needs of our neighbors in remote lands. See Figure 16-5. Modern transportation and communication systems have made it possible to travel, communicate, and do business around the world. Our human spirit must rise to the challenge of trying to keep pace with what technology has facilitated so that we can understand, appreciate, and care about our global neighbors.

FIGURE 16-5 Globalization requires building partnerships around the world.

Source: Illustration by Dennis Murphy.

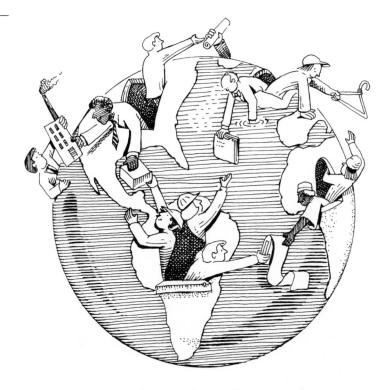

DEVELOPING A GLOBAL PERSPECTIVE

Recent years have seen the fading away of a remarkable array of borders and barriers in our world. All of these changes have moved us by degrees from relative isolation to increased globalization and interdependence. A new sense of openness and cooperation has surfaced. First, we witnessed the fall of the Iron Curtain, which literally and figuratively liberated millions of people who had been isolated from the rest of the world. We saw the former European Community drop barriers among member nations to become the European Union, which continues to add member countries. We saw the North American Free Trade Agreement become a reality, linking three major countries into a single market, with presidential hopes of extending the free trade area to other parts of the Western Hemisphere. We saw Asian nations form the

Asia Pacific Economic Cooperation Conference. Regional and subregional trading arrangements sprang up around the world. The successful completion of the Uruguay Round ushered in a new era of more open trading relationships.

A growing number of nations have moved to the stage of thinking beyond their borders. See Box 16-5. Businesses were considerably ahead of nation-states in this trend, and the new open trade arrangements will help to facilitate even more what businesses were already doing.

Modern communications and transportation systems have removed the barrier of distance. Through satellite television transmission, we can observe an earthquake tremor virtually at the moment it happens halfway around the world, see shots actually fired in the Persian Gulf War, watch minute-by-minute changes in the Hong Kong stock market, or feel the pain of starvation in Somalia via poignant televised images.

Reducing the distance barrier and increasing the flow of information have also spawned a

"CHARGE IT TO MY VISA CARD, AND SEND IT BY FEDERAL EXPRESS"

Even the process of writing this book has been very much affected by the globalization of business and the rapid flow of information. Several textile and apparel industry executives in other countries learned about earlier editions and wanted to order a copy. On several occasions, these executives asked the author to have the publisher send them a copy. They requested that the publisher "charge it to my Visa card and send it by Federal Express." The transaction was as simple as if it were within the United States. Additionally, in efforts to update information for the book, the author has sought the assistance of contacts in various countries. For the second edition, faxes came from places like Switzerland,

Belgium, Hong Kong, England, Canada, and Bangladesh, as well as from several offices in Washington and New York. In many instances for this third edition, communications and transfer of data came by e-mail. First, the availability of fax machines changed the minimum time required to get international information from 2 to 3 weeks to sometimes less than an hour. And, more recently, e-mail has not only permitted fast communication, but also costs nothing to a professor connected to a university server.

These examples illustrate the greatly reduced speed, costs, and difficulty of communicating and doing business globally over a relatively short period of time.

new breed of global consumer. These are consumers around the world who see on television the latest fashions unveiled in the leading fashion centers of the world and want the garments available in local markets that same season. Lifestyles observed on television may be imitated in many countries quite far apart but involving similar clothing, hair styles, and accessories for persons of very different racial and ethnic origins. Young professionals in Tennessee, Turkey, Taiwan, and Tunisia may dress and behave very much alike. Teenagers in dozens of disparate countries are listening to the same music and watching the same movies. These global consumers will shape worldwide commerce in profound ways.

In short, this is a time—more than ever—to think globally.

Increased Interdependence

Individuals and companies will be required to have increased international competence if they are to be active participants in an increasingly interdependent world. Technological advances of the 20th century have brought us closer to other nations and other peoples. Today, citizens of many countries are more closely linked to distant nations than neighboring states or provinces were to one another at the turn of the century. Economic and political changes have transformed widely divergent economic and marketing systems into an interdependent global marketplace. Our global trading partners are our global neighbors, and together we share a world that will require greater understanding and appreciation of one another.

If representatives of any nation think of their global trading partners as neighbors and as persons with whom they share a long-time existence, this perspective requires them to interact with other nations as neighbors. This goes beyond understanding other languages and cultural differences. Our trade relationships must also reflect the honor and integrity with which we treat our next-door neighbors. Even as we deal with the difficult area of textile trade, we must not lose sight of the larger concern for global relationships.

In the past, the United States was known globally for its unsurpassed generosity in foreign aid and for sharing its abundant resources with many other regions of the world in other ways. Americans, as well as citizens of all nations, must not let the political difficulties of trade obliterate our broader global concerns. Although we may have to establish guidelines to moderate trade problems, we must also remember the broader issues at stake. Even if continued regulations on textile trade are necessary for a time, we should be prepared to enforce these in ways that maintain our integrity among our global neighbors.

IMPLICATIONS FOR INDUSTRY PROFESSIONALS

The fading away of borders and barriers that we have observed in recent years propels us even more rapidly than ever before into a global economy. We must think globally!

Individuals employed in the softgoods industry must understand the breadth and complexity of issues related to textiles and apparel in the global economy in order to function effectively in the future. Most professionals in the softgoods industry will not be expected to resolve policy issues related to textile trade. On the other hand, individuals' positions and their work are likely to be affected by trade activities. Textile and apparel professionals must be able to look at the larger picture—the global view—of production and trade for these sectors. They must be able to follow global trade activities as critical determinants of market activities at the immediate working level.

We are no longer functioning in a national economy; we are operating in a global economy. We must think in terms of an international market rather than a national market. In addition, we are citizens of a global community. We must be aware of and concerned about international issues that affect our economic well-being, our social interactions with neighbors on the other side of the world, and the political issues that affect our relationships with global neighbors.

Virtually all aspects of the softgoods industry are affected by this globalization. The future of one's company and the competitiveness of the industry segment of which that firm is a part are affected, often profoundly, by global activities. For example:

- A professional in the softgoods industry must understand the impact of textile activity in China (or any country) on a domestic department store's merchandising efforts.
- Similarly, one should understand how the provisions of the quota phase-out may affect the volume and cost of textile and apparel goods available to the retailer and the consumer.
- Executives at a firm in almost any country should be asking, "What is the potential for exporting our company's products?"
- What are the advantages of establishing close working partnerships within the domestic industry or the global industry?
- What factors should my company consider in weighing domestic versus offshore sourcing?
- How does a free trade agreement affect my company's business?
- How does my retail company become more global?
- What are my company's options for securing a broad range of fabrics to use in producing apparel?
- How much will tariffs add to the price of merchandise?
- What are the potential problems encountered in bringing merchandise through U.S. Customs? What are the possible penalties?
- What considerations are important to keep in mind if my firm decides to establish a joint venture operation in another country?
- If the survival of my firm seems in jeopardy due to high levels of imports, what responses might be appropriate?

These are revolutionary times in the global economy. An informed global perspective will be required of professionals in the softgoods industry. For both individuals and companies, this global perspective is *no longer an option*.

APPENDIX

Participants in the Multifiber Arrangement

	MFA				E-CONTRACT CO		
	1	11	111	IV	1991 protocol	1992 protocol	1993 ^c protocol
Argentina	Χ	X	X	X	X	X	
Australia	X						
Austria	X	X	X	X	X	X	X^d
Bangladesh	X	X	X	X	X	X	X
Bolivia ^a		X					^
Brazil	X	X	X	X	X	X	Xq
Canada	X	X	X	X	X	X	X
China (PRC) ^a			X	X	X	X	X
Colombia ^a	X	X	X	X	X	X	X
Costa Rica				X	X	X	X
Czechoslovakia	X	X	X	X	1	,	^
Czech Republic						X	
Dominican Republic	X	X	X	X	X	X	
Egypt	X	X	X	X	X	X	X^d
El Salvador ^a	X	X	X		X	X	X
EU	X	X	X	X	X	X	X_q
Finland	X	X	X	X	X	X	X_q
Ghana	X	X		,,		^	^
Guatemala ^a	X	X	X	X	X	X	
Haiti	X	X	X		Α	^	
Hong Kong (until 1986:							
the UK for Hong Kong)b	X	X	X	X	X	X	V
Honduras			^	^	^	^	X
Hungary	X	X	X	X	X	X	X
India	X	X	X	X	x	X	X
Indonesia	X	X	X	X	x	X	X
Israel	X	X	X	^	^	^	X
Jamaica	X	X	X	X	Χ	Χ	X

^aAccession ex Article 13.2.

bSince 1986 Hong Kong, having full autonomy in the conduct of its external commercial relations and the other matters provided for in the General Agreement, is deemed to be a contracting party to the GATT in accordance with Article XXVI.5(c) of the General Agreement. Hong Kong communicated to the Chairman of the Textiles Committee that it continued to participate in the MFA (see COM.TEX/46). *Note:* A number of participants acceded after entry into force of MFA-I/II/III or IV and therefore only participated for a limited period of the respective MFA.

[°]Signatories of the 1993 Protocol as of May 27, 1994.

^dProvisional

	MFA						
	1	11	111	IV	1991 protocol	1992 protocol	1993 ^c protocol
Japan	Х	X	Χ	X	Х	Χ	Χ
Kenya							X
Korea (Rep. of)	X	X	X	Χ	X	X	X
Malaysia	X	X	X	X	X	X	
Maldives	^		X				
Mexico ^a	X	X	X	X	X	X	
	X	^	, ,				
Nicaragua	X		X	X	X	X	X
Norway Pakistan	X	X	X	X	X	X	X
	^	^	X	^			X
Panama	X		^				
Paraguaya	x	Χ	Χ	X	X	X	X
Peru	X	X	X	X	X	X	X
Philippines			X	X	X	X	7
Poland	X	X	X	×	x	x	X
Portugal (for Macao)	X	X		X	x	X	^
Romania	X	X	X		x	x	X
Singapore	X	Χ	X	X	^	×	X
Slovak Republic						^	^
Spain	X			.,	V	V	Χ
Sri Lanka	X	X	X	X	X	X	^
Sweden	X	X	X	Χ			vd
Switzerland	X	X	X	X	X	X	Xq
Thailand ^a		X	X	X	X	X	Χ
Trinidad and Tobago	X	X					
Turkey	X	X	X	X	X	X	X
United States	X	X	X	X	X	X	X
Uruguay	X	X	Χ	X	X	X	Χ
Yugoslavia	X	X	X	Χ	X		

Source: From International Regulation of World Trade in Textiles (p. 160) by N. Blokker, 1989, Dordrecht, The Netherlands: Martinus Nijhoff; personal communication with T. Jenkins of GATT (1993); personal communication with M. Raffaelli of GATT (May 27, 1994).

Bibliography

- A big no to sweatshops. (1997, April 16). *Los Angeles Times* (on line).
- A quality market: Internal changes offer commercial opportunities in South Africa. (1996, August–September). *Textile Horizons*, pp. 30–33.
- Abend, J. (1992, May). Canada's plight and plan. *Bobbin*, pp. 62–70.
- Addy, J. (1976). *The textile revolution*. London: Longman.
- Agarwala, P. (1983). The new international economic order. New York: Pergamon Press.
- Aggarwal, V. (1983). The unraveling of the Multi-Fiber Arrangement, 1981: An examination of international regime change. *International Organization*, 37.
- Aggarwal, V. (1985). Liberal protectionism: The international politics of organized textile trade. Berkeley: University of California Press.
- Albright, J., & Kunstel, M. (1987). Stolen childhood. Washington, DC: Cox Newspapers.
- Alexander, M. (1987, August 14). Textile legislation socks it to consumers. *Citizens for a Sound Economy Issue Alert* (Report No. 16). Unpublished report.
- American Apparel Manufacturers Association. (annual). *Focus: An economic profile of the apparel industry.* Arlington, VA: Author.
- American Apparel Manufacturers Association. (1980). *Apparel trade primer*. Arlington, VA: Author.
- American Apparel Manufacturers Association. (1982). Fashion apparel manufacturing: Coping with style variation. Arlington, VA: Author.
- American Apparel Manufacturers Association. (1984). *Apparel manufacturing strategies*. Arlington, VA: Author.
- American Apparel Manufacturers Association, Apparel Political Education Committee. (1982). *The MFA and the American apparel industry*. Arlington, VA: Author.
- American Apparel Manufacturers Association, Technical Advisory Committee. (1996). *Maximizing assets and resources: Survival tactics for the apparel industry*. Arlington, VA: Author.

- American Association of Exporters and Importers, Textile and Apparel Group. (1987, July 30). Summary of statement of the textile and apparel group of the American Association of Exporters and Importers (AAEI-TAG) before the Senate Finance Committee in opposition to S. 549. Unpublished summary. New York: Author.
- American Textile Manufacturers Institute. (quarterly). *Textile Hi-Lights*. Washington, DC: Author.
- American Textile Manufacturers Institute. (1986, September 19). Statement of the American Textile Manufacturers Institute, Inc., filed with the United States International Trade Commission in re the probable economic effects on U.S. industries and consumers of a free trade area between the United States and Canada. Washington, DC: Author.
- American Textile Manufacturers Institute. (1993, March). Berry Amendment. *Textile Hi-Lights*. Washington, DC: Author.
- Ankrim, E. (1988). Understanding world trade—An economic perspective. In D. Wentworth & K. Leonard (Eds.), *International trade teaching strategies* (pp. 3–7). New York: Joint Council on Economic Education.
- Ansari, J. (1986). *The political economy of international economic organization*. Boulder, CO: Rienner.
- Anson, R., & Simpson, P. (1988). World textile trade and production trends. London: The Economist Intelligence Unit.
- Apparel Job Training and Research Corporation. (1981, November). Analysis of problems and needs of the import impacted segments of the women's and children's apparel manufacturing industry. Supported by U.S. Department of Commerce Grant No. 99-26-07086-10.
- Apparel Russia looking at new prospects for business. (1993, February). *Apparel International*, pp. 8–10.
- Arlen, J. (1985, January 17). Retailers to seek allies in free trade battle. *Daily News Record*, pp. 1, 4.
- Arnst, C., & Edmondson, G. (1994, September 26). The global free-for-all. *Business Week*, pp. 118–126.

- Arpan, J., de la Torre, J., Toyne, B., Bacchetta, M., Jedel, M., Stephan, P., & Halliburton, J. (1982). *The U.S. apparel industry: International challenge, domestic response.* Atlanta: Georgia State University Press.
- Asia's wealth. (1993, November 29). *Business Week*, pp. 100–112.
- Au, K. (1997). The current status of the Hong Kong clothing industry. *Journal of Fashion Marketing and Management*, 1(2), 185–191.
- Australian Industries Assistance Commission. (1980). Report on textiles, clothing, and footwear. Canberra: Author.
- Australian Industry Commission. (1997a). The textiles, clothing and footwear industries, draft report, volume I. Canberra: Author.
- Australian Industry Commission. (1997b). The textiles, clothing and footwear industries, draft report, volume II. Canberra: Author.
- Axell, R. (Ed.). (1990). Do's and taboos around the world. New York: Wiley.
- Axell, R. (Ed.). (1991). Gestures: The do's and taboos of body language around the world. New York: Wiley.
- Axline, W. A. (1979). Caribbean integration: The politics of regionalism. London: Frances Pinter.
- Bagchi, S. (1989, June 20–21). *Textiles in the Uruguay Round: Alternative modalities for integration into GATT.* Paper presented at the conference of International Textile Trade, the MFA, and the Uruguay Round, Stockholm.
- Bagchi, S. (1994, December). The integration of the textile trade into GATT, *Journal of World Trade*, 28(6), 31–42.
- Balkwell, C., & Dickerson, K. (1994). Apparel production in the Caribbean: A classic case of the new international division of labor. *Clothing and Textiles Research Journal*, 12(3), 6–15.
- Bark, T., & de Melo, J. (1988, September). Export quota allocations, export earnings, and market diversification. *The World Bank Economic Review*, 2(3), 341–348.
- Barnathan, J., Curry, L., Einhorn, B., & Engardio, P. (1993, May 17). China: The emerging economic powerhouse of the 21st century. *Business Week*, pp. 54–68.
- Barrett, J. (1990a, October 11). House sustains textile bill veto. *Women's Wear Daily*, p. 3.
- Barrett, J. (1990b, October 12). In wake of textile bill defeat, GATT talks emerge as bigger battleground. *DNR*, p. 2.

- Barrett, J. (1990c, July 18). Textile bill clears Senate: 68–32. *DNR*, p. 11.
- Barrett, J. (1992a, September 29). House moves to block U.S. aid for exporting jobs. *Women's Wear Daily*, p. 18.
- Barrett, J. (1992b, October 5). House voting on AID programs siphoning U.S. jobs. *Women's Wear Daily*, p. 19.
- Barrett, J. (1993, November 18). NAFTA wins in House. Women's Wear Daily, pp. 4–5.
- Barrett, J. (1997, July). The African dilemma. Women's Wear Daily (global edition), pp. 82–83.
- Barry, E. (1998). Personal Communication.
- Barry, M., & Dickerson, K. (1987). Developmental patterns of Asia's apparel industry. In W. Kim & P. Young (Eds.), *The Pacific challenge in international business* (pp. 195–206). Ann Arbor, MI: UMI Research Press.
- Barry, M., Warfield, C., & Galbraith, R. (1987, May 4–7). Dispersion retailing: A global export strategy. In *Textiles: Product design and marketing*. Papers presented at the Annual World Conference. Como, Italy: The Textile Institute.
- Bartlett, R., & Peterson, R. (1992). A retailing agenda for the year 2000. In R. Peterson (Ed.), *The future* of U.S. retailing: An agenda for the 21st century (pp. 243–292). New York: Quorum Books.
- Bauer, R., Pool, I., & Dexter, L. (1963). *American business and public policy*. New York: Atherton.
- Baughman, L. (1987). Analysis of the impact of the Textile and Apparel Trade Act of 1987. Washington,DC: International Business and Economic Research Corporation.
- Baumann, W. (1997, June). Survival through globalisation. *Textile Asia*, pp. 72–74.
- Bayard, T. (1980). Comments on the Federal Trade Commission staff report on effects of restrictions on United States imports: Five case studies and theory. (Available from the Office of Foreign Economic Research, U.S. Department of Labor, Washington, DC.)
- Belaud, J. (1985). Textiles: EEC policies and international competition. *European News Agency*, p. 37.
- Benjamin, M. (1997, April 17). No sweat for companies to agree. *Los Angeles Times* (on line).
- Bergsten, F. (1975, April 8). The opportunity for U.S. consumers in the multilateral trade negotiations. Statement before the International Trade Commission on behalf of Consumers Union, Washington, DC.

- Berman, B., & Evans, J. (1995). *Retail management: A strategic approach* (6th ed.). Englewood Cliffs, NJ: Prentice Hall.
- Bernstein, A., Konrad, W., & Therrien, L. (1992, August 10). The global economy: Who gets hurt? *Business Week*, pp. 48–53.
- Bernstein, H. (Ed.). (1973). Underdevelopment and development. Harmondsworth, England: Penguin Books.
- Berry, J. (1984). *The interest group society*. Boston: Little, Brown.
- Bhagwati, J. (1989). United States trade policy at the crossroads. *The World Economy*, 12, 439–479.
- Biggs, T., Moody, G., van Leeuwen, J., & White, D. (1994). Africa can compete! Washington, DC: World Bank.
- Birnbaum, D. (1994). Birnbaum's directory of garment factories and agents 1994–95: Hong Kong & South China. Hong Kong: Design Inspiration Bookshop.
- Black, J. (1992, April 10). Discounters poised for global growth. *DNR*, p. 10.
- Blackhurst, R. (1986). The economic effects of different types of trade measures and their impact on consumers. In *International trade and the consumer*. Paris: Organization for Economic Cooperation and Development.
- Blackhurst, R., Marian, N., & Tumlir, J. (1977). *Trade liberalization protectionism and interdependence*. Geneva: General Agreement on Tariffs and Trade.
- Blokker, N. (1989). *International regulation of world trade in textiles*. Dordrecht, the Netherlands: Martinus Nijhoff.
- Blomström, M., & Hettne, B. (1984). *Development theory in transition*. London: Zed Books.
- Bogert, C. (1989, December 4). Why there is no soap. *Newsweek*, pp. 46–47.
- Bonacich, E., Cheng, L., Chinchilla, N., Hamilton, N., & Ong, P. (Eds.). (1994). *Global production: The apparel industry in the Pacific Rim.* Philadelphia: Temple University Press.
- Borrus, A., Zeller, W., & Holstein, W. (1990, May 14). The stateless corporation. *Business Week*, pp. 98–106.
- Bow, J. (1996, December 16). Bangladesh's textile sourcing goes local. *DNR*, pp. 8, 19.
- Bow, J. (1997a, June 26). Hong Kong at zero hour. Women's Wear Daily, pp. 10–12.
- Bow, J. (1997b, July 22). The China challenge. Women's Wear Daily/Global, pp. 54–58.

- Bramley, C. (1997, June). South Africa—going global? *Textile Asia*, pp. 84–85.
- Brandis, B. (1982). *The making of textile trade policy* 1935–1981. Washington, DC: American Textile Manufacturers Institute.
- Branigin, W. (1997, February 24). Sweatshops are back. *The Washington Post* (national weekly edition), pp. 6, 7.
- Brody, M. (1983, July 25). Naked protectionism: Quotas on clothing imports chill producers, consumers alike. *Barron's*, p. 11.
- Brown, D. (1987, July 30). Statement before the U.S. Senate Committee on Finance re: the Textile and Apparel Trade Act of 1987. Unpublished report from Consumers for World Trade, Washington, DC.
- Brown, J. (1981). A cross-channel comparison of supplier-retailer relations. *Journal of Retailing*, 57(4), 3–18.
- Bucklin, L. (1966). *A theory of distribution channel structure*. Berkeley: Institute of Business and Economic Research, University of California.
- Buirski, D. (1992). South Africa—A matter of identity, a matter of urgency. *Textile Horizons International*, 12(11), pp. 20–29.
- Bureau of Census. (various years). *County business patterns*. Washington, DC: U.S. Government Printing Office.
- Bush asks business aid on fast-track authority. (1991, March 6). Women's Wear Daily, p. 24.
- Business America. (monthly). Washington, DC: U.S. Department of Commerce.
- Business Week. (weekly). New York: McGraw-Hill.
- Cable, V. (1987, September). Textiles and clothing in a new round of trade negotiations. *The World Bank Economic Review*, pp. 1, 619.
- Callcott, J. (1984a, November 27). GATT meeting split on textile protectionism. *Daily News Record*, pp. 3, 8.
- Callcott, J. (1984b, November 29). U.S.–Third World dispute puts GATT on hold. Women's Wear Daily.
- Callcott, J. (1984c, November 28). U.S.–Third World trade aims collide at GATT annual parley. *Daily News Record*.
- Canadian group established to promote fashion industry. (1993, March 3). *Daily News Record*, p. 8.
- Canadian Textile Institute. (1993). Canadian textile and apparel industry data. Unpublished materials.
- Caporaso, J. (Ed.). (1987). A changing international division of labor. Boulder, CO: Lynne Rienner.

- Caribbean/Latin American Action. (annual). *Caribbean Basin databook.* Washington, DC: Author.
- Carr, B. (1987). Development education in an ethical/humanistic framework. In C. Joy & W. Kniep (Eds.), *The international development crisis and American education* (pp. 59–76). New York: Global Perspectives in Education.
- Cateora, P. (1996). International marketing. Homewood, IL: Richard Irwin.
- Catudal, H. (1961). The General Agreement on Tariffs and Trade: An article-by-article analysis in layman's language. Pub. No. 7235. Washington, DC: U.S. Department of State.
- Cedrone, L. (1993). Sourcing the Caribbean and Latin America: 20th annual 807/CBI comparative analysis. *Bobbin*, 35(3), 62–63.
- Chandler, S. (1996, week unknown). Look who's sweating now. *Business Week*, pp. 96, 97.
- Chapkis, W., & Enlow, C. (1983). Of common cloth. Amsterdam: Transnational Institute.
- Chen, K., & Jackson, K. (1996). The statistical coverage of China's textile industry. *Journal of the Textile Institute*, 87, Part 2(1), 82–88.
- Chen, K., Jackson, K., & Kilduff, P. (1996). Strategic restructuring in the Taiwanese textile industry, with particular reference to relocation. *Journal of the Textile Institute*, 87, Part 2(2), 117–129.
- Child-labor law bills introduced in Congress. (1993, March 19). Women's Wear Daily, p. 15.
- China begins to take action. (1997, March). World Clothing Manufacturer, p. 4.
- China cancels contract for U.S. wheat. (1984, August 23). *Women's Wear Daily*, p. 18.
- Chirot, D. (1977). *Social change in the twentieth century.* New York: Harcourt Brace Jovanovich.
- Choate, P. (1990). Agents of influence. New York: Alfred A. Knopf.
- Christiansen, G. (1988), International curriculum for the professions. *National Forum*, LXVIII(4), 27–30.
- Chute, E. (1989a, May 8). AAMA will not back any bills to curb imports. *Women's Wear Daily*, p. 7.
- Chute, E. (1989b, April 11). Textile, apparel groups seek more data on GATT pact. Women's Wear Daily, p. 18.
- Chute, E. (1990a, July 5). Jittery retailers await outcome of GATT talks. *Women's Wear Daily*, p. 2.
- Chute, E. (1990b, March 7). U.S. unveils details of MFA phaseout plan. *DNR*, p. 3.
- Chute, E. (1990c, May 16). U.S. proposal for GATT on global quotas draws derision from importers. *Women's Wear Daily*, p. 20.

- CIRFS (Comité International de la Rayonne et des Fibres Synthétiques). (1987). *Information on manmade fibers*, 24. Paris: Author.
- Clairmonte, F., & Cavanagh, J. (1981). *The world in their web*. London: Zed Press.
- Clark, J. (1986). For richer, for poorer. London: Oxfam. Clawson, D. (1995). Latin America. In J. Fisher (Ed.), Geography and development: A world regional approach (pp. 391–470). Upper Saddle River, NJ: Prentice Hall.
- Cleghorn, S. (no date). Signature of 450,000. New York: International Ladies' Garment Workers' Union.
- Cline, R. (1984). Exports of manufacturers from developing countries. Washington, DC: Brookings Institution.
- Cline, W. (1978). *Imports and consumer prices: a survey analysis*. Unpublished report. Washington, DC: Brookings Institution.
- Cline, W. (1987). The future of world trade in textiles and apparel. Washington, DC: Institute for International Economics.
- Coker, J. (1993, November). World textile and clothing consumption: Forecasts to 2002. *Textile Outlook International*, pp. 10–41.
- Coleman, J. (1989). The Canadian International Trade Tribunal: What is it and what does it do? Ottawa: Canadian International Trade Tribunal.
- Colgate, A. (1987, October). The other side of the story. *Bobbin*, pp. 88–95.
- COMITEXTIL. (1986). The importance of reciprocity of access in textile markets. *COMITEXTIL Bulletin*, 86/1, 24–30.
- COMITEXTIL. (1990). Levelling the playing field in international textile and clothing trade. Brussels: Author.
- COMITEXTIL. (1992). The world trade of textile and clothing products. *COMITEXTIL Bulletin*, 92/6.
- COMITEXTIL. (1993a). Structure of the textileclothing industry in Europe. COMTEXTIL Bulletin, 93/4.
- COMITEXTIL. (1993b). Textiles: An industry for Europe. Brussels: Author.
- Commission of the European Communities. (1992, April). From single market to European Union. Brussels: Author.
- Compromise plan adopted by GATT. (1984, December 3). Women's Wear Daily.
- Congressional Budget Office. (1991). *Trade restraints* and the competitive status of the textile, apparel and nonrubber-footwear industries. Washington, DC: Author.

- Congressmen seek to block loan to China. (1984, July). *Textile World*, pp. 24, 27.
- Conley, J. (1997, January/1996, December). Enter the dragon. *International Business*, pp. 40–44.
- Consumers' Association gives brief to Textile and Clothing Board. (1985). Canadian Apparel Manufacturer, pp. 62–70.
- Consumers for World Trade. (1984). How much do consumers pay for U.S. trade barriers? In *CWT Information Paper*. Washington, DC: Author.
- Cooke, S. (1997). An investigation into the time scale for the emergence of a market for western clothing in Vietnam. *Journal of Fashion Marketing and Management*, 1(2), 154–182.
- Cotton Trade Journal. (1955, December 30), p. 1.
- Cotton: Vital asset. (1992, April). Textile Asia, p. 140.
- Council of Textile and Fashion Industries of Australia Ltd. (1997a, September 10). Australia's TCF sector primed for the future with a pause in tariffs (press release). Melbourne: Author.
- Council of Textile and Fashion Industries of Australia Ltd. (1997b, July). *Industry commission inquiry into Australia's textile, clothing and footwear industries* (unpublished report). Melbourne: Author.
- Council of Textile and Fashion Industries of Australia Ltd. (1997c, February). *Pathway to meeting APEC objectives: Managing the change* (unpublished report). Melbourne: Author.
- Council on International Educational Exchange. (1988, August). Educating for global competence: The report of the Advisory Council for International Educational Exchange. New York: Author.
- Council on Wage and Price Stability (COWPS). (1978). A study of the textile and apparel industries, including prices, wages, employment, foreign trade capacity. Washington, DC: Executive Office of the President.
- Crawford, M. (1959). The textile industry. In J. G. Glover & R. L. Lagai (Eds.), *The development of American industries*. New York: Simmons Boardman.
- Culbertson, J. (1986a, September–October). The folly of free trade. *Harvard Business Review*, pp. 122–128.
- Culbertson, J. (1986b, August 17). Importing a lower standard of living. *New York Times*, p. 1.
- Curzon, G., de la Torre, J., Donges, J., MacBean, A., Waelbroeck, J., & Wolf, M. (1981). *MFA forever?* London: Trade Policy Research Center.
- Dafoe, F. (1986, September). A cautious "go for it" from the apparel/textile sectors. *The Canadian Apparel Manufacturer*, 10, 8–13.

- Dam, K. (1970). The GATT: Law and international economic organization. Chicago: University of Chicago Press.
- Daniels, J., & Radebaugh, L. (1986). *International business*. Reading, MA: Addison-Wesley.
- Dardis, R. (1987). International textile trade: The consumer's stake. *Family Economics Review*, 2, 14–18.
- Dardis, R. (1988). International trade: The consumer's stake. In E. S. Maynes & ACCI Research Committee (Eds.), *The frontier of research in the consumer interest* (pp. 329–359). Columbia, MO: American Council on Consumer Interests.
- Dardis, R., & Cooke, K. (1984). The impact of trade restrictions on U.S. apparel consumers. *Journal of Consumer Policy*, 7, 1–12.
- Daria, I. (1984, August 10). Importers go to court over rules. *Women's Wear Daily*, pp. 1, 11.
- Das, B. (1983). The GATT Multi-Fibre Arrangement. *Journal of World Trade Law*, 17(2), 95–105.
- David, P. (1970, September). Learning by doing and tariff protection: A reconsideration of the case of the antebellum United States textile industry. *Journal of Economic History*, pp. 521–602.
- Davidson, W., Feigenoff, C., & Ghadar, F. (1986). *International competition in textiles and apparel: The U.S. experience.* Washington, DC: National Chamber Foundation.
- de la Torre, J. (1975, September–October). Product life cycle as a determinant of global marketing strategies. *Atlantic Economics Review*, pp. 9–14.
- de la Torre, J. (1984). Clothing-industry adjustment in developed countries. London: Trade Policy Research Center.
- de la Torre, J., Jedel, M., Arpan, J., Ogram, E., & Toyne, B. (1978). *Corporate responses to import competition in the U.S. apparel industry*. Atlanta: Georgia State University Press.
- Delaney, J. (1996, May). Vive la difference. *International Business*, pp. 42–43.
- de Llosa, M. (1984). Threatened legacy. *American Fabrics and Fashions*, 131, 7–12.
- De Vorsey, L. (1995). Western Europe. In J. Fisher (Ed.), *Geography and development: A world regional approach* (pp. 185–254). Upper Saddle River, NJ: Prentice Hall.
- DesMarteau, K. (1997, February 17). U.S. apparel contractors: Can they beat the odds? *Bobbin*, pp. 32–38.
- Destler, I. (1986). *American trade politics: System under stress*. Washington, DC: Institute for International Economics.

- Destler, I. (1992). *American trade politics* (2nd ed.). Washington, DC: Institute for International Economics.
- Destler, I., Fukui, H., & Sato, H. (1979). The textile wrangle: Conflict in Japanese-American relations, 1969–1971. Ithaca, NY: Cornell University Press.
- DiBiaggio, J. (1988). A case for internationalizing the curriculum: Higher education institutions in the United States. *National Forum*, LXVIII(4), 2–4.
- Dicken, P. (1992). *Global shift: The internationalization of economic activity* (2nd ed.). New York: Guilford Press.
- Dickerson, K. (1983, September). U.S. industry pridefully promotes domestic products. *Apparel Industry Magazine*, pp. 37–42.
- Dickerson, K. (1988a). Meshing of the wheel of retailing and international trade theory to examine current apparel retailing procurement practices: A working model. In R. Kean & J. Laughlin (Eds.), *Theory building in apparel merchandising*. Lincoln: University of Nebraska Press.
- Dickerson, K. (1988b). The textile sector as a special GATT case. *Clothing and Textiles Research Journal*, 6(3), 17–25.
- Dickerson, K. (1989). Retailers and apparel imports: Variables associated with relative proportions of imports carried. *Journal of Consumer Studies and Home Economics*, 13, 129–149.
- Dickerson, K. (1994, April). *Textile CEO survey*. Presentation at the annual meeting of the American Textile Manufacturers Association, Orlando, FL.
- Dickerson, K. (1996). Textile trade: The GATT exception. St. John's Journal of Legal Commentary, 11(2), 393–429.
- Dickerson, K. (1997). Apparel and fabricated textile products. In *U.S. Industry & Trade Outlook* '98 (pp. 33–1 to 33–14). Lexington, MA: DRI/McGraw-Hill and U.S. Department of Commerce.
- Dickerson, K., Dalecki, M., & Meyer, M. (1989, July). Apparel manufacturing in the rural heartland: Its contributions to local economies. *Bobbin*, pp. 104–110.
- Doing business with Australia. (1996, July–August). World Clothing Manufacturer, pp. 40–43.
- Dornbusch, R. (1997, July 14). The Asian juggernaut isn't really slowing down. *Business Week*, p. 16.
- Douglas, S. (1989). The textile industry in Malaysia: Coping with protectionism. *Asian Survey*, 29(4), 416–438.

- Douglas, S. (1992). The administration of textile and apparel quotas: A case study of Malaysian policy and its implications for the U.S. *Clothing and Textile Research Journal*, 11(1), 1–9.
- Douglas, S., Douglas, S., & Finn, T. (1994). The garment industry in Singapore: Clothes for the emperor. In E. Bonacich (Ed.), Globalization of the garment industry (pp. 197–213). Philadelphia: Temple University Press.
- Dreyfack, K. (1986, March 3). Even American know-how is headed abroad. *Business Week*, pp. 60–63.
- DRI/McGraw-Hill and Standard and Poor's and U.S. Department of Commerce/International Trade Administration. (1998). *U.S. industry and trade outlook* '98. New York: McGraw-Hill.
- Drucker, P. (1977, March 15). The rise of production sharing. *Wall Street Journal*, p. 22.
- Dublin, T. (Ed.). (1981). *Farm to factory*. New York: Columbia University Press.
- DuMont, S. (1994). *The textile industry: Back to the future . . . as soon as possible.* Paper presented at the World Economic Forum. Davos, Switzerland: Author.
- Dunn, B. (1988a, December 6). Third World ministers seek end to MFA. *DNR*, pp. 2, 11.
- Dunn, B. (1988b, December 7). Third World nations in tougher stance at GATT talks on MFA elimination. *DNR*, pp. 2, 5.
- Dunwell, S. (1978). *The run of the mill*. Boston: David R. Godine.
- The East Asian miracle. (1993). Washington, DC: World Bank.
- ECHO. (1991). *Textiles and clothing in Eastern Europe*. London: The Economist Intelligence Unit.
- Economic Consulting Services. (1997). Export overview study: Mexico. Unpublished report. Washington, DC: Author.
- Economic Policy Institute. (1993). Employment multipliers in the U.S. economy. Washington, DC: Author.
- Edwards, C. (1988). Textiles. *U.S. industrial outlook* 1988. Washington, DC: U.S. Department of Commerce.
- Edwards, S. (1997, April 18). NAFTA offers Latins little they can't have now. *The Wall Street Journal*, p. A19.
- Ehrenreich, B., & Fuentes, A. (1981, January). Life on the global assembly line. *Ms.*, pp. 54–71.
- Ehrlich, P. (1985a, August 22). Hong Kong warns of trade war. Women's Wear Daily, p. 2.

- Ehrlich, P. (1985b, August 26). US delegation hears Asia trade bill threats. *Women's Wear Daily*.
- Elliott, M., & Elliott, D. (1997, May 19). Why the world watches. *Newsweek*, pp. 30–35.
- Ellsworth, P. T., & Leith, J. C. (1984). *The international economy*. New York: Macmillan.
- Emert, C. (1993a, December 8). Customs Modernization Act will provide hefty fines for infractions of import rules. *Women's Wear Daily*, p. 4.
- Emert, C. (1993b, August 24). Customs plans to get tough on anti-transshipment efforts. *Daily News Record*, p. 12.
- Emert, C. (1995, September 11). CNN report scores CITA for import quota behavior. *Women's Wear Daily*, p. 21.
- Enderlyn, A., & Dziggel, O. (1992). Cracking Eastern Europe. Chicago: Probus.
- Engardio, P., Barnathan, J., & Glasgall, W. (1993, November 29). Asia's wealth. *Business Week*, pp. 100–108.
- Engardio, P., Moore, J., & Hill, C. (1996, December 2). Time for a reality check in Asia. *Business Week*, pp. 58–66.
- Etgar, M. (1976, August). Channel domination and countervailing power in distributive channels. *Journal of Marketing Research*, 13, 254–262.
- EU Commission. (1993, October 26). Report on the competitiveness of the European textile and clothing industry. Unpublished report.
- The European Community and the textile industry. (1985, December). Brussels: Commission of the European Communities.
- European Economic Area. (1994). Eur-Op News 3(1), 2. European Union. (ongoing). Luxembourg: Office for Official Publications of the European Communities.
- Execs cheer for NAFTA. (1993, November 18). *Women's Wear Daily*, pp. 6–7.
- Fairchild News Service. (1993, November 18). Mexico breathes easy. *Women's Wear Daily*, p. 5.
- Farnsworth, C. (1988, August 8). U.S. trade bill increases import of mercantilism. *International Herald Tribune*, p. 11.
- Farnsworth, S. (1992, June 2). NKSA blasts Customs on anti-dumping rule. *DNR*, p. 2.
- Farrell, C., Mandel, M., Javetski, B., & Baker, S. (1993, August 2). What's wrong? Why the industrialized nations are stalled. *Business Week*, pp. 54–59.
- Fayle, P. (1993, May). *The East Asian region—Power-house of growth*. Paper presented at the meeting of the Textile Institute, Hong Kong.

- Federal Election Commission. (1998). Business and PAC contributions. Unpublished. Washington,
 DC: Public Records Office of Federal Election Commission.
- Federal Register. (1996, November 5). Part II. Office of Management and Budget. Economic Classification Policy Committee: Standard Industrial Classification Replacement—The North American Classification System Proposed Industry Classification Structure; Solicitation of Comments; Notice. Washington, DC: U.S. Government Printing Office.
- Federal Trade Commission. (1997). *New labeling regulations*. Washington, DC: Author (from Web site: http://www.ftc.gov/WWW/opa/9612/care-3htm).
- Feitelberg, R. (1996, October 7). Knocking off the knockoffs. *Women's Wear Daily*, pp. 10, 17.
- Feldman, A., & Levine, J. (1993, January 4). Sprucing up the cocoon. *Forbes*, pp. 64–65.
- Fiber Economics Bureau. (various dates). Fiber Organon.
- Fibers, Textiles, and Apparel Industry Panel, Committee on Technology and International Economic and Trade Issues. (1983). The competitive status of the U.S. fibers, textiles, and apparel complex: A study of the influences of technology in determining international industrial competitive advantage. Washington, DC: National Academy Press.
- Finnerty, A. (1991). *Textiles and clothing in Southeast Asia*. London: The Economist Intelligence Unit.
- Fisher, J. (Ed.). (1992). *Geography and development: A world regional approach* (4th ed.). Upper Saddle River, NJ: Prentice Hall.
- Fisher, J. (Ed.). (1995). *Geography and development: A world regional approach* (5th ed.). Upper Saddle River, NJ: Prentice Hall.
- Fishlow, A., Diaz-Alejandro, C., Fagen, R., & Hansen, R. (1978). *Rich and poor nations in the world economy.* New York: McGraw-Hill.
- Fitzpatrick Associates. (1991). *The clothing industry and the single European market*. London: The Economist Intelligence Unit.
- Fixing America's economy. (1992, October 19). Fortune, special feature issue.
- Foner, P. (Ed.). (1977). *The factory girls*. Urbana: University of Illinois Press.
- Food and Agriculture Organization of the United Nations. (1995). World apparel fibre consumption survey: 1995. Rome: Author.

- Food and Agriculture Organization of the United Nations and the Secretariat of the International Cotton Advisory Committee. (1996). *The world cotton market: Prospects for the nineties.* Rome and Washington, DC: Authors.
- Frank, B. (1985). *Profitable merchandising of apparel* (2nd ed.). New York: National Knitwear and Sportswear Association.
- Frank, C. (1977). Foreign trade and domestic aid. Washington, DC: The Brookings Institution.
- Frazier, G. (1983, May). On the measurement of interfirm power in distributive channels. *Journal of Marketing Research*, 20, 150–166.
- Friman, H. (1990). Patchwork protectionism: Textile trade policy in the United States, Japan, and West Germany. Ithaca, NY: Cornell University Press.
- Fröbel, F., Heinrichs, J., & Kreye, O. (1980). *The new international division of labour*. Cambridge: Cambridge University Press.
- Froyen, R. (1986). *Macroeconomics: Theories and policies*. New York: Macmillan.
- Further trade talks cleared. (1989, April 10). Women's Wear Daily, p. 11.
- Gälli, A. (1992a, August). Baltics in distress. *Textile Asia*, pp. 109–111.
- Gälli, A. (1992b, November). East European prospects. *Textile Asia*, pp. 113–121.
- Gälli, A. (1993, September). Europe, how far the decline? *Textile Asia*, pp. 137–140.
- Gälli, A. (1996a, February). Ten-year preview. *Textile Asia*, pp. 134–137.
- Gälli, A. (1996b, November). Textile location in Eastern Europe. *Textile Asia*, pp. 131–134.
- Garland, S., Harbrecht, D., & Dunham, R. (1993, November 29). Sweet victory. *Business Week*, pp. 33–35.
- GATT talks stalled, but hope seen for textile, apparel issues. (1991, December 23). *Women's Wear Daily*, p. 7.
- Gelber, N. (1989, July). Deciphering the CBI and tariff nomenclature. *Bobbin*, pp. 20–24.
- General Agreement on Tariffs and Trade. (annual before 1995). *International Trade*. Geneva: Author.
- General Agreement on Tariffs and Trade. (1960, May 17). GATT Document L/1164. Geneva: Author.
- General Agreement on Tariffs and Trade. (1966). *A study on cotton textiles*. Geneva: Author.
- General Agreement on Tariffs and Trade. (1974). Arrangement regarding international trade in textiles. Geneva: Author.

- General Agreement on Tariffs and Trade. (1977). *International Trade*, 1976/77. Geneva: Author.
- General Agreement on Tariffs and Trade. (1984, July). *Textiles and clothing in the world economy.* Geneva: Author.
- General Agreement on Tariffs and Trade. (1985). General Agreement on Tariffs and Trade: What it is, what it does. Geneva: Author.
- General Agreement on Tariffs and Trade. (1986, August 5). Extension of the Multifiber Arrangement agreed. (Press release 1390). Geneva: Author.
- General Agreement on Tariffs and Trade. (1987a). Protocol extending the arrangement regarding international trade in textiles. Geneva: Author.
- General Agreement on Tariffs and Trade. (1987b, November, 30). *Updating the 1984 GATT Secretariat study: Textiles and clothing in the world economy.* Special distribution. Geneva: Author.
- General Agreement on Tariffs and Trade. (1992). Textiles and clothing. *GATT activities* 1991. Geneva: Author.
- General Agreement on Tariffs and Trade. (1993). *GATT international trade* 91–92. Geneva: Author.
- General Agreement on Tariffs and Trade. (1994).

 Agreement on textiles and clothing,
 MTN/FA/Corr. 8. Final Act Embodying the Results of the Uruguay Round of Multilateral Trade Negotiations. Geneva: Author.
- George, S. (1984, November–December). Scholarship, power and hunger. *Food Monitor*, pp. 23–26.
- Gerlin, A., & McCartney, S. (1995, May 2). Regal comeback: King cotton reigns once again in South as production surges. *The Wall Street Journal*, pp. A1, A8.
- Ghadar, F., Davidson, W., & Feigenoff, C. (1987). U.S. industrial competitiveness: The case of the textile and apparel industries. Lexington, MA: Lexington Books.
- Giddy, I. (1978). The demise of the product life cycle in international business theory. *Columbia Journal of World Business*, Spring, 90–97.
- Giesse, C., & Lewin, U. (1987). The Multifiber Arrangement: "Temporary" protection run amuck. *Law and Policy in International Business*, 19(1), 51–170.
- Glasse, J. (1993, March). CIS report. *Textile Outlook International*, pp. 42–61.
- Glenday, G., Jenkins, G., & Evans, J. (1980). Worker adjustment to liberalized trade: Costs and assistance policies. Staff working paper 426. Washington, DC: World Bank.

- Goldman, S., Nagel, R., & Preiss, K. (1995). Agile competitors and virtual organizations. New York: Van Nostrand Reinhold.
- Goldstein, J. (1983). A re-examination of American trade policy: An inquiry into the causes of protectionism. Unpublished doctoral dissertation, University of California, Los Angeles.
- Greenberg, E. (1997). Retail trade. In U.S. Industry & Trade Outlook '98 (pp. 42-1 to 42-8). Lexington, MA: DRI/McGraw-Hill and U.S. Department of Commerce.
- Greenberger, R., & Friedland, J. (1996, January 9). Latin nations, unsure of U.S. motives, make their own trade pacts. Wall Street Journal, pp. A1, A4.
- Greene, J. (1985, May 17). Retailers to lobby harder vs. trade bill. Daily News Record, p. 11.
- Greenhaw, W. (1982). Elephants in the cottonfields: Ronald Reagan and the new Republican South. New York: Macmillan.
- Greig, A., & Little, S. (1996). Deregulation and restructuring: The (unintended) consequences of Australian Labor's TCF industry policy 1983-1996. Journal of the Textile Institute, 87, Part 3, 107-118.
- Grossman, G. (1982, December). The employment and wage effects of import competition in the United States. Working Paper No. 1041. Cambridge, MA: National Bureau of Economic Research.
- Grunwald, J., & Flamm, K. (1985). The global factory. Washington, DC: The Brookings Institution.
- Guillaumin, C. (1979). Culture and cultures. Cultures, 6(1).
- Gunawardena, D. (1993). Focus on investment-Sri Lanka. Paper presented at the Textile Institute World Conference, Hong Kong.
- Guobiao, J. (1993, May). The development of China's textile industry and its reform and opening. Paper presented at the Textile Institute Conference, Hong Kong.
- Hackett, D. (1990, April 19). Textile bill drama: Cracks in the coalition. DNR, pp. 3, 11.
- Hamilton, C. (1981). A new approach to estimation of the effects of non-tariff barriers to trade: An application to the Swedish textile and clothing industry. Weltwirtschaftliches Archiv, Band 117, Heft 2, 298-325.
- Hamilton, D. (Ed.). (1990). The Uruguay Round, textiles trade and the developing countries. Washington, DC: World Bank.
- Hamilton, J. (1989). Worlds apart: The high price of ethnocentricity for clothing and textiles and the cultivation of a global perspective. Critical link-

- ages monograph. Monument, CO: Association of College Professors of Textiles and Clothing.
- Hamilton, J., & Dickerson, K. (1990). The social and economic costs and payoffs of industrialization in international textile/apparel trade. Clothing and Textiles Research Journal, 8(4), 14-21.
- Hammes, S. (1991, December). Europe's growing market. Fortune, pp. 132-133.
- Hanson, J. (1980). Trade in transition: Exports from the Third World, 1840–1900. New York: Academic Press.
- Hartlein, R. (1988, December 22). Textile, apparel importers form USA-ITA trade group. Women's Wear Daily, p. 2.
- Heiland, R. (1980). Progress report: Georgia Institute of Technology study of market strategies. Domestic apparel program: Technical review. Washington, DC: U.S. Department of Commerce, International Trade Administration.
- Herskovits, M. (1952). Man and his works. New York: Alfred A. Knopf.
- Hess, A. (1986, February 7). Says trade bill nixed to protect consumers. Daily News Record, p. 19.
- Hester, S. (1987). The impact of international textile trade agreements. International Marketing Review,
- Hickock, S. (1985). The consumer cost of U.S. trade restraints. Federal Reserve Bank of New York Quarterly Review, 10(2), 1-12.
- Honigsbaum, M. (1988, July 7). ITC to probe alleged dumping of baseball caps by China. DNR, p. 11.
- Hooper, C., Dickerson, K., & Boyle, R. (1994). A new course in world trade. America's Textiles International, 23(4), 52-56.
- Horwitz, T. (1993, May 18). Europe's borders fade, and people and goods can move more freely. Wall Street Journal, pp. A1, A10.
- Hosenball, M. (1984, June 27). House unit: "Strongly oppose" int'l textile loans. Daily News Record, pp. 2, 8.
- House committee faults warning that restraints will hike consumer costs. (1985, October 9). Women's Wear Daily, p. 16.
- House fails to override veto by 8 votes, but . . . (1986, August 7). Daily News Record, pp. 1, 11.
- Howard, J., & Moore, J. (1997, September 10). Prime Minister, the Hon. John Howard, MP; Minister for Industry, the Hon. John Moore, MP joint press release on the textile, clothing and footwear industries. Melbourne: Author.
- Hu, Q. (1993). Attitudes of Chinese consumers toward foreign-brand apparel: A Shanghai study. Unpub-

- lished paper. University of Missouri, Department of Textile and Apparel Management, Columbia.
- Hufbauer, G., Berliner, D., & Elliott, K. (1986). *Trade protection in the U.S.: 31 case studies*. Washington, DC: Institute for International Economics.
- Hufbauer, G., & Rosen, H. (1986). Trade policy for troubled industries. Washington, DC: Institute for International Economics.
- Hughes, J. (1987). A retail industry view of the Multifiber Arrangement: How congressional politics influence international negotiations. *Law and Policy in International Business*, 19(1), 257–261.
- Hughes, R. (1995). The Uruguay Round: New approach for the textile and clothing sector. ITC International Trade Forum, 4, 4–29.
- Hui, W. (1996, October). Reviving China's silk industry. *Textile Asia*, pp. 72–73.
- Hunsberger, W. (1964). *Japan and the United States in world trade*. New York: Harper & Row.
- Huntington, P. (1997, June 26). Australia's prime time. *Women's Wear Daily*, pp. 8, 9.
- Hurewitz, L. (1993). *The GATT Uruguay Round: A negotiating history (1986–1992): Textiles.* Deventer, the Netherlands: Kluwer Law and Taxation Publishers.
- ICF Incorporated. (1987). Analysis of the employment and economic welfare effects of the Textile and Apparel Trade Act of 1987. Washington, DC: Author.
- Ilyasoglu, E., & Duruiz, L. (1991). Turkish clothing industry. Istanbul: Turkish Clothing Manufacturers' Association.
- Imports: Après le déluge, what? (1978, April). *Clothes, etc.*, pp. 55–59.
- Imports 2001. (1997, May). Apparel International, pp. 12, 13.
- India defends child labor. (1993, May 18). Wall Street Journal, p. A13.
- Institut Français de la Mode (IFM). (1993, May). Garment sourcing options for EC markets. *Textile Outlook International*, pp. 91–123.
- Institut Français de la Mode (1995, February). Study on employment development and qualification needs in the European clothing industry. Paris: Author.
- International Apparel Federation. (1993). *Yearbook* 1993. Berlin: Author.
- International Apparel Federation. (1997). *International Apparel Federation Yearbook* 1997. London: Author.
- International Labour Office. (1991a). Vocational training and retraining in the textile industry. Geneva: Author (Textiles Committee).
- International Labour Office. (1991b). Working conditions in the textiles industry in the light of tech-

- nological changes. Geneva: Author (Textiles Committee).
- International Labour Office. (annual). Yearbook of labour statistics. Geneva: Author.
- International Labour Office. (1993). Yearbook of labour statistics. Geneva: Author.
- International Labour Office. (1996). *Child labour: Targeting the intolerable*. Geneva: Author.
- International Organization of Consumers Unions. (1991). IOCU urges end to Multi-Fibre Arrangement (press release). The Hague: Author.
- International Standing Working Group of Textile Geography (GEOTEX). (1989). *The role of the textile and clothing industries in national development*. Torin, Italy: Dipartimento Interateneo Territorio, Universita e Politecnico di Torino.
- International Textiles and Clothing Bureau. (1988, April 27). Document for special distribution to GATT Negotiating Group on Textiles and Clothing for the Uruguay Round, MTN. Geneva, Switzerland: Author.
- Isard, P. (1973). Employment impacts of textile imports and investment: A vintage-capital model. *American Economic Review*, 63(3), 402–416.
- It's not just "English spoken here": World economy has Americans learning languages. (1988, August 8). *International Herald Tribune*, pp. 1, 5.
- Jacobs, B. (1993a, September). Anti-transshipment initiatives at center stage. *Bobbin*, pp. 24–30.
- Jacobs, B. (1993b, December). Elvis sighted at Customs. *Bobbin*, pp. 12–14.
- Jacobs, B. (1996, February). Customs reinvents the audit process. *Bobbin*, pp. 20–22.
- Jacobs, B. (1997, July). H.R. 1432 could propel sub-Saharan sourcing. *Bobbin*, pp. 88–89.
- Japan Spinners' Association. (1982, October 18–22). The spinning industry in Japan: 100 years of progress to the present day. Paper presented at the ITMF annual conference, Osaka.
- Jenkins, G. (1980). Cost and consequences of the new protectionism: The case of Canada's clothing sector. Ottawa: North-South Institute.
- Jenkins, G. (1982). *Cost and consequences of the new protectionism*. Cambridge, MA: Harvard Institute for International Development.
- Jenkins, G. (1985). Costs and consequences of the new protectionism: The case of Canada's clothing sector (2nd ed. rev.). Ottawa: North-South Institute.
- Jeremy, D. (1981). Transatlantic industrial revolution: The diffusion of textile technologies between Britain and America, 1790–1830s. Cambridge, MA: MIT Press.

- Jonas, N. (1986, March 3). The hollow corporation. *Business Week*, pp. 57–59.
- Juvet, J. (1967, September–October). The cotton industry and world trade. *Journal of World Trade Law*, pp. 540–563.
- Kabala, S. (1992, April). Global communications. Apparel Industry Magazine, pp. 40–46.
- Kacker, M. (1985). *Transatlantic trends in retailing*. Westport, CT: Greenwood Press.
- Kacker, M. (1986, Spring). Coming to terms with global retailing. *International Marketing Review*, pp. 7–20.
- Kacker, M. (1988). International flow of retailing know-how: Bridging the technology gap in distribution. *Journal of Retailing*, 64(1), 41–67.
- Kalantzopoulos, O. (1986). The cost of voluntary export restraints for selected industries. Washington, DC: Industry Department, Industrial Policy and Strategy Division, World Bank.
- Kallin, M. (1996, February). Europe and the ATC. *Textile Asia*, pp. 86–94.
- Keesing, D., & Wolf, M. (1980). *Textile quotas against developing countries*. London: Trade Policy Research Center.
- Keohane, R., & Nye, J. (1977). Power and interdependence: World politics in transition. Harvard Center for International Affairs. Boston: Little, Brown.
- Kepp, M. (1997, August 19). They're selling a lot more than thongs in Brazil these days. Women's Wear Daily, pp. 1, 10–12.
- Khanna, S. (1991). International trade in textiles: MFA quotas and a developing exporting country. New Delhi: SAGE.
- Khanna, S. (1994, March). The new GATT agreement: Implications for the world's textile and clothing industries. *Textile Outlook International*, pp. 10–37.
- Kidd, J., & Ehrlich, P. (1984, August 6). New Customs rules set off alarm in Asia. *Women's Wear Daily*, pp. 1, 11.
- Kidwell, C., & Christman, M. (1974). Suiting everyone: The democratization of clothing in America. Washington, DC: Smithsonian Institution Press.
- Kim, J. (1996). Commentary: Korea's response to globalisation. *Textile Horizons*, p. 5.
- Kim, K. (1992, December). The quest for efficiency (Korea). *Textile Asia*, p. 115.
- Kim, W., & Young, P. (Eds.). (1987). The Pacific challenge in international business. Ann Arbor, MI: UMI Research Press.

- Kniep, W. (1987). Development education: Essential to a global perspective. In C. Joy & W. Kniep (Eds.), The international development crisis and American education (pp. 145–158). New York: The American Forum.
- Knight, F. W. (1990). The Caribbean: The genesis of a fragmented nationalism. New York: Oxford University Press.
- Knobel, B., & Carey, P. (1993, February). Why Russia? *International Business*, pp. 53–56, 60–63.
- Koekkoek, K., & Mennes, L. (1986). Liberalizing the Multi-Fibre Arrangement: Some aspects for the Netherlands, the EC, and the LDCs. *Journal of World Trade Law*, 20(2), 142–167.
- Kolbeck, W. (1983, July). The meaning of retail price, or why the retailer doubles my price. *Bobbin*, pp. 81–86.
- Koshy, D. (1993, April). Changing sourcing strategy of Indian importers: Are we in quick sand? *Clothesline* (India), pp. 71–74.
- Kotabe, M. (1992). Global sourcing strategy. New York: Ouorum Books.
- Krueger, A. (1980). Protectionist pressures, imports and employment in the United States. *Scandina*vian Journal of Economics, 82(2), 133–146.
- Kryhul, A., & Chute, E. (1988, December 12). Textile talks stalled as GATT meeting ends. *Women's Wear Daily*, p. 11.
- Kurt Salmon Associates. (annual). *Textile profile,* apparel profile—The KSA perspective. New York: Author.
- Kurt Salmon Associates. (1993). *The textile and clothing industry in the EC until* 2001. Düsseldorf: Author.
- Lachica, E. (1990, July 18). Restrictive quotas on textile imports cleared by Senate. *Wall Street Journal*, p. A10.
- Lancaster, G., & Wesenlund, I. (1984). A product life cycle theory for international trade: An empirical investigation. *European Journal of Marketing*, 18(6–7), 72–89.
- Langley, M., & Mossberg, W. (1988, August 4). Senate approves major trade measure by vote of 85–11 and sends it to Reagan. *Wall Street Journal*, pp. 3, 6.
- Laris, M., Clemetson, L., Liu, M., & Hirsh, M. (1997, March 3). A fast drive to riches. *Newsweek*. pp. 32–34.
- LaRussa, R. (1986, December 1). Bentsen against attaching textiles to main trade bill. *Daily News Record*, pp. 3, 5.

- LaRussa, R. (1987, June 25). Consumer–industry coalition warns Congress of trade bill dangers. *Daily News Record*, p. 15.
- LaRussa, R. (1989a, February 2). Lloyd of Tenn. named to chair Textile Caucus. *Women's Wear Daily*, p. 15.
- LaRussa, R. (1989b, October 25). Textile trade lobby may be splintering. *Women's Wear Daily*, p. 27.
- Lebedev, V. (1997). World apparel forum. International Apparel Federation Convention (1996) Book (pp. 106–110). Istanbul: Turkish Clothing Manufacturers' Association.
- Lee, C. (1987). Foreign lobbying in American politics. Unpublished doctoral dissertation, University of Missouri-Columbia, Columbia.
- Lee, G. (1993, October 4). 807 keeps airports and harbors humming. *Women's Wear Daily*, p. 18.
- Lee, J. (1966, March–April). Cultural analysis in overseas operations. *Harvard Business Review*, pp. 106, 111.
- Leiter, J. (1986). Reactions to subordination: Attitudes of Southern textile workers. Social Forces, 64(4), 948–974.
- Lerner, G. (1969). The lady and the mill girl: Changes in the status of women in the age of Jackson. *American Studies Journal*, X, 2–10.
- Leung, P. (1992, December). Foreign funding perils. *Textile Asia*, pp. 72–74.
- Leung, P. (1996, May). Quota for quality goods. *Textile Asia*, pp. 72–82.
- Leung, P. (1997a, May). Exports down, imports up. *Textile Asia*, pp. 67–77.
- Leung, P. (1997b, February). Giant producer falls. *Textile Asia*, pp. 65–76.
- Leung, P. (1997c, July). Rapid recovery of exports. *Textile Asia*, pp. 96–106.
- Levi Strauss & Co. (no date). Levi Strauss & Co. business partner terms of engagement and guidelines for country selection. San Francisco: Author.
- Levi's life. (1992). San Francisco: Levi Strauss & Co.
- Levitt, T. (1983, May–June). The globalization of markets. *Harvard Business Review*, pp. 92–102.
- Lewis, R. (Ed.). (1995, November). What's in a name? Is it a brand, a private label, or a store? "Infotracs" special supplement to *Women's Wear Daily*, pp. 1–35.
- Lewinson, D. (1994). *Retailing* (5th ed.). Englewood Cliffs, NI: Prentice Hall.
- Lockwood, L. (1984, April 13). 150 importers pledge \$1M to fight quotas. *Daily News Record*, pp. 2, 11.

- Lurie, J. (1982). America . . . Globally blind, deaf and dumb. Foreign Language Annuals, 15(6), 413–420.
- Lusch, R., & Brown, J. (1982). A modified model of power in the marketing channel. *Journal of Marketing Research*, 19, 312–323.
- Lynch, J. (1968). Towards an orderly market: An intensive study of Japan's voluntary quota in cotton textile exports. Tokyo: Sophia University Press.
- Maas, A. (1980, September). Retailers' view. *Textile Asia*, pp. 176–180.
- Mackie, G. (1993, August). Jute—Can it survive the battle with polypropylene? *Textile Horizons International*, 13(4), 51–55.
- Magnusson, P. (1997, April 21). Beyond NAFTA: Why Washington mustn't stop now. *Business Week*, p. 46.
- Magnusson, P., Malkin, E., & Vlasic, B. (1997, July 7). NAFTA: Where's that "giant sucking sound"? *Business Week*, p. 45.
- Maizels, A. (1963). *Industrial growth and world trade*. Cambridge: Cambridge University Press.
- Mallen, B. (1963, summer). A theory of retailer– supplier conflict, control, and cooperation. *Journal of Retailing*, pp. 24–33, 51.
- Management Horizons. (1993). *Global retailing* 2000. Columbus, OH: Author (a Division of Price Waterhouse).
- Mansfield, E. (1983). Economics. New York: W. W. Norton.
- Mantoux, P. (1927). The Industrial Revolution in the eighteenth century. New York: Harcourt Brace Jovanovich.
- Markup benefit of private label is cited. (1984, July 23). *Women's Wear Daily*, p. 24.
- Marszal, T. (1985). Tendencies of the spatial development of textile industry in the world. *Folia Geographica*, *6*, 33–48.
- Martin, J., & Evans, J. (1981, March). Notes on measuring the employment displacement effects of trade by the accounting procedure. *Oxford Economic Papers*, 33(1), 154–164.
- Matsusaki, H. (1979). Marketing, culture, and social framework: The need for theory development at the macro marketing level. In O. Ferrell, S. Brown, & C. Lamb (Eds.), Conceptual and theoretical development in marketing. Chicago: American Marketing Association.
- Mattila, H. (1996). Expected changes in European garment retailing and their impact on garment and textile production. *Textiles Magazine*, (2), pp. 20–24.

McCormick, H. (1985, September 18). Crafted with Pride: The \$11 million offensive. *Women's Wear Daily*, pp. 12–14.

McCormick, J., & Levinson, M. (1993, February 15). The supply police. *Business Week*,

pp. 48–49.

- McDonnell, P. (1995, August 13). Thai sweatshop workers savor freedom. *Los Angeles Times*, pp. B1, B5.
- McGowan, P. (1987). Key concepts for development studies. In C. Joy & W. Kniep (Eds.), *The international development crisis and American education* (pp. 37–58). New York: Global Perspectives in Education.
- McHale, J. (1969). *The future of the future*. New York: George Braziller.
- McHugh, P., Merli, G., & Wheeler, W. (1995). Beyond business process reengineering: Towards the holonic enterprise. Chichester, UK: Wiley.
- McMurray, S., & McGregor, J. (1993, August 4). New battleground: Asia targets chemicals for the next assault on Western industry. *Wall Street Journal*, pp. A1, A4.
- McNamara, M. (1993, December 21). No subsidies, less use cloud mohair's future. *Women's Wear Daily*, p. 11.
- McNeill, W. (1965). The rise of the West: A history of the human community. New York: Mentor.
- McNeill, W. (1986). Organizing concepts for world history. *Review*, X(2), 220–235.
- McRobert, R., & Smallbone, T. (1980, September). Consumers' interests. *Textile Asia*, pp. 170–176.
- Mead, W. (1997, April 17). East Asia needs a new growth strategy. *The Wall Street Journal*, p. A22.
- Meadus, A. (1992, October 30). Counterfeiters beware: This law's for real. *Women's Wear Daily*, pp. 1, 14, 15.
- Mexican Investment Board. (quarterly). Mexico: Mexico investment update.
- The MFA is too costly a joke. (1984, December 22). *The Economist*, p. 73.
- Mintz, I. (1972). *Û.S. import quotas: Costs and consequences.* Washington, DC: American Enterprise Institute for Public Policy Research.
- Moffett, M. (1993, March 8). U.S. firms yell olé to future in Mexico. *Wall Street Journal*, pp. B1, B5.
- Moin, D. (1985, June 17). The retailers: Defending their sources. *Women's Wear Daily*, p. 8.
- Mollett, A. (1995). The textiles and clothing industries of Southern Africa. In *International Reference*

- Book and Membership Directory (pp. 70-74). Manchester, UK: The Textile Institute.
- Monthly Record. (1936, September 30). The Manchester Chamber of Commerce.
- Moran, C. (1988, September). A structural model for developing countries' manufactured exports. *The World Bank Economic Review*, 2(3), 321–340.
- Morawetz, D. (1980). Why the Emperor's new clothes are not made in Colombia. World Bank staff Working Paper no. 368. Washington, DC: World Bank.
- More corporations, less bureaucracy. (1987, December). *Textile Asia*.
- More poly plants being built in China. (1994, February 17). *DNR*, p. 10.
- Morke, M., & Tarr, D. (1980). Staff report on effects of restrictions on United States imports: Five case studies and theory. Washington, DC: Federal Trade Commission, Bureau of Economics.
- Morton, M., & Dardis, R. (1989). Consumer and welfare losses associated with Canadian trade restrictions for apparel. *Canadian Home Economics Journal*, 39(1), 25–32.
- Mullin, T. (1985, September). New threats to imports. *Stores*, p. 82.
- Multicultural correctness. (1993, January). World Trade, p. 28.
- Munck, R. (1984). *Politics and dependency in the Third World*. London: Zed Books.
- Munger, M. (1984). The costs of protectionism: Estimates of the hidden tax of trade restraint. Working Paper No. 80. St. Louis, MO: Center for the Study of American Business, Washington University.
- Myerson, A. (1997, June 22). The principle, a case for more "sweatshops." *The New York Times*, p. E5.
- Naisbitt, J. (1994). *Global paradox*. New York: Avon. Naisbitt, J. (1996). *Megatrends Asia*. New York: Simon & Schuster.
- Nash, J., & Fernández-Kelly, M. (Eds.). (1983). Women, men, and the international division of labor. Albany: State University of New York Press.
- National Cotton Council of America. (annual). Cotton counts its customers: The quantity of cotton consumed in final uses in the United States. Memphis: National Cotton Council of America.
- National Governors' Association. (1987). Educating Americans for tomorrow's world: State initiatives in international education. Washington, DC: Author.

- National Governors' Association. (1989). *America in transition: The international frontier.* Washington, DC: Author.
- National Retail Federation. (1993, August). *NAFTA textile and apparel provisions: A summary.* Washington, DC: The Trade Partnership.
- National Retail Institute. (annual). *Retail industry indicators.* Washington, DC: Author.
- National Retail Merchants Association. (1977). *How consumers benefit from imports*. Unpublished report.
- Neundörfer, K. (1987). The fourth Multi-Fibre Arrangement: Protocol of extension and bilateral agreements of the EEC text and commentary. Frankfurt: Gesamttextil.
- No gain without pain. (1992, August 15). *The Economist*, p. 54.
- Noland, M. (1990). Pacific Basin developing countries. Washington, DC: Institute for International Economics.
- Nurkse, R. (1961). *Patterns of trade and development*. Oxford: Basil Blackwell.
- L'Observatoire Européen du Textile et de l'Habillement. (annual). *The EC textile and clothing industry (year)*. Brussels: Author.
- O'Day, P. (1994, May). The U.S. perspective on manufactured fibers: Issues and trends. Paper presented at the 5th Beijing International Conference on Man-Made Fibers, May 10–14, Beijing: Author.
- O'Donnell, T. (1988, July). Customs and imports. *Textile Asia*, pp. 98–110.
- Odyssey begins major U.S. expansion plan. (1991, January). *Apparel Industry Magazine*, p. 10.
- Ohmae, K. (1985). *Triad power*. New York: Free Press. Ohmae, K. (1990). *The borderless world*. New York: Harper Business.
- Olsen, R. (1978). The textile industry: An industry analysis approach to operations management. Lexington, MA: Lexington Books.
- Olson, D. (1987a, April). *Interest groups and the politics of industrial policy and textile trade legislation*. Paper presented at the annual meeting of the Midwest Political Science Association, Chicago.
- Olson, D. (1987b, September). U.S. trade policy: The conditions for congressional participation. Paper presented at the 1987 annual meeting of the American Political Science Association, Chicago.
- Onkvisit, S., & Shaw, J. (1997). International marketing: Analysis and strategy. Upper Saddle River, NJ: Prentice Hall.

- O'Reilly, B. (1992, December). Your new global work force. *Fortune*, pp. 52–66.
- Organization for Economic Cooperation and Development. (1983). *Textile and clothing industries*. Paris: Author.
- Organization for Economic Cooperation and Development. (quarterly). *Quarterly labor force statistics* (No. 1). Paris: Author.
- Orgel, D. (1989, January 10). Associations heat up own "trade war." *DNR*, pp. 2, 13.
- Ormerod, A. (1993, May). Why new textile mill projects fail. Paper presented at the Textile Institute meeting, Hong Kong.
- Ostroff, J. (1990, January 4). See merger adding muscle in Congress. *DNR*, p. 6.
- Ostroff, J. (1991a, December 19). GATT Textile Committee completes plan to end MFA within ten years. *Women's Wear Daily*, p. 10.
- Ostroff, J. (1991b, October 25). See new trade talks getting under way. *DNR*, p. 8.
- Ostroff, J. (1992a, July 30, 1992). ITC is ordered to reconsider decision on sweater dumping. *DNR*, p. 4.
- Ostroff, J. (1992b, January 8). Textile, apparel makers blast GATT plan on MFA. *Women's Wear Daily*, p. 20.
- Ostroff, J. (1993a, November 10). Clinton pledges Customs aid in bid for undecided. *Women's Wear Daily*, p. 10.
- Ostroff, J. (1993b, December 16). GATT gets it done. *Women's Wear Daily*, p. 8.
- Ostroff, J. (1993c, December 29). Getting set for NAFTA. *Women's Wear Daily*, pp. 6–7.
- Ostroff, J. (1994a, January 7). U.S. to China: If no progress, quotas get slashed Jan. 17. *Women's Wear Daily*, p. 2.
- Ostroff, J. (1994b, January 12). Study shows textile, apparel duties took big bite out of U.S. consumers. *Women's Wear Daily*, p. 28.
- Ostroff, J. (1994c, April 5). U.S. appears backing down on pressuring Asian nations to open markets to textiles. *DNR*, pp. 2, 5.
- Ostroff, J. (1995, December 29). Hayes nomination sandbagged in Senate. *Women's Wear Daily*, p. 9.
- Ostroff, J. (1996a, August 8). Islamic group sets conference over firing of Penney's clerk. *Women's Wear Daily*, p. 12.
- Ostroff, J. (1996b, November 11). Costa Rican underwear quotas ruled illegal. *Women's Wear Daily*, p. 11.

- Ostroff, J. (1997, July 4). Report: NAFTA helped both U.S. and Mexico. *Women's Wear Daily*, p. 24.
- Owen, J. (1997, July 8). FTC unveils plan for care label symbols. *Women's Wear Daily*, p. 18.
- Ozzard, J., & Feitelberg, R. (1996, June 27). As logos go global, counterfeiters unfurl the welcome mat. *Women's Wear Daily*, pp. 1, 8, 9.
- Pannell, C. (1995). Monsoon Asia. In J. Fisher (Ed.), Geography and development: A world regional approach (pp. 555–668). Upper Saddle River, NJ: Prentice Hall.
- Pantojas-Garcia, E. (1990). *Development strategies as ideology*. Boulder, CO: Lynne Rienner.
- Paretti, V., & Bloch, G. (1955). Industrial production in Western Europe and the United States, 1901 to 1955. Banca Nazionale del Lavoro, Quarterly Review.
- Parry, J. (1990, April). Time is running short . . . *Tex-tile Asia*, pp. 26–27.
- Pechter, K. (1992, August). In Europe's epicenter. *International Business*, pp. 44–49.
- Pelzman, J. (1983). Economic costs of tariffs and quotas on textile and apparel products imported into the United States: A survey of the literature and implications for policies. *Weltwirtschaftliches Archiv*, 119(3), 523–542.
- Pelzman, J. (1984). The Multifiber Arrangement and its effect on the profit performance of the U.S. textile industry. In R. Baldwin & A. Kreuger (Eds.), *The structure and evolution of recent U.S. trade policy* (pp. 111–149). Chicago: University of Chicago Press.
- Pelzman, J., & Bradberry, C. (1980). The welfare effects of reduced U.S. tariff restrictions on imported textile products. Applied Economics, 12, 455–465.
- Pelzman, J., & Martin, R. (1987). Direct employment effect of imports on the U.S. textile industry. Economic Discussion Paper 6. Office of Foreign Economic Research, Bureau of International Labor Affairs. Washington, DC: U.S. Department of Labor.
- Perlow, G. (1981, January). The multilateral supervision of international trade: Has the textiles experiment worked? *American Journal of International Law*, 75(1), 93–133.
- Perman, S. (1993, December 8). Department stores to focus more on own brands. *Women's Wear Daily*, p. 24.
- Pestieau, C. (1976). *The Canadian textile policy: A sectoral trade adjustment strategy.* Montreal: C.D. Howe Research Institute.

- Peterson, B. (1985, January 31). Death of a textile plant. *The Washington Post*.
- Pine, A. (1984, January 6). How president came to favor concessions for U.S. textile makers. *Wall Street Journal*, pp. 1, 13.
- Plant, R. (1981). *Industries in trouble*. Geneva: International Labour Office.
- Pohlandt-McCormick, H. (1985, September 18). Crafted with Pride: The \$11 million offensive. Women's Wear Daily, pp. 12–14.
- Pollard, S. (Ed.). (1990). Wealth and poverty. Oxford: Oxford University Press.
- Population Reference Bureau, Inc. (1993). 1993 world population data sheet. Washington, DC: Author.
- Porter, M. (1980). Competitive strategy: Techniques for analyzing industries and competitors. New York: Free Press.
- Porter, M. (1985). Competitive advantage: Creating and sustaining superior performance. New York: Free Press.
- Porter, M. (Ed.). (1986). Competition in global industries. Boston: Harvard Business School Press.
- Porter, M. (1990). *The competitive advantage of nations*. New York: Free Press.
- Poulson, B. W. (1981). Economic history of the United States. New York: Macmillan.
- Powell, B., & Hirsh, M. (1997, September 22). The ailing tigers of Asia. *Newsweek*, pp. 50–51.
- Powell, B., & Matthews, O. (1997, September 1). Moscow on the make. *Newsweek*, pp. 36–38.
- Price Waterhouse/Management Horizons. (1994). Retail world: Window of opportunity. Columbus, OH: Author.
- Pullen, R. (1988, November 2). Apparel, textile, retail PACs backing candidates to tune of \$2M. *Daily News Record*, p. 7.
- Raffaelli, M. (1989, March 21–22). Some considerations on the Multi-Fibre Arrangement: Past, present and future. Preliminary manuscript sent to author. Paper presented at the workshop on International Textile Trade, the Multi-Fibre Arrangement and the Uruguay Round, Stockholm.
- Raffaelli, M., & Jenkins, T. (1995). *The drafting history of the Agreement on Textiles and Clothing*. Geneva: International Textiles and Clothing Bureau.
- Ramey, J. (1992a, August 19). Mexican women want U.S. brands. *Women's Wear Daily*, p. 16.
- Ramey, J. (1992b, September 30). U.S. funding of offshore apparel factories fuels spirited debate. *Women's Wear Daily*, p. 24.

- Ramey, J. (1993, March 16). Cotton moves to protect its subsidies. *Women's Wear Daily*, p. 22.
- Ramey, J. (1995, January 12). Apparel price plunge: Unsettling symptom of saturated market. Women's Wear Daily, pp. 1, 8, 9.
- Ramey, J. (1996, December 12). Yule shoppers asked to care on child labor. *Women's Wear Daily*, pp. 5, 15.
- Ramey, J. (1997, July 8). Anti-sweatshop panel pushes on. *Women's Wear Daily*, pp. 6, 20.
- Ratti, A. (1997, February–March). Commentary: In the year 2000, let the silk shine. *Textile Horizons*, p. 5.
- Resnick, R. (1984, October 8). Importers—stores lose bid to kill new origin rules. *Daily News Record*, pp. 1, 15.
- Retail Industry Trade Action Coalition. (1987, July 30). Prepared statement of the Retail Industry Trade Action Coalition (RITAC) in opposition to S. 549, The Textile and Apparel Trade Act of 1987. Unpublished statement presented before the Committee on Finance, U.S. Senate.
- Ricardo, D. (1960). *Principles of political economy and taxation*. New York: E. P. Dutton. (Original work published in 1817)
- Ricks, D., Fu, M., & Arpan, J. (1974). *International business blunders*. Columbus, OH: Grid.
- Ringlestein, R. (1989, January). The U.S. textile outlook. It could be a lot worse. *Textile World*, pp. 60–64.
- Roberts, S. (1988, September 29). President vetoes bill that limits imported textiles. *The New York Times*, pp. 1, 16.
- Robertson, D. (1938, March). The future of international trade. *Economic Journal*, p. 48.
- Roboz, T. (1981, September). In response . . . Bobbin, pp. 28–32.
- Rosen, S., Turnbull, B., & Bialos, J. (1985). The renewal of the Multi-Fiber Agreement: An assessment of the policy alternatives for future global trade in textiles and apparel. Washington, DC: National Retail Merchants Association.
- Rostow, W. (1960). *The stages of economic growth*. Cambridge: Cambridge University Press.
- Rubenstein, J. (1992). *The cultural landscape: An introduction to human geography* (3rd ed.). New York: Macmillan.
- Ruggiero, R. (1997, April 28). The high stakes of world trade. *The Wall Street Journal*, p. A18.
- SA sees little lasting harm for Wal-Mart in NBC show. (1992, December 28). Women's Wear Daily, pp. 2, 9.

- Sajhau, J. (1997). Business ethics in the textile, clothing and footwear (TCF) industries: Codes of conduct. Sectoral Activities Programme Working Papers. Geneva: International Labour Office.
- Sakong, I. (1993). *Korea in the world economy.* Washington, DC: Institute for International Economics.
- Salvatore, D. (1987). *International economics*. New York: Macmillan.
- Samolis, F., & Emrich, T. (1986). *The politics of U.S. textile trade policy: Two centuries of temporary protection.* Washington, DC: Retail Industry Trade Action Coalition.
- Sara Lee Corporation. (1993). *Annual report* 1993. Chicago: Author.
- Sato, H. (1976). The crisis of an alliance: The politics of U.S–Japanese textile trade, 1969–71. Unpublished doctoral dissertation, University of Chicago.
- Scheffer, M. (1994). The changing map of European textiles. Brussels: L'Observatoire Européen du Textile et de l'Habillement.
- Schiavo-Campo, S., & Singer, H. (1970). Perspectives of economic development. Boston: Houghton Mifflin.
- Schiller, B. (1983). *The economy today*. New York: Random House.
- Schlotzman, K., & Tierney, J. (1983). More of the same: Washington pressure group activity in a decade of change. *Journal of Politics*, 45, 351–377.
- Schwartz, L. (1984, September 27). Mfrs., importers again slug it out in Capitol. *Daily News Record*, p. 7.
- Schwartz, L. (1986, August 7). Import bill dead: House sustains veto. *Women's Wear Daily*, pp. 1, 20.
- Scott, A. (1989, October 10). Peru gets OK to market vicuna. *Women's Wear Daily*, p. 38.
- Seckler, V. (1997, July). Wal-Mart Global is on track. *Women's Wear Daily* (global edition), pp. 4, 98.
- Seckler, V. (1997, July 2). Winning the battle at Sears logistics. *Women's Wear Daily*, p. 10.
- Senate nixes funds as Carib debate heats. (1992, October 1). Women's Wear Daily, pp. 1, 10.
- Senate of the United States. (1997, April 22). Senate Bill 626, 105th Congress, 1st Session. Washington, DC: Author.
- Shelton, L., & Dickerson, K. (1989). Government textile trade: Implications for industry, government, and education. *Journal of Home Economics*, 81(4), 46–52.

- Shooshtari, N., Walker, B., & Jackson, D. (1988). Retail trade associations: Enhancing members' power in relationships with suppliers. *Journal of Retailing*, 64(2), 199–214.
- Silbertson, Z., & Ledic, M. (1989). The future of the Multi-fiber Arrangements: Implications for the UK economy. London: Her Majesty's Stationery Office.
- Silva, F. (1993, August). Mexico: The making of a new market. *Bobbin*, pp. 38–46.
- Singer, N. (1997, July). The Russians are buying. *Women's Wear Daily* (global edition), pp. 60–66.
- Singletary, E., & Winchester, S. (1996). Beyond mass production: Analysis of the emerging manufacturing transformation in the U.S. textile industry. The Journal of the Textile Institute, Part II: Textile Economics, Management and Marketing (87), 97–116.
- Skartvedt, D. (1979, February 2). Productivity gains keep textile, apparel prices low. *Daily News Record*, p. 2.
- Sklair, L. (1989). Assembling for development. Boston: Unwin Hyman.
- Smallbone, T. (1986). Consumer interest in textile and clothing policy. In *International Trade and the Consumer.* Paris: Organization for Economic Cooperation and Development.
- Smith, A. (1930). *The wealth of nations* (5th ed.). London: Methuen. (Original work published in 1776)
- Spalding, L. (1985, September). Block those quotas. *Stores*, pp. 45–51.
- Spinanger, D., & Zietz, J. (1985). Managing trade but mangling the consumer: Reflections on the EEC's and West Germany's experience with the MFA. Kiel Working Paper No. 245. Kiel, Federal Republic of Germany: Institut für Weltwirtschaft.
- Stabler, C. (1986, December 22). What is culture's role in economic policy? *Wall Street Journal*, p. 1.
- Standard & Poor's. (annual). Textiles, apparel and home furnishings—Basic analysis and textiles, and Apparel and home furnishings—Current analysis. New York: Author.
- Standard & Poor's. (1984). Standard & Poor's industry surveys. New York: Author.
- Standard & Poor's. (1987). Standard & Poor's industry surveys. New York: Author.
- Standard & Poor's. (1988). Standard & Poor's industry surveys. New York: Author.
- Standard & Poor's. (1992). Standard & Poor's industry surveys. New York: Author.

- Stanton, B. (1987, October 9). Retailers finding out that lobbying Congress can pay off. *Daily News Record*, p. 33.
- Statistics Canada. (1993). Ottawa: Government of Canada.
- Steele, P. (1988). *The Caribbean clothing industry: The U.S. and far east connections*. London: The Economist Intelligence Unit.
- Steele, P. (1990). Hong Kong clothing: Waiting for China. London: The Economist Intelligence Unit.
- Stein, L. (Ed.). (1977). Out of the sweatshop. New York: Quadrangle.
- Stern, L. (1969). Distribution channels: Behavioral dimensions. Boston: Houghton Mifflin.
- Sternquist, B., & Tolbert, S. (1986, May 23). Survey: Retailers shun industry's Buy American program. *Marketing News*, p. 8.
- Stokes, R. (1984). *Introduction to sociology*. Dubuque, IA: W.C. Brown.
- Streeten, P. (1972). Technology gaps between rich and poor countries. *Scottish Journal of Political Economy*, XIX(3), 213–230.
- Strida, M. (1985). Early location of textile industry in central Europe. *Folia Geographica*, 6, 71–79.
- Strugatch, W. (1993, February). Make way for the Euroconsumer. *World Trade*, pp. 46–50.
- Sturdivant, F., & Granbois, D. (1973). Channel interaction: An institutional-behavioral view. In B. Walker & J. Haynes (Eds.), Marketing channels and institutions: Readings on distribution concepts and practices. Columbus, OH: Grid.
- Sub-contracting spotlight. (1997, July). Knitting International, p. 10, 12.
- Subhan, M. (1993, September). Not yet at sunset. *Textile Asia*, p. 21.
- Sung, K. (1980, September). Protectionism and premia. *Textile Asia*, p. 18.
- Sung, K. (1993). *Asian textiles* 2000. Paper presented at the Textile Institute Conference, Hong Kong.
- Sweet, M. (1994, February). Recent trade treaties likely to stimulate continuing changes in global sourcing of apparel. *Industry, Trade, and Technology Review* (published by the U.S. International Trade Commission), pp. 1–8.
- Tait, T. (1996, May). Made in India—team work style! *Apparel International*, 27(5), 30–32.
- Taiwan Textile Federation. (1997). *The development of Taiwan textile industry*. Unpublished document. Taipei: Author.

- Taussig, F. (1914). *The tariff history of the United States* (6th ed.). New York: G.P. Putnam's Sons.
- Taylor, H. (1984, November 9). FTC ready to unveil its new origin label rules. *Daily News Record*, p. 3.
- Taylor, H. (1990, August 20). I.T.A. dumping margins on Taiwan sweaters set as high as 24.02%. *Women's Wear Daily*, p. 15.
- Taylor, W. (1912). *Factory system and factory acts.* London: no publisher given.
- TDA told retailers' problems make importing a necessity. (1985, June 6). *Daily News Record*, pp. 2, 15.
- Textile and Clothing Board. (1985, October). *Textile* and clothing inquiry: Report to the minister of regional industrial expansion (Volumes I and II). Ottawa, Canada: Government of Canada.
- Textile Asia. (October 1973), cited in Aggarwal, 1985. Textile Institute. (1993). Asia and world textiles. Textile Institute Conference Proceedings, Hong Kong. Manchester, England: Author.
- Textile Organon. (monthly). Published by the Textile Economics Bureau.
- Textile trade bill: A good fight that isn't over yet. (1985, December 19). *Daily News Record*, pp. 2, 10.
- Textiles Committee (GATT). (1992, December 9). Textiles Committee Meeting: Item A (II): Annual report of the Textiles Surveillance Body, Statement by the Chairman of the TSB. Report given to the GATT Textiles Committee, Geneva, Switzerland.
- Theron, P. (1997). Statistical review: Overview of the South African clothing industry. *Journal of Fashion Marketing and Management*, 1(3), 283–287.
- Thiede, R. (1992). Eastern Europe, the Commonwealth of Independent States, and the Baltic States. In J. Fisher (Ed.), *Geography and development* (pp. 263–331). New York: Macmillan.
- Third world countries to remain atop apparel market: UN study. (1987, November 3). *Daily News Record*, p. 7.
- 3rd world exporters take up cudgels again against U.S. (1984, November 9). *Daily News Record*, p. 18.
- Thurow, R. (1997, May 5). In global drive, Nike finds its brash ways don't always pay off. *The Wall Street Journal*, pp. A1, A10.
- Torre, R. (1997, July–August). Tigers and slugs. *International Business*, pp. 19–21.
- Toyne, B., Arpan, J., Barnett, A., Ricks, D., & Shimp, T. (1984). *The global textile industry*. London: George Allen & Unwin.

- Trading trends: The EU textile and clothing sector. (1997, June). *Knitting International*, p. 13.
- Trela, I., & Whalley, J. (1991). *Internal quota allocation* schemes and the costs of the MFA. Working Paper No. 3627. Cambridge, MA: National Bureau of Economic Research.
- Tribe, L. (1978). American constitutional law. Mineola, NY: Foundation Press.
- Tucker, B. (1984). Samuel Slater and the origins of the American textile industry, 1790–1860. Ithaca, NY: Cornell University Press.
- United Nations. (1990). *Global outlook 2000*. New York: Author.
- United Nations. (1992, December). NGLS Go-between. Special insert No. 24. New York: Author.
- United Nations. (1992). World economic survey. New York: Author.
- United Nations. (1996). World economic and social survey 1996. New York: Author.
- United Nations Centre on Transnational Corporations. (1987). Transnational corporations in the manmade fibre, textile and clothing industries. New York: Author.
- United Nations Conference on Trade and Development. (1984). *International trade in textiles, with special reference to the problems faced by developing countries*. New York: Author.
- United Nations Population Fund. (1993). *The state of world population 1993*. New York: Author.
- United Nations Statistical Office, various sources.
- United States Chamber of Commerce (International Division). (1992). *A guide to the North American Free Trade Agreement*. Washington, DC: Author.
- United States Congress, Office of Technology Assessment. (1987). *The U.S. textile and apparel industry: A revolution in progress.* Washington, DC: U.S. Government Printing Office.
- United States Department of Commerce. (annual, now on line. See OTEXA Web site). Foreign regulations affecting U.S. textile/apparel exports. Washington, DC: Author.
- United States Department of Commerce. (1985, October). *Highlights of U.S. export and import trade, FT 990.* Washington, DC: Author.
- United States Department of Commerce. (1993). Chapters on textiles, apparel, and leather. *U.S. industrial outlook* 1993. Washington, DC: Author.
- United States Department of Commerce. (1993, monthly). *United States national trade data bank [CD-ROM]*. Washington, DC: Author.

- United States Department of Commerce, Bureau of the Census. (every 5 years). *Census of retail trade: Establishment and firms size.* Washington, DC: U.S. Government Printing Office.
- United States Department of Commerce, Bureau of the Census. (annual). *County business patterns* (*year*), *United States*. Washington, DC: U.S. Government Printing Office.
- United States Department of Commerce, Bureau of the Census. (1994). *County business patterns*, 1994, *United States*. Washington, DC: U.S. Government Printing Office.
- United States Department of Commerce, United States National Trade Data Bank. (1993). CD monthly series (also available on line for a fee). Washington, DC: Author.
- United States Department of Labor, Bureau of Labor Statistics. (1993, January). *Employment and earnings*. Washington, DC: Author.
- United States Department of Labor, Bureau of Labor Statistics. (quarterly). *Employment and wages*. Bulletin 2419. Washington, DC: Author.
- United States Department of the Treasury, U.S. Customs Service. (periodic). *Importing into the United States*. Washington, DC: U.S. Government Printing Office.
- United States Department of the Treasury, U.S. Customs Service. (1987, June). ACS (Automated Commercial System Operations) overview. Washington, DC: U.S. Government Printing Office.
- United States Executive Office of the President, Office of Management and Budget. (1987). Standard Industrial Classification Manual. Washington, DC: Author.
- United States International Trade Commission. (1983, September). The effect of changes in the value of the U.S. dollar on trade in selected commodities. Washington, DC: Author.
- United States International Trade Commission. (1985a, July). *Emerging textile-exporting countries*. USITC Pub. 1716. Washington, DC: Author.
- United States International Trade Commission. (1985b, May). *The Multifiber Arrangement*, 1980–84. USITC Pub. 1693. Washington, DC: Author.
- United States International Trade Commission. (1987a, October). *International Economic Review*. Washington, DC: Author.
- United States International Trade Commission. (1987b, December). U.S. global competitiveness:

- *The U.S. textile mill industry.* USITC Pub. 2048. Washington, DC: Author.
- United States International Trade Commission. (1993a, November). *The economic effects of significant U.S. import restraints*. Investigation No. 332–325. Pub. 2699. Washington, DC: Author.
- United States International Trade Commission. (1993b). Potential impact on the U.S. economy and selected industries of the North American Free-Trade Agreement. Washington, DC: Author.
- United States International Trade Commission. (1994). *Harmonized Tariff Schedule of the United States*, 1994. USITC Pub. 2690. Washington, DC: U.S. Government Printing Office.
- United States International Trade Commission. (1997, September). Likely impact of providing quotafree entry to textiles and apparel from Sub-Saharan Africa. (Pub. No. 3056). Washington, DC: Author.
- United States Senate, Committee on Finance. (1985, July 15). *Textile and Apparel Trade Enforcement Act: Hearing before the Subcommittee on International Trade*. Washington, DC: U.S. Government Printing Office.
- United States Senate, Committee on Finance. (1986). Textile and Apparel Trade Enforcement Act: Hearing before the Subcommittee on International Trade. (September 12 and 23, 1985). Washington, DC: U.S. Government Printing Office.
- United States Trade Representative. (1993). *USTR* annual report 1993. Washington, DC: Author.
- Uruguay Round comes to end as 109 trade ministers sign pact. (1994, April 18). Women's Wear Daily, p. 27.
- U.S. consumers seen gaining by lifting of apparel quotas. (1980, July 25). Women's Wear Daily, p. 2.
- U.S. textile pact with Myanmar is not renewed. (1991, August 1). Women's Wear Daily, p. 10.
- van Benthem van den Bergh, G. (1972). Science and the development of society. In *Science and the world tomorrow*. Discussion paper at the 20th anniversary conference, NUFFIC.
- Van Fossan, C. (1985, March 14). Retail decisionmaking and direct importing. Unpublished excerpts from a speech delivered at Kurt Salmon Associates Third Annual Sourcing Breakfast, New York City.
- Vernon, R. (1966, May). International investment and international trade in the product life cycle. *Quarterly Journal of Economics*, 190–207.
- Vernon, R. (1971). Sovereignty at bay: The multinational spread of U.S. enterprises. New York: Basic Books.

- Vigdor, I. (1996, June). Outlook remains strong in Russia. *ATI*, pp. 78, 80.
- A voice for free trade. (1987, April). *Textile Asia*, pp. 156–157.
- Voice of Industry. (1847, March 26).
- Wall, M., & Dickerson, K. (1989). Free trade between Canada and the United States: Implications for clothing and textiles. Clothing and Textile Research Journal, 7(2), 1–10.
- Wallerstein, I. (1974). The modern world-system: Capitalist agriculture and the origins of the European world economy in the sixteenth century. New York: Academic Press.
- Wal-Mart Corporation. (1997). Wal-Mart annual report. Bentonville, AK: Author.
- Ward, K. (Ed.). (1990). Women workers and global restructuring. Ithaca, NY: Cornell University ILR Press.
- Ware, C. F. (1931). The early New England cotton manufacture. Boston: Houghton Mifflin.
- Watters, S. (1992, August 19). U.S. to Canada apparel exports triple. *Women's Wear Daily*, p. 17.
- Werbeloff, A. (1987). Textiles in Africa: A trade and investment guide. London: Alain Charles Publishing.
- Werner International. (annual). Spinning and weaving labour cost comparisons, summer (year). New York: Author.
- Wertheimer, B. (1977). We were there: The story of working women in America. New York: Pantheon.
- Westbrook, J. (1997, August). New investment area. *Textile Asia*, p. 84.
- What is culture's role in economic policy? (1986, December 22). *Wall Street Journal*, p. 1.
- Wheatley, N. (1996a, September). Eastern Europe wakes up to Western needs. *World Clothing Manufacturer*, pp. 16–22.
- Wheatley, N. (1996b, July–August). Hungry China hovers over Hong Kong. World Clothing Manufacturer, pp. 10–13.
- Wheeler, D., & Mody, A. (1987). Towards a vanishing middle: Competition in the world garment industry. *World Development*, 15(10/11), 1269–1284.
- When free trade means higher consumer prices. (1977, September 5). *Business Week*, pp. 61–62.
- Whittier, J. (1845). Stranger in Lowell. Boston: Waite, Peirce, & Co.
- Wightman, R. (1977, October 19). Retailers told to educate consumer on free trade. *Women's Wear Daily*, p. 50.

- Wightman, R. (1978, December 15). Consumers save \$2 billion by buying imports. *Daily News Record*, p. 1.
- Wightman, R. (1981, March 18). Stores, importers ask for punch on trade policy. *Women's Wear Daily*, p. 10.
- Wightman, R. (1984, June 28). Retailers rally for quota cuts. Women's Wear Daily, pp. 1, 15.
- Wightman, R. (1985a, December 19). House won't attempt to override veto until August 6. *Daily News Record*.
- Wightman, R. (1985b, February 5). New coalition forms to battle for import curbs. *Daily News Record*, pp. 1, 19.
- Wightman, R. (1985c, March 11). RITAC chief: Quotas costing consumers billions. *Daily News Record*, p. 5.
- Wightman, R. (1986a, August 4). Affected industries here call pact a total disaster. *Daily News Record*, pp. 1, 6.
- Wightman, R. (1986b, March 20). Study says '84 protection cost U.S. consumers \$27 B. *Daily News Record*, p. 14.
- Wightman, R. (1986c, September 11). U.S. warns it will exit GATT talks if priority issues omitted. *Daily News Record*, p. 21.
- Wightman, R. (1987, January 13). Retail group begins battle against quota bill. *Daily News Record*, p. 10.
- Wilner, R. (1987, December 3). Importers need to bone up on Harmonized System regs. *Daily News Record*, pp. 3, 11.
- Wolf, M. (1982, January 12). Textile pact: The outlook. *The New York Times*.
- Wolf, M. (1983). Managed trade in practice: Implications of the textile arrangements. In W. Cline (Ed.), *Trade policy in the 1980s* (pp. 455–482). Washington, DC: Institute for International Economics.
- Wolf, M., Glismann, H., Pelzman, J., & Spinanger, D. (1984). *Costs of protecting jobs in textiles and clothing*. London: Trade Policy Research Center.
- Wolff, A., Howell, T., & Noellert, W. (1988). *The reality of world trade in textiles and apparel*. Washington, DC: Fiber, Fabric and Apparel Coalition for Trade.
- World Bank. (annual). Global economic prospects and the developing countries. Washington, DC: Author.
- World Bank. (annual). *The World Bank atlas*. Washington, DC: Author.
- World Bank. (annual). World development report (year). Washington, DC: Author.

- World Bank. (1987). World development report 1987. Washington, DC: Author.
- World Bank. (1991). World development report 1991. Washington, DC: Author.
- World Bank. (1993). The East Asian miracle: Economic growth and public policy. Washington, DC: Author.
- World Bank. (1995). World development report 1995. Washington, DC: Author.
- World Trade Organization. (1995). WTO (World Trade Organization): Trading into the future. Geneva: Author.
- World Trade Organization. (1996a). World Trade Organization Annual Report 1996, Volume II. Geneva: Author.
- World Trade Organization, Textile Division. (1996b). Workshops on the phasing out of the Multifibre Arrangement and new strategies for exports of textiles and clothing. Unpublished paper presented in New Delhi and Bombay. Geneva: Author.
- World Trade Organization. (1996c). WTO ministerial conference, Singapore. Information for the media. Geneva: Author.
- World Trade Organization. (1997, January). WTO focus, (15), 22–23.
- World Trade Organization. (1997, July 31). Comprehensive report of the Textile Monitoring Body to the Council for Trade in Goods on the Implementation of

- the Agreement on Textiles and Clothing during the first stage of the integration process. Unpublished report G/L/79. Geneva: Author.
- Wurth, P. (1981). The arrangement regarding international trade in textiles. *Aussenwirtschaft*, 36(1), 57–69.
- Yates, R. (1988, August 7). Trade bill bitter pill for Asian Partners. *Chicago Tribune*, pp. 7–12.
- Yilmaz, T. (1991, November). *The Turkish clothing industry*. Paper presented at the International Apparel Symposium, Istanbul.
- Youzhe, C. (1996, May). Silk: Crisis after crisis. *Tex-tile Asia*, pp. 70, 71.
- Zaracostas, J. (1993, December 8). U.S. works out deal with EC to make smaller cuts in textile, clothing tariffs. *Women's Wear Daily*, p. 4.
- Zaracostas, J. (1993, December 10). MFA extended for 1 year. *Daily News Record*, p. 2.
- Zaracostas, J. (1996, November 4). ILO gathering ends with call for more efforts on sweatshops. *Women's Wear Daily*, p. 38.
- Note: *Daily News Record* changed its official name to *DNR* in 1988. Citations reflect the name used at the time articles were published.

Subject Index

AAEI (American Association of
Exporters and Importers),
409–10, 526
AAMA (American Apparel
Manufacturers
Association), 367, 408-9,
415, 525n.
Absolute advantage theory,
101–2
ACMI (American Cotton
Manufacturers Institute),
340n.
ACTWU (Amalgamated
Clothing and Textile
Workers Union), 320, 409
Adjustment costs, 512
Adjustment strategies. See also
Competition
automation, 426, 428
domestic product
promotions, 280–81
European countries, 424
in fiber industry, 294–95
goal of, 423, 553
justifications for, 430–32
plant closings, 275, 425–26
policy strategies, 428–30
QR systems, 279–80, 318,
477–78, 553
rationalization, 272, 422,
423–24
restructuring, 204, 275–76,
460, 483
specialized market niches,
278–79
tariffs as, 424
technology investments, 276–77, 424
of U.S. textile complex,
272–73, 422, 423–28
2/2-/3, 422, 423-28

Aesthetics, 89-91, 263

```
AFMA (American Fiber
    Manufacturers
    Association), 408, 525
Africa
  textile complex, 247-50
  textile industry development
      stage, 141
Afrocentric apparel, 249
Agents of influence, 411
Aggregate ceiling limits, 352
Aggregate demand, 98
Agile competition, 131-32
Agile manufacturing, 281-82
Agility
  advantages of, 281-82
  defined, 131
Agreement on Textiles and
    Clothing (ATC), 372-78
Agricultural Act of 1956, 396-98
AID (U.S. Agency for
    International
    Development), 439
Allied Signal, 293–94
Amalgamated Clothing and
    Textile Workers Union
    (ACTWU), 320, 409
American Apparel
    Manufacturers Association
    (AAMA), 367, 408-9, 415,
    525n.
American Association of
    Exporters and Importers
    (AAEI), 409–10, 526
American Cotton
    Manufacturers Institute
     (ACMI), 340n.
American Fiber Manufacturers
     Association (AFMA), 408,
     525
American Retail Federation
    (ARF), 410
```

```
American Society for Testing
    and Materials (ASTM), 515
American Textile
    Manufacturers Institute
    (ATMI), 381, 407, 525
American Textile Partnership
    (AMTEX), 277
Andean Group, 76
APEC (Asia Pacific Economic
    Cooperation) forum, 75, 76,
Apparel industry. See also
    Apparel production; Textile
    complex; Textile industry
  Afrocentric apparel, 249
  Canadian, 224-26
  care label symbols, 515-16
  child labor in, 155-57
  competition among
      developing countries,
      145-47, 148
  competition in, 21–23
  competitiveness factors, 175,
      311-12, 422, 429-30
  conflict with retailers, 457-59
  consumer expenditures,
      492-96
  defined, 19-20
  development of, 39-40
  development stages, 145-48
  employment in, 5, 7, 45–46,
       152–55, 308, 319
  fragmentation of, 308
  global competition, 46–47
  global perspective on, 5–14,
       17-18, 445-46
  import flow chart, 406
  imports, impact of, 46
  interdisciplinary perspective,
  job losses in, 320–21, 428–29
```

as labor-intensive industry, 39, 319–20 labor unions in, 39, 250, 320, 409, 422, 524-25 logistics, growth of, 14–15 marketing initiatives, 443 marketing strategies, 318 markets for, 315-18 in Mexico, 226-29 poor quality problems, 470-72 reform movement, 39 sourcing strategies, 312–13 tariff costs, 475–76, 501 technological advances, 311 - 12trade patterns, 191–96, 321–27 transnational corporations' role in, 113 in U.S., 307-27 U.S. exports, 193, 194, 325, 327, 429, 448 U.S. imports, 195–96, 325–27 Apparel Industry Partnership, Apparel marketing, 318 Apparel merchandising, 318 Apparel production. See also Production; Textile production in Asia, 167–68 in Caribbean basin area, 68, 69-72 code of conduct, 161, 162-63 contracting, 154, 157-58 developing countries and, 9-10, 145-47, 184-85, 470 - 72and development theories, 113 - 28domestic options, 313–15 economic and political systems' effects on, 84-86 economic system contrast in, 82-83 employment patterns, 171-74 as employment source, 5, 7, 152-55, 308, 319 global overcapacity, 151–52 global patterns, 169-70

global shifts in, 321–23 labor costs, 157, 173–74, 319–20, 463, 469, 558 manufacturing difficulties, 309-10 and the new international division of labor, 129-31, 549 operations types, 310–11 retailers and, 159 sweatshops, 154, 157-59 Apparel trade. See also Textile trade; Trade closed or partly closed markets, 438 consumer gains from, 496-500 dumping, 435 foreign aid, 438-40 global share, 183-84 importers' role in, 459 leading exporters, 193–95 leading importers, 195–96 in less-developed countries, 184-85 patterns of, 191–96, 321–27 politics and, 198, 199, 520-22 restrictive tariffs, 437–38 SITC classification, 182 subsidies, 436-37 Apparent U.S. consumption, ARF (American Retail Federation), 410 Argentina, 233 Arkwright, R., 31, 33 Arm's-length trade, 110-11 Arrangement Regarding International Trade in Textiles. See Multifiber Arrangement (MFA) Artificial fibers, 293 ASEAN (Association of Southeast Asian Nations), 74, 76, 218, 219, 220–21, 415 ASEAN Federation of Textile Industries, 415 Ashcroft, John, 542 Asia apparel production leader,

167 - 68

bilateral agreements with U.S., 350 overview of, 72-75 textile complex in, 204–23 and U.S. country of origin rules, 211-12 Asia Pacific Economic Cooperation (APEC) forum, 75, 76, 224 Asociación Nacional de la Industria Quimica (chemical industry), 412 Association of Southeast Asian Nations (ASEAN), 74, 76, 218, 219, 220-21, 415 ASTM (American Society for Testing and Materials), 515 ATC (Agreement on Textiles and Clothing), 372-78 ATMI (American Textile Manufacturers Institute), 381, 407, 525 Australia, 223–24 Automatic replenishment responses, 279

Babbitt, Bruce, 534 Backward integration, 261 Bagchi, Sanjoy, 395 Balance of trade, 101 Ball, George, 346 Baltic states, 63, 240-43, 244 Bangladesh, 222-23 Banking, development of, 121 Bar coding, 279n. Barriers to entry, 272 Bhutan, 223 Bilateral agreements, 340 Binding quotas, 511 Black Sea Economic Cooperation Region, 76 Bonded warehouses, 228 Brazil, 232-33 Bretton Woods agreement, 43 Britain. See England Brunei, 221 Burden sharing, 353, 356, 430 Bureau Europeén de Unions des Consommateurs, 514

Burlington Industries, 276 Bush, George, 68, 367, 371, 380, 523 CAC (Consumers' Association of Canada), 514 CACM (Central American Common Market), 76, 232 Call mechanisms, 355 Camera Nacional de la Industria del Vestido (apparel), 412 Camera Nacional de la Industria Textil (textiles), 412 Canada bilateral agreements with U.S., 63, 350 NAFTA's effects on, 65–66, 226 policy structures, 411–12 textile and apparel industry in, 224-26 U.S. textile machinery buyers, 306 Canada-U.S. Free Trade Agreement (CFTA), 380, 381 Canada-U.S. free trade area, 65 Capacity utilization rate, 295-96, 297 Capital emergence of, 31 internationalization of, 129 reinvestment programs, 311 - 12Capital deepening, 428 Capital-intensive products, 105 Capitalism in China, 84 emergence of, 31, 33, 41, 122 in market systems, 81 merchant, 121 Capitalist economic systems, 80 Care label symbols, 515-16 Caribbean basin, 68, 69-72, 229-32, 315 Caribbean Basin Initiative (CBI), 230-31 Caribbean Basin Textile Access

Program, 231

Caribbean Economic Community (CARICOM), 72,76 Caribbean Parity, 231 CARICOM (Caribbean Economic Community), 72, Carter, Jimmy, 523 Cartwright, Edmund, 33 Catalog sales, 461 Category ceiling limits, 352 Category killers, 460-61 CBI (Caribbean Basin Initiative), 230-31 CEECs (Central and Eastern European Countries), 240 CEETEs (Central and Eastern **European Transition** Economies), 65 Cellulosic fibers, 293 Central America, 232-34 Central American Common Market (CACM), 76, 232 Central and Eastern European Countries (CEECs), 240 Central and Eastern European Transition Economies (CEETEs), 65 Central Europe, 63–65 Centrally planned systems, 53, 81, 241 CFTA (Canada-U.S. Free Trade Agreement), 380, 381 Channel control, 462 Channel distribution, 276, 462-63, 483-84 Child labor "Dateline" exposé, 479 in developing countries, 155 - 57in England, 34 in the U.S., 36, 37 China. See also Hong Kong apparel exports, 193, 194 dumping allegations, 435 economic system, 81-82 emerging state capitalism, GATT and WTO membership issues, 85-86

impact on textile industry, 213 - 18labor costs, 216 most favored nation status. 482, 564 quota limits, 475 textile imports, 190 textile industry development stage, 142 textile subsidies, 436 women workers in, 154 c.i.f. data, 274 Circumvention, 403 CIS (Commonwealth of Independent States), 63, 240-43, 244-47 CITA (Committee for the Implementation of Textile Agreements), 398–400 Citizens for a Sound Economy (CSE), 514 Clinton, Bill, 371, 381 Closed economy, 222 Closed markets, 438 CMEA or COMECON (Council for Mutual Economic Assistance), 63, 240 CMT (cut-make-trim) packages, 158, 314 Colombia, 233-34 COMECON or CMEA (Council for Mutual Economic Assistance), 63, 240 COMESEA (Market for Eastern and Southern Africa), 76 Commerce, U.S. Department of (DOC), 398Commission of the EU, 413 Committee for the Implementation of Textile Agreements (CITA), 398-400 Common market, 59 Commonwealth of Independent States (CIS), 63, 240-43, 244-47 Communications advances in, 5, 12–13 and the new international division of labor, 130

technology advances, 10-13

Comparative advantage theory, 102 - 4Competition. See also Adjustment strategies among developing countries, 145-47, 148 among retailers, 460 in apparel industry, 311–12, 315 - 17cost factors, 175 global effect of, 46-47 growth of, 21–23 impact on U.S. textile complex, 271-75, 422, 429-30 and labor conditions, 154, 158 - 59in textile/apparel production, 151 - 52Competitive Advantage of Nations, The (Porter), 107 Competitive advantage of nations theory, 107–10 Complete integration, 59 Comprador, 123 Concentration, 261 Congress, U.S., 400, 524-26 Congressional Textile Caucus, 400 Consultation calls, 357 Consumer confidence, 268 Consumer demand. See Consumption Consumer expenditure measure, 178-80 Consumer Federation of America, 514 Consumers. See also Consumption attitude toward imports, 477 benefits of international trade on, 499-500 costs of protection to, 501-11 gains from global trade, 496-500 global, 514-16 imports, pricing of, 467 lobbying efforts, 500–501, 513-14 quotas, costs to, 501-2, 504-5 retailers and, 266-68

tariff costs, 501, 504 textile and apparel expenditures, 492–96 Consumers' Association in the United Kingdom, 514 Consumers' Association of Canada (CAC), 514 Consumers for World Trade (CWT), 514, 526 Consumption. See also Consumers apparel markets, 318 fiber, 180-82 global patterns of, 174–80 stagnant, 180 U.S. textile complex and, 266 - 71Contracting arrangements, 154, 157 - 58Contractors, 311, 313 Costs adjustment, 512 as competitiveness factor, 175 dynamic, 503 imported products and, 466–67, 475–76 imports of textile manufacturers, 301 of labor, 157, 463, 469 regressive, 506 social, 235-36 sourcing, 313 static, 503 of trade protection, 501–11 Cottage industries, 31, 138, 153, 154 Cotton, 293. See also Natural African production, 248 early production of, 31 global market, 294 growth boom, 97, 98 Japanese textile exports, 339, 340 subsidies of, 437 Cotton gin, 31, 35 Council for Mutual Economic Assistance (CMEA or COMECON), 63, 240

Council of Logistics Management, 14 Council of Ministers, 413 Counterfeit goods, 404 Counterpressure groups, 481 Countervailing duties, 357 Country of origin, 211-12, 281 Country-of-origin labeling, 444 Country of origin rules, 211, 480 Coxe, Tench, 35 Crafted with Pride in U.S.A. Campaign, 280, 443-44 Credit cards, 14 Crompton, Samuel, 31 CSE (Citizens for a Sound Economy), 514 Cultural environments, 86-91 Culture as cause of trade problem, 452 - 53defined, 86n. material, 88 Currency devaluation of, 42, 43, 66 dollar value, effect of, 46, 274 euro, 62 Customs Modernization and Informed Compliance Act (Mod Act), 404 Customs Service, U.S. country of origin regulations, 211, 480 ELVIS system, 405 enforcement tools, 405 inspection authority, 403 merchandise processing, 407 quota enforcement efforts, 474 - 75responsibilities of, 403-4 Customs union, 59 Customs values, 274 Cut-make-trim (CMT) packages, 158, 314 CWT (Consumers for World Trade), 514, 526

"Dateline" exposé on child labor, 479 Deindustrialization, 131 Delocalized production, 237–39

global patterns, 115 Dependency theory, 120 patterns in textile complex, Developed countries defined, 23 149-51 defined, 5, 21, 52-53 second-world semiperiphery, deindustrialization in, 131 developing countries and, stages, in textile industry, 78 - 80141-44, 145-48 **Economies** fair trade demands, 432-40 theories of, 113-28 future outlook for, 551-56 third-world periphery, 122-23 closed, 222 outsourcing, 128-29, 147-48, Direct foreign investment, 113 312-13, 446, 463-66 Direct investment, 447–48 share of textile imports, Distribution 186 - 87communications advances, structural relations with poor open, 222 12 - 13countries, 125 global patterns of, 5 Developing countries. See also Distribution channels, 276, Newly industrialized 462-63, 483-84 countries (NICs) Diversionary dumping, 435 apparel production and, 9-10, Division of labor, 101 145-47, 184-85, 470-72 Domestic content laws, 503. See child labor in, 155-57 also Rules of origin competition among, 145-47, Downsizing, 280 148 Downstream activities, 20 defined, 5, 21, 53 Drucker, Peter, 558 developed countries and, Dumping, 435 78 - 80Dunkel, Arthur, 371 fiber production, 294 DuPont, Eleuthère Irénée, 35 future outlook for, 556-59 globalization's effects on, 4, 5, DuPont (company), 280, 293-94 9 - 10Durable goods, 265 imports from, 140, 341 Dyeing and finishing, 263 and new international Dynamic costs, 503 division of labor, 128-31, 549 Wages EAI (Enterprise for the as periphery countries, 123 Americas Initiative), 68, problems of, 54 380 structural relations with rich East Asia, 205–18 countries, 125 Eastern Europe textile production and, 9-10, economic transition, 63-65 28, 139-40, 145-47, 148, EU agreement with, 62–63 184 - 85textile complex, 240-44 transportation limitations in, transition to market economies, 82–83 U.S. aid to, 438-40 EC. See European Community women workers, 153-54 Development (EC) Economic and Monetary Union country groupings, 52-54 (EMU), 62 first-world core, 122 Economic integration, 59 flying geese pattern of, 205 Economic interdependence, 42 gap between rich and poor, 152-55, 308, 319 Economic nationalism, 42, 101 113 - 14

Economics concept clusters, 96–99 in material culture, 88 Economic systems, 80-82, 83-84 Economic union, 59 centrally controlled, 53, 81, 241 flying geese of Asia, 205 global, 2-4, 17-18 market-directed, 82-83, 196-97 of scale, 292 service, 522 EDI (electronic data interchange), 443 EEA (European Economic Area), 62 EEC (European Economic Community), 60 EFTA (European Free Trade Association), 62 Egypt, 249-50 807 production, 230, 314, 316 Electronic data interchange (EDI), 443 Electronic visa information system (ELVIS), 405 Embargoes, 35, 474–75 Emery Global Logistics, 15 Employment. See also Labor; in cottage industries, 31, 138, 153, 154 decline in apparel industry, 320-21, 428-29 decline in textile industry, 45-46, 422, 425-26, 428 - 29global patterns of, 171–74 of immigrants, 258, 265 NAFTA's effect on, 381 outside the home, 36-37, 39 political problems of, 521-22 in retail, 459 in textile and apparel industries, 5, 7, 45-46,

in U.S. textile complex, 258, European Union (EU). See also Fair trade, 432-40 264-65 European Community (EC) f.a.s. data, 274 of women, 36–37, 152–55, 258, agreement with Eastern Fashion Europe, 62–63 consumer changes in, 268 EMU (Economic and Monetary Association Agreements, 242 globalization of, 5, 20 Union), 62 burden sharing complaint, imports and, 467-68, 473 End-use products, 261, 263 353, 356, 430 transient nature of, 309-10 England multifiber arrangement and, Fast track authority, 68, 367, 371 adjustment strategy, 424 349, 350, 353, 354–55 FDI (foreign direct investment), early factory conditions, 34 overview, 60-62 65 - 66foreign trade, growth of, 41 policy structures, 412–15 Female Labor Reform Industrial Revolution, 29–35 textile complex, 234–40 Associations, 38 textile trade regulation, 40, Exchange rates FFACT (Fiber, Fabric and 339 Bretton Woods agreement, 43 Apparel Coalition for Enterprise for the Americas floating, 44–45 Trade), 365, 409, 481 Initiative (EAI), 68, 380 impact of, 184, 186, 198 Fiber consumption measure, Entrepôt, 210 Executive branch of U.S. 175 - 78Equilibrium price, 99, 100 government, 523-24 Fiber, Fabric and Apparel Ethnocentrism, 86 Export-processing zones, Coalition for Trade EU. See European Union (EU) 153 - 54(FFACT), 365, 409, 481 **EURATEX** (European Apparel Exports. See also Imports Fiber industry, 292–95 and Textiles Organization), defined, 21 Fibers. See also Manufactured 414 - 15dumping, 435 fibers; Natural fibers; Euro, 62 Hong Kong textiles, 342–43 Textile production Europe. See Central Europe; Japanese textiles, 339, 340 artificial, 293 Eastern Europe; European justifications for, 110–11 category shifts, 441 Community (EC); leading apparel exporters, cellulosic, 293 European Union (EU); 193-95 consumption of, 175, 180–82 Western Europe leading textile exporters, noncellulosic, 293 **European Apparel and Textiles** 188-89 production of, 261-62, 294 Organization (EURATEX), for market expansion, 448-50 synthetic, 293 414 - 15mercantilism era, 40-41, 101 types of, 262 European Community (EC). records of, 182 First cost, 476 See also European Union subsidies, 436-37 First-world countries, 53 (EU) textile mill products, 304–5, Floating exchange rate system, history of, 60 44-45 per capita fiber consumption, U.S. apparel, 193, 194, 325, FLSA (Fair Labor Standards 180 327, 429, 448 Act), 158 European Council, 413 U.S. textiles, 305 Flying geese pattern of European Economic Area development, 205 (EEA), 62Fabric, production of, 263 Flying shuttle, 31 European Economic Factor proportions theory, Forced labor, 160 Community (EEC), 60 104 - 6Foreign aid, 438–40 European Free Trade Factors of production, 105 Foreign direct investment (FDI), Association (EFTA), 62 Factory girls, 37–38 65 - 66European Observatory for Factory Girls' Association, 38 Foreign exchange, 141 Textiles and Clothing, 235, Factory system, 33, 34, 35–37 Foreign trade, expansion of, 41 413 Fair Labor Standards Act Foreign Trade Association European Parliament, 412–13 (FLSA), 158 (FTA), 415

Formal sector, 160
Forward integration, 261
Fourth-world countries, 54
France, adjustment strategy, 424
Free Enterprise of the Americas, 68
Free trade, 41
Free trade area (FTA), 59, 62, 68
Free trade era, 382
Free trade zones, 153–54
FTA (free trade area), 59, 62, 68
FTA (Foreign Trade Association), 415

GALs (Guaranteed Access Levels), 232, 316 GATT. See General Agreement on Tariffs and Trade (GATT) GCC (Gulf Cooperation Council), 76 General Agreement on Tariffs and Trade (GATT) basic principles, 341 China's participation in, 85-86 establishment of, 44, 340 integration schedule, 374, 375 Japan's admittance to, 342 Kennedy Round, 368-69 long-term arrangement, 347 - 48market disruption concept, 344 - 45MFA and, 361-62 most favored nation (MFN) principle, 44, 341 multilateral trade negotiations, 368-78 political pressures and, 537 short-term arrangement, 345 - 46Tokyo Round, 369-70 trade restrictions/ liberalization contradiction, 370 Uruguay Round, 211-12, 370-72, 376-78 Generalized system of

preferences (GSP), 380

Gentlemen's agreement, 198, 361 Germany adjustment strategy, 424 OPT usage, 238 textile industry development stage, 144 Gifford, Kathie Lee, 157, 159 Global cyberspace market, 13 Global factory, 129 Global interdependence, 2-4, 17-18, 20, 566-67 Globalization consumption patterns, 174-80, 514-16 defined, 20 development patterns, 115 economic, 2-4, 17-18 economic impact of, 555 employment patterns, 171-74 of fashion, 5, 20 interdependence and, 2-4, 17-18, 20, 566-67 of production and marketing, 444-50 production patterns, 5, 167–70 of retailing, 484-88, 561 social dimensions of, 555, 562 - 64of textile and apparel industries, 5-14, 17-18, textiles as a development barometer, 149-51 trade patterns, 180-99 of U.S. textile complex, 282 - 84Global products, 5, 20 Global quotas, 366 Global retailing, 484-88, 561 Global tracking systems, 13 GNP (gross national product), 52, 55–58, 264 Gold-exchange standard, 43 Gold standard, 42 Greater Europe, 62–63 Greige goods, 111, 263 Gross margin, 467 Gross national product (GNP), 52, 55-58, 264

Group ceiling limits, 352
Group of 77, 79–80, 350
Group of Three, 76
Growth on growth provision, 374, 375
GSP (generalized system of preferences), 380
Guaranteed Access Levels (GALs), 232, 316
Guaranteed market access, 442
Guilford Mills, Inc., 283
Gulf Cooperation Council (GCC), 76

Hargreave, James, 31 Harmonized Tariff Schedule, 401 Haves, Rita D., 394, 540 Heavy industry, 240 Heckscher, Eli, 105 Hollings, Ernest F., 345 Hollow corporations, 512 Home Shopping Network (HSN), 461 Hong Kong dumping allegations, 435 as fabric importer, 450 role as part of China, 208-10, textile exports, 342–43 textile imports, 189, 190 Horizontal integration, 275 HSN (Home Shopping Network), 461 Humanity, 88 Humphrey, Hubert, 348

IACC (International Anti-Counterfeiting Coalition), 404

IAD (Industry Assessment Division), 400

IAD (International Agreements Division), 402

IAF (International Apparel Federation), 395

IBERC (International Business and Economic Research Corporation), 410–11

ILGWU (International Ladies' Garment Workers' Union), 39, 320, 409 ILO (International Labour Office), 159-60, 393 IMF (International Monetary Fund), 43 Immigrants, in U.S. textile complex, 42, 258, 265 Imperial Preference System, 343 Import brokers, 404 Importers, 457, 459 Import penetration ratio, 298 Imports. See also Exports attitude toward, 457-59, 466-70, 477 costs and fees, 466-67, 475-76 defined, 21 from developing countries, 140, 341 fashion and, 467-68, 473 growth and effect of, 46, 274 impact on U.S. textile complex, 272 justifications for, 111 leading apparel importers, 195-96 leading textile importers, 189-91 mercantilism era, 40-41, 101 problems of, 470-77 records of, 182 retailers' attitude toward, 457-59, 466-70 textile mill products, 298-304, textile share by developed countries, 186-87 U.S. apparel sector, 195–96, 325-27, 429 U.S. import flow chart, 406 Import substitution, 41, 142, 338 In-bond production (maquiladora productions), Incentives, as economic choice, 96-97 India, 219, 222 Indonesia, 220 Industrial adjustment, 272

Industrial Revolution, 29-35 Industry Assessment Division (IAD), 400 Industry classification systems, 288-89 Industry structure, 261 Informal sector, 138, 153, 154, 160 Infrastructures, 130 Integration as adjustment strategy, 424 backward, 261 economic, 59 forward, 261 horizontal, 275 vertical, 261, 275 Intelligent manufacturing, 282 Interdependence, 2-4, 17-18, 20, 42, 566-67 Interest groups. See Lobbying and lobbyists Intermediate inputs, 20, 142 International activities, 20 International Agreements Division (IAD), 402 International Anti-Counterfeiting Coalition (IACC), 404 International Apparel Federation (IAF), 395 International Bank for Reconstruction and Development (World Bank), 54 International Business and Economic Research Corporation (IBERC), 410 - 11Internationalization of capital, International Labour Office (ILO), 159-60, 393 International Ladies' Garment Workers' Union (ILGWU), 39, 320, 409 International licensing, 446–47 International marketing, 450-54 International Monetary Fund (IMF), 43

International monetary system, International Organization of Consumers Unions (IOCU), 513-14 International retailers, 487 International Standard Industrial Classification (ISIC), 288 International Textile Manufacturers Federation (ITMF), 395 International Textiles and Clothing Bureau (ITCB), 358, 393–95, 559 International Trade Center (ITC), 393 Internet, 12, 461 Intrafirm trade, 111–13 Inventions, 31, 33, 35, 39 Inventory management, 269 Inventory replenishment strategies, 443 IOCU (International Organization of Consumers Unions), 513 - 14ISIC (International Standard Industrial Classification), Israel, free trade area agreement with U.S., 68 Italy adjustment strategy, 424 textile industry development stage, 143 ITC (International Trade Center), 393 ITCB (International Textiles and Clothing Bureau), 358, 393-95, 559 ITMF (International Textile Manufacturers Federation), 395 Japan admittance to GATT, 342

apparel exports, 194

economic development

leader, 205, 206-7

negotiations with U.S., 349–50 per capita fiber consumption, 180 and sogo shosha, 148 textile exports, 339, 340 textile imports, 189–90 textile industry changes, 561-62 textile industry development stage, 143, 338 textile production in, 139-40, 168-69 J.C. Penney, 461 Jefferson, Thomas, 35 Jenkins, Edward, 365 Jenkins bill (Textile and Apparel Trade Enforcement Act of 1985), 357, 364–66, 370, 481, JIT (just-in-time) responses, 279 Jobbers, 311 Jockey International, 445, 447 Ioint ventures, 217, 448 J.P. Stevens, 276 Just-in-time (JIT) responses, 279 Jute, 222 Kay, John, 31

Kay, John, 31 Kellwood Company, 445 Kennedy, John F., 345, 347, 368, 523 Kennedy Round, 368–69 Kernaghan, Charles, 157, 159 Korea, 212–13, 435 Krugman, Paul, 154

Labor. See also Child labor;
Employment; Wages
for apparel industry, 39,
319–20
Chinese costs of, 216
in contracting system, 157–58
division of, 101
domestic, protection of, 431
forced, 160
industrial reform movement,
37–39
migration of, 41–42
monitoring and reform
efforts, 159–61

new international division of, 128-31, 549 productivity, effect on, 296 redundant workers, 235 relative cost principle, 103 sweatshops, 154, 157-59 trade and labor standards, 161, 164 unionization of, 39, 250, 320, 409, 422, 524–25 women workers, 36–37, 152-55, 258, 265 Labor, U.S. Department of (DOL), 398 Labor theory of value, 103 Laissez-faire philosophy, 101, 337 Lancashire Pact, 343 Land-to-capital relationships, 105 Language, 91 Laos, 221 Latin America, 66–68, 69 Law of demand, 98-99 Law of supply, 97 Lead time, 313, 472–73 Leapfrogging, 219 Lebedev, Valentine, 245 Lenahan, Walter, 411 Less-developed countries. See Developing countries Level of living, 54 Leveraged firms, 276 Levi Strauss & Co., 160, 280, 283, 445 Liebenow, Larry, 69 Light industry, 242 Lights-out plants, 426 Lobbying and lobbyists consumer organizations, 513 - 14consumers' perspective, 500-501 costs of, 506 early, 35 for foreign embassies, 405 international interest groups, 393-95 national interest groups, 407 - 11

pressure on policymakers, 519, 524–26 tactics, 528–33 Logistics, 14–15 Long-term Arrangement Regarding Trade in Cotton Textiles (LTA), 347, 523 Lowell, Francis Cabot, 36 LTA (Long-term Arrangement Regarding Trade in Cotton Textiles), 347, 523

Maastricht Treaty, 62 Macroeconomics, 20–21 Mainstream/modernization theories of development, 115 - 19Malaysia, 220 Man-Made Fiber Producers Association, 408 Manufactured fibers. See also Natural fibers in Japan, 206 production of, 143 in Taiwan, 208 in U.S., 262, 293–94 Manufacturers, 310–11 Maguiladora productions (inbond production), 228 Markdowns, 280, 471 Market, defined, 81 Market access, 377, 442 Market-directed economies, 82-83, 196-97 Market disruption, 344 Market Expansion Division, 402 Market for Eastern and Southern Africa (COMESA), 76 Marketing cultural problems, 90, 453

global arrangements, 444–50 industry initiatives, 443–44 international considerations, 450–54 micromarketing, 4, 485 orientation, 269, 318 strategies for apparel industry, 318

Markets for apparel industry, 315-18 closed, 438 guaranteed access, 442 specialized niches, 278-79 Marks and Spencer, 478 Markups, 461 Mass merchandisers, 460 Matrix buying, 462 Mature industry, 206 Mauritius, 249-50 McDermott, Jim, 542 Mechanization, 426 Megatrends Asia (Naisbitt), 72 Mercantilism, 40-41, 101 Merchandise trade, 183 Merchandise trade balances, 101 Merchant capitalism, 121 MERCOSUR or MERCOSUL (Southern Cone Common Market), 69, 76 Mexico apparel supplier to U.S., 322 - 23NAFTA's effects on, 65-66, 228-29, 315 policy structures, 412 textile and apparel industry in, 226-29 U.S. textile machinery buyers, 306 MFA. See Multifiber Arrangement (MFA) MFN (most favored nation) principle, 44, 341 Microeconomics, defined, 20 Micromarketing, 4, 485 Mills, Wilbur, 364 Mills bill, 364 Minimum viable production, 358 MNCs (multinational corporations), 111-13 MNEs (multinational enterprises), 446 Mod Act (Customs Modernization and Informed Compliance Act), 404

Mohair subsidies, 437. See also

Natural fibers

Monsanto, 293-94 Monsoon Asia, 72-75 More-developed countries. See Developed countries Morocco, 249-50 Most favored nation (MFN) principle, 44, 341 Mule, 31 Multifiber Arrangement (MFA), anti-surge provision, 356 bilateral agreements, 351-52 call mechanisms, 355 category system, 352 criticisms of, 361-62, 550-51 development of, 348-50 end of, 364 extended fiber coverage, 358, 359 features of, 353 GATT and, 361-62 growth rate quotas, 354 impact of, 559-61 MFAI (1974–1977), 350–53 MFAII (1977–1981), 353–55 MFAIII (1981-1986), 355-57 MFAIV (1986–1991), 357–59, minimum viable production clause, 358 operation of, 363-64 participants in, 568-69 retail opposition, 481 Multilateral agreements, 346 Multilateral approach to trade problems, 340 Multilateral trade negotiations Kennedy Round, 368-69 Tokyo Round, 369-70 Uruguay Round, 211-12, 370-72, 376-78 Multinational corporations (MNCs), 111-13 Multinational enterprises (MNEs), 446 Myanmar, 221

Multinational corporations (MNCs), 111–13
Multinational enterprises (MNEs), 446
Myanmar, 221
NAFTA. See North American Free Trade Agreement (NAFTA)

NAICS (North American **Industry Classification** System), 288-89, 290, 291 Naisbitt, John, 72 National Governors Association (NGA), 18 National Retail Federation (NRF), 410, 482, 526 National Retail Merchants Association (NRMA), 410, 466 Nation-states, 101 Natural fibers. See also Cotton; Manufactured fibers jute, 222 production of, 141, 262 ramie, 358, 359 in U.S., 293 wool subsidies, 437 Nepal, 223 New international division of labor, 128-31, 549 New International Economic Order (NIEO), 80 Newly emerging countries, 139 Newly industrialized countries (NICs). See also Developing countries defined, 21, 53 offshore production of, 322 structural development and, 122 New producer nations, 140 NGA (National Governors Association), 18 NICs. See Newly industrialized countries (NICs) NIEO (New International Economic Order), 80 Nike marketing approach, 90 9802 (formerly 807) production, 230, 314, 316 Nixon, Richard, 44, 348-49, 364, 523 Nonbinding quotas, 511 Noncellulosic fibers, 293 Nondurable goods, 265 Nonstore retailing, 461 Nontariff barriers (NTBs), 369,

502 - 3

lobbying tactics, 528–33

PACs and, 530, 531

North America, textile industry in, 224-32 North American Free Trade Agreement (NAFTA), 76 Canada, impact on, 65-66, 226 creation of, 65-66, 380-81 Mexico, impact on, 65-66, 228-29, 315 opposition to, 381 political debate over, 531-33, 535 provisions, 382 retailers' position on, 381, 482 textile industry support, 381 North American Industry Classification System (NAICS), 288-89, 290, 291 North American Textile Council, 411 North-South dialog, 79 North-South divisions, 78-80 NRF (National Retail Federation), 410, 482, 526 NRMA (National Retail Merchants Association), 410, 466 NTBs (nontariff barriers), 369, 502 - 3

OAP (Overseas Assembled Provision), 224 Observatoire Européen du Textile et de l'Habillement (OETH), 235, 413 Occupational Safety and Health Act (OSHA), 429 OECD (Organization for Economic Cooperation and Development), 80, 393 OETH (Observatoire Européen du Textile et de l'Habillement), 235, 413 Office of Textiles and Apparel (OTEXA), 398, 400, 401 Offshore production, 309, 322 Ohlin, Bertil, 105 Omnibus Trade and Competitiveness Act of 1988, 367-68

OPA (outward processing arrangements), 209 OPEC countries, structural development and, 122 Open economy, 222 Open-to-buy funds, 473 Opportunity costs of resource use, 96 OPT (outward processing trade), 209, 237-39 Organization for Economic Cooperation and Development (OECD), 80, 393 Ormerod, Allan, 558 OSHA (Occupational Safety and Health Act), 429 OTEXA (Office of Textiles and Apparel), 398, 400, 401 Outsourcing. See Sourcing (outsourcing) Outward processing, 237–39 Outward processing arrangements (OPA), 209 Outward processing trade (OPT), 209, 237-39 Overseas Assembled Provision (OAP), 224 Overseas buying efforts, 464 Overshipping, 474

PACs (political action committees), 530, 531 Pakistan, 222 Parity, 72 Pattern of work, 312 Per capita fiber consumption, 175 Per capita gross national product, 52 Perot, Ross, 381 Philippines, 221 Plant closings, 275, 425-26 Point of sale (POS) information, 279 Policymakers. See also Textile trade policies global politics and, 533-43

and labor organizations,

524-26

pressure on, 519, 522-26 Political action committees (PACs), 530, 531 Political systems, 83–84 **Politics** effect on trade, 198, 199, 519-22 lobbying tactics, 528–33 NAFTA delegate, 531–33, 535 on global level, 533-43 Porter, Michael, 107 POS (point of sale) information, Postindustrial Western Europe, Power retailers, 460–61 Prebisch, Raúl, 120 Predatory dumping, 435 Pressure groups, 481 Price averaging, 467 Price deflation, 317 Prices apparel, 493 equilibrium, 99, 100 low-cost imports, 498-99 markups for imported goods, 466-67 and protectionism, 503-4 textile, 496 Private labels, 317, 461-62, 468 Privately held firms, 276 Privatization, 241 Product cycle theory, 106-7 Production. See also Apparel production; Offshore production; Outward processing trade (OPT); Textile production communications advances, 12 - 13global arrangements, 444-50 global patterns of, 5, 167-70 global shifts in, 548-50 outsourcing, 128-29 value-added, 206, 219, 265 Production economies of scale, 312

Production orientation, 318 Production sharing, 129-31 Productivity, 173, 296, 312, 424, Protection and protectionism. See also Quotas; Subsidies; Tariffs: Textile trade policies Congress and, 524-26 consumer costs of, 501-11 emergence of, 35, 41, 42-43, 337 - 40executive branch and, 523-24 justifications for, 430-32, 521 - 22legislative approaches, 527-28 unexpected outcomes, 440-43 Protestant ethic, 89 Publicly held firms, 276

QR (quick response), 279–80, 318, 477-78, 553 Quality issues, 470–72 Quality Value Convenience (QVC) channel, 461 Ouick response (QR), 279-80, 318, 477–78, 553 Ouota flexibility, 353 Quota premium, 504 Quotas. See also Protection and protectionism; Tariffs binding, 511 consumer costs, 501–2, 504–5 country of origin rules, 211, 480 defined, 316 gentlemen's agreement on, 198 global, 366 Hong Kong and, 209, 211 importance of, 314 nonbinding, 511 retailers and, 474-75, 481 under STA, 346 tariffs, comparisons with, 338 unexpected outcomes of, 440-43 welfare loss, 510 QVC (Quality Value

Convenience) channel, 461

R&D (research and development) expenditures, 293 Ramie, 358, 359 Rationalization, 272, 422, 423 - 24Rationing, as economic choice, 96-97 Reagan, Ronald, 365, 523 Reciprocity, 434 Redundant workers, 235 Reexports, 208, 210 Regressive costs, 506 Reich, Robert, 157, 159 Relationship building, 484 Research and development (R&D) expenditures, 293 Restructuring, 204, 275-76, 460, 483 Retailers and retailing apparel market, 317–18 and apparel production, 159 catalog sales, 461 channel relationships, 462-63, 483-84 conflict with suppliers, 457-59 consumer demand and, 266-68 country of origin rules, 211, 480 domestic buying movement, 478 - 79globalization of, 484-88, 561 imports, attitudes toward, 457-59, 466-77 matrix buying, 462 NAFTA support, 381, 482 overview of, 459-62 political actions, 481–83 power retailers, 460-61 private label lines, 461-62, 468 private label programs, 317 quotas and, 474-75, 481 rapid replenishment, 443 restructuring efforts, 460, 483 sourcing strategies, 463-66 textile trade policies and, 479 - 83

Retail Industry Trade Action
Coalition (RITAC), 365,
410, 481–82
Retaliation, 431, 506
Ricardo, David, 103
RITAC (Retail Industry Trade
Action Coalition), 365, 410,
481–82
Riverside Manufacturing
Company, 451
Rules of origin, 357. See also
Domestic content laws
Russia, 245–47

SACU (Southern African Customs Union), 76 SADC (South African Development Community), Safeguard mechanisms, 374 SAFTA (Southern American Free Trade Area), 76 Sara Lee Corporation, 276, 283-84, 445 Sato, Eisaku, 349 Scarcity, as economic choice, 96 Scarcity rent, 504 Scrambled softgoods chain, 276, 277 Sears, 461 Second-world countries, 53 Section 204 of the Agricultural Act of 1956, 396-98 Semidurable goods, 266 Service economies, 522 Sewing machine, 39, 40 Sewn products industry, 20 Shipments, 215, 273 Short-Term Arrangement Regarding International Trade in Cotton Textiles (STA), 345-46, 523 SIC (Standard Industrial Classification) system, 288 Silk industry, 216–17 Singapore, 220 SITC (Standard International Trade Classification) system, 182

Slater, Samuel, 35, 36 Smith, Adam, 41, 101, 337 Smokestack industries, 520 Smoot-Hawley Tariff Act of 1930, 43 Social changes, 235–36 Social costs, 235–36 Social institutions, 88 Socialist economic systems, Softgoods chain defined, 20 integration of, 478 introduced, 261, 266-68 relationships within, 278 scrambled, 276, 277 traditional, 275 Softgoods industry consumer impact on, 492 defined, 20 Sourcing (outsourcing) in the ASEAN region, 219 in Caribbean basin, 229 costs, 313 globalization of, 446 introduced, 128-29 retail use of, 463-66 side effects of, 147–48 strategies, 312-13 South Africa, 250 South African Development Community (SADC), 76 South America, 66-68, 69, 232 - 34South Asia, 219-23 Southern African Customs Union (SACU), 76 Southern American Free Trade Area (SAFTA), 76 Southern Cone Common Market (MERCOSUR or MERCOSUL), 69, 76 South Korea, 212-13, 435 Special interest groups. See Lobbying and lobbyists Special protection. See Protection and protectionism Spinning jenny, 31

Sri Lanka, 223

STA (Short-Term Arrangement Regarding International Trade in Cotton Textiles), 345-46, 523 Standard Industrial Classification (SIC) system, Standard International Trade Classification (SITC) system, 182 Stans, Maurice, 349 State, U.S. Department of (DOS), 398 Static costs, 503 Stockouts, 280 Structural adjustment. See Adjustment strategies Structural decline, 521 Structural theories of development, 119-25 Structural unemployment, 296, 521 Subcontractors, 158 Subsidies, 436-37. See also Protection and protectionism Sunrise industries, 521–22 Sunset industries, 520 Super 301 provision, 368 Sweatshops, 154, 157-59 Synthetic fibers, 293 T&DD (Trade and Data

Division), 402 Tagliani, William, 394 Taiwan, 207-8, 435 Taiwan Textile Federation (TTF), 207 TALC/SAFLINC (Textile, Apparel and Sundries Linkage Council), 278 Tariffs. See also Protection and protectionism; Quotas as adjustment strategy, 424 as apparel cost factor, 475-76, 501 in Australia, 224 consumer costs, 501, 504 effects on costs, 301 emergence of, 35, 41, 42

harmonized system, 401 highly restrictive levels, 437 - 38as import protection, 368 9802 provision, 230, 314, 316 quotas, comparison with, 338 Smoot-Hawley Act, 43 welfare loss, 510 Technology as adjustment strategy, 276-77, 424 in apparel industry, 311–12 in communications, 10-13 early inventions, 31, 33, 35 fiber production and, 295 leapfrogging, 219 in material culture, 88 textile production, 296 trade, influence on, 197 transforming, 4-5 U.S. investments in, 276-77 and virtual companies, 132 Technology transfer, 218 Textile, Apparel, and Footwear Act of 1990, 367 Textile, Apparel and Sundries Linkage Council (TALC/SAFLINC), 278 Textile and Apparel Trade Act of 1987, 366, 481–82, 509 Textile and Apparel Trade Enforcement Act of 1985 (Jenkins bill), 357, 364–66, 370, 481, 509 Textile complex. See also Apparel industry; Textile industry; Textile machinery industry; Textile mill products industry; United States textile complex Africa, 247-50 Asia, 204-23 Australia, 223-24 Baltic states, 240-43, 244 Central and South America, 232 - 34Commonwealth of Independent States

(CIS), 240–43, 244–47

defined, 18-19

Eastern Europe, 240–44 North America, 224–32 Textile components industry, 295-305 Textile consumption, 175 Textile Fiber Products Identification Act, 444 Textile industry. See also Adjustment strategies; Apparel industry Canadian, 224-26 capacity utilization rate, 295-96, 297 child labor in, 155-57 China's impact on, 213-18 competition among developing countries, 145-47, 148 competition in, 21–23 competitiveness factors, 175, 422, 429-30 conflict with retailers, 457–59 consumer expenditures, 492-96 defined, 19 development patterns in, 149 - 51development stages, 141-44, 145-48 global competition, 46–47 global perspective on, 5–14, 17–18, 445–46 history of, 28-39, 139-40, 292 import flow chart, 406 and the Industrial Revolution, 29-35 interdisciplinary perspective, in Japan, 143, 338, 561–62 job losses in, 45–46, 422, 425–26, 428–29 logistics, growth of, 14–15 marketing initiatives, 443 in Mexico, 226–29 NAFTA support, 381 reform movement, 37-39 transnational corporations' role in, 113 in U.S., 143, 289-307 Textile machinery industry, 305–7

Textile machinery manufacturing industry, 263 - 64Textile mill products industry exports, 304-5, 429 imports, 298-304, 429 in Mexico, 227 outlook for, 305 trade and, 298 in U.S., 262-63, 295 Textile Monitoring Body, 376 Textile production. See also Fibers; Manufactured fibers; Natural fibers developing countries and, 9-10, 28, 139-40, 145-47, 148, 184–85 and development theories, 125 - 28economic and political systems' effects on, 84–86 employment patterns, 171-74 as employment source, 5, 7 factory system development, 33, 34, 35–37 global overcapacity, 151-52 global patterns, 168–70 technology for, 296 Textiles Division of WTO, 390-91 Textile sector, defined, 19 **Textiles Monitoring Body** (TMB) of WTO, 391, 392 **Textiles Surveillance Body** (TSB) of WTO, 353, 391 Textile trade. See also Apparel trade; Textile trade policies; Trade consumer gains from, 496-500 global share, 183-84 leading exporters, 188-89 in less-developed countries, 184 - 85patterns of, 185–88 politics of, 198, 199, 520-26 SITC classification, 182 Textile trade associations for exporting nations, 411

Textile trade policies. See also Apparel trade; General Agreement on Tariffs and Trade (GATT); North American Free Trade Agreement (NAFTA); Policymakers; Protection and protectionism; Textile trade Agreement on Textiles and Clothing (ATC), 372–78 closed or partly closed markets, 438 development of, 337-45, 360 dumping, 435 European interest groups, 414 EU structures, 412–15 fair trade demands, 432-40 foreign aid, 438-40 future outlook for, 559-61 generalized system of preferences (GSP), 380 global pressures on, 533–43 global shifts in production, 548-49 international structures, 388 - 95legislative approaches, 364–68, 527–28 long-term arrangement, 347 - 48multifiber arrangement, 348 - 64multilateral trade negotiations, 368-78 NAFTA, 380-82 North American structures, 411 - 12overview of, 379 restrictive tariffs, 437–38 retailers and, 479-83 short-term arrangement, 345 - 46subsidies, 436-37 Textile visas, 404 Thailand, 220 Third-world countries, 53–54 TMB (Textiles Monitoring Body) of WTO, 391, 392

TNCs (transnational corporations), 111-13, 446 Tokyo Round, 369-70 Total Quality Management (TQM), 280 Trade. See also Apparel trade; Textile trade; Textile trade policies American agreements, 65-72 arm's-length, 110-11 Asian integration effects, 74-75 balance of, 101 Central and Eastern Europe cooperation, 63-65 and development patterns, 114-15 European Union (EU), 60-63 fair, 432-40 fiber industry, 294-95 global patterns of, 180-99 importance of, 95-96 influences on, 196-99 intrafirm, 111-13 labor standards and, 161, 164 market forces regulation, 42 mercantilism era, 40-41, 101 regional blocs, 60, 75-78 specialization for, 100, 197-98 textile mill products industry, 298 theories of, 100-110 voluntary exchange, 99 Trade adjustment, assistance, 369 Trade and Data Division (T&DD), 402 Trading blocs, 60, 75–78 Trading with the Enemy Act, 349n. Traditional softgoods chain, 275 Transition economies, 53 Transnational corporations (TNCs), 111-13, 446 Transportation systems, 13, 130 Transshipping activities, 212 Treasury, U.S. Department of (DOT), 398 Triple transformation provision, 381

TSB (Textiles Surveillance Body) of WTO, 353, 391 TTF (Taiwan Textile Federation), 207 Tunisia, 249–50 Turkey, 245

UNCTAD (United Nations Conference on Trade and Development), 79, 350, 391, 393 Underdevelopment, 115 Underground economy, 160 Unilateral restraints, 347 Unionization of Labor, 39, 250, 320, 409, 422, 524-25 Union of Needletrades, Industrial and Textile Employees (UNITE), 250, 320, 409, 422, 525 United Nations Conference on Trade and Development (UNCTAD), 79, 350, 391, 393 United States. See also United States textile complex apparel exports, 193, 194, 325, 327, 429, 448 apparel imports, 195-96, 322-23, 325-27, 429 apparel industry, 307-27 bilateral agreements with Asian countries, 350 bilateral agreements with Canada, 65, 350 child labor, 36-37 country of origin rules, 211-12 fiber industry, 292-95 foreign aid policies, 438-40 free trade area agreement with Israel, 68 and global interdependence, 17 - 18import flow chart, 406 labor reform efforts, 160-61 NAFTA's effects on, 65-66 per capita fiber consumption, 180, 182 politics of textile trade, 198,

199, 520-26

protectionism, 35, 41, 42–43 sweatshop operations, 158 - 59textile development, 33-36, textile exports, 188, 189, 305 textile imports, 189, 190 textile industry, 143, 289-307 textile machinery industry, 305 - 7textile mill products industry, 262-63, 295 trade negotiations with Japan, 349-50 trade policies and Caribbean basin, 230-31 United States Association of Importers of Textiles and Apparel (USA-ITA), 410 United States textile complex adjustment strategies, 272-73, 422, 423-28 challenges to, 271-72 changes in, 273-82 competition and, 271-75, 422, 429 - 30consumer demand, impact of, 266 - 71contributions to GNP, 264 economic importance of, 258-61, 264-66 employment in, 258, 264-65 end-use products, 261, 263 foreign investment in, 284 in global market, 282-84 immigrants' role in, 42, 258, 265 segments of, 261–64 textile machinery, 263-64, textile mill products, 262-63, 295 United States Trade Representative (USTR), 398, 537 United Tailoresses, 38n. Universal Product Coding (UPC), 279n. Upstream activities, 20

Uruguay Round, 211–12, 370–72, 376–78 USAIC (U.S. Apparel Industry Council), 409 USA-ITA (United States Association of Importers of Textiles and Apparel), 410 USITC (U.S. International Trade Commission), 402–3 USTR (United States Trade Representative), 398, 537

Value-added products, 206, 219, Van den Bergh, Van Benthem, 119 Velocity costs, 313 Vendors, 443 VER (voluntary export restraint), 339, 342 Vereen, Jerry, 451 Vertical integration, 261, 275 Vertical retailing, 464 VICS (Voluntary Interindustry Communications Standards Committee), 278 Vietnam economic system, 81-82 textile and apparel production in, 221 Virtual companies, 132 Voluntary exchange, 99 Voluntary export restraint (VER), 339, 342 Voluntary Interindustry

Communications

(VICS), 278

Standards Committee

Wages. See also Employment; Labor in apparel production, 157, 173-74, 319-20, 463, 469, Chinese textile workers, 216 in CIS countries, 245-46 in Eastern Europe, 242 for maquila workers, 228 reduction of, 38 in Western Europe, 237 of women, 37, 153-54, 319 Wallace, George, 348 Wallerstein, Immanuel, 120 Wal-Mart Stores, Inc., 478–79, 485 Waltham system, 36-37 Walton, Sam, 479 War of 1812, 35 Water frame, 31 Wealth of Nations (Smith), 101 Web (World Wide Web), 12, 461 Weber, Max, 89 Welfare costs of protection, 507-9 Welfare loss from tariffs or quotas, 510 Western Europe economic integration in, 60 - 63fiber industry, 295 national characteristics, 59-60 postindustrial, 239 textile complex, 234-40 textile industry development stage, 144 textile trade policies, 343 WestPoint Stevens, 276 Whitney, Eli, 31, 35

Whittier, John Greenleaf, 36 Women employment of, 36-37, 152–55, 258, 265 and reform movement, 37-39 in textile and apparel production, 152–55 wages of, 37, 153-54, 319 Wool Products Labeling Act, 444 Wool subsidies, 437 World Bank (International Bank for Reconstruction and Development), 54 World-systems theory, 120 World Trade Organization (WTO) China's participation in, 85-86 GATT replaced by, 44, 372, 388-90 political pressures on, 538 Textiles Division, 390–91 Textiles Monitoring Body (TMB), 391, 392 Textiles Surveillance Body (TSB), 353, 391 trade blocs and, 77 World Wide Web (Web), 12, 461 WTO. See World Trade Organization (WTO)

Yarn-forward provision, 381 Yarn production, 263. See also Natural fibers Yugoslavia, 238–39

Zelnik, Michel R., 10-11

Glossary Index

Absolute advantage, 134 Adjustment, 286, 330 Adjustment costs, 516 Ad valorem tariffs, 516 Aggregate demand, 134 Agile manufacturing, 134 Agility, 134 Agreement on Textiles and Clothing (ATC), 383 Anti-dumping duties, 455 Apparel licensing, 330 Apparel marketing, 330 Apparel merchandising, 330 Apparent consumption, 330 Arm's length trade, 134 Arrangement Regarding International Trade in Textiles, 383-84 Artificial fibers, 330 Automatic replenishment, 285

Backward integration, 285 Balance of trade, 134 Barriers to entry, 285 Bilateral agreements, 384 Binding tariffs, 384, 516 Bonded warehouses, 252 Bound tariffs, 516 Burden sharing, 384

Call mechanism, 384 Canada-U.S. Free Trade Agreement (CFTA), 384 Capacity utilization rate, 330 Capital, 48 Capital deepening, 455 Capital-intensive products, 134 Capitalism, 48 Capitalist economic systems, 92 Capitalists, 48 Category, 384 Centrally planned system, 92 Channel control, 489 Channel of distribution, 489 c.i.f. values, 285 Circumvention, 384 Closed economy (or market), 252 Common market, 92 Company, 286 Comparative advantage, 134 Competitive advantage, 134 Compradors, 134 Concentration, 285 Concentration ratio, 285 Congressional Textile Caucus, 417 Consultation call, 384

Consumer confidence, 285

Consumer expenditure, 201

Counterpressure group, 489

Cottage industries, 165

Contracting, 165

Consumer cost of protection, 516

Countervailing duties, 384, 455 Country of origin, 252 Culture, 92 Customs union, 92 Customs value, 285 Cut-make-trim (CMT), 165

Deadweight losses, 517 Deindustrialization, 134 Dependency theory, 134 Devaluation of currency, 48 Development, 92, 134 Direct foreign investment, 134 Direct investment, 455 Discriminatory restrictions, 384 Distribution channel, 286 Division of labor, 134 Domestic content laws, 516 Domestic production, 286 Downsizing, 286 Dumped products, 455 Durable good, 286 Duty, 49, 386 Dynamic costs, 516

Economic development, 93 Economic integration, 93 Economic nationalism, 49 Economic system, 93 Economic union, 93 Economies of scale, 330 Economy, 93 807A, 330 807 production, 330 Electronic data interchange (EDI), 455 Embargoes, 49, 489 End-use products, 286 Entrepôt, 252 Equilibrium price, 134 Establishment, 286 Ethnocentrism, 93 Euro, 93 Exchange rates, 201 Exporting countries, 384 Export license, 417 Export processing zones, 165 Exports, 49, 201-2

Export subsidies, 455
Factors, 489
Factors of production, 93, 134
Fair trade, 455
f.a.s. (free along side), 286
Fast track authority, 384
Fiber consumption, 202
Fiber, Fabric and Apparel Coalition for Trade (FFACT), 384
Firm, 286
First cost, 489
Floating exchange rates, 49
F.O.B. (free on board), 202

Forced labor, 165

Foreign direct investment (FDI), 93 Foreign exchange, 165 Foreign trade zone, 165, 202 Formal sector, 165 Forward integration, 286 Free trade, 49, 384 Free trade area (FTA), 93 Free trade zone, 165, 202

Gains from trade, 517 Generalized System of Preferences (GSP), 49, 384 Gentlemen's agreement, 202 Global quotas, 384 Global retailers, 490 Global retailing, 490 Gold-exchange standard, 49 Gold standard, 49 Greige goods, 134, 330 Gross domestic product (GDP), 93 Gross margin, 490 Gross national product (GNP), 93 Gross profit, 490 Growth on growth, 384 Guaranteed access levels (GALS), 330

Harmonized System, 384–85 Harmonized Tariff Schedule, 384–85 Heavy industry, 253 Horizontal integration, 286

Import brokers, 417 Import duties, 386 Importers, 490 Importing countries, 385 Import penetration ratio, 330 Imports, 49, 201-2 Import substitution, 49, 165, 385 In-bond production, 253 Indirect subsidies, 93 Industrial adjustment, 286 Industrialized countries, 49 Industrial Revolution, 49 Industry strategy, 455 Industry structure, 286 Infant industry protection, 385 Informal sector, 165 Infrastructures, 134 Integration, 385 Interest group, 417 Intermediate inputs, 165 Internationalization of capital, 134 International marketing, 455 International monetary system, 49 International regime, 385 International retailers, 490 International Standard Industrial Classification (ISIC), 330-31

Classification (ISIC), 330– Intrafirm trade, 134 Inventory management, 286 Inventory replenishment, 455 ISO 9000, 253